Aaron Marks' Complete Guide to Game Audio

For Composers, Sound Designers, Musicians and Game Developers

Aaron Marks' Complete Guide to Game Audio

For Composers, Sound Designers, Musicians and Game Developers

Third Edition

Aaron Marks

CRC Press
Taylor & Francis Group
Boca Raton London New York

CRC Press is an imprint of the
Taylor & Francis Group, an **informa** business

AN A K PETERS BOOK

CRC Press
Taylor & Francis Group
6000 Broken Sound Parkway NW, Suite 300
Boca Raton, FL 33487-2742

© 2017 by Taylor & Francis Group, LLC
CRC Press is an imprint of Taylor & Francis Group, an Informa business

No claim to original U.S. Government works

Printed on acid-free paper

International Standard Book Number-13: 978-1-138-62885-4 (Hardback)
978-1-138-79538-9 (Paperback)

Library of Congress Cataloging-in-Publication Data

Names: Marks, Aaron, author.
Title: Aaron Marks' complete guide to game audio : for composers, sound designers, musicians and game developers / Aaron Marks.
Other titles: Complete guide to game audio
Description: 3rd edition. | Boca Raton : Taylor & Francis, 2017. | Includes index.
Identifiers: LCCN 2016033210 | ISBN 9781138795389 (paperback : acid-free paper)
Subjects: LCSH: Sound--Recording and reproducing--Digital techniques. | Computer games--Programming.
Classification: LCC TK7881.4 .M368 2017 | DDC 794.8--dc23
LC record available at https://lccn.loc.gov/2016033210

Visit the Taylor & Francis Web site at
http://www.taylorandfrancis.com

and the CRC Press Web site at
http://www.crcpress.com

Printed and bound in the United States of America by Sheridan

*To the two most wonderful women in my world—Cynthia,
my wife, and Kristina, my daughter. Without their love,
inspiration and support, this book would not have been possible.*

Contents

Foreword

By Keith Arem

For the past 20 years, I've had the privilege to be involved in one of the most fascinating and dynamic professions in the entertainment industry. Composing, directing, and producing for video games is a challenging entertainment career—every bit as exciting as, if not more exciting than, working in the film or television industry. The game industry is a diverse and changing world, and this book can be your passport to a rewarding and fruitful profession.

The Industry Then

People often ask me how I got started in the games industry. Being a talent director, game composer, or sound designer isn't the most well-known profession—so how does someone actually get started?

Well, the first rule of thumb is…you have to love games!

Defender, Tempest, Berserk, Asteroids, Choplifter, Battle Zone, Phoenix, Sinistar, Dragon's Lair, Spy Hunter—those were the glorious programs that shaped my early childhood growing up. Sure my education revolved around math, social studies, English, and all the usual school requirements—but video games influenced me in ways that no class ever could. Games opened my eyes to new worlds, new ideas, and especially new sounds.

As a child, I remember watching *Tron* in the theater and thinking how amazing it would be to live in a universe of games. My wish was soon answered when my father brought home an Apple computer for our family. I quickly realized that this new technology altar was much better equipped as a home gaming console than a mere family word processor.

As I got older, I discovered I could combine my love of computers with my love of music. My passion for synthesizers and performing in bands birthed a whole new career. Throughout high school (much to my parent's dismay), I would drag our family computer to my local gigs and sequence live on stage. After high school, I went on to earn my bachelor's degree in audio engineering and electronic music synthesis—which perfectly merged my passion for computers with music and recording. I was fortunate enough to be offered my first record contract my

freshman year of school, and eventually signed a recording deal with my band Contagion on Capitol Records during my senior year.

Even on tour, I couldn't escape my passion for games. One of my fondest memories from our first North American tour was playing *Street Fighter* in the back of the tour bus between cities. One concert, we even hooked our Nintendo to the other band's video projection wall and played a match on their screens during the performance.

When I returned from touring, I decided to make my introduction into the game industry by working with a local developer in Los Angeles. After quickly learning the ropes with early console development, I was approached by Virgin Interactive to become their in-house staff composer. Within a year, I was promoted to their Director of Audio and began supervising all music and sound for Virgin's internal and external titles. Directing audio for one of the largest game publishers in the United States and Europe gave me a fantastic first-hand education, and an incredible working experience in one of the fastest growing industries of its time.

After several years working as an in-house director, I decided it was finally time to go out on my own, and launch my own facility. I established PCB Productions in 2000 to focus on AAA game audio. Since starting my own company, I have had the incredible honor and opportunity to work with some of the industry's finest developers, publishers and talent. Over the past several years, I have been fortunate to be part of many successful franchises, including *Call of Duty, Tony Hawk Pro Skater, Titanfall, Ridge Racer, Ghost Recon, Prince of Persia, Spiderman, Persona, Star Wars*, and many, many others.

The Industry Now

The games industry can be a creative, exciting, and challenging place for musicians and sound designers. Through sound and music, a game can completely immerse a player in another universe or reality. The creative freedom to manipulate moods, environments, and atmospheres is limited only by the technical capabilities of the machine and a designer's imagination.

While being creatively liberating, interactive game audio can also be technically demanding. Scoring and designing audio for games can often be much more challenging than motion pictures, due to the simple fact that games are, by nature, nonlinear. A simple example of this can be demonstrated by a car passing the camera. In a film or television program, where the picture is established and consistent, the image of the car pass-by is a linear time-established scene that can be scored, synchronized, recorded, and mixed by a sound designer or musician. By contrast, in a 3D game environment there can be hundreds of variables that determine how and where the car exists within a 3D space. Because a player can view the car from a multitude of angles, the sound must be capable of being manipulated to match the image from any viewpoint. A simple car sound may need to be looped, layered, panned, pitch-shifted, down-sampled, and format converted—just to accommodate a simple car-pass sound.

Another significant difference from films is that an audio designer typically doesn't always have control to "mix" the sounds in-game, because many titles allow sounds to be individually manipulated and triggered based on gameplay.

In a real-time game environment, there may be hundreds of pieces of dialog, music, ambience, and Foley sound effects—each with its own volume, pitch, and positioning within the 3D environment. It's generally up to the sound engine and programmer's code to determine how these elements will be mixed real-time in the game. (It's no wonder that even the most amazing sound effect or piece of music can become utterly annoying if it is played incorrectly or too repetitively in a game!) It's important for audio designers to learn as much about how their sounds will be *implemented*, as much as how their sounds are *created*. Having a strong understanding of game mechanics, programming techniques, and platform limitations will make your life much easier.

Until recently, software sound design had not been recognized as a highly-regarded profession—mainly due to the poor *fidelity* of most consoles. In the past, PC speakers and console systems had limited audio quality and kept the resolution of sound to a minimum. In recent years, there has been a strong focus on sound in games—and next-generation systems and speakers have made great strides to address the memory and bandwidth for audio. Dolby encoding, steaming, surround speakers, and increased memory have given sound professionals a whole new field to play on.

Another fascinating aspect of games is that our technology is continuously changing. With every new technology development, enhanced software package or hardware device, each new game title strives to out-perform the previous one. As technology improves each year, every title attempts to find new ways of becoming faster, bigger, and louder than before. For an audio professional, this means constantly adapting to new systems, recording techniques, and compositional methods to keep up with an ever-evolving industry.

Because the games industry is a "hit-driven" business, many titles are based on well-known established properties or major motion pictures. Almost every box office hit has spawned interactive games or apps based on its property. This is also true for superheroes, comic books, sports teams, racing cars—you name it. For a game audio engineer or composer, this can be an exciting opportunity to work on a big Hollywood production or with star talent from prestigious titles.

Another interesting observation about the games industry is the youthful age of its creators. In most companies, the average age of game development teams ranges from 20 to 40. This is not an industry of children, but rather a generation of people who grew up playing games and chose to deviate from a "normal" career route. Until recently, a career in the games industry was seen as a low-wage job for kids. However, in recent years the games industry has yielded higher profits than the music and film industries combined. Because most musicians and audio designers already know the struggles of justifying their careers, the game environment is a great place to fit in—and never have to wear a tie.

Given the relative youth of our industry, the game community is unfortunately void of experienced, well-rounded role models. As I forged my way through the industry, there were not many well-known game audio professionals who stood as an example of how to make a career in games. Sure, Bill Gates and Steve Jobs were an inspiration for computer entrepreneurs everywhere, but there weren't many game audio professionals who led the way for future generations. *Aaron Marks' Complete Guide to Game Audio, Third Edition* has served and continues to

serve as that role model for game audio and is a great resource for anyone looking to enter this fascinating industry. New and old engineers alike will find this book as a strong reference tool to understand the interactive arena and how to survive in it. This definitely would have been useful when I was getting started.

Good luck with your future projects, and I look forward to playing one of your games soon!

Keith Arem
PCB Productions, Encino, CA

Acknowledgments

It would have been nearly impossible to write a book of this scope without the help and inspiration of many remarkable people. I'd like to give special thanks and recognition to the many individuals and teams who helped keep my facts straight and the proverbial nose to the grindstone.

A heartfelt thank you to: My family (all of the Marks', Van Cleave's, Sartor's, Posey's, and Rodgers'), Watson Wu, Mark Scholl, Sean Connelly, Caitlin Murphy, Claudia Kisielewicz, Jessica Vega, Tom Todia, Keith Arem, Todd Fay, Tommy Tallarico, Mark Temple, Henning Nugel, Ingo Nugel, George Sanger, Nathan Madsen, Jon Holland, Bradley Meyer, Brian Schmidt, Marty O'Donnell, Christopher Tin, Tim Larkin, Pasi Pitkanen, Elspeth Eastman, Todd Kinsley, Aaron Walz, Jesse Harlin, Duncan Watt, Corina Bello, Brian Tuey, Christos Panayides, Jon Jones, Darryl Duncan, Chris Rickwood, Rodney Gates, Tom Salta, Richard Jacques, Lennie Moore, Neal Acree, Jack Buser, John Griffin, Lori Solomon, Michael Henry, Jamie Lendino, Joey Kuras, Chance Thomas, Greg O'Conner Read, Sam Gossner, Kysick Chang, Sunzoong Kim, Rex Baca, Laura Lewin, Miguel Isaza, and Pete Bernard.

Thanks also to: Taylor and Francis, Elsevier/Focal Press, Sony, Sucker Punch Productions, Dolby Labs, The Audio Spotlight, DesigningSound.org, *Game Developer Magazine*, Gamasutra, The Art Institute of California—San Diego, SoCal TRACON, and the game companies and producers who have given me the chance to not only prove myself but to gain the wisdom to teach others.

And to the many others not listed, your contributions were all very much appreciated! Thank you!

Author

Music had always been a part of Aaron Marks' life. But it wasn't until 1995, when his overgrown hobby officially became On Your Mark Music Productions, that he began offering it to the world. He began with his local Southern California radio and television scene, composing jingles and scoring public service announcements—with eventual sights on Hollywood. Instead, he fell headfirst into the games industry, where his sound design and voice-over talents also emerged—leading him to music, sound design, field recording, and voice-over credits on more than 275 game titles for the Xbox and Xbox 360, PlayStation 2 and 3, Wii, Dreamcast, CD/DVD-ROM, touch-screen arcade games, Class II video slot machines, Class III mechanical and video slot machines, coin-op/arcade games, smartphones, online and terminal-based video casino games, and numerous multimedia projects.

In addition to *The Complete Guide to Game Audio*, Aaron is the lead author of the book *Game Audio Development*, (Delmar/Cengage Learning, 2009) and has written for *Game Developer Magazine*, *Gamasutra.com*, *designingsound.org*, *Music4Games.net*, and the Society of Composers and Lyricists. For many years, he has designed and taught several accredited college courses on game audio, interactive media, production sound, and field recording at The Art Institute of California—San Diego, was a member of the AES Technical Committee for Games, and was on the launch committee for the Game Audio Network Guild (GANG). He is the owner of On Your Mark Music Productions, where he continues his pursuit of the ultimate soundscape, creating music and sound for a multitude of projects.

Author's Selected Gameography

Hundreds of Class II, Class III, and online slot machines and video casino games	Multiple world-wide clients spanning over 20 years: Audio direction, music, sound effects, voice over, and implementation for terminal-based, web, and smartphone platforms.
Ghost in the Shell Online	Neople: Field recordings of a large variety of pistols, rifles, machine guns, grenade launchers, impacts, weapons Foley, and explosions for this online first person shooter game.
Metro Conflict: Presto	Red Duck: Field recordings of a large variety of pistols, rifles, machine guns, grenade launchers, and weapons Foley for this online first person shooter game.
Red Orchestra 2—Heroes of Stalingrad	Tripwire Interactive: Field recordings of a large variety of World War II German and Russian pistols, rifles, machine guns and anti-tank rifles for this AAA first person shooter game.
Operation Flashpoint: Dragon Rising	Codemasters: Field recordings (M1A1 Abrams tanks, Amphibious Assault Vehicles, Light Armored Vehicles, HMMWV's, trucks, etc.), military liaison and coordination, script consulting for this AAA first person shooter game.
Tom Clancy's Endwar	UbiSoft: Original musical score for the PSP and Nintendo DS edition of this step-time strategy game. Musical performances in association with Nugel Bros Music.
Colin McRae's DIRT	Codemasters: Voice-over direction and performances, recording and editing for this multi-platform, rally car, race game.
The Settlers II—10th Anniversary, The Settlers-Traditions Edition, The Settlers, 10th Anniversary Vikings Edition	UbiSoft/Funatics: Original musical scores for these highly popular strategy games. Musical performances in association with Nugel Bros. Music.
Just for Girls: Episode II, Cow's Quest and Sweet Dreams: Epsiode III	Feel Fine Games: Original music, sound effects, and voice overs for these iPhone/iPad games.
bittos, bittos+, and *bittos-e*	Unconditional Studios: Music and sound effects for this wonderfully addictive puzzle game on a variety of platforms.
ESPN MSL Extra Time	Konami Computer Entertainment of America: Music cues and sound bank programming for this PlayStation 2 soccer title.
I, of the Enemy and *I, of the Enemy—Ril Cerat*	Enemy Technology (developer): Musical score, sound effects, and narratives for these multiplayer space strategy games.
Feet of Fury	Cryptic Allusion (developer): Original dance tracks for this dance game with emphasis on player-versus-player combat on the Dreamcast.
Bloxx, Shanghai Express, Palm Reader, Zillionaire, LoveOMeter, Mezmerized, Kubis, Slide 'Em	uWink, Inc.: Sound effects and music cues for these touch-screen arcade games.
Online casino/arcade game sound effects and music	Flipside.com, VirtualVegas.com, PrizeCentral.com, iWin.com: More than 70 individual Java-based games for these web sites.
The Many Faces of Go Deluxe	Smart Games: Sound effects for this CD-ROM strategy game.
Hardwood Solitaire II	Silvercreek Entertainment (developer): Sound effects.
Hardwood Hearts	Silvercreek Entertainment (developer): Sound effects. Finalist at 2nd Annual IGF held at GDC.
Fallen Heroes	A&B Entertainment (developer), ionos, inc. (publisher): Sound effects and character narratives for this CD-ROM title.
SC3	A&B Entertainment (developer), ionos, inc. (publisher): Musical score, sound effects, and character narratives for this CD-ROM title.

1

An Introduction to Game Audio

Insert Quarter Here

Any worthwhile journey begins with a first step, followed by another and then another. Regardless of whether you are already many miles down the road or are just about to make that first stomp, this book is designed with you in mind. Working in the multi-billion-dollar game industry as an audio content provider is a challenging and rewarding avenue—best traveled with a useful guidebook in hand. My thanks to you for bringing this particular one along.

There are as many reasons as there are individuals for wanting to work in video games. Doing something you enjoy, creating games which millions will experience, or getting a paycheck for it, are all undoubtedly given the most often. Another, perhaps more enticing reason, is the mystique and prestige associated with it. Most of the world is still practically computer illiterate, and those of us who can get inside "the box" and make it do incredible things hold a measure of prominence in our society. We like to be that kind of person.

There are countless job descriptions within the industry: programmer, artist, animator, game designer, producer, and so on. But the ones which probably drew you to pick up this book are titles such as game composer, musician, sound designer, or audio content provider. These are the jobs which will bring us the kind of satisfaction we crave, creating music and getting paid to do it. It will also give us another way to get our music "out there" and maybe even be considered for a Grammy Award in the process. It will give us some needed recognition and acceptance from our family and friends who thought being a musician was a waste of time, and might even serve as a stepping stone to another career—such

as film or television, if you wish. There are endless possibilities to meet your personal and professional goals as a game composer and sound designer. And really, it's not such a bad career, either.

Music had always seemed to be a part of my life, and like everyone else, I had big dreams. I just didn't have a clue as to the "what" or "how" part of it, though. I did know how to spend money, and as my abilities and interests grew, so did the number of instruments and recording gear in my inventory. So much, in fact, my wife became concerned with the excessive outflow. The foot was brought down with a resounding thud and a new challenge was posed: I could not buy any more "gear" unless I made money with what I had, and after that, this little hobby of mine was to remain self-sufficient.

Originally, local television and radio seemed to hold some promise but as I jumped into that madness with both feet, I quickly realized the competition was fierce and I was merely plankton in an ocean populated by whales. Out of necessity, my strategy widened and diversification became fundamental. I looked into composing for music libraries, local video production companies, and multimedia. I had to have more gear, after all.

I soon learned just how these other businesses worked. They all wanted grand, original orchestral scores, à la John Williams, but only wanted to pay $200 for them. Considering the amount of time and effort you need to pursue this course, there is no way to see any return on the investment and it became painfully obvious that even though I was still overwhelmed by the urge to sell my music to someone, this was not the way to go about it.

I didn't naturally move to video games, though. I was still playing the original Nintendo at this point and didn't consider what I was hearing to be the kind of music I was even interested in creating. And I was certain nobody was actually making any money for "game music" either.

But when scoring for video games did finally run up and slap me across the face, I realized my perceptions of this strange new world were woefully distorted.

Constant pursuit of more gear is great motivation for selling your audio to the game industry. (Courtesy of AMC Studios.)

The gaming world has advanced far beyond what I had imagined and the music has become utterly fantastic! And to top it off, I discovered some game composers were making $50,000-plus per game for just a month or so of work. Now I was interested!

Thus began an incredible journey, making money selling my flavor of noise, realizing my goals and dreams, taking my "hobby" to a successful business, and, most importantly, bringing peace and harmony to the home front. But, because I knew absolutely nothing about the business, it took a couple of years to struggle into it, learn the ropes, and find my niche before I began to arrive at some semblance of success.

That, in a nutshell, is the purpose of this book—to educate you, to help you decide if this industry is right for you, and then give you the knowledge to take on the gaming world by storm. My experiences have given me a certain view of this unique industry and this is what I intend to share with you. If I can provide you the assistance to hit the ground running and save a couple of years in the process, my objectives have been fulfilled. So, sit down, hang on, and enjoy the ride.

The Bleeps and Bloops of Yesteryear

In 1971, video games made their grand public appearance with the game *Computer Space*. Although this game isn't as well remembered as some, society took to this new form of entertainment—plunking down stacks of quarters at a time. A year later, Atari's *Pong* took its place in history. This console game was uncomplicated by today's standards; the few sounds it played were simple, single-tone electronically generated bleeps. Atari's home entertainment offering in 1975 brought *Pong* into our homes, but it wasn't until 1977 that the Atari 2600 game system brought the first (although slight) improvement in game sound.

As the thirst for these games grew, so did the technology and the search for more stimulation was set into high gear. Various methods and audio processors were applied to aurally satisfy the game player and keep them coming back. In 1979, Mattel presented their Intellivision system—offering a sound generator capable of three-part harmony. Atari answered back in 1982 with their 5200 platform and a dedicated audio processor called Pokey. The Pokey chip used four separate channels which controlled the pitch, volume, and distortion values of each—allowing a four-piece virtual band to perform for the first time.

From here on out, each new game system introduced had more audio resources to draw from. The original Nintendo Entertainment System (NES) in 1985 used five channels of monophonic sound. 1986 brought Sega's introduction into the ring with monophonic sound generators using four octaves each. By 1989, the NEC Turbo Grafx brought six voices with stereo output—and the Sega Genesis brought 10 voices. Both incorporated a later add-on which allowed for CD-quality audio, and at last we were getting to enjoy some music and sound the way it was meant to be heard. Audio processors continued to improve, adapting synthesizer chips, 16-bit processors, more voices, more memory, better compression and decompression algorithms, and even internal effects processors.

But far away from the consoles and dedicated gaming platform market, the personal computer was beginning to show its potential. Initially, the sound quality was no better than the early console games: the generated bleeps played back through an even more horrendous-sounding internal speaker. Memory space was always an issue and the considerations for audio were last on a very long list

of priorities. As a response to the almost hopeless situation, separate sound cards were developed with small synthesizer chips which allowed for very small message files (encoded with triggers similar to the roll on a player piano) which told the device what sounds to play and when to play them. The sound bank consisted of 128 sounds with the capability to play a total of 16 notes at a time, and this use of the MIDI (Musical Instrument Digital Interface) standard gave us some hope. The tinny, cheesy sounds early cards produced were a far cry from the real thing, but at least the compositions were improving and musicians were replacing programmers at an increasing rate.

The computer sound file, such as today's *.wav* and *.aif* files, utilized a compression algorithm which enabled real recorded sounds to be played back initially in the *.voc* format. This gave a musician the ability to track music in a studio using traditional recording methods and then convert to the required sound file format. The sound quality wasn't much better than the MIDI music being expelled; initial sample rates of 11 kHz, 8-bit, mono were hardly even AM radio quality but at least the composer wasn't restricted to the sound palette which came with the hardware. Sound designers benefited as well, enabling their creativity to literally explode. The stage was set, ready for the next level and beyond.

Where Sound Is Now

Today, game audio has evolved into an art form all its own. Game music quality, the release of stand-alone game music CDs, and their potential for a Grammy Award have at last put us on par with the television and film industries. Hollywood-quality sound effects and celebrity voice-overs are commonplace and help create an incredible, almost movie-like experience. Who would have thought this even possible 30 years ago? Game audio has made a quantum leap forward, and we not only have the talents of many veteran game composers and sound designers to thank, but also have the game industry for its continued support and the technological advancements of audio hardware.

While 22 kHz, 8- or 16-bit sounds are still in use for some applications, 44.1 kHz, 16-bit, stereo (CD-quality audio) are the standard audio properties of today's audio content—with some game consoles even capable of playing sample rates of 48 kHz. Larger storage space, higher-capacity memory, and faster processors continue to develop—which make the increase in audio file sizes possible. Higher sample rates and resolutions equate to better-sounding audio but the trade-off is larger storage space.

In the not-so-distant past, stereo playback was considered the ultimate. Today, however, this is merely the minimum standard used in games. Surround sound has quickly become the missing immersive dimension players have been looking for and it is almost unheard of to have a major game title released without it. With gameplay becoming increasingly more complex, surround sound allows the player to make use of their sense of hearing for directional cues and to really put them in the game. 5.1 and 7.1 playback systems are in more than 120 million homes, thanks to the efforts of companies such as Dolby and DTS and because of the popularity of the home theater; game developers have taken this phenomenon and run with it to create incredibly engaging experiences.

Imagine being fully engulfed by sound. Walking down a dark corridor in a first-person shooter, hearing your footsteps below you, environmental sounds coming from air ducts and doorways, suddenly you hear a noise behind and to

your left, you turn to be confronted by a ghastly beast wanting you for lunch. You fire your weapon, the sound reverberating all around you, shell casings tinkling on the floor, and the creature falls to the ground with a thud. That is some serious entertainment! Total immersion is the main feature of today's games, and you as a composer or sound designer can expect to set that stage.

Adaptive and interactive audio is the latest concept to see industry-wide support and increased usage in games. In an effort to better follow the unpredictable and ever-changing on-screen action, music and sound which can "adapt" to what the player is experiencing is being integrated into gaming and quickly establishing itself as a new standard. With film, all music and sound effects are postproduction elements placed after the visual elements have been created. As a movie plays, the linear soundtrack follows along—setting the appropriate mood for each scene, building tension, or tugging at your heartstrings. However, most video games aren't predictable in that sense and a music score can seldom anticipate what will happen next to a player. Audio presentation methods have been developed over the past several years to interact with what the player is experiencing; whether they are casually exploring a game level or locked in heated battle with an opponent, the music and sounds will change accordingly. Adaptive audio tools, such as Firelight Technology's FMOD and Audiokinetic's Wwise, enable a developer to have more control over the mood and the game player's experience, often leading to spectacular results.

A score created with a live orchestra can really give the total "movie-like" experience to a game title, and today's large game budgets and skilled composers make this form of music much more common. While an orchestral score is not always the right choice for a game project, most triple-A action titles tout this type of music as a main selling feature, ultimately giving the players a better experience for their money. The chances are very good you will eventually lend your talents to one of these massive undertakings as you make your way to the top of the field.

"A" Studio at Dolby Labs in San Francisco, where surround sound equipment and techniques are designed and tested.

CHRISTOPHER TIN
Composer

Christopher Tin is a two-time Grammy-winning composer. He is best known for composing the song "Baba Yetu" for *Civilization IV*, a piece which received widespread acclaim, including winning the only Grammy awarded to a piece of video game music. "Baba Yetu" has been performed all around the world, from Carnegie Hall to Disney Concert Hall, and is one of the first video game pieces to become a widely performed modern choral classic.

Game credits: *Civilization IV, Civilization Online, Karateka, Pirates of the Caribbean Online, World of Cars Online, Pocket God*

www.christophertin.com

Describe your thought process for creating music and/or sound effects.

While the most important thing to writing music for media is to always write in service to the project, I also try to find ways to write music that stands up on its own outside of the game.

Are there any particular secrets to your creativity?

I try not to fall into any sort of routine—I'd rather my inspiration come to me in different ways, than have a set manner of working. That means that when starting any given project, I could be doing anything from improvising at the piano, playing with a sequencer, or just taking long walks with my dog humming to myself.

Are there any secret techniques that you regularly employ?

Yes! There are. ☺

When do you find you are most creative?

In the mornings, when I first wake up. I try to reserve morning hours for composing, and afternoons and evenings for business affairs and musical grunt work (score prep, etc.).

Do you have a specific ideology which drives your way of doing business?

Take great care of your clients. It's a lot easier having repeat clients than it is to bring in new ones!

How do you approach negotiations with a new client?

I let my agent deal with it, but usually I try to be as accommodating as possible, without putting myself in a difficult position.

Do you have any tips when working with developers?

Really try to listen to what it is that they're looking for, and don't be afraid to speak up if you think that their ideas are not what's right for their project. Ultimately you'll defer to their wishes, but don't forget that they're hiring you as an expert in your field, and will want your opinions as well.

What advice can you give when working with a developer which has ensured a good working relationship and a good final product?

At the end of the day, everyone wants two things: (1) someone easy to work with and (2) someone that produces good work. Those are the two pillars of a successful relationship.

Any specific "lessons learned" on a project which you could share?

You're only as strong as the weakest piece in your portfolio, so never ever do a bad job on a project. Even if it's a small, free favor for a tiny project—always make sure that anything you do is a great representation of your ability.

The previously popular MIDI music standard has had its ups and downs over the years and has come close to falling by the wayside as the public expressed its disappointment with it. Internal instruments gradually became better as sound card manufacturers included high-grade synthesizer chips, but because this quality differed greatly among manufacturers, what sounded good on one card sounded like a train wreck on another. This lack of consistency, while leading the decline in its usage, has actually fostered other viable solutions for the format and we are currently seeing a resurgence in MIDI use.

Down-Loadable Sounds (DLSs) and other audio features have kept MIDI as a practical format offering advantages of its own. Because these "sound sets" can be loaded as needed into the internal memory and triggered by standard sequenced data, the instrument quality is always consistent no matter what system or sound card the player has. An added advantage is an almost infinite palette of

instruments can be loaded, even new samples for each game level, as a way to keep the player immersed and entertained. Allowing composers and sound designers to pick and choose their own sounds, instead of being stuck with whatever the sound card manufacturer has installed, increases the creative quality while keeping file sizes small and giving more flexibility to the developer. Smartphones, tablets, and handheld consoles, such as the Nintendo 3DS and Sony PSP, can take advantage of sound sets to keep music engaging and interesting.

Overall, the general trend shows a sustained movement toward improved sound quality. Arcade games have better customized speaker arrangements, subwoofers, and more powerful playback devices. Home gaming consoles have stereo, surround and digital outputs, and additional sound controls built in. PCs include upgraded audio hardware as standard and can stream quality audio straight from the disk or directly from Internet sources. Game developers consistently understand the impact of superior music compositions and film quality sound effects, and their increase of sound budgets allows them to hire veteran audio professionals to make this happen. Composers and sound designers are even brought in earlier in the development cycle, as part of the design team, instead of as an afterthought during the final phases of production as in the early years. Eventually, video games will be interactive movies where the psychological effects of music and sound will be dominant.

The growing frontiers for games today are the World Wide Web, smartphones, tablets, and smart TVs. Games played either over or on the Internet have enjoyed a tremendous boost with the wide availability of broadband access. Previously, dial-up and slow modem connections restricted audio to small file sizes and MIDI music—using audio properties as low as 8 kHz, 8-bit, mono, and unflattering compression. Now, with faster connections and high-quality compression schemes, Java, Shockwave Flash, and online games are enjoying respectable audio. These advances have crossed over to cellphone-based games as well, making what was once a limited audio experience a lot more exciting. There are definitely many more technological improvements which will be made over the next few years, and if history is any indication, game audio quality will follow the same path.

Where Sound Is Going

The future holds some incredible offerings for game audio. It's given that computer processors will continue to get faster, memory will continue to be plentiful and cheap, and as the hardware side of things improves, the gaming experience will follow close in trail. And it's only obvious, too, game audio will be right there to take advantage of it. The DVD format has effectively replaced the CD, and the Blu-ray Disc (already in use on the Xbox One and the PlayStation 3 and 4) has traction to replace the standard DVD. These give an incredible increase in storage space, allowing all audio to be at least 44.1 kHz, 16-bit, stereo if desired.

As audio properties predictably reach for a higher standard (such as 96 kHz, 24-bit, surround), Blu-ray and the next format generations will allow plenty of room to accommodate it. The sound quality will be right in the "audiophile" range, which, in turn, will drive the need for better recording methods and equipment, extremely talented composers and sound designers, and accompanying elevated audio budgets. The only real flaw in this theory is the general acceptance of reduced-quality, compressed audio files, such as mp3s, which are quite prevalent

in many sources of personal entertainment. Although this might lead you to believe that audio quality isn't a big concern to the masses, you can feel encouraged even these less than desirable formats are being improved upon—sounding better with each new update. And if they are used at higher settings, in the range of 196–256 kbit/sec, the quality is nearly indistinguishable from uncompressed digital audio files.

Surround sound usage will become even more widely used by developers, encouraged by consumer surround equipment becoming cheaper and more abundant. But, as new formats such as 7.1 and 9.1 gain momentum, these will be incorporated enthusiastically into games for an even more incredible experience. Immersion isn't just a buzz word in the industry, but it's a reality which is being wholeheartedly pursued with the help of even more enveloping surround formats. Current 5.1 or Dolby ProLogic II, as incredible as they are, will eventually be formats of the past.

Looking back even 5 years from now, interactive and adaptive audio at the moment will be seen as barely in their infancy. The potential of these concepts is so incredible and has the ability to single-handedly drive the audio creation and implementation processes far beyond anything we can even imagine at this point. The future looks very promising for alleviating repetition and creating a more engaging experience for the player, as audio elements change more effectively to match the action. To keep pace with the demand for the increase of required audio assets, we may see the trend of larger audio teams (both in-house and third-party contractors) and longer and more involved production schedules. More powerful audio creation and middleware tools will be developed to aid in the increasingly complex task, and scripting (performed by the composer, sound designer, or newly designated audio scripting specialist) will be the standard method of implementing the vision of the audio experts. Regardless of the work involved, the end results will still be the main focus and interactive sound could quite possibly be the entire future of game audio.

The ever-increasing complexities of audio creation and implementation have begun an interesting trend in the manpower required to accomplish the job. What was once handled by a single, accomplished individual is leaning toward a more specialized compartmentalization of skills, and in the near future, it will be almost impossible for any one person to effectively manage even a medium-sized project. In-house audio departments, especially for large development houses, will require a full staff of composers, sound designers, voice-over directors, audio editors, engineers, and mixers, to name just a few, in order to concentrate on the many small details. To stay competitive, independent game audio studios will also have to staff appropriately or establish alliances with other independents to meet the demands and maintain a high quality. The landscape is definitely changing, and the good news is there will be many more job opportunities and career possibilities.

The future of game music will require a higher caliber of composer as live orchestras, live musicians, and large audio production budgets become even more prevalent. This isn't to say that film composers, although experienced at orchestral scores, will have any distinct advantage. Interactive scores can be highly complex, and game composers will also need the ability to write in multiple layers to enable the music to follow the always unpredictable path of the player. Game music is expanding in every direction, and it will make film scoring seem easy by comparison as the task becomes even more technical.

MARK SCHOLL
Composer, Sound designer, Percussionist

My studio space is primarily about having a very comfortable, very quiet, and peaceful space to write. I used to use a lot of live instruments but with both development time constraints and budget constraints I have moved toward buying as many high-quality sample libraries instead so I can cover every possible instrument I would need. So at this point, I have basically geared myself toward being entirely self-sufficient.

The equipment is of course extremely important at this stage in our history. We now have the ability to create just about any style of music on our own with a fair degree of realism within our personal studio spaces. It is amazing what is available to us today compared to even just 10 years. I am having a great time with the realism I can get with sample libraries. There are definitely some very forward thinking, problem-solving companies out there—for example, the Vienna Symphony legato feature is tremendous!

But, as incredible as all of this modern gear is which pretty much anyone can buy these days, it ultimately comes down to the reality that a composer still needs to have the natural, creative, artistic ability, and a practical real-world knowledge about music to really stand out. And, of course, you still have to be personable and be able to interact well with all kinds of people—your gear won't do that for you. I have found that 99% of the people that you will work with who are not musicians or composers won't ever say something like, "Gee, is that the East West Gold XP or the Vienna Special Edition contrabassoon sample playing unison with the arco bass section? The sample is really nice but wouldn't he have needed to have taken a breath about two bars earlier?"

Computers: Mac G5 Intel quad core using several external and internal multi-terabyte drives for both working and separate drives for storage. 17″ Macbook Pro

Audio interface: MOTU 8 Pre

Software: Digital Performer

Monitors: I primarily use high-end Bose and Sony desktop speakers with a subwoofer

Sound modules/VST instruments: At least 150 different sample libraries covering as many possible instruments as well as multiple articulations for each instrument. Native Instruments Komplete, East West Orchestral Gold XP, VSL: Vienna Symphony Special Edition, Atmosphere, Trilogy, Stylus RMX 1.5, Chris Hein Horns, Chris Hein Guitars, Garritan Jazz, MOTU Ethno, Quantum Leap RA, Stormdrum, Symphonic Choirs, Synthogy Ivory

Outboard gear/effects plug-ins: Mostly Digital Performer's processing plug-ins and moving toward iZotope mastering tools. Avalon 737 Tube Preamp, Yamaha OV1 mixer, MOTU 828 MKII

Keyboards: 88 key M-Audio for main studio and Alesis 49 key for portable studio

Other instruments: About 100 various drums, cymbals, and percussion instruments. 5 complete acoustic drum kits for various styles and 13 different sizes of snare drums for a total of 35 acoustic drums, 32 Sabian Cymbals (Sabian endorser), tons of hand percussion and hand drums, several Dejembe's/congas, etc.

Microphones: Variety of AKG and Sennheiser mics. AKG C4000 B Condenser, Sennheiser 421 Dynamic, AKG D112 Kick mic, (2) AKG 535 condenser mics, Shure SM57, Cad Pac Drum Mics

Remote recording gear: Tascam field recorder

In a completely different musical direction, the power of the next-generation consoles gives another interesting possibility to developers. For a variety of reasons—such as restrictive budgets, console capabilities, or needs of the game—prerecorded music is not always the best solution and developers can employ the bulletproof MIDI format as the answer to audio interactivity. Audio files, even in compressed formats, can take up valuable storage space and processor capacity. As a way around these limitations and to enable a nearly unlimited amount of music, instrument samples can be loaded into memory and triggered via MIDI messages. While this initially seems like a giant step back to the ancient days of "chip music," the quality of instrument samples, in-game effects processing, and skillful composers who live and breathe MIDI have made this a viable format once again. Interactivity is the wave of the future, my friends, and new applications of old tools such as MIDI will help make that happen.

On the sound effects horizon, the crusade to alleviate repetitive sounds will continue with some very exciting possibilities. Many current ventures address

this particular weakness, some focusing on processing prerecorded audio while others consider actually generating sound effects in real time as they are needed. Each concept approaches the subject from a slightly different angle but with the same result in mind.

Prerecorded sounds can be manipulated quite easily as the power of audio engines and high-quality effects processing are integrated more effectively into the chain. As an example, multiple machine gun shots would be incredibly boring if the same single-shot sound were triggered over and over again. With this process, each shot will be randomly manipulated in pitch, volume, and equalization—and the timing of each successive shot will vary slightly for realism. The power of this method is clear since only one shot sound is needed, instead of having to create dozens of variations, saving production time all the way down the line. The same can be applied to any repetitive sound. This technique has already experienced success in many games, but the unlimited future refinements are what is creating the most excitement.

Another promising possibility for sound effects hinges on the work being done toward generation in real time and on the fly. Unlike prerecorded sound effects which have been created and integrated into the game prior to their playback, generated sounds don't physically exist until a sound generation engine creates them. These types of sounds require no previous efforts by sound designers; they don't need to record them, edit them, mix them, or even deliver them to the developer for integration. Not only does this save the time and effort to complete them, but saves storage space and offers unlimited variations of sounds—guaranteeing the player will never hear the same sound twice—ever.

On top of fresh sound generation, this technique will also allow for every conceivable physical environment and acoustical modeling possibility. Using our machine gun shot example, each shot will obviously have a slightly different sound generated by the audio engine to start, but the variables of what environment the shot is being fired in, the reflective surfaces which will affect that sound, and the types of surfaces the bullets are impacting and ricocheting off of will be unlimited. The bad news is that this has the potential to negatively affect the job of the game sound designer as developers eventually move toward in-game sound generation. The good news is that our jobs are still safe for many more years as this technology matures into something worthwhile. Currently, sound generation is being used for simple, almost "white noise" kind of sounds such as rain and wind with some excellent results.

Real-time audio mixing within the game environment is another forthcoming technique which is also gaining momentum. Developers currently have the option to mix the levels of each of their audio elements manually, where each sound or music cue has an established preset volume in code, or they can also dynamically adjust the music and sound effects through the use of scripting. A large portion of today's game titles can create a fulfilling soundscape using either of these current methods, but the growing complexities of future games will demand more efficient and effective techniques. Sound volume, panning, occlusion and obstruction, simulated acoustic modeling, and environmental physics are just some of the parameters which will be manipulated in real time as the player interacts with the virtual world. Although most of these considerations will be subtle, the effect on the added realism and believability will be immense.

Chances of Finding Work

With the current and future states of game audio, you can imagine the need for skilled audio craftsmen to provide that content. But, what are your chances? With the thousands of game companies worldwide and the unending flow of the production pipeline, your chances are actually pretty good. We are in an exciting time in this industry, with continually evolving technology making the entire game experience incredibly realistic and the public constantly hungry for more. Together they feed the development of bigger and better games—and audio will play a vital role in that total experience.

The last show of hands suggested an estimated 100,000 game developers (with 48,000 working in North America alone) and more than 1000 official game development companies operating within the industry. Consider the number of "garage" or student developers and their individual game projects which could easily add another couple of thousand to the list. These figures allude to the number of games in production but we can only really imagine the actual number of commercial, showcase, or student game ventures in the works.

To get the big picture, do a quick Internet search looking for key terms such as *video games, video game development,* or *game developer* for a nearly endless list of games and the companies who make them. The Electronic Entertainment Expo (E3) is *the* video game-related event of the year, and by wandering the never-ending show floor, it is easy to witness firsthand the immenseness of the industry. Old-fashioned sleuthing can also reveal an interesting perspective. Walk into any major computer software retailer and gander at the row upon row of game boxes on display. Head off to a local arcade and take in all the coin-op game consoles vying for your attention. Do another search of the Internet for online, Shockwave Flash, or Java games. You'll never find them all! Are you getting the picture yet? The games industry is *huge,* and there is always work for those of us who are good enough, persistent enough, and lucky enough to be in the right place at the right time.

The Rewards

Providing audio for games can be a unique challenge and sometimes a job well done can be the ultimate reward. But satisfaction alone cannot put food on your table or buy any of the new gear you have to have. While the money can be quite good, and often is, there are other enticements which make composing for games a worthwhile endeavor.

We've all heard the statement that the perfect job is being able to take what you love doing and make a living at it. I couldn't agree more. The one constant throughout my life has always been music and to me, it makes perfect sense to pursue it as a career. There is no greater reward than taking your passion and getting someone to pay you to do it.

Tim Larkin—in-house composer and sound designer for Valve (formerly in-house at Cyan Worlds)—is a perfect example. He has worked on a long list of game projects such as *DOTA 2, Counter Strike: Global Offensive, Team Fortress 2, Half-Life 2* (Episodes 1 and 2), *Portal, LAIR, Left for Dead, Splinter Cell 4, Middle Earth, The Incredibles, Pariah, Lord of the Rings, Robota, Prince of Persia, Where in the World Is Carmen San Diego?* and, of course, on Cyan projects, such as *Myst, Riven, Uru: Ages Beyond Myst, Myst V: End of Ages,* and *Myst Online/URU Live.* He has some serious formal music training and experience and can write his own ticket

Tim Larkin.

in the game world or in any other creative endeavor for that matter (such as sound designer on the Academy Award-winning animated short film *The ChubbChubbs* and conducting the DOTA 2 segment of the current Video Games Live tour).

But, instead, he enjoys his in-house position and the steady paycheck and benefits it brings. As an alternative to constantly marketing and concerning over where the next job is coming from, Tim prefers the comfort and security—which, in turn, allows him to focus more on his craft. "Working in-house as a composer and sound designer, I enjoy the interaction with a creative team and I am ultimately more focused on the creation of the art," says Tim. His particular reward is having steady work and doing something he loves.

Believe it or not, there are actually people who aren't in this business specifically for the money. They can pursue their passion of music in a creative and supportive setting and earn a good living in the process. It might seem crazy now, but a few years as a contractor might just change your mind about in-house work. Don't thumb your nose just yet.

Fame

In Japan, game score composers enjoy "rock star" status among their appreciative fans. Rabid admirers flock in mass to see appearances of their favorite video game

stars, continuing to drive a whole other aspect to the audio side of the industry. Sales of video game soundtracks continue to top the charts there as well, giving more avenues to pursue.

The fame and glory of being a recording artist is quite well known to us in the United States, and game score composers and musicians are standing poised to take advantage of this type of notoriety. We don't share the spotlight with "name brand" artists and we don't have hordes of screaming fans following our every move, but we do have a sort of recognition that can feed our egos and drive us to do more and to do it better. Eventually, as the popularity of game soundtracks grows and more of the public becomes aware of our existence and fans bases develop, the fame that many seek will be at hand.

A few years back, "music by Bobby Prince, composer for *Doom*" on a box cover was a common sight. Talk about fame! Bobby Prince has always been well known by us on the inside, and the industry has benefited by using his "fame" as a selling point. Not only that, but Bobby was rewarded as more game companies just had to have him. He went on to do many games, such as *Wolfenstein 3D*, *Duke Nukem 3D*, *DemonStar*, and *Axis and Allies* among others, and with that string of hits, his fame continued. I'll take luck over skill any day and Bobby just may have been in the right place at the right time getting involved in a hit game like *Doom*. The music was pretty darn good, too.

And how about George Sanger, aka The Fatman? Having spent many years in Texas, I can appreciate the grand Texas-style way of doing things and George

George "The Fatman" Sanger, a game audio legend.

GEORGE SANGER (AKA THE FATMAN)

Game audio legend, Philosopher, Author of *The Fatman on Game Audio—Tasty Morsels of Sonic Goodness,* New Riders Games, 2003, Indianapolis, IN.

Describe your thought process for scoring/creating sound effects.

My mom gave me one art lesson: picture the thing on the page, then trace what you see. Do that. Only with your ears.

Are there any particular secrets to your creativity?

Yep. And I'm just as curious as you are.

When do you find you are most creative?

When I'm being sassy during interviews, and other times I feel that belly-laugh thing in my gut. Like many Actual Artists, I have tried to nurture that state. That is what makes us kind of retarded. Real artists laugh coffee out their noses. Crap artists tell you how much money you're going to make on this project, and they talk about the music they are working on more than they work on it.

Any specific "lessons learned" on a project which could be shared?

Too many to count.

Do you have any negotiation techniques or stories which others could learn from?

It is hard to be sure a musician knows that you respect his value and his time. When I am paying a musician, here is my MO:

> I can never pay you what you are worth, which is infinite. All I can pay you
> is this much, which is all I can pay you and still convince my money sense

that hiring you is a good idea. When you get here, the check will be written out and on my desk. The session will go until 4:00. If 4:00 comes around and we're still working, I want you to put your horn in the case, push me out of the way, grab your check off the desk and leave.

Likewise, it is hard to name a price that will fit a client's budget, and the haggling process can erode the sense that there is respect between the wo negotiating parties. I have been known to say, "make me an offer that you feel has dignity. If I can do the job for that amount without feeling that I'll be losing money or wasting time, then I will happily take the job."

Do you have any development stories which served as a good lesson learned or something which can be avoidable in future projects?

Happiness in working life depends very much on the people you pick to work with.

If you can help it, don't work for anybody who mistakes being a fussy consumer for being a good producer. You will know them by phrases like this: "This is going to be a great game because we actually play games and we know what sucks."

Corporate butt-heads can ruin your day, too. Watch out for anybody who uses the phrase "responsible to the shareholders." His goal is to make a creative product that's sure to sell. That's impossible, so he will either try to crush the creativity out of the project to make it just like something else that has sold before, or he'll make you do and redo your work out of frustration with his own double-bind goals, trying to find something that draws no negative comments from anybody in the company who hears it.

Similarly, try not to work for young cocky guys with money who haven't had a nice big failure yet, especially if they are funded by money they got from a parent.

Guys without money who just can't stop coding, that's a different story. And the more that being with these people feels like you're in a cool movie about a cool band, or feels like you've finally come home, then that's where to hang out. EVEN IF IT'S NOT GAME MUSIC THAT THEY'RE DOING.

Any great stories you want to share?

www.fatman.com/stories.htm

How did you find your way into the games industry?

The thing that I do sought me out like it was a stalker and I was a delicious presidential movie starlet leading a peace march. But I'm not sure I'd call it "being in the games industry."

I like making noises for people who could use to have some noises. Many of the people I love and dig working with are in the games business. Many things that we think of when we hear "games industry" have nothing whatsoever to do with me or what I like or what I do.

has it down cold. He's done a stable full of games, such as *The 7th Guest, The 11th Hour, Wing Commander, Might and Magic III, Total Recall, Star Trek III, NASCAR Racing, Putt Putt Saves the Zoo, ATF,* and more than 250 other games since 1983, and brings his own panache and flair to the gaming industry—he and his "Team Fat" having composed some truly innovative and absolutely memorable game scores. I'm sure every kid in America has heard his music and could sing along with some of the themes. Not only does his ten-gallon hat and his grandiose compositions make him stand out, but his book *The Fat Man on Game Audio: Tasty Morsels of Sonic Goodness,* past magazine columns, and his efforts in joining the gaming forces at his yearly Project B-B-Q make him hard to ignore. Everyone knows who The Fatman (www.fatman.com) is, and that's not such bad notoriety.

And what about Marty O'Donnell? Ever heard of him? You bet anyone who owns an Xbox and has played any of the Halo titles is a fan. This guy came from the world of TV jingles; his most notable one being the Flintstones Chewable Vitamins commercials (i.e., "We are Flintstone kids, 10 million strong, and growing"). He has also created audio for the *Myth* series, *Oni* and *Riven* and because of it, has become one of the most recognizable names inside game audio today.

There are varied degrees of "famous," and depending on what you may be seeking, you will definitely find it in the gaming world. Whether it is a sort of notoriety within the industry for your work ethic and superior audio product, nationwide fame as a game score composer playing your music to thousands of screaming fans, releasing a hit soundtrack CD, or just being known by the kids on your block as the person who does those cool tunes for video games, they are all worthwhile places to be and have their own separate and distinct rewards. Not only is it great to be recognized by your peers in the industry but it's also hard to beat that warm and fuzzy feeling having touched a young teenager's life and inspiring him or her to learn music. It's all right here, ready and waiting.

Fortune

Making a living doing what you love and the corresponding notoriety are enough reward for some, but let's face it, one of the real reasons composers and musicians become involved with the gaming world is the potential to earn their fortune. The movers, shakers, and deal makers are the ones making things happen in this occupation and their business tenacity has made them financially well off.

When game music began and the programmers were slowly being replaced by composers, the miniscule income was almost hardly worth it. But as game budgets skyrocket into the millions of dollars, composers also collect their share by creating appropriate, thought-provoking, and well-crafted music—with professional musicians and the occasional symphony orchestra to boot. There are very busy composers out there who earn $50,000 to $60,000 for an hour or hour and a half's worth of music per game, and some of them do a dozen games a year! Do the math, there is some serious cash potential. And that isn't even the end of it.

Consider earnings from royalties, bonuses, soundtrack releases, fees for the same music on different game platforms (stock keeping units), and money from licensing in commercials, television shows, and movies (ancillary rights), and you can see the sky is wide open. If you've negotiated a good deal and signed a contract with a big developer, the potential to have income from simultaneous sources, all from the same music score can really make a difference.

There are several game composers whom fortune has indeed smiled upon. They all possess similar traits and have made games very exciting with their musical offerings. Their deal-making skills, reputation for providing quality, on-schedule audio, and stature within the industry have all contributed to their continued success.

Tommy Tallarico has lived one of my favorite game audio success stories. His tenaciousness and drive has taken him from working two full-time jobs, 16 hours a day and literally living on the beach when he first moved to California in 1991 to a highly respected businessman and philanthropist living in a bazillion-room estate with a Ferrari, among many others, parked in his garage. His deal-making skills and excitement for what he does is legendary, and composing music for more than 300 games and over 10 games soundtrack releases to date has secured his place at the top.

He has won more than 50 industry awards for his work; has hosted weekly TV shows such as *Electric Playground*, *Judgment Day*, and *Championship Gaming Series*; is quite prevalent on many other game-related broadcasts; created the Video Games Live franchise; was the main personality behind the formation of the Game Audio Network Guild (G.A.N.G.); and is a leader in many other quests, including game audio's inclusion in the Grammy Awards. His amazing journey is something we can all draw something from. Later in this book, I'll be sharing with you much of Tommy's deal-making prowess, sample contracts, and ideas that have made him so successful. Stay tuned.

Tommy Tallarico is one of the most recognized and most influential champions of game audio.

Tools of the Trade

WATSON WU
Composer, Sound designer, Field recordist

My two studios are dual purpose—meaning I can record my own music and design sound effects. With advancements of high-capacity hard drives in speedy computers, I can own less studio gear to complete the jobs. For field recordings, I have a few large Pelican cases, plastic bins, and bags to house my field recorders, mixers, cables, mics, and mic blimps. I'm a microphone junkie!

I typically stick to buying what I need. Occasionally I'll buy a cheap mic to try it out. There aren't many demos out there that give a good representation of what the mic sounds like for guns and loud cars. If you don't try out different mics, you'll miss out on other possible sounds.

Computers: 3 Asus i7 desktops (each with 32 GB RAM, RAID HDs), 2 Mac Pro desktops (with 32 GB RAM, RAID HDs), 3 Mac laptops, Drobo 16 TB, and other backup drives

Audio interface: Sound Devices USBPre2, MOTU 8Pre, and MBox

Software: Reaper, Vegas, Sound Forge, Pro Tools, Native Instruments, GigaStudio, etc.

Multi-track system: Reaper, Pro Tools, Vegas, Sound Forge, etc.

Monitors: Mackie 8″ and M-Audio 8″ monitors

Keyboards: Yamaha, Korg, Novation, and other controllers

Microphones: More than 50 of various brands like Rode, Sennheiser, Neumann, Ambient Recording, AKG, Shure, DPA, Holophone, Crown Audio, EV, Audix, Audio-Technica, Roland, Soundman, Line Audio, etc.

Remote recording gear: Sound Devices 788T-SSD field recorder, 744T field recorder, 442 field mixers, MixPre-D field mixer, USBPre2 field mixer,

Edirol R-44 field recorder, Rode iXY, Tascam DR-40 recorder, Tascam DR-60Dmkii field recorder, Olympus LS-11 recorder, Zoom H2n recorders, etc.

Other relevant gear: I own various gear that are critical to successful field recordings. First are my Remote Audio headphones to monitor guns, explosions, and super loud vehicles. Being able to listen to loud sounds (at a softer level) during sessions is a HUGE BLESSING. Second are my Sound Devices field mixers and recorders. They capture fantastic sounds! InstaSnakes by ETSLan.com are great for long runs of cabling whenever I work on medium- to large-size budget gun recording jobs. Being able to use shielded CAT5e cables (up to 1900 feet) makes my life a whole lot easier! I'm not the person who would often buy ultra-expensive equipment, but it's about how you use what you have

Let's Go Get 'Em

Creating audio for games is an incredible ride and if you stick with it long enough and have your act together, you'll eventually have something to show off to all of your friends. Who knows, you may even win a Grammy to adorn your mantel. Speaking of the Grammys, Appendix B goes into detail about this coveted award and what we need to do as game composers to make it a reality; it's not as easy as simply showing up to the party, you know. Game audio definitely has much to offer, so, if you're ready, let's see what this corner of the multi-billion-dollar games industry is all about.

2

Essential Skill Sets and Tools

Important Skills

Now that you have been properly motivated to consider the game world as a place to sell your music and that burning flame inside you has been turned up a notch, let's check out the important skills and equipment you will need to work and thrive in this industry. I think it is probably safe to assume most of you either have done some composing or play a musical instrument (or two) and you might even have much of the equipment already. If not, I welcome you into our world and applaud you for doing your homework.

The practicing one-man band is the working method of choice for the majority of game composers. By not having to rely on anyone else, the process becomes streamlined and more gets done. You can stay focused for longer periods of time and compose some compelling scores without interruption. Unless I'm using a specific musician for his or her sound or for something I am not capable of doing, I never have to wait for anyone to show up—because I am already there! It's a great way to work, lets you work when you are at your most creative and saves a lot of downtime waiting for someone to show.

There are also many music "teams" within audio production houses, who have specific duties and skill sets which all complement a project. Even in that atmosphere, it is advantageous to everyone if you are familiar with the other functions of a production.

Attitude

Attitude plays a big part in this business and is the one thing which can set you apart or destroy your chances altogether. The very first game job I got, I found out

later, was because of my attitude. I had absolutely no experience composing for games or doing sound design, and while it initially factored into the developer's decision, my confidence and positive attitude are what got me the gig. Since it seemed to work the first time, it has become a permanent part of my sales pitch and how I do business.

Your passion and drive will certainly be enough to get you started, but no matter how much you already know or think you know, there will always be more to learn along the way. Always remain receptive to new ideas and concepts. Technology improvements are rapid, and by staying up with all the latest, you place yourself in a good position to take advantage of them. It's always nice to say, "Yeah, I'm familiar with that," rather than having to show your ignorance. Sometimes it can mean winning or losing a contract.

Business Sense

As the one-man show, you can expect to wear many hats—playing the roles of composer, musician, engineer, producer, technician, sound designer, voice talent, salesman, marketing director, secretary, accountant, janitor—hey, wait a minute! Where did all the music stuff go? Unfortunately, composing music and sound design can come into play less than 25% of the time and maybe only around 5% if you are just starting out. You have to remember you are in business and you are selling a product.

All of the rules, strategies, and abilities of commerce come into play here. Being successful means being business savvy and remaining focused on your "product." Until you've attained success and can hire a staff to provide for your business needs, you won't be able to just sit at your piano and write. Then again, who wants to do that all of the time anyway? A little hard work and dedication on your own behalf makes your efforts even that much more gratifying. Take some time and study how a business works and you'll be miles ahead of anyone who fuddles through it blindly.

Marketing

Another critical skill, absolutely unrelated to creating audio, is the ability to market yourself. I rate this second in importance behind the administrative side of business for good reason. It doesn't matter one iota if you were a child prodigy, mastered every instrument before you were 8 years old and have the abilities of a world-class composer if no one knows you exist. You can't just open the doors to your business, expect customers to flood into your studio, and the phone to ring off the hook, unless you've spent some quality time beforehand making sure the right people are aware of your existence. And if they know about you, make sure you properly entice them to buy your product. All of this is part of marketing.

Marketing is as old as business itself, the more you know and use, the more work you will have. You will find yourself spending a good majority of your time planning and implementing ways to get customers in the door, constantly chang-ing strategies and ideas as you go—searching for the most effective method that brings in the most money for the effort. And you thought you were going to spend all of your time composing and creating sound effects. Well, sorry to burst the bubble, but this too can be an exciting challenge. There are very successful people who specialize in marketing as a career and it may initially seem overwhelming to you. But once you get the hang of it, it becomes second nature and lots of fun.

Later in this book I'll spend more time on this subject with some very basic marketing concepts and strategies geared toward your efforts in the game world. If you can't wait, go ahead and flip to Chapter 4. I'll wait here. But come back soon, I'm going to start talking about music stuff now.

Music Skills

The key piece to this puzzle is your skills as a composer, musician, engineer, producer, and technician—which is probably what you've been waiting to hear. These days, most music is done in the composer's home or project studio—forcing us into the "jack of all trades" role. It is paramount you are familiar, if not an expert, at all of these tasks. Keeping the creative process unhindered and free flowing is fundamental to composing. Nothing ruins your creativity faster than having to stop to troubleshoot or look something up in a manual. The more you know now, the better.

Musicianship

Your musicianship should be well practiced and solid as a rock. Sequencers and multi-track recording software can enhance these abilities and fix mistakes—but trust me, building upon a solid foundation will save you much headache in the end.

I also recommend that no matter what your main instrument is, become proficient on the keyboard. The MIDI keyboard, next to the computer, is essential equipment which has the ability to access all other MIDI instruments and software in your arsenal. It is a focal point by which you can control other keyboards, sound modules, samplers, electronic drums, virtual instruments, and even start

Guitar virtuoso Jon Jones laying guitar tracks for Konami's *ESPN MSL Extra Time* game.

and stop your computer recording software. This workhorse is in constant use and a must to have mastered.

The keyboard, as a musical instrument, can be highly expressive—with nearly unlimited sounds you can play from it. Musically speaking, this knowledge and power is inspiring—but too much of one direction can become stale and characterless.

If you are already a keyboardist, pick up the drums or guitar, anything other than the keys, and learn to play. It will open up another world, giving you better understanding of how music works and giving you another instrument on which to compose. Styles can vary widely when composing on piano for one tune and guitar for another. Your outlook will always be fresh and the music will reflect positively.

Another advantage will be self-sufficiency. Although I enjoy composing and playing with other musicians, it saves time not having to wait a week for a player to show—enabling me to get my work done quickly. The clock is running and busy production schedules are not always flexible enough to accommodate. Most composers in the game industry are multi-instrumentalists, having become so out of necessity.

Creativity and Compositional Skills

Never written a song? Then this might not be the business for you. Game music is designed to create a specific mood and audio "feel" to the accompanying virtual world and it is something you should be able to pinpoint exactly within the first couple of tries. While you may be strongest in one particular style of music, consider studying and composing in a variety of others as well. All games are not simply techno or other upbeat rhythmic compositions only there as background clutter. They serve a specific purpose and are skillfully mastered to absorb the player fully into the experience.

You might be lucky enough to find work composing in "your" style, but I prefer to diversify and have more potential jobs available. Orchestral is always the big trend, but techno, rock, pop, urban, ethnic, dance, sports, bluegrass, children's, religious, and so on are other styles—just as legitimate and paying just as well. There are even games which may include music in many of those styles on the same project. You want a developer or publisher to rely solely on you for their musical needs and not seek out anyone else. One-stop shopping is convenient for them, good business sense for you.

Practice composing short pieces in various styles as a creative drill. This will increase your repertoire while simultaneously adding more variety to your demo reel. Early in Brian Tuey's (currently audio director at Treyarch) game audio career, he consciously chose to push his creative envelope by trying previously undiscovered approaches to his music making. He happily admits this technique helped his creativity and broadened his musical horizons by exploring other avenues he hadn't previously considered. Try composing "Egyptian surf music" or "heavy metal monk chants" and see where it leads you. It's really not as far off as you think. Sometimes developers can have some crazy ideas and your creativity will be appreciated.

Writing for games is not like writing for your own album release. You will not have the luxury of time, composing and recording only when the "mood" strikes you. Like any other fast-paced adventure such as writing for commercials, weekly TV shows, and film, you must be able to turn your creativity on like a

faucet. It must be an immediate action, ready to go at a moment's notice. If you wait for the elusive muse to appear, then the rapidly approaching deadline will be gone and you'll be left looking foolish. You do not want to be the one person the project is waiting on. Time is money and any delay could mean wasted funds for the developer and publisher—who are all counting on you. If you are used to composing only when you feel like it, fight the urge, write when you don't want to, pretend you have a looming deadline, and just do it. As you progress through this business, you'll discover it gets easier turning on the switch. The problem comes with turning it off and knowing when to say a piece is done. The curse of being a perfectionist, I guess.

Engineering Skills

Know the equipment and software you are working with inside and out! Study the manuals, try new techniques in your spare time and know their strengths and weaknesses. Waiting until you are recording a project is too late to figure out how to use your gear. Losing a sound in the maze of electronics can lead to some extensive delays and may tamper with your mindset at the most inopportune time.

Be well practiced at your engineering skills. Know how to get the best sound from your instruments and have the EQ (equalizer) and effects processor settings memorized. Standardize and streamline the process, if you can, by leaving the same instruments plugged into the same channels on your mixer and fight the urge to change it. It will save you significant time during a session to be to able to grab the right knob or fader without having to think about it.

The marketing departments in every equipment and software manufacturer are hard at work enticing you to buy their latest and greatest products. If you are a recording facility and have rich, demanding clients who love to spend money, then you have a legitimate need to buy the newest gear. But if you are a project studio existing only to record your music, you might not. My general philosophy is to buy only the gear that will make me more competitive and profitable, not

Engineers should be very familiar with the gear in front of them in order to keep the creativity moving in a forward direction. Tom Todia working his magic! (Courtesy of Tom Todia.)

buy gear because I've got to have it. By staying solidly on the trailing edge of technology, I don't have to constantly relearn new equipment and software; instead, I keep and maintain what works for my composing and recording methods. It's not that I refuse to upgrade, because I do when it's needed; I just don't do it unless it satisfies both of my requirements. By staying with familiar gear that works longer, I'm able to work without having to think about the technical issues and disrupting the creative process.

Early in my game career, I had a project with a new game company requiring me to add sound effects to their cinematics (in-game movies). The game was still in development and they were trying to add an audio personality to these cut scenes and have something to show their investors at the same time. Unfortunately, the software they were using was completely new and the learning curve for me was steeper than normal. What would have been a 2- or 3-day sound design project became a 5-day undertaking because they also required me to add sounds to the cinematics myself using their software.

After day 2, I called the company who developed this "tool" and discovered I could not layer sounds on various tracks as it advertised but had to do a composite on a single track instead. No problem, except there was no reference to synchronize to and a stopwatch was unreliable when the animations bogged down or skipped frames. A trusty calculator and a lot of trial and error finally did the trick, but not after a couple of days added to the production cycle and much grumbling. A new program without all of the bugs fixed and no one available who had any experience with it brought a normally speedy sound design process down to near gridlock—a great lesson when introducing something new into your process. Beware.

Familiarity with your equipment will make your job easier and I cannot stress its importance enough. Consider audio engineering courses at your local college, volunteering yourself and studio to record demos for local bands, or remixing your old tunes—all in the name of keeping your ears open and staying on top of your game. A skill without practice becomes a hindrance. Suddenly, I'm a philosopher.

Producer Skills

As the proverbial one-man band, you are also acting as the producer. When producing other band projects, it's easier to remain more objective to the overall project because you are not emotionally attached to the music as a musician would be. In this case, you would have the luxury of focusing on the overall picture—keeping it on track, motivating and evoking heartfelt performances from the musicians, and sheltering them from any outside influences which might disrupt their creativity. It is indeed a job in itself.

When producing your own music, the line becomes blurred and may not always be the best situation unless you can take a step back and maintain your objectivity. This is almost an acquired skill, obtained slowly and painfully through your years of experience—but it is something you should strive for in your quest.

You cannot fall in love with your music as the artistic endeavor "creation" can be. Because this is a work-for-hire situation, you have been commissioned to write a score which will enhance the overall game project and that must always be your first priority. You are creating for the project, not for yourself. If a producer asks you to take out a passage of the music and it happens to be your favorite part,

you must be able to detach yourself, as a producer would, and make the change. Remember, none of this is personal—as you might sometimes feel. It is all strictly business and it demands objectivity from everyone involved.

Another producer function which must be considered is the knowledge of how the music and/or sound effects will interact in the soundscape. During the development process, there are particular questions to ask—designed to gain an overall understanding of what sonic activities are present in a game. If separate narration is to play over particular music, that should be considered and the final mix of the music should have a "hole" in that frequency range to accommodate the voice-over. Otherwise, the programmer may decrease the music volume to compensate—which may degrade the entire audio moment. The same thing applies to sound effects. If there are heavy explosions in the lower frequency range, then the music should have less bass end so that the most important sounds are heard. It can be a lot to consider but an on-the-ball producer can make all the difference. If you intend to release the game's music as a CD soundtrack, the music will have to stand on its own and you'll probably need two entirely different mixes to make this happen.

Technical Knowledge

Another skill set which goes hand in hand with the musical and engineering skills is solid "technical" abilities. You can fudge on this and get away with hiring outside help, but you'll be increasing overhead and traveling further away from your goal of being self-contained. You've probably been picking up more than you think, repairing and troubleshooting your way to successful recording sessions.

Basic skills like tracking down a faulty patch cord and being able to solder it back together, being able to successfully splice together a complicated MIDI setup and having it work, being able to understand and synchronize different pieces of equipment, and integrating your computer into the recording process by yourself are assets that will save you time and money. There is a myriad of complicated, specialized equipment which needs to somehow all work together, and if you can make it happen with only minor assistance, you have already mastered this.

Computer Knowledge

In this day and age, it is nearly impossible to compose music and design sound effects for video games without having a computer. Plus, how do you expect to know what is going on without playing a game or two yourself? The first word in "computer games" is *computer*. Know thy computer!

A developer is considering you as the sound contractor on a big game project and, after the non-disclosure agreement is signed, sends you a beta version of the game to load on your computer for a look–see. What do you think your chances are going to be if you can't get the program to work on your machine? Sometimes, it takes a bit of finessing and coaxing to get a game to work—and if you can't do it, the developer sure won't have the time to either. This is a severe example and highly simplified, of course, but the truth is, the developer is already extremely busy with their task of getting a game to market and prefers to deal with the path of least resistance. I've been told by several developers they would never consider hiring anyone unless that individual possessed solid computer skills. Computer literacy is a good thing and will keep you from being knocked out of the competition.

Today's music making has become centered almost entirely around the computer as well. Sequencing programs, multi-track recording programs, sound editing programs, virtual instruments, effects processing plug-ins, notation software, accompaniment software, samplers, and the like are studio mainstays and you've got to know how to make them all work correctly. If you can install a sound card, MIDI, or digital recording interfaces on your own, that can be a big plus. No one knows your system better than you, unless you have a trusted computer guru readily available to serve your needs. On-the-spot troubleshooting can save the day.

Most of the sound design process is done on a computer as well. Initial recordings, the editing process, and conversions to the final playback format are all completed inside this machine. It definitely pays to be knowledgeable and unafraid in this frontier. The more you know and understand about it, the better off you will be.

Sound Design

Another important skill which will serve you well in the games industry is sound design. You may not know it yet, but as a musician you already have the foundation for this and all it takes is some fine tuning to make it another profitable part of your business.

Consider the creation of a sound effect to be like a mini musical composition. You first choose the "sounds" which will work best toward your end goal. You cut, paste, layer, EQ, pan, fade, add some effects processing, do a final mix—and, voilà, instant sound effect. Suddenly, you realize you build a musical piece the same way. Well, it's practically the same—except the choice of instrumentation is slightly different and instead of the final mix being minutes, it's seconds long.

Think about this, too. For those of you who create your own keyboard patches or samples, these are the same skills sound designers use on a daily basis. They don't always use everyday sounds or sound effects libraries; they will also use keyboards and tone generators and manipulate them to create the effect they are looking for. It's the same thing you do when you develop your own original keyboard patches. You're a sound designer, too! Keep that in mind.

"Diversify and thrive" is a business axiom which applies well to game audio folks. You don't have to create music for just video games, but always keep your options open—and also consider jobs composing for multimedia, video, radio, TV, and film. You have a valued skill; don't waste it on one medium. The same goes with your sound design talents. By becoming proficient as a sound designer, you've just doubled the amount of jobs you can do in games. Game developers almost expect a composer to double as the sound designer as well or to at least have someone on their team who acts in that capacity. They see it this way: you have a recorder and a microphone, so you must be able to do sound effects, too. Ridiculous, I know, but that is the misconception the wise have capitalized on. There is no reason you can't also.

Another great reason to have "sound designer" on your resume is to make yourself and your audio production house a developer's or other client's one-stop shop. The game development process is already complex enough and the fewer people producers have to explain their vision to, the better. They would much rather hire one person, saving them the entire process of dealing with an extra body and keeping things simple. They know anytime "anything audio" is needed they can call you. By making yourself and your company look that much more

attractive, you have opened up the world of possibilities—whether you prefer to work as a contractor or a full-service in-house audio authority.

Voice-Overs

As the person with the recorder and microphone, you've just been assigned yet another task for your already vast capabilities. Did you know you can also be expected to not only be able to audition and hire character actors and voice-over talent but direct and record them, too? You've already got your finger on the pulse of the musician world, why not voice talent? But all I wanted to be was a game score composer, you say. Sure, but you'd be giving up another opportunity to make some money and giving the developer a reason to look for someone else to take care of them. You already possess the skills needed to make great recordings and you can probably already motivate your artists into some dazzling performances. With a little bit of patience and practice you can develop an expert approach to this line of work as well.

Needed a hot guitarist for a recent project of yours? Where did you go to find them? Did you try word of mouth, the newspaper, a talent agency? Where would you go for voice talent? How about the same places? For voice talent, you could even try your local radio and television stations for the people who do all the commercial voice-overs. Jon St. John, radio and voice-over personality in Southern California, was also the voice of Duke Nukem and many other voices in *Half Life—Opposing Forces, Evil Dead, Twisted Metal 4, The Sonic the Hedgehog* game series, *NASCAR Racing 4, NBA Shootout, Ken Griffey Jr. Baseball*, and others. Voice acting is what he does and he does it very well. Just because they hold a certain celebrity status on TV or radio, there is no reason to be intimidated by them. They are normal people looking for work, so introduce yourself and make them part of your network. You'll never know when they could come in handy.

Talent agencies are another great source and are not as complex as you might think. You let them know your criteria and they arrange auditions for you. After sifting through audio and video demos or even sitting patiently while they perform for you in person, it's fairly easy to pick your favorite and set up a recording session. And, with fees ranging between $250 and $2500 per session for standard voice talent (which you already included in your contract for the job, so it isn't coming out of your pocket), there is really no reason not to bring in the experience of a seasoned actor to maintain a high quality. We are in the profession of hiring talent on occasion, so learn to use this resource.

The point here is, you have probably been through all of this with musicians before, so you already have the knowledge to make it happen. While this particular skill won't make or break your game scoring career, it will make you much more attractive to your clients.

Many game composers and sound designers act as their own voice talent. It goes back to what I mentioned earlier about becoming self-sufficient by learning several instruments. When a deadline is looming and you have to wait for your talent to appear, this type of stress can easily disappear by becoming your own readily available voice actor.

As a creative entity in music, your mind is already geared toward performance and I'd be willing to bet you have plenty of those "funny voices" in your repertoire which you could take advantage of. And with creative use of EQ, effects, and some pitch shift, you can make a man sound like a woman and vice versa. Personally, I've been a pesky gremlin, goblin, seductive woman Russian agent, barrel-chested

gladiator, southern steamboat captain, race track announcer, card dealer, lispy fashion designer, fighter pilot, air traffic controller, cowboy, game show host, king, queen, geek, orc, elf, dog, cat, parrot, frog, rabbit, fish, and an assortment of cartoon characters. I took a little of my high-school drama days, my impatience and a microphone, and added another sideline to the job that, frankly, I'm having an awful lot of fun with. I got into this industry to do music but have remained open to all the possibilities. Our type of creativity can pay off in many ways.

Industry Knowledge

The only thing left on this long list of essential skills which will make you competitive in this foreign land is knowledge of the gaming industry itself and how it works. It is a world unto itself and far from your comfort zone as a musician. If you already possess some solid business sense, you are another step ahead of the crowd—but knowing when and where to strike in games is the secret. Do research. Talk to any friends or acquaintances who are in the industry, find out how their companies work, who to talk with to get the jobs, and most importantly, how they do what they do. Talk to other game composers, sound designers, and voice talent. These people have plenty of knowledge and are willing to share it. Don't expect them to give you names and phone numbers of their clients, they have fought hard themselves for them, but they will gladly discuss the process and the technicalities. Most are very open and friendly.

Be a sponge. Absorb everything. Stay alert for any information about the games business. Subscribe to a few magazines (such as *PC Gamer, Game Informer Magazine,* or *GamePro Magazine*) for the consumer side. *Games Industry* webzine (www.gamesindustry.biz) for the business side of game making. There are many, many other sites available free of charge which are full of great information. Gamasutra (www.gamasutra.com) is a great resource for industry information and job leads, for example. We'll talk about more of these in Chapter 4.

Every time you walk into a retail outlet, check out the video game isles; pick up boxes and look at the companies who are making these products. Buy a few. Don't be shy. They're a tax write-off for your business now. You can't expect to do audio for games if you aren't familiar with the major titles, what technology is being used, and what types of sounds they are making, now can you? Rent games from your local or online stores. No one said this was going to be all work now, did they? After all, this is the games business. We do have fun on occasion.

The point of all of this is to be educated about the industry in which you work. It is in constant motion as smaller companies are taken over by larger ones, companies disappear 1 week and spring up somewhere else under a new name the next. A producer you worked with on one project may have jumped ship to another company or even started his own. By keeping your finger on the pulse you can guarantee your survival and flourish. Evolution is constant. Education is paramount. Know your business.

Tools for Your Business

Musical arsenals vary greatly with each composer. Some prefer a minimalist approach, to keep technology from interfering with the process and let them create truly unencumbered art. Others have to possess all of the latest and greatest gadgets and gizmos, computer wizardry, and plug-in noise-making

boxes—preferring to let technology drive the creative course. Both extremes produce appropriate game scores which serve the virtual experience quite well. Most of us, however, are somewhere in the middle. The trick is finding what works best for you and whether you will do it leading the pack, using up-to-the-minute hardware on the leading edge, or working comfortably with the tried and true on the trailing edge. There are advantages and disadvantages to each.

By purchasing equipment and software the second it hits the store shelves, you are always guaranteed to have the newest possible technologies at your disposal. With the highest sample and bit rates at your command, your music has the potential to be pristine and an example of sonic perfection. And based on your equipment inventory, you are also more likely to be able to handle jobs that utilize these technologies. Since most of us usually wait until a job requires a specific piece of gear before we incur the expense, by already having it and being familiar with it, you may have the advantage. But don't let this belief be the influential force in your business.

There is always something newer and better on the market. By the time you've purchased what you thought was the best piece of equipment, something else is introduced just a little leaner and meaner. You will quickly go broke racking up tremendous debt in a hurry with this mindset.

Another disadvantage that becomes quite frustrating, you may buy this great "gotta have" piece of gear, get it back to the studio, and realize it won't interface with your existing setup. Back to the store you go, only to find no one has developed, or even thought of yet, the cable, box, or driver which you need to make it work. Or maybe you get lucky. But then you get it back, plug it in, and discover some horrendous software bug has stopped you cold. Give the manufacturer a couple months to develop a patch, box it back up, and send it to the factory for them to fix it there. Think I'm being a bit extreme? Not at all. It's happened to me and many others I've met in my travels.

The trailing edge of technology is not a bad place to be with most equipment. The manufacturers have had plenty of time to work out the kinks and receive plenty of input from consumers about which features they feel are useful. By the time the next version does appear, you are working with technology that has been on the market for a time and upgraded with some very convenient features. Not a bad trade-off for some patience and disciplined spending.

What about the constant learning curve involved with the continuous flow of new equipment through your doors? It would be much different if you were running a full-blown recording studio but as the sole composer and business proprietor, no one has that kind of time to spend learning and relearning. As your studio setup becomes second nature, very little effort is needed to record or find the sound you're looking for with familiar parts at your fingertips. Streamlining your composing and recording process will keep you efficient and running smoothly as you work to move your product out the door.

Now, why have I been pushing this line of reasoning? Let me tell you. I want you to keep these points in mind as we go through the list of absolutely essential equipment you need. I will cover the basics, bare bones setup, the nice-to-have gear, and what established game composers are using themselves to do the job. You can get this venture off the ground with very little, but as money starts coming in, it will be very tempting to spend it on toys which will do nothing for your bottom line or your success. My advice: Buy only what will make you competitive and only what will make you money. Trust me on this. It's easy to get carried away.

Interview

TIM LARKIN
Composer, Sound designer

Describe your thought process for creating music and/or sound effects.

The thought process is almost always the same, generally starting with visuals. I give that a little time to sink in then begin thinking about the context of the sound and how it will relate to its surroundings as well as story elements. Context is so important. I often hear sounds in trailers or games that sound good but feel out of place or distract from their purpose. It's not just about making cool sounds—it's about making sounds that work. Everything from the size, space, distance, and reason is so important. All of these things contribute to making the sound interesting as well as supporting the role of the story and context.

Are there any particular secrets to your creativity?

I wish there were. Generally, it's pushing through regardless of whatever roadblocks you might be encountering. Sometimes an idea isn't that great to start out with, so I'll continue to iterate until I start to hone in on what works. Sometimes that can take a while. Other times, you hit it on the head right away. I wish that were the rule, but generally it's the exception.

Do you have any interesting sound design creation techniques which affect the type of sounds you create?

When creating sound design, I think the one of the most important things is to have great source material to pick from. I like having my work sound unique whenever possible, so I record quite a bit of my own source. It's amazing to me how often I can cut something in that's my own source and it comes very close to working right away. I think that you often have a better connection with the source you record yourself and therefore have a better understanding of how it will work in context.

When do you find you are most creative?

I'm most creative when I'm energized and rested. Generally, after a physical activity, my brain and body feel refreshed and much more receptive to creating. Working out, skiing, hiking, and playing tennis are all generally great precursors to getting some quality work done.

Is there a typical workday for you?

Not really. Each day brings with it something new. Depending on what type of project I'm working on it can vary from spending the greater part of the day composing music to mixing to creating sound design or just trying to get my computer to cooperate. I spend most of my time currently at Valve in my studio there, but also work from home when I can with an almost identical setup. Working at Valve means more interactions and meetings with various team members while I tend to be a bit more isolated at home. That can also mean getting more done at home with less interruption.

Any good business advice to offer?

Whether I'm working freelance or working with a company, I always try to make the client or team feel like I'm making their job easier. In essence, I feel that I provide a service, whether it is creating sound or music. I want them to feel like they're happy with the results and they didn't have a difficult time getting them. I've worked with many that impede the process more than contribute to it. That's not a pleasant experience for anyone involved.

What skills should composers have to succeed in the games industry?

I've said this many times before, but I think that knowing the line between good music and bad is key. Too many demos I hear are just not good. Period. However, the composer gets attached to the piece for one reason or another and can't understand why it's not appropriate, or not good. Listen to the classics, listen to movies and games, and compare your work and production to what's out there. If you listen enough, you should be able to realize the differences between what you're doing and what's successful and eventually make up the difference.

Any horror stories which have impacted how you do business?

I've always done the work I'm hired to do. There have been a few times when things got so busy that I needed help and hired a contractor. It was a disaster. I spent more time fixing the work of the contractor than had I done it myself to begin with. I'm not saying that contracting out is bad, but it didn't work well in that situation and have never done it since. Trust is huge and getting to know someone who works like you do and has a similar esthetic and commitment to the same level of quality is extremely important.

There are many pitfalls when "working" in the game industry. Have you had any bad experiences?

I think you need to approach working in the game industry as you would in any other industry. Just because it's a creative job that you're doing doesn't mean you're going to deal with like-minded people. Even when you're working with people that do the exact same thing you do, they're all going to be very different. You need to be able to adapt to political situations, people who are type A, type B or whatever. You still have a cross section of the population you're working with and you'll never know what you're coming up against. Just because you're working in games doesn't mean that everyone who works in games is cool.

I would also say however that overall my career in games has been incredibly rewarding. I've been extremely lucky to have worked with some of the most talented people in the business as well as working at some of the most cutting-edge companies making some incredible products. Bad experiences yes, but I try not to let those experiences shape my attitude or work. That's just life.

Assuming most of you own an instrument or two and have some type of medium to capture them onto, believe it or not, you could almost get by with this as is. If you have the ability to get music to a developer in a polished form, you are in the game. But most developers won't have the time or the expertise to convert your audio to their required final format. It's up to you and probably best that way. You are the ears of a development team and most likely have a few more years of experience in the audio arena than they do. You know what the music is supposed to sound like and what noise was designed into it. By delivering material in its final format, you can almost relax—knowing the audio is sounding its best.

Computers

If you don't have a computer, get one. You will need it for many tasks and these days it is an indispensable part of every studio. As the brain of your operation, it not only accomplishes your administrative tasks such as e-mail, Internet access, word processing, and accounting but is used extensively in the creative music making and sound design process. MIDI sequencing, sound editing, multi-track recording, mastering, and DVD duplication are all vital activities which center around this appliance. You cannot get by without it.

The software you purchase will ultimately drive the minimum requirements of the computer you use. For MIDI sequencing or basic sound editing programs, any computer built within the last 5 years or so is adequate. If you have one in a closet somewhere, pull it out, dust it off, and put it back to work. But if you want to spare some frustration and a lot of finger tapping while files process, I recommend starting off with the best machine you can initially afford—something with the fastest processor, the most RAM, and the largest hard drive you can get your hands on. Audio files tend to be large and gobble up storage space and processor speed at an incredible rate. Make sure you have a reliable archive system to save to. A DVD-R or external drive will work well, but since you'll have the tendency to be burning audio discs anyway, a DVD-R will cover both initially. Regardless of what you buy to do the work, make sure it is a system that will carry you for at least a couple of years. Upgrading computer systems is a

A typical computer audio workstation.

lifetime process, so at some point you need to just stop the cycle and do the job until you absolutely need to make another purchase. Drive that baby 'til it won't go no more.

An extremely fast Internet connection is something else you should consider when piecing together your studio computer. A dial-up modem is nowhere close to being viable, so consider a T1 line, DSL, or cable modem as essential. One of the greatest things about our jobs is that we don't have to actually be on site at the developer's office. As long as the final audio work is presented in the correct format, that's pretty much all they care about. Delivery is mostly through the Internet and when files sizes are 11 MB per minute of audio it's not uncommon to send off files of 100 MB or more. It's been more than 15 years but I still vividly remember the pain of staying up all night to send a measly 10 MB file from a 14.4 k modem. I went out the next day and bought the fastest connection I could find, never once regretting the decision. I now regularly inquire to my Internet service provider every 6 months or so about any available speed upgrades. I was surprised to find out I could double my already blazing speed by spending an additional $6 a month. Sign me up!

A Word about Hard Drives

Recording multiple music tracks in real time to a hard drive can tax any system. One way to ensure flawless recording is to have a high-speed drive or one rated for A/V use. Stay away from bargain brands; look for reliable product names which have a proven track record. Don't skimp on the quality of this type of storage medium. It will be getting plenty of hard work in its life and a catastrophic failure will shut you down. Western Digital, Seagate, Maxtor, and Fujitsu are solid bets. Dedicated hard drive storage systems are also available—such as Drobo and Synology storage arrays or Glyph Technology's rack-mounted units which are designed specifically for audio use. Even better bets.

Interfaces

Having a computer is almost worthless without the appropriate interfaces to connect your gear. You could compose and do sound effects completely on a computer. Using loop, notation, or sequencing programs which play software-based synthesizers, virtual instruments, and samplers, you could make some great video game audio. There are a few composers who do but many like to have this as just another option. Interfaces with your electronic instruments and recording gear will greatly expand your possibilities.

You will need a good sound card—one which sounds good without adding noise with all of the plugs you need to get audio in and out of your computer easily and cleanly. Nowadays, it is possible to find a decent sound card which not only has analog audio inputs and outputs but digital as well. I recommend having one with the digital input/output (I/O) option, which you can route sound to and from your digital mixing board, digital recorder, or instruments which also comes equipped with the appropriate connections. By keeping sound in the digital domain, you are avoiding any unwanted discoloration from needless

conversions back and forth from analog to digital—maintaining audio as you originally intended. Higher-end professional cards are common and plentiful; a little research will help you find just the right one for your needs. If you don't have the cash now, start with a good consumer-grade card and then upgrade as you can. This device is one of the most important computer accessories for our business and having a good one is paramount.

Some type of MIDI interface or appropriate USB connection is also required between your computer and external electronic instruments. Selected sound cards have MIDI capabilities but only on a limited basis—and usually with only one MIDI input and one MIDI output giving you 16 channels of information. As a basic setup, this is workable, but for your eventual growth, a further investment will secure a separate MIDI card with two in and outs, for 32 channels, or consider a high-powered audio interface with this capability included. M-Audio makes some pretty good interfaces for the PC and MAC with 1×1, 2×2, and 4×4 options. RME products are a nice step up and have a rock solid track record that rivals the Digidesign interface lineup. This can seriously increase your MIDI capability and overall system control and performance. There are also multiuse interfaces with included internal sound cards which allow for both full audio and MIDI capabilities.

Software

With a solid computer system ready to go, let's talk about the software which will help us put together our audio product. I don't currently endorse any particular software but am extremely familiar with the programs in use at my facility, so I might occasionally lean in that direction. This is *your* bread and butter, so in the end you'll need to decide on the combination which works best for your specific needs.

Sound Editors

Sound files cannot be manipulated in the computer domain without a strong audio editing program. If you don't have anything else, make sure you definitely have one of these. In fact, I'd say it is virtually impossible to work in the games industry without one. Once music is created, it has to be translated into an acceptable computer format for playback within a game—and this type of software has that ability. It can also ensure it sounds its best with EQ, volume, compression, effects, and many other features. Also, by supplementing what you hear, this visual method will show any dead space before or after the sound, any peaks which may distort, and the overall loudness of the sound. This can come in handy when trying to keep file sizes down. Silence takes up the same amount of space as noise, plus, when you see a sound as a solid square block of color, you may reconsider the mix with more dynamics.

One of the most popular sound editing programs is Sony's Sound Forge. Others you might also consider are Adobe Audition, Steinberg's Wavelab, Goldwave, or Audacity. Having a good main editing program will make life easier for you in the end, so don't scrimp if you can help it. Also consider having several of these programs available, to keep your ideas fresh and to take advantage of each program's better features. I initially didn't consider an old shareware version of Goldwave to be worth my time until another sound designer mentioned it had a great Doppler effect. Now I use it exclusively for that one effect. You just never know.

Adobe's capable audio editing software, Audition.

Multi-Track

Music constructed using several instruments and sounds is recorded onto some form of multi-track system, whether it is a tape- or software-based medium. By recording each instrument to its own track, more total control is afforded during mixdown phases. Although it is certainly plausible to record using "virtual" MIDI tracks, there are many occasions when addition of non-MIDI instruments, such as guitar, live drums, and vocals, helps break up the mechanical feel of the music and humanize it. When creating sound effects, though, software-based multi-track systems allow the best all-around options.

Multi-track software is not absolutely essential if you have the capability of a multi-track tape machine, but it is very useful for music and sound design. Pro Tools is a favorite for some, but there is also an equal number who dislike it with equal fervor. Steinberg's Nuendo, Cakewalk's SONAR, Sony's Vegas Pro, and Apple Logic are other solid programs which fulfill the multi-track mission. Again, it comes down to personal preference and budget. You can get by without it, so don't beat yourself up if the budget doesn't allow for it yet. It is, however, something to keep in the back of your mind.

Nuendo and SONAR are two powerful programs at different ends of the price spectrum. Nuendo is Steinberg's high-priced no-holds-barred software version of the professional Digital Audio Workstation (DAW). Its strengths are with combined multi-track audio and MIDI production, automated and surround mixing, use of internal virtual instruments, and a very neat little feature which lets you undo any edit at any time during the production even if it was 100 edits ago. This is a very professional-looking program, reminiscent of a large studio mixing console with more plug-in processor support than you can shake a stick at—a great program if you want to spend the money.

If you still want the power of combined audio and MIDI production without the large expense, try Cakewalk's SONAR. This incredible program takes its expertise in MIDI production to an entirely new level, adding unlimited audio tracks, internal virtual instruments, advanced loop production tools, real-time

Steinberg's multi-track audio and MIDI powerhouse, Nuendo.

effects plug-ins, and tons of extras. This program has quite a bit to offer. Vegas Pro is strictly a digital audio production tool, so if you require MIDI support, a program like this will do you well.

Very early in my game career, I had been doing sound design with a no-frills audio editing program. I would layer, cut, paste, and expend much time in trial and error—forging new sounds in the stereo and mono realm. I was quite happy until I met a fellow sound designer who was using Pro Tools. My jaw hit the floor when he showed me the awesome capabilities of creating sound effects in a multi-track atmosphere. Instead of the old hope-and-pray method, this was indeed nirvana.

By having each layer of sound on a different track, you have complete control—and as the layers become thicker, you can still go back and tweak by

Cakewalk's powerful MIDI and audio production application, SONAR.

individually equalizing, panning, fading, and processing them to your heart's content. And the best part is these programs are nondestructive, leaving the original sounds untouched. Only during playback and final rendering do the plug-in effects assist to produce the end product. Since then, I haven't looked back and do all of my sound effects creation in multi-track. After they are rendered, I polish them up in my audio editing program for their final stop before delivery.

Sequencers

Sequencing software is a must when dealing with instruments using the MIDI standard. Every professional keyboard, sampler, sound module, and electronic drum kit utilizes this interface—along with many types of outboard gear, like sound effects, and guitar processors. By having an appropriate MIDI interface between your computer and gear, you will be able to act as the one-man show— having control over your entire setup with the touch of a button.

Several sequencing programs are available, some simple and others incredibly advanced, integrating multi-track audio options and plug-ins. If you aren't familiar, I suggest starting out with simple (and inexpensive) then build up as you become proficient. Cakewalk SONAR, Steinberg Cubase, Mark of the Unicorn (MOTU) Digital Performer, and Apple Logic are mainstream products with good track records and many years of experience behind them. The one you choose depends on you, though. You'll find that over the years you will gravitate toward software you are comfortable with regardless of what other people may say, and for me it was, and still is, Cakewalk (now SONAR). As my needs grew, so did the complexity and features of the software—and I've not had a reason to go elsewhere. That ol' comfortable shoe still fits. I'm pretty sure if I'd started out with any other program I'd be saying the same thing about them, too. It's hard to go wrong, as long as it helps you in your creation process.

Loop Software

Other nice-to-have programs which help computer game score writing are those which utilize loop libraries. Originally, I wasn't too keen on them—thinking they could eventually replace composers with programmers and save a buck or two. But then I heard the so-called "music" these non-musicians were coming up with and I relaxed. The musicianship of these prerecorded tracks is usually good, but the arrangements are what give away the amateurish production. There is much a true musician can do with these tools to make them sound great.

The Sony ACID series, with an abundance of loop libraries in varied styles, can turn some wicked grooves on its own. It can also set your creative wheels in motion, giving you some great ideas to pursue when you may be feeling less than inspired. Propellerhead's ReCycle and Cakewalk's SONAR are useful programs as well, establishing grooves and processing loops by matching tempos to keep everything in sync.

The only real downfall to composing in this manner is that occasionally you will hear bits and pieces of different games using the exact same loop. To remedy this, try using loop libraries as audio seasoning to add some texture and interest to your tracks or make sure you don't always use the preset key and tempo values of the program. Go out of your way to ensure uniqueness. I'll also use a drum track or prebuilt groove as the basic track, which I add to with my own blend of sound.

Sony's loop-based production tool, ACID Pro.

Plug-Ins

You can never have enough effect processors in your hardware arsenal and you can never have enough effect plug-ins for your software setup. The manipulation of sound is what keeps things interesting to our ears, and there are literally hundreds of plug-ins which add their own brand of flavoring to the mix. Many of the previously mentioned programs come with several plug-ins preloaded, giving you the option to add reverb, chorus, flange, or other effects to your sounds. The problem with these included effects is that everyone else has them, too. By adding other plug-ins, you guarantee a distinct sound to your mixes that are fresh and stand out from the sonic crowd.

Of course, the manufacturers of these add-ons know this and have priced them accordingly. So, to keep you out of the poor house, only buy what you really need and what will make you competitive. I know, I've said it before. You can find these in any music catalog that sells software, music stores, and at your online retailers.

Mastering

Mastering software is mainly designed with CD production in mind and if you plan on releasing any of your game soundtracks, this will come in handy. When producing music for games, though, this type of software, while not used exclusively in the creative process, has a few features which are practical. Before I submit music in its final format, I'll run it all through my mastering software—ensuring consistent volume levels, adding cross-fades to those cues which will run together and add any last compression or final touches.

I'm mainly concerned with the overall picture, making sure the music sounds like it came from the same place, written for the same game, and that they work

Tools of the Trade

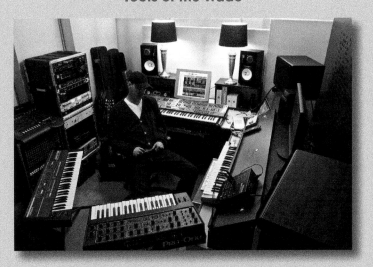

JON HOLLAND
Composer

My studio space is always being reconfigured to keep it fresh. I love both analog and digital gear. Both have their place and produce their own unique sonic character. I have a history with analog synthesizers that goes back to my childhood. I have owned most of the popular synths at some point in my life (Moog Sonic Six, Minimoog, Arp 2600, Oberheim SEMs, Prophet 5, TR808, TR909, CR78, Super JX). I'm really loving the new wave of analog synth companies bringing back these great instruments and moving the whole analog thing forward. I'm also trying to do as much acoustic recording as possible and like to experiment with mics, compressors, and preamps. I'm a guitar player mainly, so I really enjoy hearing air move through a room.

Computers: MacBook Pro/Apogee Duet, Apple Mac G4/Pro Tools 5.2/4xDSP cards. (My favorite vintage digital tool in all the land. I've had it forever.) Most processing is in the box, but mixes may soon be getting summed through an analog mixer onto DSD as my master archive format. Experimenting with various AD/DA converters for input and output. I'm planning to add a Pro Tools 11/HDX system as soon as I can. Keeping the old system 'til it dies'

Software: Apple Logic 9, Apple Soundtrack, Reason 6.5

Monitors: Yamaha NS10M and JBL Monitors

Midi/USB controllers: MAudio Keystation Pro 88, Roland PC-200MKII

Hardware synths: Roland JD800, Roland Juno 106, Sequential Pro One, JV1080

Software synths: Arturia V Collection (v3), Lennar Sylenth1, Cakewalk Z3TA + 2, IK Philharmonik, Apple Softsynths

Microphone: AKG 414TLII + Various Mics and Preamps

Instruments: Electric and Acoustic Guitars

Additional favorite gear: DBX 160x (modified by Audio Upgrades)

IK Multimedia Production's analog mastering software, T-RackS Classic.

well together. Video games can jump around from menu screens to action to cinematics to credits fairly rapidly, so the music for each can be heard by the player close together. I want to make sure they are all of equal volume and sound quality, none sticking out and calling attention to itself. The music should be there to enhance the game, not take it over. Programs available include Steinberg Wavelab, IK Multimedia T-RackS, and Sony's CD Architect.

Sound Modules, Keyboards, and Virtual Instruments

Computer? Check. MIDI and audio interface? Check. Software? Check. How about instruments? Yeah, that's probably something you'll need. If you had only a single instrument, I suggest a decent keyboard with a good variety of sounds—including percussion and an MIDI port on the backside. That's really all you need. Later, when we get into the actual composing process, it will make more sense but know it is completely possible to do it all from one good keyboard. You only use a few patches per song, maybe a dozen or so at the most, and a keyboard with 256 patches will have plenty of sounds at your disposal. As a basic setup, this will work nicely.

Do I recommend having only one keyboard? Most certainly not! Have as many sound modules, samplers, virtual instruments, keyboards, and electronic noise-making devices that you can to keep yourself inspired and to keep your music fresh. By having an infinite amount of sounds at your beck and call, you can be more versatile and have a better chance of finding the perfect sounds for each project. This increases your chances of obtaining a variety of jobs, the limiting factor being only your creativity—not your sounds.

A well-equipped keyboard station is essential when composing for video games.

I once received some very good advice from TV theme great Mike Post. After listening to a demo of mine, I asked him what I could do to make my music better. He said the most immediate, positive effect I could have was to increase the number of sounds available to me. By doing so, I could remain in love with the composing process—always having a new, exciting aural experience awaiting me with a push of a button. He mentioned that feeling you have, when you bring home a new sound module or keyboard, when you first turn it on and that creative rush that lasts until you look at the clock again hours later. You can be proficient at composing but to really stand out, the inspiration and emotion that filters through is the key to it all. I totally agree. By making your new purchases slowly and wisely, this can be a feeling that lasts for years.

I highly recommend a good keyboard which you can use as a master controller for the various sound modules, virtual instruments, and samplers you'll eventually be buying. Try something with a full 88-key compliment, so you have plenty of room to split sounds and have the full range available from top to bottom. Once you have a good keyboard, you can save money by acquiring virtual instruments or rack-mountable sound modules—which are usually cheaper versions of an existing keyboard. Make sure these modules are expandable and have plenty of room to grow with additional sounds and memory. The end goal is to buy the most sounds for the least amount of cash outlay—a relatively simple concept in theory, of course.

Other Instruments

Because we are creating for computer games, it isn't necessary to just use computer and electronic devices. In addition to your keyboards, sound modules, and computer, good old-fashioned analog musical instruments, which can be played live with your MIDI-controlled virtual tracks, are a superb supplement. They can

add an entirely new dimension to your music and also keep it from sounding mechanical and boring. Guitars, drums, vocals, various percussions, brass, and so on are all perfect to add that extra flare. Even though we are creating music to play behind a game, it doesn't mean it can't be good music. By using all of the tools available to you, the listener will always be surprised by new sounds they hear—enhancing their overall gaming experience.

If you don't play another instrument, take some time to learn the basics or have musicians who do in your talent pool for those projects needing extra zing. By doing so, you will have increased your musical options and kept yourself competitive in the market. Remember earlier I mentioned most game composers are multi-instrumentalists or can fake it really well.

Field Recording

Other nice-to-have equipment will serve your sound design career and add some extra spice to your musical creations. During various sound design gigs, you may be tasked with either FOLEY work or creating original sound effects. Prerecorded sound effects libraries are easy to reach for, but say you're looking for a fresh sound which hasn't been heard in the last wave of games. You have the alternative of dragging items into your studio to record, but after you've made a mess a few times, you'll think twice. The best option is to have a portable recorder and a good microphone which you can haul out to the field in search of unique sounds. Why be restricted to what you can drag into your studio or by the length of your microphone cable? A decent portable field recording rig will really open the world of sound design and give you a nice competitive edge in the process.

Zoom's H series, Sony's PCM series, Tascam's D680, Fostex's FR-2LE, and Marantz's PMD661 are examples of solid transportable units with great sound, features, and price. An assortment of shotgun, stereo, and general purpose microphones will complete the collection depending on your needs. Music stores, music catalogs, and online retailers have great selections available with a variety of feature sets and in a wide price range. If you intend to do any practical field recording, portability and convenience will be important—even beyond that of a laptop's mobile recording capabilities. There's a lot to talk about on this subject and we'll get into more detail about this subject in Chapter 9.

Sound Effects Libraries

What good sound designer doesn't have an extensive sound effects library? Practically none. Most game sound designers who have been around for a few years either own or have use of practically every sound effects library ever made. Why? In their quest to maintain freshness and added creativity to their sounds, they have scoured the modern world for these prerecorded easy-to-use time-saving audio wonders. Television and film have used these resources practically since recordings were first made; it's only logical the billion-dollar game industry does the same. Cinema quality and the extra bang for the buck keep the game-buying public happy.

Initially, it is possible to do sound design work without a sound effects library. I got away with it for a few years, creating effects either from scratch or by manipulating sounds collected with my microphone. It was a great learning experience, delving into the sonic world and learning how sounds are perceived by the human ear and how to create sounds from practically nothing. It probably would have been much easier to take classes on the fundamentals of sound and would

have taken less time, but by discovering concepts yourself, their lessons tend to remain with you much longer.

Eventually, as you remain in this business, projects will require more than what you can create from scratch. Unless you've got friends in the Marines who let you record streaking low-level fighter jets, firing weapons, and explosions, you need an alternate method. The next step would be to comb the Internet and its offerings. There are many sound hobbyists who post recordings on their websites for public use. This approach can get you out of a jam but can also get you into one. Unless you know for sure, there is no telling where these sounds originated and possible copyright violations could arise. A developer is usually not too happy being party to a lawsuit for sounds you don't own or have licensed to you. Most contracts, which you sign with them, have a paragraph which clears them of any wrongdoing and puts all of the responsibility on the sound contractor to not violate any such copyright laws. It could end up being very expensive for you. Does it ever happen? Rarely, but I wouldn't want to be the one out of a thousand who ends up in court.

The solution: sound effects libraries. They are abundant and cover sounds from almost everything which makes noise on the globe. By purchasing these libraries, while not actually obtaining "ownership" of the sounds, you are granted a license to use them in your work. It doesn't get much better than that, nice and legal-like.

The prevalent sound effects library providers are Sound Ideas, The Hollywood Edge, and Blastwave FX. I recommend asking for their demo discs or perusing their online samples to get an idea of the sound quality and types of effects available. Whether you purchase now or not, knowing what sounds are actually available and where to find them when you do need them will save a lot of frustration later.

Sound Ideas (www.sound-ideas.com)
105 West Beaver Creek Rd., Suite 4
Richmond Hill, Ontario, Canada L4B 1C6
800-387-3030 USA
800-665-3000 Canada
info@sound-ideas.com

The Hollywood Edge (www.hollywoodedge.com)
c/o Sound Ideas
105 West Beaver Creek Rd., Suite 4
Richmond Hill, Ontario, Canada L4B 1C6
hollywoodedge@sound-ideas.com

Blastwave FX (www.blastwavefx.com)
Detroit, MI
313-887-0370
info@blastwavefx.com

There are also many online retailers who allow direct download and individual licensing for single sounds. This is great when you need just one or two sounds and don't want to buy an entire library series. Search *sound effects* on any search engine and you'll see what I mean. The following are a few of the more popular sources:

- Sound Dogs (www.sounddogs.com)
- Frank Bry/The Idaho Recordist (www.therecordist.com)
- AudioSparx (www.audiosparx.com)
- Audio Network (www.audionetwork.com)
- SoundSnap (www.soundsnap.com)
- Shockwave-Sound.com (www.shockwave-sound.com)
- PowerFX (http://powerfx.com)
- Sound-Effects-Library (http://powerfx.com)
- Watson Wu (www.watsonwu.com)

Development Systems

At the end of our list of tools for the discriminating game composer and sound designer is the game console development system. This is specialized equipment which allows developers to test game content without having to create a new build to disc each time and you the ability to deliver final sounds which have been fully tested in the game environment. Older game consoles such as the Nintendo 64 and GameCube, PlayStation 1 and 2, Sega Dreamcast, and Game Boy projects, as examples, required these "dev kits" to properly format the audio and were a necessary part of the development process. These systems had to be licensed to you for a hefty sum, but it was possible to outsource this conversion work to others who are already licensed and trained or to work out an arrangement with the developer if needed, saving you time having to learn the development system.

At this point in time, you happen to be quite lucky. Since the introduction of the next-generation game consoles (Sony PlayStation 3, Nintendo Wii, and Microsoft Xbox 360) around 2005 and continuing with the eighth generation of consoles, the need for a stand-alone development system for the audio creator is almost a thing of the past. To create audio content these days, you almost don't even need anything beyond what you may already have in your arsenal. There are platform-specific tools you can use, mainly software programs, which will increase your options, such as XACT for Xbox and SCREAM for PlayStation. While not required, the availability of a dev kit helps streamline audio development and play testing allowing more focus on creation. These are available though the respective manufacturers and are recommended if you become involved with a project on these platforms.

Chapter 11 discusses many specifics about each type of game console and their respective audio production and implementation needs. It is another personal choice whether to add these tools to your lineup. They will require extra time to understand, but on the other hand, you can still work and do well without them. In the end, though, it is not an absolute necessity to have a development system to be able to do work on a project, but there are distinct advantages to having one to implement and test your own sounds in the game before delivering them to the developer.

Preparing Your Studio for Surround Sound

As I alluded to earlier, 3D audio is a powerful and popular feature of video games. With DVD, Blu-Ray players, multi-channel gaming consoles, and home theaters in many households, surround sound is *the* audio standard and everyone expects to hear it. Whether you do surround for games, your own music projects, or for

other media, you will eventually need to have the setup to make it happen. This section will explain what you need and provides the basics to set it up for a variety of studio configurations.

Equipment and Placement

Obviously, the first thing you need is the proper tools for this unique application. Software-based studio setups can make use of internal surround encoding and decoding script, such as Minnetonka's SurCode or the Neyrinck Soundcode suite of Dolby surround sound production tools, as a plug-in to whatever multi-track program you are using. For those who don't have the ability to do it in software, separate devices are necessary.

Dolby Labs, which has built a strong relationship with game creators, manufactures specific equipment for Dolby Digital encoding and decoding—the Model DP569 Multichannel Dolby Digital Encoding Unit and the Model DP580 Reference Decoding Unit. While it isn't entirely necessary to have the decoding unit, Dolby recommends that playback is heard through it while mixing in order to hear any subtle changes the surround matrix may create.

Hardware was previously available for ProLogic and ProLogic II applications but has since been replaced with software. Consumer Dolby Surround Pro Logic and ProLogic II decoders, as found in various stereo and home theater receivers, could be used as decoding hardware if needed. However, these consumer decks include circuitry to auto balance and correct left- and right-channel errors and may pose a problem when mixing because this feature hides the very problem you would be checking for.

In addition to an encoding/decoding setup, a speaker system that includes a left, right, center, two surrounds, and subwoofer is necessary for proper playback in a studio environment. Most everyone already has a left and right pair of speakers, so an addition of only four would be required.

A center speaker can be added to your existing pair, but be sure the addition matches either the acoustic characteristics of the two front speakers for consistency or you could install three identical near-field monitors designed just for this purpose. It isn't necessary all speakers be the same model but it is recommended. Large left and right speakers and a smaller center speaker from the same line are acceptable. If possible, the center speaker should have the same high- and mid-frequency drivers as the left and right speakers. When placing the front line of speakers, all of them should be equidistant from the mixing position—and the left and right speakers should be as far apart as the engineer's head is from the center speaker. This will provide optimum coverage and keep the listener in the sweet spot.

The frequency response of the surround channels for Pro Logic and ProLogic II is in the neighborhood of 100 Hz–7 kHz, so larger speakers for bass reproduction and extended range tweeters for ultra-high frequencies are not necessary. However, if the studio will be producing Dolby Digital mixes, it is recommended that the surround speakers have a frequency response as close to the front speakers as possible. The surround speakers should be placed on the side walls a minimum of 2 feet behind and at least 2 feet above the engineer's seating position. They should point to a spot 2 feet above the engineer's head for maximum effect. It is not recommended that surround speakers be pointed directly at or below the listener's seating position. For a Dolby Digital setup, the rear speakers should be placed 110 degrees from center. ITU recommendations are available for each system arrangement variant and are worth investigating for specific placement details.

JESSE HARLIN
Composer

Jesse's career in interactive audio spans two millennia. He is currently the freelance composer behind www.dunderpatemusic.com. Before that, he was the staff Composer/Music Supervisor for LucasArts, a Lucasfilm Ltd. company for 10 years. He's written an alien language, fulfilled his childhood dreams of rock stardom, and written space pig folk music (no lie). He also wrote the monthly "Aural Fixation" column for Game Developer Magazine for 6 years. His credits include games such as *Star Wars: The Old Republic*, *CounterSpy*, *Star Wars: Republic Commando*, *Lucidity*, and *Wartune: Hall of Heroes*.

www.dunderpatemusic.com

Describe your thought process for creating music.

When I'm writing music for a project, I like to start with constructing my fundamental building blocks for a piece. Those generally take two forms. I often start with trying to write the main theme for a game first. It then becomes a piece that I can draw from as repeated inspiration, a road map for the rest of the game. I also like to try and place restrictions on my orchestration. In an age of endless sample libraries and countless instances of software instruments within sessions, it can be very tempting to just keep adding new instruments into the mix. I

often like to say to myself, however, "Self, you only have 12 instruments for this track. If you find yourself wanting to reach for a new one or add some new texture into the piece, you have to either figure out how to do it with what you already have, or give up something you're currently using." The end result is often a more signature sounding score for each project.

Are there any particular secrets to your creativity?

It's been said to me that if you feel secure in doing something, then you're probably not challenging yourself enough at that moment. I try and remember that as often as I can. Sometimes I find that deadlines mean you have to lean on a crutch of what-you-know instead of radical reinventiveness. Shortcuts aren't a bad thing when you're slammed for time. But when you have the ability to push yourself and try and grow and learn new things, you should always try and do so.

Are there any secret techniques that you regularly employ?

My main instrument throughout my education was voice. As such, I bring a consideration regarding breath and phrasing to all of the MIDI programming that I do. It's a simple thing to forget about, but it's very common to hear composer's program parts for wind and brass players and forget to program breaks into the phrases for "breaths." Not to say that you have to put actual breath sounds into your mock-ups or synthestrations, but if you don't leave gaps for a simulated breath, the effect is subconsciously unnerving and sounds fake.

Do you have any interesting sound gathering/sound creation stories?

On *Star Wars: Republic Commando*, one of the levels was set within an "insect cathedral." In order to try and get the sounds of something approaching insect choral music, I ran the output of Pro Tools through a Heil Talkbox (the kind of thing Frampton came alive with). It basically pumped the sounds of buzzing bees and whale calls out of a speaker, up a rubber tube and into my mouth where I then revocalized them back into a microphone. The effect didn't turn out to be very musical or helpful; but David Collins, the game's Audio Lead, took the recordings and used them as some of the vocalizations for the game's alien creatures.

Do you have any advice which can help lay solid groundwork and ensure a successful production for the audio content creator?

Figure out early on who the main stakeholders are? who makes the final decisions? Who are you trying to please? There's nothing more frustrating and fruitless than creativity by committee. The less number of people you have to please, the better. So, figure out early on if it's the audio lead, the producer, the director, the art lead, etc. that you have to answer to and make sure that relationship is strong. It will save endless headaches down the road.

Do you have any interesting sound design creation techniques which affect the type of sounds you create?

I try and always include at least one live instrument in every piece of music I record. Sometimes it isn't feasible, but I try to do so as often as styles, schedules, and budgets permit. It could be as simple as recording my own hand claps on something. Anything you can do to breathe a little life into your music is valuable.

When do you find you are most creative?

Nighttime. Frustratingly, from about 6 p.m to 2 a.m. Of course, with a family and a 1-year-old son, my typical day is from about 8 a.m to 5 p.m. You can see where I might have a dilemma there.

Any worthwhile creative advice you'd like to share?

Composers: play around with ring modulators. They're surprisingly effective in music production.

Is there a typical workday for you?

In 15 years, I don't think I've ever had a day go the same way twice.

What skills should composers have to succeed in the games industry?

A love for, appreciation for, and understand of all things interactive. If you're not interested in interactive audio, why are you doing game audio? Go do film or TV. The potential to create a different experience for every single person that experiences your work by the use of interactive audio is unique to our medium of entertainment. Revel in it.

Do you have a specific ideology which drives your way of doing business?

Be nice. It's that simple. There is always going to be someone more talented than me, more creative than me, more experienced than me. However, if I'm confident while simultaneously being accommodating, if I can get the team what they need without becoming another headache that they need to manage, then I've done my job and done it well. The chances are that team will want to work with me again. This industry is small and it's all about forging and maintaining relationships.

Any good business advice to offer?

Don't ever work for free. You aren't doing anyone any favors when you do that. In fact, all that you're doing is teaching developers that "hire" you that what you do, and by extension what all composers or sound designers do, has no value. If the project goes well, they won't be likely to pay you next time for their next project. They'll just look for more free work and you've taught them that it's out there waiting for them to exploit. For the sake of your own career and those around you, don't work for nothing. Your training, equipment, and knowledge base all have value. If they could do it themselves, they would. But they can't. So they need to hire you. Otherwise, you're not earning a living. You're just a hobbyist.

How do you approach negotiations with a new client?

New to freelancing as I am, I'm still figuring this all out. I'm more used to being on the other side of the table.

Do you have any negotiation tips which work well for you?

Still learning. I'll get back to you when I have any.

Do you have any contract stories which others could learn from?

If you get asked to work for a rate that is really low, seriously question whether you want to do it or not. If you're working for something so low that you feel like you're being taken advantage of, it's going to color your entire experience on that project. Yes, there might be reasons to work for less than you think you're worth. But know that once you set the financial bar with a company, it's really difficult to raise it. And working on a project when you feel you're being taken advantage of, especially a long project, is tough on the psyche.

Have you ever had any development issues negatively influence your workflow?

I've been in the industry long enough to remember the olden days when each game had to have its own proprietary audio engine written for it. I've often described it like trying to score

a film while simultaneously having to invent the projector to play it back. Those days were insane and tedious and never seemed to end well. Each project resulted in some kind of compromised Frankenstein's Monster's Audio Engine™ that was so kludgy it meant that we'd start over again with the next project and try to avoid our previous mistakes.

All of that madness means that I'm forever appreciative of the apparent standardization we're moving toward as an industry with middleware options like FMOD, Wwise, and Fabric. Standardization of tech and tools is critical. When you're not wasting time learning or building technology, you can spend your time thinking about how to use it more effectively and creatively.

Do you have any advice to ensure successful audio implementation?

Iteration, iteration, iteration. I would recommend to composers that they get as involved in the implementation process as they can and as much as the dev team will let them. The more you learn about interactive implementation, the more you can apply it to interactive music system design. If you aren't hip to interactive music system design and the potential options available to you via audio middleware systems like FMOD or Wwise, then one of two things is going to happen: either the dev team is going to lead you by the hand through the process of interactive scoring and you'll be a burden to them, or you'll just be asked to score the game like you would a film and you won't actually be involved in the interactive component of the game at all. Both FMOD and Wwise are free to download and learn. So learn them.

Staying organized is important, especially if you are working on multiple projects, which is part of your daily routine. How do you keep up with it?

I have to have things written down and visible. So, for me, that means having a whiteboard that I write up projects and tasks on. There's also a palpable satisfaction I get from physically checking something off of a list, so I'll also often create detailed Excel spreadsheets that serve as status trackers and asset lists. Learn the joys of conditional formatting and make use of it.

If I'm working on a project where I'm leading a team of people who are all external contractors in different parts of the world, like I did on *Star Wars: The Old Republic*, I'll set up our asset list and cue tracker documentation in something like Google Docs. This way everything is in one centralized location. There's no way with a team of external contractors to all make use of something like version control software, so passing Excel documents around between contractors quickly gets data out of sync. Google Docs, however, is a means of keeping all data centrally located and accessible to everyone at any time on any computer.

There are many pitfalls when "working" in the game industry. Have you had any bad experiences?

While I've found that the people in the game industry are generally extremely bright, extremely creative, and extremely supportive, I've also found that the companies in the game industry aren't like the people. You don't owe companies anything. You don't owe them your loyalty. You don't owe them your life. You don't owe them yourself. But the game industry can be brutal and the longer you work within in, the greater the chance that some company will ask you to give up any or all of those things for them. Crunching for months on a project only to be laid off when it's done? Sadly commonplace. Don't give up your own life, your own family, and your own happiness for the well-being of a corporate entity. It won't love you back and you'll only end up missing time with the people who will. This is a large issue that people have been struggling with in the game industry for decades now.

How did you find your way into the games industry?

I was in college studying music composition with a focus on film scoring. It dawned on me 1 day that I'd study film scoring all day and then go home and play games. Surely someone must have been writing music for games. Why couldn't that be me? This was back in the 1990s. At the time, there was no collegiate presence for games. That didn't stop me, however, from asking every teacher, every visiting lecturer, every other student if they knew anything or had any leads about how to get into composing music for games.

By a stroke of luck, a game company in the same city as my school called my composition teacher and said "We just wrote a score for a new Sony PlayStation game and Sony hates the soundtrack. Do you happen to have any students there who would want to work on some game music?" As a result, I ended up scoring a PlayStation game as my final senior year composition project.

So it was a mixture of luck and not luck. It was luck that the call came in to my professor. What wasn't luck was that I'd pestered—respectfully—everyone I met about my interest in doing games so that, when the call came in, I was the first person my professor thought of to connect with the dev team. After that, my foot was in the industry's proverbial door.

Any other advice you'd like to share?

Keep in mind that musical underscore is only one of three major weapons in your musical arsenal: non-diegetic underscore, diegetic source music, and silence. Not all are right for every game. Angry Birds doesn't need any source music. But wall-to-wall underscore isn't the right solution for everything. Remember that even the original *Legend of Zelda* had rooms with no music. The absence of music will usually make the return of music more impactful.

If all three speakers in the front are identical, the power amps for each should be rated equally as well. If the center speaker is smaller and center channel bass is being redirected to the left and right channels, the power rating of the center amp should be at least 75% of the left and right amps. The total power provided for the surround channel should not be less than that of either the left or right channels. The preferred method is for each surround speaker to have a separate amp at least 50% of the power of the left and right amps. If one amp is used for the surrounds, it should be rated the same as the left and right. There are also many active monitor systems available which have amplifiers built into the speaker cabinet which would serve this purpose well.

Your audio console's flexibility will greatly affect surround mixing capability. While it is possible to create a surround mix on a console with as little as a stereo bus and one auxiliary send, the ability to do complex mix moves will be nonexistent. A console, or software, with film-style panning allows the greatest flexibility for desired sound placement. The exact need for a particular application will depend on the complexity of the mix. Be sure, when deciding to purchase new equipment, to think about future needs and not just what's in store for a current project.

Studio Setup

We all know there are as many methods of audio creation as there are creators, which supports the idea that the studio setups of each of these will be different. Budgets, locations, and accessibility of equipment dictate that no two setups will

be alike and integrating surround equipment into them can sometimes prove to be a challenge. New mixing surfaces provide the luxury of discrete surround channels, designed for this new day and age. For the budget minded, older consoles are still viable so are worth mentioning. They can still perform the task but require a little finesse to make this addition.

On all consoles, left and right outputs are standard—and these will connect to the surround encoder's left and right channels exclusively. Older consoles can utilize either the auxiliary send busses or another left- and right-channel output in order to connect the center and surround channels to the mix. Using the aux bus will be most limiting when panning a signal but it will work fine for simple music mixes. Using another left and right output source would be the better option if available, although still not quite as flexible as a film-style setup with individual outputs dedicated specifically to the four channels.

Once the issue of console channel outputs has been resolved, these discrete signals will be routed to the encoding unit. From there, the encoders left and right outputs can be recorded as a two-channel encoded mix. Playback and monitoring is accomplished when the two encoded channels are returned to the decoding unit's discrete inputs and further routed to the surround speaker system as four separate signals.

Computer-based multi-track recording systems can also produce and record surround material with minimal requirements, the latest crop of applications having surround encoding capability actually built in. Starting with digital audio software with multi-channel capability, the signals will flow to a

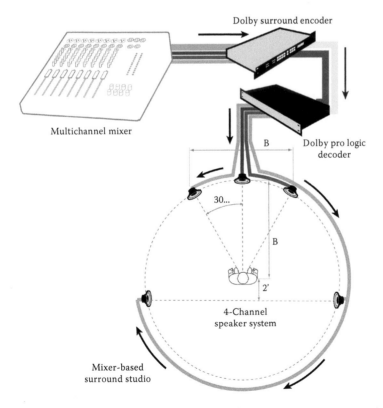

A mixer-based Dolby Pro Logic Surround studio setup.

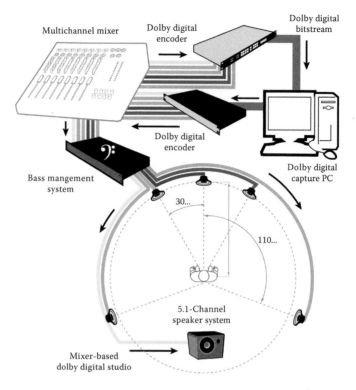

Multichannel mixer

Dolby digital encoder

Dolby digital bitstream

Dolby digital encoder

Dolby digital capture PC

Bass mangement system

30...

110...

5.1-Channel speaker system

Mixer-based dolby digital studio

A mixer-based Dolby Digital studio setup.

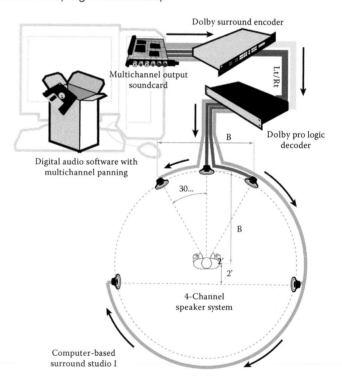

Dolby surround encoder

Multichannel output soundcard

Lt/Rt

Dolby pro logic decoder

Digital audio software with multichannel panning

B

30...

B

2'
2'

4-Channel speaker system

Computer-based surround studio I

A computer-based Dolby Pro Logic surround studio setup utilizing outboard encoding and decoding units.

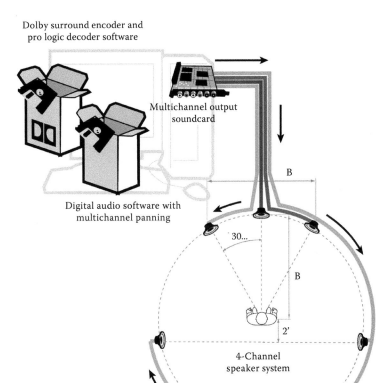

Dolby surround encoder and
pro logic decoder software

Multichannel output
soundcard

Digital audio software with
multichannel panning

B

30...

B

2'

4-Channel
speaker system

Computer-based
surround studio II

A computer-based Dolby Pro Logic surround studio setup utilizing internal encoding and decoding software.

multi-channel output soundcard. From there, the four channels would move to the encoding unit, to the decoding unit, and out to the amplifier/speakers. For programs which utilize software surround encoding and decoding, the output from the multi-channel soundcard can go directly to the speaker system or will bypass the decoding circuitry of the consumer amplifier which may be connected. Computer-based recording using Dolby Digital technology would also require a bass management system to be connected between the sound card and speaker setup.

Surround Tips

Dolby Pro Logic and Pro Logic II decoding rely on amplitude and phase differences between the two channels of a left/right signal to extract the four channels. As a result, there are certain things to keep in mind when mixing in Dolby Surround:

- Only one signal can be steered at a time by a Pro Logic decoder and this must be the dominant signal. The rest of the mix is distributed equally among the remaining speakers.
- The surround channel rolls off at frequencies above 7 kHz and below 100 Hz, so you may notice this limited frequency response of the surround channel in certain situations.

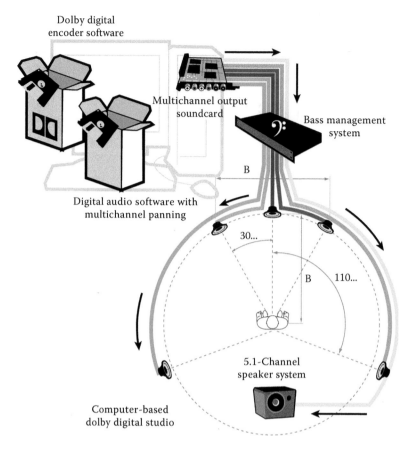

Dolby digital
encoder software

Multichannel output
soundcard

Bass management
system

Digital audio software with
multichannel panning

B

30...

B 110...

5.1-Channel
speaker system

Computer-based
dolby digital studio

A computer-based Dolby Digital studio setup utilizing internal encoding and decoding software and an external bass management unit.

When mixing with four channels, the following are some general guidelines recommended for obtaining good results:

- If you want to hear exactly what your audience will hear, it is best to monitor and play back through a decoder.
- Track and pan the sound of all important objects continually as they move.
- Although the dominant signal is the only sound being steered by the decoder at any one time, it is still okay to pan multiple signals in different directions. When a signal is no longer dominant, the decoder finds the next dominant one to steer. Therefore, it's important that all signals are positioned properly even when they are not dominant.
- Unless there is a specific reason not to do so, include the center channel when panning from left to right.
- There should be no essential information in the low-frequency effects (LFEs) channel. This should be used only for bass enhancement.
- The best way to understand how Dolby Surround works is to use it. Practice creating different types of mixes. Listen to games and movies in Dolby Surround to gain a greater sense of the possibilities of the medium; you can learn many tricks from careful listening.

Tools of the Trade

BRIAN SCHMIDT
Composer, Sound designer, Audio programmer, Game audio pioneer

My gear philosophy is to find out what is causing me creative or productivity bottlenecks and spend money and/or time to fix it. If it's a time/production bottleneck, it might mean faster SSDs, some new software, etc. If it's creative bottleneck, it might mean picking up a new brass library, etc. I'm not really that much of a gearhead; it's really easy in the biz to get hung up on gear/plug-ins/synths and forget about the music and the actual work.

Computers: Main production is a custom built 8-core i7, Windows 7 machine, 64 GB RAM, five 1 TB SSD with redundant external backup drives. Portable system is a Surface Pro 4, 1TB SDD, running Windows 10

Audio interface: Presonus AudioVox 1818VSL

Software: Sonar, Digital Performer, Sound Forge (9), Nuendo, Reaper

Monitors: Adam A7X's, Yamaha NS10's and (yes) Auratones

Sound modules/VST instruments: EastWest/Play, Complete Composer's Collection (platinum). Kontact Komplete, Some Cinesamples, nine-volt audio's complete collection

Outboard gear/effects plug-ins: I have a great Drawmer LX20 analog compressor I use when tracking (great for bass!). I also have pretty much the full complement of fx from WaveArts (I'm particularly fond of Trackplug) and iZotope. Also don't forget library management software—I use Basehead, which helps productivity immensely

Keyboards: Main keyboard interface is Yamaha Motif XS-8

Other instruments: Roland V-Drums, Peavey MIDI Bass controller, Several bass guitars, Fender Strat, Cerveny Tuba

Microphones: U87, Newmann Dummy head binaural mic, various others.

Remote recording gear: Zoom H4

Dolby Support

Dolby Laboratories has been very active in gaming over the years, so much in fact they established a game development relations branch to support game developers and audio content providers. They have extended their hand to the community and are available for questions and advice at *games@dolby.com*. Just be sure to let them know I sent you.

Other Composer Setups

We've spent some time discussing recommended equipment needed to work in the game industry as an audio content provider. You're probably thinking it's all well and good, but what do the other guys who are doing this every day really use? Be sure to keep an eye open throughout this book for various composer setups and gear lists that answer this very question. Examine their audio tools, find the trends, and discover what everyone else is using to do today's great game audio.

3

Getting Organized and Ready for Business

Understanding the Business of Game Composing

It's getting close to decision time. You have the capacity for music and sound design, an excellent attitude, and the total willingness to make this a successful venture. But, do you really want to? Is the games industry the right place to sell your music? Do you even want to work that hard?

Truthfully, not everyone can do the job. You might be able to compose some fantastic music, but your business ability or lack thereof will stand in the way. Historically, musicians are not well respected by the powers that be as business minded. Management types do not fully understand "creative" people and tend to stereotype them into neat categories which suit their purposes. We, on the other hand, know better. Just because we may come across sometimes as "free-spirited," it doesn't mean we don't have our act together and aren't capable of comprehending the complexities of the business world. Regardless of the trade you are in, your "product" is almost worthless unless you can sell it. Keep that in the front of your mind.

To do this type of work, you must be creative and be able to craft an original "mood" to enhance the game you are writing for. You must remain detached and objective when asked to rewrite passages or redo any work. You must have a great attitude and always come across in a positive and professional manner despite any instinctive urges to say what you really think. And to be successful, you must have it in your mind that you are in this for the long haul. By dedicating your efforts and focusing on your personal and professional goals, you will outlast anyone who thought they could get their music on a major game title

within a month of opening their doors for business. It can be frustrating at first, but rewards come to those whose calculated patience remains intact.

Expectations

A lot is expected from a game composer. Because the audio provider is often an aloof character seldom understood by a producer, they usually end up working alone—providing a third of the game experience literally by themselves. Because we can work off-site and at odd hours, our creations are waiting to be nervously examined—usually in their entirety near the deadline with little chance for reworks. No pressure there.

I spent about 5 days working tediously on a piece of music for a medieval-themed game project. The artwork presented was dark and ominous, with evil dripping from every scene. The producer let me take it all in. I mentioned the previous adjectives, heads nodded, and it felt like we were all on the same page. Five days later, I submitted completed music—excited by what I felt was a direct hit. Later in the day, I got a call. "Hey, we got your music. Great stuff. But, ah, we all talked about it and decided it was too dark and too ominous for our purposes. We decided we want to try something more whimsical and cartoonish instead." Aaaggghh!! So, with 2 days until the deadline, it was back to the drawing board and music for a whimsical medieval cartoon emerged instead.

Crazy? Yes, but you occasionally have to change gears and run off in an entirely new direction. As a game's personality slowly matures and the producer's vision takes shape, original ideas for music may not fit when played within the context of the game. If your first submission doesn't fit, carefully crafted after absorbing the essence of the game, the composer is still expected to magically throw another masterpiece together to match the new ideas. That's what we do. We pull sound from thin air and make glorious music out of it. It's a puzzle to most people how we do it. Producers tend to forget that each one of these little tunes we just "threw together" is actually a child we gave birth to, nurtured, watched grow, and then sent on its way out into the cold world. But for those children who do come back, we can put them on our demo reel or save them for the next dark, ominous, and evil game.

Reasonable Costs

Something else to chew on before diving head first into this venture is the costs involved and the return on your investment. Professional music equipment and software is expensive. It is built to be rugged and hold up under constant use—more so than occasional use of consumer gear. Manufacturers know you are willing to pay a bit more for pro equipment and increase profit margins accordingly. Because this gear costs a little bit more, your income will need to be able to meet the demand.

Initially, you probably won't be making fistfuls of dollars and you will have to weigh the expenses of doing business with the potential of income to be generated—and then decide what works best for you. I'm guessing if you bought this book, you have already made a sizeable initial investment in your equipment and are looking to capitalize on it now, so you probably aren't planning on acquiring much more expensive gear in the near future. If you are making payments or are using this as a sole source of income, it might add some extra impact to my next statement:

Never give any of your music or sound effects away for free.

In the beginning, it is very tempting to do just that, in order to beef up your resume. But what it does instead is let a game developer take advantage of you and cheapen our profession. At the very least, make sure your expenses are covered. While the rush of creating music for your first game can invigorate your soul, it will be short-lived when you have to sell some of your equipment to pay the rent. It's just not worth doing it for free. Your talent adds value to a product they will sell and make money from. As an integral part of the team who put it together, make sure you receive your fair share.

We'll cover how to determine your pricing structure so that it is in line with the game industry later in this chapter. Right now, you should be formulating your considerations: how to make a reasonable profit against the cost of doing business within your plans and if the income you make will be enough to reach these goals. By analyzing this beforehand, you can see the numbers in black and white and decide whether it is even worth going into business prior to wasting a lot of time, money, and effort. I'm not trying to talk you out of pursuing this type of career, don't get me wrong; I'm giving you a cold dose of reality to make sure this is a balanced presentation. The reality of business is that sometimes it makes better financial sense to not go into business. Perhaps composing and sound designing as a part-time gig to supplement other income makes better sense.

Whatever you do at this point, though, be sure to read the rest of this book for the full story before coming to any conclusions. This would just be one of the many factors in any final decision. While it did cost money in the beginning, my passion for music and many other enticements the games industry has to offer was enough to see me through.

Flavor of the Month

While we are on the subject of reality, let's get another dose. Your music will not be perfect for every job. Even if you are well-versed in various techniques and can compose jazz, acid rock, and classical expertly, your music will not be perfect for every job. *Even* if a game cries out for your strongest style and there is no doubt that you could nail it, your music will not be perfect for every job. Instead of getting into a one-sided philosophical discussion about this phenomenon, let's just agree on this, OK?

We call it "flavor of the month." Even after you've composed for 100 games, your "flavor" may not be what they are looking for and you won't get the job because they like someone else's "flavor" better that month. It's kind of like a "fad," the unexplainable force which shifts the focus onto someone else for a while. Your "flavor" is made up of your personal composing and recording style, like recording artists who maintain their "sound" from album to album. They have their own sound regardless of what they do because of who they are. Not much you can do about that.

The rest of the "flavor" comes from your instruments, your sample and loop libraries, your mixing board and recording equipment, your interface, your software, and from the room you record in. They all contribute to the particular sound which people will associate with you. You can change that, though. Keep your sounds fresh, trade in your old gear regularly, and try different recording techniques—anything to be different than before. Then again, maybe it's your "sound" which makes you money. A paradox only you can solve.

Composing versus Sound Design

As you prepare for business, you want to set yourself up to be successful. In our case, we sell our "sounds"—whether it's music or sound effects. About now, you should be deciding on what you have to offer the gaming world—what "products" you have to sell, and whether you can sustain your enterprise with what you have. If you've decided to deal strictly with music, then so be it. Get your music together and get out there and sell it. Make your success. If you've decided sound design is more your bag, then get your sounds together and go for it. Take your product and hit the market running.

The main question you should be asking yourself is, "Can I make the kind of money I need *and* stay busy in the games industry with the product I am offering?" If you are only selling one product, chances are you are not going to stay as busy as you'd probably like. Well, not at first anyway. With that in mind, you can initially plan to supplement another source of income with this venture until business picks up and you've reached a livable income level.

I mentioned in Chapter 2 that using your audio talents and recording equipment in another form of audio work will increase your income and chances of success. There is plenty of work for composers who go out and search in other arenas, but for those of you who like what you see in the games industry, you should keep within the perimeter and reach into every facet of it. Like I've said, the advantages of making your audio house the only source for a game developer are endless. And as your reputation grows within this tight-knit group, more work will follow naturally so you can spend more time creating and less time pounding the pavement. This means being composer, musician, sound designer, voice talent, field recordist, engineer, producer, and all-around audio pro.

It can be done selling a single product. You can be successful and meet your personal and professional goals. There are many who have, and more who will. But you need to sit down, take a hard look at what you want to accomplish, and then make the decision.

In-House Audio versus Independent Contractor

You've decided to compose music, create sound effects, or both for video games. Your next choice is to determine the method you will use to accomplish the task, either as an in-house sound person, working directly for a game developer as an employee on their premises, or as an independent contractor. Both have distinct advantages and also carry their own baggage. There are no particular rules governing the decision. You can bounce around and do it whatever way suits you, gaining experience and exposure from various projects and the many ways of doing business.

Initially, you may face a roadblock or two chasing either avenue. A game developer may not even consider you for an in-house position unless you have certain experience in the industry and perhaps a game or two under your belt. In a case like this, maybe you can get your foot in the door by applying for another position—say, intern, game tester or as an assistant to the audio department. Do a good job and keep your eyes open for composing and sound design opportunities. Once the company knows you, trusts you, and sees how valuable you can be as an audio resource, you may naturally migrate into the job you were eyeing.

Tommy Tallarico started out as a play tester at Virgin Interactive and ended up as their audio director until branching out on his own. Brian Tuey, having done music for a couple of games as an independent, was hired on at Gigawatt as a game tester to learn more about the inner workings of video games. As expected, they started to ask for his assistance in a few audio matters and he quickly moved into their audio department—then became audio director at Luxoflux and is now enjoying his position at Treyarch. Rodney Gates, formerly of Sony Online Entertainment, set his sights on game audio, put together a killer demo, and mailed it to practically everyone. His talent and passion won him a job which has led to quite a career.

In-House Composing

Working in-house as a composer or sound designer is not a bad way to make a living. Tim Larkin at Valve enjoys the innovative environment working with the company's other creative minds—constantly energized by the surrounding forces. Mark Scholl has been working in-house for more than 8 years, and while the industry can be volatile, he says nothing beats working face to face with a development team. Todd Kinsley enjoys the security of his full-time job at Genesis Gaming and loves spending his days creating.

Working directly for a game developer gives you more time to concentrate on the job at hand, enabling you to give it your best on a daily basis. You receive a steady paycheck, always confident of how much and when it will arrive. This security goes a long way in keeping the support of your family—relieving the pressure they may have put on you for previously "wasting your time." Additional benefits, such as health coverage and paid vacations, can be other carrots dangling in front of you.

Relentlessly looking for work can drain the heartiest of souls. By working in-house, all of your creative efforts can be focused on your music and sound creations. Often, while working as an independent in the middle of one project, you will be spending your prime time looking for the next. Your mind can be more relaxed and focused on music writing without the added headache of searching for more work. As the in-house employee, the company will take care of it for you. Many in-house composers can attest to the positive effects this has had on their music. This is especially true for artists who don't care too much for the business side of the industry.

If you enjoy working in an extremely creative and nurturing atmosphere as an essential member of a team, then an in-house position is definitely for you. There is just something about being among other imaginative types, living within the game you are creating, watching it grow and receiving instant feedback on your role. Communication between other project members is critical and physically being there keeps the lines open—whether you overhear someone talking in the hall or if they come to you directly. There always seems to be a bit of a barrier between a game developer and an independent contractor—even a slight level of mistrust. You feel immersed in the process instead of feeling like an outsider.

Working around other artists, craftsmen, and tunesmiths helps create a mysterious aura—an unexplainable atmosphere which primes the juices and keeps you at your best. If you find you are not capable of self-motivation or sometimes need that an extra kick in the pants, an in-house gig will give you the charge to produce some truly inspired music which might have been difficult when working in isolation. My best work always comes from being around and working with other creative forces directly. There's just something about keeping trusted associates nearby to keep your audio mission on track.

High Moon Studios in Carlsbad, California, has a well-equipped audio department. Former audio director Gene Semel is seen here mixing audio for their hit game *Darkwatch*. (Courtesy of Gene Semel.)

In-House Equipment

Game companies have various policies regarding equipment purchases. Knowing your previous experience with audio has more than likely brought with it a gear list to match, some leave it up to the composer to equip their studios with their own funds. The company's advantage: They don't have the expense of endless equipment purchases. Your advantage: You can take it all with you if you leave and you have complete control over what is bought. They know music and recording gear is expensive—far more so than, say, a computer and a graphics card they'd need to buy for an artist or programmer. Most of the time, they will supply a computer without hesitation. The rest is up to you.

Large game companies may have another view. If the number of games in production warrants it, they'd rather equip their own studio to match their quality and compatibility requirements. Electronic Arts is a prime example. They have a large state-of-the-art studio complex in-house to use exclusively for their myriad of game projects. By equipping their studios with high-end gear, their sound is completely under their control. The company's advantage: They own all the equipment, which stays as people move on. Your advantage: You get to play with top-notch gear you didn't pay for and gain some valuable experience you normally couldn't have afforded.

There are also game companies which fall in the middle of the previous extremes. Occasionally, developers may require their audio department to have specialized equipment for which they foot the bill. In other instances, they may have specific sound libraries in mind for a project, either sound effects or samples, and unless you want to buy them for your own collection, they will pay. Generosity is dependent on budgets, but an occasional bonus in the form of an extra piece of gear is not entirely unheard of. Your relationship with the developer will determine the amount of money thrown your way for purchases in this environment.

Expect the unexpected when working in-house. If it makes noise in a game, you will do it. The purpose of having an audio department is to keep the company from outsourcing any of its work. The last thing they want to do is pay a

contractor to do voice-overs or sound effects when they are already paying you to occupy space. Larger game companies may have several working in audio, all with particular specialties. It may not be as critical for a composer to also do sound design. But for other game companies—where the audio department is made up of a single entity—they will more than likely have to be a jack of all trades. For those of you who are self-sufficient, or like to work alone, this is a situation where you can thrive. Others, with expertise in one area, may find this a bit more difficult.

You may also be expected to know or learn how to implement sound in a game as well as writing actual programming code to make your sounds work. You may have to port to other game platforms and be familiar and licensed with any proprietary development systems. A lot of technical work may await you, so it's important to know what you might be getting into when shopping for a company. If you have this kind of wisdom, you will be extremely marketable. If you learn, it can contribute to your job security.

One serious disadvantage to working in-house is that your position and/or the company could disappear at any moment. This is not to say every game company is inherently unstable, but there are many who struggle to make monthly payroll. Instead of paying an in-house composer $60,000 a year to work on scattered projects, it might be beneficial for them to hire contractors at a lower rate as each project warrants.

In this volatile industry of takeovers and buyouts, your game team runs the chance of being disbanded by new owners—especially if they already have duplicate positions staffed elsewhere. Most of the time, company acquisitions are a chance to buy the rights to intellectual property, game engines, licenses, AI (artificial intelligence), game titles, development tools, and so on and to make the previous owners some money. Their concern is not really the employees. Every so often, a successful team may survive intact, but it is indeed a rarity.

Independent Contractors

For those of you who enjoy the open road, life as an independent contractor is for you. There is so much more to this business than just composing music or designing sound effects. Little triumphs and exciting moments along the way make you feel like the king of the world—winning that first big contract, negotiating a sweet deal, having developers call you on a project instead of you calling them, or having your peers accept you and invite you in on a project—all contribute to the personal triumph you'll feel. It's not always about the music you create. There is that little something extra which motivates us as well.

The advantages are many for those who opt to give up the security of an in-house job. The freedom of running your own business your way and calling all the shots is a serious enticement. How about picking and choosing which projects you work on? Or unlimited income potential? Hey, hey! Now we are talking!

Working in-house is strictly a work-for-hire arrangement. The game developer pays you a salary and in turn, everything you produce as partial or finished work belongs to them. They own all the rights and are free to do whatever they want with your creations. It's painful sometimes watching your work used in a movie or commercial, knowing you'll never see another dime from it. As an independent, you are free to negotiate whatever kind of deal makes you happy. You can license the music to them to use for their project, but save the rights to everything else. Music soundtrack releases, use in movies, licenses for other game

platforms—they all add up to some substantial income for you. Consider having several projects with the same type of deal simultaneously. Your income becomes almost limitless. There are also game royalty deals or bonuses you can negotiate. If a game becomes a hit, you are also rewarded for your hard work and vital contributions to the project with regular payment. Not such a bad arrangement.

Independents have the freedom to work if and when the mood strikes. But if you don't have self-discipline, you'll end up taking a long self-inflicted vacation instead. And it is certainly much easier to schedule in time with the family or other obligations. It's nice to have that sort of independence.

It's also sweet to have the liberty to pick and choose which contracts to pursue. In-house composers work on whatever is thrown their way. Occasionally, there may be a project presented to you beyond your abilities or you may not feel comfortable with the company—sensing you'll end up working hard for a game which will never be released. Companies that don't quite have their act together will end up driving you crazy, asking for the impossible, and cost you time and money. Initially, you'll want to take every job that comes your way, but sooner or later your guts will tell you when it's time to pass this headache off on someone else and let your competitor pull their hair out over it instead. You can also consider exposure, money, or the good old "fun factor" when choosing games to work on.

Richard Jacques often uses his location for inspiration when creating the epic scores he's well known for. (Courtesy of Richard Jacques.)

HENNING NUGEL
Composer, Sound designer

Henning was born in Dortmund, Germany. After years of playing keyboards and guitars in several bands, he joined forces with his brother Ingo and founded Nugel Bros. Music in 2001. Focusing on music composition and sound design, their portfolio soon included clients as EA Games, Ubisoft, Funatics, and Blue Byte and game titles like the well-loved *Settlers II—10th Anniversary Edition*. After Ingo's sad passing in 2007, Henning kept the company going and continued working on various game audio projects. In early 2013, he rejoined the friends and colleagues of Dynamedion as an external freelance composer.

Selected Gameography (excerpt):

Football Manager 2002 (EA Games Germany)
The Moment of Silence (House of Tales/DTP) by order of Dynamedion
Darkstar One (Ascaron/UbiSoft) by order of Dynamedion
The Settlers—10th Anniversary Edition (Funatics/Ubisoft)
The Settlers II Orchestral Suite (Original Arrangement) performed live at GC in Concert at the Gewandhaus Leipzig
The Settlers II—Rise of Cultures (Funatics/Ubisoft)
Endwar PSP and NDS (Funatics/Ubisoft)
Orchestral Themes for Gamestar awards gala shows in Munich 2010 and hosted by Gamestar and GamePro (IDG Publishing)
Perry Rhodan Tamer interactive Audiobook for iOS (Audiogent)
UFO Online (Funatics/Gamigo)
Risen 3 (Piranha Bytes/Deep Silver) by order of Dynamedion
Sacred 3 (Keen Games/Deep Silver) by order of Dynamedion

www.nugelbrosmusic.com

Describe your thought process for creating music and/or sound effects.

Before starting to score of a game, I usually sift again and again through the information the developer gave me beforehand, mainly concept material, sketches, plot summaries, etc. It's

important for me to get a basic idea and feel of the game, some kind of emotional picture. This is where I think about what style of music would fit the game best. Should it be purely orchestral or more contemporary with electronic and rock elements or a mixture of it all. Of course, quite often the developer has already decided upon a certain kind of music style he wants incorporated in his game and has perhaps already sent some demo cues taken from the various film scores which feature that particular style. So in this case, I usually skip the thinking about the music style and turn toward the deeper analysis of the game structure, events, and characters (of course always depending on the amount of info material given by the developer). If there are specific characters, locations, or objects the game centers upon, I usually like to create motifs which are going to recur, often in modified or altered versions, all through the game. I also often like to create a specific main theme for the game's title screen. This might feature some of the aforementioned motifs which are going to appear later on in the game. In some cases, I might compose a specific "global" main theme which might pop up at certain key moments in the game. I've always found the concept of using themes and motifs very helpful to create a balanced and organic soundtrack.

After having decided about the above preliminaries, I usually sit down at the piano which is the instrument I use mainly to sketch out ideas and chord progressions. In some cases, let's say for a game with a more folk music sounding style, I might take the guitar, flute, or violin to develop ideas and motifs. There are also times that I come up with a nice percussion rhythm first from which I build the rest of the track.

I then normally start producing the main theme which will also serve as a first demo for the producer. In due course, the rest of the tracks will be finished and sometimes rewritten. In between, there will be discussions with producers and developers about sound engines, formats, and other stuff that can have a certain influence on how the music will be integrated into the game.

Are there any particular secrets to your creativity?

Not really secrets. Creativity is based a lot on learning and experience, at least judging from my own situation. I grew up in a musical family as my parents are and my grandparents were very good players on their particular instrument (mostly piano or violin). At an early age I began with playing the recorder for a short time followed by a classical piano education. After that I played keyboards and guitars in several different bands with styles ranging from wave rock, gothic metal to electronic pop music. I now have an arsenal of instruments in my studio which I like to play and record for different projects: lots of flutes and whistles, an Irish bouzouki, my grandfather's violin and percussion stuff.

So when I compose music, it's all of these things together that are part of my creativity. The lessons I have learned by playing these instruments and listening to so much music, the bits of theory here and there, the experience in writing music and always comparing the creations with the stuff of my peers and masters, the failures and successes. This particular and personal combination of experience and intuition is the backbone of my creativity.

When do you find you are most creative?

I often get some good ideas when being outside the studio, mostly while doing my daily jogging laps. I also find myself "listening" to music in my head and shifting scraps of melodies back and forth while doing something completely different like gardening or housework, etc. Yet, most of the time, I have to be creative while being in the studio and as there are certain

time limitations to a project these are often the times when I *have* to be productive regardless of the "muses" kissing me or not. Still I'm happy to say that there are not many days where my creativity has let me down.

Any worthwhile creative advice you'd like to share?

There were times when I quite regularly bought new sample libraries when they came out. But, instead of helping me with my composition, the sheer mass of stuff at my disposal kept bogging me down. At some point I radically got rid of the libraries that I had never used very much and that cluttered my hard drives and set up a template just with the stuff I needed (which still occupies around 35 GB of memory on my slave PC). I cherry pick the new libraries I purchase. They either have to feature a huge improvement in sound or greater ease of use or complement my template with sounds that I was missing before. Time is money and when you are working on tight schedules you actually cannot afford to "learn" a sample library. So, I take care to focus on the products that I can get a good sound out of without it taking too much away from my composing time.

Is there a typical workday for you?

I get up regularly at 7 in the morning to start the first round of composing. I check e-mails and read the news. I try to get out at some point and have a little walk or jog in the woods or around the lake. This helps a lot to keep mind and ears fresh for the rest of the day. I normally work about 8–12 hours a day, give or take, depending on the schedule. Mostly I don't get enough sleep.

Do you have a specific ideology which drives your way of doing business?

Be kind and respectful and people will treat you the same.

Any good business advice to offer?

Always remember that composing music for a game has to make the client happy. It's not about fulfilling *your* artistic dreams. Feedback on your work will not always be favorable. Be prepared to rework your tracks or even write new ones. Don't worry about this. It's normal to not hit the bull's eye the first time. Every rework is a lesson learned. Also, if possible, write short previews of the tracks (about a minute length). This way the client knows where you're headed and if he does not like the direction at least you did not waste time on a fully produced 3-minute track.

Any horror stories which have impacted how you do business?

Actually no horror stories, as such. You have to be aware that there is always the risk you might not get fully paid (or even at all). I did some music for a project where the budget was rather tight, so I consented to be paid half of the fee at release of the game and the other half when the respective amount of copies had been sold. The game got released eventually and I got my first half of the fee. Yet, though the project was a very high-quality production, it did not make the break-even, so I never got my other half of the payment. Another lesson learned, I guess.

What advice can you give when working with a developer which has ensured a good working relationship and a good final product?

Well, the best thing is when there's an audio director who has a clear vision of how the soundscape and the music should turn out for the game. This happened to me only with bigger projects as the developer's budget for smaller projects very often doesn't allow for a dedicated audio team member. But it really helps a lot when there's someone on the developer's side that actually speaks audio.

Staying organized is important, especially if you are working on multiple projects, which is part of your daily routine. How do you keep up with it?

You absolutely have to know how fast you are able to write. There's no way of planning your day if you are unable to set yourself milestones in relation to your writing speed. The rest is just outlook or excel.

Do you have any development stories which served as a good lesson learned or something which can be avoidable in future projects?

We are all used to writing e-mails to correspond with one another and if you are writing about audio, this can become tedious business. I found that making a quick phone call regularly solves problems much faster. While working on a theme recently I had actually begun working on the third version before I picked up the phone and called the audio director. We ended up singing lines of melody to each other and in the end I knew where we were headed. And the next version I sent out turned out to be what he wanted.

Any horrible endings to a project which others could learn from?

There are rare times when you just cannot get your head around what the client wants. You go from rework to rework but to no avail. It happens. Don't let it get you down and don't overanalyze it. Move on to the next project.

How did you find your way into the games industry?

Having received a classical piano education as well it was my brother Ingo's greatest ambition to compose music for games. He sent out practically hundreds of demo CDs to game developing companies. Eventually in 1999, when he got his first commission he asked me as his brother to team up with him. Of course, being an enthusiastic gamer myself it took no time to convince me. We had found out before that we could work together very harmoniously and that the music did profit from our mutual contributions. We soon agreed on the company name "Nugel Bros. Music."

In-house composers, as the name implies, work on the game developer's premises. They get up in the morning and fight traffic to get to their windowless studio, which was formerly a broom closet. If they are lucky enough to have a window, it usually overlooks a parking lot full of cars or the nearby freeway. So, another big plus for the independent is working wherever you want—letting issues such a convenience and the view guide your productivity and inspiration. Composer Chance Thomas has a stunning location near Yosemite National Forest which has served him quite well. His studio has two large glass walls: one overlooking a two-story glass atrium and the other opening to the surrounding forested acreage and five huge windows offering inspiring views of nearby Thornberry Ridge and Deadwood Mountain. There is a handcrafted spiral oak staircase leading up to the studio entrance and a walk-out redwood deck just outside the control room. The studio is decorated with Haitian art, pictures of St. John and St. Bart, photos of his family and a handful of awards, plaques, and little golden statuettes. Jon Holland enjoyed his personal Yosemite view overlooking forests of 100-year-old pines during his time there as well. These guys have made great use of what inspires them.

Most composers tend to work at home in their project studios—foregoing regular office hours and the commute, preferring to work where they are comfortable

and close to the other important things in life. Some have nearby studios and composing space, which allow them to get away from any distractions, close the doors, and come out when they are through. An office building isn't always the best place for your finest work.

"All work and no play makes Jack a dull boy." If Jack played music constantly and never took a break from it, Jack would become boring and his music lifeless. As an independent contractor, this can never happen to you. Your business forces you to do other things that help keep your musical perspective fresh. I usually find that after a week or two of working the phones, negotiating deals, and being caught up in the administrative chores that when it's time to do music, I'm chomping at the bit, ready to roll. I'm excited about the music and go into it with a better attitude than say, walking into the studio for the fifth straight week to rework that same "piece from hell" that I can't seem to get right. In a case like that, I end up walking away from it for a week anyway and nailing it by the second day back. The change of pace running your own business is a healthy side effect. The time away from the music will only make it better.

The only serious disadvantage to being out on your own is the eternal question: Where will my next project come from? There is uncertainty in this business. A lot, as a matter of fact, for the independent contractor. One day you'll have several contracts lined up, your production schedule overflowing for the next couple of months, and then suddenly, you'll be scratching your head wondering where the next check is going to come from. Everyone has experienced it at some point in their career—it's an inevitability. Make sure you plan accordingly and budget your income for any dry spells.

There are other ways around the empty bank account syndrome. Look for ongoing contracts, that is, open-ended agreements that carry with them several yearly projects. Always consider negotiating royalty agreements where payments are made on a quarterly basis, spreading out your receivables to compensate during downtime. At first, consider composing as a side job and relying on a full-time job for living expenses. The extra income can be put in the bank to support yourself when you make the big break. Stay one step ahead and you'll be fine.

Audio Demo Reel

Unless you are an established game music composer or sound designer in the industry, chances are, you will need a professional representation of your audio skills to get your name out there and to win the job. Your previous work or current audio samples can be neatly packaged into a *demo reel* and sent directly to the powers that be—giving them a chance to listen to your breathtaking work.

Demos come in all shapes and sizes and everyone seems to have their own philosophy as to what makes them effective. However, in all of those varied opinions, no one will argue the need for one. They are truly valuable tools in the quest for the perfect audio for a project. After talking with several game and multimedia producers, developers, and other sound artists, many points seemed to continually stand out. Consider the mystery revealed.

Putting Your Demo Together: The First Step

The highest priority when considering your demo is quality. Without a doubt, the first thing a producer will notice is how it *sounds*. Cut corners where you have to. Trim out the fancy labeling, stationary, packaging, and the full-color brochures,

but never, ever skimp when it comes to the caliber of your sound. Use high-grade instrumentation, studio equipment, and recording medium. Think quality all the way down the line. Do what you have to; just make your audio sound great. Remember, if it doesn't sound "professional" in a demo that you've had months to work on, how will they believe that you'll sound good when dealing with a rushed 2-week project deadline?

Your mix should contain that pro quality on a variety of playback systems. There is no way of telling what system your demo will be listened to on. If you are extremely lucky, their audio department will play it on studio equipment similar to yours—but the majority of the time, it will be listened to either in the car or on a computer. If you have ensured, through a careful mixdown process, that your music sounds equally good on your studio monitors as it does on your MP3 player, then you've covered all of the bases. Before I am completely satisfied with a final mix, I will critically listen in my car, on my home stereo, on my MP3 player, and on my daughter's boom box. It passes the test only then.

Demo Content

There are very few unbreakable rules, but this is one.

> Put your absolute best work in the first 2 minutes of your demo. Always.

Media buyers are busy people and usually wade through stacks and stacks of demo reels. Chances are they won't have the time to listen past the first couple of tracks. Always lead with your strongest piece and style. A great song that takes too long to get to the point has no place here. Feature your personal flavor. Show your originality, versatility, and compositional and sound design skills.

Ensure each track has impact and gives a continued strong impression. If you lead with shorter pieces, be sure to include longer tracks to show consistency and to let them know you can hold a listener's attention throughout. If one style is your specialty, that is certainly okay—but keep in mind that it may also limit your clients. Show plenty of versatility on your reel. Here is some advice gleaned through *Pet Peeves* producers have eagerly shared:

- Do not repeat works to make your reel longer.
- Do not place work in chronological order from the beginning of your efforts. They urge you to get right to the point and show what you can do in the present with little wasted time.

Short and Sweet

Did you know that 40% of media buyers only spend between 2 and 5 minutes listening to a demo? Another 40% only spend 6–10 minutes. The average preferred length of a reel is only 7 minutes. That is not much time to present all the work you've done over the years, but it is more than enough to interest a producer. By leaving them wanting more, it builds interest and gives you another chance to present more music and have your name in front of a prospective client one more time.

Keep the length of your demo in check. An hour of music is probably a bit much. It's completely understandable to be proud of your work, but unless you're showcasing all of the mega hits you've worked on throughout your career on purpose, it's doubtful a busy game producer will ever hear it. Conversely, it could also give them a chance to discover your flaws—which is something you definitely don't want.

Demo Style

There are as many ways to present your work as there are composers and sound designers. Your creativity can be let loose to make your creations stand out. There are no hard and fast rules; again, just make it sound great.

I've heard demos which use music, sound effects, and narration like a radio commercial to present an audio product. Most producers I spoke with, however, agreed that it distracted them from getting to hear the music or effects and the quality of the tracks. They prefer to hear music either presented as a montage or as numerous short (1:00 to 1:30) selections in rapid succession. Five full-length pieces of various styles are also acceptable.

The demo montage makes the strongest impact. The 5–7 minutes worth of music, fading from one selection to the next, blended together to almost sound like one song of different styles will definitely keep them listening. Include only the best sections of your work, taking them on a musical expedition full of surprising twists and turns. It's unbeatable. I normally include two montages: one with a harder edge, full of intensity, and a softer, more emotional montage. Because the montage does not show your musical thought process or prove you can hold a listener's attention with a single song idea, I also include a few longer tracks, that is, songs done in their entirety, just in case they are curious and wish to put me to that test.

Minute to minute-and-a-half selections are another surefire way of presenting your pieces. With only 7 minutes on stage, you have to make it fast—and this is a great way to show off your musical dexterity. The one thing I've noticed when listening to these types of demos is my urge to hear more! And because I can't immediately hear more of a track, I end up playing the entire CD over again! It's a trick that has been used in pop music for many years. By keeping a song short, it is requested again and again in order to satisfy the hungry radio listener—invariably making it the number one requested song of the week. Chart-toppers are usually just good songs marketed wisely. If your demo is of this style, be sure to include a few longer pieces, too. A demo with five complete selections of music also works well. Pick the current popular game music styles, such as

- Orchestral
- Alternative/rock
- Ambient
- Sports
- Playful/quirky

A spread like this will cover the bases nicely. Make sure each selection is 100% perfect—something you would be proud to put your name on. This is no place for half-finished pieces or excuses. They should all be polished and ready.

A sound effects demo can equally stand out. I don't recommend just playing a sound effect, then playing another. It's boring and shows a lack of imagination. Remember, you want to impress the producer and make it impossible for them to look anywhere else.

If you choose to put sound effects tracks on your website or CD, may I suggest creating a "scene." Forge an action-packed audio journey using your original effects and Foley sounds to create the excitement. It doesn't have to be long or totally outrageous; it only needs to favorably show your sound design and production skills. Producers are most concerned that you have the knowledge

and ability to do good sound effects before they hire you. Check out the various composer websites featured in this book for a wide range of audio examples and demos. You'll see what I mean.

Another way to present your sound design achievements could be on DVD or as a computer movie file (*.wmv, .mpg, .mov,* and so on). If you've done audio for any multimedia presentations or game intro sequences, for example, these would be a great stage to show your efforts. Nothing quite has the force as project-specific sounds created for moving picture.

Narrations are another breed. If you want to advertise your ability to record superb voice-overs, consider adding a track of narration—on its own or between audio tracks. I don't recommend sticking a microphone in front of your face and talking about whatever comes to mind. Experienced vocal talent, and perhaps even yourself, should perform from a well-crafted script. You can talk about the music and sound effects included on your demo, either adding an intimate touch or raising the excitement level. Or, you can include examples of a previous narrative project. Make sure you've added some subtle sound effects or musical bed behind the speaker to give it continuity and keep it interesting.

The Presentation

Demo reels are very personal things—a part of ourselves and a part of our professional image. We want to look qualified but stand out at the same time and draw attention. From the look of the packaging to the impact of the tracks, it all fuses together to convince our prospects that we are the best person for the job. First impressions can go a long way.

Think ahead of time about the impression you are trying to make and then make it a good one. Because this is not retail sales, graphics and expensive packaging are not mandatory. Make the demo sound fantastic and look pro. From the moment the package arrives on a producer's desk, you are making an impression. Bright packaging will certainly get you noticed, but then again it may backfire. While musicians are expected to be a little outlandish, a company seeking outside media will more than likely be playing conservatively.

Decide what market you are trying to make it in and customize the tracks on your demo reel appropriately. I try to decipher what sort of music or sound effects a client may be looking for, then I search my existing material for something similar. A producer looking for music to a game marketed to the 8- to 12-year-old girl is probably not interested in hearing heavy metal, and I don't send it. A custom demo reel for each prospect can help you zero in on their target.

Include your contact information on everything—from the demo to all of the other envelope stuffers. Materials get separated and you'd hate for someone to discover the perfect piece of music for their project without any idea who sent it. Affix your copyright information to the CD or embedded with an MP3 as well. Other items to consider including in a demo package are as follows:

- A cue sheet. Name each track and explain what they are listening to as well as whether the piece has appeared in a previous body of work, what it was used for, and any production notes used to explain your motivation for composing the piece
- A resume of any past work
- Promotional materials, brochures, and press clippings
- Business card

MARTY O'DONNELL
Composer, Sound designer

Marty O'Donnell received a Bachelor of Music Composition from Wheaton College Conservatory and a Masters of Music Composition from USC in the early 1980s. He started an original music and audio production company with Michael Salvatori. From their studio in Chicago, O'Donnell/Salvatori wrote and produced music and audio for hundreds of TV and radio commercials, as well as movie scores. In 1997, they began working on games and did the audio design for Cyan's *Riven: The Sequel to Myst*, and all the music and audio for Bungie's *Myth: The Fallen Lords*. Marty joined Bungie as full-time Audio Director in May of 2000 ten days before they were purchased by Microsoft and subsequently wrote and produced award-winning music and audio for the *Halo* series. In 2007, he helped establish Bungie as an independent game company and built an audio team to work on the upcoming game *Destiny*. Recently, in collaboration with Salvatori and Sir Paul McCartney, he completed an orchestral/choral suite titled *Music of the Spheres* scheduled to be released this August. In April of 2014, he started his own company Marty O'Donnell Music.

www.MartyODonnellMusic.com

Describe your thought process for creating music and sound effects.

Sound makes it real—music makes you feel. That's my basic approach to audio and music in games. Sound design can be hugely important in terms of the player's emotional response, but there is nothing better than the perfect sound effect to make people believe in the reality of their experience. When it comes to enriching the emotional journey of the player, music does it best.

Are there any particular secrets to your creativity?

I believe that creative people cannot entirely remove themselves from the culture in which they're immersed. However, to be truly creative, you can never simply copy culture. You must attempt to create something unique. Love what you're making and make it your own. As Schumann said "In order to compose, all you need to do is remember a tune that nobody else has thought of."

Are there any secret techniques that you regularly employ?

I've always felt that my biggest inspiration was a deadline. Actually, working with other creative people on a project that excites all of us is the best technique to getting amazing creative results.

Do you have any interesting sound gathering stories?

I remember getting a great sound by cutting into an apple with a sharp knife close to the microphone. My partner Mike Salvatori finished the mix on the session while I was getting stitches in my hand at the emergency room.

Do you have any advice which can help lay solid groundwork and ensure a successful production for the audio content creator?

Education is key. I believe that a solid liberal arts degree is foundational even for more technical careers. However, it isn't always essential and there are many successful sound designers and composers who have become experts in their fields by being mentored by other experts at companies or studios. I don't recommend being completely self-taught. You will miss out on simple lessons and spend way too much time correcting mistakes.

Do you have any interesting sound design creation techniques which affect the type of sounds you create?

I love watching really great Foley artists work. The most important thing with Foley is to create a sound that reflects the expected result not necessarily the most accurate result. Real car crashes never sound as exciting as the sound we're expecting. I learned a lot making sounds for commercials. The most appetizing sound of a crunchy potato chip doesn't come from actually recording a snapping chip. I've jazzed up the sound by breaking dried grape vines.

When do you find you are most creative?

I'm best mid to late day. Sometimes my best time is late at night after I'm on a roll. For me, it's important to keep going while the muse is active. Also, collaborating with someone I respect. It's easy to get unstuck when someone else is there to bounce ideas off of.

Any worthwhile creative advice you'd like to share?

Try and work even when you don't feel like it. Create something on a daily basis. Consistency will pay off eventually. Truly creative people can create on demand and don't have to wait until "the spirit moves them."

Is there a typical workday for you?

Not really. The project determines what I'm doing on any given day. Table reads of scripts, designing studios, figuring budgets, composing, directing actors, editing sound effects—all of these things might be in any given day.

What skills should composers have to succeed in the games industry?

Make sure you love games. Love what audio does for the game experience. These aren't skills, but if you don't start there I don't believe you'll be successful. Be excellent in your craft—whether it's composing, sound design, or production. Be able to work well with others. Don't be precious about the things you've created. The project is most important, not your music or sound. Stay current and fluent on the latest tools and audio middleware.

From your perspective as an Audio Manager, what advice can you give to composers and sound designers working in games?

Listen intently. Contribute to creative discussions explicitly. When an audio director asks, "What do you think?" answer openly and honestly. Passive aggressive behavior is poison to the collaborative process. Take correction in the spirit it is given but don't lose your vision for what you think is right. This isn't easy, but simply following instructions means that you will not have long-term value to the team.

Do you have a specific ideology which drives your way of doing business?

Be honest in all your dealings. Integrity will always win out in the long run. Also I've always felt that this industry should be about the people first, the product second, and the profit third. Treating the people you work with as though they are the goose that lays golden eggs will result in more golden eggs. Being nice to the golden egg gets you nothing. Be nice to the goose.

Any good business advice to offer?

There are basically two types of people in the game business: creative and exploitive. This may sound a bit harsh, but I believe it to be true. Most all of us who create audio or write music are creative. We need to partner with people who know how to exploit our creations, otherwise we won't eat. Exploitive people are good at expanding IP, marketing, publishing, selling—all the things that are essential to our business. The good news is that creative people can learn some of those skills, whereas exploitive people can probably never learn how to create. .

Any horror stories which have impacted how you do business?

I've made similar mistakes several times over several years. Usually involving work-for-hire creations that get reused and remonetized in ways I never anticipated. I believe that music, because of its unique property of being able to be repurposed for entirely different uses, needs to be handled differently than most other IP. Performing rights organizations like ASCAP and BMI are essential for all composers at a minimum. It's also essential to license and protect your publishing rights, or at least make certain that you as the composer keep some share of future ancillary monetization. As a good lawyer friend told me once, "Learn from your mistakes and don't spend time trying to right every wrong done to you. Move on, create something new, and make a better deal. If you can't do that you shouldn't be in the business anyway."

How do you approach negotiations with a new client?

Find out all you can about the person and their track record. The project is important but not as important as the people you'll be working with. Integrity and trustworthiness are the highest characteristics I'm looking for. If those are apparent, then don't bother with trying to get the gig.

Do you have any negotiation tips which work well for you?

Try and get to know the people first. Find out about other interests they have, and projects they've worked on in the past. It doesn't hurt to find out a little about their personal lives. Finally, really try and understand the full scope of what they'd like you to produce for the project and try not to be the first one to say a number.

Do you have any contract stories which others could learn from?

Composers write music that can have a life beyond the project for which the music is intended. I believe that composers need to figure out ways to stay attached to their compositions even

in a "work-for-hire" situation. Licensing, sharing in ancillary publishing, and registering the work with a performing rights organization are essential elements of composer's contract negotiations. At times I've tried to write contracts myself and that has never worked. Hire a good music entertainment lawyer who understands music IP and you won't regret it.

Do you have any tips when working with developers?

Try and understand the game from the developer's point of view. Be a part of the team and start playing the game as soon as it's possible. The earlier you get involved in development, the more valuable you'll become.

What advice can you give when working with a developer which has ensured a good working relationship and a good final product?

My most successful working relationship lasted more than 14 years because I was the Audio Director and Composer for the studio. Being there day in and day out working on all aspects of production from pre to post was great. It's also important to understand the business of game development and publishing. I also was able to hire great talent for audio design, music composition, production, and engineering. A great team can really take the pressure off and result in even greater music and audio.

What advice can you give when working with a developer to ensure you are able to make great sounds?

There are audio solutions that really can't be accomplished until other decisions have been made and some other assets are close to being completed. Audio people and composers can prototype quite realistically but until certain progress has been made in game design, art, and engineering, the audio team can't really get close to finishing. Tools and iteration are extremely important for the audio team to be successful.

Have you ever had any development issues negatively influence your workflow?

Over-scoping and indecision are killers. Passive aggressive behavior is almost impossible to overcome. Starting work in an engine that isn't ready to take content can be horribly discouraging and result in months of wasted effort.

Do you have any advice to ensure successful audio implementation?

Having tools that allow the audio team to hear their work in real-time and adjust and iterate is essential to successful audio implementation. Middleware such as Wwise and Fmod are getting better all the time.

Staying organized is important, especially if you are working on multiple projects, which is part of your daily routine. How do you keep up with it?

Any specific 'lessons learned' on a project which you could share?

There is never enough time to finish a project. There is simply the moment when you are no longer allowed to work. Always plan for postproduction or polish and then double the estimated time. You might get about 20% of those days at the end if you're lucky.

There are many pitfalls when "working" in the game industry. Have you had any bad experiences?

Intellectual property is a precious commodity. The interesting thing is that it's really up to the fans to decide which IP is and isn't meaningful. There are people and companies who want to

take valuable IP and make it their own without exchanging something of value. They dilute it, change it, and steal bits of it and soon the original author/owners of that IP are no longer in control. That is a bad experience.

Any horrible endings to a project which others could learn from?

Halo 2.

How did you find your way into the games industry?

I've played games since *Dungeon* on a mainframe in the 1970s. *Zelda* on NES was a revelation; however, it wasn't until 1993 when I played a beta version of *Myst* that I saw an industry starting to mature in a way that I felt I could contribute. I met the Miller brothers through a friend (Josh Staub) and somehow convinced them that I could help do audio for *Riven* and that was the beginning of a long fruitful career.

Any other advice you'd like to share?

Be positive but don't always say yes. Be collaborative but don't always compromise. Don't mistake the golden egg for the goose that laid it. Be nice to the goose, you'll get more golden eggs.

What Format Is Best?

CDs used to be the obvious and expected answer to the question of best format, but there are many other options to consider as well. SoundCloud.com is growing in popularity and allows for easy integration into your website. LinkedIn has a feature to showcase your talents and is also another popular venue to consider. For those with accompanying visuals, YouTube and Vimeo allow for both audio and visual as a means to demonstrate work which is especially good for sound designers. These are all great venues to get your creations "out there" for a potential client to stumble upon or to send direct links to interested parties when requested. While it might be a bit difficult to manage, multiple locations will most definitely increase your odds of being heard.

CDs are still a solid format and it's always a good idea to have them available when requested. Whether you burn them individually on your CD writer or have your demo professionally duplicated, they are an effective way to present your musical mastery. They have the best sound quality plus allow a listener to quickly scan through material, saving them valuable time. The disadvantage to you, of course, is they might use that feature and miss the best parts of your music.

Another potential problem, you can't control what kind of CD player they use and where they use it. They could listen through their PC, boom box, home stereo, or car with a variety of sound quality differences—another reason to mix for any possibility. My preference is to have them listen in their car, so I have a captive audience with nothing to really distract them, and I often encourage that. Besides, music just sounds better when the scenery is moving. For the do-it-yourselfers, there are several CD labeler kits out there which are better looking than a smeared Sharpie pen any day—so be sure to use a good one.

If a developer is auditioning several potential composers or sound designers, they will typically listen to them at the same time—often with several other team members in attendance. Because they don't want to have to switch back and

forth between different formats and players, and like to use the same one to get a standardized comparison, I make it a point to ask what type of demo the media buyer prefers. While CDs are the most requested, they can ask for anything from downloadable MP3 files to DVDs.

MP3 files, and other compressed formats like *.ogg* or *.wma*, are a popular demo format as well. Obviously, their unique advantage is immediate delivery and easy posting to your website. Their file size and good sound quality are an excellent way to strike as the prospective client is giving your talents consideration. They must be interested or they wouldn't be there, right? This could provide immediate feedback and possibly close the sale for you. This format would also work well if a client asks you to send a demo as an e-mail attachment. You are already making points by giving them what they want.

The smaller file size of compressed audio comes at a price, though. While compression schemes are getting better with each new generation, they still can't beat the sound quality of a comparable uncompressed audio file like you would find on a CD. And, because the purpose of a demo is to not only show your skills as a composer or sound designer but to showcase your production values as well, pristine audio is incredibly important. Sending an MP3 demo is good, but be sure to follow up with a CD version as soon as possible to ensure an accurate first impression. Higher bit rates, above 128 kb/sec, sound best—especially when showcasing your work to a potential client.

DVD demos are gaining in popularity and are almost a guarantee the media buyer will listen or view it on a good display and playback system—which is *exactly* what you want! In the mind of a potential client, a DVD in their hand means they are in for an experience. Having watched hundreds of blockbuster movies in the past, this reinforcement gives the DVD demo a psychological advantage right from the start—which you can really take advantage of. If you have past work to showcase, such as cinematics or in-game footage, film, television, video, or theater work, this is an excellent format to really grab their attention. Hearing music and sound effects is one thing, but hearing it within the context of the project it was created for is priceless.

While DVDs can give your work another possibility to really shine and be unique, it can also backfire if your menu and visuals don't look professional. If you have the resources and the ability to create a good-looking interactive DVD, it can really pay off—but will have the complete opposite effect if it's not. The idea is to showcase your music and sound design favorably, and if your talents in the visual arena don't quite cut it, consider hiring a professional to help out or keep to the tried and true compact disc. Finally, be sure to check with a potential client's ability to play DVD-Rs or have them professionally duplicated on a yearly basis to avoid this potential deal breaker. If they can't play it or have to waste time looking for something to play it on, you might as well have not sent it at all.

Delivery

So, now you've created a demo reel to be proud of. Staring adoringly at it on your desk, though, won't get you very far. You have to get it to your prospect and in one piece. The best way is to hand deliver it and perhaps introduce yourself to some key players at the same time. Sadly, most of us can't afford a road trip every time a request comes in, so we have to rely on someone else to make the delivery for us. A couple of tips to consider:

- Always ship your CD or DVD in a protective case and use padded envelopes or specialty shipping boxes. Believe it or not, too many demos have arrived smashed and unplayable. The media buyer probably won't have the time to call you to request another and instead will listen to the ones they've received from other potential composers.
- Don't waste your money sending your demo UPS, FedEx, certified, or anything more expensive than first-class mail unless specifically asked to do so. While you may feel the urgency to send out your reel, believe me, there is none on the receiving end. Save yourself the money.

Follow-Ups

You've sent out your demo reel, now what? You start pestering the producer, right? Wrong. The last thing a busy producer wants to do is be hounded. If they got in contact with you for your reel, they know it is coming and they probably already have time set aside time in their schedules to review all submissions. And until that time, you probably won't hear a peep. It's taken months before I've gotten any word back sometimes. Just be patient.

It is okay for you to check in with them after a couple weeks to ensure they received the package in one piece. This shows your professionalism and concern for delivering the product to them. But, do not badger them as to whether or not they have listened to it yet. Believe me, if they are interested, they will call. Occasionally, some will send a "no thank you" letter and even return your material. Don't be offended if your hard work comes back. They know sending demos can be costly and they are giving you the chance to reuse it again. I think it's a fine gesture.

I have developed a simple tracking method I use religiously. I log the date and the company I sent the demo to. After 10 days, I proceed with my follow-up—either a phone call or e-mail. I now know they received my package and I relax. If they call me, I check another box. If they hire me, I check another box. But I never, ever ask them if they've listened to it. I've only done it once and now it seems to be the running joke. Every time I call, he takes mine from the bottom of the pile and puts it right on the top. (I've even been there once to see him do this.) It is soon buried under other arriving packages and sits there until I call a month later and we repeat the process. One of these days, he'll actually have the time to listen to it and I know I'll get the gig.

Some Final Demo Reel Thoughts

Never make apologies for your demo. If you feel the need to apologize for the lack of quality or the lack of substance, you are not ready to send it out. No one wants to hire someone who appears insecure. Insecurity means inexperienced, which in turn tells the producer he will be spending a lot of time holding your hand throughout the project. Be confident about what you can accomplish. They are more willing to educate you in the ways of the games industry if your self-assuredness shines through and they know you can indeed create fantastic sound.

Keep your demo reel up-to-date. As you add clients, you will have new music to add. If you don't like the customizing idea, be sure to at least produce a new demo every year. Keep it fresh and exciting. Send it to all of your previous clients and prospects.

Sending unsolicited demos has got to be one of the hotter topics in the industry and there still is no definitive answer. If you have the money and the time, you

can beat the odds by shot-gunning demos to every game company and multimedia house on the planet. You are bound to pick up a job or two that way. But what good is it to send it to someone who didn't want it, didn't ask you for it, and lets it sit unopened in a box with hundreds of other packages? I would much rather have the extra momentum of having it requested from someone who is sincerely interested. In my opinion, your time and money are better spent being selective rather than chasing probability.

Like everything else in business and the game industry, timing is everything and sometimes it's *who* you know not *what* you know. But by having a professional-looking and professional-sounding demo reel in your possession, you are equipping yourself for success and ready to beat the odds. Someday, who knows, with many successful titles under your belt and a name recognized by millions, you won't even need to look for work. It will find you. Imagine that!

Determining Your Costs

The last thing to do before we fling open our doors is to work out our fees for services rendered. However, we can't do that until we've determined what it costs for us to operate. It's an ongoing process once you're working, but starting out, you need a point of reference. Unfortunately, it's not as simple as finding out what everyone else is charging and doing the same. Until you've been around long enough to demand the higher fees, consider determining what you need to live on and what your business operating costs will be and go from there. Pad in a decent profit and you are in business.

How does the musician/sound designer compute his operating costs to make a competitive bid? It is not as simple as saying, "Hey, I want to make 500 an hour!" Initially, decide on your needs for the project—whether it is purely for recognition sake, a resume project, or just to cover the cost of overhead. We then calculate in many different factors to cover the expense of creation and consider each of them accordingly. For the final numbers, the fees will generally be lumped together. Separate fees are developed for cases when this is not feasible.

Types of Fees

First off, we need to determine what our cost is to do business. In our line of work, several different billable talents are present—which all have value. Until you resolve what the actual costs are, you may be losing money without ever knowing it. This is an important step.

Creative Fees

Creative fees are for the actual creation, composing, recording and arranging of the music, and sound effects. It is based on the time it takes to create a minute of music or a single sound effect and whether or not the work will be licensed for single use or will be bought outright. For most games, the buyout option is standard—but sounds or music used on websites or in Java applications may be licensed for exclusive use for a period of time. The licensing option is often cheaper, the creator retains the ownership rights, and the sound can be used again after the contract period has expired.

This fee is the most difficult to uncover and is generally based on what the market will bear. It can be added to your total fee structure or can be substituted with your hourly wage. As your name grows, you will be able to charge more—your

Tools of the Trade

BRADLEY MEYER
Audio director (Sucker Punch Productions)

At work I have my own room with insulated walls. Unfortunately, they skimped on construction so I share a ceiling with my sound designer next door, the walls aren't insulated well enough and the bathroom is on the other side of another wall. It's a lesson in working with what you have. My room is set up with a 5.1 surround system (as well as some crappy speakers and headphones for evaluating mixes on different listening devices). I have a decent size room (10′ × 5′) for recording sfx and scratch VO—it's a pretty versatile setup. All the character movement and footstep sounds were done in there for *inFamous Second Son*, and we've done countless other recordings for various other sounds now living in our library.

At home I have more of a home studio setup. One room in my house with a stereo monitor setup, Mackie control, and minimal wall treatment. Recording sounds at home is a matter of recording in any room (provided the neighborhood is relatively quiet) or going out in the field.

My gear philosophy is super simple: use the best tool available for the job. If you're doing field recording and have access to a Sound Devices recorder and, say, a Schoeps shotgun mic, use it. If you only have a Zoom H2 with its built-in mic, use it. There's plenty of forums and talk among colleagues about which DAW is best and the answer is the one you're comfortable with. I spent 10 years designing in Logic because that's what we used at work and I got really good with it. I've never been a huge fan of ProTools (even though I use it at work), but have always found it excellent for dialog editing and cutscene layout and mixing. I often use Reaper to chop and process my raw recordings to add to my sound effects library because it's fast and does what I need for that process very quickly and easily. I'm starting to look into Nuendo because of their Wwise integration. Same thing should apply to plug-ins: use what you like, what you're comfortable with, what you think sounds good, and what you can afford.

Computers: I use Macs though will probably be moving to PC for personal use soon. At work, we try to maintain compatibility to other Sony studios, so we'll keep using them for now. We have 8 core Mac Pros, 24 GB RAM, and two 4 TB drives (one for projects, one for backup) at work. At home, I currently have an old Mac Pro (circa 2008) and a Mac Book Pro (circa 2009/2010) each with ~12 GB RAM and lots of hard drives for my sfx library, projects, and backups.

Audio interface: At work, I have an Avid HD 8×8×8 I/O because at the time it was the only way to get ProTools HD which I did for Sony cross-compatibility. At home, I have a Mackie Onyx 400F, but their latest firmware (which I haven't updated to) removed 192 kHz support, so I'll be buying an RME Fireface UFX soon.

Software: Sound Forge, Izotope RX, DAWs I mentioned I use various ones: Logic, Reaper, and ProTools mainly at home. ProTools at work, though we may be switching over to Nuendo soon in light of Avid's idea of PT 12 and Nuendo's Wwise support

Monitors: Genelec 5.1 at work. Dynaudio BM6A mkII at home

Sound modules/VST instruments: Izotope Iris, Madrona Labs Kaivo, Native Instruments Komplete

Outboard gear/effects plug-ins: Melda TotalBundle, Zynaptiq Morph, SoundToys, Waves Mercury (for Sony compatibility), GRM Tools. At home, I also have OhmForce and McDSP plugs. Will probably have FabFilter FX pack by the time you read this as well

Keyboards: M-Audio KeyRig 49 at work. Madrona Labs Soundplane and a crappy Kay Audio keyboard at home

Other instruments: Guitars, flutes, harmonicas, and a ridiculous amount of weird sound toys and noisemakers

Microphones: Work: Sennheiser MKH 8060, MKH 8040 (×2), Rode NT-5 (×2), Earthworks SR-30 (×2). Home: Sennheiser MKH 8060, Shure SM-57, SM-58, KSM141(?), Neumann TLM-193, Aquarian Audio XLR-2A Hydrophone, Barcus Berry Planar Wave contact mic, Roland Binaural mic

Remote recording gear: Sound Devices 702, Tascam DM100 mkII, Edirol R-09, Zoom H4n

Other relevant gear: Anything that makes a noise!

creative fee increasing exponentially. If you are John Williams, your creative fees might start at $250,000 and move up from there. Johnny Game Composer might be able to command $10,000. The value of your stock is entirely dependent on how valuable or in demand you are for a game project. If they just "gotta have" you, they are willing to pay more for the privilege.

The best part about this fee is that there are no costs involved—nothing to buy and no expenses to cover! Consider it everything you've done in the past—the culmination of your hard work, studying and music lessons all rolled up into one. It's the investment you've already made that determines your talent's worth. All of this will factor in the negotiations and how much you can make. Think about how it will impact your price and whether or not the product will be sold outright or only licensed for use within one particular application.

> If all the rights to your music are sold, the price should be at least four times more than licensed work.

Studio Fees

Renting an outside studio can be expensive, especially when a full orchestra or live band is involved. Studio fees cover that. It is also intended for the composer/sound designer to be able to cover the actual costs, maintenance, and general

3. Getting Organized and Ready for Business

Marty O'Donnell (left), seen here collaborating with Paul McCartney on *Destiny*, can command a higher price than most for an original game score. (Courtesy of Marty O'Donnell.)

operation of their personal studio. Equipment payments, insurance, utilities, and general maintenance requirements are factored together to arrive at an hourly rate. Most sound creators, however, work out of their homes and are able to keep the cost down.

This fee is the actual cost to use an outside studio or what you would charge someone to use your project studio if you were to rent it out. It's easy to determine when dealing with another studio, but how would you figure out the value of your facility?

- Are you making payments on any equipment?
- Does your electricity bill go up noticeably whenever you power up?
- How much do you spend to have equipment serviced or repaired?
- Are you paying extra for another phone line, insurance, or Internet access?

Add that up and divide by the number of hours in a standard work month (160) and you'll have a rough estimate of what you need to cover your costs. Figure in an appropriate profit margin of 25% to 30% and there you go. Check prices at other local studios for their hourly rates to see how you compare. The advantage you have is that your overhead is far lower than a professional recording studio and that savings can be passed on to your client.

Here's an example of a typical cost analysis for a basic project studio setup.

Monthly equipment payments	$1000
Electricity	$50
Maintenance	$50
Phone	$45
Internet	$60
Insurance	$30
Total	$1235 per month

Divide this total by the number of billable hours per month. This is based on a standard 40-hour workweek, although you can work 16 hours a day very easily.

Tracking live drums in a home studio isn't always practical. If a commercial space is required, be sure to include this fee in your bid to cover the expense. (Courtesy of Nathan Madsen.)

$1235 divided by 160 hours = $7.71 an hour
Or another way to think about it: $61.68 per day

If you were working 40 hours a week, 5 days a week, making money on billable contracts, this would be what you need to charge just to cover your studio costs. Not everyone works that many hours on projects—so it will vary, obviously, for less studio time. I just want you to start thinking along those lines.

As you determine the fees to charge for your studio usage, be aware of this. By working out of your house, using your own project studio, you can substantially affect the costs of studio time by keeping it lower than any professional studio. Because your overhead is lower, you can price your services competitively and pass along the savings to your clients. As you start out, an enticement to the smaller game developers will be your lower costs—their hope to get some pretty decent music for much lower than the big boys, which is a perfect place to start as you build your resume.

Consider a price range between $15 and $30 an hour for studio time—our example working both 1 week and 2 weeks out of the month. We want to play conservatively and make sure we recoup our costs. If you work 1 week out of the month on an audio contract starting out, you are doing pretty good. Add 30% as your profit margin and the figures change to $20 to $40 an hour.

Talent Fees

The actual performances by musicians and voice talent are included in talent fees. Some music composers may charge to play instruments on the tracks; others will include their part in the creative fee. Figures will vary based on the caliber of talent requested and outside talent; therefore, virtuosos or famous players will increase this price accordingly.

As you build your local talent pool, establish what their per-hour or per-session fees are and do the appropriate math. It will vary by area, as major cities and

music hubs demand higher rates than those in out-of-the-way places. A reasonable per-session rate would be between $250 and $500 for mid-level performers in major cities where talent is in demand. Less prevalent talent can charge between $50 and $200 per session.

If you choose to charge for your own musicianship or voice talents, select an appropriate figure which will keep you competitive. Again, because you are the creative entity and a one-man show, you can get away with smaller fees to get the business. Many times, I've been told I was hired because the big guys were just too expensive. Find your niche and price accordingly.

Media and Material Costs

Recordable CDs and DVDs, external hard drives, thumb drives, digital or analog recording tape, shipping, and any other costs incurred while recording and delivering the final product are covered in this fee. Any material you use in the creation process needs to be discovered to figure your out-of-pocket expenses—everything from your recording medium to the stamps you put on the envelope. If you had to buy it for use on the project, you need to know the cost and ensure it is covered in the fees. Leaving this out will chip away at your profit margin. A 100% markup is not uncommon for CDs and DVDs when figuring them into a bid package.

Hourly Wages

The hourly wage is a unique formula calculated using the sound creator's salary requirements based on the available billing hours for the year, the cost of healthcare and other benefits, vacations, holidays, and retirement. Because we don't work for a regular "company," this fee is our actual wage.

After vacations (you'd like to take), sick time, and the hours of administrative duties running your business are factored, roughly 1000 hours per year are available to bill for your creative work. If you want to make $30,000 a year, you'll need to charge roughly $30 an hour. After taxes and company benefits such as healthcare, you'll charge 30% more or roughly $40 an hour to clear that same amount. This is a fairly close example of what you may find others charging. Insert your own figures to see what you should charge.

The Kicker

Also known as the "fudge factor" or "margin of error," this is an additional fee to cover any unexpected problems or minor adjustments to the project. Because the game development process is a continuously evolving one, additions are commonplace and this fee allows them to be included without having to renegotiate the entire project. Reactions to the kicker are varied, but time saved from having to renegotiate a contract is priceless and it is always more palatable to charge less rather than to charge more. If the project happens to expand far outside the original borders, renegotiations will be necessary. Fifteen percent is generally a good figure to use.

Rate Calculation

An established composer can charge $1500 upward to $2000-plus per finished minute of music. Established sound designers can charge between $150 and $200 per sound effect or hourly at a rate of $175 to $250 an hour. While they may be making more money than when they first started out, and deservedly so, their

cost of doing business and overhead have also increased. As you gain experience, you'll find that more expensive recording gear and software will help push your music another step further. As you leave behind the $3000 analog mixing console for a $10,000 digital one, your payments increase to match. There really is no ceiling.

To calculate our rate, we need to have a good idea of the length of time it takes to do what we do. While you are putting together your demo reel, keep track of how long it takes to compose, record, and mix down 1 minute of music. Average this out over the course of the production and you have a good idea. Experienced composers, working from scratch, can do 2–3 minutes a day. Those using loops and programs such as Sony's ACID can do considerably more. When I started in radio and TV commercials, my general rule of thumb was that 30 seconds of music took 4 hours—start to finish. Today, I'm up to about 1 minute in a 4-hour period depending on the style of music.

Sound designers need to do the same. While working on various original sound effects, keep track of the time it takes to do one sound effect. My working model is an average of 2 hours per original sound effect. That doesn't mean that it takes that long to get one sound recorded. After many attempts and ideas for a sound are created, the final incarnation of the effect will have taken roughly 2 hours. Sometimes sound effects happen immediately and you are done. Other times, it's like pulling teeth—with 2 days passing before one materializes. We're looking for the *average* of the process to determine what our costs are.

Using our previous examples, we can finally conclude what our rates should be. I will be using the "4 hours per finished minute of music" and "2 hours per sound effect" models in the calculation with no outside musicians or voice talent.

Hourly wage and/or creative fee:	$30.00
Studio fee:	$7.71
Total cost:	$37.71 per hour

Then multiply by the number of hours to complete using your working model:
1 finished minute of music: $4 \times \$37.71 = \150.84
1 sound effect: $2 \times \$37.71 = \75.42

Figure in the 15% fudge factor:
1 minute of music: $\$150.84 \times 15\% = \173.47
1 sound effect: $\$75.42 \times 15\% = \86.73

Add in the material fee for the project:
1 minute of music: $\$173.47 + \$15 = \$188.47$
1 sound effect: $\$86.73 + \$5 = \$91.73$

In this example, recouping our costs and covering our minimum salary requirements, we've determined the cost of one finished minute of music to be $188.47. If we lowered our salary, costs, or were able to complete more music in less time, the price would go down further—what you make on a job being your bargaining room. First out, you will probably be able to charge only $250 to $300 per finished minute of music—which, coincidentally, is a 30% profit margin added to our cost.

It's a fair price for someone with average musical and no game experience. And when you factor in the number of minutes in a game, say, 45 minutes to

an hour, that would be \$11,250 to \$15,000 for a project using your own instrumentation and no outside talent. That's not a bad start, considering this doesn't even include royalties, bonuses, and any soundtrack album releases you might negotiate.

Sound design is another animal. If you are offering it as another service of your business, it takes your time away from doing other creative activities, so your costs will be the same as above. If you are only doing sound design, your overhead will undoubtedly be much less—the only equipment needed being a computer, sound library, and remote recording gear at most. Looking at the previous example and offering this as another benefit of our business, our cost on a single sound effect is \$91.73. Adding a 30% profit margin, \$119.25 would be our fee.

Can you get that much in the games industry? Not at first. Sound-effects-only projects tend to be paid on a lower scale—the games market not tolerating the same pricing structure as music. The big boys can command about \$15,000 per game project doing sound effects only, but this is after a few years under their belts. New sound designers in the games business can expect a rate of \$25 per hour or even \$25 per sound effect. It varies greatly with the deals you work out. If you're doing the music on a project as well, you'll be able to make up your costs on the sound effects by charging a comfortable overall fee for the project.

I have yet to make the same amount on any project; sometimes it's at an hourly rate, other times it's per sound effect. When I started doing sound design several years ago, I started at \$25 per sound effect. As my skills increased, I changed to \$25 an hour. Later, it changed to \$50 per sound effect and then \$50 an hour. These days, I charge either \$75 to \$100 per sound effect or \$75 to \$100 an hour—depending on the situation.

Producers have many different ways of choosing sound effects, and some will have you tweak and redo sounds to death to get them just right. My train of thought is usually this: say a small project requires five specific sound effects. If I send 15 sound effects to a producer I have crafted using their specifications and he chooses to use 5 of those, I charge per sound effect. They trusted my talent, were happy with my judgment, and accepted my first pass. If that same producer would have chosen five sounds but had me rework them several times or wanted different sounds, I would charge by the hour. Obviously, we weren't communicating or I would have gotten them right the first time. They can be extremely picky and have the tendency to micro-manage every aspect of a project, and that's okay, too. It's *their* vision for the production; I can respect that and will give them exactly what they want. But, because my time has value, for projects which work this way, an hourly rate is more appropriate—keeping me from losing money and wasting time.

Organization Is Key

At this point, we should be fairly well organized. We know what we plan to do and how we plan to do it—either as in-house or as an independent contractor. We have examples of our work on a great-sounding demo reel and know how to send them out. We've also figured out what we want to charge for our services and have the basis to judge our initial income potential. Time to reel in the business!

Tools of the Trade

PASI PITKANEN
Sound designer, Field recordist, Composer

As a sound designer, I am responsible for planning, recording, manipulating, and designing high-quality audio content for games. To achieve this, I have a perfectly calibrated acoustically treated studio/recording room with professional audio monitoring setup by Genelec. I also have a good collection of microphones that I use both in the studio and out in the field. With this setup I can do pretty much everything I want and can no longer blame the equipment if something does not sound good.

I usually follow the KIS rule (Keep It Simple) when looking and investing on new gear. I always do thorough research on the gear and force myself to think: Do I *REALLY* need this?

Computer: Windows desktop computer with i7 Quad-core processor, 16 GB of RAM, 2–3 TB hard drives, two monitors, Kensington Slimblade trackball, and a normal keyboard

Audio interface: Roland Octa-Capture

Software: Steinberg Cubase, Reaper, Adobe Audition, iZotope RX, Unity, Fabric, FMOD, and Wwise

Multi-track system: Steinberg Cubase, Reaper

Monitors: 2× Adam A7s, 2× Genelec 8240s, and Sennheiser HD600 headphones

VST instruments: Native Instruments Komplete bundle, Spitfire Percussion, Spitfire Albion I, Audiobro LA Scoring Strings, Spectrasonics Omnisphere, Cinesamples Cinebrass, and a lot of different sample libraries from Sonokinetic, Soundiron, 8Dio, etc.

SFX libraries: My own large sound effects collection that grows rapidly each month. I also have a huge collection of sound effect libraries from Sound Ideas, BOOM Library, Hiss and a Roar, etc.

Effects plug-ins: Cubase plug-ins, FabFilter Pro bundle, and ValhallaDSP Valhallaroom

Keyboards: Novation Impulse 61, M-Audio Keystation 88es, and Korg nanoPAD 2

Microphones: 2× Sennheiser MKH8040, Neumann TLM103, Sennheiser MKH416, Røde NT4, 2× Line Audio CM3s, 2× JrF C-series contact microphones, and 2× JrF D-series hydrophones. Line Audio CM3s, 2× JrF C-series contact microphones, and 2× JrF D-series hydrophones

Remote recording gear: Sound Devices 702 with a bag, Sony PCM-D100 with Rycote portable recorder audio kit, Sony MDR-7506 headphones, and various Rycote windshields

Other relevant tools: Google Nexus 7 and Apple iPad Air

4

Finding and Getting the Jobs

It's official. You are ready to tackle some challenges and make some money. Unlock the front door, put out your "open for business" shingle, turn on the lights, and prepare yourself for the onslaught of customers who have been patiently waiting for this moment. The phone starts ringing off the hook. Life is good. Not! It's a nice thought but you're going to have to be a bit more proactive than that and get a little dirt under your fingernails first.

Marketing

Drumming up business and getting the customers through your doors with wads of cash in hand will take some considerable effort. For most of us, playing the role of marketing director and salesman is as unnatural as brushing your teeth with your other hand. The best part, though, is after a bit of practice and patience, it can be yet another act we do without even being cognizant of it. After a while, you'll be throwing a dash of "marketing" in with everything you do. It's not difficult really. Don't let the fact that there are college degrees in marketing, huge companies which do nothing but marketing, and individuals who spend their every waking hour as marketing experts intimidate you one bit. We can use some of their tricks and hard-won secrets to our advantage.

Tell Everyone

The very first thing you need to take care of is to tell everyone what you do. I mean *everyone*! Don't be shy and play coy. Don't consider it bragging or showing off, and while it might not feel like it, it's actually "marketing." Tell your mother,

father, brothers, sisters, grandparents, uncles, aunts, cousins, friends, coworkers, and neighbors as a start and see what happens.

Whether you know it now or not, somewhere within that small group, somebody knows someone who has a friend whose brother's cousin's girlfriend went to school with a guy who is a programmer at a game company. That guy can be your foot in the door! But, you'll never meet him unless everyone knows you are trying to do audio for video games—so tell everyone! I'm not kidding about the kind of connections you can make by being open about your new endeavor. Let me share some of my personal marketing success stories.

Tale #1

After about 6 months into my business venture, I decided to take a couple of weeks off and serve my country as I do from time to time as a military reservist. I received a phone call from an individual who was gathering information about doing the same. During the course of our conversation, I asked him what he did for a living.

"Oh, I'm the president of a software development company here in town."

"No kidding!" I said, "Do you ever do any games?"

"Yeah, we do contract work for other game companies, mostly programming, but we are gearing up for one of our own game projects."

"Sounds like fun. Do you foresee needing any music for your game?" I queried.

"As a matter of fact, we just let our sound guy go; he just wasn't working out."

"What a shame. Well, you know, I do music. I just happen to run a music production company, maybe we ought to get together."

As it turned out, we lived two blocks from each other and met the next day at my studio. After playing some cuts from my demo reel, I was shaking hands with the president and vice president of this company—signing on for their first game. Not bad considering that all I did was tell him what I do. It turned out to be my first game project and led the way to many more. And the best part is, I've done three games for these guys!

Tale #2

One evening I received a phone call at the house. My wife handed over the telephone and said it was some guy named Mike Post. I chuckled and proceeded to give my friend a hard time. He always calls up as someone "famous," and I smiled at his originality at this one. Well, it turned out it wasn't the friend I thought it was and the voice was indeed *the* Mike Post! Surprise, surprise! He'd always been a TV theme composer idol of mine, my favorites being *Quantum Leap*, *Magnum PI*, and *The A-Team*. It was quite a treat. After my adrenaline rush returned to a more controllable level, I asked him what prompted the call. After all, it isn't every day I get phone calls out of the blue from real-life famous people.

The story: A guy I'd met at the local airport asked me to send a demo. He really enjoyed music, shared the passion, and wanted to hear what I was up to. In his garage at home, he was listening to my music when a friend walked in. Liking what he heard, he borrowed the tape to let another friend of his give a listen. He mailed it to a golfing buddy of his who "plays music in Hollywood." Turns out this golfing buddy was Mike Post! So now, Mike was telling me that he never listens to demos sent to him because if he never hears them, he can't be sued for

stealing ideas (or something similar). But at his friend's insistence, he listened to mine and was calling to talk about my future. This story did not land me a game audio job per se, but shows what can happen when you tell everyone what you do! Get the word out and see what happens. Now, keep reading.

Tale #3

It started with, "Do you know anyone with a microphone?" and ended up with me voicing the daily News, Lifestyles, Health, and Comedy features on the Sprint Mobile Network for more than 2 years! It's one of those "friend of a friend" stories that always happens to someone else; this time I really found out what telling everyone could lead to!

A friend of mine, who works for the government, was talking with a friend of his who had recently started up an audio outsourcing business. They were planning to do all sorts of audio and news segments for national radio stations and the cellular market but didn't know where to find the people to "voice" the spots. To keep their initial costs low, they were considering doing the recordings themselves and casually asked my friend if he knew anyone with a microphone. He said it took him all of about 2 seconds to think of my little hobby and set the wheels, to what was an incredible 2-year ride, in motion. Five days a week, I printed out a dozen scripts and flapped my gums at a microphone—all so people didn't have to read the tiny little text on their cell-phone screens.

What started out as a casual remark really turned into an interesting sideline for me—one that expanded exponentially as negotiations with every major cellular carrier in the United States ensued. After all of these years in the games business, "Tell everyone" still proved to be a valuable strategy. I highly recommend it! Oh, and you know I took care of my friend, don't you worry.

Look Professional

While we are out there beating the bushes, things are going to start happening fast and furious. Bid requests, information requests, demo requests, and our pricing structures are going to be sent out to prospective customers as fast as they hit your desk. What you send out and how it looks are going to have a big impact on whether you get called for the next step. I am a firm believer in first impressions.

What you put inside that envelope can make all the difference. If you hand-write a bid on a scrap piece of paper, you're telling them you are an amateur, that your music product will probably be amateur as well, and that you don't care about the little details. On the other hand, if you send an information packet in an expensive binder with high-gloss paper, color laser printing, and gilded edging, you're telling them you are way out of their league and they probably couldn't

GameBeat Studios' eye-catching logo.

Christos Panayides' CP Audio Services.

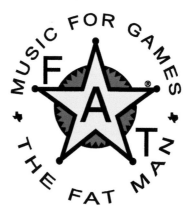

There's no doubt what "The Fatman" does by looking at his logo.

afford you. You want to give an impression that you can do the job within their budget in a professional, reliable manner.

The key is to look professional in every respect. You don't need to spend a lot of money and go overboard. You just want to make your prospective clients feel confident that you have your act together, know what you are doing, and won't waste their time or money.

Design a Cool Logo

Work a logo up yourself or find a graphic artist if you don't have the ability. I'm sure a graphic arts student would love a "real-world" project to put in their port-folio and would jump at the chance. The idea is to have something eye-catching

and something professional. Put it on your website, business cards, stationery, and envelopes. Put it on your demo reel and make bumper stickers, hats, and T-shirts, if you like. Have a recognizable symbol that everyone will associate with you and your quality work. Later, we'll talk about negotiating deals where your

Keith Arem's company, PCB Productions, and its simple yet effective logo.

The Nugel Bros.' ear-catching logo.

Nathan Madsen's logo takes the guesswork out of what his business does.

logo can appear on the game box cover and splash screen during the opening sequence of a game. You'll definitely need something to show the world by then.

Business Supplies

Stationery, envelopes, mailing labels, business cards, and DVD labels should all be acquired. You can have them designed by a print shop for fairly reasonable prices. If not, try spending a little time at your computer formatting various templates which include your logo and contact information. The only thing I don't recommend skimping on is business cards. Pay $25 to $30 and have 500 cards printed. You'll be passing many of these out and they will be the first impression people get of your company. Cards with perforated edges and dot matrix printing convey a sense that this person won't be around for long.

Web Sites

Potential clients are out there waiting, but they may be a little shy. They have your card, but don't feel like getting into a long drawn-out conversation to find out what they need to know. Instead, they may turn to your website. Websites are easy to set up and maintain and the minor server space cost per month makes them a great marketing tool. So, set one up and pack it full of information.

Make it look professional. This is another great place for that new logo of yours. Explain what you do, how you do it, previous projects, maybe a biography about how you got where you are, any press clippings, some music and sound effects samples, and, of course, contact information. Don't go overboard with the audio samples—just a few short pieces to build their interest and get them to request your demo reel. Downloadable MP3s or a SoundCloud widget works well. Your reel will still sound the best, so make sure you have an e-mail available for their orders.

Be sure to keep your website updated. As you finish projects, get them on there. Be proud, and show prospects that others found you suitable for their projects and that they will, too.

A Note on Embedded Audio

Don't use embedded audio on your website. If you use it within the context of an Adobe Flash presentation, that's different and perfectly acceptable. The audio I'm talking about is the MIDI music or digital audio files which play in the background while someone browses your site. Not only will it feel like you are pushing your audio on them, but there may be some technical issues as well.

First off, not everyone has the updated plug-ins on their browser which play back the type of audio you embed. Secondly, even if they did, there is no guarantee of the quality which spits out the other end. I know, we do audio. We want people to hear it and why not have it on our websites? I'd much rather have nothing than have something that could lock up someone's browser, just sound horrible, or worse, cause them to leave your site to install the update. MIDI music is very prone to sounding like garbage. It sounds great on the computer it was composed on, but the various sound cards out there almost guarantee it won't sound the same on someone else's. Don't use embedded audio and save yourself some embarrassment and some business. Stick to downloadable audio samples and you can't go wrong.

ELSPETH EASTMAN
Composer, Voice actor

Feel free to call me Ellie! When I was a kid, I loved the music in the games I played and had a collection of soundtracks I listened to all the time. I had this Casio keyboard that I'd use to play with MIDI on Cakewalk, and I wanted to emulate the composers I heard. Since then, I've had my music/voice in games, and never imagined I'd end up in the very book I read for sources of inspiration!

I started out my journey in 2011 when I went on a whim to the Game Developers Conference, and have not looked back since then. I love the audio community and the inspiration/energy you get from just being around other people in games, and I've gotten the chance to work with fantastic friends. I've written the soundtrack to *Trip Harrison: Origins*, *Wholesome Family Dinnertime*, *I Saw Her across the World*, and other upcoming titles.

My music was originally why I wanted to get into games, but I branched out into voice acting as well in 2012, seeing as I had a mic and all the audio equipment to mix it. I've provided voice for the independent scene like *Crypt of the NecroDancer* and *Guns of Icarus Online*, and additional voice work for larger titles like *Killer Instinct* and *Where's My Water*. I also create a lot of videos surrounding game audio on my YouTube channel, Rated E with Elspeth. (YouTube is an excellent place to showcase your work, by the way!) While hearing my music or voice in a game is super cool, the collaboration with other passionate, driven people is a greater reward in and of itself.

www.elspetheastman.com

Describe your thought process for creating music.

I like to know the story of the particular game for which I'm writing. I'm always inspired by the concept art or lore of a project, and so I develop the sound around these other aspects so it all flows nicely. It's always a great thing to know the personalities of the people whom you're working with, as well—what music would they really enjoy hearing? Are they people who have affinities for rich, deep, choral soundtracks, or do they prefer folksy-pop acoustic ballads?

Are there any particular secrets to your creativity?

Sitting down and making myself write is key. Make yourself do it. Learn to turn on that drive and you will make something wonderful, I guarantee it! Also, large amounts of caffeine and remembering to eat can't hurt. Also, starting with good, solid team development is always a plus!

Are there any secret techniques that you regularly employ?

Not really anything too obscure or secret, but I find that doing a quick breathing exercise really helps clear my head of schedules, deadlines, all of that, and lets me focus more intensely on the project at hand. I also have a pillow on my chair, so that I'm comfortable and my posture isn't slouched for hours on end. Ergonomics are definitely something to take into account when you're working with lots of audio!

Do you have any interesting sound gathering/sound creation stories?

A lot of the crazier sounds like lasers or animal screeches or creepy atmospheres I can actually imitate with my voice, and it's handy when I can't quite find the sound I'm imagining. There are also times when I'll be screaming into the mic for a horror soundtrack or script, and the neighbors will get really worried. Once, I was supposed to sob into the mic and we had to keep doing different takes—and my neighbor knocked on the door to ask if everything was okay. This has happened on several occasions!

Do you have any advice which can help lay solid groundwork and ensure a successful production for the audio content creator?

Compressors and limiters, all day, every day. Throw one of each on a master track, and take it from there. I NEVER start work on a blank canvas—I always have a template setting where I know the audio will sound delicious on any medium.

Do you have any interesting sound design creation techniques which affect the type of sounds you create?

When I had a guinea pig, I would hold the mic up to her and let her squeak into it for a couple of minutes, and then alter the audio to become an atmosphere. Before I got acoustic foam, I had my mic in my closet surrounded by blankets to absorb the noise. It worked well until I moved and had a bunch of echo coming from the hallway!

When do you find you are most creative?

Late, late, late at night. Some nights I'll start at 9 p.m. and work my way to the next morning. When the birds are chirping, you know that's a good sign of productivity!

Any worthwhile creative advice you'd like to share?

Be comfortable and have a clean workspace. Let sunshine in if you have windows. Clutter can definitely add to stress, so try and untangle all of your cords, dust everything, and get yourself a glass of water to refresh yourself often.

Is there a typical workday for you?

Not really typical—being a freelancer, you're not really sure what's going to come down the pike, so there will definitely be a lot of self-promotion every day and responding to e-mails. I'll get up, make a lot of coffee, start working on a recording or soundtrack, and take a breather every 2 hours. Some days, I don't have much work, so I either study independently on music and new gear coming out, or I'll play a game. In this business, game playing is essential!

What skills should composers have to succeed in the games industry?

First and foremost, networking skills. If you aren't really able to make friends or talk with people easily, you might have a bit of a hard time finding work, as a lot of the business is who you know. A background in music composition is a close second, of course, as you should probably have listened to a lot of different styles and absorbed as much as you can about music theory. As a composer, you should be able to compose whatever style people ask of you, so keep your mind open to different genres!

Do you have a specific ideology which drives your way of doing business?

One thing I know is that for me, being a part of a development team is one of the greatest places to be. You're having fun and making money, and in the end, you see a project that shines from all the hard work, and you were involved with that. Making people happy and getting repeat business is one thing—the reward of creation is another entirely and on a whole different level!

Any good business advice to offer?

Always stand your ground. If you're not comfortable with something, speak your mind, and know what you're worth! Also, if possible, contact others who have worked with this developer/business and ask if it's a good plan of action. People who have bad experiences tend to speak louder than those who haven't.

Any horror stories which have impacted how you do business?

I don't really have many, but I know the feeling of being replaced, and it's not a good feeling to have. Unless you trust that person, state upfront what you want out of a project—if someone asks you to do something, try to sign a contract that sees you as a part of the project from start to finish. If they're wary or have someone else in mind, you may end up doing a lot of work without seeing it ever reach a gamer.

How do you approach negotiations with a new client?

I'm open-minded, and I listen. I ask a lot of questions and I am prepared to listen to what they need, and then stick to my rates. I often end up asking what a client's budget looks like, as I do a lot of work for indie clients, too.

Do you have any negotiation tips which work well for you?

Be very friendly and energetic, but know exactly what you're getting yourself into. Be prepared for change, and be firm but agreeable.

Do you have any contract stories which others could learn from?

If I could bold this, I would: Read The Whole Thing. You could be liable for anything written in paper, and if your signature is on there, you might not be aware that you just signed over all your rights and only get a flat rate of $50 for hours of work. This hasn't happened to me, but I know folks who have gone through headaches working with others who might not be so considerate of a composer's time.

Do you have any tips when working with developers?

From my experiences, when I am asked to compose or voice something, people are very happy to talk with me and I reciprocate that energy. I remember why I wanted to get into

games in the first place and it's because the majority of developers are creative, intelligent people. When I'm asked to work with them, I treat it as a privilege and work quickly and efficiently to meet their needs, and I also try to learn more about who I'm talking to so that I feel more comfortable presenting my work to them.

What advice can you give when working with a developer which has ensured a good working relationship and a good final product?

Keep it up. Follow that developers adventures, send out feeler e-mails, and say hello once in a while. You probably follow each other on Twitter already anyway, so be a part of their life to let them know you're still up for more projects! They'll remember you.

What advice can you give when working with a developer to ensure you are able to make great sounds?

I always send them a track when they ask for a short demo, and give them a paragraph when they ask for a reading of a sentence. Under promise, over deliver.

Have you ever had any development issues negatively influence your workflow?

There have been a couple times where I'm writing a soundtrack and the story of the game decides to go in a completely different direction, and so I'm left with all these tracks that I put work into that will never get heard. When your work doesn't go into the project, it can be a downer and might affect the way you compose afterwards for other chapters.

Do you have any advice to ensure successful audio implementation?

Attention to detail. Seriously. Remember that it's a very dynamic process and you have to go over everything 500 times. The difficulty will vary depending on the environment or engine you're working with, but for me, this is a form of audio that requires patience and trial and error.

Staying organized is important, especially if you are working on multiple projects, which is part of your daily routine. How do you keep up with it?

Spoiler alert: I'm terribly disorganized but I can pull it off to look like I know what I'm doing! But seriously, I have about 50 different to-do lists and alarms set on my phone, so I don't forget to do things. I'm absent-minded at times, and so I take care of smaller projects first then start on the bigger ones that take more time. I allow myself a little reprieve by playing some games (great way to get inspired) and then get back to it!

Any specific 'lessons learned' on a project which you could share?

There was one project where I wrote 2 hours of music, expecting payment. I didn't know this client very well, but I took his word that I'd be paid. You can probably guess how it ended up—no payment, and the game never published. It wasn't due to anything I did, but the developer definitely needed to iron out some personal problems.

I used to believe that working for free was fine to do for projects when you were just starting out—but people will try to take advantage of you and ask for more than you originally thought. It took a while for me to set up rates that I knew were reasonable from experience and from talking to others. When you've reached a certain point where you have enough of that experience behind you, don't take on free work unless you have the time for it; if you know it's going to be fruitful in some form or another, it's your own judgment call, but remember your worth!

There are many pitfalls when 'working' in the game industry. Have you had any bad experiences?

I tend to avoid meaningless confrontation, but I have been pestered to do free work to the point of aggravation and it being near bullying. Essentially, I told the person thanks, but I was not interested and that I was already overworked, but there are people who are not interested in your schedule unless you agree to their proposal. I ended up blocking this person from my e-mail list so that I wouldn't become stressed when I saw their messages turn to venom.

There will be those asking you to do "help out," and unfortunately, these people almost always have no budget. There is a difference between "helping out" and "contracting." If you have too much on your plate, kindly thank them for reaching out, and politely decline. If they continue to bother you, you don't owe them any further explanation—cut out the negativity, avoid the subject, and scroll down to see what other opportunities await you in your inbox.

Do you have any development stories which served as a good lesson learned or something which can be avoidable in future projects?

A couple of years ago, I was once asked to write a theme for a very cool game series, and I was stoked. This was back when I was still setting up my e-mail for my website and things were positively jumbled. It was around 4 a.m. that I received this e-mail as my server had been down all day. I made it a point to confirm and write out something when I was more cognizant.

However, in the mess that was my inbox, I began deleting what I thought was the junk mail, and ended up losing the date and the e-mails from which I needed pertinent information. My only connection to the developer was lost, they moved on, and I felt like a total idiot. If you receive an e-mail that you're excited about and you know you'll respond, send back a preresponse. Something like "Hey there, I just got this message, but I'm so happy you asked me to be a part of this! Let me get back with you tomorrow as it's 4 a.m. and I'm moving like a sloth. Here's my phone number and Skype!"—or something to that effect. It's always good to back up your projects on a list or on your phone so that you can always know what you agree to or might want to take on. I'm friends with the developer now, after much searching on Facebook, but I might have been unlucky!

Any horrible endings to a project which others could learn from?

As of yet, I have not had any horrible endings, but that's not to say I won't! I do have a couple examples, though. My friend flew out all the way to New Mexico from Vermont for a voice gig, and it turned out to be an audition, even when he'd asked many questions pertaining to the "job." He didn't get the audition and spent over $800 on the days he was there, for nothing. Another friend wrote 5 hours of music, and was continually promised payment, as it stated in her contract that she would be getting a flat rate. She was paid nothing as the project went on for another year without any progress on the game, and she was asked to rewrite many different times without a goal in sight.

Do your research on companies to make sure they're being truthful—you may want to jump at an opportunity as quickly as possible, but it's always a good idea to background check first, just so you know what you're getting into. Ask for a deadline, and make that deadline. If they can't hold up their end of the bargain, it's probably best to rethink your priorities.

How did you find your way into the games industry?

I went to the Game Developers Conference for the first time back in 2011, and I went to an Independent Games Festival panel. I had my iPad, my business cards, and my headphones with me. I began talking with the people next to me and they asked what I did, and I said

I wrote music (at the time, I hadn't written anything for any games and was extremely nervous). They listened and loved what they heard, and the person to my left asked if he could listen as well. He takes the headphones and after a couple minutes says, "This is really good." That person was Jeff Ashbrook (a shout-out to him for giving me the chance to write on *Trip Harrison: Origins!*) and from there I started making new connections and working with different people. Word of mouth spreads quickly!

Any other advice you'd like to share?

Be yourself. Might sound cheesy, but I am 100% pun-cracking, absent-minded, V8-chugging Elspeth, and people know me for who I am, not who I pretend to be. There is always room, no matter what anyone says, for development and different personalities and growth within the industry, and that's what makes me happiest to be here. I scraped together money for my first trip to California, and I know that if you have the determination and passion, you have this in the bag. Don't doubt yourself! Write that song, record that perfect sound, and make your demo reel! Go for the gold!

Industry Presence

If you plan on working in the video game industry for very long, you'll need to develop a presence. Some call it a "buzz" or "hype." Whatever you call it, it will build momentum toward your goal as a musician and will keep your name on everyone's lips. The day I got an e-mail from one of the industry's top game composers asking me who I was and "how come I've never heard of you before?" I knew I was doing something right.

Tommy Tallarico has a rock solid industry presence. His unbridled excitement about video games has gotten his name on more than 300 game titles; brought him a regular guest speaker gig at industry functions on all things audio; has gotten his face on weekly television as the host of *Electric Playground*, *Judgment Day*, and *Championship Gaming Series*; and has him as a consultant to many, many audio-related companies including DTS. Everyone knows Tommy Tallarico. This skilled showman made it his quest to become recognized, to have a presence and as the creator and host of *Video Games Live*, he's just getting started.

Another example of presence is George "The Fatman" Sanger. He's been creating audio for games since 1983 and has done well more than 250 games in his career, but most people know him as the guy who runs around in glittery "Nudie" cowboy outfits. That's his shtick and it works very well for him. He also acts as a consultant to many companies and goes one step further by awarding his "Fat Labs Certified" seal to game hardware which meets his demanding standards of audio excellence. Now that's presence.

There are many other lesser-known game composers and sound designers who have a presence—albeit at a lower, more subtle, volume. Look through any computer music or recording magazine for their interviews. Look around on the Web. Look at advertisements with their endorsements. Look for their bylines. They are everywhere, carving out their particular niche in the industry. There are plenty more to fill. The idea is to have your name out there, seen by your peers and prospective clients. They will definitely think you are doing something right if you are getting all this exposure, even if you are the one creating it all. It's nice having someone recognize your name even if they can't remember why. It gets your foot another step inside that door.

The author's music production company logo.

Mark Scholl's colorful banner.

Tom Salta's company logo.

Watson Wu's logo has given him celebrity-like status in the industry with his highly recognizable profile.

Aaron Walz's music logo.

Basic Marketing Tools

How you develop your presence is completely up to you. There are no rules to follow; creativity is your winning bet. Nothing beats your music on a hit game, though, followed up with a lot of industry press. You can ride the wave into several more games and keep the momentum. Most of us, though, aren't going to have the fortune of a blockbuster project the first time out. It's going to take some creative magic of our own to turn on the hype machine. But there are some basic marketing tools to add to your regimen to help make things happen.

Direct Marketing

Build a list of developer and publisher addresses and points of contact. Addresses can be found on the backs of game boxes and from their websites. Important connections are producers, creative directors, and audio directors—but at a minimum, have the human resources (HR) departments dialed in. Put together an information package—an introduction to you and your services—and start sending them out. Unless those in the industry know you exist, you are not going to get the gig. Tell them who you are, what you do, and how your services will make their lives easier.

Some say that sending out *anything* to a HR department is a grand waste of time. I agree to a point, but I've gotten calls from companies who say they

received my name from their HR office and want me to submit a bid. Most of them keep your information on file from 6 months to a year and forward it to producers when requested. Hey, you have to start somewhere.

Telephone Marketing

Pick up the phone and start calling around. Ask for the audio department or the person in the company in charge of buying outside content. The smaller the company, the better. Large companies tend to have roadblocks in place which can rarely be negotiated. The switchboard operators and receptionists are highly skilled at sensing salespeople and are usually under strict orders to stop them cold. If you run into this situation, explain that you are a game composer or sound designer and you wanted to let them know of your availability.

Knowing you're not an office supply guy with extra reams of paper or toner to unload helps break the ice. Unless you are the 20th composer to call that morning, you might get forwarded to a contact within the company. At worst, they'll patch you through to the dreaded HR department.

Another trick is to ask the name of the person who buys audio, say thank you, and call back a couple of days later asking specifically for them. If you get through, great! If not, ask for voice mail and speak your introduction. You can also ask for the person's e-mail and try an introduction that way. Don't be surprised if you don't hear from anyone right away, if at all. They may not need you for their current project, but might keep your name handy to bid on the next. Play the odds. Do this enough times and you'll succeed. Again, at worst, you've made your introductions, they know you exist, and all you have to worry about is following up every few months to keep your name fresh.

This method can be a little time consuming, of course. But there is nothing written that says you have to call everyone the first week. Spread it out over several months—breaking up the time investment into more manageable chunks. By chipping away at it slowly, you won't get overwhelmed and it won't seem like such a daunting task.

Tommy Tallarico Studios' logo says it all. It capitalizes on his name recognition and his music services.

Tools of the Trade

LENNIE MOORE
Composer

Most of my work involves live musicians so my studio is geared to allow me to compose and orchestrate quickly, mock-up demos for clients, record individual players as needed, feel comfortable working in the space for many hours and without any ear fatigue. Outside of booking a scoring stage when I need it, I can do any type of project here.

I like the gear to stay out of my way. I want the hardware to work with a high degree of stability and the software to not slow me down or get in the way of my creative flow.

Most-used equipment: Steadtler Mars Lumograph 2B pencils/combi white erasers, Royal PowerPoint electric pencil sharpener

Computers: Custom-built (by me)12-core Dual Xeon X5650 2.67 GHz CPU, 48 GB DDR3 1600 ECC SDRAM, multiple Seagate Hybrid 2 TB drives, breathes fire!

Audio interface: M-Audio ProFire 2626

Software: Cubase, Pro Tools, Wavelab, Ableton Live, Sibelius, Finale, Wwise, FMod Studio

Monitors: 5.1 Dynaudio Acoustics

VST instruments: Tons! 8dio, Spitfire, Project SAM, EastWest Quantum Leap Symphony Orchestra and Choirs

Effects plug-ins: SSL Duende Native, Nomad Factory Integral Bundle, Waves Platinum/ IR360, PSP Audioware

Keyboards: MIDI Controller Keyboard

Internet and E-Mail Marketing

This is by far the most bang for your buck and the easiest way to scope in on the people who make decisions. Case in point: For every 100 letters I mailed the old-fashioned way, I got roughly 10 responses. Seven were "We'll keep your information on file" letters and three were requests for a demo. If I was lucky, I'd have

one bid request out of that whole effort, but it was a lot of work for little reward mostly. Rarely did it lead to a job.

When I began e-mailing my introductions, the most astonishing thing happened. Out of 100 e-mails I sent, 25 responded. Twelve to fifteen of those requested a demo. Three to five of those requested a bid submission or speculative demo for a project. And out of 100 e-mails sent out, I ended up getting at least one if not two jobs. It was the exact same letter I had snail-mailed, but my targeting strategy was much more focused. Ah, success!

This particular method is fairly lengthy, but indeed a gift from the gods. Start building your e-mail address book with every contact you make. Visit developer websites and dig around for the right person. Send them an introduction. Personalize it as much as possible. You could save a lot of time by adding everyone to the same "to": line, but this will come across as impersonal when the recipients see they were just part of another mass e-mail. Try sending to one person at a time (or using a program which does this); put their name at the top of your letter and their company name somewhere in the text. Even if they are smart enough to see through your ploy, they will still appreciate the extra effort and perhaps you'll score a point. Make your letter succinct, to the point and leave the impression you mean business. Always invite them to follow up, request a demo, or call just to say hi.

Print Advertisements

Print advertisements can include a classified ad, a corner spot in a company newsletter, or a full-blown page ad in a national publication. It's undoubtedly the most expensive part of a marketing plan and not something to take lightly. A well-designed ad, strategically placed, can build your name recognition and get you a project or two. It will tell prospects you must be doing well to afford such exposure and will make them curious. Obviously, you must be successful to pay for such an attractive ad.

On the other hand, if your ad doesn't look professional or is buried deep within pages of other ads, you might as well just walk over to the toilet, throw in your money, and flush. I've had a few composers tell me they tried print ads and all were disappointed with the results. They also only ran their ad once. To gain exposure through print advertisement, you must continually bombard your target audience using multiple shots across their bow. Try running an ad every other month, several places in the same magazine or in multiple magazines in the same month. It will eventually bring some business in your door. Even those cheesy late-night commercials on TV run more than once. You'll usually see the same one over and over for a couple of weeks before it sticks in your mind. The same principle can be applied to print.

I don't recommend television or radio ads. They cost serious cash and don't necessarily focus on the business you cater to. Unless you could buy some time on a closed-circuit company broadcast, you are better off spending your money elsewhere. This type of broadcast media is ineffective for our purposes. I don't know of anyone who has ever used it.

Press Coverage

One medium I know everyone uses is the press. Nothing like having them do a little work for us for a change. Press coverage equals free advertising. You can issue a press release to your local newspapers and television stations highlighting a

recent milestone or to give them ideas for a special interest piece: "Local Composer Signed to Score Battlefield VIII," "Area Music Production House to Offer Sound Design," or "Local Musician Creates Music for Video Games." For your local market, it will give you a much-needed push to help establish yourself. And, if you plan it correctly, you can either saturate for some serious immediate coverage or draw it out over a period of time for continued lower-key publicity.

Large-city newspapers are very effective, as is mentioned in a game development magazine or website. It gives solid exposure within your immediate market and continues with our motto: *Tell everyone what you do.* Small "news bites," mentions, or quotes supporting related industry articles and interviews are great ways to get your name to the point of recognition with your potential clientele. You can build alliances with journalists, giving them leads on interesting stories and making yourself available as an expert when they need to verify facts. It's all part of the well-oiled marketing machine. Consider using it.

Write Relevant Industry Articles and Books

Are you technically astute and have a way with words? Like to write? Consider sharing your knowledge and expertise with the rest of the gaming industry in the form of magazine or "webzine" articles, blog, or a book as another form of marketing. Your byline is a powerful way to garnish some industry attention and start building a name for yourself. If you luck into a regular writing gig, you'll find folks start to look at you as an expert. It lends much credibility to your resume and keeps your name alive in a world where you are only as good as your last project.

The Game Developers Conference takes place yearly in San Francisco, California.

Presence at Industry Events

It's a great idea to be seen at industry events and trade shows. Everyone will see how seriously you take the game industry and that you are very much a part of it. With a high concentration of the *actual people* who make games, chances are very good that you will make valuable contacts which will last for many years. It's an opportunity for everyone to put a face with a name and will make you stand out when they start thinking of audio for their next project. While your music and sound effects in a game is your number 1 marketing tool, your personal attention and commitment in showing interest and being among your fellow game creationists at these functions runs a very close second. Get out there and press the flesh. Be seen.

Industry Events Worthy of Your Attendance

Game Developers Conference (GDC)	An industry insiders' event and gathering of game developers from around the world—showcasing the latest game development tools and hundreds of educational forums and discussion groups.	www.gdconf.com	March
GDC Next	An event focusing on creating the game experiences of the future bringing together the creators of tomorrow's biggest and most innovative video games.	www.gdcnext.com	November
GameSoundCon	As the name implies, game audio is the one and only subject of these gatherings. This growing conference varies by location and dates, giving anyone interested easy access.	www.gamesoundcon.com	Varies
Special Interest Group on Computer Graphics (SIGGRAPH)	Their annual international conference and exhibition focuses on computer graphics, animation, and other interactive techniques. A gathering of artists from around the globe. A very interesting look at how they do what they do.	www.siggraph.org	August
Project Bar-B-Q	An intense conference designed to influence music hardware and software over the following 5 years.	www.projectbarbq.com	October
Audio Engineering Society (AES) Convention	A gathering of audio professionals devoted exclusively to audio technology. Includes a game audio technical committee.	www.aes.org	Varies
Electronic Entertainment Expo (E3)	The world's premier trade show for computer and video games and related products focusing on marketing and sales support of games. A trade show like no other you must attend at least once in your life!	www.e3expo.com	June
ComicCon	A focus mainly on comics and anime, but games and game makers are also well represented. A great place to network and enjoy unbridled creativity.	www.comic-con.org	July

Word of Mouth

Another effective marketing tool is word of mouth. By amassing an army to spread the word on your behalf, you've affected a marketing machine which only gets

bigger and more effective over time. Beginning efforts with your family and friends will stir up some interest. But, the best way to do this is through previous clients.

People and companies you've done business with in the past carry tremendous weight. If you've worked around the industry for a while, your reputation will usually precede you no matter what you do to the contrary. Game developers talk. If you were hard to work with, overpriced, produced lousy music, or never delivered on time, that information will spread throughout your market faster than you could ever comprehend. You might as well pack up and move out. It is extremely important to work hard, be honest, deliver superior goods on time, and always go above and beyond what is asked of you. Always. If you do a good job at a fair price, people will remember. When producers get together, you never know when the subject of audio will come up. If I work with someone, I want them telling all their peers what a great job I did.

Use every meeting with potential clients as a chance to market yourself and your wares. Leave them with a positive impression and encourage them to pass on your name to others. Timing is often the key. If they can't use you now, maybe they know of someone who does or will remember you for later.

Other Resources for Marketing Success

There are many titles on bookstore shelves which cover the issues of marketing. None are geared specifically toward the game industry, but they are relevant just the same. Business is business and products are products no matter what line of work you are in. Here are a few books that will help you get your audio "product" in the face of the games business:

Money Making Marketing: Finding the People Who Need What You're Selling and Making Sure They Buy It, Jeffrey Lant Assocs, June 1995, Boston, MA	Dr. Jeffery Lant
Guerrilla Marketing, May 2007, Boston, MA, *Guerrilla Marketing Attack*, February 1989, Boston, MA, *Guerilla Marketing Weapons*, May 2013, Boston, MA, *Guerilla Marketing Excellence*, January 1993, Boston, MA, and several others, Houghton Mifflin, May 2007, Boston, MA	Jay Conrad Levinson
The Complete Idiot's Guide to Cold Calling, ALPHA Publishing, August 2004, Indianapolis, IN	Keith Rosen
Cashtracks: How to Make Money Scoring Soundtracks and Jingles, Cengage Learning, October 2005, Boston, MA	Jeffery P. Fischer

Where to Look for Clients

If you were a game company, where would you be? That's the question you need to ask yourself when you set out to gather information on prospective clients. And, actually, it's not as hard as you might imagine. Game developers are a fairly visible lot if you poke your nose in the right places. They are all over the planet and every game needs someone to do the music and sound effects. The trick is matching your services to their needs. You need to establish "who" they are and "what" their needs are first.

Internet

The Web is the ultimate source for information on computer games and the developers who make them. It is a veritable gold mine which can, literally, make you rich. Practically every game developer and game publisher has a presence on the Web and it's a great place to start. You can either search for every game company

yourself or use game development resource sites which have pages of game company listings, links to their websites, and contact information. Many game developers also post job openings on their sites, which can lead to solid contacts.

At the time of publication, the following websites cater to game developers and either include job openings or game developer listings for further exploration. Many also serve as a general forum for development topics and the latest news.

Selected Game Developer Website Listings and Job Research

Gamasutra	www.gamasutra.com
GameDev.Net	www.gamedev.net
Gamespot	www.gamespot.com
David Perry's Game Industry Map	www.gameindustrymap.com
GameDevMap	www.gamedevmap.com
IGN	www.ign.com
Game Jobs	www.gamejobs.com
Game Job Hunter	www.gamejobhunter.com

Industry Magazines and Books

Hit your local newsstands or the Internet for these monthly publications which cover a wide spectrum—from technical issues, to the big business side of things, to strategy and gameplay. Every one of these magazines is packed with game companies, either in the form of "help wanted" ads or Internet addresses. These will help to define who the developers are and give you an idea of the type of games they produce, rounding out your research files. It is important to determine which companies license game engines, create graphics, or contract out programming services. These are specialized companies who, more than likely, won't require audio and thus you won't need to waste time with them. Concentrate your efforts on the companies who make the end product.

Telephone Books

Don't overlook the obvious. If your market is a good-sized metropolis, the odds are decent that a game or software company is close by. Pick up the yellow pages or the business section of the white pages and look! Look under *Computer Software Publishers and Developers, Computer Multimedia, Software,* and the like for some leads and then pick up the phone. If they don't use audio in their work, perhaps they know of someone who does. Be sure to ask. Make every call count—letting people know your availability or initiating a lead to someone else. Get names, numbers, and e-mail addresses of the decision makers and follow up with information packages and demos. A phone call may be all it takes to get the ball rolling.

Store Shelves

Take a trip to the local software retailer with pen and paper in hand. Pick up game boxes, look on the back, and find the names of the developers and publishers who are making them. It may seem painfully apparent, but it's a great way to add names to the list when starting from scratch. After a while, you'll start to notice the trends and the leaders—a particular publisher who has his or her hands in many games and the ones who seem to dominate the market.

This is valuable information which will keep you up-to-date on the latest types of games out there and what types of music they might be looking for. An abundance of racing games equals high-energy techno or rock music. Medieval games use heavily orchestrated music. The trip to the store can be an important

TODD KINSLEY
Composer, Sound designer

I've been working full-time in games since 2007, both in-house and freelance. I've created audio for a variety of titles, including PC games, Web games, and mobile games. I've also created original music and sound design for 150-plus slot machine games (cabinet, web, and mobile), which included time working in-house for the largest slot game developer in the world: IGT (International Game Technology).

Notable titles I've worked on include

Battle Chess: Game of Kings by Interplay/Olde Skuul. This is a 2014 reboot of the legendary original *Battle Chess*.

Delaware St. John (1, 2, and 3) by Big Time Games. The DSJ series are retro point-and-click detective/horror adventure games that developed something of a cult following.

Elvira's Monster Match 'N' Stack by Big Time Games. Notable to me, because I got to edit voice-overs by the legendary scream-queen Elvira: Mistress of the Dark!

Blood Life—This slot machine game by IGT was one of the first to incorporate skill-based bonus games (including a physical joystick), making it one of the first hybrid slot machine/video games.

www.toddkinsley.com

Describe your thought process for creating music and/or sound effects

My thought process varies, but I typically think first in terms of musical genre. I've worked on a large number of slot machine games, and slot games consist of as many varied game themes as there are colors in a rainbow—a very wide rainbow. My first thought is typically something like, "What genre of music would most people associate with this kind of game theme?" If it is a game about a chipmunk cowboy, naturally my mind goes to an old-west cowboy movie musical theme. But then the fun is putting a twist on that established musical genre, by combining it with another. In the case of my chipmunk cowboy example, I might

combine cowboy music with a Looney Tunes-esque cartoon music twist, creating an original hybrid musical style–cartoon cowboy. This kind of music hybrid creation has come up a lot in my career. I've created Barnyard Hip Hop, Techno Cowboy, Leprechaun Punk, Cute Horror, that's where a lot of the fun is for me, putting a new twist on an established genre.

Are there any particular secrets to your creativity?

As is the case with most full-time audio professionals I know, nothing inspires creativity like a deadline. When I have "all the time in the world" to work on a project, sometimes I flounder a bit, but when there is a solid deadline, the creativity flows because of sheer force of will. Well, force of will *and* pizza. Creativity seldom flows on an empty stomach.

Are there any secret techniques that you regularly employ?

It's probably not much of a secret, but we live in an age where you can sit at your computer, do a quick Web search, and find examples of almost any kind of musical style that exists. It's simply amazing to have almost instant access to that much musical inspiration. I seek out existing examples of musical genres this way when starting most projects. It is typically the starting ground, from which I can grow my original hybrid genres. Stravinsky once said, "Good composers don't borrow, they steal." Personally, I don't steal music from other composers, but I definitely steal inspiration from them!

Do you have any interesting sound gathering/sound creation stories?

One of the first lessons a sound designer learns is that many sound effects in media (film, TV, games) do not sound like their real-world counterparts. For example, the sound of someone being punched in an action movie/game sounds far different from someone being punched in real life. Many techniques and physical materials are often involved to create a movie/game punch sound. Very early on in my career (or rather in my precareer) I did not understand this, so I attempted to record punching and slapping sounds the only way I knew how—by punching and slapping myself silly! I could not understand why my repeated attempts were not replicating the sounds I'd heard in movies and games my whole life. If only I had recorded a video of young me beating myself up in front of a microphone I could be an Internet video sensation!

Do you have any advice which can help lay solid groundwork and ensure a successful production for the audio content creator?

I have two pieces of advice. First, if you find yourself constantly turning track after track up in your mix, you're doing something wrong. Learn the art of subtractive EQ and subtractive mixing. The biggest mistake I hear from fledgling mixers is the desire to mix everything louder than everything else.

Second, during the mix stage I highly advise checking your mix against a preexisting professional mix in the genre in which you're composing. For example, if you're mixing a new rock song, compare and contrast your song against a track from a great-sounding rock band you respect. Oh, and don't use an MP3 or other compressed format track as your comparison! Mixing your track to sound like an MP3 is going to make it sound terrible if you actually convert it to an MP3 later on.

When do you find you are most creative?

Like many of my peers, I find I am most creative in the evening. However, the evening is also when I am presented with the most distractions and attractive alternatives to working (such

as the eternal siren's call to actually *play* video games). As such, I have learned to foster "creativity on a deadline" as I call it. I can summon creativity almost any time I need it, though I freely admit that it is much more difficult early in the morning especially if I was up playing games until 3 a.m. the night before.

Any worthwhile creative advice you'd like to share?

As a composer, you are not going to reinvent the wheel. You have to accept that anything you compose is ultimately going to be at least partially derivative of music that came before you. The key is to not spend all your time racking your brain trying to invent some completely new genre of music, but rather spend your time developing your own creative twist (voice) that you can add to (and express through) musical genres.

Is there a typical workday for you?

I tend to get a later start than my 9-to-5 friends and relatives. I have also been *slowly* working toward becoming a healthier person, so I typically start the day now with a long walk with my dog. Once the four-legged-love-of-my-life has been walked, I fire-up my system, and check my e-mail, to see if I have any new communication from my employers regarding projects. Typically by 10 to 11 a.m. I am in full-on audio creation mode, and I tend to stay that way until the work for the day is finished (including eating lunch at my workstation most days). If I'm lucky, I can usually stop somewhere in the 6 p.m., 7 p.m., or 8 p.m. range. If there is a pressing deadline with work left to do, I stay at it as long as needed. If the sun comes up before I go to bed, so be it.

What skills should composers have to succeed in the games industry?

Aside from the obvious (the ability to compose and produce good music), I think the ability to network is incredibly important. The top (and even middle) game audio jobs are not being posted online; they are being filled by composers who already know someone on the game team at the company in question. You will never see a job ad online that reads, Wanted: Composer to create music for the next *Halo* game (or *Call of Duty* or *Assassin's Creed* or *Final Fantasy* or virtually any currently popular AAA title). It just doesn't happen! You will occasionally see rare ads for junior-level positions (though typically for sound designers, not composers). If you want to work on mid-level games or higher, you need to build a network of friends and colleagues who work in video games. If you don't like to network, don't become a game composer. Actually, I don't really need to say that, because if you don't network, you *won't* become a successful game composer, regardless of your intention.

From your perspective as an Audio Manager, what advice can you give to composers and sound designers working in games?

After you pass the initial entry-level of skill, there comes a point where the differentiation in skill level between you and your competition becomes smaller. Nobody likes to admit it, but you reach a point where you and your competition have roughly the same amount of talent and skill in your profession (composition and/or sound design). Sure, there are a few rare exceptions, those to whom extreme talent seems to have been gifted to them by aliens. But in general, there comes a point where noticeable differences in ability seem to level off. At this point, things like your friendliness, reliability, passion, and professionalism start being the major deciding factors between who gets the work, and who doesn't. Being friendly, reliable, passionate, and professional is every bit as (and sometimes *more*) important than your skill level. Cultivate those personality traits, and they will serve you well.

Do you have a specific ideology which drives your way of doing business?

Whether you work freelance or in-house, it is important to get others excited about your work. By "others" I mean people beyond the audio team. Creating games is a team sport, but the audio end of things often gets overlooked and undervalued. It is up to YOU to get others excited about what Audio is doing. I believe that no one will assign appropriate value to you or what you do, unless you guide them.

Any good business advice to offer?

Whether you're freelance or in-house, I highly advise keeping a close eye on your taxes. Taxes shouldn't be something you only think about once a year. There are legal strategies to minimize your tax burden year-round. If you don't know what these are, read a book (or two), and maybe make an appointment with an accountant. You can literally save thousands of dollars a year by truly understanding your taxes.

How do you approach negotiations with a new client?

There are game audio pros out there who truly enjoy hunting for new work/jobs. I am not one of them. Some consider negotiating with a new client to be a thrilling game of cat and mouse. I see it more as a thrilling game of *Operation*, in which much-needed body parts are being ripped out of me against my will! OK, maybe it's not quite that bad, but I certainly can't say I enjoy it. Of course if you want to work on the game, at some point you have to have a negotiation with the client.

There is an old saying that says roughly, "When it comes to naming a price, the first person to talk loses." The client always has a budget in mind for the audio for the project. If you name a price first that is below the budget, you have effectively given away part of the income you could've made from the project. It is an old-school tactic, but if you can dance around giving the client an opening number long enough, they will almost always toss out a number. Once they do, you have at least some idea of the budget, and you can negotiate from there.

Just to be clear, this also applies to in-house audio people who are negotiating their initial salary. Always let the employer throw out the first number. In fact, it is even more important to in-house people, because once you set that original salary level, you are unlikely to see your salary increase significantly throughout your tenure at the company. Most annual raises are very minor.

Do you have any negotiation tips which work well for you?

Don't be afraid to stop talking during a negotiation. By nature, most people dislike voids of silence during a conversation, and will say almost anything to fill them. Don't be afraid to take a significant pause, and see what kind of information the client might volunteer.

Do you have any contract stories which others could learn from?

My contract stories (with a lesson) are rather typical, and basically involve me agreeing to do a project for a certain price, then finding out later that the initial budget was set much higher than I bid. *Sigh.*

Do you have any tips when working with developers?

You really need to realize that there is more to a game than audio. You need to think about how your piece of the game (audio) fits into the greater whole. You also need to realize that the

personnel from other departments are often just as passionate about their piece of the game as you are about the audio. Work with them to find ways to make working with audio easier for them. Use audio to enhance their parts of the game, and they'll love you for it. Be flexible when it comes to audio changes that occur due to disciplines outside of audio. It is truly not an "Us versus Them" situation. In the end, there is one team, and everyone who is working on the game is on it. Help make the game as a whole the best it can be.

What advice can you give when working with a developer which has ensured a good working relationship and a good final product?

Regardless of if you're in-house or remote, one of the best pieces of advice I can give is to respond promptly to communication. If you receive an e-mail with questions in it, reply. If you receive a text or a Skype message, reply in a timely manner. Managers typically have a lot of people to manage, so don't make them hunt you down for answers. It is very easy to hide away in our studios, concentrating on our "art," but you don't want to emerge from your creative cocoon to find that the company has moved on without you.

Have you ever had any development issues negatively influence your workflow?

Everyone who works on games has had development issues negatively influence their work-flow at one time or another. Miscommunication is most often the source, although some-times it's something completely out of your control (such as management deciding to go a completely different direction with a game, after several months work). You really just need to roll with the punches.

Staying organized is important, especially if you are working on multiple projects, which is part of your daily routine. How do you keep up with it?

To me, one of the most helpful things is to have a standard procedure with regards to creating folders (on my computer) for projects. Over the years, I've developed a folder structure that I know well, and try to use on every project. Every game gets a standard set of folders and subfolders, and I know generally what files go into each. This makes it much easier for me to stay organized.

Any specific 'lessons learned' on a project which you could share?

Early on I remember trying to do a significant upgrade to my audio software in the middle of a project. Of course the upgrade wasn't compatible with my operating system. Unfortunately, I didn't have the discs immediately handy to reinstall my former system. Needless to say, I lost a lot of time. I learned to never update your system in the middle of your project—just don't do it!

There are many pitfalls when 'working' in the game industry. Have you had any bad experiences?

In the game business we're always preaching about how important networking is, and how having friends across the industry is one of the keys to a long term career. This is typically very true. However, I once experienced a situation where a friend helped me secure a new job at his company, and then later there was a large shake-up that involved the company firing him, and possibly filing criminal charges against that same friend. Suddenly my association with my friend went from being a major asset, to being a liability. I had absolutely nothing to do with the supposed questionable activities of which my friend was being accused, but because of my close association with him, I too found myself under extra scrutiny for a while.

Any horrible endings to a project which others could learn from?

Personally I think the worst end to a project is when you work long and hard on a game, and then for whatever reason that game does not get released to the public. It happens to virtually everyone who works in games, but that doesn't make it any easier when it happens to you.

How did you find your way into the games industry?

Prior to my work in games, I had a career as a sound designer and composer for live theater. I also spent time as an audio mix engineer on cruise ships mixing live shows. It's kind of funny, I had loved and played games my whole life, but it had never once occurred to me that someone actually got paid to make the audio for games. Somehow i ran across an employment ad on the Internet seeking a sound designer for the game. The entire concept completely fascinated me. It fascinated me so much, that I kind of became obsessed with it. I actually left my job, and moved in with one of my brothers to save on expenses. I got a part-time job to pay my bills, and spent the majority of my free time researching game audio. This is what led me to the first edition of *The Complete Guide to Game Audio*.

People are going to think Aaron is lining my pockets with silver here, but the truth is the truth, that book changed my life. It was my introduction to the world of game audio. Following what I learned in the book, I started making game demos (essentially making audio for games that didn't exist). Then I started meeting unpaid "game development teams" on the Internet, and started making audio for those games. None of those free projects ever reached the release phase. After a while, I landed a few low-paying freelance contracts for indie games.

The way I landed my first true full-time, in-house job is actually quite a boring story. I basically saw a job ad on the Internet and applied. Fortunately, I had the demos from my indie and unpaid game work to use in support of my application. Those demos are what got me the job. If it wasn't for the combination of my brother Scott allowing me to stay with him, and Aaron's book, I don't know that I would've ever found my way into games as a career.

Any other advice you'd like to share?

Be excellent to each other. That, and back up your data every day.

fact-finding tour. It's something you'll do on a regular basis even after you've been composing for a while to remain current on things.

Keep in mind when browsing through the retail aisles, that it is usually the major game companies that can command shelf space. Retailers are only interested in moving product and aren't interested in having an obscure game take up space for the one or two individuals who might buy it. High-volume games are the money makers. Take a look in several different retail outlets and smaller software and "game-only" stores for a broader offering.

Game Developer Headhunters

While hot in pursuit of clients or an in-house job, you might also consider contacting companies who have made a living out of filling vacancies at software and game development firms. These people are extremely connected to the business, earning wages by matching talent to the job and usually having all the latest gossip about what might be happening inside the companies' walls. They normally cater to programming and graphic artist positions but may keep an eye out on

your behalf if you ask nicely. They literally live and die by the effectiveness of their networks and are always anxious for any leads.

I once offered a small upstart game company to a headhunter (I asked permission first, of course), mentioning they were looking for an artist. In turn, I was rewarded with several names and numbers of local game producers. They understood my needs and were able to share solid contacts. Because you are out there every day looking for your prize, circulating some of that golden information with the right people could open some doors. Of course, always ask permission from the company before you unleash a headhunter on them—and never share privileged information or articles covered by a nondisclosure agreement. You can find these companies after a brief Internet search or in a phone book under *Employment Services* or *Recruitment*. Digital Artist Management, Game Recruiter, and Mary-Margaret are popular ones specializing in the games industry.

Networking

Starting from day 1, every person you come across has the potential to lead to a paying contract—whether they are a programmer, play tester, artist, producer, receptionist, or even the janitor. Other game composers and sound designers, although considered as competition, can be part of your network and lead to some work as well. By cultivating continued friendly relationships you'll be privy to information on jobs and companies those on the "outside" do not have.

Word of a game developer adding bodies could mean they are staffing a new project, hearing that a developer and a sound contractor are at odds, or knowing an in-house composer is preparing to make a leap into film scoring can all put you in the perfect opportune place. There is even the possibility for some subcontracting or overflow work being tossed your way from other composers. We all have to take vacations some time and are in a perfect spot to cover for our peers on short-term projects. Keep your eyes and ears open and make yourself available. The last place I ever expected to get a job from was my competition, but it's happened enough now that I'll believe anything.

Nextdoor Neighbors

It may seem like scraping the bottom of the barrel, but I'm guessing, unless you live far from civilization, within a block of your humble domicile, you can find some audio work. There are so many jobs which deal with *computers*, *software*, and games out there that several of your neighbors might work in the industry or have close connections to those who do. In my own little block of suburbia, I've

- Scored and designed sound effects for one CD-ROM game
- Created sound effects for two websites and music for one Flash presentation
- Edited music for several ice skating competitions
- Engineered the final mixdown on three CD projects
- Mastered and duplicated an album for a band from Mexico City
- Recorded and edited narration for a massive multimedia presentation

All of these came through contact with just my neighbors! Imagine what I could accomplish if I went out two blocks! Word spreads quickly when people know there is a recording studio in the neighborhood. You'll be their first stop, since the sense of community will make your services that much more attractive. You live in their neighborhood, so you must be okay.

You might get the occasional off-the-wall request from time to time—a house-wife wanting to sing and record her favorite song as an anniversary present, a teenager wanting to get a recording of his guitar prowess as a demo or some music "without the vocals" for the elementary school talent show. But that's what makes it fun. Perhaps the money comes after the husband hears the CD and wants to hire you for a corporate training video he's in charge of filming or when the teenager gets hired by a well-funded band and they want you to produce their next blockbuster album. Or when a parent in the audience at the talent show happens to be producing a video game and wants you to do the score! You just never know. Never discount the contacts you can make in your neighborhood.

Finding Your Niche

Creating music and sound effects for video games is like any other business practice. Much time is spent studying the layout, determining client needs, and developing a strategy to get your product in their door. If you have grand intentions, the focus will be only on the largest game publishers and the big moneymaking game titles. If you are being more realistic, smaller developers, upstarts, and multimedia companies would be the better place to start. Either way, the direction your business is geared toward has to fit in with and deliver the product no one else could do previously. In other words, you need to find your place in life—your niche.

Looking back, it took 4 years to find mine. Original plans for local TV and radio support gave way to a couple of small game developers. Those led to a couple of upstart companies who were keeping an eye on their cash outlay. Since I already had another full-time job paying the bills, I could keep my costs low and appeal to their budget. For about 2 years, most of the projects I did were for small upstart companies. That was my niche. As my experience grew, my efforts leaned toward the medium-size companies. Lately, as the medium-size developers are getting larger or swallowed up by the big fish, I've stumbled upon good fortune and a new niche. My low fees used to be where I drew the most attraction. Now it seems to be my "style" and work ethic. I'm still in search of the "highest paid game composer" niche, though. Hope to see you there someday.

Stay Educated

Information is the key to finding your place in the game industry. Games are a multi-billion-dollar a year affair, and there are tons of data available to those who want it. Keep your eyes and ears open. Read, investigate, research, talk to other industry players, stay educated. The more you know about what is going on around this business, the better. It may seem a bit like what investors continually do; that is, following the trends or trying to stay one step ahead of them. You are out to do the same thing, but investing your talent and time instead. It can pay off equally as well. By following the ebb and tide of the gaming industry, your niche will be whatever you make it.

Example: Gaming platforms come and go. Suppose you decide it's time to become licensed for the Nintendo Wii system. You go through the process, pay your money, and add it to your company's services. You're all set. Funny thing, though, Nintendo's *new* platform is released and developers stop producing Wii titles and begin work on the new Wii U titles. Now where does that put you? That's what I'm talking about when I say "stay informed."

Start Small

For the composers and sound designers who are ready to cut their teeth and learn something about the industry, my advice is: Start small and work up. Unless you happen to luck into a hit game out of the chute, no one from the larger game companies will ever consider you unless your experience can guarantee them a trouble-free production cycle. It helps to have a project or two on the resume.

As mentioned previously, your initial focus should be on small game developers, small Web design firms, and small software companies. Look for production teams which consist of one to five members only; the smaller the better. Look for the guy working out of his spare bedroom trying to be the programmer, artist, designer, producer, et al. He's the one who is so overwhelmed, he'd be happy to place some of the burden on you and would tolerate your inexperience for the relief it brings. He may be able to teach you more than you could learn on your own, proving invaluable in your career to come. Obviously, the small developer will be working to keep costs down and you should be able to offer savings for the chance to put a project on your resume. Don't work for free, of course, but work out an amicable agreement where you take less on the front side out of the production budget and more on the back side out of the product's returns.

The initial niche you can fill is lower costs. What you lack in experience, you more than make up for with savings to them. Their willingness to spend more time holding your hand through the process indicates their need to save some cash. If you were to charge full price for your services up front, the likelihood that the game would ever see the light of day is slim. And, as your first game project, you may have some income but won't have a product on the market to show for it—leaving you basically right where you started. The key is to use this as a stepping stone to the next level, which will naturally bring in more income as you progress.

Therefore, use this first game with the small developer as a learning experience. Learn your craft, make mistakes when it isn't as critical. These small developers will tolerate your learning curve for the chance to make their game a reality. It makes better sense to have someone concentrate on making the audio content perfect rather than an overworked programmer adding in bland stock sound effects between naps.

After you've had experience with a couple of smaller projects like these, you'll be ready to start approaching the medium-size developers. It's an extremely fluid venture—moving from one role to the next, defining your place among the other developers of games.

Start Locally

By now, your list of prospective clients is sure to include several companies which are fairly local. These need to be your first targets, so get out there and show your face. If you do it right, every local game and multimedia house will know you are available to help on their projects. Eventually, you'll be expanding your scope until full global coverage is attained. Most of the time it is not necessary to meet with clients face to face, nor is it cost effective.

Game producers understand that while they may be in San Francisco, their perfect person for the audio job could live in Florida or Germany or New Zealand. With the advent of broadband Internet connections and overnight package delivery, audio delivery is not a concern. But your experience level is. Until you've put your name on a couple of game projects, expect a developer to keep a tight rein. And they cannot do that unless you are local. So, for the first

couple of projects, expect a bit more face time with the producers until they know you can handle the job. With experience, expand out of your local area.

Getting the Break

The first question any developer or publisher will ask is: "What games have you worked on?" Your answer will determine what happens next. Whatever you do, don't succumb to the urge to fib—thinking you'll get away with it. The first time you do, your credibility will be shot full of holes. Everyone knows everyone in the game industry. While it is actually quite large, enough people move from company to company that at some point, everyone used to work together. A quick phone call to the producer who did the game you claim you worked on will not corroborate your story.

So what do you say? Before I got my first game gig, I didn't have a clue either. It actually took a couple months to figure it out. When someone asks what games you've worked on, and assuming you actually have none to your credit, your answer will be "None." Then when they've cast you aside and looked away, hit them over the head with: "But I've been composing music for the last 10 years, play keys, guitar, bass, and drums. I've also engineered and produced three local band CD releases, one of which is the band I actively play in."

"I've done local radio and television spots and just recently completed a 5-minute public service announcement which won a regional award for the score." Et cetera, et cetera. "While I've never actually worked on a video game, I am expert on all things musical and can, without a doubt, compose the perfect music for your game. Here is my demo reel, which highlights the various styles I am proficient in—including one which I think will suit this game quite well. If you'd just give me a shot, I will give this project my full attention and strive to exceed your expectations. So, what do you think?"

See where I'm going with this? No, you haven't worked on a video game—but, yes, you are an experienced composer and can do the job. What you are looking for is that first break. Once you get it, you must, at all costs, give them your complete and undivided attention. Kiss their butts, if you will.

> You want to ensure they never find a moment to regret hiring you. Make the music great, beat their deadlines, go all out to make the audio shine, and above all, exceed their expectations. Always do more than asked.

Your work on the first game will set the tone for the next and give you a reference who will enjoy bragging about how great you are. There's no better advertisement than that!

Networking Basics

As I discussed earlier, the ability to network goes hand in hand with your marketing crusade—to connect with others in your profession with whom you can trade favors, gossip, rumors, hunches, and maybe a job lead or two. You can trade techniques, equipment recommendations, stories, studio time, or just friendly advice with someone who has been out there making it happen and is eager and excited to share their wealth of knowledge. I'm not talking about going out and making a nuisance of yourself, pestering hardworking individuals with a barrage of questions that could take a book to answer. Come to think of it, that's pretty much how I started on this project—but I digress. The point is, your goal is to

Tools of the Trade

KEITH AREM
Director, Composer, Sound designer, President (PCB Productions)

Our facilities are designed to accommodate all aspects of production, from tracking and recording to designing and mixing. Each studio is matched, allowing engineers and projects seamlessly to move between rooms.

You should be able to operate and navigate your equipment immediately, without the constant need of a manual. Good interface design and ease-of-use will make your equipment become a more dependable tool in the long term. If your gear requires you to constantly read the manual, or dig too far into menus, it becomes slow and unmanageable, especially in 4 a.m. sessions when you're trying to get a creative idea out.

Computers: Mac Pro 12-Core Xeon E5

Audio interface/software/multi-track system: ProTools 11, Sound Forge, Avid/Digidesign Icon

Monitors: M&K

Microphones: Gefell, Neumann, Sennheiser, Schoepps, Rode

Remote recording gear: Sound Devices

Other relevant instruments/equipment/hardware/software: We created a proprietary recording process and technology called "VOCAP" to allow talent to perform together, capturing realistic, natural performances, and allowing actors to *re-act* to each other.

become a respected member of the industry whom your peers can associate with in a friendly, professional manner. This is no place for a star struck fan to stalk their favorite game composer.

Your network should have value. For the games business, the obvious choices are producers, artists, programmers, composers, and sound designers. But, also consider contacts further out on the fringe. Try contract lawyers, accountants, other businessmen, and entrepreneurs. Other working musicians, engineers, and producers in the music industry are equally important—as are sound designers and composers who work in television and film. You can learn a lot from others who specialize in these fields and additionally, as part of your network, they can answer any question you may have, any problem that arises, with a quick phone call or e-mail. Alliances with journalists, TV reporters, and editors will also expand your public relations possibilities. Networks can be practically endless. It will take a few years to build, but before you know it, you'll be a part of others' networks as well.

4. Finding and Getting the Jobs

The ultimate goal of your network is to make it yet another way to stay connected to your livelihood. Networking goes hand in hand with our marketing efforts and will pay off in the end, with income or lifelong friendships.

Industry Functions

Not only will your appearances at GDC, E3, SIGGRAPH, or ComicCon keep your face in front of past and future clients, it is also another way to stay in touch with your networking buddies. I've witnessed several happy reunions that result from people literally bumping into each other on a crowded expo floor. In our busy lives, we can sometimes let correspondence go—but these shows are a perfect way to stay in touch. Everyone is out of their studios and offices with an open agenda. It's a great time to catch a few uninterrupted minutes, say hi, and see how everything is going.

Make Yourself Available, Make Yourself Known

Building a solid network is almost as complicated as marketing yourself to prospective clients, but the same basic principles apply. Review the basic marketing steps posed earlier in this chapter but insert *composer* and *sound designer* everywhere you see *prospective client*. Same idea, but with a different purpose. Obviously, others need to know you exist and accept you as a peer. Beyond that, you need to make sure you are available to meet with them on their turf as the opportunities present themselves. I'm always curious how other game audio folks do what they do and anxious to see their setups in person. It's easy to get submerged in other tasks, but I always try to schedule time to spend an afternoon with peers. You will learn a lot just seeing how the other half lives, what their working spaces look like, and listening to their ideas and visions. You have to make time. It's that important.

As your network gains in stature, consider hosting get-togethers with as many people as you can cram into your domicile at one time. Nothing fancy, just pick a convenient time and start inviting. The idea is to get people together of like minds and interests and watch what happens. I've been to a few, dropping whatever I was up to at the time for the chance to mingle with some really neat people. Most others will do the same, thanking you several times for the chance to socialize and exchange ideas with their peers. Don't forget to invite me.

Game developers, producers, programmers, artists, and audio folks out of their caves and into the light at the annual Game Developers Conference.

5

The Bidding Process

How Much Do You Charge?

Game sound designers and music composers are constantly bombarded by this question. Our first instinct is to answer back, "How much do you have?" or my personal favorite, "For projects I know nothing about, my standard fee is one million dollars." Though we never actually say it out loud, underneath our happy-go-lucky artistic exterior, the businessperson inside is thinking it. A list of questions and pertinent details immediately comes to mind to make a competitive quote.

So, we estimate a figure. Based on what? We're not sure, but the question was asked, and we aim to please. Then, one of two things happens. We get the contract, or we don't. And if you're just throwing around price quotes with no idea of what you are bidding on, it's usually the latter. The producer or media buyer is asking a sensible question—doing their best to obtain the finest media for the project and keep it within budget, but it is not always an easy task. Unfortunately, leaving out the particulars will cost them more time, more money, and many more headaches. You should take it upon yourself to solve this potential predicament.

Effective communication between producers and sound artists from the earliest stages can bring invaluable teamwork and the exchange of ideas. Producers who have a solid idea of the information needed by sound creators, our thought process and the guidelines we follow to deliver the perfect quote are effective asset managers who cultivate success. Sound artists utilizing standardized guidelines to determine their fees, options for payment, and winning bid procedures would bring it home.

Let's Play Twenty Questions

- "We are constructing a large multiplayer strategy game and in need of soundtrack help. I can't say much beyond that. What are your prices?"
- "Take a look at the game on our web site. We are rethinking the sound effects. Quote us a price and remember, we don't have a money tree, more like a money weed."
- "Can you duplicate sounds? We have copyrighted sound that we need changed slightly, but not much. Let us know a cost."
- "Can you give me an idea of the costs of SFX?"
- "Please send a demo and tell us how much you charge."

These are *actual* quotes from inquiries I've received over the years. The questions are well founded, just slightly vague on pertinent details, so nebulous in fact that I have to fire off a barrage of questions in return, such as

- "A full orchestral or single-note MIDI score?"
- "*Star Wars*–quality sound effects or modest everyday sounds?"
- "Next-gen console or cell phone?"

Suddenly, the fog begins to clear. The sound guy isn't making this stuff up and actually has some solid points.

Details, Details, Details

From the beginning, the more information provided the better. Having all of the details up front can streamline the process and cut costs for the developer instead of going back and forth with questions and answers. Not only can we as sound experts anticipate potential problems but solve them well before they get out of control. If the project calls for a score, sound effects, and narration, it's a great idea the sound creator knows about it! As a full-service production facility with experience directing various musical and voice talent, you could handle the project for less than three different audio contractors. Then again, maybe not. My preference is to have these out in the open first.

I am also fond of the "6 Ps" (Prior Planning Prevents Piss Poor Performance) when running my production company. Deadlines are manageable when you can plan ahead. An established set of reasonable milestones is a must. Just as the developer has planned ahead, so must the sound artist. We map out our production schedule based on theirs and budget our logistics accordingly. The game developer has a hard time getting artists and programmers together on a project, so likewise they need to understand our plight of getting a bunch of musicians to show up on time and ready to play. We need time to plan and time for the unforeseen. Fickle musicians and their unpredictable gear doth not a successful project make! For the busier sound folks, we may have other concurrent projects and need to determine if there is time in our production schedules to take on another.

Asking the Right Questions

Exactly what does the organized musician or sound designer need to determine if they can perform the service and produce a competitive bid? This list of questions should definitely have answers prior to your final submission.

AARON WALZ
Composer, Sound designer

Aaron M. Walz is a composer and sound designer for mobile, social, AAA, and casual games with a BA in Music. He runs Walz Music & Sound, is a cofounder and managing partner of the Game Audio Alliance, LLC, and is a long-term on-site contractor at Kabam, where he works on titles like *Heroes of Camelot*, *Dragons of Atlantis*, and *Wartune*. He wrote the theme song for *Ravenwood Fair* (John Romero), is the composer of the RPG series *Aveyond*, and produced voice-overs and music for Cherry Credits' regional releases of *Dragon Nest* and *SD Gundam Capsule Fighter*. In addition to audio creation, Aaron is also experienced with implementation and middleware.

Aaron has received several awards for his work including "Best Game" at Microsoft's Independent Games Festival (for *Hardwood Hearts*) and Game Tunnel's "Best Sound" for *Aveyond*. *Ravenwood Fair* was also nominated for Best Audio at the GDC Online Awards.

Aaron sings and records with several projects and performs with the Golden Gate Men's Chorus, where he serves on the Board of Directors as the Marketing Chair. Aaron strives to create music for media that stands alone as a worthy contribution to art. He is the audio speaker content adviser of the Casual Connect game conference for the Casual Game Association. His biggest influences are the great Japanese game composers. He also enjoys tennis, bowling, cooking, and wine tasting.

www.walzmusic.com

www.gameaudioalliance.com

Describe your thought process for creating music and/or sound effects.

After having a meeting with the client to go over the design doc as it pertains to audio, artwork, animations, vision, lists, story, etc., I often relate the game to games I've played or music

and sound that I've heard and enjoyed. I'm a lifelong gamer. I then have a few ideas right off the bat (sometimes crazy ones) and limit my scope to those at first. I then create limitations around certain timbres, spaces, moods, genres, and instrumentation. I try to create something artistic and unique that stands alone as pleasant and interesting out of the game. I prefer doing almost all sound design in my DAW, so I can apply universal effects, play any music or ambients, all nondestructively. It also becomes easier to sync to gameplay footage and animations, thus saving time.

Are there any particular secrets to your creativity?

Being a happy, rested person. Following my passion. Being open-minded and challenging myself and learning new things all the time. Writing things down so that I won't forget ideas. Playing lots of games all through my life. Coffee. Alcohol. Stretch breaks and ear rest. Mental health days.

Are there any secret techniques that you regularly employ?

I often make up words to instrumental songs. This gives me a rhythmic backbone and structure immediately. The words are never known to the client or players, but I can sing along to them in the game, helpful if you need catchy themes or a melody isn't coming otherwise. I also limit and structure myself around theoretical constructs such as 12 tone rows and retrograde, etc.

Do you have any interesting sound gathering/sound creation stories?

I love crickets. One of my fondest memories of my late father was being on his shoulders as a child listening to them in the backyard. One night, I was sleeping over at a friend's house and happened to be coming from a session earlier that day. I took out all my gear in the middle of the night and recorded the backyard chirps, and went back inside to not disturb the insects. However, when listening back, I noticed there were several animals checking out the mic I left there and making the creepiest sounds you have ever heard for a few minutes! Great material though. Any zoologists out there?

Do you have any advice which can help lay solid groundwork and ensure a successful production for the audio content creator?

Don't assume. Ask lots of questions. Don't waste time. The customer is always right, but at the same time, you are the expert. Oh, never be late. Under-promise and over-deliver, but not too many options as to be unclear or uncommitted.

Do you have any interesting sound design creation techniques which affect the type of sounds you create?

A lot of sounds I need to make for games I work on are magical. I try to stay very orchestral and acoustic with these. It includes using pitched and nonpitched instruments in a unique way. The line between sci-fi and magic is a tricky one. I stay acoustic and apply effects. Pitched percussion is especially useful. I layer a lot, kind of haphazard so as to make happy mistakes.

When do you find you are most creative?

I'm really not a morning person. I'm good at remedial tasks until about 11 a.m. So, I do a lot of admin in the morning. I prefer being creative a few hours after lunch and late at night. But I've had to learn to be creative all the time, and it was easier than I thought. I get very creative and productive from 8 p.m. to midnight. When a deadline is coming, I get really creative. Without milestones, it is hard to harness full creativity.

Any worthwhile creative advice you'd like to share?

Learn music theory. Force yourself to write according to counterpoint rules, etc., at least in orchestral genres and as a starting place. Try all sorts of limitations. You will create things you would otherwise never create. For example, only write a piece using certain interval leaps, in a strange meter, or a scale you never use.

Is there a typical workday for you?

If all is flowing well, I would write a 1-minute piece of music. Or, record and mixdown about 100 to 200 lines of voice-over. Or design about 20 sound effects. Or some combination. Plus, I engage in social media, e-mails, client meetings, other creative things like working on my sound effects library, marketing, and outreach. If I have time, practicing singing and playing the piano. This kind of day is full and fulfilling. Oh, and sending invoices! That's really fulfilling.

What skills should composers have to succeed in the games industry?

First, I don't know many people who succeed only as composers. Learn to do everything well in the game audio business. Secondly, learn to be flexible and versatile in styles, even if you have strengths in certain areas. Organization and people skills will go a long way. But as a composer, theory and ear training are a must, as well as exposure to many styles and playing games. If you are a contractor, shed your paycheck mentality quickly. You earn what you work for.

Do you have a specific ideology which drives your way of doing business?

I'm so glad you asked this question. Yes. I strive to create music and sound that stands alone as art outside of the game. I've operated this way for years. Raise that bar! And elevate audio understanding, appreciation, and awareness in the industry. This is how I run all my panels at Casual Connect Game Conference, where I'm the audio content advisor.

Any good business advice to offer?

Take credit for what you've done. Sell yourself in a lovable way. Game developers won't give you credit in their games, so keep track and toot your horn and share your achievements and what you do to everyone you know. Know a lawyer and an accountant as friends for affordable advice. Create a niche and a story for yourself. Don't give up. If you want to do it, and you work hard and adapt and wait, you will get there. Success is a line. But don't cut, please.

Any horror stories which have impacted how you do business?

Make sure you establish a contract or statement of work immediately. I've been burned terribly before and wasted time and effort. And had someone cancel a project and require a very large refund I wasn't expecting to return at that time. That was certainly a low point.

How do you approach negotiations with a new client?

Clearly, but with a simple, business-casual vibe. No one wants to get bogged down in legality, but it's crucial that you have this discussion and make your needs and expectations known. It helps to have all your own contracts, but be open to using and modifying theirs. Aaron Marks has some great ones in his book. Use and adapt them! I don't do any work until things are in place, and usually an upfront payment is delivered.

Do you have any negotiation tips which work well for you?

I include revisions and meetings, to a certain extent. Also, remember to make it about them and their product. For indies, offer a nonexclusive option. Also play around with payment milestones. Royalties are for the birds at this point, I believe.

Do you have any contract stories which others could learn from?

I used to call my initial 50% upfront payment a deposit in the contract. All I'm going to say is never ever use that word. Ever.

Do you have any tips when working with developers?

Remember you are the expert, but don't be a know-it-all jerk either. The middle ground is the magic. Never assume anything. Be clear and respectful. Don't use big musical words like cadence and subdominant. Care about their project and understand it is their baby. Be the best babysitter ever.

What advice can you give when working with a developer which has ensured a good working relationship and a good final product?

When a developer ensures a good final product and a good relationship, just enjoy it and work at your highest ability. Stay open and collaborate. It is always a dream when I work with John Romero, because he knows just what he wants, but is also open to my interpretations. Stay clear and open. Handle your own frustration. Ask for what you're worth. If you feel ripped off, you won't do a good job. I also advise delivering things in batches and having rules about how feedback is handled, to stay orderly. And make sure you can test the sound in the game before release.

What advice can you give when working with a developer to ensure you are able to make great sounds?

Make sure you have access to a build and/or all animations. Be prepared to capture video yourself, but don't be afraid to ask for videos. I really like syncing to animations, arranging all the SFX that way in a realistic game-ready way, and then layering the background music over the sounds, to make sure everything sounds good and clear together. Don't deliver the SFX separately to listen to if you can help it; combine it with music, the way it will be in game.

Have you ever had any development issues negatively influence your workflow?

Lord yes. When the whole studio staff critiques your sounds, and they all offer contrasting feedback and then wait for you to defend yourself. Does the artist want my uneducated visual feedback? Or maybe I'll take a stab at the storyboard. Also, developers sometimes backpedal. I learned to keep separate DAW files of every revision I do.

Do you have any advice to ensure successful audio implementation?

A hot button for me. Learn about Unity, Fabric, FMOD, etc. Don't be afraid to suggest methods of implementation based on what you know is possible for the developer. It's really hard to win any awards for audio via the "throw over the fence and pray" mentality. Get involved and be knowledgeable. Implementation is half the battle. Test the sounds in the game! Make sure everything is in sync and tune, and in the same space.

Staying organized is important, especially if you are working on multiple projects, which is part of your daily routine. How do you keep up with it?

Google Docs. Dropbox. Google Calendar. I could not survive without these tools to organize my time, life, files, priorities, and workload. Stay productive in a consistent way, and you'll be a lot happier, and thus work better as well. I keep everything online after a project for easy access. I also hire some people to take care of things that eat up my time.

Any specific 'lessons learned' on a project which you could share?

One of the first major voice-over projects I did, the developer kept changing the script, during and even after our sessions. I learned that I have to carefully set expectations and timing around this. At the end of the day, my name was on it, and the voices did not always match the text displayed, which makes us both look bad.

There are many pitfalls when 'working' in the game industry. Have you had any bad experiences?

Be really careful about sending rough drafts and sketches. Some developers will not understand unpolished versions of things or be able to imagine the finished product based on sketches. They can be useful, but have made me lost gigs.

Do you have any development stories which served as a good lesson learned or something which can be avoidable in future projects?

One of my biggest horror stories was working for a major developer on a major IP sequel, and losing the contract. Why? Because I phrased things wrong. They requested many changes in direction, and I explained I had to charge more for this. Since this wasn't established at the start, it made them angry. Make sure to be very clear with your statements of work at the start. If I had charged more at the beginning or established an hourly rate, it might have been better digested than "I have to charge twice now."

Any horrible endings to a project which others could learn from?

I did a handful of Foley recordings and composition for a client I had wooed for a long time, thinking we were close enough to begin without the contract in place. Bad idea. They hired someone else and stopped speaking to me out of embarrassment.

How did you find your way into the games industry?

I wanted to do what I do by the time I was 10 and taking piano lessons—playing Nintendo, all the while learning game tunes by ear. I created a game music website in college where I sequenced tunes via MIDI, and included others' work as well. I started to include my original songs, and an indie developer hired me to do a game that ended up being a hit. I started speaking at Casual Connect Game Conference and met my business partners, including Greg Rahn, of Broderbund fame and currently Kabam's audio director.

Any other advice you'd like to share?

Get to know and get along with everyone, regardless of position and company. People move around a lot in this industry, and they will remember you for better or worse. Always hone your skills and perform in some sort of ensemble or as a soloist, so you're exposed to new music and techniques. Have a can-do attitude. Trust in life and love what you do! Interestingly, one of my first professional game sound jobs was the music for Hardwood Hearts. Only after reading Aaron Marks' book many years later did I realize he also worked on the sound design. Small world!

What Platform Is the Project Intended For?

Game platforms each have their own idiosyncrasies and ways they manage sound programming and reproduction. Different equipment may be needed to produce these sounds such as a development system. You may have to rent or buy additional equipment or hire a subcontractor because of your lack of expertise in a certain area, and this will factor into the projected costs. If you cannot develop for a particular platform, be ready to hire additional help for guidance and to convert formats. Check with the developer, too. They may know of someone who specializes in this type of work and save you some time. Remember, this is a team effort.

Are You Bidding the Project or Just One Song or Sound Effect?

Composers and sound designers normally charge less per audio element for working the entire project than for creating individual music tracks and sound effects. It makes sense that once the factory is tooled and the "sound palette" is chosen, creating music and effects in the same vein takes less setup and production time. There are also those times when only a single musical piece or sound effect or two are needed and we should have pricing structures available for those instances.

How Much Music Is Needed? Number of Tracks? Lengths? Styles? Format?

Obviously, the more music needed, the more it will cost. A song's length also determines the fee. Because most composers normally charge per "finished minute," it only makes sense that a 3-minute song would cost more than a 1-minute one. To plan production time, use your working model.

> Four hours to compose from scratch, record tracks and mixdown for each 30 seconds of music is pretty typical.

Composing and recording in several *different* styles could change the price, too. Some composers are capable of many styles; some are only great at one. If a developer only has one genre of music in mind, it should work out well. But if country, jazz, rock, and classical are all needed for the same project, it could cost a little more. Calling in other musicians to lend their talent costs money and should be written into the bid.

The format of the tangible, deliverable medium—such as CD, DVD, and compressed audio formats like *.mp3* or *.ogg*—should be revealed here to ensure you have the required equipment. For digital files, the sample rate in kHz, 24-, 16-, 8-, or even 4-bit resolution, and stereo versus mono are all extremely important to know about in advance. Early in my game career, I found out my old computer's processor could not handle recording files using the 44.1 kHz sample rate and forced an upgrade. Not that I mind upgrading, and I just *really* hate surprises! Plan on recording everything in the highest possible sample rate regardless of the final format requirements and converting down—your only limitations being your storage medium and processing power.

Are Sound Effects Needed? How Many? What Specific Sounds? Recognizable or Original Creations? Actions to Accompany? Critical Timing Points for Animations or Character Movement? Type of Device Used for Playback? Format?

If you get the call for music, find out if they also need sound effects for the project and offer your services. The probability is high that you are also equipped to

handle sound effects, right? The equipment used in a recording studio and methods used to record sound are the same for both specialties. The minor difference is the programs you may use. Combining these tasks with one content provider is less expensive for the developer in the long run, plus it is one less person for them to meet with.

Attention to detail regarding sound effects at the outset can help the process considerably. It shows the developer has looked at their sound needs and assessed requirements early in the project. Although the precise sounds may not be planned, ideas for weapons, environmental, and administrative functions may have formed and an idea of the number should be passed on to the sound designer. Using a personal working model, the designer can calculate how long their production cycle would be.

> A general rule is one completely original sound effect requires 2 hours of time to create.

The more sounds, the more it will cost, but complexity can also raise the price. Standard or recognizable sounds from natural or man-made occurrences are usually "no-brainers." While effects libraries already in existence can provide some sounds, they may need manipulation to match character movement or an action. Other processing may be needed to adjust volume, equalization, or length. But generally, these are considered elementary.

The sounds which will be the most valued are the "Star Wars"—quality original creations—fresh, wildly fantastic sounds which take your breath away. Completely original, highly creative effects cost more. For the developer, finding the right person with the patience, know-how, and the shared vision may take a little digging—but I don't know of too many sound designers who won't at least give it a shot. We do, after all, crave a good challenge.

I never thought the type of playback device mattered until a company approached me to do some sound effects. I received a list of effects and the format to save them in, pretty cut and dry. I proceeded to create some really killer sounds, extremely proud of myself, and convinced I had indeed pulled off an impossible feat—ready to shatter the most powerful subwoofer in existence. Turns out, they would never even see a speaker system; they were sounds intended to be burned onto a tiny chip for playback on a T-shirt! Gasp! So now, as you can imagine, I *always* ask what the playback device will be. That way, I can design them specifically for the audio characteristics of the device. Lesson learned.

Any Dialog Needed? Do You Need to Hire Voice Talent? Will There be Background Sounds to Accompany Narrations? Do You Have Rewrite Authority of Scripts?

Dialog fits into the sound recording category, and generally, anyone capable of music recording can also record narration. That's how a developer looks at it. As with sound effects and music, packaging this task together will normally yield a lower overall cost from the sound contractor while also making it one-stop shopping. If they already have narratives recorded, you can usually provide the service of editing them if needed, maximizing the sound, cutting them to length, and adding any additional background or Foley sounds.

If narratives are to be recorded, you will need to know if you will be providing the voice talent and budget accordingly. Many sound guys have access to local talent or use talent agencies to find just the right personality. Auditions are usually

free, paying only when the talent has performed the work—which surprisingly enough, for a 4-hour session, starts between $250 and $350 for nonunion to $825 for union-affiliated actors (2014 SAG-AFTRA rate). This is well worth the price for professional voice talent. A developer may ask if you have any experience directing narrative sessions—a good question. After dealing with musicians, though, you are probably fairly adept at coaxing great performances from practically anyone.

Rewrite authority for a script is a big plus and can be a money saver when the clock is ticking. Knowing this will determine how large the "fudge factor" will be. I once had voice talent who could not say, "… live to tell their tales." No matter how many times we tried, this tongue twister never came close to resembling the script. A quick rewrite got us back on track instantly. Had we been required to track down the producer for permission, it may have taken longer—or worse, the talent may have had to return later, costing me the price of another session.

Timeframe Needed?

If they need it tomorrow, it will cost more. If they need a half hour of music in a week, it will also cost more. The more projects put on hold and any severe lack of sleep, the price jumps up accordingly. But, if we have been able to plan ahead and are afforded the time to schedule around other commitments, standard rates will apply. Rush jobs in any industry can be costly.

Delivery Method?

The beauty of the Internet is the immediate distribution of digital data. Attaching a sound file to an e-mail or posting to an FTP site is the method of choice, and assuming we have access, it is also the cheapest. Costs begin to rise as the delivery method changes. If the developer requires shipment on a hard drive, thumb drive, or removable media such as CDs or DVDs, there will be a cost involved. It'll only be a few dollars for a one-time shipment of the final deliverables, but if several milestones over a period of time are expected to be overnighted, then this can start to add up. Understanding the costs you can incur on a project will allow you to cover it in your bid submission later on.

Is a Speculative Demo Needed?

An established development company typically draws upon many musical/sound design resources at once, having them create specific music and sounds for a project from their guidelines and then choosing the best one. If the developer lets you know ahead of time that they require a speculative demo, it will save a lot of frustration for everyone—allowing you to schedule it in with your other projects. But normally, a composer's suitability can be determined from a previously submitted demo reel. But be ready, just in case. Some developers will pay a reduced rate for your time; others consider it your investment to win the job. Be sure to check.

What Is the Production Budget?

The production budget can be a touchy subject. If they already have numbers in mind for the sound budget, request at least a ballpark estimate. This will disclose the budget to be met and how serious the project is (i.e., whether it is a veteran development team or newcomer to the industry operating on a shoestring budget). For the small developer, you can offer budget solutions dependent on the information and ask for payment up front, at milestones, royalties, lease, or even barter agreements. We are part of the development team and do not want to doom a project before it

Tools of the Trade

RODNEY GATES
Sound Designer, Owner—SoundCues

I feel that gear and software shouldn't get in the way, and over the years, I have made the switch from Avid Pro Tools to Steinberg Nuendo (at least at the home studio for SoundCues). With the advent of Pro Tools 11 going 64-bit and Avid essentially deprecating all of their previous expensive hardware, it became apparent to me that this is not a worthy road to invest in. Though I still use and love Pro Tools at work in our existing setup, I no longer require it with native DAW systems having gotten so powerful over the past few years.

In short, if I had a brand-new audio department to build at a new game studio, I would go with Steinberg Nuendo on PC using RME hardware. Done!

Here's the typical gear list in our offices at SOE:

2008 Mac Pro with 16 GB of RAM, up to 4–5 TB of storage

Avid Pro Tools 10 HD2 with 96 I/O audio interface (one room has an HD Omni interface with Pro Tools 10/11)

Various plug-ins from Waves, SoundToys, Massey, iZotope, McDSP, Native Instruments, and other standalone audio software products like Celemony Melodyne Studio, WaveWarper, and Dehumaniser Pro

Blue Sky System One 5.1 monitoring (we also have one Focal CMS 5.1 system)

Dorrough hardware meters

Blue Baby Bottle microphone with Sound Devices MixPre—we use this for creature vocalizations and the occasional bit of temp dialog. We don't have a recording space at SOE, so we typically use it in our offices and use iZotope RX to remove any noise, which works extremely well (it is THE best noise reduction/correctional software tool ever)

Sound Forge 10 Pro and Acoustica Free Edition on the PC side for fine editing (Acoustica for equal power loop crossfade capability—something Sound Forge *still* hasn't grasped)

Shared sound library with SCEA. This includes every SFX library from Sound Ideas and Hollywood Edge, as well as a vast proprietary collection of custom recordings. It is awesome

Here is my gear list at home (SoundCues):

Custom-built i7 2600 K quad core PC with 32 GB RAM, 120 GB SSD system drive, twin 2 TB SATA III HDDs for sessions and samples, an ATI 6950 video card supporting two 21″ 1080p monitors and one 32″ 1080p HDTV for video. I made the decision in 2011 to *not* go with Mac and never looked back

KRK V Series II Monitoring in 5.1 with a Blue Sky bass management controller Mk II

Denon DN-A7100 unit with balanced outputs for use with the DAW, blu-ray discs, and game consoles

RME Multiface audio interface

Edirol PCR-800 61-key MIDI keyboard controller

Aphex 107 2-channel mic pre

Mics: AKG C1000S, Shure Beta 57, Rode NT4, Shure BG 4.0, MXL condenser. A pretty basic, inexpensive collection. But then again I have no good studio space to mic things up

Steinberg Nuendo 5.5.6 with Nuendo Expansion Kit (NEK)—64-bit

Sound Forge 10 Pro, Audacity, and Acoustica Free Edition editors

Perforce for sample library management, backed up by Dropbox and Amazon Glacier services

Various plug-ins and software from Waves, Softube, iZotope, Nomad Factory, Sound Radix, Plug-In Alliance, Sibelius, Finale, Native Instruments, WaveWarper, and a slew of free, great VST plug-ins collected over the years. Nearly everything is 64-bit

A ton of virtual instruments collected over the years, mainly for Kontakt and PLAY

Sony PCM D50 field recorder

Guitars: 2013 Gibson SG Standard (natural finish), 1990 Ibanez 540R Radius (pre-JS model) with EMG pickups, Fender P-Bass

Coming soon:

StudioComm Model 78/79 monitor controller. Might move to 7.1 someday.

Synology NAS with 16 TB of storage. Great solution for all of my sound libraries, sessions, Perforce depot, and family photos/videos too

even has a chance. Flexibility is a practice of many sound professionals. As long as the compensation is worthy of your efforts, there is nothing to lose.

Who Will Publish? What Method of Distribution?

These questions are especially reasonable if the possibility of royalty payments surfaces in the negotiations. A game which will be self-published by a new inexperienced developer and distributed by word of mouth does not exactly scream success. A well-established veteran development team, on the other hand, who is using a giant publishing and distribution company and an onslaught of marketing ultimately has a better chance. Everything is negotiable, and it pays to have all of the facts in the beginning to help make an informed decision.

Payment Method?

If a developer already has a standard method of payment, find out and determine if it is acceptable for your needs. No one has a problem dealing with cash; some up front, some after acceptance of the first pass, and the rest upon final approval. It is the standard for most companies. Find out their standard terms for payment as well. "Net 30" is the bare minimum to ensure you get paid in a timely manner, but some have different methods—which might make a difference when reviewing a prospective project. The last thing you need is to find out their standard term for payment is 6 months after the game has shipped.

But if there are other methods in mind, royalties on the backside or a salary or hourly wage, for example, some discussion may be warranted. Would you want to shoulder the risk? You might consider the gamble if you are willing to help keep your production costs down on the front side for a much larger piece of the pie on the end. It might be well worth your time. You never know when that game will become a smash hit.

Target Market?

Who do they expect to buy the game? A classically trained pianist may not have the ability to write music for a game targeted to the teenage male. A heavy metal guitarist may not be exactly right for the 3- to 8-year-old female market. As the composer, it is our responsibility to let them know if we can in fact handle the scope of the job—and providing this little detail up front can save a lot of time.

Who Has Final Authority to Accept Your Work?

This is an important point which needs to be nailed down early; the answer will factor heavily into your bid submission. A producer may stand up and proclaim, "It is I who has final authority!" That would be a perfect scenario, and you wouldn't need to worry about all those other little fingers in your business as much. You could charge on a "per project" or "per sound effect" basis and feel confident you wouldn't lose money. But if the answer is "the entire team," well, you've got your work cut out and my guess is you'll be spending some considerable time doing reworks. Achieving consensus would be nearly impossible. An hourly wage might be more appropriate to ensure all of that extra time is accounted for and you have something to show for your efforts. Or, you could add 5% to 10% more into your margin of error to cover what looks to be a severe headache in the making.

This will eventually need to be worked out anyway, no later than the contract negotiations to be safe, and will serve as the last step before any milestone or final payments. When the designated individual accepts your work, ensure a check in

Knowing a game's prospective audience will allow you to honestly assess whether you are willing or able to do the job.

your name is being processed. Occasionally, some will try to wait until the game is finished or released before parting with their funds. By having it in the contract, they can be held to their side of the bargain.

Preproduction Made Simple

With the previous list in mind, the producer or media buyer can easily increase the chances of a trouble-free bidding process by answering as many of the questions as possible. Make sure you've got them answered to your liking before making your final calculations. Any surprises could change the parameters of the bid, causing a devaluation of services.

Even before the project is put out for bid, the media buyer can do their homework. Investigating various sound production companies beforehand is a good idea to help stay ahead of the game. Web search engines, developer resource web sites, and the numerous unsolicited e-mails, inquiries, and resumes can be (finally) taken advantage of. They should request your current demo reel, references, and past work samples. Do your part to encourage them. They'll be thankful when the time comes.

Developers should plan as far ahead of the bidding process as possible, gathering any preliminary work, design documents, artwork, character biographies, storyboards, and lists of other comparable games on the market and have them handy to show the sound artist. I always appreciate getting these extra details at the bidding process. It is a classy gesture—one which will strengthen the new relationship immediately. The more you know, the more likely you will get your part right the first time.

Good developers keep the sound guy informed. Details and ideas change fast and furiously during the development of any title, and the timeframe while waiting to receive bid replies is no different. Any major specification changes should be immediately forwarded to the prospective audio providers to ensure accuracy on your part. Platform changes, surround sound, or interactive music scores come to mind as important examples. Timely feedback on rejections, accepted submissions, and words of encouragement are always nice, too. Be on the lookout for any information between the lines. Sometimes, a developer may swear they gave out certain information, but in reality, it was never said directly. Extrasensory perception is a good thing if you've got it. Asking lots of questions is your next best bet.

Contract Payment Options

During negotiations, the single most recurrent topic is the payment option. Cash flow is important to both parties. You, the contractor, endeavor to receive payment in your favor—whereas the developer strives to keep their money as long as possible. It is a usual practice in the business world and not confined to the games industry but frustrating nonetheless. There are a few options to ease the pain on both sides of the fence and to help make the bid more attractive. Consider offering some of these options to ease the financial pinch a developer may be feeling. Remember, you're the problem solver and there is no reason you can't take that beyond just doing music and sound.

Salary or Hourly Wage

The easiest scenario, by far, is to be brought in as part of the development team and accept either a salary or hourly wage as consistent work is produced. No squabbling or haggling as terms of the contract are changed and giving the sound creator a sense of project ownership are highlights of this particular option. This situation is best for larger or well-funded developers but totally unrealistic if no development money is available.

Payment According to Milestones

Given a hard list of required audio content, set milestones and have the developer schedule payments according to them. The downside is that this will force them to plan ahead and have exact specifications nailed down. The plus side is that it motivates you, the sound artist, to meet them. (I'm always more focused when I have a deadline to work toward myself.) If they don't wish to be tied, payment terms of half up front, the other half upon completion or variations in between, are also feasible. Payment according to milestones, however, is the standard practice.

Good Faith, Barter Arrangement and Small Royalties

This example has wide-open possibilities. By starting with a small "good faith" payment, the developer is showing commitment to the project and to the sound artist. Because cash may be a problem, barter arrangements of some type are workable depending on each other's needs and offerings. Trades of computer equipment, web space hosting or site design, or graphics such as logos are all practical. A royalties option on the backside would round out the final payment for services. This option is great for the newer cash-starved developer and for the sound creator who is part-time or has other income.

Straight Royalties

By not taking *any* payment during the development process, the sound artist would be entitled to a larger portion on the backside. A generous royalties schedule would be established to pay the content provider after the title is released. While this is indeed the best-case scenario for a developer, because the sound creator is assuming the risk, it can be the worst for you. Newer composers and sound designers may elect this option as a way to become established and for the steady cash flow as they work on other titles. Wiser ones will consider it if the game has hit potential.

Variations of the Above

In the free marketplace, creativity is not always confined to art. Utilizing any or all of the previous examples, an agreeable compensation schedule can be established meeting the needs of both parties. All one has to do is ask.

Speculative Demos

We touched upon speculative demos earlier, but it's a subject which is important enough to warrant its own discussion. A *speculative demo* is a submission of music done by a prospective composer created specifically for a certain project. It is a way for the developers to see how close you can come to their ideas without actually committing themselves to hiring you. Usually, after deciding upon a few composers, a developer may request this type of demo to help narrow the field.

They should be as specific as possible regarding the type and style of music they seek—giving examples of works in other games or music artists which feed the right mood. If at all possible, it is best if they have only one person (i.e., the producer) give their input at this point. A favorite previous spec demo request of mine included this description: "… mid tempo with breakbeats, dark, abstract hip-hop, not too fast or too slow, gritty and industrial, but not jarring or abrasive." It was fairly obvious the *entire* development team contributed their ideas to the cause! It's a difficult task to please everyone.

So, it is extremely important to receive a concise description for mood of the game. You only have one shot to get it right. Occasionally, and if I have the time, I include at least two similar musical directions for the "judges" to choose between on a spec demo—doubling my chances.

Covering Your Expenses

It is a fair business practice to be covered for the very basic production costs for the speculative demo. As incentive, you can also agree to deduct this fee from your contract after being hired. But, unfortunately, this isn't always the case. Developers want to keep their expenditures down to a minimum and may feel that if you want the job bad enough, you'll do it for free. My argument is: If they've heard my demo, they know my production values and should be able to determine whether I am suitable for the job. While I'm not opposed to doing a speculative demo, I believe my time can be better spent working on *real* projects which pay the full fee.

Normally, you won't be able to charge full price for your spec demo. Any charge should cover "reasonable" production costs—basically your time, any outside talent, and material fees. Your standard creative fee is generally waived. For a 1-minute piece normally sold for $1000 to $1500, consider $300 to $400 as the most you can expect for the effort.

CHRIS RICKWOOD
Composer

Chris Rickwood is an award-winning composer known for creating dramatic musical scores for video games. His past work ranges from catchy melodies underscoring fights with cartoon evil geniuses to massive soundscapes suitable for building and destroying empires. Blending the traditional with the modern, Rickwood's musical style is often a marriage of current musical genres with traditional instrumentation and orchestration—hip-hop for hammered dulcimer and djembe or heavy metal for full orchestra are the norm. Credits include *Age of Empires Online, Madden NFL 12, Orcs Must Die! Series, Ghostbusters: The Videogame, Tribes: Ascend, Smite,* and *Paladins.*

www.rickwoodmusic.com

Describe your thought process for creating music and/or sound effects.

Fail fast and fail often! I've tried every technique in this book, but what works best for me is to stop thinking and just do it. It will be bad at first, but if you stick with it eventually you will create something that you never thought you could ever do.

Are there any particular secrets to your creativity?

There are no secrets. Soak in everything around you, push your limits, and just start creating. Creating is actually pretty easy, but your insecurity and ego get in your way. The only way to get past this is to keep at it and let things happen. I also find it best to separate the idea stage with the edit stage. In the idea stage, I try everything and kind of just sling everything into the DAW that I can think of. Ableton Live is great for this. Then when you have all of those pieces, there are usually one or two "good" ideas to pursue and that's when you can really start composing. The idea stage doesn't even have to be musical, it can be prose or visual.

Are there any techniques that you regularly employ?

I create a lot of tools that help reduce the friction of creation. For example, I have a small script that I run that will spit out a tempo, a time signature, and a key. That's a starting point I can work with and not over think the process.

Do you have any advice which can help lay solid groundwork and ensure a successful production for the audio content creator?

Listen. Listen to the world, different music, stuff you hate, stuff you love, your clients, your fans, and most importantly, listen to yourself.

Do you have any interesting sound design creation techniques which affect the type of sounds you create?

Ableton Live has been a game changer for me. I was turned on to the idea by Matt Piersall who does all of his source creation in Live. Using Drum Racks and the Push controller, you can throw a ton of sounds on different pads each with their own effects chain. Then you can go crazy with the automation in real time for each pad. And with all of the wonderful plug-ins as well as the Max-MSP effects, you can really mangle your sounds into something completely new.

When do you find you are most creative?

5 a.m. to noon or 9 p.m. to 1 a.m.

Any worthwhile creative advice you'd like to share?

To boost my productivity, I will create daily deadlines of what I want to accomplish and try to stick to them as much as possible. Sometimes, I get really granular and say, "I'm going to sketch this thing out in 15 minutes… GO!" It really helps get over that hump of getting things started especially when you are an expert procrastinator like myself.

Is there a typical workday for you?

Ultimately, I'm pretty lazy, so I try to get most of my creative work done in the morning. So, I usually do my writing and sound design as soon as I wake up. Then eat breakfast and do some real-life stuff, then continue writing until lunch time. After that I'm pretty spent, but I've done more work than most people do by lunch time. So, after lunch, I do less creative tasks like implementation, project management, e-mail, or score study. Sometime, I'll work at night like 10 p.m. to 1 a.m.

What skills should composers have to succeed in the games industry?

I think what separates video game music from other types of music is the need to sustain an idea for an undetermined amount of time without sounding static. For example, if you are writing battle music, you are required to create a cue that is intense and gives the sense that the intensity is growing in a looping piece of music. It is a lot harder to do than it sounds.

Do you have a specific ideology which drives your way of doing business?

Now that I'm later in my career (dare I say "old") things have changed quite a bit. I tend to take on projects that are really interesting or challenging and say no to everything else. In practice, it is hard to turn down projects, but in the end, you end up happier and also create better work.

Any good business advice to offer?

Be patient.

Any horror stories which have impacted how you do business?

Yes, but I don't want to relive them. Life is about making mistakes. That's how you learn.

How do you approach negotiations with a new client?

I do all I can to retain ownership of the music copyright and license the music to my clients. Not everyone is willing to do it. At the very least, I will negotiate ancillary rights for the work I create.

Do you have any negotiation tips which work well for you?

Know what you are worth and be willing to fight for what you deserve. Also, if you are creating fully sampled score (no live budget), it will probably be more work for you that you probably aren't charging for.

Do you have any contract stories which others could learn from?

Double check, no… TRIPLE check your numbers! I once had a project where the assets were specified in great detail on an Excel spreadsheet. Everything looked fine on the spreadsheet and in the contract, so we signed it and started production. I carefully mapped out the schedule to make sure all of the deadlines were hit and even padded it by adding an extra week for each milestone. The project went great, and we hit the first milestone with relative ease. I then went to the spreadsheet to check off everything we had done and noticed that something didn't add up correctly. After checking off the assets we delivered, there were about 100 more sound effects left to create than I thought we should have. After banging my head up against the wall for a few hours, I discovered that the formula that added up the number of assets left out two rows of the spread sheet! So, even though the contract and the total on the Excel sheet seemed correct, it actually left out a whole group of sound effects.

This error completely screwed up the time budget and the financial budget. Unfortunately, the developer wasn't very cooperative about any of it and didn't allow more time or money for the clerical mistake that they made. And, even though the contract wasn't in my favor, I still felt I needed to provide them with the complete list of assets. Lesson learned.

Do you have any tips when working with developers?

Proactive communication is critical. I'm pretty bad about just doing my work without a lot of status updates. Most clients don't want to micromanage you, but giving them daily or at least weekly updates go a long way in boosting their confidence in your work.

What advice can you give when working with a developer which has ensured a good working relationship and a good final product?

Listen to their needs, do your best work, deliver on time, and be an absolute professional with everything you do. Also, try to get to know your clients as people rather than business colleagues. Friends are much more fun to work for than "clients."

Have you ever had any development issues negatively influence your workflow?

The battle with audio is that it is often dependent on everything else in the pipeline. And, those dependencies can often change after you've committed your work. For sound design,

I'm often required to do my work after everyone else has finished their work. This makes it really hard to get ahead of the schedule on anything.

Staying organized is important, especially if you are working on multiple projects, which is part of your daily routine. How do you keep up with it?

Automation. Different clients have different tools to track issues. I use tools like Zapier to keep track of these different websites (Trello, Jira, Box, Google Docs, etc.) and cull them into one master list. If I'm working on several projects at the same time (which I always am), I divide my day up to make sure I'm making forward progress on all of my projects. And probably most importantly, I get help from other people.

Any specific 'lessons learned' on a project which you could share?

You are going to make mistakes. You'll probably break a build. You'll probably overwrite someone else's work. You'll probably miss a deadline. Own it. Don't make excuses. Apologize and provide a solution to the problem.

There are many pitfalls when 'working' in the game industry. Have you had any bad experiences?

Yes. If you haven't had bad experiences, then you're not really trying. Read Stephen Pressfields, *The War of Art* to understand what I mean.

How did you find your way into the games industry?

I always thought music for games would be fun to do. My schooling is in music, and I have a Master's degree hanging on my wall that proves that I am "qualified" to write music for a living (OK, it's not really hanging on the wall and it doesn't really qualify me for anything). Anyway, back when I was in graduate school, the mid-1990s, I read an article in one of the trade rags that highlighted the game audio industry. It looked exciting and cutting edge, and NOBODY wanted to do it! Where do I sign up? Coincidentally, at the end of the article, it gave the names and address of the audio directors at some of the biggest game studios with the specific instructions to mail in your demo. Seizing the opportunity, I slapped together a cassette tape and floppy disk of MIDI tracks (yeah, I was bleeding edge) and mailed them to all of the addresses.

I actually got a couple of calls back, but specifically remember the call from Tommy Tallarico. He basically told me that my writing was great but the production sucked. It was true, but I was a poor student at the time and didn't know the first thing about music production, but at least the door was cracked. A couple of years later, I read that Tommy was doing the music for *Evil Dead* and would be using a live orchestra and choir! This was perfect for me. First, I was a huge *Evil Dead* fan, so I was instantly excited about the project. Second, since they would be using live players, production skills were not that important. So, I picked up the phone and asked Tommy if I could write a few cues for him. Luckily, he agreed and let me submit a few tracks which ended up getting used in the game. Sweet, my first real credit, my entry fee into the industry!

Any other advice you'd like to share?

This is a really competitive business, and it's easy to get discouraged in your progress. Make sure you take the time and reflect on the fact that you work with some of the smartest technical people in the world and with some of the most creative people in the world using some of the most cutting edge technology in the world.

The ownership issue can blur the fee structure. If a developer asks for a speculative demo and agrees to cover production fees only, you maintain all rights to the music. Assuming, of course, that you aren't hired for the job, it still leaves you with music to sell to other projects in the future and something to add to your demo reel.

Now, let's say you didn't get the gig, but they want to keep the music. What you do here is completely up to you. It's my guess they liked it enough to want to use it in something and I'd be careful. I would charge my full fee, give them all the rights, and call it even. They may counter with, "If you give it to us for the spec price, we'll keep you in mind for the next project." Again, it's totally up to you what you agree to—but there are no guarantees, and they probably won't call despite what they say. If they like the composer they hired for this project, that person will more than likely get the next one as well. It's definitely a gamble—trying to look like the nice guy—but the odds are not in your favor and rarely will they call again. Put on your business hat when negotiating points like this and make sure you aren't taken advantage of.

Words of Caution

Music created with the project specifications in mind will give the development team a good idea what audio life to give the project and enables them to adopt the best one. They are basically taking advantage of you, though—looking for free musical ideas for their project. Developers have been known to contact several composers for ideas, even though they've already chosen one in advance. It may turn out to be an exercise in futility for you so, stay alert.

While asking for a speculative demo is a win–win situation from the developer's standpoint, it can be a waste of time for you. Newer sound folks are usually more than happy to spend a week or two sweating and bleeding over a speculative demo, investing their time and money only to find out they have wasted it. Established composers don't need to expend this effort—having a proven track record to fall back on instead.

You have a clear choice when faced with this request. If they've heard your demo reel, you can sell them on what you've already done. Point out a piece on the demo which may be similar in nature to what you are thinking musically and play up the value of your production quality. If your argument doesn't sell them and they insist, it's time to decide. At first, your temptation will be to jump on every request. If you have nothing else going on at the time, work out the spec fee and go for it. Income is good regardless of where it comes from. But, keep in mind, this will take your efforts away from larger money-making endeavors such as reeling in the big fish. There is nothing wrong with turning down this type of request, choosing instead to stick with your business plan. Why should you risk wasting your time when there is no guarantee anything will come of it? While it may be a calculated risk, sure things feel a whole lot better.

The Bid Submission

Well, here we are—back full circle to the question, "How much do you charge?" This time, however, we are armed with the knowledge, motivation, and a list for success. All of the parameters for the game have been laid out, and it's time to

determine your fee. Obviously, the amount you charge is a big factor in determining whether you get the call or not—so, don't take the subject lightly.

After you've set a figure, mull over your interactions with the developer to decide whether they are giving you free artistic rein or will be nonstop thorns in your side and then let that gut feeling be your guide. Let that intuition be the basis for the bid you submit. It's not an exact science, but it will affect your motivation and ultimately the quality of the job you do.

> A wise man once said, if you grumble through an entire project, you are not charging enough.

More than likely, there will be other composers bidding on the project as well. If you can find out who they are, great. It will give you an indication of the price range they warrant, and you can strategize over how to win the bid. Don't immediately go for the "cheapest composer angle," underbidding just to get the project. By doing so, developers will expect all composers to work cheaply and devalue our efforts. You'll end up working on their next project for this cut-rate fee, unable to earn more for your efforts—setting a bad precedent which will take you years to recover from. I'm not saying this because other composers (or myself) are afraid to lose a contract to the lowest bidder. I'm throwing it out in hopes you will understand that once you are known as the "cheapest composer in town," that's the only type of projects you'll get.

The Bid

For the final bid submission, there is no magical format to follow which will land the contract. Most bids are submitted via e-mail these days—plain-old boring text explaining how much you would charge for the project and what would be accomplished for the price. Occasional submissions are requested through a more formal letter, but either way, what counts is the facts: your professionalism and their gut feelings.

When you make your submission, ensure the recipient actually received it and find out if there are any questions which need answering before their final selection. A phone call is the best way to follow up, especially if you've never met or spoken before. It will add a personal touch and humanize the dry, impersonal bid. If the chance presents itself, request a visit to offer your bid in person and meet everyone face to face. Although it is highly improbable you'll be able to afford jetting off to meet all prospective clients, there still is something to be said for that kind of commitment and dedication. But remember, it still won't guarantee you the job. For a little extra insight into the bidding process, here is an illustration of a bid request you may encounter and an example response.

Example Bid Request

Dear Game Composer,

We are currently requesting bids for an upcoming game release for the PC. We will be requiring a number of different types of music for the project. The game takes place in space and is in the "combat/strategy" genre. In making our decision, we will first consider quality; second, cost; and third, timeline.

For now, if you could furnish us with the following, we will be able to consider your bid:

- Resume of past game work.
- Sample track or part of a track, either done for this proposal or from your archives, which matches one of the descriptions below.
- Cost per track, with any discounts if we request over a certain number of tracks.
- Completion timeline. The project does not require the final soundtrack for 4 months, although we would like to have it much sooner if possible.
- The music tracks will play throughout the game. All voice and sound effects will be heard over the tracks. There will be a bit of silence after a track is complete before the next one begins (done similarly in *Command and Conquer*).

Here are a few track descriptions. Pick whichever type you want for your bid sample.

- An action piece in a classical genre (*Star Wars*, "Raiders," etc.)—could be a synth mix.
- Rockin' thrash, industrial-esque perhaps.
- Militaristic techno—hard, driving beat, and a cool sci-fi tune. Nine Inch Nails minus the ear-splitting cacophony or Eurythmics "1984," John Carpenter's "The Thing."

We want to avoid recognizable lyrics, although voice can be cool as an instrument and stay away from "happy, Disney-action themes." I will be going through the bids in 2 weeks. Please call or e-mail me if you have any questions. You can obtain information about our company from our web site. Thank you.

Sincerely,

Producer X

Example Response

Dear Producer X,

Thank you for the opportunity to be considered for your new space game project. Enclosed is the demo reel and bio you requested. I've included several tracks from my archives in a brief musical montage similar to the styles you described. After I've had a chance to speak with you directly, to get a better feel for the game, I'll be able to hit your target dead center.

Although I do not have any published game titles yet, I am currently under contract with two separate software companies scoring music and designing sound effects. Company A has me contracted for two games: *Space Game 1* and another game yet to be named. One project is expected to be released in 2 months and another by next spring. Company B has contracted me for one title by summer and an option to continue my contract indefinitely. I'm quickly adding projects to my resume, so please don't be alarmed by my lack of published software titles. I have much experience composing and record-ing music—having done many local TV and radio commercials, PSAs, and

am involved with several album projects. I can do what you hire me for without question.

My rates depend on many of your requirements, but $4900 would include buyout fees for five 3-minute songs/themes and five 1-minute pieces—20 minutes of music in all, using the instrumentation heard on the demo. Additional music beyond the 20 minutes is $149 per minute. I can offer 60 minutes for $11900. An individual track per finished minute, and based on your request, would start at $349. The quality and value of my services are guaranteed; if you are not happy with the music I compose for you, you pay nothing.

The timeline is fairly straightforward once approval for the styles and lengths of music is granted. The first piece would take 2 weeks for composition and recording, each piece after that (1–3 minutes in length) would require no more than 1 week. Once the factory is tooled, so to speak, and my sound palette is chosen, the music comes fast and furious. A week would also be needed for reworks, if there are any. I say a week to be conservative; 5 days is usually the norm.

My musical/production/computer experience dates back many years, and my local area network is always available to draw upon. My reliability is unquestioned, and if you'd like to speak with any of my clients, they would be happy to share their experiences. I believe in the utmost quality of each production and strive for perfection. My in-house digital studio is fully equipped to reach these goals and to allow my creativity and inspiration to be recorded quickly. I have been composing for many years, played guitar and drums in various bands, play piano, and have been actively engineering and producing. I have the knowledge and the chops to provide quality music on time and most certainly within budget.

Please feel free to call if you have further questions or need clarification. Again, thank you for your consideration, and I hope to speak with you soon.

Sincerely,

Game Composer

Note that the previous illustration is geared toward the new "game" composer. There is discussion about the lack of resume titles, and you'll note the price quote is much lower than what an established game composer might charge. The quote was based on a very low overhead for the composer and that the developer was small and fairly new. This example "sells" the composer's talents a bit more than what is typically needed, so was a little more wordy than normal—something you'll eventually narrow down to "just the facts" in future bids.

An aspect to note in the example: The entire point of this process is for developers to survey various sound contractors, find a fee which will fit their budget, and get great audio. They are searching for the most bang for their buck, period. We aren't anywhere close to negotiating royalties, bonuses, or other contract items, so don't use this as a forum for that. You'll note the example didn't even breach those subjects. Once you win the contract and they have rallied around, heralding you as their new audio sage, then contract issues will be considered. If you were to walk in with a long list of contract demands, they would definitely consider the path of least resistance (i.e., your competitor) and leave you standing there with your mouth open.

Tools of the Trade

TOM TODIA
Sound designer, Field recordist

My studio is entirely computer-based. I have no outboard recording or processing anymore. I try to keep my studio as minimal as possible so that there is more time for the design and less to worry about gear.

My gear philosophy is "less is more." Own only what you need to do your work at an appropriate quality level. Your design ideas and attention to detail is what makes you a professional. Gear is expensive and too much of it can simply slow your process down. I also like to keep the money I make. Having gear is important, but so is survival. Buy items that you need for a project and build up your gear over time, not all at once. If you are taking out loans and/or debt, make sure you are weighing the return properly. Personally, I am a frugal audio soul.

Computers: 2 Mac Book Pro laptops, Quad Core 2.6 GHz, 8 Gigs RAM, 1 Terabyte internal, 2×4 Terabyte backup drives, 27-inch second monitor

Audio interface: ProFire 610

Software: Pro Tools, Logic Pro, Sound Forge

Multitrack system: Pro Tools, Logic Pro, Sound Forge

Monitors: Blue Sky 2.1, M Audio BX5, BeyerDynamic DT880 (Headphones)

Sound modules/VST instruments: Native Instruments Reaktor, Izotope RX Advanced, Native Instruments Kontakt, Logic Pro Sculpture

Outboard gear/effects plug-ins: Crysonic FX bundle, Waves Renaissance Bundle, Michael Norris Spectral Magic Bundle, Paul Stretch (TC/E)

Other instruments: Shaker, Various Percussion, Piano, Cello, Violin

Microphones: SM57, Gauge ECM84 Stereo, AKG 416, SASS-P Stereo Ambient Mic, Rode NT4, Contact Microphones, Hydrophone

Remote recording gear: Zoom H2 and H4N, Sound Devices 702

There Is Still More

After the bids are submitted and the nail-biting begins, there is still more we can do. Maintain an open line of communication, build rapport, ask questions, and grow to understand each other's needs. The process is by no means over. There are times I have even been asked to rebid based on new parameters only discovered during our conversations. When it comes down to two bids, developers should talk to both composers. A gut feeling will let them know who is right for the job. After all, you will be working closely together for some time, and it is reasonable to assume you should be able to communicate ideas and get along. Don't be afraid to pick up the phone, and do a little digging on your behalf.

The bid is, without a doubt, the least favorite part of the game development process but is inevitable. Knowing and sharing the ingredients of a sound bid will make this experience better—setting the mood for the project, and establishing a cohesive team that ultimately breeds success.

6

Making the Deals

Dear Game Composer,

Congratulations! You have been chosen among five competing composers and sound designers to score music and create sound effects for Company X's next mega-blockbuster smash game! Because you stand well above your peers, the choice was not a difficult one. Your vision is clear, your dedication is evident, and we look forward to working with you on what proves to be a very exciting project. We'll be in touch very shortly to discuss all the pertinent details.

Before we can proceed, however, we will require you to agree to and sign some standard paperwork: a nondisclosure agreement (NDA) and professional services agreement (PSA). You will find these documents enclosed. Please fill them out in their entirety, sign and date in the appropriate places, and return them to us within the next 5 working days. After we have them in our possession, we can get down to the business at hand.

Again, it is a pleasure to have you on board as part of our team. Should you have any questions, feel free to contact me.

Yours in gaming,

Producer X

You've hit the big time! Your adrenaline is flowing, your hands are shaking. This is a significant moment—one you've worked hard for. Except, when you sit

down to examine the pages of "legalese" they need you to sign, the weight of the situation pulls you unwillingly back down to earth—a touch of fear rising from your stomach. What are you going to do?

Your first instinct may be to just sign and initial everywhere, send it back, and get it over with. You want to make music! Wrong! You have to realize this contract is skewed heavily in their favor—their interests fully addressed. That would be the *worst* thing you could do at this point.

Find a decent contract lawyer—preferably one who is familiar with the idiosyncrasies of the games industry. Consult with them before signing any contract and discuss ways to include your interests in it as well. If you absolutely cannot afford the $200, find a trusted advisor you can rely on—someone who is familiar with business contracts and could recommend an appropriate course of action. Consider, at a minimum, getting advice from a game producer or another composer who has dealt with these types of situations. By doing so, it will protect your interests, give you an insight into the process from day 1, and will let the game developer know you are not just a great composer but also a savvy business person.

Dealing with agreements, contracts, and all the other legal paperwork can be enough to try anyone's patience and make them think twice about this line of work. These basic "formalities," necessary evils most people take rather nonchalantly, are enforceable and binding agreements between two parties which can be used for or against you in a court of law. In the previous example, Company X (knowingly or not) is gently forcing you into their agreement without appropriate time for you to consult your experts and consider each point. If you ever find yourself in this type of position, ask for more time to review the contract and offer any counterproposals if you come across something unreasonable.

Don't get suckered into signing something you haven't read and fully understood. I've found myself sitting in a boardroom full of company executives staring at me, all seemingly waiting for my pen to touch the paper. While the pressure to look like a "team player" was tremendous, I asked for some time to review the documents first. Another time, a producer kept reminding me my first payment was on his desk and would be sent out as soon as I signed the contract—that is, he was dangling the carrot. In another instance, a substantial payment was withheld from a previous contract after the company had been bought out—insisting I sign their *new* agreement first. You will meet with many similar situations in your travels.

> Never sign any legal document unless you understand and agree to it 100%. Your livelihood and sanity are at stake.

Understanding Industry Contracts and Terminology

Before you can make the deals that bring success, you must understand and become familiar with the legal contracts you'll see along the way. Some can be extremely simple statements which proclaim, "Upon receipt of payment in full, Company X owns all rights to the following audio files." Other contracts are pages of undecipherable legalese which can take days to read. Regardless of what you may encounter, common sense and a little knowledge will go a long way. Let's take a look at some of the more common terms and "standard" agreements.

Nondisclosure Agreements (NDAs)

Before most companies even let you *see* their operation, they require your signature on an NDA. Basically, it is a document that says anything you see and hear

is top-secret and cannot be shared with anyone outside the company. It's a fairly simple concept which takes three pages to say, unfortunately.

The following example is a nondisclosure statement in its simplest form. You will often see these as additions to contracts, instead of a standalone document.

> It is understood by the below signed individual that all information obtained while providing service will remain confidential and that he/she will not directly or indirectly disclose to any third party or use for its own benefit, or use for any purpose other than the above-mentioned project.

By signing an NDA, you are sworn not to divulge any information about the company's projects. This legal document will make you think twice about talking. The last thing you need is a lawyer standing up in court waving an NDA with your signature on it. Game companies take this very seriously, and I recommend keeping a tight lip for your own sake. Everyone working in the industry has signed at least one of these, so when conversation turns uncomfortably toward the specifics of your new project, it is always safe to say "I'm under nondisclosure," and they will understand.

An in-house composer will sign an NDA when first taking a job, but after a few months working with the company, her or his loyalty would never be questioned. As a contractor, game companies have more of a reason to hold you to such agreements. Because you don't "belong" to them and it's hard to keep a close eye on you, they are a bit more mistrustful. You have contact with many other game companies who are all competing in the same marketplace, and a slip of the tongue could end up costing a company their entire project. With millions at stake, this type of industrial espionage (accidental or not) is highly frowned upon. They would not hesitate to drag your butt into court to recoup their losses.

Consider the following example. Say you worked on a project with Company Y and might have overheard some information about their next ultra-secret game title. Over at Company Z, where you are talking to a producer about doing their next game, what you heard over at the other company casually comes up in conversation. It turns out they have a similar game in the making and based on the information you just provided, they move their timetable up in order to beat Company Y to market. The game is released with great fanfare and is acclaimed as an innovative and trend-setting game. Company Z's stock shoots up and orders for millions of copies of the game flood in from around the globe. Two months later, Company Y releases their game with mediocre reception. It's proclaimed a copycat and dies a miserable death on the store shelves. Company Y can't understand why they failed horribly. Then, one of the producers casually mentions to the CEO that you had done the audio on Company Z's game, and he remembers how angry you were at not winning the contract for this game. Suddenly, their legal team springs into action and decides you had to have been the one who leaked information about their secret project. Whether you were the one or not, they may have a case against you if you signed their NDA.

I don't mention this to raise fear. I want you to understand that video gaming is a serious business and discretion on your part is necessary. What you learn about a company in the course of conversations should *always* be held in confidence—regardless of whether an NDA was signed. If you get the reputation of being a blabbermouth, companies will stop talking to you. You wouldn't want

competitors learning your secrets, especially if you've discovered a niche where you've cornered the market—so be respectful of the game developers whose life-blood is the success of their product.

Work-for-Hire Agreements

When a song or sound effect is created, these audio entities are owned entirely and exclusively by the creator unless that creator happens to be working under a work-for-hire agreement. This type of contract states, in various manners, that any work created for a specific project is owned by the company that hired you. There's little doubt who owns the work in question. In-house composers and sound designers are always under this type of agreement. They work directly for a game developer, the developer pays them a salary to be on their staff, and thus the company has the rights to everything created on their premises.

There are varying agreements which allow in-house personnel to retain rights to their creations if they are not done for a specific project, but to keep this concept simple, assume if you work in-house, the company owns all of your work. It can be negotiated to use the studio for your *own* projects after hours or to do other freelance work during down time which you would keep all rights to. Some companies are okay with this; others strictly forbid composers to do any outside projects. Be sure to ask if you apply for an in-house position and intend to continue doing outside contracting work.

For the third-party contractor, this type of agreement is left a bit more open to interpretation and negotiation. It is entirely possible, by signing an agreement in the developer's favor, for them to own everything you do for a specific project. This means every scratch music track you produce during the composing and recording process and every sound used to produce the sound effects could potentially belong to them.

For example, I did a sound effect of an old prospector and his mule walking up to a gold mine where the character says, "Well, looky there now Betsy, it's the Lucky Nugget!" The sound is a compilation of the character's voice, a mule braying, pots and pans clanging, and a crow squawking. It was created under a work-for-hire agreement. The original agreement stated the developer would own all of the sounds used to create the effect, including the voice characterization done by hired voice talent. I negotiated, instead, that the sound they would own would be the work in its final form and *not* the pieces used to construct it.

My argument was straightforward. Everything up until the point of completion was an "idea," and it would create problems trying to control ownership of a sound that I don't own the rights to in the first place. Some sounds were taken from licensed sound libraries, and some I recorded myself. If they had insisted, I would have explained while it could be done and that I would be willing to sell specific sounds I had recorded, it would severely limit my creativity having to rely solely on my own remote recording abilities and then being able to use the sound only once. Because of the time involved, they could not afford to pay me to go out into the field to record donkeys and crows every time I needed one. Having my own library and other licensed sound libraries at my disposal saves an incredible amount of time and money.

The work-for-hire agreement is not a bad way to proceed if you pay attention to the points of the contract. They are negotiable, and it behooves you to ensure your interests are covered. The developer will have to own *something*, there is no getting around that, unless limited licenses are involved—whereas you grant

them the full use of music and sounds in the one game on the one platform. Then, licensing issues will come into play if they want to use it on other platforms or sequels to the game. It gets even more complicated, so hang on.

Copyrights

Copyright issues could easily make for an entire book, but instead, I will attempt a few highlights in a couple of paragraphs. Copyrights can be complicated and as clear as mud, needing an entire staff of lawyers to understand completely.

> In a nutshell, whomever owns the copyright to a piece of work, either music or a sound effect, owns the work in its entirety and is free to use and/or license the work for whatever and to whomever they choose.

For our purposes in the gaming world, the developer or publisher will almost always demand to own the music and sound outright, leaving little room for discussion. By doing so, they can now reuse your music and sound effects in every sequel to the game, on every platform, in every television commercial, in every movie, and even release a soundtrack album—all without you ever seeing another dime.

Now, to sidetrack for a moment, if you end up licensing the audio for every instance mentioned previously, you are set to do very well without lifting another finger. The work is already done, and the game companies are just paying you more to use it in the other instances. If they insist on owning the copyrights, it becomes another matter—and in order for you *not* to lose future monies for your efforts, you must charge them a much higher fee for a complete buyout. With development budgets first on their minds, you can offer the same work for less money in a licensing arrangement. If they insist on owning all rights, they will have to understand it will cost them more for you to leave your work and walk away.

An argument, using the previous story about the old prospector, could also relate to copyright issues. Who owns the voice characterization? In this case, the voice talent does. The only portion the game company owns is the line he spoke embedded in the complete sound effect. This "sound" is just another one of the layers of sounds which make up the entire effect in its final form. They don't own the character. Now, if they were making a game called *The Zany Adventures of Mr. Prospector and His Mule, Betsy*, the vocal characterization rights could be transferred to the game company. When a character is created for a large project, such as *Duke Nukem*, the game company will purchase the rights for that voice characterization to ensure that other games don't hit the market using their specific character. They will pay quite a bit more to retain ownership and the rights to exclusively use the character.

Licenses

Licensing is when the owner of a copyrighted piece of work grants exclusive or nonexclusive use of the work for a negotiated fee. When a song is composed and recorded onto a particular medium, the composition is protected under copyright laws. If you file an application with the U.S. Copyright Office for the piece of work, you own the copyright in a more official and legal sense. As we mentioned before, if you sell that song to a game company to use in their game, you've transferred the copyright to them and they are free to use it in every game, every commercial, and every soundtrack they produce until the copyright expires and the music enters

the public domain. Licensing comes into play when you let another entity, such as a game company, borrow your song for their project—but you retain all rights to it.

Smaller developers would be more likely to seek out licenses to use your work in their game because it is more affordable for them. Because they are not buying the rights to the work, they will instead pay a smaller fee for the privilege of using it. You will grant them limited use of the work to be used *only* in their game and nowhere else. Depending on the agreement, they may negotiate that you cannot sell the music to another game company for a reasonable length of time—so that they may retain some semblance of originality. It doesn't mean you can't turn around and sell the music to a film or TV project; you can indeed if it's part of the agreement.

Music and sound effect libraries use this concept in their daily business practices. Audio can be released in CD/DVD format as well as offered as a download from the Internet. When a purchase is made, it may be implied mistakenly that the buyer owns the music and sound effects. You've got a physical piece of matter in your hand which was paid for; it can be naturally assumed it belongs to you. In the case of library titles, this is a wrong assumption. The company is only granting the license to use the included materials as stated in their purchase agreement. You don't have an exclusive right to the sounds. Any other party who pays the users fee can use it in their projects.

Licensing is possible in the gaming world, although developers usually strive to own the original compositions in their projects outright. But a cost-conscious one might consider the option of licensing instead.

Platforms

Game platforms are considered to be any console, computer system, or game system a computer or video game can be played on. The PC, Mac, Wii, Wii U, Xbox 360, Xbox One, PlayStation 3, PlayStation 4, Nintendo DS, Sony PSP, Android, iOS, and video arcade consoles are all examples of separate game platforms. You will often hear a developer say a game will be "ported" to another platform, meaning that conversions will be made to the game in order to work on another game platform. Your ears should perk up a little when you hear that word because it could mean some extra income for you. I'll give more details in the section "Negotiable Contract Points" shortly.

SKUs

A SKU (pronounced "skyew"), or stock-keeping unit, is another way of saying "game release" or "game platform." It's actually a unique code assigned to merchandise for inventory purposes. When making video games and porting them from one platform to another, a new SKU will be generated for the new version of the game to be sold to the public. These numbers can be found in the product's bar code, enabling stores with computerized inventory and point-of-sale systems to keep track of merchandise. Practically, every item you find for sale in a store will have its own unique SKU—whether it's the grocery store or the record store.

For us in gaming, it can mean additional income to the insightful content provider. Not only could a game be released on a different platform as another SKU, but say the same PC game is translated to another language for sale overseas, the game could be identical in every respect except for the language—and this SKU could earn you income if your music and sound effects are used in it. While technically it won't be issued a distinctive code for sale in the United States, it's considered a different product and could earn you additional monies.

Ancillary Rights

Ancillary rights pertain to the usage of content outside the project it was originally intended. Music and sound effects for games occasionally stray into other domains, such as TV, film, and CD soundtrack releases—far from the original purpose of their creation. When working under an agreement to compose music or create sound effects, the intention is to conceive these original pieces for the video game only. This is as far as they ever go most of the time. But the billion-dollar video game industry is far-reaching, and there will be instances when music you've composed or sounds you've designed will appear outside the boundaries of the game.

"Earthworm Jim" is an example of a video game character turned Saturday morning cartoon star. Tommy Tallarico had done the music for the game series, and because of his negotiation prowess, he was also paid when the music was used in the cartoon series. The game company owned the music rights in the game, but Tommy had included an ancillary rights clause to split any net profits earned by his music outside that game. Bobby Prince of *Doom* fame had also negotiated ancillary rights to his audio work in the game and was compensated after a few sound effects appeared in several movies. This type of agreement allows the composer and sound designer to continue to collect the benefits and rewards of their efforts when their work appears outside the games realm. While it isn't quite the standard in the industry, enough game composers and sound designers are including it in their agreements that it is becoming more and more commonplace.

Bonuses and Royalties

Being part of a blockbuster game project is like winning the lottery. It's never anything we plan on. After months of putting our blood and sweat into the music and sound obligation, we normally part with a nice paycheck and thanks for our efforts. Occasionally, a game does so well that it breaks sales records around the world. In cases like this, it isn't enough to just be part of the winning team; it has to be in your contract for you to receive a bonus or royalty payments.

Bonuses are usually more palatable for a game company. For example, if their break-even point on a game is 60,000 units, a bonus after 100,000 units sold is a comfortable margin and the game company shouldn't have a problem with sending additional money your way. They can be set up in various stages, say a $10,000 bonus after 100,000 units, a $25,000 bonus after 250,000 units, and so on. It's completely up to you and the company during contract negotiations. Bonuses are easy to calculate and audit because they are based solely on the number of units sold.

Royalties are payments of a percentage of sales, usually made in quarterly installments. Unlike the music industry, the games industry usually turns its nose up at this type of arrangement. Calculating payments demands too much bookkeeping and time. It's not unheard of—just not a pleasant experience for the game company. If they scoff at the idea, consider the next option.

A more "planned" form of royalties, similar to bonuses, are straight percentages. These payments are calculated from net profit, after the game company has recouped its costs and has had a reasonable return on the investment. Like bonuses, payments can also be structured in stages based on the number of units sold or the amount of money earned in increasing levels. The percentage could also be established at a comfortable number past their break-even point. An acceptable figure in the industry for established game composers is 1%–1.5% of the net profits.

NATHAN MADSEN
Composer, Sound designer

I'm a composer/sound designer who's worked on various projects such as *LEGO Universe* (PC), *Ninjatown: Trees of Doom!* (iOS), and Anime IP like *Dragon Ball Z* and *Full Metal Alchemist*. Most recently I've worked on *MechWarrior: Tactical Command* (iOS), *Threads of Mystery* (Facebook), and *Dragons and Titans* (Facebook). I got my start at FUNimation Entertainment then moved to Denver to join NetDevil. After the company closed, I started freelancing full time with my company Madsen Studios LLC. I also teach private piano lessons and record live symphony concerts in Aurora, CO.

http://madsenstudios.com

Describe your thought process for creating music and/or sound effects.

The first thing is to learn as much about the game and it's worlds as possible. This helps you get the right look and feel for the audio. Secondly, you need to know what device(s) it's going to be on. This helps you narrow down the processes needed and the type of files you'll be supplying. In other words, you're most likely not going to do a 7.1 surround mix for an iOS game. Thirdly, I like to give my clients options. In other words, more audio than was requested. This gives the client more options as well as more references, which can really help with feedback.

During production, I work very closely with my clients. I prefer to give consistent updates, so the client is actively involved in the audio production. This way I stay on the mark and on schedule. Guy Whitmore recently said, "Play it, don't say it" at a GDC talk, and I completely agree! Show your client how awesome the audio can be in a mock up then work with the team to make as much of that a reality. This is usually more powerful than design documents, which can usually go unread by most of the team.

Are there any particular secrets to your creativity?

To be honest, I struggle with inspiration (i.e., being creative) outside of freelancing projects. Part of this is because much of my time is spent working on audio for others which doesn't leave much left for personal projects. Another factor could be that clients often have deadlines and restrictions. It takes more discipline to stick to deadlines and restrictions on personal projects. So, to answer this question directly, once I'm working with a client I get super excited which helps my creativity.

To maintain that creativity, I really pay attention to my body and mind. If, during production, I get into a slump and start to get stressed or tired, I take a break. Play a few video games or watch a movie. Go for a jog. Work out. Even sleep! It's amazing how changing your surroundings and situation can reset your inspiration and help you stay creative. Eating healthy, working out, and trying to get enough sleep also really helps you turn on creativity more consistently. It's not always possible, especially during crunch times, but the better you take care of yourself, the better you can perform under tight deadlines.

Are there any secret techniques that you regularly employ?

It's going to sound like a boring answer, but I seek out YouTube tutorials regularly. I also keep a steady line of industry books in my reading queue. I don't even consider these techniques as "secret" because there's so much public material out there for us to learn. During my downtime, I make mock up trailers and videos to keep learning new things. Now that I have a child, my free time is even more limited. If I didn't set aside time to learn and study new techniques and gear, I'd never get around to it. Time management is so critical to keep up with the fast pace of our industry.

Do you have any advice which can help lay solid groundwork and ensure a successful production for the audio content creator?

Get audio involved as soon as possible! In the beginning, it could be talks about what could be done with audio or passing around reference tracks. Don't let audio be the last minute add-in that it commonly can be. If you're getting some push back from the rest of the team (i.e., we're too busy with X, audio doesn't matter, we'll do that later), then I'd recommend you put together an awesome mock up that shows what intentional (rather than last minute) audio could be. Get the rest of the team excited about the possibilities then work together to solve any tech/production hurdles.

Be fluid. Be willing to revise. Be a team player. Go beyond the expectations.

When do you find you are most creative?

Having a baby now, I'm finding I have to squeeze my creative periods into whatever slots I can find. These days that's normally from 9 a.m. to 4 p.m. on most weekdays with the random late night or really early weekend morning thrown in, as needed.

When those crunch times come along, I work longer hours and my wife and I tag team with our son. Usually, the adrenaline is already pumping by the time I get to a crunch period, so it helps with energy and creativity. And if I'm really tired, a Kit Kat and Coke does wonders!

Any worthwhile creative advice you'd like to share?

It really comes down to taking care of yourself, in my opinion. I've seen some folks really push it and work on little to no sleep. In the short term, this is fine and we've all done it. But it's not sustainable. If you take better care of the physical side, then the mental side will usually be up for the creative challenges. If not, seek what inspires you to recharge your batteries.

Also consider your workspace. What setting helps you be the most creative? A cluttered, dark room? A bright, clean, modern room? Hardware versus software? Posters or toy figurines? If you're not sure, experiment with what setting helps your muse the most. It really does make a difference.

Is there a typical workday for you?

After dropping my son off to daycare in the morning, I usually workout then get right to work. During the day, I'm bouncing between various projects—from music to sound design to voice-overs. I work as much as possible until 4 p.m. when I have to go pick up my son.

What skills should composers have to succeed in the games industry?

Making great music is just the base level, just the beginning. You also need to be able to sell yourself and your ideas. Having some knowledge of game audio (i.e., how it's implemented, what are the limitations and advantages, what's the gaming culture) can really be helpful. If you're freelance, then you need to be able to read and potentially even write contracts. Negotiating the terms well and making your client trust your abilities and talents is key to success. Sometimes, you have to be political. This doesn't mean being fake, but it does mean getting people to sign on to your vision and your approach. Also, if you're freelance, then you'll need to handle all of the financial aspects like keeping tax records, handling purchasing new gear for the studio, and invoicing clients. It's a wide range of hats to wear, but it definitely keeps things interesting from day to day.

The great thing is most of the skills carry over into other branches of life. They're people skills. Games are a collaborative effort. Be able to work with the team. Be someone you'd want to work with! Be memorable!

Do you have a specific ideology which drives your way of doing business?

My ideology is very simple: Give the client more than they expect, sooner than they expect it.

This mantra can look like many different things, and there's not just one approach to it. Be creative and look for ways to make yourself (and your work!) stand out from the rest.

Any good business advice to offer?

The best advice I can give is to remember how you felt when you had a bad experience with a business. Remember how they failed and learn from that. Do everything you can to not be like that bad business. Nobody is perfect, and you're going to make mistakes. But if your clients realize you're doing the very best you can, often they'll give you more slack when the "uh oh" moment comes.

Another tip is to always treat your business model as fluid because our industry is definitely VERY fluid! You'll be more successful if you adopt more modern, proven techniques, and be able to show flexibility in how you coordinate with your clients.

Any horror stories which have impacted how you do business?

I've had my work stolen from me a few times. It always burns and really makes you question humanity. But thankfully, this is a very small fraction of my work, and each time I've tried to learn from my own mistakes. Each time I've implemented new steps and safeguards to try and prevent future instances. Paying a few hundred bucks for a lawyer to proof your contract can really help!

How do you approach negotiations with a new client?

Negotiations come down to trust, basically. So, I try to make the client realize that I'm the right person for the job and that I'm willing to compromise on terms to make it a mutually beneficial situation. Stressing that nothing's written in stone (at least not yet!) seems to really

help. But keep things in balance when negotiating. You don't want to work for peanuts or end up with a bad deal. In the end, it's all about creating a mutually beneficial compromise, which leaves both parties happy.

You want to come off as interested and invested but not desperate. Desperation doesn't invoke trust.

Do you have any negotiation tips which work well for you?

Give your client options to choose from, so they can see what best fits their needs and resources. Also, make your bids modular, so they can opt for more content if the budget is available.

Make your bids transparent, so they can clearly and easily understand your costs and their options.

Do you have any contract stories which others could learn from?

Early in my career, I worked on a middleware development project. The company ran out of money and offered me extra back pay if I kept working for them. I trusted them and kept making more audio. Big mistake. I never saw any more money, and the company attempted to void my contract because they didn't want to pay any longer. So, my advice would be to stick as closely to the contract as possible. If the situation changes drastically, it's better to end the current contract, settle any outstanding balances then attempt to make a new contract that reflects the new situation than making addendum after addendum.

The old saying KISS (Keep It Simple, Stupid) comes to mind!

Do you have any tips when working with developers?

Follow Guy Whitmore's mantra "Play it, don't say it." Give the developers a full idea of your audio vision in a way they can experience instead of reading a design document. Most of the time design docs are never read anyway.

Give them plenty of options, especially when it comes to sound effects. Having just one sound effect can invite the third degree of critique when, in reality, it may not be that noticeable in a fully realized sound environment. I remember hearing a story about producers giving a footstep sound the third degree because it was the only sound in the game build for a bit. The audio team had to stress that once more of the soundscape was in place, the footstep sounds would make more sonic sense.

What advice can you give when working with a developer which has ensured a good working relationship and a good final product?

I like to include the client in my work as much as possible. I've heard of a few audio directors/teams leaving the client out intentionally until last minute to give them a full vision but often means it's too late for changes. I disagree with this approach and would rather have a collaborative effort from all involved.

If your developer doesn't know how to "talk" audio (and many do not), then go after the emotions you want the player to feel. Seek out references from other projects, which the developer feels has the right feel and mood. Also, remember to bring a bit of your own vision to the table. It all goes back to playing it, not saying it. Oftentimes, the best discussions about game audio are actually NOT about game audio. They're about the story, characters, emotions, and moods of the game. Leave out the specific terms (like glissando, crescendo, arpeggio) because it's likely your teammates won't have the knowledge or the mind's eye to really understand

what you're discussing. But almost everyone understands anger, joy, mysterious, spooky, or quirky.

What advice can you give when working with a developer to ensure you are able to make great sounds?

Really push to have video capture or animations to create sounds. I've had some clients push back saying the team was too busy or that they wanted me to do video captures. This is a bad idea for several reasons but mainly because I may not know which animations are ready for sound and which ones are not. Also, I had a project one time, which didn't display all of the animation to the player, therefore making my video capture not as useful. If you're getting push back from the clients, then say "sure, I can do video captures for X amount per hour." This is usually enough incentive for the client to suddenly find the free time to do video captures.

Having animations or video capture from the client directly helps ensure you're working on finalized, ready-for-sound assets.

Do you have any advice to ensure successful audio implementation?

This can be really hard to do when working freelance. I play the builds often and give notes to the client, but honestly, you're relying on someone else to make those changes. That person may be super busy or even worse, not really concerned with the audio experience! If possible, I specify in the contract that I'll be involved with implementation. Either as a consultant or hopefully as the implementer! Thankfully, I've had several clients bring me on site to do implementation to get the best results. Often, however, clients want to keep their builds protected from outside freelancers and do the implementing themselves. This is where really good, steady communication is key. There are several ways to do this: spreadsheets, emails, phone calls, Skype, etc. Find a method that works for both you and the team to keep communication fluid and up to date.

Staying organized is important, especially if you are working on multiple projects, which is part of your daily routine. How do you keep up with it?

I use the Notes program on my Mac to help juggle multiple projects. This helps with the high-level view of things. Then, on each individual project, there are specific programs/approaches are set up by the client or by me to help keep things organized.

Any specific "lessons learned" on a project which you could share?

Stick to the contract as best as you can. Be flexible and work with your team but avoid situations, which can change the working agreement too much. An example would be if a team runs out of money and starts promising back pay at some later date but still wants you to keep working. Most of the time, you end up working for nothing.

There are many pitfalls when "working" in the game industry. Have you had any bad experiences?

Working in-house is very different from freelance. So, for those of you working in-house jobs, I'd suggest you read up on office politics. Even in a career as casual (in terms of dress and sometimes structure) as games, office politics can make or break you. These are people skills, which carry over into so many other arenas, so it's a very worthwhile study!

Another pitfall is how often studios/teams are being let go. I've seen friends move from town to town every 3–4 years. This can be really hard, especially if raising kids. This is the

primary reason why I decided to become a vendor (i.e., freelance) instead of joining another studio.

How did you find your way into the games industry?

I started out as a regular music education major in Texas. I'd always been a gamer and a music nerd, so it was natural to try to find a way to combine both passions, but I had no idea how to approach the business side of things. During my second year in graduate school, I came down with a really bad case of walking pneumonia. This gave me two solid weeks of staying in my room and hacking up my lungs. It also gave me the chance to read a new book I had just purchased: the first edition of *The Complete Guide to Game Audio* by Aaron Marks! It really inspired me and filled in many of the gaps related to contracts and the business side of videogames. After trying out public school teaching for a little while, I created a website which featured some of my work and tried to start landing clients. Exactly 1 year to the day, I landed my first in-house job at FUNimation Entertainment. I was there for about 2 years before going up to Denver to work as the music and sound lead on LEGO Universe with NetDevil.

Any other advice you'd like to share?

Have fun! People can tell when you're enjoying yourself and passionate about your work! It shines through your audio and your personality. Also, always be learning. There's a lifetime, actually more than a lifetime's work, of material out there to learn and master. Never feel like you've mastered it because, trust me, you haven't. Even the best pros out there are still experimenting and learning new things.

Always dream of what can happen next then take steps, every single day, to making it happen!

Normally, bonuses and royalties are negotiated by game composers who do music or both music and sound for a project. It is less common for a sound designer to negotiate bonuses and royalties for sound effects only, but not far-fetched. I, as a sound designer, wouldn't consider asking for a bonus on smaller games where I only do a couple dozen sounds. For major game releases and hundreds of effects, that would be a different story. It is entirely dependent on the situation. But, it never hurts to ask. The worst that could happen is they say "no."

Deals with publishers will be more lucrative because they've got the bigger pie. That pie, in turn, gets divvied up among the developer and everyone else associated with the project. If you were to make the deal directly with a developer, unless they are self-publishing the title, you would be negotiating for a piece of their smaller slice of pie. Most of the time, the developer has to consult with the publisher when royalties and bonuses are brought to the table anyway, so why not just deal with them directly on the matter?

Property Rights

To further complicate matters, we can sell music to a game company but keep the property rights to release it as a soundtrack. It is similar in theory to negotiating ancillary rights, but this endeavor won't be split with the game company. "How can that be?" you ask. A game company is not a record company; they aren't set up that way, and they don't understand the intricacies associated with it. They sell games. They distribute games. They do not sell music. There are record companies set up to duplicate, market, distribute, and sell game music, and its success can be attributed to their years of experience. If I were to release music I'd worked

hard on and was proud to share apart from the game experience, then I would want to go with the outlet with the most potential.

Still, the music will be associated with the game it was created for—and having the game company's support will make the experience much easier for both parties. While they may be reluctant at first, once they see the excitement your efforts bring to their product, they should be thrilled. You will shoulder the risks entirely—covering all the costs of the soundtrack release, handling all of the details, and never involving their time or resources in the process. They take no risk whatsoever and reap the advertising benefits and hype your efforts create. They'd be blind to miss the potential rewards of this type of plan.

But, if for some reason the developer still has issues with releasing the property rights, consider a compromise and offer them a 50/50 split of the revenue as an enticement. In return for their shared commitment in the up-front costs associated with a soundtrack release, they can share in the benefits of any sales without expending any effort. What business wouldn't be interested in making money from someone else's work? And, you'll have the possibility of increasing your earnings on the same music. Whether your costs of production, duplication, and packaging can in fact be recouped for putting a soundtrack together, by maintaining the property rights, you'll at least have the option if the opportunity presents itself.

Talent Releases

Whenever guest musicians and voice-over talent are involved on a project, it is always a good idea to have them sign a talent release. This legal document releases all of the interests and legal rights of their performances to you, the contractor, and/or the game company. By doing so, the developer can be assured their interests are protected and that someone who may have played a small role in the overall production doesn't come back years later, after the game is a hit and sue for more money. In most cases, these documents are a requirement and will be a part of your contract to ensure no one else has any interest in a piece of work but you.

These documents also serve as a mini-contract for your guest talent, outlining the services required of them, how much they will be paid, and any other specific points unique to the project. Professionals expect to sign such paperwork, and they understand the need. Others, not as accustomed to the particulars, might not be as willing to part with their signature and may need some gentle persuasion. Be careful to not get into a situation where your hired talent doesn't sign the release. If you use it in the project, it could lead to more trouble than you are willing to deal with when the developer comes looking for you down the road. Make the agreement plain and simple; either they sign the release or they don't get paid. Period.

> Be sure to check out the sample agreements and contracts in this chapter and on the companion website (www.crcpress.com/cw/marks).

Negotiable Contract Points

When negotiating contracts, the sky can be the limit. The process generally hinges directly on the personalities involved on the two sides—what their interests are and how creative they want to be when solving issues. Simple and reasonable requests can be taken care of easily, but difficult issues can take weeks before reaching some type of consensus—leaving behind tension and ill will.

During contract negotiations, your general concerns will be how much work you need to do, how much time you have to do it in, and when and how much you get paid for doing it. In most simple gaming projects, there won't be much more than that. We are gearing up for the larger projects—where you work hard, get paid well, and can receive additional rewards for your efforts. There is much at stake for game companies and for you, which is why we need to be smart when dealing with these types of situations.

Part of being "smart" is knowing and understanding what contract points are acceptable in this particular business. The items discussed next are by no means all-inclusive. We will cover some serious ground, but in order to get it all, I'd need to write another book. For those of us who are imaginative with contract negotiations, there will be many "one-time" opportunities that present themselves, and it will be up to you to take advantage of them. It will simply become another natural part of doing business.

Money

The primary negotiable contract point is money—mainly how much you will get paid and by what method. Much time can be spent dancing diplomatically around this particular issue. You know your costs and what you would want to make on the project. This is the leeway you have to play with during negotiations. Assuming the game company had you bid on the project first, they also have a good starting number with which to work from, too. You heard right: "starting" point. Don't feel compelled to stay with your original figure to avoid looking greedy. The parameters of the project might have changed several times since your original bid submission. You will need to adjust your price accordingly. They need to understand that it is due to their changes, not yours. Be ready for it.

Once a game company brings you in as part of the team, they tend to begin coming to you for everything: advice, favors, and other trivial audio matters. They may think it would be cool to have audio for their company logo. They may need a sound effect for another project and will ask you to do it. They will call on you for almost everything, and while it's certainly okay to do these kinds of favors, you need to be aware it will be taking time away from other valuable moneymaking endeavors. Keep this in the back of your mind during negotiations and bring it to the table to justify your request for more money if they challenge your figure. Remember, they are a business attempting to keep as much money in their pockets as possible—and since their bottom line is the most visible to management and investors, their need to justify expenditures is tremendous. These "favors" can tip the scale in your favor.

If the amount of money you request for the project becomes an excuse for them to find someone else, concede this "deal ender" and consider making up losses in other areas. If the amount of initial cash outlay is the problem, change the amounts of milestone payments to their liking—with the later payments being the highest. Or, negotiate your payments, bonuses, or royalties from their incoming receipts instead of from their operating capital—or negotiate equivocal services; perhaps artwork for your website, programming a simple interactive demo for your promotion package, website hosting, or maybe even a trade for some computer or recording gear they have lying around. If there is a problem, work together to solve it instead of facing each other unblinking from opposing ends of the table. By being flexible, you will gain points to use during other issues of the negotiation.

Licensing

As mentioned earlier, most game companies insist on owning the music and sound effects created for their project. Under a work-for-hire agreement, this is clearly stipulated and will give you the impression there is nothing left to negotiate. Again, we could not be further from the truth. Everything is still completely negotiable! There are many types of licenses in this type of work—more than we could ever cover sufficiently. Whatever you do, during discussions about licensing, be sure to keep your options open and ready for anything.

If a game company complains your prices are too high for the buyout option, suggest they license your music and sound at a lower cost instead. You'll recall that by licensing your music, they don't have ownership—just a license to use it in their work. You would still retain full copyrights and could sell or relicense the work to others at your discretion. Smaller game companies who end up licensing work will negotiate an *exclusivity agreement* that states the music won't appear in any other video game application or does so only after a predetermined length of time has expired (usually a year or two, depending on the life expectancy of the product). You can be very creative here.

Another licensing issue could be your right to self-promotion; that is, to use works you created for demonstration purposes. If a company opts for the full buyout, they own the copyrights—leaving you begging permission to use your own music. Seems silly, I know, but that's the way it is in the big world. Under normal circumstances, they have no qualms letting you promote your work and will license the music back to you for this purpose. They will never volunteer it though. It will be something you have to ask for because it is serving your interests and not theirs. Here's an example of wording you might use for this application:

> Right to self-promotion. Contractor has the right to self-promotion and is allowed to use, as creator of said works, any works created under this contract, to demonstrate the capabilities of contractor either in demo reel or computer file format at any time after acceptance of the work as final, without any further permissions required from company.

Platforms

You sold your sonic masterpiece to a game company for a PC project and you assume that is that. Wrong again. What if they port it to the Xbox One, PlayStation 4, or the Wii U or make an arcade game out of the darn thing? Would you get compensated for your music and sound effects ported to these new versions? Unless you had it in the contract, the answer is a heartbreaking "No!"

Did you know there are people whose sole job in life is to take another composer's music, reperform, rerecord, and convert it to a format compatible with another gaming platform? Why are they paying someone else to do it when they could be paying you instead? Why wouldn't they want the original composer to redo their own music in all its glory? Who knows. In order to protect this future income, have it as a contract point—stating you will do any conversions needed to port the music to any other game platform they request for an agreed-upon sum. Assuming the music was great in the first place, you are assuring them that the same quality and feel will be accomplished in the new format—maintaining the high standards originally set forth. Another person's interpretation of your music is an unknown; you risk ruining the entire audio mood of the game. What would game developers rather have: the original composer recreating his

heartfelt masterpiece or someone else coldly regurgitating musical notes for a paycheck? Remind them of your value and get it in the contract.

SKUs

Almost hand in hand with the platform issue is the SKU. Don't walk away knowing they plan to release the project on other game platforms and in other languages to be sold internationally. Are you crazy? The company intends to make fistfuls of cash by releasing the game in several different versions using artwork, programming, and sound already paid for. Except for the cost to port and repackage, their profit margin is huge. What do the original creators receive for their hard work and dedication? Nothing, unless they negotiated this point in the contract. Get it in your contract!

> SKUs, next to royalties and bonuses, allow the greatest income potential you can realize.

In order to take advantage of this potential moneymaker, you'll have to negotiate that the music and sound effects you create and sell to them are for the *primary SKU only*. If they use it in another, they have to pay you for that right. Big games, with average budgets in the millions of dollars, will cost a publisher roughly $200,000 to port to another platform. After much market research, they know this SKU will make a hefty profit for them or they wouldn't have wasted their time doing it in the first place. Do you think they would really care if you asked them for an additional $10,000 for every SKU your audio appeared in?

With large budgets, this is just a drop in the bucket and won't affect their bottom line whatsoever. But they will probably resist, saying they've paid you for the audio, it's their property, and they can use it, however, they like. Until you sign the contract, it's not their music—so you would really be arguing about nothing. If they intend to make other versions of a game, using your audio and making a handsome profit for themselves, why couldn't they reward the hardworking creators who made it happen for them with a measly 10,000 bucks? As an enticement, you can offer to make any necessary conversions for that fee, saving them the cost of having someone else do it. It then becomes an "extra service" you perform, and they can justify it to the bean counters. If $10,000 is still too steep, after you've exhausted every argument, consider dropping it a couple thousand—but don't ever give it away for free.

Ancillary Rights

Occasionally, other moneymaking opportunities present themselves outside of gaming. If the popularity of the game spawns a TV show, cartoon, or movie, chances are your music and sound will be licensed as part of this new undertaking as well. Who gets paid for it? It depends on what's in the contract.

As mentioned previously, ancillary rights are not standard in the industry yet. For the big composers, however, it is more so and the practice will eventually trickle down to everyone else. One of the ways to achieve this is to make it a standard request for each contract. Eventually, when a game company pulls out their contract for signature, this clause will already be there. After every composer they've dealt with brings it to the table, they'll catch on and save some time by just doing it up front. That will be a nice change.

For those who regularly negotiate this point, the usual agreement is to split the net profits derived from the reuse of your music and sounds 50/50. Because

they will be spending money to make these new endeavors a reality (hiring lawyers, additional marketing, and administrative chores), it is appropriate to split the money *after* they've recouped their costs (i.e., the net, not the gross income). Divvy up the profits more in their favor if need be; say, 60/40. If you are open to some give and take in the process, you can still walk away with a tidy sum. Or, you could hold fast and lose the deal completely. It's a fine art indeed.

The same goes if they decide to release your music on a soundtrack CD. You can either negotiate to split the profits from this type of product or try another tactic: negotiating the property rights to release the music on your own, which we'll talk about shortly. The direction and the mood of the proceedings depend on the personalities at the bargaining table, which points they hold fast to, and what your needs are to secure fair compensation for your work. If they don't like splitting their profits with you for a soundtrack release, consider doubling your fee to make up for the lost income potential. An example: If the CD of your music sells 100,000 copies, your potential income could be $250,000! Doubling your rate from $50,000 to $100,000 for complete buyout on the project might seem like a lot to them, but it won't come close to the possibilities of what your hit game soundtrack could do in Japan or Europe. Consider what worldwide sales of your music could bring to the publisher, and it seems ludicrous not to share in the fortune.

Bonuses and Royalties

There are many ways to proceed when dealing with these types of contract points. Generally, the easier you can make it for them, the more willing they will be to agree to your terms. They shouldn't have a problem spreading the wealth to the people who helped make the game a success, and as a composer and sound designer, you are responsible for a third of the total game experience. Good businesses appreciate the contributions from the creative team and will reward them accordingly. Others, more concerned with squeezing every bit of profit they can from a game, will be less likely to. If you have the misfortune of running across the latter type, you will have to work much harder to convince them you are deserving of more compensation. If it becomes a heated contest, then consider walking away from the deal—because at this point, it has all the signs of a rocky relationship and no money in the world would be worth it.

Royalties are not common, so the path of least resistance would be to request structured bonus payments as the alternative. Instead of requesting a percentage of their income from the game, which becomes complicated back in their accounting department, suggest bonuses based on the number of units sold. All you have to keep track of is how many of the darn games they've sold and if it has passed one of your negotiated milestones. Simple enough. And, because this money is from incoming receipts and purely based on sales figures, they are assuming no risk and will lose nothing if a game doesn't sell well.

To establish your bonus structure, you need to know their break-even point and then set your first installment at a comfortable level above it; say, 75% to 100% more. As an example, if a game's break-even point is 60,000 units, it would be acceptable to ask for a $10,000 bonus after 100,000 units had sold, $20,000 after 200,000 units, and so on.

Because these negotiations are happening prior to any work being done, this incentive can have a direct impact on how well you do your job. If they've set a generous payment schedule in front of you and correlate your creative efforts with the success of the game, you will be highly motivated to do the best work

you've ever done. With that kind of backing and trust, you will naturally step up to the plate and hit a home run! Psychologically, it is an incredible boost to your creative powers and you will strive to make this game a hit. Remind them of this, as part of your presentation. Let them know what you can do if properly stimulated. Or, explain what the opposite effect will have. While you are a professional and can provide high-quality music and sound effects regardless, the lack of inspiration and the sense that the company is just a sweatshop will have a dramatic negative effect.

Property Rights for Soundtrack Release

As a composer, it is essential for our success and business well-being that a music soundtrack CD is released. It is the type of national exposure and moneymaking potential that may have enticed you into the music business in the first place, except that we are accomplishing it now in the games industry. If the sales potential exists, you or the publisher will want to do it. Either way, your music has to be able to reach the masses and this is the perfect method. If acquiring the ancillary rights and splitting the gross profits for the soundtrack do appeal to the game company in question, perhaps they would be willing to let you try your hand at releasing one instead. It won't cost them a cent, and they will take absolutely none of the risk while gaining the marketing and exposure advantages. Unless they have plans to release a soundtrack in the works already, there is absolutely no reason they couldn't let you give it a try.

Name Credits, Logos, and Splash Screens

Naturally, after all of this effort, money is not the only thing you want to negotiate. There are many other points to take advantage of which will increase your business and name recognition. There is no better advertising for your services than the music and sound effects you've proudly created presented within a game. For vanity's sake, millions of people living the experience your audio creates is an uplifting event. For marketing sake, having other game developers researching and playing these games, hearing your efforts, is the best "demo" you can offer. When game companies decide to do a project, they generally examine every other game in the genre. Wouldn't it be great to have them discover the perfect composer for their new production in one of these games? Of course, it would!

Now, in order for future clients and fans to know who did the amazing audio, it has to be seen somewhere. Don't take this point for granted, thinking they will automatically give you space on their credits page. Most companies do attempt to give credit where credit is due, but just to make sure, have it in your contract that they will, at a minimum, include your name in any printed or on-screen credit sections. Take it a step further and have them include your contact information or web address, too.

You can also request to have your name and logo on the box cover and as one of the opening splash screens while the game is loading. You can't beat the value of your audience anxiously awaiting the game to start and seeing an entire screen with your name on it, something like: "Music and sound effects by award-winning composer…." It also builds excitement just before the curtain is opened. Psychologically, it will even make their perception of the sound better because, obviously, this sound guy must be good if they have his logo everywhere! TV and film always give a full screen to the key players, so the public is accustomed to this method of presentation. For the rest of the game, the player will be listening

a little bit closer to see who this notable personality is. That's what you want—to be noticed!

At this point in time, there are not many composers and sound designers requesting their name or logo on the box cover or on the splash screen. And, to tell you the truth, I believe it's just because they haven't thought of it yet. Here's a chance to get a leg up in the marketing department if you're in the mood. Game companies don't mind flashing a small picture file or sparing some pixels for your name on a splash screen, but logos on box covers may be another story. PC game boxes have generous real estate to accommodate 1/4-inch by 1/4-inch logos. Xbox, PlayStation, and Nintendo boxes, CDs, and game cartridges are much smaller, and it's usually not possible to squeeze them on even if they wanted to. What little space there is they keep, and it will be fought over ferociously in-house between their marketing, art, and sales departments. In cases like this, push a little harder for that splash screen because it will probably be all you can get.

Final Authority

It is extremely important to have the person who has final approval of your work identified and that person's name put in the contract. Why, you say? Because you want to get paid, that's why! Otherwise, decisions will be put off, waiting for someone else's opinion, and it will go around and around in the company until the game is published. No one wants to take sole responsibility. There are many creative people with varied opinions involved during development, and it is impossible to please everyone. Have one named individual who can give "thumbs up" to your submissions, going on their own gut instinct or after taking a poll, allowing you to meet milestones and get paid according to the schedule in the contract.

Here's another war story for you. I've had a couple of companies whom I've done sound for call me up in a bind and need some sounds done within a couple of days. I jump on it, fire them off, and then never hear a thing back. After a couple of weeks, I start to wonder and grab the phone to find out they are beta testing or waiting for the company president or something else to happen before they make the decision on which sounds they will keep. Weeks turn into a couple of months and still nothing. Finally, after about 3 months, now that the game has been released, I find out what I need to know and send an invoice. A lot of work to be paid for a dozen sound effects, and by the time the check arrives, I've forgotten what project it was for. If we'd agreed upon the final authority at the beginning and in this case, changed my billing method from "per sound effect" to an hourly rate and billed them immediately, we both could have saved the extra effort.

I work best knowing who it is I'm trying to please. Ultimately, it is the game player, of course, but in this business, it will normally be the executive producer or creative director or someone high up on the project's design team. You'll have to work closely with this individual, and it will be important to know their thought processes, what they need to make the decisions, and how best to keep them happy. There is a bit of "schmoozing" involved, but the definitive test will be the quality of sounds you submit. If they get the sense you are working hard, they'll feel they are getting their money's worth and are more apt to use sounds and music you've submitted instead of having you redo them.

Navigating Negotiations

Musicians and sound designers are not generally taken to be serious business-men. The free and easy lifestyles we supposedly live make us a little too "wild" for the business world, and we are quickly pigeonholed into this category. One of the unique traits that set game composers apart from the rest of the musician world is that we do have a fairly good nose for business, which we have to have in order to run a successful company. But the stereotype is so well entrenched; you'll have to try much harder to prove yourself.

The demo package is the game company's first look into what we are about. The bidding process is their first chance to see whether we have some brains to go along with our creative genius. The contract negotiations will set the tone of your business relationship, whether you are the whiny prima donna artiste they originally feared or a professional service provider with a good sense for business and honest concern about the product's success.

Normal contract negotiations start by the person who brought you on board (usually the game producer) faxing or e-mailing you their contract. You spend a few days looking it over—talking with your legal advisor, adding your points, countering with your version, or simply signing. If you did have something to add, they'll mull it over, talk to their legal people, hem and haw among themselves, and counter with their new version. At this point, you will find it much easier to just pick up the phone and talk directly to the producer. E-mails can cloud the process, becoming too time-consuming or harmless comments can be taken out of context, unintentionally offending someone. You can safely discuss the points which are most important, reach some sort of agreement, and then wait for their legal department to give the final okay. Once they've finalized the contract, you'll sign it and then get down to what you've been hungry for: making music and sounds. Simple enough.

The more complicated negotiations may require you to fly to their office with your team and meet face to face with a boardroom full of their people. It doesn't actually happen as much as you'd think, though, so don't get nervous. Be prepared for this possibility only when you start dealing with large companies with large budgets and large global interests.

A Real-World Negotiation

Out of the dozens of contracts I've negotiated, there was only one which didn't go very well. Most of the time, it's a simple business affair with the two parties calmly and professionally discussing the needs of both companies. We resolved them amicably and moved on with our lives. This particular example was definitely a case of big egos on their part and concrete stubbornness on my part, and in the end, we both walked away—they without sound for their game and me without a contract. I mention it here as a real-world case of what can happen when the two sides can't see eye to eye. Maybe we can both learn something.

I was called to a game developer's office to discuss a work-for-hire contract with the company's president and executive producer. The game was funded by a big name in Hollywood and, on the outside, looked to be a promising title. It was to be released for the PC and PlayStation simultaneously, with later plans for a Nintendo version. We were still 1 year away from the expected release, and it appeared I could accommodate the project in my schedule. It looked like the kind of game I wanted to be associated with and I was anxious to get to work.

Tools of the Trade

DARRYL DUNCAN
Composer, Sound designer, President—GameBeat Studios

One of the things that has changed and evolved so much in the gaming industry besides the industry itself is the technology used to create the music and sound effects. The most obvious and profound change I believe is how music creators have gone from a mostly "hardware" production environment to an almost exclusive computer-based software environment. Having been creating music for a living since 1986, I have been a hardcore proponent of hardware production, not that I have had much of a choice in 1986, but I have witnessed firsthand the evolution of music technology and how it has gone 98% virtual. Nowadays, the only hardware items you need in a powerful and capable music production set up are the computer, a controller keyboard, studio monitors, and an audio interface. Outside of that pretty much, everything else can reside in the computer.

Today's virtual instruments, soft-synths and drum modules are absolutely incredible and in my opinion have evolved to be far more powerful, flexible and feature packed than yesterday's hardware counterparts. I am working currently almost completely virtual, and I feel I have more production power and sound sources at my disposal that I ever have in my entire music production career.

Computers: Two ProTools 128 track HD3 Accel digital multitrack systems, Two Apple Macintoshs—MacPro 12 Core workstations—w/32GB of RAM, Two Windows Pentium 4—3.2 Ghz Machines

Peripherals: Four—2 Terrabyte Cheetah 10,000 rpm Drives for ProTools & Two—750 GB Utility drives, 4 1 Terrabyte FW Drives, DLT 70GB Backup & Archive Drive, Iomega Rev BackUp Drives, Jaz Drive/Glyph CD Burner

Software: Ableton Live, Reason, Intakt, Reaktor 5, Absynth 3.0, B3, Kontakt, ReBirth, ACID, Bias Peak, Opcodes Studio Vision, MOTU Digital Performer, Cubase VST, Masterlist & Adaptec Toast CD Burning software, enough ProTools plug-ins to make anything sound like anything!

Monitors: Event 20/20 Monitors, KRK RokIt 300 Watt Powered studio Monitors, Event 800 W SubWoofer, Yamaha NS10's

Mics and preamps: Neumann 147 Tube Mic, assorted Tube & Condenser Microphones, TC Electronics—Gold Channel Mic PreAmp, United Audio Mic PreAmp

Synths/sound modules/VST instruments: AKAI MPC4000 OSv1.71, NI Maschine Studio, NI Maschine MKII, NI Komplete 9 Ultimate, Yamaha Motif ES7, Roland Fantom 8, Roland XV-5080 128 voice Synth Module, Kurzweil 2500RS, Korg Triton Rack, Virus TD Manalog synth, Yamaha RM1X, EMU Vintage Keys, EMU Orbit, EMU Planet Phatt, Alesis D4 Drum Module, Roland-U220, U110, S770, S330, JD800, D70 & MKS50, Ensoniq SD-1, Sequential Circuits Pro1, Korg EX800, Akai MPC60-Modified, Roland R8 Drum Machine, Korg S3 Drum Machine, EMU SP-12 Drum Machine Sampler, Sample & Loop CDs (too many to mention), Yamaha TX816-DX Rack, Digitech VH1, Vocoder, Oberheim Strummer, Snarling Dog Wah-Wah Pedal, Boss Envelop filters, Digitech Talker Vocoder box

Remote recording gear: Portable DAT recorders and shotgun mics for live "on-location" sound effect recording

Sound Effects Libraries: Sound Ideas—The General 6000, Sound Ideas—The General Extensions, Wild World of Animals, Nightgale Voice Box—Vocal SFX Library, Hollywood Edge—Motion Picture Library, Warner Brothers—Sound Effects library, Concept FX sound effects library, Symphony of Voices—Vocal Library

Other relevant equipment: Soundcraft 48 channel inline mixer for synths, Rane 16 channel keyboard mixers (x2), Panasonic 3700 DAT tape recorder

The speculative demo I had submitted was good enough to beat out three other composers, and I was excited to be their man. I showed up 10 minutes early and was ushered into the boardroom to wait until the company's key players could attend. After a half an hour sitting alone, the president walked in, apologized for the delay, said it would be just a couple more minutes and disappeared. Forty-five minutes later, three of them walked in, apologized, and we settled in. At this point, I'm forcing a smile. I'm on their home turf, outnumbered, my butt is getting sore, and I have the sudden urge to use the restroom. Instead of giving them the chance to disappear and get involved with something else, I shuffle in my seat and decide to hold it instead. We've got work to do, and I have another commitment to attend to later that day.

"Aaron, thanks for coming. We're looking forward to having you on board as an integral part of the team and can't wait to get things rolling. We've got high hopes for the game and we'll probably be working you hard," the president said, firmly in charge of the meeting. I nodded my head, smiled, and continued to listen. They moved into the history of the company, how the game came to be, and mentioned Mr. Hollywood's name about a dozen times. I continued to nod and smile, trying to hold in my excitement as things were building toward a good offer. I was waiting for someone to slide a copy of a contract in front of me, but soon realized they didn't have one. Instead, they verbally covered the high points—all the standard contract stuff, nondisclosures, ownership of the rights, my duties, blah, blah, blah. I kept copious notes during the process, noting that they required that I be on-site 3 days out of the week. I put a star by it. I'd have to find out what they meant by that. I feverishly continued, trying to digest what

they were saying and preparing my rebuttal speech—the opportunity I knew had to be coming soon.

"All right, Aaron. That's it. Thanks for coming."

"Uh, but I've got a few questions and a couple of items I'd like to discuss," I stuttered, slightly stunned by the speed of my dismissal.

"Sorry. We're out of time," he said, looking at his watch. "We've got something pressing to attend to. We'll fax you the contract shortly. Just sign it and fax it back. In the meantime, you can start working on some other ideas, and if you could have them to us by the end of next week that would be great. Thanks again," and they were gone.

I sat alone in silence for a moment wondering what the hell just happened. Did I say something wrong? No, couldn't have been that. I never got to open my mouth. Oh, well. These guys are obviously busy, I shouldn't worry. I'll give them a call tomorrow instead.

On the trip home, I couldn't avoid the uneasy feeling I was getting about this job. I couldn't put my finger on it, but something wasn't quite right here. Different game companies have different styles, but these guys were downright odd. Why did they keep name-dropping? Why did they call me all the way to their office for that? Why do I need to be on-site? A lot of questions; much to answer. Maybe I shouldn't start any work on this until we have a signed contract.

The next day, I called Mr. President, he seemed to be in a good mood and more receptive to two-way conversation. He talked a lot about the project and what kind of audio feel they wanted, sticking to a safe subject. I heard him mention they would be doing their own "sound design" in-house, using one of their programmers. They had just bought a sound library they would be using exclusively. "Do you think we bought a good sound library? By the way, what's a good audio editing program? Do you think I can get a good one under a hundred bucks?" he asked. I reminded him I was also a sound designer and could take care of the sound effects instead of leaving it to their guy, who would surely be busy doing other duties. I also explained that the sound library he bought had been available for many years and the sounds were already overused. I could make fresh, original sounds for the game, giving it its own audio identity, so to speak. Without even talking price or considering my idea, he said "no," and that was that. I attempted to shift the conversation toward the contract and was suddenly placed on hold. He had another call. Two minutes later he was back on, saying I should be there tomorrow morning at 10 a.m. to discuss the contract. Okay, I'll be there. Here we go again.

Ten a.m., and I'm steered into the president's office. He's on the phone. I get a nod to be seated and take up position directly across from him. He's not smiling. The phone conversation ends, and without as much as a hello, he rolls in right where we left off 2 days ago.

"Here's the deal. We need 60–75 minutes of music for the game and would like it completed within 60 days," he opened.

"What kind of budget are you proposing?" I asked, trying to get a feel for the overall picture.

"The entire audio budget is ten thousand dollars—sound effects and music," he countered.

As I scrape my jaw off the floor, trying not to look offended by the apparent slap in the face, I do a quick calculation in my head. *Hmmm, my usual fee is a thousand per finished minute. That would be sixty to seventy-five thousand dollars.*

I could discount the entire project to roughly seven hundred dollars a minute. That would be forty-two to fifty-two thousand five hundred, and maybe go as low as an even forty thousand. But he's proposing sixty to seventy-five minutes at ten thousand. I would have to drop my price to about a hundred and sixty-six or a hundred and thirty-three per finished minute.

"How much is left for the music if you guys are doing the sound effects in-house?" I ask.

"About nine thousand," he says. Then seeing a sign that I'm having some trouble with that particular figure (which I thought was hidden behind my poker face), he continues. "Just think of the exposure you'd have as a composer on this game. This game is going to be big. We've already run the numbers and between the three platforms, we expect at least a quarter million units to be sold. This would be great for you. Just think of it. You could write your own ticket in the industry."

I silently doubt it and continue to grind the appropriate gears in my head. "Nine thousand would be for one platform only?"

"Nope, for all three. We need to have full ownership of the music and ten thousand is a firm number."

"If I do the music for that price, would you consider a bonus; say, after a hundred thousand units or perhaps royalties on each unit sold?"

"Nope."

"How about if I keep the rights to release the soundtrack on my own?"

"No can do. We require full ownership."

"Well, since I'd be practically giving away the music, what if I just sold you the rights for the video game? But if the music ever appeared in a TV show or movie or if you released a soundtrack, I could expect some income from that?"

"Aaron, I don't think you quite understand. We are offering you an opportunity to be a part of a very big project. Mr. Hollywood is backing us all the way and we know this will be big. With your name on this project, think of the other games that will practically fall into your lap. To have your name on a huge project is the best advertising you can get. I don't know what industry you are working in, but frankly your rates are a little high. Ten thousand is a very generous offer and we think you would be stupid to pass up this opportunity."

At this point, a hundred comebacks are running through my head—none of which I could actually say out loud. I know what rates are standard in the industry, and I'm on the lower end of that. I know having my name on a big project will have a positive impact on my career. I know he makes a good case, but I'd be losing money and spending a lot of time on this. I have to make a living somehow. "You mentioned earlier that you required me to be on-site 3 days a week. What is that about, specifically?"

"Ah, yes. We will need your help to implement the sound effects and the music for the cinematics and gameplay. We'd need you here two, maybe three, days a week for that. That isn't a problem, is it?"

"Will you pay my hourly wage for those days?"

"No, we were hoping you would include that in your fee," he said.

"Well, if I'm going to be spending time here, I won't be able to work on any other projects and I'd need to make something for my time," I countered.

"We'd like to, but it's not in our budget. We just can't do it. Sorry."

At this point, I think we'd hit rock bottom. They were asking me to score roughly 60 minutes of music, plus they wanted me on-site to help implement

(translation: help the programmer put the sounds in the game) 3 days a week for I don't know how long and pay me $10,000 for my efforts. No bonuses, no royalties, no soundtrack, no ancillary rights, no chance to make another dime off this project. I may have considered it for $50,000 to $60,000 and negotiated it down to 1 day every couple of weeks to be on-site. After all, I had to actually be in my studio to do the composing. I could tell this was going to be the veritable project from hell, and these guys were unbending. If it was such a big game with the backing of Mr. Hollywood, why wasn't there money to match? There were too many unanswered questions and I was still a little steamed at his comment asking me what industry I was working in. Somewhere in there I think he called me stupid, too.

I didn't know what to do. We'd reached a sort of impasse, and my spider senses were all tingly. It's hard to walk away from what could lead to fame and fortune, but I wasn't about to be a prostitute either—grumbling every day about working for this obviously uncaring company who placed no value on the creative people. It was pretty clear the only ones who would benefit from this "big" game were the management and Mr. Hollywood. I wouldn't be able to convince them of their arrogance without making a scene, so I had nothing else to say.

"Well, I appreciate your consideration for this project. It looks like it would be fun, but I'm going to have to pass on it," I said at last.

"What? Are you sure? You're giving up quite an opportunity here. Sure you won't reconsider? Why don't you think about it and call me in a couple of days?"

"No, it's pretty clear. I can't do it. I would lose too much money doing this project. You aren't offering me any other chances to break even and I can't take the risk the game will be as big as you say. Unless you could bend on some of the points I mentioned, I just couldn't do it."

"No, unfortunately, we can't. We have everything laid out, budget wise, and it just couldn't be done on our end."

I sat there, unthinking, staring out the window behind his head.

"Well, Aaron, good luck to you then. Sorry we couldn't work together," he said, gesturing toward the door as he got up from behind his desk.

We shook hands and I departed. After a couple of months, I finally let it go. Yeah, I blew a perfectly legitimate chance to score a "big" game title, but what I ultimately saved on headache and lost revenue is what convinced me—without a doubt—I'd done the right thing. There will be other fish to fry, I'm certain of that. But, it's funny how things work out. If this deal had been offered to me just a couple of years ago, I would have jumped at it with both feet and learned many valuable lessons the hard way.

You don't have to live it to learn the lesson. Make sure you never get yourself in a losing position. Always look at your bottom line and the interests of your "company." Any unscrupulous developers won't. They know creative people are a dime a dozen, and if they dig down far enough, they'll eventually find someone who would beg to pay them to do the project. We don't want to cheapen the industry, so fight the good fight and get paid what you are worth. Sleep with one eye open if you have to.

Follow-up: Flash forward a year and a half later as I'm strolling the corridors of GDC. It's been a great trip and I'm in a fantastic mood, enjoying the conference and a chance to see colleagues and friends I haven't seen since the last visit. I'm all smiles as I happen upon a circle of fellow composers and stop dead in my tracks as I hear that infamous game title mentioned. Funny thing, the game had

been out for about a month to a very mediocre reception (and consequently all but disappeared from existence a few months later), but I had never heard who was finally hired to do the music. Overhearing the discussion, I suddenly realized who the focus was on—and without a conscious thought, hurriedly corralled the individual to a nearby corner. "Excuse me, folks. He'll be right back."

"You did the music for *that* game?" I said as quietly as I could in the noisy space.

"Uh, hey, Aaron. Uh, yeah, I did but they ended up not using it," he said, suspicious of my inquiry and wondering why his back was up against the wall.

"Were they still only paying ten thousand for the audio?"

"Er, yeah. Hey, how'd you know that?"

"Did their programmer do the sound effects?"

"Yeah."

"Did you have to help them implement?"

He starts to smile, realizing I must have been that "other" composer the developer had talked about. "Uh huh."

"Tell me you didn't do the 60 minutes of music for only ten thousand!"

"Okay, I won't," he paused. "I only did ten!" A big grin began widening on his face.

Several seconds of silence went by as I digested what I'd just heard.

"Why, you son-of-a-gun!" I said finally, incredibly relieved that he hadn't let them take advantage of him—shaking his hand vigorously in congratulations! "I'm so glad to hear that." I was also secretly wondering why I hadn't thought of that.

"You know something, I believe I have you to thank," he whispered in my ear. "If you hadn't given them that little dose of reality, I think they'd still be trying to find someone to do the music for that. They didn't seem too shocked when I told them my rates were a thousand a minute. Guess they'd heard it before, eh?"

"Uh, yeah," I said, still in disbelief and making a mental note to put this in my bag of tricks for next time.

"But, the weird part about all of this is even after we went through all of that, I did the music and they paid me and everyone was supposedly happy. When the game came out, it didn't have any of my stuff in it. I called them up to see what happened and it turns out Mr. Hollywood changed his mind, said the feel was all wrong and ended up hiring somebody else to do the music!" He took a breath and looked around. "So, after all of this talk about getting my name on this big title and getting into Mr. Hollywood's inner circle, I'm a little disappointed."

"But, you did get paid for the music and you can still put it on your resume"— reminding him that he hadn't been taken advantage of or cheapened our talents. "And that's always a good thing."

"I guess you're right."

Negotiation Pointers

The contract and negotiation process is probably everyone's least favorite part. The creative process is held up until the contract is complete and signed, and most people are just not prepared for this type of confrontation and find it difficult to separate business from personal feelings. You'll find that a lot of people take every issue you present very personally and never quite get past it. The rest of your working relationship suffers because you turned out to be a different person than what they may have originally perceived. It's not your fault—they just become mad at themselves for not being prepared for the business issues and

your professional business charm. They are like you: creative people who just want to make video games and hate ever having to deal with contracts and legal documents. That's why the big companies have legal departments; they handle the details, and the producer gets to make the games.

When you are presented with a contract and begin the process, keep it strictly business. Stay away from getting personal or taking things personally. When two companies get together to negotiate a contract for service, with teams of professionals sitting on opposite sides of a boardroom table, there is no doubt what they are accomplishing is business. Just because negotiations seem more intimate when it is just you and a producer, it is exactly the same.

Don't be intimidated if you are outnumbered at the meeting. Think of it as a summit between all of the team members, working together to solve certain issues. This mindset will keep you away from looking at it as an adversarial confrontation and let you work together toward the common good of both parties. There will be occasions when a developer may try using this intimidation factor to keep you from asking for too much and digging into their bottom line. You'll have the upper hand instead with this way of thinking.

There will be times when carrots are dangled before you—certain enticements designed to get you to sign the contract without adding your points to it. Be on the lookout for these and never feel like you were pushed into "buying something" from an overly aggressive salesman type. If you feel pushed, back off with the ball in your court and slow the process down to a more comfortable level. One thing I will *not* do is sign something I haven't been able to fully review.

I once had a game developer's lawyer fax me a contract with the instructions to "Sign this and return to me ASAP." The red flag went up. I told him I needed a few days to review it with my legal department, and we ended up arguing about his take on copyright laws. Turns out, he knew nothing about copyrights and was actually a real-estate lawyer who was helping out the developer and wanted me to sign a document which would give his company full ownership of sounds I had licensed from a sound effects library! He didn't understand the concept that I could use licensed sounds as part of my work and sell the final product to them. Don't be forced into something you aren't totally comfortable with. While it may be a big company, with huge financial backing, your company is *your* life's blood and everything you agree to has a direct effect on its well-being.

Here is another thought. Let's say I felt strongly about earning a bonus after the game sells 250,000 units and it was the only point I brought to the table. When they say "no" that one time, there will be no psychological effect you could use to springboard on to another point. The negotiations are over. If I brought *several* points to the table, it is nearly impossible for a decent human being to say "no" to every single one of them. Even if they tried, after awhile they would realize they were beginning to sound like a parent—saying "no" without good reason.

Experienced salesmen use this trick every day. They know you will say "no" at least five times before you start to waiver and eventually begin to say "yes." That's when they swoop in for the kill and make the deal. There have been studies done on this very phenomenon, and I have experienced it firsthand myself at car dealerships and in other high-pressure sales situations. Our "trick" is to turn this around and use it to our advantage.

If you bring every contract point mentioned earlier to the table, I guarantee you, you'll walk away with one—if not several.

There is no need to be "high pressure" in this instance, but this subtle technique can definitely win you some bonus points. Now, I don't recommend trying this at your first contract negotiation with a small developer. Save it for the big boys and you'll have good results. The smaller fish may get intimidated and assume you are too high caliber for their needs.

Strike a delicate balance between what you ask for and what you know is a reasonable request. I wouldn't fight and claw my way into having a small developer, who is self-publishing a title, give me a $10,000 bonus after the game sells 100,000 copies. An instance such as that would be lucky to sell 20,000—plus a $10,000 bonus seems like a lot of money to developers on shoestring budgets. I would rather get my logo on the box and a splash screen in the game. I know they could do that.

Only *you* know what your business needs to survive, income-wise and marketing-wise. That's what a game project ultimately represents. You alone will have to look out for those interests. Even if the developer works for the most benevolent organization out there, they won't know your needs unless you express them.

You may be sitting there thinking, *Man, this guy is a greedy son-of-a-gun.* I wouldn't say it that way. I just know what the industry will tolerate and I ask for it. I became a musician for many reasons, and being able to actually make a decent living, doing it is a dream I am finally living. Business is not a place for timidness. Greatness cannot be achieved without taking care of your survival needs first and then being able to have the equipment to make grand music. It costs money, and a lot of it. I'm telling you, this is a great way to make it all happen. Make a lot of money. Buy your gear. Make awe-inspiring music. Rise to greatness on your talents and achieve the type of recognition you deserve. Ask for the bonuses, royalties, ancillary rights, and property rights and be successful. If you just sign their contract to make a fast $10,000 and nothing else, you've made the quick buck but you've missed the point. You'll always struggle and will eventually be unable to continue your pursuits. You have to take care of yourself by taking care of business first. That's what the negotiation process is really about.

Change Orders and Reworks

A *change order* happens when a developer decides the creative route they are taking is wrong and makes the decision to try another direction instead. These moments happen in every business, around the world, but the first time it happens to you, it will literally crush you. How would you feel after spending a couple of months living and breathing a project, composing a magnificent score, putting your heart and soul into it, days away from recording it with a full orchestra, and then having a producer tell you they've decided on a techno score instead? Or, how about actually completing a sound effects project and getting the word at the last minute they need to be redone for a different "period in time?" Your first instinct will be to throw your hands in the air. Your second thought will be: how are these contingencies covered in the contract?

Change orders happen. They are a way of life in the winds of creativity and big business. Expect them, prepare for them, and plan for them. But, unfortunately there is no specific formula to apply when putting it in writing. Just make sure you are not caught in a position where you are taken advantage of and start losing money on the deal.

DUNCAN WATT
Composer

Duncan Watt's career includes work in television, film, broadcasting and digital games. A seasoned studio musician and producer, Watt appeared on more than 70 album projects before founding Fastestmanintheworld Media in 2005. Duncan's work appears in a wide variety of projects, including the internationally acclaimed *Bioshock Infinite* (Irrational/Take-Two), the wildly successful *League of Legends* (Riot, 1.2 billion play hours/month), *Need for Speed Undercover* (EA/Black Box), *Stargate Online TCG* (Sony), *Brothers in Arms: Hell's Highway* (Ubisoft/Gearbox), and many others.

In addition to contract work, Watt served as audio lead on *League of Legends* at launch, and was senior composer/audio designer at the ill-fated 38 Studios (Kingdoms of Amalur/Project Copernicus). He's also the voice of *League of Legends'* fan favorites Rammus and Blitzcrank.

Outside of digital games, his music is featured in the 2013 summer blockbuster *Now You See Me* (Lionsgate), and appears in a number of popular TV shows, including *The Good Wife* (ABC), *NCIS* (CBS), *Any Day Now* (Lifetime), and *My Little Pony and Transformers* toys, apps and commercials.

When not working, Duncan spends time with his two sons, and enjoys hiking, Judo, Brazilian jujitsu, Guinness, disc golf, and a variety of mid-life-crisis-oriented activities.

www.fastestmanintheworld.com

Describe your thought process for creating music.

I try and find something I'm passionate about in every project, then let that feeling guide the process. I like to ask a thousand questions upfront, try and learn everything I can about the

project and the team's vision. Once I can find something exciting I can latch on to, we're off and running.

Are there any particular secrets to your creativity?

I like to take a concept way too far, way over the top, play it for the team, then dial it back to what sounds right. That seems to allow for happy accidents and emergent coolness. I hate leaving "awesome" on the table.

Do you have any interesting sound gathering/sound creation stories?

Way back when, I remember getting up very early in the morning and trudging hundreds of yards out in deep New Hampshire snow to these amazing high-tension radio tower cables, thinking I'd replicate Ben Burtt's *Star Wars* laser blast sound. After schlepping all the gear out, I hit the first cable with my hammer, and… "pew." Tiny little sound, total fail!

Do you have any advice which can help lay solid groundwork and ensure a successful production for the audio content creator?

Working on a game project is a collaboration, period—you're part of a team vision. If you're not up to speed and on board with that vision (or the vision isn't clear), the process could be pretty rocky. Get to know the project as intimately as possible early on, and get some of your work up in front of the team early as well—then find a way for everyone to work together in a positive fashion.

Any worthwhile creative advice you'd like to share?

I think boredom is the opposite of creativity—so, I like to get into the studio early in the morning, take care of email/business, then turn off everything—phone, email, social media, everything—and relax. I get bored quickly, so I'm usually cookin' pretty fast.

What skills should composers have to succeed in the games industry?

Of course, the #1 skill is "be a gamer," understand the language and history of music in digital games. I think the ability to both listen and communicate effectively is key too. But these days, "game composer" means a lot more than just spotting the project with the team and composing—most composers also arrange, produce, perform, mix, master, edit and finalize the music. As interactive music becomes more prevalent, many implement the material as well—which allows for cool, complex stem creation, nose-loop-tail edits, nonlinear layered presentation, and dynamic real-time mixing. Live recording plays a major role in most high-level projects these days, too. Add the word "freelance," and a strong knowledge of small-business skills comes into play as well.

Do you have a specific ideology which drives your way of doing business?

Collaborate, bring your absolute best game to the table every time, love what you do. Don't stop until it's done, do whatever it takes.

Any good business advice to offer?

The less you spend, the more you keep. That said, when it comes to quality, don't skimp. Doing good business costs money.

How do you approach negotiations with a new client?

Honestly, I try to avoid "negotiating" whenever possible. I like to get in, meet the team, get to know the project, and do an "audio audit" of the game, then come back with a proposal.

If that's not in the cards, then I like to find out the budget for the project, and figure out a way to work within that budget. It all comes down to basis regardless—$X/asset, $X/minute, $X/week, depending on the nature of the project. As long as I can protect my work and my business, there's always a way to work it out—and I hate feeling like I'm at war with the people I'm about to collaborate with right off the bat!

Do you have any tips when working with developers?

I honestly believe we all want the same thing—to make a great game. Focusing the discussion on those thoughts, we have in common solves most potential issues.

What advice can you give when working with a developer to ensure you are able to make great sounds?

Getting material in front of the team early on (and being willing to iterate within reason) can build trust quickly. Once that trust is in place, I find most teams are happy the audio is under control—and they don't have to babysit it.

Have you ever had any development issues negatively influence your workflow?

I very much dislike personality-based decisions—that is, "this is *my* game, and I just *want* it that way…." That kind of silly posturing never works out. There's nothing wrong with strong opinions, and working with a capable auteur can be fantastic—but when someone's sticking to their guns because they're afraid they're going to "lose face," or politics take over the creative process, it's time to run the opposite direction. Great leaders know when to listen as well as direct.

Staying organized is important, especially if you are working on multiple projects, which is part of your daily routine. How do you keep up with it?

I'm a strong advocate of through, transparent team documentation on each project—a good producer can make or break a project. I have my own doc system as well, so I can identify potential logjams as far ahead as possible.

Do you have any development stories which served as a good lesson learned or something which can be avoidable in future projects?

Audio is affected by almost every team on a project—from design to animation to coding to marketing—so staying current with changes each team is making is crucial. There's nothing more difficult than doing a week's work on something that's been slated to be cut, but no one's passed that information along to Audio. Most young teams aren't aware of how their decisions affect Audio, and this can force rushed audio implementation, which results in low quality. It's important to educate if necessary early on, get Audio involved in the decision chain—and establish good communication pipelines throughout the development cycle.

How did you find your way into the games industry?

I came from the music industry, and found without credits, no one would listen. So, I grabbed Source and Unreal, and got on as many mod teams as possible. From that, I got a few opportunities to do VO, then ended up being referred for a small Sony Online game (Pirates CSG Online). That credit opened up opportunities for a few years—then League of Legends came along and changed everything.

In a case where you may be working toward milestones, have it put in the contract that if any major creative changes are requested, you will keep the payments already received and a new milestone schedule will be worked out. If you are working for a flat fee, make sure something is in the contract or separate agreement which covers any added expense and time on your part. Spoken agreements are easily forgotten.

Reworks are a close relative of change orders and also something to watch for. While change orders are basically starting over, *reworks* are taking the same piece and redoing it until it is right. For music, it might mean replacing certain instrumentation that sonically interferes with something else or changing the length of the piece. Maybe that music needs a gradual fade in and fade out; maybe it needs to be louder. The same for sound effects. Many times the length of the sound corresponds with a character action and has to be matched exactly, or perhaps a certain part of the sound is very grating if heard repeatedly. Maybe it's too loud. Whatever the requirement, you will redo the audio until it works perfectly.

I personally don't have a problem with reworks. They are a completely acceptable part of the job. What does bother me, and most other audio folks as well, is taking it to the extreme where it becomes a change order in disguise. The problems begin after receiving guidance from the producer for the music and sound effects, sharing the work while it's in progress, getting the appropriate nod that you are heading in the right direction, and then having to spend an unacceptable amount of time redoing everything. Communication must be the number one priority, and if you are having trouble with it, you are bound to spend much time with reworks as a consequence.

Therefore, there has to be an agreement regarding reworks. When guidelines are established at the beginning of the relationship, a plan will be clear and no one will be taken advantage of. The developer won't have to settle for audio they aren't happy with and the contractor doesn't have to waste time redoing things. With open communication among the players, it should be fairly obvious when the contractor has reworked something to death and is starting to lose all feelings for the piece. At that point, whatever contingency was established should come into play. The bottom line is: you should never lose money on a contract, ever. You may feel slightly taken advantage of at times, and it's always a good business practice to go the extra mile for the client without complaint, but there is a limit. To protect your interests, it needs to be spelled out in the contract.

Sample Agreements and Contracts

The first time I saw a game contract, I nearly fell over backward. Now, after dealing with them enough, I'm fairly comfortable with them—and more importantly, I am able to pick up on the portions that affect my interests directly. The more you see, the better you will understand—such as how they are worded and what others are using in the business. One of the goals of this book is to get you primed and ready for these very things. This section includes actual examples to examine closely, and as a bonus, they are included as a download from the companion website (www.crcpress.com/cw/marks) for your use as well.

Contracts and agreements can come in many forms, from simple to the ridiculously complicated. It is entirely up to you which ones you use. I

recommend, however, when dealing with smaller companies, to keep it as simple as possible and not to scare them away by presenting a demanding 10-page contract. They are more than likely in the same boat as you when it comes to experience in these matters and will appreciate your conscious efforts to not cloud the already complicated game production process. As you work up to the big companies, longer contracts with many points will be accepted as the norm.

Sample Nondisclosure Agreement

The following example is a complete NDA—the type of document you will normally be signing prior to obtaining any detailed information on a project. It has been written by a contract lawyer to cover every detail. This is a standard form in the industry, and you will sign many in your career. Most are primarily concerned with guarding company secrets, but occasionally you may find wording which requires you to destroy or return materials used to create a project when the relationship is terminated. Use care when dealing with those types of contracts. Make sure, if they deal with your work product directly, they do not override any other prior agreements, and ensure the project contract specifically states it overrides the pertinent paragraphs in the NDA regarding your interests. You don't want to be faced with contractual conflictions like this in court, where a good lawyer could distort facts to say you were the one breaching the agreements.

Nondisclosure Agreement

THIS AGREEMENT is by and between Company X, Inc., a California corporation ("Company X") and the party or business signing below ("Receiving Party").

WHEREAS, Company X wishes to discuss and evaluate a potential business relationship with Receiving Party relating to video game hardware and software (hereinafter "Subject Matter"); and

WHEREAS, the progression of the aforesaid discussions will necessitate the passing of confidential information from Company X to Receiving Party.

NOW, THEREFORE, in consideration of these premises and the mutual covenants herein, the parties, in order to safeguard the disclosed confidential information, agree as follows:

1. "Confidential Information" for the purposes of this Agreement shall mean any and all information (1) disclosed in written materials, or (2) obtained visually by viewing premises, equipment, or facilities, or (3) disclosed by oral communication relating to the Subject Matter. Confidential Information shall include, but not be limited to, future market and product plans, marketing and financial data, engineering information, know-how, trade secrets, ideas, service and manufacturing processes, product designs, software data and information, and other information of a technical or economic nature related to the Subject Matter. Confidential Information submitted in a written or graphic form shall be clearly marked as "Confidential." Any information that is transmitted orally or visually, in order to be Confidential Information subject to this Agreement, shall be identified as such at the time of disclosure and identified in writing to the Receiving Party as Confidential Information within thirty (30)

days after such oral or visual disclosure. Confidential Information shall reference this Agreement.

2. Company X shall disclose such Confidential Information as it deems necessary for it to fully evaluate its interest in establishing a business relationship relating to the Subject Matter.

3. The Receiving Party agrees to (1) receive and maintain the Company X Confidential Information in strict confidence, (2) use the disclosed Confidential Information solely for the purpose of evaluating the business proposals under discussion, and (3) prevent unauthorized use or reproduction of the Confidential Information, including by limiting access to Confidential Information to employees, agents, or affiliates who are necessary to perform or facilitate the purposes of this Agreement and who are bound to hold such Confidential Information in confidence pursuant to the terms of this Agreement. (As used herein, the term "Affiliate" shall mean a corporation or business entity that, directly or indirectly, is controlled by, controls, or is under common control with the Receiving Party.) This obligation of confidentiality and limited use shall not apply to (a) Confidential Information that at the time of the disclosure is in the public domain, or (b) Confidential Information that, after disclosure, becomes part of the public domain by publication or otherwise, except by breach of this Agreement by the Receiving Party, or (c) Confidential Information that the Receiving Party can establish by reasonable proof was in its possession at the time of disclosure by Company X or is subsequently developed by that Receiving Party's employees who have no knowledge of or access to the Company X Confidential Information; or Company X Confidential Information that a Receiving Party receives from a third party, who has a right to disclose it to that Receiving Party.

4. Either party may terminate the discussions without prior notice, for any reason, at any time, and without liability or restriction, other than the obligations of confidentiality and nonuse and the obligation to return the disclosed Confidential Information as provided for herein.

5. Upon conclusion of the discussions contemplated hereunder, unless otherwise agreed by the parties in writing, all written or graphic Confidential Information together with all copies thereof shall be returned to Company X, provided, however, that one copy may be retained in the Receiving Party's legal counsel files for archival purposes as a means of determining any continuing obligation under this Agreement.

6. The Effective Date of this Agreement is defined to be the latest date below written. The obligations of confidentiality and nonuse under this Agreement shall expire five (5) years from the Effective Date.

7. Nothing contained in this Agreement shall be construed, by implication or otherwise, as an obligation for any party hereto to enter into any further agreement with the other, or as a grant of a license by Company X hereto to Receiving Party to use any Confidential Information disclosed other than for discussions or evaluations relevant to the purposes of this Agreement.

8. This written Agreement embodies the entire understanding between the parties and supersedes and replaces any and all prior understandings, arrangements, and/or agreements, whether written or oral, relating to the Subject Matter.

9. This Agreement shall be construed in accordance with the laws of the State of California.

10. This Agreement is divisible and separable so that if any provision or provisions hereof shall be held to be invalid, such holding shall not impair the remaining provisions

hereof. If any provision hereof is held to be too broad to be enforced, such provision shall be construed to create an obligation to the full extent allowable by law.

11. Each party represents and warrants to the other that it has the right to enter into this Agreement without breaching or violating any fiduciary, contractual, or statutory obligations owed to another.

IN WITNESS WHEREOF, the parties hereto caused this Agreement to be duly executed by their duly authorized representatives.

COMPANY X, INC. Receiving Party

By:_____ By:_____
Title:_____ Title:_____
Date:_____ Date:_____

Distribution of Originals
One (1) to Company X, Inc.
One (1) to Receiving Party

Sample Talent Release

This example of a talent release is about as simple as they get and as complicated as they need to be. Because the purpose is for you to obtain the rights to a hired musician or voice-over artist's performance, there isn't much more to discuss or negotiate. You may run across professional voice talent who have been around the industry long enough to see the potential of their contribution—say, in film or other nongame releases—and might persuade you to pay him or her more. They may even attempt to secure ancillary rights for the same reason. I would never deny someone running their business and negotiating use of their "product" this way, but as the sound recordist in this case, I am not in the position to negotiate this type of request.

When games use high-caliber or name-brand voice talent for a lead character in the story, it is usually the game company who will handle the deal making with the individual. All you may need to do is just record them, edit their narration, and convert it for the company. In cases where you've hired voice talent on your own, for a smaller contribution such as in a sound effect, it would be easier to hire and pay for their performance outright. If it goes beyond that, you'll spend more time than you could imagine being the intermediary between the game company and the talent—the unwilling go-between. My advice: Find someone who will perform their part, sign the release, and accept a lump payment as a fair trade.

Authorization of Release

For value received in the sum of _____ I, the undersigned, give and grant Composer/Sound Designer/Company X, its affiliates, successors, and assigns the unqualified right, privilege, and permission to reproduce in every manner or form, publish and circulate video games, compact discs, videotapes, audiocassettes, or films of recordings of my voice and/or my musical contribution arising from the production titled _____; and hereby grant, assign, and transfer all my rights and interest therein.

I specifically authorize and empower Composer/Sound Designer/ Company X to cause any such video games, compact discs, videotapes, audiocassettes, films, and recordings of my voice and/or musical performance, to be copyrighted or in any other manner to be legally registered in the name of Composer/Sound Designer/Company X.

Nondisclosure

It is understood by the below signed individual that all information obtained while providing service will remain confidential and that he/she will not directly or indirectly disclose to any third party or use for its own benefit, or use for any purpose other than the above-mentioned project.

I am of lawful age and sound mind, and have read and understand this Authorization of Release.

Signed this _____ day of _____

_____ (Signature)

_____ (Print name)

Sample Contracts

Contracts can be particularly difficult to comprehend and their impact, dramatic. What you agree to by signing on the dotted line may return as a surprise, having not fully understood the convoluted legalese. To understand these potential nightmares, learn to read them, become familiar with them, and spend some time with them prior to having to negotiate your first one.

Contract A

Our first contract example is simple by contract standards but just as legally binding. It is designed with new or small developers in mind—the idea being to keep it simple for them as well and not to scare them off by making it more complicated than it has to be. New game companies are learning right along with you. Many have never dealt with sound contractors before. If you present them with a contract like the last one in this section, they'll end up thinking they can't afford you and will go find someone else. Later, after you've done several games and start approaching the big fish, they'll end up scaring you with their contracts and lawyers instead.

Work Made for Hire Agreement

This Work-for-Hire Agreement (the "Agreement") is effective as of _____ ("Effective Date") by and between Company X, Inc. (hereinafter referred to as the "Company"), a California corporation located at _____, Composer Y (hereinafter referred to as "Contractor"), an individual residing at _____.

In consideration of the mutual covenants herein contained, the parties hereby agree as follows:

1. Services
 a. Contractor shall create audio content as determined by Company from time to time in a manner consistent with the outlines, explanations, and designs established by the Company (hereinafter "Services").
 b. The Contractor agrees that any work he submits to Company under this contract, when accepted and payment is honored, becomes the property of Company and Contractor further agrees and acknowledges he has no proprietary interest in any of these works. Ownership rights to any work not paid for shall be returned to the Contractor immediately.
2. Term and Termination. This Agreement shall continue until terminated by either party upon 10 days' written notice, provided that termination by Contractor shall not be effective until completion of any work requested by the Company.
3. Payment for Services. The Company shall pay Contractor in a manner mutually agreed upon by each party for each project contemplated. ("Payment") for Services.
4. Independent Contractor. It is understood and agreed that Contractor shall perform the Services as an independent contractor. Contractor shall not be deemed to be an employee of the Company. Contractor shall not be entitled to any benefits provided by the Company to its employees, and the Company will make no deductions from any of the payments due to Contractor hereunder for state or federal tax purposes. Contractor agrees that he shall be personally responsible for any and all taxes and other payments due on payments received by him from the Company hereunder.
5. Warranties
 a. Original Development. Contractor represents and warrants that all work performed by him for or on behalf of the Company, and all work products produced thereby, will not knowingly infringe upon or violate any patent, copyright, trade secret, or other property right of any former employer, client, or other third party.
 b. Warranty of Expertise. Contractor represents and warrants that he is highly skilled and experienced in providing the Services required. Contractor acknowledges that the Company is relying on his skill and expertise in the foregoing for the performance of this Agreement, and agrees to notify the Company whenever he does not have the necessary skill and experience to fully perform hereunder.
 c. Other Agreements. Contractor represents and warrants that his signing of this Agreement and the performance of his consulting Services hereunder is not and will not be in violation of any other contract, agreement, or understanding to which he is a party.
6. Indemnification. Contractor shall indemnify the Company from all claims, losses, and damages that may arise from the breach of any of his obligations under this Agreement.
7. Protection of Confidential Information
 a. Confidential Information. For purposes of this Agreement, the term "Confidential Information" means all information that is not generally known and that: (i) is

obtained by Contractor from The Company, or that is learned, discovered, developed, conceived, originated, or prepared by Contractor during the process of providing Services to the Company, and (ii) relates directly to the business or assets of the Company. The term "Confidential Information" shall include, but shall not be limited to: inventions, discoveries, trade secrets, and know-how; computer software code, designs, routines, algorithms, and structures; product information; research and development information; lists of clients and other information relating thereto; financial data and information; business plans and processes; and any other information of the Company that the Company informs Contractor, or that Contractor should know by virtue of his position, is to be kept confidential.

b. Obligation of Confidentiality. During the term of this Agreement with the Company, and at all times thereafter, Contractor agrees that he will not disclose to others, use for his own benefit or for the benefit of anyone other than the Company, or otherwise appropriate or copy, any Confidential Information, whether or not developed by Contractor, except as required in the lawful performance of his obligations to the Company hereunder. The obligations of Contractor under this paragraph shall not apply to any information that becomes public knowledge through no fault of Contractor.

8. Ownership and Assignment of Rights. All Work Product created by Contractor shall belong exclusively to the Company and shall, to the extent possible, be considered a work made for hire for the Company within the meaning of Title 17 of the U.S. Code. To the extent the Company does not own such Work Product as a work made for hire, Contractor hereby assigns to the Company all rights to such Work Products, including but not limited to all other patent rights, copyrights, and trade secret rights. Contractor agrees to execute all documents reasonably requested by the Company to further evidence the foregoing assignment and to provide all reasonable assistance to the Company in perfecting or protecting the Company's rights in such Work Product.

9. Duty upon Termination of Services. Contractor shall immediately deliver to Company all Work Product created under the Agreement. Contractor shall not delete any Work Product for six (6) months after expiration or earlier termination of the Agreement unless such deletion is requested by Company.

10. Subcontracting and Assignment. The Agreement and the rights and obligations of Contractor hereunder may not be subcontracted, assigned, or transferred by Contractor, in whole or in part, without the written consent of the Company. The Company may at its sole discretion assign or transfer the rights of the Agreement.

11. Governing Law. This contract will be governed by and construed in accordance with the laws of the State of California.

12. Consent to Breach Not Waiver. No term or provision hereof shall be deemed waived and no breach excused, unless such waiver or consent be in writing and signed by the party claimed to have waived or consented. No consent by any party to, or waiver of, a breach by the other party shall constitute consent to, waiver of, or excuse of any other different or subsequent breach.

13. Gender. Whenever the content of this Agreement requires, the masculine gender shall be deemed to include the feminine.

14. Right to Self-Promotion. Contractor has the right to self-promotion and allowed to use, as creator of said works, any works created under this contract, to demonstrate the capabilities of contractor either in demo reel or computer file format at any time after acceptance of the work as final, without any further permissions required from Company.

15. Sound Credits. Credit for creation of any sounds produced under this contract will be included in the appropriate "credits" section of any software product and its corresponding print media in which the sounds appear, as created by Composer Y.

16. Entire Agreement. This Agreement constitutes the complete and exclusive statement of the agreement between the parties with regard to the matters set forth herein, and it supersedes all other agreements, proposals, and representations, oral or written, express or implied, with regard thereto.

IN WITNESS WHEREOF, the parties have executed this Agreement as of the Effective Date.

CONTRACTOR COMPANY

By: _____ By: _____

Its: _____ Its: _____

Date: _____ Date: _____

Contract B

This next contract example is the one our mutual friend, Tommy Tallarico, has been kind enough to share. Skewed rightfully in the game composer's favor, it is full of all of the appropriate paragraphs which cover the interests of composers who wish to retain ancillary rights and obtain bonuses or royalties for the success of the game. Majority of the time, large game companies have their own agreements drawn up and seldom entertain a composer's contract—again, because they want their interests protected.

The work-around is to use like paragraphs and wording when introducing your points to their contract. By all means, present this kind of contract to them first. It will show your professionalism, business prowess, and the fact that you know

Audio Development Agreement

This Audio Development Agreement (the "Agreement") is made and entered into by _____ ("Composer") and _____ ("Company").

WHEREAS, Company desires to retain Composer to develop and deliver to Company the audio known as _____ musical score (the "Composition") for _____ (the "Game"); and

WHEREAS, Composer desires to develop the Composition on the terms and conditions set forth herein.

NOW THEREFORE, The parties hereto do hereby mutually agree as follows:

1. COMPLETION DATE; DEVELOPMENT: Composer shall develop the Composition according to the schedule attached hereto as Schedule 1. Composer agrees to use diligent good faith efforts to develop the Composition according to the dates specified on Schedule 1. Composer acknowledges that time is of the essence of this Agreement and that Composer's best efforts must be utilized to complete the development of Company's Game. Composer agrees to be readily available for all reasonably requested revisions to the Composition. Composer shall develop the Composition in accordance with the information, materials, or other instructions provided by Company. Company acknowledges that Composer can only achieve timely performance of the matters

required of Composer if Company timely delivers to Composer appropriate information and guidance. Company shall not attempt to declare Composer to be in default of this Agreement for delays caused by Company's inability to deliver information/guidance to Composer in a timely manner.

2. COMPENSATION: As compensation for the Composition, Company shall pay Composer the fees specified on Schedule 1. Composer acknowledges that this payment by Company represents the complete and entire obligation owed to Composer or any other party, either by Company or any other third party, for the Composition to be provided by Composer under this Agreement. If Composer uses any third parties in providing the Composition not specifically authorized and required by Company, Composer shall be responsible for the additional costs. If this Agreement is terminated without cause by Company, Composer shall be entitled to receive the next unpaid milestone within a reasonable time deemed appropriate by Company not to exceed six (6) months. All milestone payments will be invoiced by Composer and due within thirty (30) days upon completion and acceptance of milestone by Company.

3. RIGHTS: All results and the proceeds of Composer's work hereunder including without limitation, the Composition and any revisions, amendments, modifications, translations, alterations and enhancements, and sequels thereto, and derivative works therefrom, whether produced by Composer, or a third party and regardless of form, including without limitation, mechanical, code or written, and all materials produced by Composer in fulfillment of its obligations hereunder, including but not limited to reports, memoranda, drawings, documentation, and models, shall be deemed to be a work made for hire for Company within the meaning of the copyright laws of the United States or any similar analogous law or statute of any other jurisdiction and accordingly, Company shall be the owner throughout the world. However, where sounds or "demo" songs are rejected by Company and not made a part of the Composition, such rejected sounds or demo songs shall remain the property of Composer.

Without limiting the foregoing, Composer hereby assigns all right, title, and interest in and to the Composition and all of the foregoing furnished to Company hereunder, whether copyrighted or not. Composer shall assist Company and its nominees in every proper way to secure, maintain, and defend for Company's own benefit copyrights, extensions, and renewals thereof on any and all such materials. The Composition shall be used in connection with all video game systems including CD-ROM, all personal computer and home multiplayer systems and or consoles and all distribution of such games through other entertainment systems or media presently known or unknown, now in existence or hereafter created or developed (collectively the "Uses"). In the event that the Composition is published for purposes other than or not related to the Uses such as cassettes, CDs, or albums, TV broadcasts, etc. that are not published in conjunction with the Game as samplers (collectively the "Additional Uses"), fifty percent (50%) (the "Percentage") of the Net Profits ("Net Profits") will be compensated to each party. Net Profits shall be defined as money which is actually received with respect only to its direct sales related to exploitation of the Composition for the Additional Uses less any monies that have been spent or are required to spend with respect to negotiating, developing, producing, or in any way preparing the Composition for the Additional Uses.

4. CONFIDENTIALITY: Composer acknowledges and agrees that any information which it may receive from Company, will be proprietary information of Company (the "Proprietary Information"). Composer agrees, both during and after the term of this Agreement, to hold in confidence all Proprietary Information of Company and to

prevent the unauthorized copying, use, and/or disclosure of Company's Proprietary Information. Composer will place or cause to be placed on the Composition or any portion thereof any intellectual property right notices as requested by Company.

5. CREDIT: Company shall request that Composer receive credits within manual documentation, print ads, and on screen, it being understood that the publisher shall have the absolute discretion in such credit determination. The form, style, size, placement, and nature of any screen credit provided for herein shall be determined by Company (or its assignee, publisher, or licensee) in its sole discretion. Any unintentional and/or inadvertent failure to give screen credit as above provided, whether because of lack of broadcast time or otherwise, shall not be a breach of this agreement.

6. NAME AND LIKENESS: Subject to Composer's approval, which will not be unreasonably withheld, Company shall have the right and may grant to others the right to use, disseminate, reproduce, print, and publish Composer's name, likeness, voice, and biographical material concerning Composer as news or informative matter and in connection with advertising and for purposes of trade in connection with any motion picture or television program in which the Composition is used, and/or in connection with any other uses of the Composition.

 Composer hereby preapproves the use of his name, likeness, voice, and biographical material in and on packaging for the Game and within the body of the Game, as well as in printed materials concerning the Game. The rights granted herein shall not include the right to use or to grant to others the right to use Composer's name, voice, likeness, and biographical material in any direct endorsement of any product or service without Composer's written consent.

7. TRAVEL: In the event Company requests Composer to travel on behalf of Company, Company shall reimburse Composer for business class airfare, lodging in a first-class hotel, meals and local transportation, both to and from the airport, and at the place at which Composer is required to travel on behalf of Company. All reimbursements shall be made only after Company receives itemized bills for all expenses incurred by Composer pursuant to this paragraph and on a form approved by Company.

8. AWARDS: Company shall retain all awards won by the Composition. Company will use its best efforts to obtain a duplicate of any award won by the Composition to furnish the Composer.

9. COMPOSER'S WARRANTIES AND INDEMNIFICATIONS:
 a. Composer represents and warrants to Company that:
 i Composer possesses full power and authority to enter into this Agreement and to carry out its obligations hereunder;
 ii. with respect to the Composition which Composer will deliver to Company in performance of this Agreement, Composer warrants that it has the right to make and disclose thereof without liability to any third party;
 iii. Composer has not sold, assigned, leased, licensed, or in any other way disposed of or encumbered the Composition in whole or in part to any party other than Company;
 iv. the Composition is new and original and capable of copyright:
 v. neither the Composition, nor any portion thereof, shall infringe upon or violate any right of privacy or publicity or any patent, copyright, trademark, trade secret, or other proprietary right of any third party;
 vi. the performance of the terms of this Agreement and the performance of Composer's duties hereunder will not breach any separate agreement by which

Composer is bound, or violate or infringe any rights of any third party, and so long as this Agreement remains in effect, Composer shall not commit any act or enter into any agreement or understanding with any third party which is inconsistent or in conflict with this Agreement;

 vii. there are no, and there will not be, any liens, claims, or encumbrances against the Composition which would derogate from or be inconsistent with any of Company's proprietary rights with respect thereto;

 viii. Composer represents and warrants that it is, and at all times during the term of this Agreement will be the holder of all consents necessary for it to perform its obligations hereunder; and

 ix. there is presently no litigation or other claim, pending or threatening, nor a fact which may be the basis of any claim against the Composition, and Composer has not taken any action or failed to take any action which would interfere with the rights of Company under this Agreement.

 b. The representations, warranties, and indemnification rights set forth in the Agreement shall survive execution of this Agreement, the performance of the obligation of Composer hereunder, and cancelation or termination of this Agreement.

10. TERMINATION: Company shall have the right to terminate Composer for cause, provided Company compensates Composer in full for all Compositions completed and accepted as of the date of termination. Composer shall have the right to terminate this Agreement for cause. For purposes of this Agreement, cause shall mean a material misrepresentation or a material breach of this Agreement.

11. ATTORNEY'S FEES: Should any arbitration, litigation, or other proceedings (including proceedings in bankruptcy) be commenced arising out of, concerning or related to any provision of this Agreement, or the rights and duties of any person or entity hereunder, the prevailing party (solely as between Company and Composer) in such litigation or proceeding will be entitled, in addition to such other relief as may be granted, to recover its reasonable attorney's fees and expenses incurred by reason of such proceedings.

12. GENERAL:

 a. This Agreement shall be governed and interpreted in accordance with the substantive laws of the State of California.

 b. Composer shall be deemed to have the status of an independent contractor, and nothing in this Agreement shall be deemed to place the parties in the relationship of employer–employee, principal–agent, partners, or joint venturers. Composer shall be responsible for any withholding taxes, payroll taxes, disability insurance payments, unemployment taxes, and other similar taxes or charges on the payments received by Composer hereunder. Company shall have no responsibility or liability of any kind to any subcontractors providing services to or for the benefit of Composer.

 c. This Agreement and the rights it creates may be assigned by Company, but not by Composer, except that, with the prior written consent of Company, Composer may assign this Agreement, in whole or in part, and the rights it creates to Composer or any corporation in which Composer is the sole shareholder. This agreement shall be binding on the parties and their respective successors and assignees, and all subsequent owners or licensees of the corporation.

 d. Should any provision of this Agreement be held to be void, invalid, or inoperative, the remaining provisions hereof shall not be affected and shall continue in effect as though such unenforceable provisions have been deleted herefrom.

e. This Agreement, including the Exhibits hereto, sets forth the entire agreement between the parties with respect to the subject matter hereof and supersedes all prior negotiations, understandings, and agreements between the parties hereto concerning the subject matter hereof.

f. This Agreement may be executed in counterparts, but shall not be binding upon the parties until it has been signed by both parties.

IN WITNESS WHEREOF, each of the undersigned has executed this Agreement as of the date set forth below.

"COMPOSER"

By: _____
Title: _____

"COMPANY"

By: _____
Dated as of _____
Title: _____

SCHEDULE 1

Milestone 1: Upon signing of Agreement Date $15,000
Milestone 2: Complete audio for levels 1–3 Date $10,000
Milestone 3: Complete audio for levels 4–6 Date $10,000
Milestone 4: Complete audio for levels 7–9 Date $10,000
Milestone 5: Upon completion & approval of composition Date $25,000
TOTAL: $70,000

Any additional new music needed by Company from Composer will be charged at $1000 per minute per Company's approval.

Royalty or bonus terminology goes here. For example:

Provided that Company actually incorporates the Music, or a substantial portion thereof, into the Game, if sales of the Game, not including promotional or complimentary copies, exceed Two Hundred Thousand (200,000) copies, Composer shall be entitled to receive an additional Twenty-Five Thousand Dollars ($25,000).

or

In addition to the above payment, Company will also compensate Composer five (5) cents for every unit & SKU sold throughout the world.

or

In addition to the above Milestones, Composer shall receive a ten (10) cent royalty on each SKU sold after 125,000 units.

or

Composer shall receive a profit participation of One Percent (1%) of Net Receipts from any product for which Composer is entitled to receive any compensation hereunder after Company has sold 125,000 units of such product. For purposes of this Agreement, the term Net Receipts shall be defined as all monies actually received by Publisher from the sale of a product in excess of 125,000 units less deductions for the direct cost of manufacturing the product, royalties payable to third-party hardware manufacturers such as Nintendo and Sony, returns or refunds, and all forms of taxes.

what you are doing. They may not make full use of it, but you've at least put them at ease in regard to the job you can do. Conversely, you might raise their guard— introducing points they are not familiar with which will lead them to gather their legal forces. Negotiations are a game of wits, and their lawyers give them a sense of security. All the more reason to have your ducks in a row and stay one step ahead.

Contract C

The final contract example is from one of the big boys in the game development and publishing arena. Being much larger and much wiser than us common folk, they've assembled an army of officials and lawyers to cover every possibility and have used more big words than I've ever had the pleasure of seeing at once. This is the type of

Professional Services Agreement

Beginning on the _____ day of _____ a _____ ("Contractor") agrees to perform services for Company X, Inc., and its direct and indirect subsidiaries ("COMPANY X") pursuant to the following terms and conditions:

1. Acting as an independent contractor, Contractor will render the services as stated in Exhibit A ("Services"). Contractor will take direction from and report to Producer X or Creative Director X. Contractor acknowledges that time is of the essence regarding its performance of the Services.
2. In consideration for performance of the Services and upon Company X's acceptance of completion of same, Contractor will receive from Company X a fee which is payable in accordance with Exhibit A.
3. Contractor understands that he/she is not authorized to incur any expenses on behalf of Company X without prior written consent, and all statements for the Services and expenses shall be in the form prescribed by Company X and shall be approved by _____ or his/her supervisor.
4. Company X has the right, in its sole discretion, to terminate this Agreement for any reason with seven (7) days prior written notice. In the event of such a termination, Company X's sole obligation will be to pay Contractor, pro rata, for the fees with respect to all milestones achieved or Services performed, as applicable, which shall have been accepted as of that date by Company X. Company X will have no further obligation, whether financial or otherwise, to Contractor after such cancelation. Company X may terminate this Agreement immediately upon Contractor's refusal or inability to perform under, or Contractor's breach of, any provision of this Agreement.
5. Contractor will not, either during or subsequent to the term of this Agreement, directly or indirectly disclose any information designated as confidential by Company X, including but not limited to proposed products, product plans, product features, specifications, and human-readable source code; nor will Contractor disclose to anyone other than a Company X employee or use in any way other than in the course of the performance of this Agreement any information regarding Company X, including but not limited to Company X's product, market, financial, or other plans, product designs and any other information not known to the general public whether acquired or developed by Contractor during performance of this Agreement or obtained from Company X employees; nor will Contractor, either during or subsequent to the term of this Agreement, directly or indirectly disclose or publish any such information without

prior written authorization from Company X to do so. Unless otherwise specifically agreed to in writing, all information about and relating to projects under development by Company X and/or parties doing work under contract to Company X including the Services rendered hereunder by Contractor shall be considered confidential information. Contractor acknowledges and agrees that all of the foregoing information is proprietary to Company X, that such information is a valuable and unique asset of Company X, and that disclosure of such information to third parties or unauthorized use of such information would cause substantial and irreparable injury to Company X's ongoing business for which there would be no adequate remedy at law.

Accordingly, in the event of any breach or attempted or threatened breach of any of the terms of this Paragraph 5, Contractor agrees that Company X shall be entitled to seek injunctive and other equitable relief, without limiting the applicability of any other remedies.

6. Contractor will return to Company X any Company X property that has come into his/ her possession during the term of this Agreement, when and as requested to do so by Company X and in all events upon termination of Contractor's engagement hereunder, unless Contractor receives written authorization from Company X to keep such property. Contractor will not remove any Company X property from Company X premises without written authorization from Company X.

7. As part of this Agreement, and without additional compensation, Contractor acknowledges and agrees that any and all tangible and intangible property and work products, ideas, inventions, discoveries, and improvements, whether or not patentable, which are conceived/developed/created/obtained or first reduced to practice by Contractor for Company X in connection with the performance of the Services (collectively referred to as the "Work Product"), including, without limitation, all technical notes, schematics, software source and object code, prototypes, breadboards, computer models, artwork, sketches, designs, drawings, paintings, illustrations, computer-generated artwork, animations, video, film, artistic materials, photographs, and any film from which the photographs were made, literature, methods, processes, voice recordings, vocal performances, narrations, spoken word recordings, and unique character voices, shall be considered "works made for hire" and therefore all right, title, and interest therein (including, without limitation, patents, and copyrights) shall vest exclusively in Company X. To the extent that all or any part of such Work Product does not qualify as a "work made for hire" under applicable law, Contractor without further compensation therefore does hereby irrevocably assign, transfer, and convey in perpetuity to Company X and its successors and assigns the entire worldwide right, title, and interest in and to the Work Product including, without limitation, all patent rights, copyrights, mask work rights, trade secret rights, and other proprietary rights therein. Such assignment includes the transfer and assignment to Company X and its successors and assigns any and all moral rights which Contractor may have in the Work Product. Contractor acknowledges and understands that moral rights include the right of an author: to be known as the author of a work, to prevent others from being named as the author of the works, to prevent others from falsely attributing to an author the authorship of a work which he/she has not in fact created, to prevent others from making deforming changes in an author's work, to withdraw a published work from distribution if it no longer represents the views of the author, and to prevent others from using the work or the author's name in such a way as to reflect on his/her professional standing.

8. None of the Work Product is to be used by Contractor on any other project or with any other client except with Company X's written consent. If any part of such Work Product is the work of a subcontractor employed by Contractor, then Contractor will require such subcontractors to execute an assignment document in the form attached hereto as Exhibit B so as to secure for Company X exclusive ownership in such Work Product. In the event Contractor is unable to obtain exclusive ownership from such subcontractors, Exhibit C must be signed to obtain a license for the benefit of Company X. Contractor shall promptly thereafter deliver such originally executed assignment or license documents to Company X.

9. With respect to all subject matter including ideas, processes, designs, and methods which Contractor discloses or uses in the performance of the Services: (a) Contractor warrants that Contractor has the right to make disclosure and use thereof without liability or compensation to others; (b) to the extent that Contractor has patent applications, patents, copyrights, or other rights in the subject matter which is set forth in writing in Section 5 of Exhibit A, if any, Contractor hereby grants Company X, its parent, subsidiaries, affiliates, and assigns, a royalty-free, perpetual, irrevocable, worldwide, nonexclusive license to use, modify, make, have made, sell and disclose, and distribute such subject matter in any form now or hereafter known; and (c) Contractor agrees to defend indemnify and hold Company X harmless from any claims, litigations, actions, damages, or fees of any kind (including reasonable attorney's fees) arising from Company X's or Contractor's use or disclosure of subject matter which Contractor knows or reasonably should know others have rights in, except, however, for subject matter and the identity of others having rights therein that Contractor discloses to Company X in writing before Company X uses the subject matter.

10. It is understood and agreed that in performing the Services for Company X hereunder, Contractor shall act in the capacity of an independent contractor and not as an employee or agent of Company X. Contractor agrees that it shall not represent itself as the agent or legal representative of Company X for any purpose whatsoever. When Contractor is working on the premises of Company X, Contractor shall observe the working hours, working rules, and security procedures established by Company X. No right or interest in this Agreement shall be assigned by Contractor without the prior written permission of Company X, and no delegation of the performance of the Services or other obligations owed by Contractor to Company X shall be made without the prior written consent of Company X. This Agreement shall be deemed to have been made and executed in the State of California and any dispute arising hereunder shall be resolved in accordance with the law of California. This Agreement may be amended, altered, or modified only by an instrument in writing, specifying such amendment, alteration, or modification, executed by both parties. This Agreement constitutes and contains the entire agreement between the parties with respect to the subject matter hereof and supersedes any prior oral or written agreements. Nothing herein contained shall be binding upon the parties until this Agreement has been executed by an officer or agent of each and has been delivered to the parties.

Agreed to and Accepted:

Company X, Inc.

By: _____

Title: _____

Date: _____

Contractor

Signature: _____

Social Security #/Fed. ID #: _____

Date: _____

Exhibit A

1. Services

The expected completion date is _____.

Date	Milestones	Payments
__-__20_		$
__-__20_		
__-__20_		
__-__20_		
__-__20_		
__-__20_		
__-__20_		
__-__20_		
__-__20_	Final Delivery	

* Payment shall always be contingent upon timely delivery and acceptance of each milestone.

2. Payment

Contractor shall be paid for the Services in increments as set forth above after acceptance at each stage of the work performed. Anything to the contrary notwithstanding, the compensation for the Services performed hereunder shall not exceed $_____ without the express, written consent of _____.

3. Expenses

The following authorized expenditures are the maximum that Contractor shall be eligible to receive as a reimbursement. Contractor must produce receipts for all preapproved expenses for which Company X will reimburse Contractor within thirty (30) business days of receiving such receipts and expense reports. All expenses incurred by Contractor not specifically approved herein shall be the sole responsibility of Contractor.

Amount	Approved Expenses
xxx	xxx

4. Payment Schedule

Subject to Company X's prior acceptance of the milestone as provided herein, Company X will remit the fees associated with a delivered milestone to Contractor within thirty (30) business days following Company X's receipt of Contractor's invoice. All invoices must be sent to the designated representative set forth in Section 1 above.

5. Work-for-Hire Exclusions

The following includes all subject matter that is excluded from the assignment of rights granted in Section 7 and the nonuse provisions of Section 8, but which is licensed in accordance with Section 9(b):

1. NONE

Exhibit B

Subcontractor Copyright Assignment

For valuable consideration separately and previously agreed to between the undersigned and Company X, Inc., a California corporation, having a principal place of business at _____, the undersigned hereby assigns all rights, title, and interest in and to the materials described below, including the copyright thereof, in the United States and throughout the world, together with any rights of action which may have accrued under said copyrights, which are owned by the undersigned, for One Dollar ($1.00) and other good and valuable consideration, the receipt of which is hereby acknowledged, to Company X, Inc.

Work: Materials relate to "_____"

Dated: _____

By: _____

Print Name: _____

Company Name: _____

Address: _____

Phone: _____

Tools of the Trade

BRIAN TUEY
Sound designer, Composer, Audio director—Treyarch

I have a few different setups depending on if I'm composing music or working on mastering or sound design.

Music DAW

Computer: 2014 Intel Mac Pro (3.5 GHz, 6 core), 64 GB RAM

Software/Synths: Logic X, All Spectrasonics, ReFX Nexus 2, Lennar Digital's Sylenth1, East West, and many more

Monitors: Blue Sky 2.1 monitor system

Other: PreSonus Central Station Plus for control, AKAI MPK88 keyboard

SFX DAW

Computers: Intel (core duo 2.6), 16 GB RAM

Software: Pro tools HD9, Adobe Audition, Wavelab, Waves Platinum, a ton of other plug-ins

Other: Blue Sky Bass Management System, Blue Sky Pro Desk MKIII 5.1 system, with a SUB 12, Massive database of commercial and custom libraries, Tons of recording gear

Mix room

Computer: Intel (core duo 2.6), 16 GB RAM, Protools HD 9

Other: Blue Sky Bass Management System, 5 Dynaudio AIR 15 + AIRBASE 24, Consumer JBL 5.1 system with Onkyo TX NR626, two really (really) crappy desktop speakers for b comparison

contract you will want to spend much time with, understanding each sentence and what impact it will have on your interests *before* you ever put your pen to the paper.

It will be blatantly missing any points referencing SKUs, ancillary rights, soundtrack rights, logos, splash screens, and credits. This should be no surprise. Knowing this in advance, you can look to adapting it to make it agreeable to your interests. Keep your eyes open.

Conclusion

Hopefully the information shared in this chapter will help you handle the challenge of deal making with confidence. There is a huge advantage to being knowledgeable about what goes on in this industry and knowing what types of deals are out there can increase your earnings potential exponentially. I'm certain I've given up a good deal of money in my first couple of years at bat because of my inexperience. But because game composers and sound designers have created their own behind-the-scenes network and support groups and have seen the advantage of sharing their experiences, it has paved the way for the rest of us to profit.

We talk to one another and discuss our deals quite openly. Because I know what the next guy is making, I know I can ask for the same and actually get it. Once our way of thinking becomes standard in the industry, we won't have to expend so much of our business energy because everything *we* want will already be in *their* contract. Little by little I know we are making headway, having been asked to sign contracts taken from this very book. As long as we continue reinforcing what is considered "standard," we will eventually be right where we want to be. Then, we can get on with why we joined the industry in the first place: making music and sound effects.

7

Setting the Stage

For the most part, this is where the creative process begins for us sound guys and gals. Occasionally, game developers will have you on as part of the team from the beginning—this being the best situation, of course. But more often than not, they'll have a good amount of the work on the game already completed. Before they even call you, the developer will have been at work for many months planning, creating, and methodically carrying out production phases. Entering midstream is more the norm, and you can help minimize the anguish by planning ahead and knowing what to do. Getting the information you need at the right time and understanding your exact role and what is expected of you can save you enormous grief and creative setbacks. This will be the basic thrust of this chapter.

Company Liaisons

During the contract process, you will have identified who has final authority over your work. This person will be where the proverbial buck stops—the person who will approve your submissions so you can get paid. But, you will also need to know who your primary point of contact is as well. It may be the same person, and usually is, but at large development conglomerations, there may be several people to work with. Find the main one and get to know them.

Your contact will have a working style all their own, and it will behoove you to find the best way to work with that person. Communicate through every step of the process, keep the lines open, and keep them informed. It will take some time to fully understand their creative guidance and to know what they mean by it. Every human being is different, their life experiences making them so. What

means one thing to one person could mean something completely different to another, even if the exact same description was given.

For example, if I were to tell you to write a piece of music and the only direction I gave was "Make it RED!" what kind of music would you compose? I envision a searing bright red color—an upbeat, fiery, heavy metal piece with blazing guitar solos, and impassioned vocals. But maybe you see a dark, scarlet red—a sexy, slow jazz number with hot saxophone licks and piano that would tear your heart to pieces. See what I mean? By learning what makes this person tick, you'll have a better chance of knowing what they really mean. Use all of your senses and ensure the translation is pure. In this case, don't be afraid to ask as many questions as possible to ensure you pinpoint what the client wants. Asking questions is far better than to assume you know what someone is thinking.

Is your company liaison hands on or hands off? Some will want to be a part of every step of the creative process, which means you'll need to get their okay for everything. You'll create many musical "sketches," letting them choose which ones are closest to their vision. Once they've approved them, you'll flesh them out to their final versions—submitting them again for their okay on instrumentation, arrangement, length, volume, EQ, and loop points, if needed. You'll rework them until they are perfect. Many versions of sound effects will be offered, and they'll pick those that are closest, and you'll rework those until they are perfect as well. The "hands on" types are usually a little bit high strung—highly passionate individuals who live and breathe a project, taking their role very seriously. Some meddle to the point of almost interfering with your creativity; others genuinely care about the project and have their fingers in every aspect of it. Their name is on the product, and their future in gaming is the true motivator.

"Hands off" individuals work differently. Because of their need to be in a hundred places at once, they are more comfortable delegating and letting content providers "do their thing" without much interference. They will set the scene for you, give you all of the proper adjectives, and then let you create audio using the expertise they are paying you for. These types of individuals understand—either through years of experience or from their lack of it—they are incapable of doing a great job at everything. Instead, they go with their strength in leadership and put faith in you. It puts a lot of pressure on you to perform brilliantly, but don't worry. They will be there every step of the way to help keep you on track. The "hands off" type appears to be laid back, but underneath they are just as passionate about the success of the project as the next guy—they just go about it differently. They will keep the atmosphere fairly relaxed and will let you set your own hours and working methods, as long as milestones are met as promised.

Most of your company contacts will be somewhere in the middle of the previous extremes. Which one is the best to work for? It will depend on your personality type and what you need to prepare an inspired atmosphere. The "hands on" folks keep you on your toes, pushing you to do the best work you've ever done. They demand a lot, but the rewards gained by your astonishing audio will make it worth it. "Hands off" people will give you all the room and support you need to fulfill your vision of the project. They will protect you from the outside world, placing you in a cocoon—enabling you to give 110% and to take advantage of inspiration as it strikes. This person may have let you create on your own, letting you work your brand of miracle untouched, but they are just as responsible for the final masterpiece.

Executive Producers

The executive producer is generally the project lead. They have grasped the total creative vision and ensure each department is fulfilling their appropriate missions, on time and within standards. At most game companies, this individual has the final say on everything from artwork, game play, sound effects, music, narrations, cinematics, and so forth. They are normally working on many tasks at once but have the ability to know what each hand is doing. This ensures the audio you are doing will mesh precisely with audio from any other sources, such as narrations or sound effects, and will fit in perfectly with the game.

Executive producers may also be in charge of multiple game projects, especially at large developers or active Internet game companies. In cases like this, other help is needed in the form of a producer.

Producers

Game company structures are designed for the most efficient use of time, money, and personnel. The producer steps in to fill a more focused role in a game project, either overseeing a single game project in a company producing multiple game titles or managing a single department for one project. Normally, there is no "audio department producer" to report to per se, as an in-house composer, you *are* the audio department. They wouldn't ordinarily be calling you in as a contractor if they have a true audio department. So, there would be someone else assigned to direct your efforts in this case. There is the occasional huge game company which does have an in-house audio department with an audio producer and even as a contractor, you may get a call to assist on projects in rare instances. Don't be too surprised if companies like Electronic Arts or Sony give you a call. Their guys have to take a vacation sometime.

A producer's role is essentially the same as the executive producer except they are a step down in the chain of command, so to speak, and report directly to the executive producer. If the two work well together, there will be little change of direction—and what the producer tells you is the same word passed down from the boss. In situations where the word isn't clear and you feel confliction, ask the producer before you go over their heads to get clarification. You have to work closely with these people, so be conscious of egos and the need to be in control of their assignments.

Creative Directors

The creative directors are individuals who manage the design elements of a game, unlike an executive producer or producer—who is also concerned with nonproduction elements like the budget and schedule. Their job is similar, acting as the central contact point for the elements of game production—except these guys are what gives a game its "fun factor." This job is commonly filled within the online gaming communities or multimedia production houses where this fast-paced environment requires a common thread throughout the many simultaneous projects. In expanding companies, you may work with a creative director instead of a producer—who is typically close by, looking over his or her shoulder.

Audio Managers, Audio Directors, Audio Leads

More often than not, if you're hired as a contract audio provider, the game company doesn't have an audio department and these folks won't exist. But, if you're brought

in to relieve a little pressure for the in-house staff or because of your specific talent, your contact will either be the head of the audio department or an Audio Lead. The Audio Manager or Audio Director is someone who supervises a staff of composers and sound designers or several contractors for a variety of projects. An Audio Lead typically concentrates on a single game and reports to the manager or director for overall guidance. Either way, you'll be connected to someone who knows how to speak "audio" and can give some accurate direction and feedback.

Meetings with the Game Development Team

It is essential to the success of a project that the many different contractors and in-house employees all work together as a cohesive team. Each player should know a little something about what each other member is doing and how it will all fit together in the final product. The one way to do this is to be present at the many meetings and discussion groups along the way. As a contractor working off-site, this may present more of a problem if there are many miles separating you. Teleconferences are a great alternative—or, better yet, have a speaker phone available at a meeting for you to participate.

If that isn't possible, have someone attend the meetings who will fill you in on all pertinent details. Either way, make sure you are in the loop and get information in a timely manner. This will save a lot of "Didn't I tell you?" and "I thought you knew" comments. If you run into the phenomenon known as "information blackout" and feel the data you are missing is essential, talk to your point of contact, find out why, remind them you are under an NDA, are fully committed as part of the team, and need the facts to make informed, creative decisions. Do what you can to stay "in the know," especially when it can affect your part of the job.

Details to Discuss

If you were hired as the result of a bid competition, you will already have a solid idea about the parameters of the game. But, don't be satisfied that all of the information has been presented and don't make any creative decisions until you have more data. Now that you are on board as part of the team and have signed the contract, the key players will be more willing to share their thoughts about where things should go sonically. As the outsider coming into a project already in production, you will have to ask many questions to satisfy your requirements prior to starting work. Obtaining a solid overall view for the entire project will give you exactly what you need. Start with broad questions and work on the finer details as you learn more about the production. The first question will set the tone for the rest of your investigation and for the eventual audio you'll be creating.

What Is the General Theme of the Game?

Music and sound effects can make or break the immersive effect a game is designed to have. The most important question you can ask is "What is the theme of the game?" in order to have the style of audio accurate for the genre. Examples of themes are space, medieval, sports, racing, children's, religious, and horror—all of which conjure up specific images and sounds. Even if the developer wants to attempt a new approach with the audio, there will still need to be basic elements of the genre to provide that certain familiarity for the players. If a game company tried to produce a medieval racing game, you can guarantee there will be orchestral instruments playing medieval melodies all backed by a fast-paced rhythm section.

Find out their *interpretation* of the "theme," even if you know what it is. What may look "horror" to you may instead be artwork of a tunnel you'll be driving your Ferrari through or some other small inconsequential scene which has no bearing on the rest of the game. I'd hate to see this "horror" scene, decide it was the "look" of the game, and run full steam off on a tangent. Not only will this false start be costly in wasted time, but it will harm your creativity. Ask lots of questions and see every bit of artwork you can. Have no doubt in your mind what the game is all about.

A case in point: I had been contracted to do, what I thought from the bid information, was a space game. The milestones were fairly aggressive, and since I felt I already had a good idea of the theme, I ran head first into the opening, menus, and level victory themes. Two weeks of nonstop work later, and just in time for the first milestone submission, I smiled as I sent in the music—knowing for certain I'd hit the nail on the proverbial head. The developers reply was polite, but, reading between the lines, I could tell they weren't as happy with the music as I was. Something was amiss.

I pressed for specific information, attempting to understand how I could have been so far off. They were gracious and gave many thoughts for improvements. A sleepless week later, I submitted new music ideas which incorporated their suggestions—and again, I thought I was submitting very appropriate music. They didn't think so and were now growing less confident in my abilities to fulfill their vision. I too was disappointed, since I've always been pretty good at translating visuals to sound, and called for a last-ditch meeting to salvage the project.

As we got settled at a conference table, the flat screen on the wall was showing the menu screen from the game, but the scene playing behind the menu wasn't a space environment like on my working version, it was a nice green park-like setting, with trees and flowers and birds flying by. I pointed with my mouth hanging open, obviously in a slight state of shock. "The menu music I did would never work for that!" And, that's when they explained that the game was planned to have several different levels, including space, a park, and a dozen other themes—but the space level was the only one completed and the only artwork I'd seen. They felt the opening, menus, and victory cues should be something which would set the tone of the game and be able to lead into any of the environments—basically a neutral feel but open to the many different possibilities the game would reveal.

I was as surprised as they were that I'd totally misread the theme of the game, but with this new information I was able to compose new music they absolutely loved, and we were able to get back on track and head into the next milestones. The obvious lesson I learned from this was, despite what you may think you know about the theme of the game and despite what the developer thinks they told you about it, double and triple check to make sure all of the appropriate information is revealed.

What Genre of Music Will Set the Mood?

Discuss their interpretation of the music they feel would enhance the game. It may seem rather odd, you being the composer and all, but asking them will only clarify your musical direction. Remember, they've been living with this game for several months, and I'm sure the subject has already come up among themselves. Listen to what they have to say and don't be judgmental at this point. Any idea is a good idea when brainstorming. What may sound silly might give someone else the winning idea. Better yet, you might be the one with the idea and look like a hero!

LENNIE MOORE
Composer

For more than 25 years, Lennie Moore has been a proven force as an accomplished composer, orchestrator, and arranger of music for videogames, film, television, and new media. His credits include *AMD Surround House 2: Monsters In The Orchestra, Fighter Within, Red Orchestra 2: Rising Storm, Star Wars: The Old Republic* (2012 G.A.N.G. award winner, Best Soundtrack Album), *Kinect Disneyland Adventures* (2012 G.A.N.G. award winner, Best Interactive Score, Best Use of Licensed Music), *Halo Combat Evolved 10th Anniversary, The Walking Dead Motion Comic, Watchmen Motion Comic* (2009 G.A.N.G. award winner), *Magic: The Gathering—Duels of the Planeswalkers, Dirty Harry, Dragonshard, War of the Ring,* and *Outcast* (2000 nominee for Best Music by the AIAS—Academy of Interactive Arts and Sciences).

Lennie has also developed and taught *Composing for Video Games* courses at the USC Thornton School of Music, UCLA Extension, and developed the first accredited degree program for Game Audio and Interactive Media at Pinnacle College.

www.lenniemoore.com

Describe your thought process when scoring for a game.

I'm someone who gravitates toward themes. I spend a lot of preproduction time thinking about things like, "What is this game about?" I'll then create a central theme that reflects these ideas. For *Lord of the Rings: War of the Ring,* I had a hope versus despair theme that I wove into the fabric of the entire score. This was based on my extensive reading of the Tolkien books (since junior high school!) and my understanding of the characters and the story. For

Outcast, I used a central theme and tonality (or harmonic structure) as there was a component where you could eventually travel between all five regions in the game, and I wanted the player to feel that all these regions were connected by a common thread.

Are there any particular secrets to your creativity?

I pretend I'm 8 years old, playing with my toys and making up my own soundtrack, like a lot of kids do naturally. I also make it a point to not answer the phone, check e-mails, or, in general, be distracted during my composing time. I do my best to eat well and go to bed at a reasonable hour, so I can keep my creative energy consistent from day to day, especially on larger projects where I have to sustain the same high level of creative energy over several months.

Are there any secret techniques that you regularly employ?

I don't know if I have any "secret techniques." I've done so much public speaking about my work and sharing of ideas with the game audio community at conferences, I don't think there's much that I haven't revealed already. I'm still full of surprises though!

I just do everything I can to be intentional and specific in my work. When I start from there, everything comes into focus as far as musical storytelling goes.

Do you have any interesting music creation stories?

AMD (the computer chip manufacturer) hired Pyramind (who then brought me on to the project as the composer) to create a really interesting interactive experience for the 2014 Consumer Electronics Show. I was asked to compose an adaptive concert piece for orchestra where the audio would be split into many tracks in order to create a 32.4-channel locational surround experience that involved an orchestra of computer-animated monsters projected seamlessly from six projectors on the inside of a giant dome along with a 360-degree gesture control system to control the monsters in real time. All of this ran on one computer system using a Kaveri APU and one FirePro graphics card. They also hired me to help give the presentations at CES which was awesome as I can now say I demonstrated the first 360-degree gesture control system and got to conduct an orchestra of animated monsters!

Do you have any advice which can help lay solid groundwork and ensure a successful production for the audio content creator?

Be organized. Be consistent. Deliver on time and on budget. Lather. Rinse. Repeat.

When do you find you are most creative?

I'm the most creative in the early morning from 6 a.m. until about 2 p.m. The other bit that I'd add is that I'm most creative when I'm relaxed, so I make it a point to eliminate distractions before beginning any creative work.

Any worthwhile creative advice you'd like to share?

Solutions to challenging problems (more often than not) come from unusual places. If you run into a blockage, don't stare at the computer screen hoping for the muse to miraculously hit you with "the answer!" Get up and walk around. Take a break. Do something else. Work in the garden. "The answer" will come to you more often when you aren't trying to force a solution.

Is there a typical workday for you?

I always start with a cup of coffee in my hands and sit quietly before I begin work. Once I've cleared my mind, I plan out what I want to accomplish each day. Then I begin. I try to take

regular breaks to maintain my energy throughout the day. The day is usually done when I've seen a task or milestone through to completion.

What skills should composers have to succeed in the games industry?

You should understand the technology, game mechanics, and how your compositions can function within an adaptive setting.

Do you have a specific ideology which drives your way of doing business?

Yes. Consistency and reliability in addition to doing excellent creative work.

Any good business advice to offer?

Absolutely no stalking! Don't be creepy. Don't be a jerk.

How do you approach negotiations with a new client?

I usually keep it really simple. My agent handles the contracts and the numbers, and I take care of the creative end. I also try to ask a lot of questions to get to know a new client.

Do you have any negotiation tips which work well for you?

When negotiating a contract, I always ask myself what clauses, or points, do I absolutely *have to have*, what are ones I'd *like to have*, and which ones are *not an issue at all*. This helps me determine what I want my agent to really fight for. I also think it's also very important to understand the other side of the negotiating table. What do they have the rights to give or not give? Are their hands somewhat tied? Finally, I think it's important to remember that you are not negotiating with an adversary, you are negotiating with a friend. They want to hire you, and that's a great thing in itself.

Do you have any contract stories which others could learn from?

Especially when dealing with live recording sessions (or anytime I need to bring in an expanded crew), I make sure my agent pushes hard for payment guarantees (with specific dates) whenever there's a production budget. This way we make sure we can book music prep teams, orchestras, and scoring stages when we need them without putting these sessions in jeopardy because "the money is not there yet."

Do you have any tips when working with developers?

Keep in mind most developers are a combination of creatives, artists, business people, and programmers. Know what kind of people you're talking to by doing some research. That way you can relate to them in a way that is most effective.

What advice can you give when working with a developer which has ensured a good working relationship and a good final product?

In general, I find it's all about great communication. Anytime there has been an issue in the past, the resolution has been to talk it out and find a workable solution together with your client.

The other lesson, which I think is a very important one, is that there are absolutely no guarantees that the music you write will end up in a game that actually makes it to market. Having an emotional attachment to a particular score can be devastating. I've had three projects where I delivered completed scores (both of which I'm very proud of the work I did) ended

up on the proverbial shelf where they weren't released. Where I'm emotionally involved is composing and delivering a great score for every project. Once I hand it off to my clients, I have to let go of it because it's completely not up to me what happens after that. It's almost like I'm a surrogate mother carrying a baby for someone else! The key to finding peace in this type of situation is to realize that my life doesn't end with one project and to move forward to the next cool endeavor.

What advice can you give when working with a developer to ensure you are able to make great music?

It's all about being "on the same page" with the client. I make every effort to understand the tone, mechanics, creative direction, schedules, and feedback on every project to give my clients the best possible score I can provide.

Have you ever had any development issues negatively influence your workflow?

Sometimes, production schedules get delayed or halted because of issues outside of your contributions to a given project. It's best to keep clear notes, so you can pick up where you left off when the external issues are resolved.

Do you have any advice to ensure successful audio implementation?

Start with file-naming! If the client tells you to name a particular asset "level1_ambient_loop1_76bpm.wav" don't name it something else unless you want everyone at the game development company to call you at home screaming about how you "broke the build" and cost them millions of dollars which the publisher is holding until they fix the problem.

It pays to really understand all the game mechanics relating to the music assets you're creating and make sure your files are beautifully edited, levels are even and working perfectly in the game. I use testing tools such as Wwise, FMod Studio, or Ableton Live to make sure my music design concepts are working.

Staying organized is important, especially if you are working on multiple projects, which is part of your daily routine. How do you keep up with it?

I use several project management tools to stay on top of a full schedule. Everything from Excel sheets to online systems like Basecamp.

Any specific "lessons learned" on a project which you could share?

I worked on one project where all I had were screenshots to compose to. There was no way for me to see how the game *moved* and that was a challenge in figuring out how fast the battle music tempos should be. As the game was about zombie killing, I figured—zombies move slow, so I could actually do a slower tempo like 64 beats per minute but 32nd notes for a lot of intensity and it would work well. The end result was great and the client was happy, but I really prefer as much detail as the developer will allow in order to really nail it.

There are many pitfalls when "working" in the game industry. Have you had any bad experiences?

There are always challenges. Bad experiences are not unique to the game industry. Usually, you try to just roll with the punches.

I actually worked on a feature film where I found out the production company was notorious for not paying their vendors and eventually had to hire a collections agent to collect payment

for me. It was strange as it was the first and only time I ever had to do something as drastic as this. I think what got the production company to take me seriously was when the collection agent showed up on the movie set of their next film!

Do you have any development stories which served as a good lesson learned or something which can be avoidable in future projects?

I've been on a lot of composer teams (games with multiple composers providing large amounts of music) and one of the lessons me and several of my colleagues have learned when working in these situations is to:

1. Always have one person who is the lead in charge of managing time during the live recordings.
2. Compose music that is playable in the time allotted.
3. Be a team player and support your colleagues.
4. Have regular meetings throughout the project to stay in communication with the team.

Any horrible endings to a project which others could learn from?

No, not really. I've been lucky in having great experiences with all my clients. I think part of this is due to my commitment in creating consistently great music, meeting all deadlines, and being a good guy to work with. Doing this is not always easy! I have my moments when I'm stressed, challenged, or just angry about something, but I always go back to telling myself, "This is exactly what I want to be doing with my life and I love it."

How did you find your way into the games industry?

The *Outcast* developers posted on a newsgroup that they were looking for a Hollywood film composer to score orchestral music for their video game. I sent them an e-mail saying. "Hey, I'm your guy!" and after submitting some music I did with a live orchestra and choir for an Atom Bomb documentary (*Trinity & Beyond*), they saw what I could do and hired me. I'll be forever grateful to them as they introduced me to an industry that I love with all my heart and soul. I've found my people, and they are geeky programmers and technology freaks!

Examples of genres of music to consider are many—orchestral, techno, industrial, rock, country, ambient, and so on—but only a few will fit the bill for a game project. Much is dependent on the targeted age group, the theme of the game, and the taste of its creators. Your job is to blend these elements to remain true to what the game, is about, and who it will be sold to. Discuss the demographics with them, identify the intended audience, and add that to your growing list of parameters.

What Examples of Reference Music Will Fit the Game?

Remember our earlier "red" example? Even after you've narrowed down the discussions about what kind of music is suitable for the game, it doesn't mean everyone's *perception* of that music is the same. What I believe to be "techno," for example, may not be what the next guy thinks is "techno." That's why you need examples to listen to together. Play tracks from the various suggestions and work on a consensus. Now everyone will be in agreement on the style and know what to expect.

Take this a step further. Find out the elements of this style which appeal to everyone. Is it the beat? Is it the instrumentation? Is there something in particular which stands out that would be perfect for the game? Sometimes, you'll find it isn't even the genre of music they like but a specific sound used in a song or by a band. Give them chances to present their ideas clearly and to put their finger on all the sonic tidbits that will give the game its final personality. Your job is to listen.

The idea isn't to have someone else do your job but to make the game better and help your mental processing. It will be enough of a challenge composing, recording, and mixing the music but having no idea where to start can make it that much more difficult. It's been said, "Good composers borrow, great composers steal!" In this day of highly enforced copyright laws, I don't recommend stealing, of course, but by utilizing key elements of a band or style, you will be more able to get it right the first time. There isn't much of a chance you could recreate someone else's work even if you used the exact same instrumentation and sounds, so don't sweat it. You could take five composers, give them the same five loops to use, and I guarantee you'd get five very different musical presentations.

Getting your team to listen to and review prerecorded music may be the best way to start off on the right foot, but unfortunately isn't always possible to accomplish. In the beehive of activity within the game developer's lair, time is always of the essence—and this step may get left by the wayside in favor of more important developer issues. After all, they hired you as the audio expert and are paying you to do a job—so, it may be necessary to use the information you do have and your gut instincts. Try your best to schedule a meeting where you can discuss this particular issue.

What Are the Sound Effect Needs?

If you are contracted to do the sound effects, you will want to know as much as you can about any preconceived ideas the development crew has been working under. Just like the music, they may already have some ideas about what sounds would work best. The creators of certain characters may have a close, personal relationship with their work and would love to share their ideas of what makes this particular character special. You can translate their thoughts into some fitting sound effects and have an impact just by paying attention and asking the right questions.

If you aren't doing the sound effects portion of the game, it is still a good idea to find out what other audio your music will be competing with. If there are to be heavy background sounds during gameplay, it will have an impact on the complexity of the music you can offer. As the audio expert, you may have to point out to the developer that background sounds, music, and narrative playing simultaneously will cause confusion in the soundscape. Instead of the player having to turn the volume down, suggest the music you create be less dense—enhancing the experience, not highlighting a battle between all of the sonic elements.

More often than not, when there is more than one sound contractor on a project, no one knows if all of these separate elements will blend together or destroy the audio atmosphere until they are pieced together near the end of the project. To prevent this possible setback, it is extremely important to understand what other sounds might be competing and work on the problem from the beginning. Also, consider staying in close contact with the other audio contractors to share information and prevent massive reworks for you both.

Are you recording and editing the dialog, too? If you are, your tasks are getting more complex—and at these initial meetings, it's a great idea to find out so you can schedule your time appropriately. Since the contract negotiations, parameters may have changed, maybe you originally weren't going to have anything to do with the narration but now that your skills are evident and since you're on their team, why not? Be sure to renegotiate in this case and find out the details.

- Are you expected to audition and select the voice talent or have they already taken care of that?
- Do the narratives simply need to be edited, or do you need to bring the talent in and record them?
- Are you expected to write the scripts yourself?

These are just a few thoughts. Such questions will ultimately decide how much extra work you'll have in store—and if you are doing the music and sound effects, too, you'd best get busy.

If you aren't touching the narratives, character voices, or voice-overs, it is still appropriate to find out what they will consist of. Does the main character have a voice like James Earl Jones, low and intense, or is it something on the other end of the range? Instead of having to turn down the volume of the music as an answer, how about building a hole in the frequency spectrum? What the characters and other voices are saying are more important than the background music, and a little preplanning will save you having to redo that slamming bass line competing with Darth Vader's orders to squash the universe. Normally, the most understandable part of vocal work, especially on tinny multimedia speakers, is in the upper-mid to high-frequency ranges. By determining the needs of the game project first, you can ensure the soundscape is equitably managed and every facet is heard.

These first creative meetings are important. The details may seem inconsequential to the game developer, but it is imperative you discover as much of this "trivial" information as possible before you even sit down to compose. You will be very anxious to start creating, like a thoroughbred waiting for the race to begin, but exercising some patience is the way to go. Gather all of the pieces of the puzzle, sort them out, build the border frame, and then you can begin.

By sorting out the fine points first, your creative energies will be spent producing music and sound effects which have a better chance of fitting perfectly the first time, instead of dealing with the creativity-sucking frustrations of false starts and redos. Set the stage for your best work and then blow them all away with it!

Precompositional Considerations

Somewhere within the many initial meetings, someone is going to have to make an important decision: How much physical memory will be allotted to audio? The answer will have a direct impact on you—the final output quality of your audio and how you will be able to achieve the best balance of file size and sound quality. Each platform hard drive, game disc, and game cartridge will ultimately determine the memory available for all that makes up a game: programming code, engines, drivers, artificial intelligence, artwork, animations, cinematics, and sound. For example:

CD-ROMs	700 MB
DVD-ROMs:	
Single layer	4.7 GB
Dual layer	8.5 GB
PlayStation 2 and 3 using single-layer DVD	4.7 GB
PlayStation 3 using dual-layer DVD	8.54 GB
PlayStation 3 and 4 using Blu-ray:	
Single layer	25 GB
Dual layer	50 GB
Xbox One using Blu-ray:	
Single layer	25 GB
Dual layer	50 GB
Xbox and Xbox 360 using single-layer DVD	4.7 GB
Xbox 360 using dual-layer DVD	8.54 GB
Nintendo Wii U (using optical disc)	25 GB
Nintendo Wii (using Wii optical disc)	4.7 GB
Nintendo GameCube (optical disc)	1.5 GB
Sony PSP (universal media disc, UMD):	
Single layer	900 MB
Dual layer	1.8 GB
Nintendo DS game card	Typically 64 or 128 MB
256 MB maximum capability	

There is a hard limit to the amount of data competing for space in each game. Sound, fortunately for us, has moved from being the bastard child to an important aspect of gaming. Instead of getting what scraps of memory are left over after the others have their fill, audio is actually getting planned for ahead of time to share the real estate equitably—based on the needs of the game. If a game is touted as a graphical masterpiece, artwork will take up the majority. If surround sound is the big selling point, audio will have the space.

The Big Trade-Off

One must evaluate:

- How much space is available
- What method of audio playback to use
- The processor speed which will be doing it
- How much audio there is
- What quality of sound for all of this is acceptable

Cartridge-type games actually don't require much space for sound. Because they use small files that tell the unit's internal sound device what notes to play and when, their actual file size is tiny compared to the rest of the information. Games which utilize "sound fonts" use more cartridge memory because the triggered sounds are actually stored in the cartridge. Most hard drive-, CD-ROM-, or DVD-ROM-based games play recordings stored on the discs. If the game you are working on is one of these, the sample rate, resolution, and whether or not mono, stereo, or surround are required will determine your best methods of creation.

Game developers actually use many different considerations before deciding on the final sound format and parameters. I mentioned physical memory first because it is the easiest concept to grasp: there is only so much space, and you can't fill past the limit. The first and foremost factor a developer will consider is "speed." Is the game we are developing going to run smoothly on our target platform? Not only is a game's content competing for physical read-only memory (ROM) but when the game is in play and all that data are moving through the computer's insides, the pipeline through the processor has to be able to handle all of the information.

Complicated AI (artificial intelligence) and graphic-intensive scenery will chew through the available assets in a hurry, leaving little room for anything else. A way for programmers to make it all work is to cut down on the size of the data, including the audio and graphic files. Programming code is basically text files, and not much can be done to squeeze the file size any smaller. Graphics and audio are different in the sense that using less "detail" will free up more room while still presenting the visuals or audio in one form or another. You will see the same picture or hear the same sound, only the quality will be less as the file size becomes smaller. You can see why complicated games of the past weren't much to look at or listen to.

A way around overloading the processor in a PC is to use Red Book audio which is played directly from a disc—bypassing the motherboard altogether via a cable connected from your DVD-ROM drive to the sound card. This gives you great sound that never gets near the processor and frees it up to do other chores. Other games use streaming audio and heavy compression to save on both space and processor performance. As music is needed, it is loaded from the disc a little at a time, decompressed, buffered into random access memory (RAM), and played back.

All of these methods of processing and playback will have some impact on your job as the sound person. By discussing these details with the developer at the beginning of the job, you'll be working from the same page, have an understanding of the entire production process, and could possibly present alternative ways to accomplish certain goals. Plus, you'll be able to achieve the greatest possible quality on your end—which will make the project sound good. And, isn't that what we are all about?

Memory Storage Requirements for 1 Minute of Sound

Type	Mono	Mono	Mono	Stereo	Stereo	Stereo	Encoded Dolby Surround	Encoded Dolby Surround	Encoded Dolby Surround
Resolution:	8-bit	16-bit	24-bit	8-bit	16-bit	24-bit	8-bit	16-bit	24-bit
Sample rate (K):									
96 kHz	5626	11,251	17,280	11,251	22,501	34,560	11,251	22,501	34,560
48 kHz	2813	5750	8640	5626	11,520	17,280	5626	11,253	17,280
44.1 kHz	2646	5292	7938	5292	10,584	15,876	5292	10,584	15,876
22.05 kHz	1323	2646	3969	2646	5292	7938	2646	5292	7938
11.025 kHz	661.5	1323	1985	1323	2646	3969	1323	2646	3969
8 kHz	480	960	1440	960	1920	2880	960	1920	2880
4 kHz	240	480	720	480	960	1440	480	960	1440

Sound Quality versus File Size

Sample Rates

We've all heard the term *CD quality* and equate it to outstanding-sounding audio. The magic number associated with CD quality, 44,100 kilohertz (or 44.1 kHz), is actually the number of "snapshots" taken of a sound within 1 second. Comparing this to standard movie film which uses 24 frames per second, like the eye, your ear perceives 44,100 samples to be lifelike and is fooled into thinking so. Use of sample rates below this value will cause a loss of detail and dynamic range and is something we must consider as game audio providers. What are we willing to give up in quality in order to have the quantity needed for the game?

In the first chapter, we discussed an audio standard of 44.1 kHz. As storage space increases, all audio, music, and sound effects will use this particular sample rate in games. For now, though, samples rates of 22.05 kHz are still in use in some instances and sound pretty good—much like an FM radio broadcast. Sample rates of 8, 11, and 22 kHz are widely in use in Java and Flash games. These generally sound less pristine but are designed with small file size and quick loading in mind. All of the previous concerns will ultimately determine what sample rate you end up with.

As musicians, you may already be working with sample rates as high as 192 kHz. It is doubtful we will see anything that high in games for quite some time, the argument being the gain of sound quality is imperceptible to the average listener and the space it would consume too valuable. It would also be some years before hardware that could accurately play back this quality of sound would be affordable to the masses. Would the player even be able to hear and comprehend this extra effort while engaged in an all-encompassing gaming experience? When will "good" be "good enough?" Of course, I subscribe to the school of thought that says you can never have too much of a good thing, the more the merrier, the bigger the better—well, you get the idea. It will happen someday. That we *do* know.

Resolution

Another consideration in computer games which will have a direct impact on sound quality is *resolution* or bit size. CD quality not only uses a sample rate of 44.1 kHz to obtain its high quality but also a resolution of 16 bits. Professional recording equipment today generally utilizes resolutions of 16 and 24 bits, and while higher numbers make the end audio product better, it can confuse the issue when talking about games. Generally, games use 16-bit resolution—but on rare occasion use 8- or even 4-bit. The Wii Remote, as an example, utilizes 4-bit. This resolution facilitates the uploading of the sound data by keeping the file size small, and any reduction of sound quality is inconsequential since the tiny speaker is incapable of any real fidelity.

So, what is resolution? You could think of it like you do sample rates. While sample rates refer to the accuracy with which a sound is sampled within a period of time, resolution is the accuracy with which that sound is stored. Eight bits can store 256 different values, while 16 bits can store 65,536. To put that in over-simplified terms, say I have two colors, black and white, that I need to store. If I was able to store only two values of colors, everything would be perfect. I have one box for black and one box for white. But the world is not "black and white." There is a lot of gray, and I want to store as many shades of gray as possible. With 8-bit, I can store 254 shades of gray between the two extremes (black would be on one

Tools of the Trade

HENNING NUGEL
Composer, Sound designer

The studio is geared toward professional composition and production of music for different media, mostly games, adverts, and TV with the option of recording one to three instruments or voices in this room. Ensemble recordings take place in rented locations fitting the purpose. The room itself is acoustically fine-tuned with Auralex absorbers, diffusers, and bass traps. Also included is a wall-mounted LG AN110B HD projector which is used for screening film material or stills in sync to the music.

The studio has access to a balcony with comfy chairs and table facing the garden and the woods. Very nice on summer days and evenings!

Computers: 2 PCs (12 GB and 64 GB RAM with several SSDs) synced over network via Vienna Ensemble Pro 5. 1 additional PC as game testing and internet/office machine. 1 Laptop. 3 monitors including 1 Dell 29" monitor

Software: Nuendo 6.5, Wavelab 8

Monitors: Blue Sky System One 5.1, B&W DM310 with Rotel amp, AKG K-271 and Beyerdynamic DT-770 pro headphones

Mixdown: Tascam DM24, RME Fireface 800, ESI M8UXL-Midi Interface

Sound modules/VST instruments: Lots of libraries from all of the relevant sample developers

Outboard gear/plug in effects: Mesa Boogie Mark IV Amp, Melodyne, Waves plug-ins, NI Kontakt 5, Slate Digital plug-ins, Valhalla Vintage Verb

Keyboards: Studiologic Numa Nano Master Keyboard, TEC Breath Controller

Other instruments: Gibson SG Standard cherry, Charvel custom, Fender P-Bass, Fender Irish bouzouki, Yamaha western and concert guitars, violin, Ralph Sweet wooden pennywhistle, Chieftain low whistle, Irish flute, duduk, shakuhachi, mizmar, Schlagwerk cajon

Sound libraries: Lots of Sound Ideas, Hollywood Edge and self-recorded stuff

end, white on the other) for a total of 256. Using 16-bit, there would be storage for even more precise values of gray—giving a smoother transition between each shade, not such a noticeable jump as with 8-bit. I could store a better representation of our little world. Does that make sense?

Another way to describe it uses musical metaphors. If I wanted to store a sample of every musical instrument in the world on my keyboard for some grand performance, I would need almost an infinite amount of banks to store them. If I were using 8-bit, I could only store 256 instruments. If I needed an instrument I didn't have stored, I would use one which sounded close to the one I wanted instead. If I were using 16-bit, I would have a better chance of finding the exact one I needed or a close cousin with 65,536 banks to choose from. What this is saying, in a roundabout sort of way is, 16-bit resolution gives you more precise storage capabilities—allowing fairly accurate playback of what was initially recorded. The higher the resolution, the better.

The game's resolution depends on the programming side and the sound driver used. You need to find out what resolution the final audio files will be presented in to plan your quality control accordingly. It is good practice to start your process with the highest sample rate and resolution available to you, knowing the final parameters will help make up your mind about how you may approach certain bits of audio. For example, an 8-bit resolution game will give you a lot of headache with "quiet" sounds or musical passages. A residual effect of converting down to 8-bit is quantization noise, which has a very prevalent hissy, static-like quality if the sound doesn't mask it. You'll end up compensating by making the sound as loud as possible. We'll go over this in greater detail in the next chapter, but I wanted to get you thinking early. Maybe you'll think about staying away from quiet sounds if 8-bit resolution is in the cards. You'll quickly discover, too, that sometimes it is not just about making killer tunes and sound effects. It's also the science that goes into making them sound their best in the game environment.

Mono, Stereo, or Surround?

Probably the most important aspect of the sound issue is whether or not the end audio product will be in single-channel (mono), two-channel (stereo), or multi-channel 3D audio. The amount of memory available for audio will more than likely be the determining factor. Stereo files take up twice as much space as mono; surround can be encoded into two channels or delivered as six separate mono stems for 5.1 or eight stems for 7.1. Narratives and voice-overs will normally be mono unless there is some special effect requirement added to give the voice a specific sonic character. There may be audio processing available either through the game engine or through the game's platform which would add some depth to the aural experience—and in these cases, most sounds would be in mono. There are some instances where dialog and sound effects are delivered in mono, but an effect within the audio engine, such as reverb, will process them into stereo or surround outputs.

It is important from an artistic point of view to know ahead of time how many channels the music and sound effects will require. On a very basic level, music is always done in stereo; sound effects in mono. That's what we have been trained as consumers to believe and accept. Music on the radio or on CDs is always presented in stereo, and as musicians, we create music in stereo. Now, would you ever have an occasion to do it in mono? Yes, you would. How about surround? You bet. We need to start thinking outside the norm and be able to adapt your craft accordingly.

For good sound design, it is important to know how many channels to create for from the start. When I first started officially doing sound design, I approached it from a very flat, one-dimensional perspective. Only after visiting with someone with dozens of games under their belt, watching them create sound effects in Pro Tools, did I realize I'd been missing much of the equation. I watched this master create effects using the full stereo spectrum, swinging sounds from side to side, and skillfully pulling you into the whole experience. It was like a slap in the face! I ran out the next day and bought a multitrack editor and haven't looked back since.

If you are creating for a game in mono, you'll work hard to get the most out of the sound. If the sounds are done for stereo, you'll have an extra channel to work with and be able to add much more dimension to your work. Even though I create almost every sound effect in stereo, if I know it will be converted to mono later, I don't waste any time having sounds fly around from the left to the right channel. Instead, after I convert to mono, I'll spend a little extra time making the sound interesting—adding some effects processing or creative EQ. The amount of work you put into the task is dependent on how many channels of audio you are creating for.

File Types

What file format will the audio be delivered in and what format will be used in the game? Most of the time, these will be the same, but occasionally you'll deliver it in one and find out it will be converted to another later. Knowing the file type, such as *.wav* or *.aif* or *.au*, is important for final quality considerations. Because each type of file uses its own unique brand of compression and sound quality, there will be different things you can or cannot do.

Generally, the standard formats are *.wav* for PC and *.aif* for the Mac—both regarded as the best way to store sound in the digital domain. The trade-off, though (because these are uncompressed), is large file sizes. One minute of 44.1 kHz, 16-bit, stereo audio stored as a *.wav* file will take up 10.6 MB of space. A game using 60 minutes of total audio in this format would leave little for the rest of the game. Solutions to this type of problem include:

- Reducing the file size by using a lower sample rate, lower resolution, or fewer channels
- Using a different file type

Previously, developers would keep audio file sizes in check by lowering sound quality—but as new formats are born, developers are willing to try them in favor of giving the player decent sound. MP3 (*.mp3* or MPEG Layer III) is an audio format which has seen quite an increase in games. Its sound quality is comparable to FM radio but uses far less space. You'll remember an earlier comparison of a 22 kHz sample rate being equivalent to a radio broadcast. But *.mp3* can sound better and take up less physical memory than reducing the sample rate. (See the following chart.)

1 minute of 22 kHz 16-bit, stereo=5.3 MB
1 minute of 44.1 kHz 16-bit, stereo converted to *.mp3* at 256 kbits/second=1.87 MB (and sounds better!)

By this little comparison, you can see it may be better for the game experience to use a different file type to squeeze a slightly better sound quality from the proverbial stone. As the sound expert, recommend this option if it hasn't already been considered. Or, simply be ready to make whatever audio format they've chosen sound its best. As an example, let's compare different file formats with their size and sound quality.

1 minute of 44.1 kHz 16-bit, stereo
wav (Microsoft Wave PCM)=10.34 MB
aif (Macintosh PCM)=10.34 MB
dig (Sound Designer mono)=5.17 MB
au (Java G.177 u-law 8-bit)=1.99 MB
vox (Dialogic VOX mono ADPSM)=1.29 MB
wma (Windows Media Audio) at 128 kbits/second=951 kb
ogg (Vorbis) at 128 kbits/second=947 kb
mp3 file at 128 kbits/second=940 kb
rm (Real Media)=787 kb

All of these were converted from the same original file using each format's standard compression. A different format alone can change the amount of storage space needed in a game.

By looking at format sizes, you may wonder why we don't use Real Media or any other similar configuration as standard. The easiest way to understand this is to conduct your own personal experiment. I recommend sitting down at your computer, opening your audio editor, and simply practicing converting file types. Once you've done several, do a side-by-side comparison. I guarantee you will choose the original .*wav* or .*aif* file for the best quality. You'll be better able to share your audio knowledge with developers because you've converted them, heard them, and developed your own opinions.

Go ahead; it'll be good for you. Sound quality is a subjective thing, of course, but most who are "in the know" would never consider formats just because of their small size. The programming language initially determines what type of format is used, but occasionally, there are options where other choices can be made. There are also licensing issues, which will cost the developer money—such as licensing use of the MP3 format in their audio engine—that will also have a say in what is ultimately used.

Setting Up Shop

The final precompositional consideration rests squarely on your shoulders. You've soaked up vast amounts of information, and now the time has come to finally make some music and prove to the developer that they chose wisely when they called upon your expertise. So, how are you going to hold up your end of the bargain?

Plan ahead. From now through the end of the project cycle, plan your production schedule, write it down, and make sure it looks reasonable. I don't recommend madly composing and recording and hoping you complete everything by each milestone. More often than not, it will never happen and you'll fall short. Plot out how many pieces of music, sound effects, and narrative recordings are needed for each block of the production, decide how much time you'll need for each task, and then map out your schedule. Based on your working model, you can see fairly rapidly if you have a chance of completing everything on time. If

not, approach the developer and let them know you may not have enough time—instead of dropping a bomb on them the day before your work is due.

As part of your production schedule, be sure to set aside time for mental breaks, whether it is a half day, whole day, weekend, whatever—just do it. Living with a piece of music every day can quickly zap a musician of any objectivity. By letting a day or two pass between listens, you'll be able to pick up on parts which don't work and have other fresh ideas ready to go. Get out of the studio, get out of the house, and change your scenery every so often. While it is tempting to immerse yourself in work, and tight project cycles have a way of pushing you to that limit, understand what even a couple of hours can do for your mental well-being and plan for them. Also, ensure you get plenty of sleep and eat right. I know I probably sound like your mother, but in the heat of battle, it is easy to forget physical necessities. You can't expect to produce your best work if your basic survival needs aren't met. You may laugh now, but wait until that first contract when you've been in the studio a week straight before even realizing it. You don't want to burn out in this business. Pace yourself for the long haul.

Allot a day or two of prep time. Make sure you have plenty of storage medium—external drives, DVD-Rs, CD-Rs, and any other equipment you'll need for the endeavor. Make sure any maintenance you've been meaning to do is done—all construction and admin projects hanging over your head are either done or out of the way. Try to prevent distractions from arising when you are on a creative roll. A couple of days at the beginning to clear all of this out of the way will help ensure a smooth production.

Get in the Mood

Have the developer send you pictures, artwork, and storyboards—anything visual for you to look at—and then plaster your creative space with them. If it's a "dark" game, turn off the lights, set out some candles, cover the windows, and be ready to create within the virtual environment you are composing for. Conversely, for a "happy" children's game, open up all of the shades and turn on all the lights, let sunshine in, and watch lots of comedy. For adrenaline-packed games, do jumping jacks, run, listen to pumping music at full volume, and get the blood flowing every time you sit down to create.

Put yourself in the center of the game. Live and breathe every creative moment visualizing the virtual world. By doing so, you will instinctively compose inspiring music and sound effects without having to force it. Prepare your room within the first couple of days, and you will reap the dividends throughout the production. Remember to take frequent breaks from your make-believe world to keep the stimuli strong and effective. Working in the same room for weeks on end, staring at the same walls, tends to drive one a little crazy.

High Quality from the Start

From the word "go," make sure every recording, every sound source, every sample, and every piece of audio you use to construct instrumentation, music, and sound effects are of the highest quality you can afford and obtain. *Why on earth would that matter?* you wonder. Take sound effects creation, for example. Most of the time, it is a blend of several different sounds pieced together to form a desired effect. By starting with the best quality at the onset, you can build from a strong foundation and make the sound do what you want it to do and not have to be stuck with something you get from a bad source.

NEAL ACREE
Composer

Neal Acree is an award winning film, television, and video game composer and conductor whose work includes the massively popular game franchises *World of Warcraft*, *StarCraft II*, *Diablo III*, the Chinese MMO *Revelation Online*, shows like *Stargate SG-1*, *Stargate Atlantis*, *Witchblade*, and more than 30 feature films. A versatile composer with roots in classical, rock, and electronic music, Acree's music has been recorded and performed by orchestras and choirs around the world, including the hit concert tour Video Games Live.

Selected Gameography:

World of Warcraft
StarCraft II
Diablo III
Revelation Online
Wild Fire
Overwatch (Cinematic Intro)

www.nealacree.com

Describe your thought process for creating music.

I usually start creating the music on some level the first moment I am approached about a project. Whether it's a conversation with the developer, some artwork or an early build of a game, a seed is planted that continues to grow in the back of my mind until I get a chance to sit down and do some preliminary sonic exploration. That early exploration of ideas is less of a thought process and more of an instinctual musical reaction to the project. I may have strong intellectual and theoretical ideas in my head about what the music should be, but what comes out at first is often something unexpected. In this state of inspiration, I jot down a bunch of different ideas, often jumping from one to the next without giving myself too much time to second guess things.

Despite my reactionary approach to those initial ideas, I always start a project with a lot of research. The more context I have, whether it's historical, stylistic, geographical, or all of the above, the more I'll be able to draw from as I dive deeper into the project. All of the information I gather both from the developer and from my own research beyond that goes into my creative blender and oozes into my subconscious. This information also helps to create creative boundaries that will later help corral ideas into a cohesive score that hopefully fits the game like a glove.

In the days and weeks after the initial creative explosion, I'll let my brain take over and make sense of the various ideas, developing them further and in some cases combining fragments into longer pieces. Here is where I start to think about filling the musical needs of the game and planning layers within the music for interactivity. Throughout the project I often go back to that initial session and find themes that I had originally decided weren't going to work. There have been projects that I worked on for months but in actuality wrote the majority of the key themes in those first days of exploration.

Are there any particular secrets to your creativity?

The more important thing I've learned over the years is that inspiration is a mysterious and precious thing and the more I learn to stay out of its way and let it take me where it may, the more productive I am. The less I try to control it, the more I receptive I am to it. The less I try to intellectualize it, and the more I try to feel its rhythms and patterns, and align myself with its grooves, the more in sync with it I become. You have to know when to let your instincts and inspiration lead you and when it's time to be an editor. Know when it's time to push yourself and when it's time to take a break and clear your head. The worst thing you can do is talk yourself out of a state of inspiration by over-thinking things or burn yourself out chasing it.

Are there any secret techniques that you regularly employ?

Naps! Well, at the very least, meditation or some form of relaxation to refocus my creative energy. Exercise, walks, driving, gaming, or taking a shower all seem to work as well. Inspiration doesn't like to be forced, and sometimes after a few unsuccessful hours of chasing it, you just have to let it go, clear your mind, and come back fresh. This may not seem like the best approach when you're under a tight deadline, but I've found that I lose more time (and sanity) by trying to force something to happen than stepping away and coming back fresh.

When do you find you are most creative?

I'm usually most creative late at night. Not only is it the quietest time of day, but by then I've usually gotten all the business, correspondence, and other distractions out of the way for the day. Noise and distractions are mental clutter, and inspiration favors a clear and undistracted mind.

Any worthwhile creative advice you'd like to share?

I think it's important to remember that when you get stuck, you're not the first person to ever experience a lack of inspiration. Every artist, writer, and composer, even your biggest idols, has struggled at some point and doubted themselves. The only difference between the ones that endured and the ones that didn't is that the ones that endured never gave up. They took a step back, regrouped, and came back at it from a new perspective.

Is there a typical workday for you?

No, and I suppose that's what keeps it interesting. I often think that things would be easier if I had a more set schedule, but I've yet to figure out how to get inspiration to follow a schedule,

not to mention life and the ever changing deadlines we face. Sometimes, you have to drop everything when you're on a creative roll and when you're not, you have to be willing to put in the hours to get the busy work done. Sometimes you're ahead of the game so to speak, and sometimes you're playing catch up.

What skills should composers have to succeed in the games industry?

Versatility and adaptability are very important, but I think more than anything, being down to Earth and easy to work with is essential. You also need to understand how games work and how players will interact with the music. I didn't start out in the game industry, I started in film and television, but I've been a gamer my whole life. As many similarities as there are between film music and game music, I think it's a mistake to assume that because you know one, you know the other. At the same time, I think it's important for young game composers to be aware of trends in film music (both past and present) and to be able to write to picture.

Do you have a specific ideology which drives your way of doing business?

I give 100% of myself on every project, no matter how big or small. I mean this both in terms of the quality of the music I write and in the effort I put in to giving the client what they need, when they need it. I try as hard as I can in the time I have to make every note perfect, even the ones that nobody will ever hear because I'll know they're there. At the end of the day, you can't please everyone 100% of the time, but as long as I know that I gave it all, then I can rest knowing that I tried.

Any good business advice to offer?

Invest as much as you can into improving your sound and improving yourself. There have been projects where I've put every dime I made into hiring live musicians and it paid off in the long run. Early on, I invested a large amount of what I made into getting as professional of a sound as possible. It's also important to know your gear and get as much out of it as possible. Always be open to new opportunities, even outside of the normal scope of your business and try to put yourself where the action is as much as possible.

How do you approach negotiations with a new client?

I'm grateful that after years of handling the business side of things on my own, I now have an agent that handles contract negotiations for me. The more I can focus on the creative side of things, the better, both for my own sanity and for the relationship with the client. I do stay very involved though. You have to—because nobody is going to look out for your interests as carefully and protect your image as well as you. I read every contract and sometimes even handle preliminary negotiations myself, but it's nice to have someone there to back you up when you need it.

What type of things lure you to a particular project?

I evaluate each project with three questions. Is it an opportunity to work with a new client or maintain a valuable relationship with an existing client? Is it an opportunity to work in a new style or is it particularly inspiring on some personal level? Is the money good? Generally, if at least one of these things is true, then the project will probably be worth the time invested in it.

Do you have any contract stories which others could learn from?

One thing I've learned over the years is that if someone wants to hire you for way less than you're worth with the promise that they'll "make it up to you next time" or with the offer of a lot

of future work, they usually don't. Once you've shown someone that you're willing to work at a certain rate, you'll always be seen that way. There are certainly exceptions to this, but I've found that in general if you undervalue yourself, you will almost always be undervalued by the client.

Also, get everything in writing, signed, and countersigned no matter how much you trust the situation. This protects you, and it protects the developer so it's a win–win.

Do you have any tips when working with developers?

I feel that being positive and easy to work with is essential to a good and long-lasting working relationship. Remember that you are there to help facilitate the client's creative vision, and the last thing you want to be is an obstacle when there are so many other aspects to game development that they are juggling. No matter how challenging a project is, the client will never hear me complain, no matter what I might be feeling inside.

I work toward finding positive solutions and anticipating issues before they happen. I say "yes I can" even when I have no idea how I'm going to pull something off because I trust that I will eventually figure it out. Speak confidently even when you doubt yourself and you will inspire confidence in others. When you are easy to work with and deliver consistent results, you will be hired again and again.

What advice can you give when working with a developer which has ensured a good working relationship and a good final product?

In addition to being positive and easy to work with, good communication is essential to a good final product. The challenge though is that everyone has a different approach to talking about music and music is extremely subjective. Steve Martin once said that "Talking about music is like dancing about architecture." The point being that you can't always take a nonmusician literally when they try to speak in musical terms. I prefer to speak in terms of emotion as that is the language that all storytellers from directors to artists to composers and musicians can understand. What do they want the players to feel? What types of sounds and themes resonate with them? Everyone has their own personal connection with music, but if you can somehow find something that genuinely and authentically resonates with you, you will have a much better chance of it resonating with someone else.

Have you ever had any development issues negatively influence your workflow?

I think we've all had to deal with last minute changes and unexpected technical issues, but it's part of the job. Being a professional means handling these challenges quickly and calmly. Over the years, I've learned to anticipate issues before they happen. It's important to know up front what the specs and technical requirements are for the game and stay in communication with the team.

Do you have any advice to ensure successful audio implementation?

Remember that your job is to enhance the player's experience, not grab their attention and showcase your great music or sounds. Music should be felt more than heard and blend seamlessly into the sound design. It can't sound repetitive no matter how short the loop needs to be or the player will turn it off. Prepare interesting variations in your stems and anticipate every possible gameplay scenario.

There are many pitfalls when "working" in the game industry. Have you had any bad experiences?

I've worked in film, television, and games, and while I do have my war stories, I've been very fortunate to have had mostly positive experiences in the game industry. What I have learned (and fortunately NOT the hard way) is to never take any of it for granted. There is so much competition and volatility in this industry that you never know where you'll be tomorrow. I see every project as a gift, an opportunity to push myself to another level and hopefully move someone on some level.

How did you find your way into the games industry?

Mine is probably not your typical story. I had been scoring films and television for about 10 years when my agent at the time, my first agent who I had only been working with for a short time asked if I would be interested in scoring games. To be honest, I hadn't given it a lot of thought up until that point but having been a lifetime gamer and being that I welcomed any new opportunity to express myself musically I was very intrigued.

Through a series of fortuitous events, he was able to get my demo to Blizzard who was auditioning composers to score the opening cinematic to the first World of Warcraft expansion. Fortunately, for me they heard something in my demo and I got the gig which was the beginning of a career in games that has led to opportunities I never could have dreamed of.

Normally, sounds will be resampled to a lower sample rate or resolution—not the other way around. Initial sounds taken from 11 kHz, 8-bit, mono are going to have a lot of noise and other artifacts present. Trying to produce a quality effect from sounds like these is going to be difficult no matter what you do. It's kind of like recording an AM radio broadcast from 500 miles away in the middle of a thunderstorm, then burning it to a CD for playback on your studio equipment. Just because it is on a CD doesn't mean the quality will be good. It is still going to sound like that scratchy noise-ridden broadcast you originally heard.

When collecting sound libraries—either buying them from professional outlets, borrowing them from your buddy's web page, scavenging them from various sources over the years, or producing them yourself—obtain and keep only the best. Over the years, I had amassed quite a collection of sound effects as a personal hobby. When it came time to create sound effects professionally, I first gave a close listen to the sounds in my inventory. Because most had been created and saved with a low sample rate and resolution to save precious storage space, none were even close to sounding acceptable—full of noise and a definite embarrassment if I ever considered selling them for money. I refused to put my name on anything that didn't pass my quality standards, so out they all went. As I look back on the entire affair, I would have saved a great deal of my time had I started from day 1 collecting only superior sounds.

Another angle I've discovered over the years of sound design and field recording is the sample rate and resolution of your source material—the higher, the better. "High definition" may be the current marketing buzzword, but when doing serious sound design, you'll find that 96 kHz and 24-bit resolution is king. Some may argue that the end result is a sound quality the average game player will never really notice, and yes, that might be true. But, from a sound designer's perspective, higher sample rates allow for more sound "snapshots" to stretch, morph, mangle, twist, stomp, and smash which will produce a better result in quality. Try a simple time stretch on a 22 kHz, 8-bit sample and a 96 kHz, 24-bit version of

the same sound, and you'll see what I mean. You can stretch the 96 kHz version way more, and it'll still sound smooth with no artifacts.

Initially, you may have some budget studio equipment and instruments in your possession. Because we are talking about quality, ensure you know how to get the best sounds out of them until you can afford better gear. I started out with junk. The little four-track cassette deck was noisy, the old spring reverb had its own definitive personality, the drum machine was tired and mechanical—but because I'd lived with these things for more than 10 years, I actually got some pretty decent recordings from them. If an initial cash outlay is a problem, take what you have and make it shine. Squeeze everything you can from your gear. There will be small developers who won't know the difference anyway and will hire you despite the equipment you have. As the income starts rolling in, start thinking about what you can replace to make yourself sound better, give you a competitive edge, and make more money. After a few years, you will have accumulated an envious collection of high-quality gear that facilitates the superior job you are now known for. In the end, though, developers don't really care what you have, as long as your audio sounds good and works with the game.

"Gotchas" and Other Things to Watch Out For

The art and science of developing video games is now more than 40 years old, and we are slowly approaching some normalcy in an industry involved in continuous change. With this comes a standard, a tried-and-true method of creating audio for games. Different teams, however, do things just a bit differently to meet that same end result. The road occasionally becomes fraught with unseen perils, and unwanted frustrations inhibit our creativity at a time when it needs to flow. These are what you need to be on the lookout for.

Placeholders

Building and piecing together a video game is a huge undertaking, and developers take some shortcuts to create their virtual worlds before bringing in the professionals like us. To test the audio drivers and spice up the silent game tests, they may put in "placeholder" music tracks and sound effects. They usually borrow something close to what they have in mind from other games or from commercial music. This can be a good thing in some cases. Now all you have to do is replicate something similar and you're all set. Most of the time, though, this can be bad for you and bad for the game.

As the game is produced, tested, and played among the development team, these placeholders will be heard hundreds of times. By the time they bring you in, everyone will be used to hearing them and will more than likely be attached to them. Anything you come up with runs the chance of being sub-par—new sounds and music of yours not quite living up to the developer's expectations. It can be nerve-racking, to say the least. Instead of the developer letting the audio expert lend their particular brand of artistry to the mix, they will hurt the potential of the game by not giving you the opportunity to try something fresh.

Be cautious when approaching a game using placeholders and be ready to sell your ideas a little harder. It isn't impossible to get your ideas across, but as the new guy on the team, you might not be listened to as closely as you would hope. You do have one advantage in this type of situation, though. As the new guy, you are able to take an unbiased look at the game and provide the unclouded perspective

of someone who hasn't been living and breathing this thing for the last year. As you see more of the game, you will notice things everyone else may have missed—from simple word misspellings to artwork of characters missing body parts. Use this to your advantage to quickly build credibility and to show your commitment to the project. Once you've shown that you are only looking out for the game's best interests and not your own "personal" inclinations, you've got it licked.

A Developer's Listening Preference

You wouldn't think in the professional video game industry a publisher or developer's personal tastes in music would be a big factor, now would you? Don't be so sure. Imagine trying to present music to someone who hates a particular style. Even if the music is perfect for a project, a decision maker up the line may dislike your submission just because they don't like that genre. There are the occasional few who lose sight of the big picture, failing to understand who the game is designed for and the make-believe world they are trying to immerse the player in. Those are the guys you need to watch out for.

I've never heard of a fishing game using techno; country would definitely be the better choice. But don't think somebody won't try to get you to do it. If they hate country music with enough passion, they may try to influence you and those you deal with. In times like this, you need to remind the producers that, while you can appreciate their personal tastes in music, the project definitely calls for a particular style. Help steer them back on the path of what is best for the project. Can't get your point across? Then, do the style of music they want you to do, but make sure you don't end up redoing the work for free. This brings us to the next point.

Endless Reworks and Change Orders

Reworks and change orders were covered in Chapter 6, but I want to reiterate their potential impact on you. They are definitely something to watch out for in our business and one of the more standard "gotchas." There is an acceptable amount of reworks—the exact number being as many as you can tolerate. When it goes overboard, you need to stand up and say something. Perhaps you have already negotiated something in your contract about reworks and change orders and you've opened the lines of communication for a free-flowing exchange of ideas. You've done all the right things, and still you seem to be working hard on several reworks. What gives?

Some good investigative work on your part may be in order. The producer you are reporting to reports to someone else, and maybe they are the ones who are throwing a wrench in the machinery. The producer is trying to look good, too—making you work extra hard in order for him to be able to present several options to his boss. This is fine to a point. But when you are wasting your creative energies taking new approaches, these little moments quietly disguised as "reworks" appear to have become "change orders" instead. You might want to subtly remind the producer about the particular clause in the contract which requires new milestones for change orders and see what happens. I'm not trying to say you shouldn't work hard to make a game the best it can be sonically, I just don't want you to be taken advantage of without appropriate compensation.

I had a situation once where I seemed to be working harder than normal on sound effects. I couldn't understand why the sounds I'd already sent weren't working and was getting no feedback from the producer. I just kept getting

requests for different approaches to the same effects. My gut feeling was telling me to quit, but my head was saying to go that extra mile for this new client, and so I continued to march. A month went by, and I'd submitted five separate approaches. Creatively, there was nowhere else to go, and I secretly prayed there wouldn't be any more requests. When the list of sounds they picked for the game finally arrived in my e-mail, every sound was from the *first* batch I'd sent! Turns out it wasn't even the producer making the decisions but his boss, who had the final say. I promptly renegotiated an hourly wage for the next project and made a point to include the executive producer in my little network the next time.

When working as a new composer and sound designer on your first couple of projects, it is important not to let your inexperience appear obvious. Be easy to work with, but maintain that air of professionalism to ensure you are taken seriously when raising valid points such as those previously mentioned. Most of the time, developers don't know or don't care about the impact they may have on you with what seems to be "simple" requests. They are in the business of getting the game to the marketplace, and everyone on the team is expected to work hard toward that goal, including contractors. Don't be afraid to express your concern over events which may interfere with your creative activities. The producer is managing an entire team and needs to know when nothing is happening at your end. Maybe they can help. The times I've called producers in this situation, I've ended up getting either an extension of a milestone (to ease the pressure and give me a day or two to regroup), or I've gotten brilliant ideas that pointed me immediately toward a solution. They are a valuable resource, and their experience should be used wisely.

Communication Breakdown

From the very first meeting with a developer, do what you have to do to be included in the creative process and to stay there. As discussed previously, creative ideas have a tendency to change rapidly—and as a contractor, you'll end up being the last to know about important issues unless you are on the distribution list. Changes that seem "inconsequential" to the developer can have a great impact on your musical perspective and cause grief on your end.

An experience I had with an out-of-state developer illustrates this point exactly. At our initial creative meeting, we had discussed the personality of a particular character and all seemed to be in agreement. I received the scripts for the rather long narratives, hired the voice talent, and spent 2 days in the studio recording and editing the sequences. I was very happy with our work and sent it off to the developer. I received a phone call after the producer had heard the recordings saying they had changed this dark, evil character to a more mystical, less intimidating one instead. "I thought you knew," was the chilling statement I received. "Uh, mmm, ah…" was about all I could come up with as a response. We ended up throwing out that version and went back into the studio with new talent for another round. I was lucky the developer was understanding and that the breakdown in communication was not considered my fault. I didn't have to eat the cost of the first voice talent. It could have easily come out of my budget.

Another example: I got the parameters for a slot machine game, and it looked cut and dried. I had done more than 40 similar games for this developer, and lately, they had been giving me carte blanche; that is, accepting my own sonic interpretation of each game. I didn't receive any advanced artwork but was given a link to the game sponsor's website from which to glean some ideas. Unfortunately, the

site was void of any artwork, except for one little icon in the top corner, and that didn't provide much help. I fired off an e-mail to the new producer I was working with, explained my predicament, and got the go-ahead for a "fun ship" theme for this ocean liner-themed slot machine game. I spent a few days working up the sound effects, even spending money for a new sample library—determined to outdo my previous game submissions. I sent off the sound files, feeling pretty good about my efforts and went on to other business.

Tools of the Trade

GEORGE SANGER

(Aka The Fatman)—Game audio legend, Philosopher, and Author of The Fatman on Game Audio—Tasty Morsels of Sonic Goodness

If you play an instrument and it makes great sound after great sound after great sound, buy it. If you play it and think, "I could make some great sounds if I spent some time with this," then don't. Go out and get what nurtures your belly laughs. Or better yet, dream about it and do what you think it takes to get that thing.

I recently heard a recording made on a MOOG Voyager, the tones made me grin and squinch my eyes and it felt like the music was licking my eardrum. So, I'm getting one.

People say "if you're serious, you should get Pro Tools." That's not a good reason. They don't know who you are, do they? Oh, and another thing: Make your own instruments, and fix broken ones. It'll make your music deep.

Philosophy on gear: This used to be a very complicated question, not so much anymore. I'm trying out a new answer.

If you have an Open Labs MIKO, a mic, a pair of headphones, and a power cable, you will have all the hardware and software you need to do what I do for a living. If you can't do it with that, then don't blame the equipment because the problem lies elsewhere.

I usually got confirmation within a day or two that the sounds were received and which ones they wanted to use for the game. I heard nothing for a week. After 2 weeks, while conversing with the company's executive producer on another matter, I found out the producer I was working with wanted to chat with me—something about needing different sounds for the game. So, I picked up the phone to find out what's up. The artwork came back, and the new artist had interpreted their take on the game as the "golden age" of ocean liners instead of "fun ship." Now that there were two ideas in the barrel, the sponsor decided on "golden age," and since then, the producer was trying to figure out how to tell me. It seems somewhere in there, I got nudged out of the loop and missed out on important creative direction. I went back to work and created some "golden age" sounds, having to push the rest of my schedule back by a couple of days. As a contractor charging per sound effect and not by the hour, I lost money on the deal. Lesson learned: staying in the loop saves both time and money.

Conclusion

So, now the stage has been properly set for our inspired performance. We've discussed and planned our strategy, opened the lines of communication with our team, and are poised to bravely leap into the fray. There isn't anything left to do but press the little red button and start recording the music and sound effects. As long as we jump into this wisely, we will be able to get our best efforts accepted on the first try and save some serious headache. I strongly recommend using the points talked about here—not because I'm cloning an army to take over the gaming world, but because the lessons previous game composers and sound designers have learned will save you tremendous grief and make this entire experience something worthwhile. After all, satisfaction in our chosen career is the reason most often given for staying with it—not the monetary rewards.

8

Creating Music for Games

Music is a powerful force in our modern world. The right music coupled with the right visuals is absolute magic. Film and television have much to do with our perceptions, as does the music we choose for our own life's soundtrack. When we are emotionally "up" or psyching ourselves to be that way, we listen to music that is upbeat, has a positive rhythm, and makes us feel alive. Conversely, when we feel down or making an effort to relax, we feel better listening to slower, less complex music. Music affects us at a purely emotional level. Great composers know how to capitalize on this and by design, make you feel how they want you to feel.

Movies are a great way to learn methods of emotional manipulation. These complex screen dramas use music as the force to portray what pure visuals cannot—enhancing them appropriately to express what a character is feeling. There is a problem with comparing movies to video games, though. Movies are linear. They start, they play, they end. Each scene is perfectly planned, and the composer knows exactly what to compose and where to take you emotionally because it is all scripted. Most video games are not presented in linear fashion; each time a game is played, something different happens. It would be extremely difficult to score a game as you would a film, so different methods are used.

The future has moved more toward interactive and adaptive music—music which follows each twist and turn in the plot, matching your every move. It is possible to create the right atmosphere for what is to come, causing tension or giving a sense that something is about to happen—as is popular in film scores. Not all games require this type of dynamic music and rely on music instead to set the mood and provide a certain "pulse" to the accompanying scenery. The two

mediums require different skill sets, obviously, and some of us are better suited for one over the other.

Writing music for games is not necessarily a difficult thing. It does require a different mindset to deal with the number of intricacies the games business has to offer. Because you are proficient at composing music for yourself or your band, or for commercials and film, it doesn't mean you will automatically enjoy something like this. In games, you wear all hats: the composer, arranger, copyist, engineer, producer, musician, mastering engineer, CD manufacturer, and so on. The pressure and challenge of dealing with all facets can be incredible. One of the objectives of this book is to present you with details which allow you to make an educated decision about this line of work.

Game Music Categories

One of the beauties of game music is that you rarely get bored working on a project. Within video games, there are several musical specialties that guarantee to keep the perspective fresh and your skills employed. You'll get to compose scores for cinematics, background gameplay ambience, and in-your-face title themes, all for the same project. It's a great testing ground to prove your compositional skills, but it can also tax your creative stamina. It's definitely an exciting prospect—one worthy of the paycheck you receive for your talents.

Let's turn to an overview of the various types of music required in games. This is by no means a complete listing because there are no specific rules for when and where music should be applied. But certain similarities exist where game players expect to hear music, and these are the ones we'll discuss.

Intro, Closing, and Credit Sequences

The first piece of music the player will encounter is the opening (or introduction) sequence. This is presented either as a "main title theme" or a score accompanying opening cinematics. The music will help build the momentum and excitement of the game, set the mood, and establish the main storyline. This first moment capitalizes on the player's exhilaration for purchasing the game and reassures them they have spent their money wisely. This music plays an important role in establishing the quality of the game—the crucial first impression that will last until other opinions are formed. If the music sounds cheesy, it cheapens the purchase immediately—regardless of the quality of the graphics. If a compelling orchestral score greets them, the player has a sense that they are in for a first-rate experience.

Closing and credit sequences are normally where the final musical cues occur. This late in the game, they might not enhance the player's opinions, but they still serve an important purpose in the overall scheme. The closing cue will accompany a final cinematic sequence, a slide show, or the end credit sequence. It is designed to give the player a sense of closure after the effort of playing the game. Normally, it's a big accomplishment to actually finish a game, and this final fanfare will reinforce the moment. The music will set whatever final mood the developer wishes to leave the player with, whether it is triumphant and happy, or calm and serene. Someone has spent $50 and possibly weeks of their time playing your game, and we want to congratulate them and give them every reason to believe all of our games are worth playing.

The credit sequence is the chance for the development team to have their name in the spotlight and get a little public recognition. The slide show or scrolling

display is either triggered by the player from a game menu or will automatically play after the objectives of the game are accomplished. If it plays at game's end, the sequence will also serve as the closing sequence. If the sequence is activated at the player's whim, the music accompanying it will generally be designed as background music. Because a player might be exploring the menu features or taking a break from gameplay, the music should still somehow connect with the rest of the game—keeping the pace and remaining on theme. This particular music is sometimes considered "throwaway" music. A player will only hear it once or twice in the course of playing the game and is normally considered unimportant to the rest of the project. But you, as the composer, could also look at it in a different light. For pure vanity's sake, or as brilliant marketing, a composer could create their best music cue to impress prospective clients who also play these games and view the credits to see who did the audio.

Cinematic Sequences

Cinematics are merely mini, in-game movies. They are used as part of opening sequences, transitions between game levels, advances in the storyline, and a multitude of other functions that require moving pictures. From a scoring point of view, it is exactly like composing for film, that is, a linear presentation that flows from start to finish in a prescripted fashion. The music will serve the very same purpose: creating a mood, setting the pace, highlighting plot shifts, and adding tension and excitement to all of the appropriate spots. This type of composing work requires a certain skill level and is often quite difficult to do properly. Those experienced in this type of music composition generally thrive in games that rely heavily on cinematics and can also dabble successfully scoring for film.

This type of animation sequence is often paired with a full and very expensive-sounding orchestral score—usually a multilayered synthesizer and sampler arrangement. More often, though, live orchestras are being used to fill this role for total and complete realism. A lush audio soundscape can put a small-screen cinematic sequence on par with a full-scale movie production and smart developers will capitalize on this. It's not to say that other types of music won't work; a myriad of musical styles will deliver the same affect. But a good game composer will practice their orchestral proficiency despite their love of rock or techno in order to stay marketable in the industry. It can definitely take your appreciation for music to an entirely new level.

Menu Screen Music

Menu screens come in all shapes and sizes, but all act as the user's interface for gameplay selections and parameter adjustments. The player can push buttons or select various objects to set video, controller, audio, and other basic functions to personalize their encounter. Music for these screens can perform an assortment of objectives, dependent on *when* they are experienced in a game.

Initial menus are the "calm before the storm," or where the sense of excitement is built. They may require a more complex tie-in from preceding cinematics or other opening sequences and tend to be busier than a standard menu—generally opting to keep the energy level high. Menus accessed during the game can give a moment of rest from the onslaught of gaming over stimulation. Both types require music within the theme of the game, but "mid-game" menus are usually less dense than standalone music. The player isn't particularly interested in hearing an in-your-face soundtrack during these moments. They are making needed

adjustments that require some concentration. The music here should keep the player immersed in the virtual world, but not annoy them. Because there is no way to predict how long the screen will remain active, music which loops continuously is normally used to maintain a seamless rhythm.

Gameplay Music

Music which occurs during gameplay can have various purposes, dependent on the type of game. The music for driving games, for example, is usually dense, upbeat, and very loud. The player doesn't need to think about much besides where the road is and what obstacles they are trying to miss. These games rely on constant movement in both the screen and audio track to keep the player's adrenaline high. This type of music is very different in contrast to low-key background music.

Driving games are good examples of games which use "soundtracks," that is, individual songs that can usually stand up well on their own. They could easily be loaded into an MP3 player to enjoy while out on the "real" open road with the same effect. Other games, such as strategy games that require more brain power and less distraction, use more of incidental music. This music sits subtly in the background creating the mood and remaining unobtrusive. It generally flows smoothly underneath the surface to anchor a player to the virtual world while they interact in a concentrated effort on the task at hand.

Plot Advancement, Cut Scenes, and Tie-Ins

As a game progresses to the next level or drastically changes direction during play, visual and audio cues assist in the transition. As mentioned previously, cinematics are often used and are scored per usual from a musical perspective. These changes are significant, requiring a dramatic score to grab a player's attention and motivate them to make it through the next level to see the next movie. These offerings often serve as a reward to the player, where they are able to watch the on-screen action and inwardly pride themselves for making it happen—translating to satisfaction for the game purchase.

For shifts that don't use cinematics (e.g., a character entering a room to meet the level's big bad guy), the music will act as the setup for the upcoming confrontation—subtly warning or encouraging the player. The visuals don't typically change until the bad guy actually shows himself. The audio becomes all-important in this instance. Without it, the player doesn't have any foreshadowing and won't know to take out his or her weapon or to get out of the room until it is too late. While this can lead to a learning experience for a player, repeatedly dying and having to start a level over can be frustrating enough to stop playing the game. Audio cues, in this case, will play to their intelligence and allow them to use more senses than just their sight—keeping them in the fight longer and preserving their happiness.

"Win" and "Lose" Finale Cues

We've all heard these types of music cues. Since the dawn of the video game era, this particular musical feature has become a standard. When you win, an optimistic flourish of sound rewards your efforts. When you happen to be less successful, the music is either demeaning or mildly encouraging—prodding you to try again. It is almost unnatural to *not* hear something at the end of a game level. These types of cues provide proper closure to the player's experience.

Musically, these cues will remain within the game's genre and will normally utilize the same sound palette and instrumentation. Winning cues will tend to be upbeat, composed in a major scale and with a lot of pomp and circumstance. After all, the player just won! They deserve a glorious finish and a boost to their ego. It is human nature to want to win, and good games will capitalize on the basic need for recognition.

A loss can be presented to the player as a major defeat or a minor setback. Some games go all out with the losing cue and really put it to the player, making a spectacle and giving them a good razzing. These will be heavy on the minor scale and occasionally make use of childish musical putdowns to make their point. Other games are more sensitive to the player and choose not to go to that extreme. Losing isn't always a bad thing, especially in children's games. If you were to slam younger players for their "failure," it would eventually discourage them enough to give up on a game. Leaving them with the sense they were still successful and can do better next time will ultimately prove to be a better approach. Music should set the tone and not be condescending in cases like this. These cues can be difficult—the perfect blend of defeat and encouragement. You can often get by simply using a toned-down win cue—still positive but just not as enthusiastic.

Adaptive and Interactive Music

Developers are turning more and more toward adaptive and interactive music as a major improvement. This type of music is crafted to allow it to adjust in real time to what is happening to the game player, and while these terms are often used interchangeably, they actually do mean something different. "Interactive" indicates audio which the player has direct control over such as in the games *Guitar Hero*, *Rock Band*, or *PaRappa the Rapper*. If the player makes the correct inputs at the right time, the notes or music will play correctly. If they don't, the audio will be effected. "Adaptive" refers to music which reacts to the conditions within the game as programmed. When done properly, the player will feel as if they are playing with a conductor peering over their shoulder, orchestrating the best music for the situation. *Halo*, *Medal of Honor*, and *Call of Duty* are all examples which utilize this technique extremely well.

The chances are pretty good you will run across this type of project in your career as the appropriate enhancements are made and its popularity increases. This activity will require a good working knowledge of many musical styles and how they can be implemented into the game. It won't be enough just to know how to compose good music. You will need to know how to ensure compatibility between the many musical pieces which could trigger and overlap at any time.

By design, adaptive game music will adjust to the mood of the player and the game setting. Music will be slow and surreal as a player is exploring a new environment. If the game character moves from a walk to a run, the music will also keep pace by increasing in tempo. As danger approaches, the music will shift to increased tension, then to an all-out feeling of dread as the bad guy appears out of the shadows. The player chooses a weapon and begins the attack as the music shifts again to a battle theme to fire the player up. As the player gets hacked to pieces by the bad guy, the music will turn dark—conveying that the end is near. But, as the hero gets his second wind and begins a determined counterattack, the music will morph into a triumphant flourish as he imposes death and destruction upon the evil villain. This is a good example of adaptive audio—music that

swings with each turn of events and provides an almost living soundtrack, giving the feel of participating in an interactive movie. If you were to watch a recording of another person playing the game, a good adaptive soundtrack would seem as if it was specifically scored to the scene—similar to a linear movie. When it works right, the feeling is indescribable. That's where we step in.

> The basic rule to composing adaptive game music: Any change in the soundtrack must blend with any other music cue at any time.

Game players are not predictable. We don't know when they will walk, run, hide, enter a new room, meet the bad guy, draw their weapon, or do any of the other hundred possible actions that can happen during a game. But, truly adaptive music is prepared for any possibility. Ensuring the music can transition naturally is what makes it work.

Obviously, the first key to adaptive music is to use the same sound bank and same instrumentation. This provides an inherent similarity working in our favor. Another recommendation is to base all of the music around the same key. This provides a solid foundation to make key changes within the same scale and enables the music to return to a familiar root. These changes will have greater impact, while blending perfectly with the rest of the soundtrack. This is used in film scoring, and there is no reason it can't be applied here. Fade-in and fade-out music cues work very well and are used liberally to make adaptive audio applications succeed. Music that begins with a sharp downbeat is also beneficial, especially when the game mood swings quickly from peaceful exploration to combat mode or when the bad guy jumps out of the bushes. A quick, loud beginning to a musical piece has emotional impact—and if done right, will take the player's breath away, catching them completely off guard.

Loops

When physical storage space, processor speed, or RAM is a factor, efforts will be made to save space wherever possible. For audio applications, one of the best ways to achieve this goal is the liberal use of music *loops*. A music loop can quickly load into RAM and play repeatedly without placing further demands on the processing pipeline. Gameplay, menu screens, and finale screens are perfect places for this type of music. Because it is difficult to predict how long a particular screen will be active, music with the capability of continuous repetition works great. Developers may also ask for "loopable" cues as a cost-saving method. Less music equals less money to pay out, and cost-conscious businesses are always looking at the bottom line.

As a composer, loopable cues are not difficult. The only real secret is finding the perfect spot after a bar or measure to abruptly cut off the music, enabling it to seamlessly begin again. A little trial and error and quick, imperceptible fades are effective in the audio editing environment. Various loop software programs are also available if you end up doing this type of work often.

Any type of music can be looped, from orchestral to techno, with agreeable results. Longer loops are best, especially during gameplay—where the same 15-second loop would get really stale after listening to it for an hour. In these cases, 3- to 4-minute loops would be preferred—basically, full-length songs which can be repeated without a noticeable breakpoint. Menu and finale screens work best with 30- to 60-second loops, and inconsequential low-level menu screens work best with 15- to 20-second loops.

Ambient Tracks

In an effort to battle unwanted silence, ambient music can be used to maintain continuous audio activity within the game environment. This type of background music is purposefully designed as light, uncomplicated, mood-setting pieces set to linger almost unnoticed in the soundscape. Of course, if it weren't there, it would be noticed and other nongame sounds would have a chance to disturb the player.

Ambient music still remains within the style of the main theme, just a less dense version of it. These lighter cues utilize long, sustained notes and occasional percussion to break any monotony. An orchestral score would make use of string sections and the occasional timpani thrown in. Modern music could use various synth pads or simple ambient keyboard samples. Regardless of the style you are composing in, there is always a unique instrument to be used. Just be sure to keep it simple and keep the volume low.

Normally, ambient music is perfect in long gameplay scenarios where a player may need to concentrate. Think of the last time you drove somewhere unfamiliar. While you are on the highway or in familiar territory, the music is usually up pretty loud. But as soon as you turn off the freeway and need to start concentrating, the volume comes down or gets turned off altogether. It's the same in gameplay, except we don't want them to turn it off. Instead, we make it simpler for them.

More and more these days, I'm noticing ambient music in places I'd never heard it before. Sports games and flight simulators are typically devoid of gameplay music. They tend to let the stadium crowd or the roar of the jet engine provide the realistic effect. But, if you listen closely you may hear a slight bit of music playing way in the background—subtle proof that developers are continuously working to improve the overall game experience.

Stingers

Used in conjunction with other gameplay music which may already be playing, stingers are bits of music which are triggered to call attention to a sudden change in the storyline or other significant events. These pieces of music are generally very short in length, beginning and ending within a few seconds; and while noticeable over the other music, they are created to remain within the theme using similar characteristics such as instrumentation and production. In addition to punctuating a moment during gameplay and introducing, ending, or linking various sections, stingers can also be used for splash screens, logos, or other nongameplay moments. Sound effects can also be created for the same purposes, and often are, but there are occasions where a musical stinger will fit even better.

Exercises to Create Fitting Game Music

A question I often hear from prospective game composers is, "What can I do to create music that fits?" It's not enough to write good music; you have to be able to make it work perfectly within the environment. There is a little bit of human psychology involved in game composing, whether you believe it or not. You don't want the game player to turn down the volume, and it will take some effort on your part so nothing annoys them enough to do it. You will definitely need to get your point across without being obtrusive.

There are game developers out there who don't consider this, who ask for slamming music tracks and put them into the games without contemplating what the player will feel as they play the game. They take music they themselves are absorbed with and expect everyone else to like it, too. Turns out, the 6- to 12-year-old female who would play the game is completely repelled by the sound. The developer just didn't get it and wonders why they aren't around to make another game. Developers: please don't use just any music; make sure it fits the project. Composers: don't compose garbage because the developer tells you to; make sure it will work in the project—and if it doesn't, let them know. If the music doesn't fit the game, no one who sees it will ever consider hiring you for their project.

So, how does one get good at composing game music? Let's take a look at what many game composers have done to boost their success in this industry.

Watch and Listen

The one most effective technique to gain insight into the craft is simply exercising your ability to listen. Listen to the musical world around you. Listen to music while you drive, to the music in the grocery store, to the background music at a party—whatever music is playing during another activity. Think about what the music does for the happenings around you at the time. Analyze what makes the music work or not work. Is it your mood, how you feel, the action, the drama? What element is present that enhances the experience?

For me, speeding down Interstate 5 with heavy metal blaring works great! Sitting in a Texas Barbeque eating ribs and listening to old country music is heaven. Hearing a children's lullaby as I put my daughter to bed at night is fitting as well. A romantic dinner with the wife and some light jazz makes for a fine evening. Whatever music enhances the experience I am living at the time works on an incredibly emotional level and is what I strive for when composing. It's a great exercise for you to try. Would speed metal work at my daughter's bedtime? What about opera at a BBQ? Get the picture? This is an easy way to get it straight in your mind before doing it to picture.

Speaking of scoring to picture, you can learn a great deal from our cousins in Hollywood. They've been making music fit to picture for a few years and are pretty good at it. Watch a lot of movies. After you've watched the movie, go back again to *listen* to it. Listen to the ebb and flow of the melodies—to the techniques used to increase tension, build suspense, and create an atmosphere unique to the film. Listen for the music you don't hear, as well. This is the music that fits the visuals so well, it doesn't even register in your mind. This is the type of music you want to do for games, especially for the background gameplay segments. Learn from the masters. They don't get paid a million dollars per movie for nothing.

Another great way to discover scoring techniques is to analyze movie trailers. These 2- to 3-minute mini-movies can display the entire range of a movie in a short span of time. Not all trailers are done by the original film composer; most of the time, other composers who specialize in trailers perform the task. Many times, the music in the trailer has nothing to do with the film score. It's focused on building excitement to draw you into the theater. This kind of musical stimulation is perfect for learning the art of cinematic scoring. Game cinematics are normally 3–5 minutes long, with rapid changes of scenes and characters—packing enough information to carry the story to the next level with little wasted

motion. Listen and learn how movie trailers get the blood pumping and build the mood for the experience to come.

After analyzing the real world, you can also learn the subtleties of composing for games by actually playing them. Play them and pay close attention to the music, not getting the bad guy. I want you to start forming opinions about the musical soundscape, that is, what music is really good and what music stinks. You can learn valuable lessons from both. Pay close attention to how they match the theme of the game, what instrumentation was used, the density and complexity of the music, and how the score affects the mood of the game. Can you do it better? What other directions would work? What other instruments could be used effectively? I want you to get to the point that you *know* you could have done as well, if not better. This confidence will land you jobs, and knowing exactly what has worked (or not worked) in the past is experience you can advertise. Being familiar with your craft is a whole lot easier than learning as you go. Dig in now, have a little fun in the process, and reap the rewards later.

Create in Different Styles

This particular idea was touched on in Chapter 3, when I talked about putting together a solid demo reel. Put various musical styles on separate pieces of paper, put them in a bowl, and every day, take one out and compose a 1-minute piece in that style. Try rock, country, hip-hop, dance, techno, orchestral, ethnic, bluegrass, R&B—whatever you can think of to hone your skills. You don't need to be elaborate or spend more than an hour on the piece; just do a rough sketch and then decide whether you portrayed the style believably. If you didn't, determine what elements were missing and try again another time. If you nailed it, put this in your "stronger styles" category and push it hard to prospective clients. You can listen and talk theory all day long, but it won't make any sense until you actually sit down and do it. Prove to yourself and prospective clients that your capabilities match what comes out of your mouth.

While you are performing this little exercise, take a look at the methods you use to compose each style. Did you try something different each time? Was that method conducive to the creative process? Should you have tried something different? Loop-based production is great for techno and dance, but not so good for orchestral or bluegrass. Musical instrument digital interface (MIDI)- and sampler-based production is perfect for orchestral and ethnic creations. Live recording methods are good for rock. You get the message. The method is just as important as the style you are creating in. Work out all the kinks before clients are putting the pressure on you to deliver the goods—and get some great practice in the process.

Try Something New

Keeping compositional chops fresh can be a chore when working on any work for hire project. You can get pigeonholed into the same style very easily, either for a large game project or for a series of them, and your other skills will rust. It's not a problem until you get the call for an orchestral score after you've spent 2 months doing an industrial soundtrack. It will probably take almost a week to get spooled up, get organized, and get comfortable with the style before you even begin to record. When time is money, a week of downtime won't help your bottom line very well. Stay ready and stay practiced to keep life easier.

RICHARD JACQUES
Composer

Classically trained from a young age at the Royal Academy of Music in London, UK, with an extensive repertoire including jazz and popular music genres, Richard Jacques is a multiple award-winning and BAFTA/Ivor Novello-nominated composer for film, television, and video games. Best known for his critically acclaimed orchestral scores for blockbuster franchises such as *James Bond 007: Blood Stone* (Activision), *Mass Effect* (BioWare), *Little Big Planet 2* (Sony), *Alice in Wonderland* (Disney), *Starship Troopers* (Empire/Sony Pictures), and *Headhunter* (Sega), Jacques' dramatic music can also be heard in numerous premier TV and movie theater campaigns for some of the world's largest media agencies including Saatchi & Saatchi and McCann Ericsson, and top name brands such as Audi, Bacardi, Mercedes-Benz, and Stella Artois.

Described by Music From The Movies as "One of the most refreshing orchestral scores in many years," Jacques' breakout Hollywood orchestral score *Headhunter* was the first video game soundtrack to record with A-list musicians at the world famous Abbey Road Studios' Studio One. Returning to the action genre in epic style, Jacques' BAFTA and Ivor Novello-nominated original music for *James Bond 007: Blood Stone* took interactive action scoring to the next level as he delivered a high energy score which truly immerses the audience in a thrilling, cinematic Bond experience. Internationally acclaimed by critics as a *Classic Modern Bond Score*, Jacques' music includes brand new themes for all of the major characters and settings as well as various ethnic instrumentation for the exotic locations that Bond visits, including Athens, Istanbul, and Bangkok. The score was recorded with A-list musicians at Abbey Road Studio 2 and received top honors for *Best Original Composition*

from leading music supervisors at The Music and Sound Awards 2012, as well as winning *Best Original Instrumental* for *Athens Harbour Chase* at the Game Audio Network Guild (GANG) Awards.

Jacques recently opened his new state-of-the-art studio facility in central London and continues to write original music for new video game, advertising, television, film, and other media projects.

Richard Jacques is also a Director of the British Academy of Composers, Songwriters and Authors (BASCA), an Advisory Board member of the GANG and a Fellow of Wells Cathedral School. In 2013, he was awarded an Honorary Doctorate from the University of Essex (UK) for services to music and media.

www.richardjacques.com

Describe your thought process for creating music.

When I begin scoring a project, I always like to sit down with the various creative stakeholders for a decent period of time. This is an important part of my process to really engage with the team and absorb their vision for a project. Often, there will be some musical references provided, to give the composer and indication of their vision for the score. I would then embark on a period of preproduction, so I am able to determine the "sound" of the score. This could be anything from sound palette and choices in instrumentation, modal or harmonic/melodic ideas, as well as pace and feel. During this process, I would write a few test cues to get the right feel for the score and the direction I am proposing to take the project in musically. Visual reference material is important at this stage, and I always request whatever material is available, from concept artwork to video footage. I can always hear how the music should sound when I look at these references, so this is a vital part of the process.

I would say that my main focus is to give each score I work on a sound of its own and make the soundtrack unique to that product. A composers creativity can be restricted if they are told to "make it sound like this film or that game," I want it to sound like *this* film or game. Often, this is a trust issue and I am fortunate to have great relationships with many audio directors who select me for their projects because they know what I do, they know my musical voice and allow me to just do my thing. That is the perfect scenario.

Are there any particular secrets to your creativity?

Although I get asked this question a lot, I don't think there are any secrets to my creativity. It could be a DNA thing since my family is musical and my father used to do a great deal of composing when I was younger. This was a great inspiration to me, and so I guess music just runs through my veins and I am naturally a highly creative person. If I discover the secret formula, I will try to bottle it and sell it!

Are there any secret techniques that you regularly employ?

Yes, but of course these are all very secret! But seriously, there are many standard compositional and orchestration techniques that I employ, but I wouldn't say any of them are a secret. The most common one is when writers block occurs and people always ask me how to get over that. I have to write a huge amount of music each week, so being able to take time out if writers block sets in is not an option for me. I am fortunate that this very rarely occurs, but if a particular cue just isn't happening, I will move onto another cue and come back to it with a fresh approach on another day. Also, I think it is important to keep the creative process as fresh and as different as possible. I don't usually approach a score in exactly the same way as I

like to keep a fluid process in my studio and the way I begin a new project. So, I could spend a week or two recording some strange percussion instruments, or just getting a good groove, or programming some new synth sounds. I rarely sit down in front of my sequencer with the default 4/4, 120 bpm template and start writing.

Do you have any interesting sound gathering/sound creation stories?

From an orchestral recording point of view, I was at Abbey Road Studios recording a very quiet, slow, and lyrical cue for the Headhunter score. I kept hearing this sort of metallic jangling percussion, which I knew I hadn't written. After a couple of rehearsals, and after asking each section to play on their own, we discovered that the harpist was wearing a very beautiful but very noisy charm bracelet and was promptly asked to remove it!

There was another incident that involved recording around 30 high-performance sports cars for a racing game where the gearbox on a Mercedes SLK blew up. But that's another story....

Do you have any advice which can help lay solid groundwork and ensure a successful production for the audio content creator?

Planning is the most vital aspect. Game development is very complex compared with many other forms of media, and the nature of the process will often encompass many unknowns. Having an experienced team, who can predict and plan for these is also a great help when working on a complex project. It is best to have a really solid brief at the beginning of a project, both creative and technical. Any technical or implementation issues should be thoroughly tested before the bulk of the creative scoring process begins, so there are no surprises during development. I always visit the team for a good 1–2 weeks at the start of the project to ensure I am in contact with all the right personnel before moving forward. Scheduling is absolutely essential as time pressure is always against a composer, and creating key dates for live recording sessions should be done in plenty of time.

Do you have any interesting sound design creation techniques which affect the type of sounds you create?

I often start from a recorded instrument when I am creating new sounds for my scores. Being a classically trained percussionist, trombonist, and pianist, I have access to a huge range to textures and timbres and always have some crazy instruments set up in my studio. They may become so heavily processed that the original source sounds are completely unrecognizable, but I always like to capture some sounds with a human element to them before I start to work on the sounds themselves. I also do a lot of custom Kontakt programming and sampling, as well as creating various synth patches from scratch, both in hardware and software.

When do you find you are most creative?

I am most productive on the musical side between the hours of about 8 a.m. and 3 p.m. This is the time I would write key themes and get all the musical ideas out of my head. Often, when writing an important theme or melody, I prefer to do it away from the studio and just let it roam around my memory for a while. The two main themes for 007: Blood Stone were written on the back of an envelope while sitting on a London bus! Sometimes, it's good to have no restrictions of technology, a keyboard or a guitar, and most certainly a computer staring at you.

Any worthwhile creative advice you'd like to share?

Speaking from a personal of view, I believe it's important to feed the creative soul. Due to the nature of being a composer, we are outputting all of the time, so it's important to put

something back into the creative engine. I listen to a huge amount of music across all genres on a regular basis and go to many gigs and classical concerts as well as play trombone in a big band and do the occasional jazz piano gig. This helps keep the balance.

Is there a typical workday for you?

Long! Well it depends on where my client is located because often I change my sleep patterns to suit a client's specific time zone. A fairly "normal" day would involve getting into the studio around 8 a.m., and perhaps listening to the cue I wrote the previous day, while enjoying a cup of coffee. I then think about the task at hand for the day and how I am going to approach it, and I often think about this while spending an hour in the gym or swimming which gives me the time to let the ideas take shape. Then around 9.30 a.m., it's down to the main writing. I will do this up until around 2 or 3 p.m., and then after a break, I will focus more on orchestration/arrangement and production. Even on a normal day, I would finish around 11 p.m., but when things are busy, it's usually 2 or 3 a.m. with a few hours sleep in the guest apartment at my studio. It's common these days that I may only get back to my home at the weekends, although I have had to build a smaller writing room there too! What can I say, I love my work!

What skills should composers have to succeed in the games industry?

Firstly, your music should be excellent. This is just a given in this day and age. A good solid musical training (especially classical if you are wishing to be an orchestral composer) is absolutely vital. While some people think it's OK if you just have a few sample libraries, I would say that it would be hard to carve a successful career for yourself this way, because your "composers toolbox" would be somewhat limited. Skills should include composition, orchestration/arrangement, technology, synth/sampler programming, using scoring software, implementation, mixing, and mastering, among many others. While there are many people you can hire to do many of these tasks, having a good basic knowledge of them from the outset will stand you in good stead.

Always be respectful of other composers, especially regarding social media (it's quite a small business when you think about it). Be prepared to be open minded and never stop learning, and be professional and friendly others and learn to take a few hard knocks along the road.

Do you have a specific ideology which drives your way of doing business?

I tend to conduct my business in a highly professional yet friendly and approachable manner. I am fortunate that the phone hasn't stopped ringing in 20 years, so I have personally never had to do any hard selling or cold calling, but this seems to be quite common nowadays.

Bearing that in mind, I think there is always an important balance to find between connecting with people and becoming an irritation. For example, I get many composers contacting me for work or to critique their demos, but I simply don't have the time, and the same is true for busy audio or music directors. Try to have the attitude of a problem solver, so you could help out with one aspect of the score of music production, especially if the time schedule is tight (which it always is!).

For me personally, I think my positive nature and enthusiasm for what I do is always apparent, backed up my past experience, credits and awards, along with business skills and the team my studios provide a good all round solution for my clients.

Any good business advice to offer?

Try to be proactive without becoming arrogant or taking up too much time or bandwidth of busy people. Be respectful of others and do lots of networking. Get to know the industry, its people, its requirements and working practices. Keep composing and learning new skill sets, and take the business side of being a composer as seriously as the creative side.

How do you approach negotiations with a new client?

For a number of years, my agent has always negotiated my contracts, but for those composers who negotiate their own projects, it's important to understand the value of your music, as well as the ownership/assignment of music publishing and master recording rights.

Do you have any negotiation tips which work well for you?

Be flexible wherever possible and listen to what the client is really saying. When signing a package deal, make sure you have specific information about what you are really being asked to deliver, and make sure you can deliver.

Do you have any tips when working with developers?

Even though composers are usually out of house these days, it's important to remember that you are still part of a team, working toward and end creative goal of delivering a quality product. Keeping in regular contact is essential, as is visiting the team regularly for the valuable face to face time, as well as Skype/phone calls and email correspondence. Establishing delivery methods and secure transfer of data is vital, and on the business side, keep up with your various insurance packages. Learn to work with the team and become an integral part of that team for the duration of the project. Build relationships with the key creative stakeholders and be prepared to work hard, exceeding the developers expectations. Have clearly defined goals, procedures, plans, budgets, and schedules in place at the beginning of the project.

Have you ever had any development issues negatively influence your workflow?

Not really, but if it's anything it will always be the schedule. If a team (or a part of the team) is late on one aspect, then the composing still has to continue to make the milestone deadlines. There was one project I worked on that the art was coming online quite late in the project, so I was scoring scenes that were literally just gray blocks, and jumping around scoring different sections of the game before trying to tie everything together with cinematics that came in last. It was a challenge to keep an overall creative vision for the whole game, and not something I would like to repeat as I believe the quality could be affected in these situations, but I made it out the other side.

Do you have any advice to ensure successful audio implementation?

Understanding implementation, and all of the toolsets and middleware and proprietary tools available is extremely important to a composer, even if another member of the development team will actually be implementing your music. If you have a good knowledge of the technical constraints, advantages, and disadvantages of the various systems, then you will be able to compose your music accordingly, making the interactivity work much better within the game compared with a composer who doesn't have this knowledge. These days I implement about half of my own music, with the other half being implemented by my clients. As I have a deep understand of the various toolsets around, I am able to compose in various specific ways to fit the project and its music engine, while creating a compelling interactive score.

Staying organized is important, especially if you are working on multiple projects, which is part of your daily routine. How do you keep up with it?

It is extremely important to be very organized, both on the creative and business sides. I use various tools to keep everything organized, such as scheduling software, online accounting packages that my accountant has access to. I also use file sharing packages such as Dropbox and Gobbler to keep my project folders in sync across 12 computers in my main studio and 3 in my home studio. Productivity is very important too, knowing yourself and your schedule and realistically what you can achieve in a day. Also, it's crucial to be prepared for when something changes and plan your schedule accordingly. I relay on my diary and contacts, ensuring all my devices are in sync. Also when on multiple projects, I color code all email strands and contacts on a per project/client basis with separate folders. I always ensure that my home studio and main studios are in sync with libraries and software, so I can write in either, especially for weekend work, plus I always have project assets readily available. Organization is crucial!

Any specific "lessons learned" on a project which you could share?

When you are on a busy AAA project, don't be afraid to let other personnel (such as orchestrators, implementers, recording, and mixing engineers, etc.) simply get on with the job in hand. Some people find it hard letting go and giving up the reigns to these specialist people. I have been lucky to have an incredible team around me right from the very beginning, but I have seen people come unstuck in the past when they try to be a little too hands on. Also, having people based in multiple time zones can be a real help with the music pipeline. On 007: Blood Stone, I was working from my studio in London and had music copyists working round the clock in New Zealand and San Francisco, ensuring I could get cues copied while I slept.

There are many pitfalls when "working" in the game industry. Have you had any bad experiences?

I can't say I have had any "bad" experiences in the games industry, which is fortunate especially having been a major part of it for 20 years or so. The industry has changed dramatically during this time, but thankfully my talented friends and colleagues are still around and doing amazing work. Of course, the hours are pretty insane, but that's the life of a composer!

Also, one of the most common one is a project getting shelved. This is unfortunately part of the games business, because a project of developer may get into financial difficulty, or the game may be canned for other reasons. It can be tough on a creative person when you've put your heart and soul (not to mention blood, sweat, and tears) into a project for months on end, only to have a game canceled, and the stress of wondering if the developer of publisher will keep going long enough to pay you.

Do you have any development stories which served as a good lesson learned or something which can be avoidable in future projects?

As mentioned previously, good planning, budgeting, and scheduling is essential for the smooth running of a project. My best experiences have been when I have the opportunity to work with an audio director who knows me and my style inside out, then gives me a great brief and lets me get on with the job in hand. That, for me, is the perfect recipe for the perfect project.

Any horrible endings to a project which others could learn from?

I am on a project right now which has not only a very aggressive schedule (probably the most aggressive I have ever experienced), and the development has been quite challenging, so I am having to score parts of the game that are not even built yet, in a largely random order

without a particular locked brief. It's not the most ideal situation, but we all have to cope with ever moving goal posts.

How did you find your way into the games industry?

I followed a traditional classical music education in the UK, studying piano, trombone, percussion, and guitar, and completing an Honors Degree in Music. I had been a gamer since a very young age and had grown up with technology, doing small bits of programming along the way, as well as building up a basic studio setup throughout my teenage years. During the final year of my music degree at University, Sega Europe was looking for an in-house composer. After several interview rounds and a few demo tracks later, I was hired. I finished my degree on a Friday, moved to London on the Saturday, and started in the games industry with Sega on the Monday, it was literally that quick! Right place, right time you could say. I spent eight wonderful years at Sega as composer and audio director, working on big franchises such as Sonic, Daytona, Jet Set Radio, Headhunter, Outrun 2, and then formed my own company in 2000. Now, I have the luxury of working with the biggest names in the business all over the globe, as well as working in film, television, and advertising.

Any other advice you'd like to share?

Study hard, work hard, learn to cope with pressure, keep listening to all kinds of music, study scores, hear live music, play games, say goodbye to your social life, and above all enjoy it!

Keep pushing yourself into new directions. Try styles you dislike, combinations of styles, and made-up ideas such as "Venetian techno" to prod yourself into new territory. Continuously push yourself and your abilities to new levels of competence. Music in entertainment is all about creating a mood while using unique approaches. If you gain the reputation of being "distinctive," it will do a lot to help your career and the money you can demand.

Personally, whenever I spend too much time on a particular cue, the different versions I try all end up sounding blah. It's not that they won't work. It's more that I'm not happy with them because none break any new ground. A certain stale quality can snowball, and every subsequent effort continues downhill. I lose the excitement for the cue, and it shows in my work. When this happens, I find taking a step backward and approaching from a different angle yields better results. Try a different rhythm track, different instrumentation, or a different frame of mind. Get out of the studio, watch a movie, go for a jog, listen to some of your favorite music—change your latitude, as they say. But, over time—as I get deeper into the game world—this happens less and less because I have other musical experience to fall back on.

By rounding out your compositional experience, your creativity and production of other styles of music (and even your specialties) will benefit tremendously. Adding elements from other styles into your music brings an entirely new feel to your work—something exclusive, something your own. Game composer Jon Holland has many musical "side projects" to keep him busy. My favorite is his *Orphan Sister* project. This jazz offering is characteristic of the light jazz genre but with a distinctive "electronica" quality to it. The melding of two very independent musical styles has resulted in an interesting sound completely identifiable with Jon. That's the kind of distinction I'm talking about. The way to achieve this is through experimentation and experience.

Composing with the help of a studio full of talented musicians can also keep your musical perspectives wide open. Even though most game composers work alone, this approach can bring fresh air to your creativity and it can even be fun!

Practice Makes Perfect

Here is another great exercise: take existing game cinematic scores and replace them with your own music. Do the same with company logo animations, stock film footage, or even movie trailers—whatever you can find. Most DVD-ROM games have *mpg*, *mov*, or *avi* video files in them somewhere or posted on places like YouTube. Make a copy and get to work. Practicing with real cinematics is a perfect way to learn the art of scoring. You can even use them as examples of your abilities. Just be sure to make it clear you didn't perform the work in its original release. You don't want to misrepresent yourself.

Most of today's audio editing programs have the capability of replacing audio in video files. Find out what yours does and look for those types of files to practice on. It's a relatively simple process. Open the file in the editor. The video will be in one block, the audio in another. Erase the audio and resave in the video file format. Use the new audio-less video to apply your music. Don't just replace the music with a similar style. Try different ideas, see what works and what doesn't. Practice timing, build, and fade as the on-screen action dictates. Shift the music as new scenes cut in, paying close attention to what each is about and how the music can provide enhancements. Remain true to the overall presentation and ensure all of the music fits together as one cohesive piece. This type of valuable practice will pay off when the time comes to do it for real. Take advantage of any downtime to practice and stay on top of your game.

Some Technical Considerations

Before sitting down to write a game score, there are a few points that should be defined first. These precompositional technical considerations will identify the direction you will take to compose, whether it's an Xbox One game with a full surround, orchestral score, or a simple melody for a cell phone title. As touched

upon in Chapter 7, knowing all of the details in advance, before you even write a note, will help prepare you for the challenge ahead and save any false starts.

I've made many references to the importance of communication, especially when working as a contractor. By asking the right questions, it will be clearer in your mind, you'll be able to hit the mark the first time and it will make you look that much better in the developer's eyes. After all, you don't want them looking anywhere else for their music and sound needs.

Many of these concerns may already have been addressed through the bidding process and previous discussions with the developer. Don't ever assume all is constant. Double-check to make sure that none of the parameters of the game have changed and then keep a close eye out for further modifications as the production continues. I've worked on a game where the final cue was changed from MIDI to digital audio at the last minute. It wasn't a terrible change, but it would have drastically changed the way I had approached the piece if I'd known about it earlier.

Which Platform Is the Game Being Developed For?

Secrecy is a huge issue in the billion-dollar games industry. There have been times when I didn't find out what platform a game was being developed for until the last minute. Developers are wary of outsiders and are rightfully afraid to give any hints of future game releases. Sometimes, even after signing the NDA, they will remain tight-lipped until they feel comfortable releasing information. I guess it just goes with the territory.

It is important that you, the composer, know what system the game will play on as far in advance as possible—for many obvious reasons. A Nintendo is not a PlayStation is not a DVD-ROM game—they are all completely different systems with different constraints and different methods of addressing audio issues. If I were doing a cell phone title, I wouldn't go out and hire musicians or a full orchestra. That would be insane! I might, though, for a PlayStation 4 or DVD-ROM game because the chances of using direct or streaming audio are good.

What Is the Playback and Delivery Format?

You cannot compose a masterful score without knowing the delivery and playback formats. The platform a game is developed for will give a good indication of what type of playback system will be used. Console games will be played through a TV or home entertainment system. DVD-ROM or Internet games will be played through either a desktop or laptop speaker system. Arcade games will use a customized system.

Developers study their demographics. They like to know in advance if the people who buy their games also own a home theater and surround system or if their PCs are equipped with upgraded or surround speakers. Find out what their research indicates and cater to that particular type of playback system. Ultimately, you want your mixes to sound great on any system—but you can pull out all the stops for those earth-shattering effects for systems with subwoofers.

For coin-op games, find out what the developer has in mind for their customized cabinet. Larger systems have subwoofers and several different speaker pairs. Some utilize discrete playback channels for narration, music, and sound effects that keep the audio separated and provide for clearer presentation. If you are lucky enough to be creating music for this type of game, you know the music, will be receiving the attention it deserves, and will take a prominent place in the overall gaming experience. Make it shine.

Ensure you know what type of playback system your audio will eventually be heard through and gear your production toward making it sound great!

If a developer requires delivery in MIDI format, you won't waste time with live instrumentation, vocals, or audio loops. Instead, you will break out your keyboard chops and spend extra time tweaking that MIDI guitar solo to perfection. While use of MIDI greatly reduces the actual musicianship of some instruments, its characteristically small file size will far outweigh this disadvantage. As the composer, you'll have to use a different skill set to make the music dynamic and exciting. It's an entirely different frame of mind from the process of bringing in a live band and composing with traditional methods—but who ever said composing for games had anything to do with tradition? Find out what formats the developer needs as soon as practical.

Delivery and final playback formats can be the same; other times they are far different. Sometimes you will deliver a MIDI score and sound bank, and they will convert it using a development system. Sometimes you will make delivery in 44 kHz, 16-bit, stereo *wav* format, and they will convert it to 8 kHz, 8-bit, mono *au* format. Ultimately, you want the music to sound great in its final format, no matter what it may be. If the delivery and final formats are the same, you stand a pretty good chance. If it changes, fate will more than likely take over instead. Perhaps you can work out a deal where you can deliver music in its final format. That way, you retain some quality control over your hard work. Most game composer will throw the service in for free as a purely selfish way for them to ensure their work sounds good. With their names in the credits, they want to make certain their work is represented accurately. If you don't have a particular platform's development system handy, that may be difficult—but not totally disastrous.

Is a Preset Sound Bank Available?

Some game platforms make use of an internal *sound bank*—either in the system hardware itself or on detachable game cartridges and discs triggered to play by a MIDI file or some other proprietary format. Some sound banks (or *sound fonts* as they were called in the not-so-distant past) are preset into the hardware. Others are changed as a new game cartridge, or disc is placed into the machine. It is

important to find out if you will have to compose using a preset sound bank or not. A predetermined set of sounds will greatly limit the tools in a composer's arsenal and may force you into unfamiliar territory. If orchestral music is your specialty, a game platform with only a drum/percussion, piano, bass, and synth patch will limit your abilities to do a piece the way you want—the same way a sound bank with only strings, brass, and timpani will prevent you from composing anything techno or rockish.

Most preset sound banks have a decent variety to accommodate several of the most popular styles of music. But, they still force the composer into using sounds which may be uninspiring and ones which weren't chosen specifically for the piece. Look at it this way: this can be a challenge which will only make you better musically. You may have to try a little harder to make this limitation work for you, but I guarantee the results will be worth it. One of my favorite pieces of music was a proof of concept Wii project using a very limited sound bank. The challenge of using preselected instruments and sounds forced me to create *way* outside of my comfort zone, and it resulted in what I feel is some of my best stuff! Sometimes you can't get around a predetermined bank, so all you can do is make the best of it and see what happens.

Attempt to get a hold of the actual sounds first, either as samples or sound fonts—or at the very least, listen to the sounds and match them with ones you already have. By doing so, you will be able to compose using similar characteristics and dynamics and allow your mix to be close to the final game version. Don't assume that because the developer says they have a piano in the collection that it is what you think it is. Their little "toy" piano will be a surprise if you understood it to be a grand piano instead. That teary grand piano ballad will take on a different meaning when you hear it in the game played on a toy. The tears you'll be crying won't be from joy.

What Memory Parameters Will You Have to Work Within?

All of the music you compose has to fit on the game cartridge, CD, DVD, console, ROM, or RAM. Find out ahead of time what physical memory restrictions your audio will face and plan accordingly. If 60 minutes of direct audio has to squeeze into 10 MB, you'll probably have to down-sample, adjust the resolution, reduce to a single channel, and save them in a compressed format. This is an ugly example, but it gives an extreme idea of what you should be thinking about.

What instruments will be lost with the lack of high-frequency sounds? As you down-sample, the high-frequency range shrinks and instruments like hi-hats, cymbals, and acoustic guitar begin to disappear. What noise floor will you have to stay above? As the resolution is dropped, quieter passages of music won't cover up the quantization noise introduced by lower-resolution values. If the music will only play back as mono, there won't be any need to spend time with stereo sounds or effects. In addition, extra care should be taken to ensure that the final mixes don't have any phase cancelation when the original stereo tracks are paired. Or then again, maybe you should consider creating in mono from the start.

Technical Wrap-Up

The short list of nonmusical considerations we just discussed will ultimately define the restrictions your compositions must remain within. I choose to have these technical issues clear before I ever begin to compose. Writing music is an

intense experience, with no place for distractions. Understand the environment, and it will almost subliminally guide the process of creating appropriate audio.

Musical Details to Reconsider

These particular "musical" questions need to be asked, just like the previous "technical" ones, before the composing process begins. Some of them may have been answered during the bidding and contract phases as well, but they may have also changed since then. The answers may not give you the information you need to actually do the music. Previously, you needed to know how much music was needed, what formats, what platform, and so on to determine how you were expected to create and deliver your "product" and to give the developer a dollar figure for your services. The following list is specific to creating the magic which is music, without the business distractions.

What Are the Specific Intentions of the Music in the Game?

Is the music to serve as the main title theme, subtle background ambience, or other music cues designed to create tension or announce victory—or all of the above? The music's purpose should be clear prior to that first note being recorded.

What Is the Genre of the Game?

Is it a sports, horror, children's, strategy, board, puzzle, shooter, racing, flight sim, adventure, role playing, action, or arcade game? Find out, if you don't already know, the overall theme of the game project and your musical choices will narrow themselves automatically. Knowing the era and the locale of the game ahead of time will also help dictate the direction the music will take.

What Similar Music Styles Can Be Used as Examples?

If a developer tells you the score should be "industrial, not too gritty, but with an edge," what does that mean to you? They seem to know, so ask them for specific examples of music from a band, movie, or commercial. Then, find it and figure out what they are talking about. After listening several times and becoming familiar with the music, ask them specifically what it is about the music they like. Is it the beat, the guitar, or that great synthesizer patch? Is it the reverb tail on the end of each snare hit or is it the swirling effect on the electric guitar? Is it the melody or the rhythm that catches their ear? Have them put their finger exactly on the elements they would like to hear in their game. Discuss it with them until you are positive. But, even then, there are no guarantees.

An example: the developer sent along an audio example with their request for music. I listened to it several times, got a good feel for it, and decided to jump in without discussing it first. I used the same instrumentation, almost the same beat and tempo, and thought I'd matched their idea fairly well. Turns out, it wasn't any of those elements they were looking for. They liked the distortion patch on the electric guitar and wanted me to focus on that! Aaahh!!! Funny, there was absolutely no discussion about that.

Is There a Preference for Instrumentation?

Here we go again. You're supposed to be the audio expert, why can't you choose the instrumentation? Ultimately, you can and will most of the time. I prefer to throw out this question for ideas on what the developer is thinking—yet another

chance for communication to be concise and allow the music to match their vision the first time. Find out if there is anything special they would like to hear. It makes them part of the music creation, lets them in on the decision process, and gives you something to fall back on if they try to change their minds late in the game. I'd rather not waste time just because someone forgot to mention they didn't want a crunchy-sounding guitar in that racing game. Find out at the same time which ones they are definitely against.

Is the Sound Bank Predetermined or Will You Be Creating It?

The answer to the earlier question will have made it clear whether or not a sound bank will be used. The question here is: will you have to create the sounds yourself or is it preordained? Established sound banks will limit your use of instrumentation and effects, forcing use of sounds chosen by someone else. If the sound bank is left up to you to create, find out some details. How much space is allowed? What format is needed: *wav* files, *aif* files, *mp3*? What parameters are required? What sample rate, what resolution, and will the sounds be stereo or mono? In a sense, these sounds will be played back as the sounds in a sampler would—so it's up to you to find out what it takes to make them work.

A PlayStation 2 game I worked on many years back allowed for a sound bank of 2 MB. The final samples were delivered in *wav* files, but the instruments and parameters were left totally up to me. All I had to do was ensure the sounds were delivered under the 2 MB limit. Using various drums and percussions, piano, bass, organ, and synth samples, in 44.1 kHz, 16-bit stereo, the total size came to over 5 MB for my original sound bank. I composed the music in the highest fidelity possible, mainly as inspiration and because I had to listen to them throughout the entire two-month project. When the final delivery was made, I down-sampled to 22 kHz, 16-bit mono, did a final remix of the music without a conspicuous difference in quality, and made my budget of 2 MB. The best part of the experience was being able to pick and choose sounds which were inspiring to my style of composing and not being stuck with someone else's idea of instrumentation.

Today's game platforms aren't quite as limiting as the PS2, except for maybe the current generation of handheld or smartphone systems—but it's always a good idea to know if a sound bank is to be used and what resources have been allocated to it.

What Is the Length of Each Cue?

The bidding process may have revealed estimates for the lengths of needed audio. Now that the recording and implementation phases are quickly approaching, for various reasons, ideas may have been amended and levels may have been added or may have disappeared altogether. It is important to have the final length set in concrete for the pieces you are creating. If you don't and the length changes, you'll be starting over or spending some extra time with complicated editing.

Obviously, cues for cinematics will be more manageable—but splash screens, menus, and finale and background cues will need to be defined. There's no sense creating a minute of music when 10 seconds was all that was needed.

Will the Music Transition, Fade, or Loop?

Find out what the developers will be doing to your music as it is implemented in the game. What happens to the music when a player clicks out of a menu screen, for example? Will the music end suddenly or will it fade out for a couple

of seconds? Then, will the music behind the next screen slowly fade in? Will these transitions overlap or will one fade out completely before the next fades in? What will your music sound like as these two cues crossfade? This type of situation has the potential to sound like fingernails across a chalkboard as the two cues overlap. If you know ahead of time, perhaps it's possible to use the same key for each piece—something to tie them together successfully.

If the music is expected to repeat itself, will it be as a seamless loop or will the cue fade out then fade in from the beginning? Most of game music that repeats continuously is composed as a loop arrangement, but that doesn't mean it can't repeat using fades and a little bit of silence in between as a contrast. Learn what the developer has in mind and be wary of changes as new ideas are implemented.

Cues that will seamlessly loop are generally more difficult to compose. The challenge is to have enough going on—enough layers of audio events to hold the player's interest through several passes. Loops tend to become predictable, especially the shorter ones. Experimenting with different musical structures, where beats fall randomly or where the rhythm is more free-flowing, is a good way to hide the fact the player is listening to a loop. If you do it right, it will take several passes before they even realize the music is repeating. Making the loop longer is another great way to fool the player. The less a piece repeats, the better. Of course, the reason loops are used in the first place is to save space—and longer ones are not always the answer. But definitely do what you can to keep the repeats less noticeable and musical.

Compositional Methods

Composing and recording music today can be a blend of traditional methods using tape recorders and what some consider "old-fashioned" studio recording techniques and new, highly specialized, and integrated audio production systems. The good news is you really don't need to buy all of the latest and greatest software to make impressive music. The bad news is you will need it if you plan to get it into the computer and in a format the developer can use. The good news is if you already have the latest and greatest, you don't need the old, traditional ways. The bad news is you'd better learn those complicated programs inside and out if you expect to be able to use them to their full potential.

Music is music, no matter how it is composed or recorded. As long as the final output is of a professional quality in both composition and how it sounds, your audio product will stand alongside other authorities in the industry. The key is to develop a process you are comfortable with, which allows maximum output with minimal effort. Never work any harder than you have to. You'll have plenty of sleepless nights—nights where that next cue comes to you at 3 a.m. or when you're far away from your studio. There will be plenty of aggravation that only us creative types are familiar with, so why make the process any more difficult than it already is?

Get your system organized, stay focused, and be ready to turn on that creativity with the flip of a switch. Don't think about that looming deadline. Concentrate on the music, and it will literally happen by itself.

Determine Your Best Personal Methods

If you don't know already, find out when you are most creative. You want to love your job and forcing it when you don't have to will quickly turn a lifelong

dream sour. Settle on a daily working model where you compose at your creative best and take care of the logistical and business tasks when you are not. This will work wonders on the quality of your creations and the longevity of your career.

If it's a peaceful, ambient piece I'm working on, my mood will match before I begin composing. If it's a hyper, energetic piece, I'll run a mile, drink a case of Red Bull, and intake a lot of sugar before the record button is pressed. Put yourself in the appropriate mood, and the music will naturally follow. It won't always happen that way, though. Professionals can and do create impressive music without ever reaching that plane. It may drain you physically and emotionally doing it this way, so be sure to compensate with some downtime to recover.

Choosing the Best Palette of Sounds

Many years ago, a veteran composer offered me the advice of collecting as many different musical sounds as possible. The idea was to "stockpile" an assortment of samples, keyboard patches, and noise makers and draw upon them to keep my sound fresh. The only problem with having a great quantity of choices is resisting the urge to use all of them in each project. This is where the idea of choosing a "sound palette" comes into play.

Before composing for a new project, sort through the collection of samples and patches. Develop a list of sounds and instruments which initially seem to fit the theme of the game. Slowly narrow this list down to roughly a dozen or so sounds which will serve as your main "palette" and begin the composing process. By doing this first, you will make a conscious effort to determine which particular sounds will work well together instead of having to search during a hot streak and ruin your concentration. Other sounds can still be used, nothing is preventing additions to the palette, but the main instrumentation will be set. This, in turn, provides an audio personality to the game—leading every piece of music to fit automatically. A neat little trick.

Stay within the Theme

When the clock is ticking and milestones are waiting to be met, resist any temptation to be distracted or follow other paths. How do you stay on theme? The best way is to surround yourself with it. A couple of years ago, I did a heavy metal score. I like metal, but I don't normally listen to it 24 hours a day. During this project, though, it was a completely different story. I played every metal band I could get my hands on—in the car, in the studio, making breakfast, and eating dinner. I did the same thing with an orchestral project recently. By listening to and *living* with the type of music you are composing, you will be able to pick up on the subtle nuances of the style. This focus will help keep things on track and on theme.

When composing for cinematics, another trick is to watch a lot of movies and movie trailers (as mentioned previously). My least creative time is between 2 and 5 p.m., when I often feel a bit sluggish and unmotivated after the busy morning. Whenever I am doing cinematics or a film-like score, I'll break for lunch and then watch a movie during this "off-peak" moment of my day. By the time it's over, I'm fed, digested, and ready to roll after watching a multi-million-dollar Hollywood production!

Tools of the Trade

MARTY O'DONNELL
Composer, Sound designer

Gear Philosophy:

- Time tested top of the line equipment
- With multiple workstations where everyone is using the same hardware and software to enable easy exchange of sessions
- Use great speakers rather than headphones
- Record your own sounds rather than using libraries, which means building good studios and purchasing great microphones
- Get equipment for field recording and also budget for outside studios
- High-quality synths and samples—with the intention of recording live musicians if appropriate

Home Studio

- MacBook Pro 2.3 GHz
- iMac 3.4 GHz
- Pro-Tools 11, Peak, Waves IR1, Kontakt 5, Komplete 9, Ivory 2
- Yamaha SGOXS, Yamaha speakers, Shure KSM 44a
- Vintage gear: Fender Rhodes Suitcase 88, Prophet 5, TR808, DX7, Steinway Grand Piano

Immersion

Many game composers choose to fully immerse themselves in a game's "virtual" world. I don't mean playing the game for 10 minutes then writing a score for it, I'm talking *full* immersion. Get your hands on as much artwork, storyboards, full-size cutouts, and other game design paraphernalia as you can from the developer, and surround yourself with it. Cover your walls from floor to ceiling with everything related to the game. Study the storyline; live and breathe this new environment. Spend some time playing whatever versions of the game you can get a hold of.

As discussed under "Get in the Mood" in Chapter 7, you'll also want to prepare your writing/composing/recording space. If it's a dark game, compose at night, turn the lights off, light some candles, and be totally consumed by the atmosphere. A happy kid's game will require sunshine and should be worked on during the day. Keep the mood light and smile a lot.

Much of what happens when writing inspired music takes place on the subconscious level. Music created while immersing yourself in a game's environment will affect other listeners subliminally. You won't be able to compose like this every time, but important scores will benefit greatly from this approach.

Compose While Recording

Composing does not necessarily have to be a separate step apart from recording, although it can be. When writing for games with a tight deadline, consider recording while you compose. Typical music creation phases consist of an idea-gathering segment, a writing stage, an incubation period (where the music begins to germinate), and then the recording phase. When working on an everyday music project (say, for your band), this method allows for the music to develop into something over time through experimentation. Other ideas have an opportunity to surface. When making music for games, there is usually little time for this particular approach and shortcuts are needed to stay on schedule. That's where recording while composing can be a valuable tool.

A recent project proved to me how beneficial this technique can be. With 5 days to compose a 4-minute orchestral score, there wasn't much time to reinvent the wheel. Instead of using the standard songwriting method, the situation dictated a more rapid output of music which wasn't going to happen unless I made critical changes. I made the decision to create the piece with three movements, to prevent it from getting stale, and established the tempo. The music was to accompany gameplay as background music but also as a display piece for the developer to use in previews of the release. The tempo was consciously set to match the game character's walking pace since this loveable guy seemed to have a good rhythm. I fired up a sound bank, specifically created for orchestral pieces (no time to design a specialized sound palette on this one), started the sequencing program, and went to work. But, instead of working out ideas first, I chose to go straight into recording and compose as I went.

The piece began with percussions, a little bit of timpani and snare and bass drums—which laid the foundation. The opening flourish was the next step, and other instrumentation was layered from there until the piece began to sound like something. I wish I could say I had a plan. Instead, I was relying heavily on instincts and a cliché or two in the process. But, by the end of the third day, the piece had a melody, counter-melody, rhythm, bass, and plenty of percussion. I spent the next day cleaning up the various bits and pieces and fixed flubs and missed notes. At the close of the fourth day, the music was finally tight, cohesive, and ready for the last step. The final day was spent mixing, EQing, adding effects processing, and rendering the final mix with time to spare.

While I could have spent a couple of days toiling over the perfect note to play where, I opted for the adventure of just letting it happen. As each layer is recorded, your musical mind starts to hear other ideas and those are the leads you go with. It's like writing an essay in a testing situation: start with the first sentence, and the rest will follow. When taking the plunge like this, it is important to listen to

that little voice and run with it. There's no time to pine over that approaching deadline; you have music to make.

Using Loops as a Tool

For a one-man band with a lot of work and little time to do it in, music loops are a lifesaver. Where else can you pop in a CD; load up a prerecorded and fully mixed beat, bass line, rhythm section, and various other band members in your own mix; and lay a melody line over the top? These little gems are perfect for composing, generating other ideas, or as final production elements themselves.

Whenever you happen to be devoid of ideas or need something with an interesting flair or outside your musical abilities, reach for a loop library and see what happens. I don't know how many times I stared blank-faced at my drums begging them for a good groove. When they don't answer me, out come the loops and usually within a few minutes, new life is injected into the creation process. Purists may argue they aren't original musical creations—that your recordings contain elements anyone can license or even that you've stolen someone else's work! Music in the games industry is a different animal, and nobody really cares unless it detracts from the experience. As long as you've properly licensed any material used in the final work, everything is all nice and legal-like and there is nothing to fear.

Experimentation

The one thing I love about music is there are no rules except one: If it works, it works! Creating new music day after day will eventually leave you without any new fresh ideas. You'll hit that plateau where frustration grabs hold and your musical future will be in doubt. So, we must fight the phenomenon with experimentation.

For those multi-instrumentalists who have got gadgets and nifty toys strewn about, start mixing and matching. It took many years for me to consider running keyboards through the guitar effects, especially distortion. Wow! What a revelation! How about playing your instruments in unconventional ways? Banging on your electric guitar strings with a drumstick can bring interesting results. How about using effects processing in ways that aren't expected? Most people mix reverb onto drum tracks, but what about using a flange or chorus instead? I'm sure you've got plenty of ideas and have tried many already. When the going gets rough and the music starts to sound lifeless, stand on your head for awhile and look at the musical world in another way. The ideas you glean from experimenting might bring the excitement back into the creation. Don't be shy.

Compose While Playing the Game

One of the most obvious but often overlooked methods of creating perfect music is to compose while actually playing the game. I'm not talking about playing the game with one hand and a piano with the other (although that could be a marketable skill to put on your list of unique talents). I'm talking about having a working copy of the game up and running, either through a dev kit or on your computer, while you work through your compositional process. Assuming the game is in a semidecent state and there is some pertinent artwork to look at, you'll be able to get right into the game, let the musical ideas bounce around while you play it a bit, and then with a live imagination, compose. In addition to immediately

translating the experience, you will be able to tell very quickly whether the music is going to work or not.

Recording Methods

Recording music for video games is no different than standard music production. There is no mysterious underground system. There is no top-secret decoder ring you'll be handed after you join the club. Nothing like that. Music recording is music recording no matter how it is done. The only element which differs from audio CD production is the conversion to the final in-game format completed at the end of the cycle.

I'll continue to assume that most, if not all of you, are familiar with the recording process. When it comes time to record your game score, carry on with what works for you. This section explores alternatives which may or may not have been previously considered. For those of you who are musicians and have never had the pleasure of pressing that big red button, this will give you options to pursue as you get settled in. When working on game music, especially as a one-man show, it is essential your engineering and recording chops are solid.

Whether you're an experienced artisan or taking your passion to a new level, it is definitely good to be familiar with other methods. After all, different forms of music are easier to work with using different recording techniques. In a business where several styles could be recorded in a short time, it helps to have something extra in your bag of tricks.

Traditional Recording

Traditional recording methods refer to those that have been around for many years and are the essential foundation for all other techniques of recording. It's a predictable scheme near and dear to many. After the initial composing phase, musicians are brought in and their performances are tracked to tape—whether it's an analog or a digital medium. They can be recorded all at once or one at a time, whatever happens to work best for the music. Multitrack tape decks provide for separate controllable layers and the ability to overdub without affecting previously recorded music.

The mixdown process follows the completion of the "tracking" phase, where a mixing engineer and producer toil for hours over a mixing board. They adjust volume levels, equalization, and placement of instruments in the stereo field. They add effects processing, compression, and noise gates to control or enhance each track—and finally record the multitrack efforts down to two channels for a stereo mix. After all of the music for that particular project is completed, each song is "mastered." This step takes each separate tune; adjusts its overall equalization, volume, and "sound"; and matches their sonic characteristics. The overall effect is a cohesive assemblage of songs which sound like they belong together.

This type of recording is perfect for the one-man band with a need to record live instrumentation, such as guitars, horns, or vocals. Despite the use of a MIDI rig, which triggers notes from samplers and keyboards, multitrack tape decks can supplement computer playback with a human feel. It also works well for orchestras or music groups who might play off each other during a performance. The number of tracks can be limited by your hardware, but when synchronized with a sequencer, additional "virtual" tracks can be added that are almost unlimited.

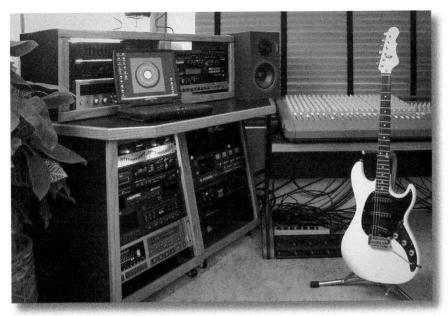

There are many studio's which are still geared towards traditional recording methods, offering options beyond computer-based tracking and mixing.

Progressive Recording Methods

As technically savvy musicians and engineers pursue the elusive better mouse-trap, new and improved ideas begin to take shape alongside traditional music recording. At first, these techniques merely assisted in the process—making certain aspects easier. These new processes evolved as complete and separate entities capable of incredible things. Today, we have a solid marriage between ideas and technology—and eventually, the traditional methods will fall by the wayside.

As luck would have it, many of these improved processes are perfect for recording music for video games. Gaming has a tendency to influence and drive computer technology. Coincidentally, music production has become almost completely computer-based—including sequencing programs, multitrack recording, audio editing, effects processing, and sound generation. It is completely impossible to produce music for games without one.

As the recording scene evolved over the last 30 or so years, one of its greatest contributions was the invention of the MIDI. This standard allows for computer-based electronic instruments and effects to interact, to allow one person to perform using multiple electronic instruments at once, or to program them all to playback prerecorded routines at the touch of a button.

Initially, dedicated hardware sequencers were designed to record a performance and allow others to be layered on adjoining tracks until a piece was complete. All you had to do was press Play and your electronics came to life, each playing a dedicated instrument through its own discrete data channel. This allowed for huge productions to be composed and performed by a single person, something unheard of only a few years earlier. The greatest advantage during final mixdown was the ability to skip a generation of tape and record the actual performance, instead of a tape recording of one. In the analog domain, this meant one less chance for unwanted noise—the constant quest.

The sequencer then moved inside the computer, with loads of added features to assist in the creation. Today, we see these types of programs paired with multitrack audio recording capabilities—more powerful than anything we've seen before. Composers have the capacity to sequence triggered sound patches and samples, and record synchronized live tracks via MIDI right alongside them with ease.

This production technique has incredible advantages, making traditional ways pale by comparison. Where else can you change instrumentation on a whim? Don't like the bass? Reset the patch until you find the one you like, all without having to rerecord. That darn snare hit was late. No problem: grab your editing tool and move it where it should be, right on the beat. Piece of cake. The 1-minute piece is too long by 2 seconds? Adjust the tempo a couple of beats faster, now it's exactly 1 minute long, just like the client wanted. See what I'm talking about? This MIDI stuff is sweet!

Some developers want their music done as a MIDI file. These files are tiny, simply containing the data that tell notes when and how long to play. The developer, in turn, takes that file and pairs it with a sound bank and has instant game music. There is no way to do something like that with the traditional tape-based music recording process. The format is incompatible.

Multitrack Computer-Based Recording

Multitrack still has its place in music production—a fact which will most likely not change for many years. Like any system that works, it has been improved upon and has discarded many of its weaknesses in the process. Gone is magnetic tape—replaced by the reliable hard drive. With affordable drives available with terabytes of capacity, storage is no longer a problem. Gone are the hardware-limited recording channels, now replaced with a virtually unlimited number of tracks.

With multicore processor speeds over the 4 GHz range and affordable RAM, this far surpasses the need for a room full of mechanical tape decks. Gone is the need for huge mixing consoles and racks of outboard effects processors. All of these are included inside the box, accessible with the click of a mouse. Can't afford one of those high-priced automated mixing desks? Don't worry, most multitrack programs have their own form of automation which can handle everything from volume and panning adjustments to effects processing.

In addition to the huge operating advantages to computer-based multitrack systems, recording on a computer allows for easy editing, limitless "undos," and file sharing previously impossible on tape-based recordings. Computer-based multitracking also allows importing into an audio editor, either one track at a time or to manipulate the final mixdown prior to delivery. And, if you are using the *wav* format, it is only one step away from becoming Red Book audio, the music CD standard.

Only a few years ago, the weak link in this formula was the sound card. Computers are full of noisy components, generating electronic artifacts that are detrimental to clean recordings. Today, most of those issues have been successfully dealt with, and computer-based recording has reached the sonic level of professional recording studio equipment. This allows us all to attain high quality at a reasonable price in the comfort of our homes. With the addition of a stable of high-priced microphones, preamps, effects, and other equipment, we just might give the big boys a run for their money.

Computer-based multitrack audio and MIDI production comes in all shapes and sizes. Find the software which matches your computer's capabilities, your budget and your thought process for the best results.

Loop-Based Production

As music production advanced, so did the methods to create unique compositions. Instead of instrument samples only being sold to musicians, some smart entrepreneur discovered a market for entire beats, rhythms, and instrument riffs. These performances were organized into tempos and packaged as music "loops"—bars and measures of repeatable patterns—that become an entire musical piece when layered together. Initially, only a small subculture of musicians took to this form of music—but others quickly joined the movement, discovering the advantages were too great to miss.

Along with the advent of MIDI, loop-based production has become another great milestone in music. With literally thousands of loop libraries available today, almost every conceivable instrumental combination has been presented—making this an indispensable tool for any game musician.

No matter how good you are at composing, there is no way to think of every musical idea. Loops can be a tremendous conduit for new ideas. With a strong groove played by a professional musician as your backing track, the music you compose on top of it will sound that much better.

Playing with talent, whether they are in the room with you physically or as a recording, has a way of bringing out your best. Want to add a live drum track to your mix, but you're afraid your neighbors may not approve? Piece together a few loops of prerecorded live drums and, voilà!—instant drums without all the trouble. Need a smoking guitar solo, but you're strictly a keyboard player? Grab a loop CD and take your pick. There are hundreds to choose from. What if you need to do a 30-second looping menu cue in a hurry? Loops are already designed to seamlessly repeat. Just time them out to 30 seconds, layer the instrumentation over the top, and you've saved the day.

Loop-production and music software has also made great strides in the past few years. Like sequencing programs, loop-based production tools, such as Sony's ACID Pro, have integrated live multitrack recording and even MIDI into their lineup. After building solid backing tracks with loops, it is possible to record your own flavor of live instrumentation right alongside them. Do the final mix and export the new stereo tracks to whatever format you need for mastering or conversions. This is an incredibly powerful music production system all on your computer screen.

Other Music Making Methods

New programs and methods of music making are introduced to the masses almost monthly (some good, some not so good). It's up to you whether you pursue new methods as they appear or not. I prefer not to. I take a more "wait and see" approach, letting other people try them out and write reviews in magazines about them first. I'll show an interest after the cream floats to the top. Programs such as Reason, ReCycle, Reaktor, and Tracktion, for example, have introduced new concepts in music production over the years by integrating software synthesis, sample triggering, loop production, and MIDI sequencing into intuitive products.

The trend seems to be leaning toward combining past music production methods into one integrated system. For a game composer, this is a good thing. In order to drive the entertainment value of our audio to the next level, we must be able to stay with the times and consistently push into new areas of music creation. Most game composers use every one of the music production methods previously discussed. It's not a "keep up with the Joneses" kind of thing—it's a matter of survival in the highly competitive music trade. Keep your ears open and be ready.

Streamline to the Final Format

If the music will be delivered to the developer in a prespecified format, it is possible to streamline the recording process and save some time on your end. For example, if MIDI files are requested, why compose an audio score on a multitrack tape deck? Some composers prefer, in order to be enveloped by their creation, to write and record their score as audio to make sure it works first. Then, when they are happy, they transpose manually, note by note, instrument by instrument, to the MIDI format. What a grand waste of time! The music will change as a MIDI file and will sound nothing like the original. So, why not compose in MIDI from the start—always knowing what it will sound like?

Conversely, why compose in MIDI if audio files are the final format? Let's say you plan to bring in a few musician friends to help record the music. Instead of relaying your ideas to them directly, you decide to let them hear a rough sketch of the intended music. So, you beat out each drum hit, each bass note, each pseudo-guitar part on a keyboard and record on a sequencer. It takes you a week, but darn it, you want to have something for the boys to listen to first. Well, you're wasting your time. Bring the guys in, sit them down, vocalize your ideas, and let them play. It may take a day at the most to practice and get their parts down, and at most, maybe another day to record. Streamline the process; don't waste time. Go straight to the final format.

Game composers don't often have the luxury of waiting for a muse to strike or to record under perfect conditions. Audio is usually the final content implemented in a game, and we can't hold up the Christmas release because we need an extra week. Keep things simple and cut corners in the production, *not* in the quality. Set yourself up to do 25 games a year, and this business will indeed be kind.

TOM SALTA
Composer

Award winning composer Tom Salta is one of the most versatile and prolific music artists/ producers working in film, television, advertising and video games. Renowned for crafting emotionally engaging soundtracks for multimedia, Salta has received widespread industry acclaim for his world-class produced scores featured in video game titles such as *HALO: Spartan Assault, HALO: Combat Evolved Anniversary, Ghost Recon: Future Soldier, From Dust, Prince of Persia: The Forgotten Sands, Red Steel* (IGN Award for Best Original Score), *Tom Clancy's Ghost Recon: Advanced Warfighter* and *Tom Clancy's H.A.W.X* series. In addition to these scoring assignments, Salta produces music for commercials, Hollywood film trailers and the world's #1 dance game series, Just Dance.

Selected Gameography:

Killer Instinct: Season 3 (Microsoft Studios)
Halo: Spartan Strike & Halo: Spartan Assault (Microsoft Studios)
Blade & Soul (NCSOFT)
Galactic Reign (Microsoft Game Studios)
Halo CE Anniversary & Halo Master Chief Collection (Microsoft Game Studios)
Tom Clancy's: Ghost Recon Future Soldier
Prince of Persia The Forgotten Sands (Wii, PSP, DS) (Ubisoft)
Tom Clancy's: Ghost Recon Advanced Warfigher 1 & 2 (Ubisoft/Red Storm)
Just Dance 2, 3, 4, 2014, 2015, 2015, 2016, 2017 (Ubisoft)
Tom Clancy's: HAWX & HAWX 2 (Ubisoft)
R.U.S.E. (Ubisoft)
Red Steel (Ubisoft/Nintendo)
Red Steel 2 (Ubisoft)

www.tomsalta.com

Describe your thought process for creating music.

The immediate questions are always "What is it for? What role(s) does the music have to play?" If we're talking about games, then one of the first goals is to figure out a unique and signature approach to the music that will represent the game. My goal with each and every score I create is to make music that people will immediately associate with the game, even after hearing just a few seconds. It takes a lot more work, time and experimentation to accomplish this, but it's worth it.

Are there any particular secrets to your creativity?

I wish there was a special trick or secret to creativity, but there isn't. For me, the art of creating requires a mind-set where I shut off the left side of my brain (the analytical side) and just go with the flow of the moment. It's not about critiquing what comes out in real-time; it's simply about getting the ideas out, being willing to accept failures and to keep going. Basically, it's musical brainstorming.

Another thing I've noticed over the years is that some of my best, and most original ideas are the ones that "just happen" without a lot of effort. So, whenever I notice myself "trying," I usually stop and step away. The raw creative ideas shouldn't be forced. It's the refining of them that takes most of the time and work.

Are there any secret techniques that you regularly employ?

It's not really a secret technique, but I know that one of the reasons my material sounds the way it does is because I've been working on my craft for about 25 years. I've learned how accurately produce and mix what I'm hearing in my head.

Do you have any interesting sound creation stories?

Two immediately come to mind.

There was a level on Red Steel 1 where they wanted me to create the music to a creepy indoor amusement park level… except in this amusement park you were the only one there and you were being hunted down to be killed by men in Godzilla suits and pink tutus. (Yeah, that was my reaction as well.) So, the plan was to create some warped circus/carousel music combined with 1960's sci-fi elements (yep, it's all on iTunes, you should check it out). In order to add to the creep factor and make it sound like an old, abandoned amusement park, I went through my garage and recorded as my old and rusty wheels as I could, including my son's old training wheels—it was both hilarious and incredibly creepy at the same time.

The other project was for a kids game, which regrettably, was never released. But it was probably my most ambitious use of custom musical sound design to date. The game was based in a paper world and I used various paper objects in different ways to mimic real instruments. For example, instead of a shaker, I close mic'd an eraser rubbing on paper. Instead of a guiro, I ripped out pages from a phone book. It was a lot of fun and some of the most unique sounding music I've made. I still remember the look on my son's face when he walked in on me as I was wearing headphones, ripping pages out of a phone book in rhythm with a huge grin on my face like a madman-priceless.

Do you have any advice which can help lay solid groundwork and ensure a successful production for the audio content creator?

I have found that it's very important to dedicate enough time at the beginning of a project to research and fully understand the scope of what will be required. I also have found that the most creative ideas usually happen at the very beginning before the deadlines creep up. So

I always try to brainstorm and create as many ideas early on which I can come back to later once I'm in crunch mode.

When do you find you are most creative?

The first few days I start on a project are usually the most creative for me. This is when everything is new I'm most excited and inspired by the project. I'd also like to point out that there is a big difference between being creative and being productive. The most "productive" stage of a project for me is usually towards the end as the deadlines approach. Most composers will agree, without deadlines, most of us wouldn't ever consider something "done."

Any worthwhile creative advice you'd like to share?

Don't critique as you create. Don't think. Don't try. Have fun.

Is there a typical workday for you?

For me, the days of all-nighters are over—I'm married with kids. I've been in the business for over 25 years and I've learned that in order to do what I do day after day, month after month, year after year, I need to pace myself like a long distance runner. A great way to do that is by keeping a balance in life. I've also learned that I can be VERY productive when I give myself less time to do something, taking breaks in between.

Routine is very important for me. My ideal work day is to get an early start, around 9 a.m. and then work up until dinner. Then, if I'm not under a tight deadline, I try to stop for the evening to spend time with my family.

What skills should composers have to succeed in the games industry?

If I had to distill it down to three main areas of focus it would: be great at your craft, be a smart business person, and marketing yourself well. All three are required but business and marketing are, perhaps, even more important that your talent.

Do you have a specific ideology which drives your way of doing business?

My ideology, which I learned from my former agent who is now retired, is that it's not about businesses and companies, it's about relationships. No matter how big a company is, you're going to be dealing with a human being there, so treat others the way you would like to be treated. Focus on their needs and how you can help them. If we want people to enjoy working with us and want them to hire us, we have to get out of the "entitlement way of thinking." No one owes us anything, no matter how good we think we are or how much experience we have. We have to remember we are in the service business.

How do you approach negotiations with a new client?

I only do business with people I trust. So I always like to get to know who I'm doing business with and have them feel comfortable with me as well. When I come onto a project, I want the client to know that I'm fully committed and passionate about it. I want them to trust me and feel that they can relax, knowing that it's going to come out great. When you develop a trust factor, it makes negotiations much easier.

Do you have any negotiation tips which work well for you?

Over the years, I've learned to simplify things. Even when there's a huge contract, there are only a few main terms that everyone cares about. All the rest is boiler plate stuff. I find it's also helpful to discuss things in simple language, not "legalese," at least when negotiating terms.

Do you have any tips when working with developers?

Yes. Make their job easier. The more you know what it's like on the "other side" the better freelancer you can be. Figure out their work and communication style and adapt to them. Some clients like to talk every day and some don't want to talk at all. Some like emails, some phone, some texting, some Skype. In order to build a good rapport, always adapt to your client's preferred way of communicating.

What advice can you give when working with a developer which has ensured a good working relationship and a good final product?

Over-deliver, and do it on time and on or under budget.

Have you ever had any development issues negatively influence your workflow?

Yes. I've learned (the hard way) that it's best to have one point person on the other side giving you feedback rather than different members of the team. This way you can ensure that you're meeting their clearly defined and agreed upon expectations and not being bounced back and forth between conflicting opinions.

Staying organized is important, especially if you are working on multiple projects, which is part of your daily routine. How do you keep up with it?

Project management is important. I typically use Trello to help me manage multiple projects and tasks. I always color-code folders on my project drive to give me a visual indication of what's in progress, on-hold or done. I also often use the "Pomodoro Method," working in 20 minutes uninterrupted periods with short breaks in between.

How did you find your way into the games industry?

Back in 2001, after a 15 year career in the music industry, I decided that video games was where I wanted to shift my focus. Playing the original *Halo Combat Evolved* is probably what inspired me most to get into the business, along with other games like *Prince of Persia—The Sands of Time and Rainbow Six*. I did a lot of research, found out who represented the best composers in the game industry and started sending my reel around. I also attended as many industry events as I could.

I quickly determined that in order to break in, I needed to market myself and approach the industry as an artist rather than as just another "new composer." So, I came up with a plan to create the artist moniker "Atlas Plug" (Atlas is Salta backwards).

I then set out to create an entire album of high-octane electronica that would be perfect for licensing in TV, film and of course video games. I felt that this would be a great way to introduce one side of my musical personality to the game industry. The plan worked out incredibly well. Microsoft was first, they licensed several tracks from the album for *Rallisport Challenge 2*. For the next several years my agents helped me find opportunities to score games. The first game I scored was *Still Life* on PC. Over the next few years I got the chance to work on bigger and bigger titles. *Need For Speed Underground 2* was my first AAA title and a year or two after that, *Tom Clancy's Ghost Recon Advanced Warfighter*. That game is what really helped establish my reputation and signature hybrid sound.

Any other advice you'd like to share?

I named my company "Persist Music" for a reason. On my wall is one of my favorite quotes by Calvin Coolidge talking about persistence. "Nothing in the world can take the place of Persistence. Talent will not; nothing is more common than unsuccessful men with talent. Genius will not; unrewarded genius is almost a proverb. Education will not; the world is full of educated derelicts. Persistence and determination alone are omnipotent." I would have never gotten to where I am without persistence. If you want something bad enough, it can happen. Never give up.

Editing Music

After the music score has been recorded, unless it is intended for a surround application, it will be mixed down into a two-channel stereo version. Whether this process is completed using more traditional tape-based methods (such as mixing to DAT) or rendered utilizing the feature on a multitrack program as a *wav* file, this process will allow further editing and conversion as needed. Your personal working methods will dictate how you accomplish this stage, ultimately ensuring the final version of the music will sound its best. Even though it is done, keep in mind that further work will need to be done to these new files before delivery to the developer.

Audio Editing Software

The next step is to import the music mix into an audio editing program for any cleanup and maximizing. If the music was recorded to hard drive, make a copy and save it in your normal working format, usually as a *wav* or *aif* file. If the recording was on any other medium, such as DAT, transfer it into the computer using an audio editing program like Sound Forge or Adobe Audition. Depending on the sound card, it is possible to input via standard analog (either RCA or 1/8-inch stereo jacks), Firewire, digital coaxial, or digital fiber optic (also referred to as Lightpipe) inputs. If at all possible, utilize digital inputs and outputs. These provide for the purest audio.

When recording into an audio editor, always record the music at the highest possible sample rate and resolution. I recommend 44 kHz, 16-bit stereo as the absolute minimum. Later, when making any conversions, this will be important. You can always sample down without any grief; sampling up is a problem. Once the computer recordings are made, save the file and prepare for editing.

Sound File Cleanup

From your audio editing program of choice, open the music file to be edited. It's a good idea to save the file you are about to work on under another file name, like *music_file_new* or *music_file_2*. That way, the original file is left untouched in case something goes wrong and you need to revert to the beginning.

The first plan of attack is the dead air on the front and back of the file. Give it a listen. Do you hear any background noise? If it is prevalent, highlight the space and let your noise reduction plug-in analyze it and process the rest of the file. If you don't have this feature, fear not. If you recorded the sound at a good level, and if it isn't a quiet piece, most of any noise floor should be masked anyway. Trim off the dead space from both ends, being careful not to cut any of the sound wave. Use the zoom feature to see exactly where the sound begins and ends if you need to. This process will ensure the file is as small as possible and that the music plays immediately after it is triggered, without silence first. Save the file.

Visual File Inspection

The predominant feature of audio editing software is the ability to "look" at the music. By visually inspecting the file, you are able to actually see noise, peaks, and clipping and get a good idea of the overall quality of the sound. What should you look for specifically?

Is the Sound Centered on the Zero Baseline?

The line that runs through the middle of each channel is known as the zero baseline. If there are electrical mismatches between the sound card and input device, it can cause the entire sample to be centered somewhere above or below it. This can cause unwanted audible artifacts you'll need to get rid of. The DC Offset function (or something similar depending on your software) will analyze the file and recenter it to zero, keeping the file as clean as possible.

This example shows a horn sample which sits slightly above the zero baseline. Although this is normal for horns, it illustrates something to be on the lookout for when dealing with other sounds.

Does the Wave File Look "Healthy"?

Does it fill much of the screen or is it a bunch of puny little lines barely perceptible until you zoom in? It is important that the actual sound is louder than any noise floor in the recording and louder than the noise on any playback system. If the volume is at least medium intensity or thereabouts, you can beef it up by either increasing the overall volume manually or using a normalization function. Normalization will scan the file and increase its overall gain, set by you, without clipping. This will maximize the volume proportionally, leaving a strong and solid sound. If you do use the normalization feature, be sure to keep an ear out for what it does to the overall dynamics of the sound. Use too much, and it'll become a solid brick wall with no room to breathe.

Does the Sound Look Too Intense?

Has the waveform saturated the screen completely? If the sound file shows a solid wall from the zero baseline to infinity, with the edges of the sound cut off, chances are this file will be distorted and lack any dynamics. Depending on the effect you are trying for, this may be alright—but the majority of the time you'll need to give something else a try. First attempt to reduce the overall volume or

This is a normal, healthy-looking music file. It's not too weak or too strong and is what most of yours should look like when working in an audio editor.

apply a moderate amount of compression. If the peaks are severed, peak restoration plug-ins are available to repair this type of damage. Listen to the results and decide if it sounds any better or if you just simply reduced the volume and applied "band-aids" to a distorted sound. In that case, rebouncing or even rerecording the sound will be your only options—just be sure to do it at a level a few notches below the previous attempt.

Are There Any Points in the File Where the Volume Peaks or Causes Clipping?

Nothing sounds worse than a digital file passing 0 dB on a level meter. These prominent peaks cause unwanted clicking and distorted screeches in sound files and need to be dealt with. One option is to reduce the overall volume of the file enough to bring any peaks below the point of clipping. Another is to apply a slight amount of compression (such as a 2:1 ratio), which in effect will squash the peaks and raise the quieter levels proportionally. My personal favorite is to use a peak limiter set to –0.01 dB, which allows for the highest possible levels without reaching 0 dB. Depending on the playback system, you may have to adjust the peak limiter to a lower setting to compensate for poor speakers. Keep an eye on the peak levels, especially after adding EQ or other processing and be prepared to repeat this step if necessary.

The previous items have been addressed by simply looking at the sound file. Audio editing programs are unique in providing visual input to creating sound. But what the file actually sounds like is obviously as important. Give the music a listen. Does it sound good? Is there any distortion or clipping? Is it a good representation of what you were trying to accomplish? Answer these questions truthfully and take care of any repairs prior to the next step.

If your music looks like this, chances are it will sound like a distorted mess! Keep the overall levels under control for audio the way you intended.

Peaks, such as the one noted here, will cause digital distortion and ruin a perfectly good take if not properly controlled.

8. Creating Music for Games

CHRISTOPHER TIN
Composer

These days, I'm adhering to the philosophy of having as compact of a studio as possible. I travel a lot, so it behooves me to be able to bring everything I need with me on the road. In the past, I was a bit of a hoarder; buying every plugin, buying random esoteric musical instruments, having a huge microphone collection. Now, I'm adhering to the philosophy of making do with fewer tools, but getting better at using them.

Computers: Mac Pro (2013 model)

Audio interface: UAD Apollo Quad

Software: Logic, Pro Tools and Sibelius

Multitrack system: Logic

Monitors: Quested VS2108 (surround), Sony 7506s if I'm on the road

Sound modules/VST instruments: Native Instruments

Outboard gear/effects plugins: UAD2 Platform

Keyboards: Alesis QS8.1

Other instruments: Variax Guitar, other miscellaneous string instruments

Microphones: Schoeps CMC5mk21 for general stereo recording, AKG 414's for close micing, Neumann M149 for vocals. Miscellaneous other mics for other duties

Preamps: Great River MP-2NV, Millennia HV-3C, UA 710-4d

Remote recording gear: my laptop!

Conversions

The music file is almost complete and ready for delivery. If the developer requires a 44 kHz, 16-bit stereo uncompressed audio file, we're done because that's what we should (at least) be working in. If you happen to be working in anything higher, follow the next steps to accomplish the conversions in the same manner.

The developer in this example requests a 22 kHz, 8-bit, mono file, so we'll need to do a couple of things. Using a copy of the last saved version of the music file, resample it to 22 kHz using the editor's resample function. Ensure the anti-alias filter setting is used to prevent any of the lost high frequencies from becoming low-frequency distortion. This will keep the sound file as pure as possible. Keep in mind the higher frequency ranges are not represented at lower sample rates and the sound will change. Listen to the file again after down-sampling and EQ to boost the sounds as necessary. Remember that the higher frequencies will not be available.

The next step is to convert from 16- to 8-bit resolution. Selecting this feature on your editor should give choices such as *truncate, round*, and *dither*. Try each choice and listen to the results. You should be most concerned with any introduction of quantization noise, which sounds similar to high-frequency static. In this example, you will notice it most where the music loses intensity and any ending fade-out. This is one of the reasons why we maximized the sound earlier either using normalization or volume increase; it masks this particular phenomenon. The noise you hear after the conversion depends on which setting you use, of course. My personal experience dictates I use either the *round* feature or *dither* with a value between 0.5 and 1.0 bits. Dithering adds what is known as *Gaussian noise*, which is designed to mask the more obtrusive quantization noise. Your opinion and the sound effect's application will determine which is best.

The final step is to save the file in the required format. If you happened to be using *aif* or anything else, simply save the file as a *wav*, give it one last listen, and you are done. For those who edit in this format anyway, there is nothing left to do but move on to the next task.

Now, imagine you have thousands of audio files to do this to. Have no fear, there is a better way. Batch converters, such as the ones found in Sound Forge and Audition, are a lifesaver for those who deal with large amounts of audio files on a regular basis. These little gems allow you to script the entire process, instructing the application what processing to execute and in what order—and to save in the desired format. All you have to do is load in the files, tell the application where and how to save them and run the script. But, if you insist, you can still do all of this manually and claim all of the glory for yourself.

9

Creating Sound Effects for Games

Sound effects are an integral part of any game—equal in importance to artwork, music, and gameplay. Good sound effects create an impact which rounds out the entire gaming experience, and without them, that experience would suffer. They are designed to completely absorb the player into a virtual world, making it believable, entertaining, and satisfying all at the same time. Continuous ambient sounds keep the player from being distracted by the "real" world, ensuring game silence doesn't ruin the immersive effect of a game. Foley sounds ensure believability. Action effects provide guttural satisfaction.

In this chapter, I won't pursue the psychological aspects of sound and its effect on the human psyche. For those who are serious about this particular aspect of audio, I do highly recommend pursuing the subject to complete your skill set and increase your design effectiveness. For now, we'll focus on the creation process for games: how particular sounds are chosen, how they are made, and how to make the process less grueling for both the development team and sound designer. I've asked fellow sound designers and game producers in the industry to share their experiences, their sound design creation and selection process, and how they came up with particular sounds. We'll also delve into how to create professional sound effects and prepare them to drop into a game.

The Creative Aspects of Sound Design

Anyone can do sound design, but not everyone can do it well. The difference between the average sound "hobbyist" and the professional sound designer is not

just that the professional gets paid. It is an intangible quality running through their veins which allows them to create audio magic out of thin air. If you are a musician, you already know what I mean. We share the same passion for excellence with the expert sound designer, having spent thousands of dollars on our "hobby" just for the sheer joy of making our own brand of genuine noise. Musicians, and anyone who has the desire, can put this same enthusiasm into making great sound effects for games.

Creativity, a microphone, the ability to listen to the world around you, and some way to edit sounds are the basics you need to jump into this occupation. To take it to the next level and beyond, you'll need:

- Remote recording gear
- Collection of sound effects libraries
- Computer
- Multitrack recording software
- High-end audio-editing program
- Experience

The best part about sound design for the gaming industry is that there are plenty of new developers out there who are willing to let you cut your teeth, gain the experience, and have the cash to propel you to that next level. There are many composers and sound designers today who started out with the bare-bones minimum and have amassed quite a collection of studio equipment from their gaming contributions. It may take a couple of years, but it is possible for those who are patient and smart.

Chapter 2 discussed the equipment and software recommended for this type of work. Refer to the section "Tools for Your Business" to refresh your memory. It's about time we uncover the mysteries of what it's all used for, and a quick review might help if this is new to you.

Types of Sound Design

In Hollywood, the art of making sound for picture is highly specialized and compartmentalized. There are experts who spend years sharpening their skills in this one particular area, a fairly constant profession. Careers as a sound recordist, Foley artist, sound editor, and sound designer can easily consume a lifetime of work. For games, the term *sound designer* encompasses all of these activities into one package. Are you ready to take all of them on? As a musician, you are already a composer, arranger, copyist, engineer, and producer. What're a few more titles to add, especially when they can earn you some extra income and sustain you through the dry music-less times? Interestingly enough, while I got into games to do music, I now earn about 75% of my income from sound design and field recording for games—so, if you don't think you're interested, you might not want to write it off just yet.

Foley

In film work, *Foley* is the art form which adds believable sound garnishment to on-screen character movements. Imagine a character running on wet pavement, slipping, then tumbling into some metal trash cans. Foley artists would perform

this sequence in a sound studio while viewing the dry footage, matching each movement precisely using various props and a team of artisans. Someone would jog in place on a wet, gravelly surface with similar footwear as the on-screen character. Someone else would create a slipping sound by quickly scraping a couple of shoes on a matching surface.

Over in another corner, someone would perform a "bodyfall" by throwing themselves or a weighted dummy on some appropriate facade, and it would all be wrapped up with yet another artist tossing a couple of metal garbage cans full of empty "trash" around in another area. After a couple rounds of practice and a sound check, it's recorded and sent out to be dubbed into the project. It's always entertaining to watch these guys at work—shuffling around, manipulating various objects, and tossing things around in concert. They seem to have a lot of fun themselves.

Doing Foley work for video games is slightly different. The advent of digital audio-editing software and synchronizing capabilities make "performances" such as the activity described previously less likely. I can't equivocally state it would never happen (and somebody would do it just to prove me wrong), but the chances of it happening are slight. Doing this kind of sound work for an animation file would utilize the same concept, but with a different delivery method.

If you were to add sound to the same scene from the previous example, most game sound designers would record the sounds separately or grab them from their sound libraries, then sync them to the actions. With every instance of the character's foot hitting the ground, they would lay an appropriate sound at the same spot—repeating the sequence until the slip. A slipping sound is added, followed by a body falling into the garbage cans, to complete the scene. In the simplest form, you would only need three sound effects to make it believable: a footfall, a slide, and a spill sound.

To soup it up a bit, you could use several footfall variations (because each step in real life never really sounds the same), some hard breathing (because the character is supposed to be running), a sliding sound, a gasp (because the character is surprised), a bodyfall, a mixture of several clanking and spilling sounds which dissipate slowly as objects come to rest and the trash can lid stops spinning, and punctuate it all with an annoyed cat screech. It seems like a lot of work for this short scene, and most of the time someone watching it will only hear the sounds subconsciously. But if the sounds were inappropriate, out of sync, or missing altogether, they would stick out like a sore thumb.

There are plenty of sound effects libraries with many different versions of the sounds you'd need for example. You'll eventually have a good supply of them to reach for, but in order to keep the sounds you produce fresh and original, you'll do your own version of Foley. This won't be as complicated as how it's done on the Hollywood scene. There won't be any pressure of performing an entire scene on the fly. Instead, you'll produce individual sounds to edit and sync later.

Continuing with the same example, let's say we have chosen to create the sounds ourselves. You can create off-site using remote recording gear such as a portable field recorder and a quality microphone or bring the props into your studio to create in a noise-controlled environment. In Chapter 10, we'll discuss field recording for games in greater detail, but for now, let's take a look at some general remote recording goals referencing our sound design example first.

Remote recording not only requires the right equipment for the job, but conditions such as weather and background noise can be a factor.

Remote Recording

Noise is always a factor, whether you are recording inside the studio or out in the field. Always be conscious of it and whether it has the potential to destroy your recordings. Loud, obtrusive, off-subject sounds will ruin your efforts every time. Recording between landing jets overhead and cars whizzing by on the street is a must in the worst-case scenarios. The only things you can control when doing remote work are when and where it takes place. Either find some place which has negligible background noise or pick a time, such as at night, when the chance of quiet is improved.

For times when you absolutely can't prevent extraneous noises, there are still ways to repair or salvage a good take. Background ambience is made up of two types of sounds: continuous and random. In the office building I'm sitting in at the moment, I can hear a ventilation fan (continuous), the hum of my hard drive (continuous), footsteps (random), distant voices (random), a door opening and closing (random), and fingers typing on a keyboard (random, although it's beginning to feel like it's continuous). Recording sounds within this atmosphere, I would have a fairly good chance at success—timing my efforts between the random sounds and blocking them out when I could. The only sounds which pose a serious problem are the continuous noises, but they too can be dealt with appropriately.

Noise reduction software and plug-ins these days are fairly good at neutralizing continuous background noise. It is highly recommended at some point you beef up your arsenal with this type of application. While you can get away with creative use of equalization, it has a way of negatively affecting your sound while eliminating all noise in the respective frequency ranges. If you tried to remove a noise (say, in the upper frequency range, like tape hiss), as you pull down the EQ faders you lose all other sounds in that range. You get rid of the hiss, but it also makes your sound dull. Noise reduction software analyzes the continuous sounds and eradicates them using complex algorithms. To take advantage of this, be sure to record a few seconds of the atmosphere you are recording in—all of the background sounds from the mic position where you plan to do your Foley

work. The software requires this to examine the sound you wish to remove and then applies what it learned to the rest of the sound file. Of course, the best way is to make sure you get a clean recording.

Another way to rid yourself of the evil background noise is to edit around the sounds you are recording. If I were recording footfalls, I would have the choice of making a sound file for each footstep or one of the entire running sequence. Doing it singularly, you would copy the single footfalls to their own individual files—ensuring there is no blank space on the front or back end of the sound wave. There may be some background noise in the actual sound, but because it happens so fast, it would barely be noticeable except to the expert ear. EQ adjustments would suffice if needed. Doing it with the entire sequence, you would mute all space between each footfall, manually or by using a noise gate, yielding a clean sequence which could be edited in later. Other layers of sound you add to the soundscape would mask the unnatural sound of a footstep, then silence, then footstep, then silence. Or, you could add a touch of reverb (after you've cleaned up the file) to simulate the environment the character is running in. Either way, experiment to see which works best for you and the sequence you are working on.

> A good rule of thumb when recording sounds in the field: Record at the level you plan to play them back in the game.

If you are creating footfalls from the player's perspective, they will be louder than if a bystander were watching them run by. Street ambience shouldn't be loud in-your-face sounds unless your character is a mouse scurrying along a gutter. You want to ensure the sound you are capturing is based on the perspective used within the game. You can adjust volume levels to suit, but your quality and realism won't quite be the same. If you record garbage cans tumbling from 50 feet away, increasing the volume to make it sound like your character is falling into them will also increase the background noise as well. You'll end up with a very noisy effect that sounds amateurish. Always consider the context of the sound before hitting that Record button.

In-Studio Recording

Most of the considerations discussed for remote recording apply to your in-studio Foley work as well. While the environment may be a bit more controlled and the potential of unwanted noise less, there are still some things to watch out for. Listen closely to the room or studio where you plan to record. Computer fan noise, fluorescent lighting hum, dogs barking, street noises, and so on can have the same effect as your on-location recordings unless you have a soundproof room. Using the same techniques for recording and editing will prove successful as well as the potential for higher quality because of your enclosed location.

The best place to record would be in a soundproof studio or perhaps a soundproof booth, that is, if you like those telephone-booth-looking things in your creative space. Imaginative uses of modular sound-absorbing dividers and gobos can help. Even creating a tent made of blankets will work miracles. Close your doors, close the windows, push towels into the cracks, tack blankets up on the walls, and you've got a pretty good spot to do your Foley work. A walk-in closet is also a fantastic spot. Stay flexible and creative and be ready to do what it takes. After all, these sounds will have your name on them.

One of the perils of recording in-studio is the mess and destruction of valuable studio components while caught up in the performance. For those who are

Always pay close attention to background noises when outside. Weather, aircraft, traffic, wildlife, and bystanders can sometimes ruin a great take which are often not noticed until you are back in the studio. Watson Wu is seen here recording the skateboarding moves of Charlie Canham.

resourceful enough to have their own separate control rooms apart from their main recording room, the dust and debris might not be too difficult to clean up after a session. Trying it within your control room may prove an expensive endeavor if some flying object manages to smash into your new monitors. Keep mindful of the sounds you are creating and the consequences of the performance. If you plan to smash cement blocks with a sledgehammer for a cool sound, consider dragging a microphone outside via a long cord instead. You laugh, but I'm telling you, it's going to happen and you're going to live with the inevitable "I told you so!"

Doing Foley sounds in your studio is really no worse than allowing an entire band of musicians and groupies trash your sanctuary. Even though I know the consequences, I still stand back after each session to survey the damage and shake my head. When I'm in creation mode, I work furiously, maneuvering all sorts of debris and carnage around—focused intently on that one little sound effect I'm giving birth to. When it's complete, I'm routinely surprised at my now cluttered surroundings—left wondering how all this garbage got there. Next time, I promise myself I'll take it outside.

The Acquired Skills of Listening and Manipulating

Developing a good ear for the sound design business takes some time. We are relied on by the game makers to conceive the perfect sounds to establish the atmosphere and believability of the virtual world they are presenting. We gaze at

Recording sounds under controlled conditions is preferred, but the mess can sometimes be extensive. Robert Burns is in-studio, enthusiastically creating sounds for one of HighMoon Studios' recent games.

dry pictures and animations, letting our aural imagination take control—hopefully we can translate what we hear in our heads into great sound effects.

Turn on your TV and mute the volume. What do you hear in your head when you watch the picture without sound? An experienced sound designer will have a multitude of sounds firing off, adding their own brand of personality to the picture. This is the first step in doing sound design. If you are staring at the screen and hear nothing in your head, try this instead: pretend a new client just gave you this cinematic to put sound to and your career depends on hitting the nail on the head. Do you hear anything now?

As another exercise, turn on a movie or something with a lot of action in it. Don't look at the screen. Instead, listen to what is happening aurally in the scene. Listen to each sound, how it is placed in the soundscape, what effect it has on your perception of what is going on. Pick a few and figure out how they were made. Which ones are Foley sounds? Which ones are actual recordings of the action? Which ones are manufactured from other sounds? Sometimes, it's difficult to tell.

It is surprising to learn that what you thought were actual sounds are something else altogether, used in a context which makes you believe they are the real sound. Take gunshots, for instance. In the real world, most small-caliber firearms are a rather boring "pop." Hollywood sound designers—always looking for something bigger than life—add small explosions notched up in pitch, the crack of a whip, a snare drum, or any sharp sound that makes a big impact on the audience when the weapon is fired on-screen. Is what you hear the actual sound of a gun firing? Probably not, but your perception makes you believe you are hearing one—so much so that if you ever hear a gunshot for real, you won't be impressed. It will assist you in this line of work if you leave behind the preconceptions built over a lifetime and move from the audience's to the artist's perspective.

Listen to the world around you. Every sound you hear is a reality-based phenomenon corresponding to an action. Many of these sounds, in a different context, could work for something else. If you were shown an animation sequence of a raging storm, how would you create thunder? You could wait for a storm to blow by and record it, hoping to get some usable thunder, you could reach for a sound library or you could grab a sheet of metal (such as aluminum or copper) and shake it. Foley artists have been doing this for years, and you know why? Because it works!

What if you needed a crackling fire? Are you going to light a fire in your studio? I'm not sure I'd subject a microphone to the heat. Instead, try slowly crushing some dry paper and plastic wrap. By itself, it might sound like paper being crushed, but presented along with a picture of a campfire, it will work great. That same sound could even be used as radio static. Need a hatching egg sound? You could buy a dozen eggs to crush or slowly peel some Velcro apart. That same Velcro sound done right could pass as radio static, too. See what I'm getting at? You can creatively use commonplace objects to produce some believable Foley sounds without all the mess or anguish of destroying perfectly good (and expensive) objects.

Sound Libraries

A close relative to the art of Foley is sound libraries. These initially started in Hollywood years ago as a way to save some time on the Foley stage by recording a vast array of everyday sounds which are then licensed to the user. Instead of running off to have footsteps and background sounds created, a sound editor could just grab one of these libraries and have them instantly. Car door slams to cracks of baseball bats to a crying baby to explosions are all within your reach. They were pretty good then and have only gotten better in quality and quantity over time.

Now, crisp, clean digital recordings are available from several different sources as all-inclusive CD, DVD, and hard drive libraries. Not only can you find everyday sounds, but some sound designers have even licensed their original creations. Larger-than-life and make-believe sounds are also available to us mere mortals for licensed use. Entire game projects have been done using nothing but library sounds, and while I don't recommend using them exclusively, they can save the day for those last-minute changes the night before going gold.

To most sound designers, sound libraries are a good stepping-off point. Everyone I've ever run across uses them, but few use them as is. The one major problem with licensed sound libraries is that anyone can have them and some sounds have a tendency to be overused. Originality is important, and when one of those overused sounds breaks the immersive effect of the game, it becomes obvious. The way around this is to creatively manipulate or use small pieces of the original sound to make something new and fresh.

At the very least, a sound designer will take a stock library effect and change its pitch either up or down. It still has the same basic presentation except the tone has changed, and while it may be recognizable, it won't be the same old tired sound. Other basic tricks would be to apply some severe EQ, either by dramatically sharpening or dulling the sound, or utilizing effects processing (like reverb or flange) to give it new character. Combining stock library sound is also another great way to create something new. For example, a bullet ricochet layered with an

explosion gives you an entirely fresh explosion. Manipulation and creative layering of sounds will breathe some new life into those stock samples.

Using sound libraries for long, background ambience, such as a city street scene behind a skateboarding game, can also benefit from some subtle manipulation. Changing the pitch up or down a couple of notches can provide enough of a change to get away with using the same sound within the same game. You could also cut the scene into several pieces and rearrange the order to keep people guessing.

Sound designers use sound libraries as one of the many tools in their arsenal to piece together good sound effects. By taking bits and pieces of an existing library sound, they can produce the exact sound effect they were after. This saves valuable time by relieving them of starting from scratch or having to run out with a microphone just to grab a simple engine noise.

In a space game I had worked on, the design team discussed ways of making use of some new gizmos easier for the player to recognize by having them sound like what they were. If it's a power pack, have it sound like one. If it's a type of communications gear, have it sound like one. But because none of us live in space and have never heard these things (and partly because they don't really exist), we decided to base them on earth-bound objects so that you recognize them immediately. For instance, one of the vehicles has a massive power plant, and one of the options for its sound is to have a mixture of a revving Indy race car and a jet turbine. I couldn't easily record either of those objects at the time, so I turned to a sound library instead. The power pack and shield will have elements of "electrical" sounds in them. The communications gear will have some static and transmission sounds, as well as a few computer bleeps. I'll get most of these sounds from an effects library, and edit and layer them to make my new sounds.

Original Development

Our third and final stop in the trilogy of sound design methodology is original development. Game sound designers masterfully use all three techniques to achieve their magic—grabbing a mic and recording a sound, picking up a sound effects library, or pulling one out of thin air. By using combinations of tone generators, software, synthesizers, and everyday objects in unusual ways, inventive sound effects emerge at the hands of a true artist. The beauty of this approach is there are no rules and no limits except one: the sound effect must enhance the corresponding action by providing the player with suitable aural feedback.

Sound designers have their own style, whether it's "over the top," "bigger than life," "cartoony," or "believable." It is dependent on their way of thinking and creating, their mindset, their personality, and what motivates them. Secondary factors that also help create a "sound" are sound effects libraries, equipment, recording methods, software, and even the microphones they use.

As mentioned, original creation can come from practically anywhere. Look around you. Everything makes a noise if you drop it, hit it, scrape it, or move it around. Pick up objects and smack them with something. Fill them with water and hit them again. Dig through your drawers, the dumpster behind the mall, the junk yard; there are plenty of sounds to be had. While you are on the hunt for individuality, don't be unique for unique's sake. Listen to how these sounds can be used for your purposes when brought back to the studio.

PASI PITKANEN
Sound designer, Field recordist, Composer

I am more than just a man from Finland with video game and movie addictions. I am also a TIGA award-winning sound designer and composer with versatility and passion. Oh, and I also create sound effect libraries in my free time.

I started to explore the world of video games and movies at an early age. I spent most of my free time playing Commodore 64, Amiga, and PC games, and watching movies on VHS. It was through these activities that I would discover the wonders of audio.

Through self-education, studies, and projects, I have acquired extensive knowledge about the recording, manipulating and processing of both live and sampled instruments/sound sources. I have two Bachelor degrees in the field of audio: Digital Sound and Commercial Music from Tampere University of Applied Sciences and Creative Sound Production from University of Abertay Dundee.

Today, I work as a Sound Designer at Rovio Entertainment Ltd. I also comanage a website called The Audio Spotlight, which highlights various audio professionals around the world, provides behind the scenes footage from the game and film industry, and keeps you up to date with the latest sample libraries and job opportunities.

Selected Gameography:

Angry Birds Stella POP
Angry Birds Transformers
Angry Birds Rio & Rio 2
Angry Birds Space
Angry Birds Seasons
Angry Birds Friends

www.pasipitkanen.fi
http://twitter.com/pasipitkanen

Describe your process for creating sound effects for games.

First, I always try to get as much material as I can from the development team and go through it thoroughly. Game design documents, early concept art, rough animations and even playable builds really help me to get inside a project and start the audio design process.

Next, I start writing the audio design document, create the first version of the audio asset list and have meetings with the development team. I like to prioritize/tag my sounds into low, medium, and high categories. Audio assets that have the high-priority tag are the most important sounds in the project. For me, these are sounds that are connected to main gameplay elements and sounds that the player would hear often in the game. Audio assets that have the low-priority tag are mostly sounds that support the main gameplay and at the same time maintain the atmosphere/mood of the game. This kind of prioritizing method helps me to plan my recording schedule for the sounds, and it also enables the developer team to see what I am doing and when.

When everything is planned and scheduled properly, I continue writing the audio design document and eventually start recording raw material for the project. I always record extra takes for each sound event in the project so that I can easily create variations of the sound if needed.

When I am done with the recordings I start my editing process by making copies of all the recordings and backing them up to a hard drive/secure server. It is always a good thing to work with a copy of the audio file instead of the original, so you won't accidentally lose it. My usual workflow for editing is the following. I open up one of the recordings, separate the useable audio content, delete the unnecessary content, and then organize the sounds within the Cubase session. I like to keep things very organized, so I make use of the folder function and group similar files under the same folder.

Then, I start the design process where I usually layer multiple sound sources together and manipulate the sounds by running them through various plug-ins and VSTs. I tend to follow the KIS rule (Keep It Simple), and so far it has worked like a charm. If I have time, I always try to utilize as much of my own recordings as possible, but sometimes you just have to bring in sound sources from commercial libraries.

I tend to mix my sounds while I am designing them, so in a sense, I don't have a separate mixing phase in my workflow. This kind of way of working works for me at least.

Are there any particular secrets to your creativity?

No secrets here. I do, however, feed my creativity from various sources. I play games, listen to music, and watch movies a lot, so I am always observing the sound and keep finding new interesting things that I want to try out myself. For example, I knew I had to get a pair of contact microphones after I watched *Gravity* in the movie theater (twice!). I was so inspired by the sound design of the movie, so I wanted to explore the world of sound through a contact microphone.

Are there any secret techniques that you regularly employ?

This is not a secret technique, but I use the pads on my Korg NanoPAD 2 and Novation Impulse keyboard to trigger various processes and effects inside Cubase. Currently, I have gain, pitch shift, reverse, normalization, and bounce processes configured to the pads. By having at least these under my fingertips, I can edit, manipulate, and design sound effects more efficiently.

Do you have any interesting sound gathering/sound creation stories?

After I had received my C-series contact microphone from JrF, I wanted to test it out quickly and hear what it could do. I started to record my metal drying rack and attached the microphone to the body. I did some quick hits and impacts with it which sounded great. Then, I got the crazy idea to try out my portable hair clipper on the drying rack. I turned on the hair clipper and managed to record some superb sounding metallic drones. One thing that I did not anticipate was that the battery on the hair clipper was dying out, so I was lucky to capture this deep metallic sweeping drone sound when it eventually died out.

Do you have any advice which can help lay solid groundwork and ensure a successful production for the audio content creator?

Always try to be part of a project from day 1. Opening the communication channel between you and the developer as early as possible is really important. When you are there from day 1, you can really influence the audio design of the project and get a lot of precious info that will help you to create high-quality audio content.

Plan and schedule your time. When you know what you are going to do each day and you stick to it, then you won't run into any problems with the deadlines. I have had multiple projects at the same time, and I could not have completed all of those without scheduling my time for each project. It takes some time from the start, but it's totally worth it in the end.

When do you find you are most creative?

I tend to be most active and creative just after lunch or in the evening. Also when I have cool and fun projects to work on, I'm constantly motivated and feel the inspiration. I guess I could reveal my secret recipe for creativity: Rooibos tea and 80% dark chocolate.

Any worthwhile creative advice you'd like to share?

The Spectral Frequency Display in Adobe Audition CS6 is really good for cleaning excess noise, clicks, and pops from your recordings. Basically, it works like Photoshop, so you can "paint" specific areas/frequencies in the audio file and then delete them or even apply various effects to them. It is also a very powerful and easy to use design tool. Give it a go!

Is there a typical workday for you?

I usually work from 9 to 5, but during crunch times, I will stay at work a bit longer. My typical workday consists of planning, recording, manipulating, and designing audio content for games that are currently in production. When I am not doing that, I am usually updating audio-related documents, having meetings, self-studying audio-related things, and testing new audio content on various devices.

How do you approach negotiations with a new client?

First, I usually try to get an idea of the client's budget. When I know the budget, I can easily adjust and customize my rates for music and sound effects. It is so much easier to work around their budget and choose my approach on how to charge the client (bulk or per audio asset). Sometimes, I offer the bulk deal, and sometimes, I charge per audio asset. If their budget is low and does not meet my current minimum rates, then I have to decide if the project is special enough to justify these measures.

Do you have any negotiation tips which work well for you?

Usually, the client asks how much I charge for music and sound effects, so I always have my current rates ready in the back of my mind. I don't reveal my rates to the client at this point,

but instead I ask the client for their audio budget and then adjust my rates if needed. Oh, one more tip… be confident, know your value, and do not undersell yourself!

1. Always create a written and signed contract with your client even if the client is your friend. This way you will always have something to fall back on when unexpected events happen.
2. Limit the amount of free revisions that the client can ask for the audio content. If they go past that amount, then you can set a separate fee for the following revisions. I always include this in my contracts because it protects me from the revision chaos that might happen in a project.
3. Include bonus milestones to the contract. You never know when a game will go viral and when it does you wish you had included bonus milestones to the contract. These milestones can be as simple as getting a small chunk of money when the game reaches a certain download figure or a specified amount of net sales.

Do you have any tips when working with developers?

The most important thing is to have a good, active, and open-communication channel with the developer. This channel will help you to stay up to date with the project, exchange ideas, get feedback, and quickly fix problems together when they emerge.

The second thing is to be ready to kill your darlings. Sometimes, the developer won't like a piece of music or a specific sound effect, even though you think it is the best thing you have ever done and fits the game perfectly. Instead of arguing about it, you should get constructive feedback and make the next version even better! Your job is to deliver high-quality audio content to the project and make your client happy.

Staying organized is important, especially if you are working on multiple projects, which is part of your daily routine. How do you keep up with it?

The most important tool that I utilize at work is an online Kanban board. My Kanban board consists of three columns: "to-do," "in progress," and "done." When I have a new project-related task that I need to do, I create it and add it to the "to-do" column on the board. When I start working on that task, I move it to the "in progress" column, and when I have completed the task, I move it to the "done" column. A notification e-mail system keeps the producer of the project up to date whenever I make changes to the task or move it between the columns. Another useful feature of the Kanban board is that people can assign audio-related bugs to me and they show up on my "to-do" column instantly. Needless to say the Kanban board is a really useful tool for me since I can easily create my own project-related tasks, keep the producers up to date, and see all the audio-related bugs in one place. I can't live without it anymore!

Another huge part of my "staying organized routine" is to always create an audio design document and audio asset list with prioritization tags for a new project. These documents help me to stay on track with each of the projects so that I know what has been done and what is next on the pipeline. There is also a small routine that I do each week at work. Monday is a project maintenance day and not a day for content creation. This basically means that on Monday's I go through all the projects that I have on my plate and check that everything audio related is on track with the project schedule. I also update all the project-relevant documents if needed.

Any specific "lessons learned" on a project which you could share?

Always make daily backups of the work you have done. I had a project that was almost finished, but then my hard drive started to act weirdly and finally died. Luckily I had taken weekly backups, so majority of my work was still there. I did lose 1 week worth of work which was unfortunate, but the developer was really nice and gave me some extra time to finish my sounds. That day, I learned to make daily backups and store them in at least two separate places. Technology will always fail at some point, so it does not hurt to be prepared for that!

How did you find your way into the games industry?

At some point, I realized that I wanted to greatly improve my skills in mixing and mastering, so I applied to "Digital Sound and Commercial Music" degree program in Tampere University of Applied Sciences, Finland. During the first 2 years there, I gained a lot of new skills, knowhow, and experience with recording, manipulating, mixing, and mastering various audio content for films, games, and advertisement. The first 2 years also helped me to get the spark for sound design, gain confidence, and finally apply to study game audio abroad.

For the third year, I spent the whole year studying "Creative Sound Production" at University of Abertay Dundee, Scotland. I had always wanted to live in Scotland, and this was basically my last chance to do it "half free." I did not know that Dundee was one of the active hubs of the UK's game industry, but after first 2 weeks at the University, I realized this and knew that I had made the right choice. The courses I took in "Creative Sound Production" greatly improved my craftsmanship in the field of sound design, game audio, and also gave me valuable knowledge of the game development process itself.

While I was finishing my studies in Scotland, my friends and I applied and got in to a video games development competition called "Dare to be Digital." During the competition, we had mentors coming in weekly and give us feedback on our game "Gravtech." These mentors came from big companies like Ubisoft, Codemasters, etc. This competition was a once in a lifetime experience, and I am really glad that I had the chance to take part in it. We were also very happy when Gravtech won the "Best Student Game" TIGA Award in 2012.

It was during Dare to be Digital when I applied to the Sound Designer spot at Rovio Entertainment Ltd. I was really surprised and ecstatic when I got the job, so after the competition I moved back to Finland and started working at Rovio.

Any other advice you'd like to share?

Practice your craft every day in one form or another! Just keep pushing yourself out of your comfort zone because that is where you learn new and exciting things.

DO:

Do remember to keep your recorder with you at all times.
Do everything you can to evangelize the importance of audio in games.

DON'T:

Don't promise something that you can't deliver 100%.
Don't ever stop learning your craft.

Another appealing source for sound is a synthesizer or sampler. Manipulating a preset sound using LFOs, filters, modulation, varied attack, sustain, decay, and so on can create some interesting effects. It can be done manually or through a sequencing program which allows management of these parameters. Sequencers are great for tweaking your performance prior to recording the final version, especially when multiple sounds are triggered. Some audio-editing programs also come with built-in synthesis to create simple tones, FM, and DTMF (dual-tone multifunction, the sounds you hear when you push numbers on a touch-tone phone). These tones are particularly useful when doing games with cartoon or computer-type sounds. By manipulating them with linear pitch shifting, they make some neat beep-like effects. Experiment and see what you can come up with. Try a flange, reverb, and chorus. Try distortion, amplitude modulation, and EQ. Try a vocoder, Doppler, or reverse. Try every on-board effects processor you have and listen to what they can do. Understand what each one does and you will be able to skillfully apply them to other complex sounds.

Original development is definitely a state of mind. As you become immersed in the virtual game world, it will be easier to create within this atmosphere. By placing yourself in the game, you can better imagine what something will sound like than by standing outside, looking in.

Editing Methods

In Chapter 2, I listed some audio-editing and multitrack software programs you could use when doing sound for games. I also discussed editing techniques for music creation in Chapter 8. I recommend having a good audio-editing program like Sound Forge, Audition at the very minimum. Multitrack software like Sonar, Nuendo, Pro Tools, Logic, and Vegas are also fantastic tools you should consider as your resources allow. These tools are key to what sound designers do and are indispensable in their everyday creative activities.

I've learned a lot from other composers and sound designers over the years by watching them in action. I've walked away from every session with another trick in my bag, usually scratching my head at how obvious it was. The tools sound designers use and the way they use them are pure magic, except the magicians in the games industry are eager to share their secrets. This particular section will communicate techniques and tricks I, and others, use in professional game sound design as if you were standing behind us watching it all happen. The intent is to start you with a strong, solid foundation, then let you loose on the gaming world.

Most audio-editing and multitrack programs are capable of performing the same types of edits and processing. I won't get into the specifics of the dozens of programs out there, but I can present generalities and features common to them all. Let's take a look at the three most common types of programs and their use in the sound design process.

Using Audio-Editing Software

The cornerstone of game sound design is audio-editing software. As you'll recall from Chapter 8, these versatile programs can record, edit, and convert sound files in a multitude of ways. The best way to explain how they are used is to put you into the action, creating a couple of sounds. We'll try something easy and move into a complex sequence.

Audacity is an excellent audio editor—and best of all, it's free!

A Simple Sound Design Example

A developer has asked you for a sound of a kitchen pot clank for a children's game to be delivered in 22 kHz, 8-bit resolution, mono, *.wav* format. Grab a pot, something to smack it with, a microphone, and some method to record it. For this example, let's assume you'll be recording directly to your computer—saving us the step of importing from a portable rig.

The first order of business is to open a new file in your editor and determine the parameters of the recording. Always start with a high sample rate and resolution; in this case, it will be 44.1 kHz and 16-bit resolution. Unless you're using a stereo microphone, we'll record this in mono for simplicity's sake. If for some reason you need this sound in stereo later, it is an easy step to open a new stereo file, paste the mono sound to both sides, and apply a pseudo-stereo effect to it.

Now, set your recording levels as high as possible without clipping—and press Record. Bang on the pot in different spots at various strengths to provide plenty of takes. Your ear may perceive things differently than the microphone, a take which you thought sounded bad might actually be the one you go with. Each take should be about 1 second apart, being careful to let the ring completely fade each time. After six to eight of these, stop recording.

A waveform will appear on your screen. It will have blank space and the obvious waveforms of each clank. Most sound editors have an automatic backup of the file stored in case your computer crashes, but to be on the safe side, store this file and name it something like *pot_clank_roughs_01.wav*. Before doing any editing, listen to the entire file and choose the best take. As you are listening, it may be helpful to place file markers near the ones with potential—saving yourself having to relisten to the entire file over and just concentrating on your favorites.

Once you've found the one you want to go with, highlight the take (leaving a second or so of blank space on each end if possible), and then drag it to the

The tail of this sound effect is below the zero baseline and could cause unwanted noise in the file.

program's desktop or copy it. The programs that allow files to be dragged will automatically open a new file set to the parameters previously specified, ensuring it is set at the same sample rate and resolution as your rough file. For those without that capability, open a new file manually and paste the clank sound into it. Save this new file as *pot_clank_01.wav*.

You're probably wondering about that dead air on the front and back of the file. Give it a listen. Do you hear any background noise? If it is prevalent and noticeable on the level meters, highlight the space and let your noise reduction plug-in analyze it then process the rest of the file with this setting. If you don't have this feature, it will still be fine. The pot clank sound is much louder than the background noise anyway and won't be noticeable with such a quick sound. Trim off the dead space from both ends, being careful not to cut any of the sound waves. Use the Zoom feature to see exactly where the sound begins and ends. This process will ensure the file is as small as possible and that the sound will play immediately after it is triggered, instead of playing any silence first. Save the file. This will be the basic file you'll be working from.

By visually inspecting the file, you should be able to tell a couple of things. (If you've read the section "Visual File Inspection" for game music in Chapter 8, the following outline will be a bit of déjà vu. Move on to the next section, "Making Your Effect Unique.")

Is the Sound Centered on the Zero Baseline?

The line that runs through the middle of your sample is known as the zero baseline. Occasionally, when there are electrical mismatches between your soundcard and microphone, it can cause the entire sample to be centered somewhere above or below it. This can cause some unwanted audible artifacts you'll need to get rid of. The DC Offset function, or a similarly named feature, will analyze the file

This sound effect looks good. It has all of the properties of a "healthy" file.

and recenter it to zero—keeping the file as clean as possible. Because we recorded this ourselves through a microphone, interface, and computer hardware, there is always a slight chance of that electrical mismatch happening.

Does the Wave File Look "Healthy"?
Does it fill much of the screen or is it a bunch of puny little lines barely perceptible until you zoom in? It is important that the actual sound is louder than any noise floor in the recording and louder than the noise on any playback system. If the volume is at least medium intensity or thereabouts, you can beef it up by either increasing the overall volume manually or using a normalization function. Normalization will scan the file and increase its overall gain, set by you, without clipping. This will maximize the volume proportionally, leaving a strong, solid sound. If you use normalization, be mindful of what it can do to the overall dynamics of the sound. Use it sparingly or stick to the volume increase function if it becomes a factor.

Does the Sound Look Too Intense?
Has the waveform saturated the screen completely? If the sound file shows a solid wall from the zero baseline to infinity, with the edges of the sound cut off, chances are this file will be distorted and totally lack any dynamics. Depending on the effect you are trying for, this may be alright, but the majority of the time, you'll need to give something else a try. First, attempt to reduce the overall volume or apply a moderate amount of compression. If the peaks are severed, peak restoration plug-ins are available to repair this type of damage. Listen to the results and decide if it sounds any better or if you just simply reduced the volume and applied "band-aids" to a distorted sound. In that case, rerecording the sound will be your only option—just be sure to do it at a level a few notches below the previous attempt.

This is the previous "healthy" sound file example turned up a few notches too many. The meter to the right doesn't begin to describe the pain this sound effect is feeling.

Are There Any Points in the File Where Volume Peaks Cause Clipping?

Nothing sounds worse than a digital file passing 0 dB (decibels) on a level meter. These prominent peaks cause unwanted clicking and distorted screeches in sound files and need to be dealt with. One option is to reduce the overall volume of the file enough to bring any peaks below the point of clipping. Another is to apply a slight amount of compression, such as a 2:1 ratio—which in effect, will squash the peaks and raise the quieter levels proportionally. My personal favorite is to use a peak limiter set to –0.01 dB, which allows for the highest possible levels without reaching 0 dB. Depending on the playback system, you may have to adjust the peak limiter to a lower setting to compensate for poor speakers. Keep an eye on the peak levels, especially after adding EQ or other processing and be prepared to repeat this step if necessary.

Making Your Effect Unique

Because the file will be down-sampled and left as a mono signal, we don't need to spend any time creating a stereo or surround effect. We can apply effects processing such as reverb, chorus, flange, pitch shift, and so on in mono with good results to add a bit of "seasoning." The clank is a short sound, so a chorus or flange will make it "meatier." The reverb will sustain the ring portion of the sound and give it some air. Equalization can alter certain frequency ranges, adjustable to your taste and the playback device. Depending on the type of microphone (and proximity), it will have its own coloration. Different mics are better at capturing certain frequencies than others. Use your ears and make adjustments accordingly. Save the file.

For example, I would use a slight touch of reverb, using a bright, small room setting. You'll notice the end of the sound does not decay naturally and is cut off

These peaks are caused by high levels and can be tamed by simply decreasing the volume, adding compression, or applying a peak limiter.

before it fades. We can fix this. Highlighting the tail and using a linear fade-out will force the sound to gradually disappear before the end of the file. For our short sound, this will suffice because we never intended for it to echo for very long. But, if for some reason you wanted the sound to appear with a normal-sounding fade, add 0.5–1.0 seconds of silence to the end of the file, add your reverb, and then delete any remaining dead space after the fade. This will allow more room for the effect to decay naturally, making it more realistic.

After processing the file, you should save it as its own file—keeping the original file untouched in case you decide later you didn't need the adjustments. With some types of editors, you will be unable to undo additions selectively, the last edit is layered over the previous changes. In order to undo something you did three edits back, it would be necessary to undo the last two as well. Saving your file in various stages will give you something to go back to in case an idea changes or an effect doesn't work out as planned. Be sure to label them accordingly or use the summary or notes to describe the sound. Staying organized is essential when dealing with a large number of files. There are some more advanced audio editors which allow for selective undos, even after the file has been saved, so there are ways around having to save different files at every adjustment. If this is important to you, expect to spend a little extra money on a high-powered program, or we'll talk about creating sound effects in a multitrack environment in the next section, which will definitely solve this issue.

The sound effect is almost complete. The developer requested the file format of 22 kHz, 8-bit, mono, and because we built the file as 44 kHz, 16-bit, we'll need to do a couple more things. Using the final version of the file, resample it to 22 kHz using your editor's resample function. Ensure the anti-alias filter setting is used to prevent any of the lost high frequencies from becoming low-frequency distortion. This will keep the sound file as pure as possible. Keep in

mind the higher-frequency ranges are not represented at lower sample rates and the sound will change. I once recorded brass shell casings landing on cement for a game project. The best part of the sound was the ring they produced, which became totally lost when I down-sampled to 11 kHz. They ended up sounding like dropped pebbles and were barely usable. Listen to the file again after down-sampling and EQ to boost the sounds as necessary. Remember that the higher frequencies will not be available.

The next step is to convert from 16-bit to 8-bit resolution. Selecting this feature on your editor should give choices such as Truncate, Round, and Dither, as you'll recall from Chapter 8. I could go on all day about which one is best for each situation, but I will defer to experimentation instead. Try each choice and listen to the results. You are mainly concerned with the introduction of quantization noise, which sounds roughly like high-frequency static. In this example, you will notice it most where the sound loses intensity and fades out. This is one of the reasons why we maximized the sound earlier either using normalization or volume increase; it masks this particular phenomenon. The noise you hear after the conversion depends on which setting you use, of course. My personal experience dictates I use either the Round or Dither feature with a value between 0.5 and 1.0 bits. Dithering adds Gaussian noise, which is designed to mask the more obtrusive quantization noise.

The final step for this simple sound effect is to save it in the required format. I normally work in the *.wav* format, and in this case, no further action is necessary. If the client wanted an *.au* format, this particular popular Java format creates its own change to the sound and additional EQ may be necessary to compensate for the loss of high frequencies. But, if you were using *.aif* or anything else, save the file as a *.wav*, give it one last listen, and get ready for the next sound effect.

A Complex Sound Design Example

Building a sound effect using an audio editor is normally a simple affair. It gets wildly more complicated when you have to string together or layer other effects in order to compose an involved sound effect such as a full audio sequence for a cinematic or animation. In our next example, the developer has requested a realistic multipart sound effect of a low-flying aircraft getting shot down by an angry shotgun-toting farmer. The file is to be no more than 6 seconds in length, delivered as a 44 kHz, 16-bit, stereo *.wav* file. Let's put this together using just our two-channel audio editor of choice.

This sequence will be made up from several layered sounds to form the final version. The first step is to gather all of the individual sound files and manipulate them accordingly. Using our first example as a guide, record and save the following stereo sound effects.

- Airplane flyby
- Single gunshot
- Short explosion
- Small crash with metal fallout

Develop an idea in your mind of the "scene" you plan to create and where the listener will be during this. The farmer's perspective seems like the logical choice, so we'll start from there. I picture him miffed, watching his cows being pestered by the low-flying aircraft and rushing out to the field with his shotgun. The

aircraft enters from the far left, the farmer takes a potshot at it when it gets to the center, and as it moves to the right side, it explodes and crashes in a burning heap.

Luckily for us, the developer wants this in stereo—so we'll get to show our stuff. Unlike our previous mono example, the manipulations and processing will have an effect on the stereo spectrum. Depending on what sound file you acquired, the aircraft flyby could pose the greatest challenge. Using the panning feature, adjust the effect so the aircraft sound begins in the left channel, moves to the center at about 2.5–3.0 seconds, and ends on the right. The explosion effect will happen to our right. Using the panning feature again, adjust the explosion so that 60%–75% of the volume of this is to the right side. The crash sound will happen far to the right, so manipulate this to 85%–90% of the sound to the right. You don't want to put 100% of the sound of the crash to the right because in real life your left ear would still pick up some of the sound. This will keep it sounding natural. If you are using the other suggested sounds, also consider them in the stereo spectrum and run them through the pan feature. We plan for the gunshot at center stage, so no adjustment is necessary on this file. Save all of the new files.

For effective realism, also consider using a *Doppler effect*. Apply it to sound effects which are in motion either to or from the listener's point of view. In this example, the explosion and crash could probably stand a touch of this because their sound sources start close to the listener but move away at the speed the aircraft was flying. Be careful not to overdo the effect; a slight touch is all that is needed. If the airplane engine sound you started with was from a static perspective, you could apply this particular effect to its maximum extent and get a believable flyby.

Now let's piece this baby together. Open a new file as 44 kHz, 16-bit, stereo and make it 6 seconds long or insert 6 seconds of silence if the first feature is unavailable. Starting in a logical order, grab or paste the flyby pan effect to this new file. If it's longer than 6 seconds, don't worry. At the 4-second mark, mute the remainder of the sound. Because airplane engines don't make engine sounds after they've exploded, you won't need the rest of that noise. Save the file as *version 1*. Next, add the gunshot file and place the beginning of the file at about the 2.5–3.0-second mark. The important part here is to ensure the volume of the gunshot is consistent with the rest of the sequence. It will be louder than the flyby, but not overwhelm the scene. Mix the volume without fades and give the entire sequence a listen. More than likely, the gunshot will have caused the wave to peak and possibly distort somewhat—so pay attention to what it sounds like. Apply compression or a peak limiter to control it and save the file as *version 2*.

Next, we add the explosion. Find a logical spot after the gunshot where you feel the airplane might explode. It should be somewhere between the 3.5- and 4.0-second mark—definitely not past the point where you performed the mute. Unfortunately, 6 seconds isn't a lot of room to get an explosion and crash to decay naturally—so we have to keep an eye on the rapidly approaching finale. I chose to have the explosion happen quickly after the gunshot in order to save room on the end for the other sounds. Paste the sound over the existing file in the same fashion as the gunshot. The explosion will indeed be a big moment in the scene, so make it as loud as you can in the context of the rest of the sequence. Don't sweat having the sound decay past the 6-second mark; we'll take care of that when we add the crash sound. Check for distortion and apply the peak limiter or compression if needed. Give the entire sequence another listen. If you like what you hear, save this as *version 3*. If you don't, undo your edits to the point where it went astray and try it again.

For the final addition, we'll add the crash element. If the explosion sound took us past our 6-second max, this is the time to make a decision. For me, it depends on what qualities the crash effect has and how much it will add or detract from the explosion. In this case, I have chosen to cut off the existing explosion sound right at the 6-second mark and use a linear fade-out for the last second of the explosion. This will fade the explosion sound so that it doesn't cut out noticeably and give some room for the metal fallout. Since my crash sound has a nice

impact, using it within the explosion sound will add an interesting overall effect. So, as I add the crash sound, I carefully align the sounds so that the point of the explosion and crash impact coincide. Adjust the volume and mix them appropriately. Because the explosion and impact sounds are both loud, be careful not to mix so that it becomes overly distorted. Once you've mixed the new sound, listen to the entire sequence again. Adding sounds with high transients guarantees some out-of-control peaks, so you will definitely have to keep them restrained. Pay close attention to the levels and adjust any peaks with a limiter if needed. Also listen to the structure of the sequence. It should flow believably from the left channel to the right without being obvious. Save the file as *version 4.*

Before we can stick a fork in this and call it done, critically listen to the overall sequence one last time. The sounds should all blend and give the impression they were recorded as the action was played out for a microphone in the farmer's field. A touch of EQ and light reverb might help bring them together if needed. If worse comes to worse, you might need to go back to a specific sound, EQ it, and then start the process over from there. Because we saved several versions along the way, we can go back to any step and not have to redo acceptable work. It takes a bit of work using an audio editor alone, but it can be done.

If you are satisfied with the sequence at this point, cut off any excess sound past our 6-second max and fade the last 0.5–1.0 seconds of the file. This will keep the file within specifications and prevent it from cutting off unexpectedly. Save the complete sound effect using an obvious file name, such as *farmer_flyby.wav,* and you are done.

I chose the previous two examples to introduce you to concepts you will encounter making sound effects using an audio-editing program. With a little patience and practice, you can produce single sounds or complex layered effects. Once you get the basics down, they become second nature and you'll soon find yourself whizzing through the entire creation process without much trouble. There is much more audio editors can do and I encourage you to become familiar with yours. The tools are available for serious sound manipulation, but it takes a little bit of digging to find out everything your editor can do. Spend time experimenting before you get busy with work. That way, your creativity won't have to fight with technology when making professional sound effects.

Using Multitrack Software for Sound Design

The day I discovered the use of multitrack software for sound design creation was a professional rebirth for me. I remember exactly where I was, who the sound designer was, and the color of the massive brick that struck my thick skull. Ah, the years of headaches I could have prevented! If you plan on making sound design a part of your audio production services, I implore (no, I beg) you to acquire a good multitrack audio program. Your creative life will become infinitely easier with this powerful tool at your disposal. If this is the first time you've been introduced to this concept, I guarantee you are 5 years ahead of where I was at this point.

A good multitrack program, however, cannot stand on its own. Your audio-editing software is still required for final sound effects editing, so don't make the mistake of only buying a multitrack program. If you have to make a choice, buy the audio-editing program first and make upgrades later. Or, consider a program like Sony's Sound Forge Pro or Adobe's Audition—which actually does both very well.

You'll soon discover the extreme joy of creating sound effects in multitrack. If you tried the previous complex sound design example on your standard audio

editor, you will immediately realize the simplicity and flexibility you have doing it this new way. Imagine having the ability to add effects and EQ and to control panning and volume in real time to each individual track, and then to instantly hear the results. You won't have to save every step or suffer through numerous undos and redos as you craft a sound. It will be great.

Let's take the farmer flyby example and create it here again as a comparison. The delivery parameters shall remain the same: no more than 6 seconds in length and delivered as a 44 kHz, 16-bit, stereo *.wav* file. Gathering individual sounds will be performed and created the same way using the audio editor. Nothing changes here except there isn't any need to cut to length or add effects processing to prepare for the mix process. Collect your sounds: some cow pasture ambience, an airplane flyby, a mumbling farmer voice, a shotgun-loading sound, a single gunshot, a sputtering engine, a Mayday transmission, a short explosion, a scream, and a small crash with metal fallout. Let's use them all! We can mix this longer list of sounds without even batting an eye.

Again, before slapping sounds together, start with a picture in your mind of how the scene will play out. This time, though, we will be adding additional sounds plus an ambient track of the cow pasture—so the overall soundscape will be a bit more dense. Pay close attention to what sounds are "action" sounds and which ones are purely "window dressing" to add additional realism. This much layering can get busy and may work against us unless we keep a close eye on it.

A good rule of thumb is to keep background sounds in the rear and those sounds which tell the story in front.

Sony's Vegas Pro allows for nondestructive complex audio editing guaranteed to take your sound design to another level.

Resist the urge to have mooing cows and chirping birds hogging your scene. Use them sparingly, as a chef does with seasonings.

On your multitrack program of choice, open a new window with at least 10 available tracks. It is possible to create the sequence in one track, using cross-fading and mixing, but because you paid extra for the convenience of multiple tracks, we'll put one sound on each track and use its full potential. If the number of tracks does become an issue for you because of hardware resources, it is possible to place multiple sounds on each track. By placing nonoverlapping sounds on the same track, it is still possible to adjust individual volumes, durations, and fades while cutting down on the number of tracks your processor has to deal with. Any effects processing or EQ inserted in a track, though, will affect every other sound. For our purposes, we'll assume that one sound will go on one track and that all processing will be done separately.

Track number 1 will start out with 6 seconds of cow pasture ambience. If you have a longer piece, shorten it to fit or mute the track after the 6-second end mark. How you do this depends on the features of your program. Some will even allow you to size a file by moving either end to fit. If your ambient file is only 6 seconds, consider simply repeating it twice or overlapping them with cross-fades to allow smooth transitions between the pieces and to keep them from sounding like a loop. Play the track, listening for any unnatural sounds such as clicks or pops. Don't worry too much if the overall sound isn't 100% perfect, because this is the background sound. The volume will be low, and other sounds playing will cover up most of the discrepancies. With the background in place, save the project file and begin adding the rest of the sounds.

On the next track, let's add the flyby—starting at about 0.5 seconds. We want the background ambience to be heard first. This way, the listener's subconscious will hear it, even though it will be buried. If the airplane noise started simultaneously, the listener would pay attention to the airplane and probably never even hear the cow pasture. Human nature will lead you to key in on the "action" and disregard any background distracters. This form of selective listening can sometimes work against our efforts, causing us to compensate appropriately.

Depending on the flyby sample you are using, you may have to shorten it to about 4 seconds to fit the scene. If it already works well as a stereo effect with the aircraft coming from stage left to the center at about 3.5 seconds, set the volume and save the file. If you are using a mono sample, exercise the panning feature to get the desired movement. Set your index points for the panning controls to simulate the flyby and ensure the sound moves past center stage about halfway through the sequence. Adjust the volume and save the file.

For the rest of the individual sounds, place them on their own track with start points in roughly the order you would expect to hear them. Have the farmer mutter, load his gun, and fire it. Then have the engine sputter, a short Mayday from the pilot, an explosion and scream, and then cap it off with the fallout ending at 6 seconds into the sequence. Adjust the pan for the final sounds to have them play further and further to the right to keep a fluidity over the entire scene, from the sputtering engine to the fallout sounds. Adjust any sounds which are longer than the sequence length, fading before 6 seconds. Once that is complete, save the file and then proceed to adjust volume levels.

As in our previous example, make sure the levels all blend from the listener's perspective (i.e., the farmer). Make the gunshot and explosion the louder of the sounds. You may also want to add compression to these particular sounds

which have a sharp attack for an extra boost without suffering from clipping. For sounds that might get buried, such as the muttering farmer and Mayday, consider using a touch of EQ to increase the higher frequencies—just enough to be able to understand what's going on. For the pilot's emergency transmission, EQ out the lower and mid frequencies to give it that tinny radio quality. You might even have a preset for this very effect. The artist has the discretion to use any other effects processing—some slight reverb perhaps or a hard flange for the tail end of the explosion just for fun. This example doesn't really require much. Again, save the file. Yeah, I know; I keep harping on this, but the first time your system crashes and you lose 2 hours of hard work, you'll become a believer. Save early and save often.

Building a complex sound effect in the multitrack environment is fairly simple. Once the sequence is tweaked to perfection, save the work as a "mixed," "rendered," or "bounced" file for further processing. This process assembles the multitrack sequence into a single sound file which will then be further manipulated. From the audio editor, open this mixed file and run through the checklist we were introduced to in the first sound effect example.

- Is the sound centered on the zero baseline? Utilize the DC Offset function.
- Does the sound file look "healthy"? Increase the volume level or use the Normalize function.
- Is it too intense? Apply compression or decrease the volume.
- Are there any major volume peaks or clipping? A peak limiter or slight compression will take care of these.

How does the sequence sound now? There is definitely a lot going on in our soundscape—everything from very subtle sounds to in-your-face explosions. If you can make this sound great, you are on your way to making some professional high-quality sound effects.

Comparing the two processes now, you might feel this method is far superior to the time-consuming and almost archaic way of doing business using a straight audio-editing program. Multitrack affords many options to layer complex sounds without having to save and resave multiple files. Nondestructive editing is a godsend, and I often beat myself up for waiting so long to incorporate it into my creative practices. If you intend to be in this business for any length of time, this will be an investment that will pay for itself every day.

Sequencing Software and Samplers

The final stop on our sound design creation tour is the use of samplers and sequencing software as production tools. This method goes back many years to the Hollywood scene—sound designers in film having paved the way for the invention of audio-editing software while pioneering this particular technique. This routine is still in use by some as their system of choice using hardware- or software-based elements. Whether you physically load a hardware sampler full of basic sounds and then manipulate them via keyboard or sequencer or trigger samples stored on your computer with an internal software sequencing program, the end results are the same.

It is still necessary to have an audio editor in your arsenal even if you use a sampler and sequencer setup. Editing basic sound elements before loading into a sampler has to be done somewhere, as well as editing and formatting of the final

product. It is impossible to create audio for games without one, so again, a sampler and sequencer will only supplement the creative process. It all comes down to what works for you, what drives your creativity, and what method serves the means.

The simplest form of sampler-based creation is its use as a basic pitch shifter over the chromatic scale. My personal favorite is to record party guests at their uninhibited best, load it into the sampler, and listen to their uproarious laughter accompany the playback. Middle C becomes the unprocessed recording. Everything up or down the scale from there becomes cheap party fun. The lower the notes triggered on the keyboard, the lower the pitch of the original recording. The opposite is true for the higher notes. This is an easy way to instantly find out what pitch of sample works best for your application. It can also be used to layer the same samples—adding a note lower or higher to the original to fatten it up or to add some interesting artifacts. This doesn't work the further you stray from the root. As pitch is dropped, the sample playback becomes longer. As the pitch is increased, it becomes shorter—making it difficult to seamlessly overlap. If you triggered three notes of the same sample to simultaneously playback, the higher-pitched one will finish first and the lowest pitch will be last.

The best creative use for sampler-based rigs is to layer multiple elements for one large effect or sequence in a real-time atmosphere. In this manner, it is perfect for performing to a cinematic (much like a Foley artist would do with their props)—except all of your "props" are preloaded into a sampler. Some artists prefer to perform this task manually, matching keys visually to the actions or sequence—relying on their own timing skills. Others utilize a sequencer to create complex effects, layering triggered sounds using MIDI data synchronized to specific visual cues. Both methods require an understanding of your particular sampling device and how to set up sounds across a keyboard for optimum use.

Our previous sound effects sequence of the farmer flyby can be done using this sampler-based technique, although a couple of extra steps are needed to prepare. Preproduction now includes loading the various sound effect elements into the sampling device and assigning each sample to a key or group of keys.

To make this already complicated process less demanding, let's build the sequence using the four basic sound effects: flyby, gunshot, explosion, and crash samples. You could simply load these four sounds and have each triggered by one key and get away with it, but where would the fun be in that? To illustrate the potential of this setup, let's load them chromatically so that they have an octave "key group" from which to be triggered. This way, we can pick and choose which pitch we like and layer multiple explosions and crash effects as the feeling strikes us.

It is possible to perform this sequence while recording to any medium, but you'll be bypassing important features of the sequencer. By recording MIDI data to sequencing software, we can take advantage of automated panning and fader controls—not to mention some limited effects processing and the ability to tweak the multiple triggered sounds to perfection.

Open a new file in your sequencer and set up four tracks to the same MIDI channel, preferably the one your sampler is also set to accept commands from. Either from a master keyboard controller or by using a mouse on the piano roll screen, trigger the flyby sample to start on track 1 at the 0:00 mark. Save the file. On track 2, trigger the gunshot sample to play at 0:03 seconds. The explosion can start at 0:035 seconds on track 3 and the crash at about 0:04 to 0:045 seconds on track 4. Save the file. This will be the basic sequence.

Start by adjusting the pan of each track. Different software accomplishes this in different manners. Some merely establish what percentage of left, right, and center the track will play for the entire playback sequence. You set a number value and it never changes. More advanced programs will allow linear changes to this feature that serve as a sort of software automation. If your software will only let you "set and forget," pan the flyby sample between full left and center. Since the gunshot, explosion, and crash will fill the soundscape, it will be difficult to distinguish the location of the initial engine noise—totally masking the fact that it isn't moving. Also, by panning the other sounds appropriately, it will give the sequence the desired movement—even though we are only using static settings. No adjustments need to be done with the gunshot because it is fired from the center position anyway. The explosion can be set at about the "one o'clock" position, just right of center, and the crash sound almost to full right. This will give the stereo field plenty of action and give a believable feeling of movement. But we can go one step better.

If the program allows for automated panning, movement can happen in real time. Start the flyby sample from the full left position and set the automation to adjust the pan position until the aircraft comes dead center at 3 seconds. The gunshot can be left where it is (in the center) because our listening position is with the farmer. The explosion can start at the center and pan further right as the sequence progresses, the crash starting further to the right to also end full right at 6 seconds. This type of automation will create the desired movement for the sequence on its own, leaving the dirty details to the program instead of having to deal with it manually in an audio editor. Save the file.

We can also set the individual track volume levels in the same manner as was done for the panning process, either "set and forget" or automated. Usually, fixed volume levels will work fine in a short sequence like this—but depending on the original samples, a little manipulation may be in order to make it sound good. It is a good idea to use linear fades on each of the samples, especially the explosion and crashing sounds, in order to stay within our 6-second limit. All sounds should fall to zero by the end. If not, later work within the audio editor will need to be done.

As further tweaks are made to tighten up the sequence, consider adjusting equalization for each track or adding compression or other subtle effects. If the sampler outputs are split to run through a mixing board, use any built-in features on the board and any outboard gear to add that perfect final stroke to the piece. It is also possible to run this into a multitrack program as individual tracks to take advantage of its features as well. If worse comes to worst, record it as a mixed file into an audio editor and make adjustments from there. Keep in mind, though, anything you do will affect the *entire* sound file—not just the one sound you may have been trying to deal with. Regardless of how the piece is mixed and brought together, utilize an audio editor to complete the final checklist in the previous examples and save to the desired file format.

The same sound effect sequence has been built using yet another array of tools, all with a similar result. For quite some time, this last method was considered the only way to do postproduction sound design work and still has a place with some of the more established creation teams. The method you use is dependent on the tools you currently have, your personal sound effects "thought process," and above all what gives you the best results for the effort. My personal recommendation is to use multitrack and audio-editing software paired together as

the ultimate sound effects creation tool. Don't discount the sampler-based setup entirely. You never know when a developer may call asking for a MIDI-triggered bank of sound effects. Plus, it's really handy when you're looking for the perfect pitch of a sound element. Live auditioning is a great tool!

We've spent a considerable amount of time discussing the mechanics of sound design creation. Let's turn our attention back to how this fits with video game production.

Sound Design in the Production Cycle

Sound design creation can begin at any point in the development. Experience, however, dictates that it not be done too hastily. Initial artistic concepts and storyboards can provide a decent advanced look at the intended genre and what sort of sounds may be needed, whether general Foley sounds or imaginative "far-out" sounds are required. But because early concepts of art and gameplay have a tendency to evolve continuously, actual sound design this early is a waste of time.

Joey Kuras, while sound designer for Tommy Tallarico Studios (currently senior audio engineer at Epic Games)—with personal credits of more than 120 games—was given a list of effects needed for the James Bond game *Tomorrow Never Dies* very early in the project. He designed and delivered more than 200 sounds per the developer's request only to have almost 90% of them discarded as the production matured, redoing them later in the project. On another project, he received a list of unspecific and vague sounds. For instance, a request for a "splash" sound had little meaning. Was it a rock, a 400-pound person, a cannonball, or a building? Is it in a bathtub, a pond, or an ocean? No one could be specific, and they ended up waiting until later in the project.

This is an easy lesson for all of us. Sound design at the outset of a project is usually not wise. Producers have the difficult task of determining audio needs of a game early in the development cycle, and if a contracted sound designer is used, the producer must find and negotiate with an individual whose skills and credits match those of the game being developed. When a game company is spending $30,000 for sound effects alone, they want to get their money's worth. If the game will have a wide range of settings and characters, trying to imagine and pinpoint a large bank of effects can be tricky.

It's important to bring the development team together to begin thinking conceptually about the game audio as early as possible. Planning is key. If they've decided on a sound designer, that person should be brought in on discussions and given an opportunity to share their experience. Developers shouldn't wait on the audio implementation details until later. But starting work on the actual creation of game sound effects too early often leads to major headaches down the line.

If money isn't a terrible concern, the developer can choose to add rough sound effects to help inspire the team. Putting in placeholder sounds can give life to soundless artwork and open the floodgates of creativity. As the sound designer, don't do this for free, of course, negotiate fair compensation for your work. And be careful—these "temporary" sounds have a way of becoming final sounds and unless your payment plan is spelled out ahead of time, you may be out money. As an example, say you get a call to do 10 placeholder sound effects.

Your normal rate may be $100 per sound effect; therefore, $1000 in your pocket. But because the developer needs them today, you knock out these rough ideas in 8 hours and charge them an hourly fee for your services. As the project progresses, the team gets used to hearing your rough sounds and decides they should stay in the final version. When it comes time for payment, you discover these 10 sounds have been left off the final invoice. The developer reminds you that you have already been paid at an hourly rate for the effects. So, now these 10 sounds bring in only $400 (working at $50 an hour). Don't naively think a developer doesn't have some money-saving tricks up their sleeve. Suddenly working on a "per sound effect" rate makes some sense.

Most of the time, a game is far enough along that characters, movements, and a defined gameplay model are present before a sound designer ever enters the picture. Being able to meet with the development team, view some rough game levels, and perhaps see some animation is crucial to churning out applicable sound ideas.

Specific Sound Design Questions to Answer

Once the final contract negotiations have taken place and documents are signed, the other details regarding the project are normally released to the sound designer. This is the point where "clear and concise" means the difference between complete audio bliss or a sound disaster. Ask for the specifics in order to make things crystal clear.

What Genre of Game Is This Intended to Be?

It is important for the music and sound effects to keep within the spirit of the game—whether it's space, driving, fishing, or sports. Get a good overall "feel" for the game. Find out which current games are similar in tone and investigate them. (This is where buying video games becomes a tax write-off, by the way!) See movies that fall in the genre to look for ideas and set the stage for your creative juices.

Sample Rate, Resolution, and Stereo versus Mono?

At some point, the development team will have done all of their homework to determine how much space will be allotted for graphics and sound. This will help decide how high the sound quality can be and what parameters the sounds will be created within. While you should always create sound effects in the highest sample rate and resolution possible, conversion to lower ones will affect sound quality and destroy any subtle nuances you may have added.

Will the Sound Effects Be Treated through Any In-Game Software or Hardware Processors?

Driving games are an example where reverb is used quite frequently. Most of the sounds will have an "echoey" quality as the player drives through a tunnel. This is the kind of information you need to know as the sound designer. Additional processing by a game engine will determine to what extent certain sounds are processed beforehand. You could have a problem if the developer plans on applying reverb to an already processed sound. The developer should decide and communicate as soon as possible if there are plans for this type of processing. That way, you can be sure to not overprocess any files on your end.

Are Any Ambient Sounds Needed?

Remember, we don't want the player distracted by silence. While this is more of a content-type question, the creation process is complicated and many details fall through the cracks. By asking this question, you may jog memories or present ideas the developer may not have thought about previously. The sound designer wouldn't know if they intend to play music instead unless he or she was also the composer. This alleviates a phone call to you late in the production for forgotten ambient sounds or music. If these types of sounds are required, determine if they need to be loopable or will playback as random background sounds. Looping sound effects get monotonous, and delicate surgery may be necessary to make them less so.

Will Certain Effects Have Priority During Playback?

There can be instances during gameplay—such as when a player unlocks a hidden door, stumbles into a trap, or is attacked by a villain—when one single sound punctuates the moment. These are the ones you want to represent the biggest bang for the buck. Because other sounds won't be drowning them out or playing over them, you won't have to make considerations for other effects being heard at the same time. These are the types of sounds you want to take the player's breath away. Have a developer point to them so that you'll know which ones to pull out all the stops for.

Will There Be Any Voice-Overs or Speech Commands That Need to Be Heard?

As the sound designer, you may be involved with voice recordings and can process them via EQ or volume to ensure they can be heard and understood. This process is similar to having the vocals stand out in a song mix. If you're not involved directly, you can add that particular service to your list and offer it to the developer.

Is Any Dialog Needed? Background Sounds to Accompany the Narration?

Dialog fits into the sound-recording category, and generally, anyone capable of sound design can also record narration. If narratives are prerecorded, you can usually provide the service of transferring to digital files, maximizing the sound, cutting them to length, and adding any additional background or Foley sounds. If narratives are to be recorded, you need to know if you will be providing voice talent and budget accordingly. Developers may ask if you have experience directing narrative sessions; if not, the producer may fill that role. Maybe you will be the voice talent. If so, make sure there is appropriate compensation for your efforts.

Any Special Sound Considerations?

Is the game intended to playback in Dolby Digital or DTS, with studio-quality speakers or subwoofers? Are they planning to advertise the game's cinema-quality sound? Ensure your longevity in the business and seek out this tidbit of information so you can really nail it. These higher-quality systems demand even better sounds since they have the tendency to reveal every nuance. Conversely, if the sound is being played back through something like the Wii Remote speaker, you won't need to waste time with subtleties that won't even be heard.

What Platform Are the Sounds Being Created For?

This will suggest what type of playback system the consumer will use and the confines of the final sound effects. I mix to several playback systems, from "el cheapo" grocery store multimedia speakers to high-end studio monitors. The sound effects should work well with them all, but the main focus should be the system the majority will be using.

What Type of Music, If Any, Will Play as the Sounds Are Triggered?

This will give you an indication of other sonic activity happening during gameplay. If the music is a softer, orchestral score, the sound effects can be geared toward that mood and not sound obtrusive. If a rock soundtrack is to play, harsher sounds and careful manipulation of effects in the higher and lower frequencies will ensure they stand out. The sounds should all work together to enhance gameplay, not aggressively compete. The last thing we want to do is cause the player to turn the sound off.

Are Any Sound Resources Available to the Sound Designer for Licensed Materials?

The Simpsons, Alien vs. Predator, Star Trek, Star Wars, and *South Park* games, for example, are based on film or television properties produced under licensing agreements. If the publisher or developer has secured use of the actual sounds from these works, do you have them at your disposal to manipulate for the game or are you expected to recreate them from scratch? While you may not have an actual hand at creating them, you are equipped to edit and convert them to the proper formats and need to know if this will be part of your tasking.

Are Any Special File-Naming Conventions Required for Final Delivery of Sounds?

If the development team is overly organized or if they waited until late in production to bring you on board, they may already have file names programmed into the code. While renaming files is not a big deal, it may help cut down on confusion when delivery is made if they are already named appropriately. The developer should make this need clear or define an acceptable method. Large game projects demand organization, and this will help keep everyone on the same page, especially when a sound the developer renamed needs to be tweaked. You definitely don't want to spend hours searching through your differently named files for the right one.

When Can I Expect a Build of the Game?

The sound designer needs to actually play the game they are creating sounds for, not just so they can have a little fun but also to ensure the sound effects are a good match. Detailed descriptions, artwork, and graphics can really only go so far, and it isn't until that moment you first see and hear everything working together do you know if it's right or not. For PC games, this is a relatively easy request. Console games are a little tougher unless you have a dev kit. In cases like this, consider obtaining one through official channels or as a loan from someone. The best-case scenario is having the ability to audition sounds within the game, either by simply replacing sounds in the games audio directory or creating your own build using a development kit. Sending the sounds off to the developer and waiting for them to make a new build is the other alternative, which may take a little extra time but eventually accomplishes the same thing, although not as efficiently.

CORINA BELLO
Sound designer

I am currently working as an associate Sound Designer at High Moon Studios where I have had the amazing opportunity to work on *Call of Duty: Advanced Warfare*.

www.killstreakaudio.com

How did you find your way into the games industry?

I was inspired to pursue sound design at a young age. When I was in high school, I had the privilege of touring a couple of local game studios. Funny enough, those studios were High Moon and Rockstar! It was after these visits I was inspired to pursue a career in games. I hadn't decided specifically on audio at the time, but during my visit I was incredibly inspired by the audio team at Rockstar, who spent some time talking with me about their sound design process.

In a continuing effort to pursue my career in games, I enrolled at The Art Institute of California—San Diego to earn my Bachelor's degree in Audio Production. During my time there, I explored and pursed many different avenues of audio, but I always fell back on game audio as my true passion. I remember my first class with Aaron Marks, hearing him talk of his experiences in game audio and being so incredibly inspired that I rushed home and wrote him an overexcited e-mail begging for every piece of advice to starting out in the industry!

It was in my final year at The Art Institute that I truly realized my passion for game audio when I had the opportunity to work with the Game Art and Design students as they completed a Sony mentorship program. For the class, the students worked with Sony Online Entertainment in San Diego to create levels in the Unreal engine based off some of SOE's games. I worked with the students to create audio for these levels. Having the opportunity to work with these students and become a part of the development process was an incredibly eye-opening experience for me. At that time, I knew sound design for games was my calling. Once I had that moment of realization and made sound design my priority, everything fell into place. I maintained a positive attitude and began networking with the sound designers in my area, asking for advice from anyone who had the time and patience to dole it out.

After graduating, I completed a short internship at a voice-over recording studio in Los Angeles where I got some excellent experience editing dialog and cleaning up vocal takes. Shortly thereafter, I was hired at High Moon studios as an associate sound designer. At High Moon studios, I have had the pleasure of working on the current gen version *Call of Duty: Advanced Warfare*.

Do you have any advice which can help lay some solid groundwork and ensure a successful production for the audio content creator?

As I've learned and grown as a sound designer, it has become apparent to me that when I first started, I regarded sound design as much more complicated than it actually is. I had this idea in my head that I needed all of the fancy plug-ins, expensive microphones, top of the line sound libraries, etc. However, once I started working at High Moon and speaking with more experienced sound designers, I realized I was overcomplicating the design process. The most important thing when designing a sound is to ensure you have a good, original source. It will always sound best if you pick something that sounds closest to your goal, rather than trying to manipulate some obscure sound to sound the way you want it. The best practice is to simply pick up a recorder, whether it's a thousand dollar microphone with a Sound Devices rig or a simple handheld recorder and go out and record what you need!

For my own personal rig, I don't have much; just a Zoom H4n, a Rode blimp, and an NTG2 shotgun microphone. It would be nice to have an amazing Sound Devices rig, but in my opinion it's not necessary (in most cases). Many of the veteran sound designers I know record most of their sounds with a small portable recorder and those recordings go into some of the biggest games in our industry.

Do you have any sound design creation techniques which affect the type of sounds you create?

I don't have many special tips or secret tricks in regard to sound design, mostly as I still have so much more to learn myself. But in my experiences so far, I have learned something very important to keep in mind when layering your source: frequency content. It's imperative to be aware of the frequency content of your source because too many pieces within a similar frequency range are simply going to muddy up your mix, and if you are missing an element with a frequency range this could also take away from the potential of the sound. EQ is also very useful in this situation. By properly utilizing your EQ, you can set up all the different source sounds to leave room for each other by EQ-ing each of them in the proper range.

Another thing I have realized is that it is very important to be aware of how many sounds you layer on top of each other and to be sure you aren't stacking too many! It was a common practice for me as a young sound designer to simply grab a few pieces of source, throw them all on top of each other, and call it a day. I realized how ineffective this was when one of my seniors pointed out to me that one probably wouldn't even be able to hear some of the elements I had layered in the sound. It's a good practice to take a step back from your sound every once in a while and try listening to it with elements soloed and muted to make sure they are all coming through in the final mix.

Any other advice you'd like to share?

What it really comes down to, and the most important advice I could give to anyone trying to find his way into the game audio industry, is that you should constantly strive to learn more and always have a positive attitude. Always remain humble. Never assume that you have learned all there is to know. Constantly ask others for advice and guidance, and heed

it! For me, it was that moment of realization when I was working with the students at The Art Institute that I decided what I wanted and told myself I could do it. It's that positive attitude and constant desire to learn more and reach my goals that got me to where I am, and I am constantly grateful to have made it this far. When you strive for your goals and remain humble and positive, you will achieve them.

Determining Necessary Sounds

The process of determining which sound effects are needed can take on many forms. There are times when the sound designer will be presented with a long grocery list of sound effects to create. Other times, the developer will present a prerelease copy of the game and let your experience decide. Either way, it's not a cut-and-dried process and will require much patience, flexibility, and teamwork. Tommy Tallarico describes his experience.

I've been in the industry long enough to know you can have a sound effects list, on average of 200–250 sound effects per game—which will end up changing at least 400 times. Sound effects are most definitely postproduction. The developer will insist they need a series of sounds; let's say, of magic appearing, a loop, the magic sound traveling, and then one sound hitting a person and one hitting a wall. In reality, it's going to be one sound of the magic releasing and one generic hitting sound. So, where they've listed 12 sounds you'll do 2.

Initially, a developer will want a sound effect for every action in the game—from simple button clicks on a menu screen to intricate character movements, weapons, environments, background ambience, and so on. Providing this type of feedback to a player is, in essence, the magic that draws them into the virtual world. They interact with the game and are rewarded with aural and visual cues adding to the feeling of being *inside* the game making things happen. Sound effects play a grand part in this design, and at the onset, the developer will want to cover every possibility. As reality slowly creeps in, they will discover there isn't the need or the want of every sound effect on their list. The soundscape would become grossly overloaded, random access memory and processors would be jammed, and new programming issues would arise from the chaotic use of sound—not to mention the sanity of the game player as his or her ears are bombarded with too much information. It should become clear which sounds have priority and which ones aren't really needed. Unfortunately for you, this won't happen until late in the game. Try to have it narrowed down as soon as is practical.

Sound Effects Lists

If you stick with game sound design business long enough, you'll end up seeing practically every form of sound effects lists imaginable. I sometimes refer to these as "wish lists" because they often never get totally fulfilled. Most will look like the following:

> Game: *Video Poker*
> Sound effects needed: Intro sequence
> Background ambience
> Card shuffle
> Card turnover
> Card select
> Button push

Win 1
Win 2
Jackpot

This example of a small video poker game isn't much on detail. It leaves a lot of questions to ask prior to beginning work. Without artwork accompanying this request, it's pretty much open to interpretation. I'd guess it would be a standard Vegas-style video poker machine with all the bells and whistles, a fairly straightforward project. But what if the producer had taken time to fill in some details? A better sound effects list would look like the following.

The game is *Jungle Adventure Video Poker*. This game will have the look and feel of a jungle with ancient ruins covered in overgrowth. The game screen will consist of an ancient temple with the five cards appearing in the entryway. These cards will be made of old stone tablets with early inhabitants on the face cards. Two large waterfalls will sit on either side of the temple, creating a relaxing cascade of water. This game should have a tranquil atmosphere, with an occasional tribal drum beat heard far in the background—nothing dangerous-sounding, just enough to add to the ambience.

Sound effects needed:

Intro sequence	Plays as the opening screen appears. This will set the mood for the game. Play heavily on establishing the jungle theme while giving the flavor the player has stumbled across an ancient game.	4 seconds maximum.
Background ambience	Starts after the intro sound effect stops. This looping effect should be of gentle cascading water to simulate the waterfalls, adding to the relaxed atmosphere.	2–3 seconds maximum.
Random ambient sounds	Four different effects. These sounds will be triggered at random as background ambience. Ideas such as bird calls, tribal drums, jungle noises, etc. would work well here.	No more than 2 seconds maximum for each.
Card shuffle	This sound will indicate gameplay is ready to begin. Because we are not using conventional cards, some sort of primitive sound (perhaps wood hits or a short drum beat) would work well.	3 seconds maximum.
Card turnover	This sound will play as cards are turned over. The sound of a heavy stone being moved or dropped may work nicely.	1.5 seconds in length.
Card select	This sound will be heard as the player touches the card to indicate which ones they will hold. This should be a firm but neutral sort of sound because the player will hear it many times during the course of play.	1 second maximum.
Button push	As the player presses any button on the game console, this sound will play. Similar to the card select sound, it should be neutral—but slightly more "fun" in nature.	1 second maximum.
Win 1	This sound will be triggered for a small win. It should stay true to the jungle theme, giving positive reinforcement to the accomplishment without going overboard. A mixture of animal noises and jungle sounds might work well as an example.	3 seconds maximum.
Win 2	Another notch in intensity up from Win 1. The player will have achieved a substantial win when this sound is triggered. Stay within the theme and make it positive.	3 seconds maximum.
Jackpot	This sound will be heard after a royal flush. It should be loud, triumphant, and attract a crowd when the player achieves this rare reward. Pull out all the stops and make this one really shine!	5 seconds maximum.
Delivery format:	44 kHz, 16-bit, mono *.wav* files	
Delivery date:	1 week from the date of this request	

This is a good example of the type of sound effects list you would like to receive every time; the developer has put some time and thought into the game. Their vision is clear and concise, and there is no doubt concerning the atmosphere they are trying to create. They have given you precise ideas yet have left enough room for your interpretation as a sound artist. If artwork is available, now would be the best time to ask for it. The visuals will give you extra ammunition to do your work.

More detailed lists may accompany a developer's request for sound effects, especially when animation and artwork are unavailable. Using the previous example, intricate timing may need to be matched.

Card turnover	This sound will play as cards are turned over. There should be a 0.5-second delay for the card select sound to fade before this one begins. Once the card is selected, the stone will rise slightly and then proceed to turn for 1.5 seconds before settling back down with a small cloud of dust. Key timing points to hit: 0.5 delay from trigger of sound before the sound plays; at 00:00.5 the stone rises; at 00:01.0 the tablet begins to turn over (lasting 1.5 seconds); at 00:02.0, the stone settles with a thump and a small cloud of dust appears from the edges.

This one small animation sequence is very intricate, and the developer is trying hard to provide you with every detail. But, until the animation is complete, it will be impossible to know for sure if all of this planning will pay off. More than likely, you'll have to redo this sound later—after the animation is finalized. The more details the better when doing sound effects, but effective sound design is best when completed postproduction.

When receiving any type of list, I recommend going over it line by line with the producer in person or at least over the phone. Get as many details as possible for each item, discuss every possibility, and narrow down the field to a couple of solid ideas. I once had a ridiculously simple request for the sound of a small stone game piece being placed on a wooden game board. Without even talking to the developer about it, I proceeded to record a marble hitting several types of wood at varied intensities and sent back a dozen sounds. None of them were accepted. I tried again. Another dozen, another rejection. I asked which ones sounded close and received an answer. Another dozen, another rejection.

As you can imagine, this was starting to get a little bit frustrating and I picked up the phone. We talked. He performed the correct sound of a stone hitting his personal game board over the phone and within 10 minutes, I had the sound and pitch he wanted. After submitting more than 50 sounds, we were finally done. A simple task had become an ordeal because I didn't think it was important to talk to the producer. Now, it is another item on the checklist before I begin any work. Again, there is something to be said for actually communicating with other human beings on the team.

Alpha Game Versions and Other Visuals

In addition to receiving a list of requested sound effects, it is likely the developer will forward a rough version (or build) of the game. This isn't always possible, obviously, for console or arcade games unless you have access to a development system—but it's a good option for a PC, Flash, web-based, or smartphone game if one is available. It's a perfect way for you to interact with the game, as a player would, and determine the best use of sound effects. These rough versions will be

Royal Flush	250	500	750	1000	4000
StraightFlush	50	100	150	200	250
Four of a Kind	25	50	75	100	125
Full House	9	18	27	36	45
Flush	6	12	18	24	30
Straight	4	8	12	16	20
Three of a Kind	3	6	9	12	15
Two Pair	2	4	6	8	10
Jack's or Better	1	2	3	4	5

A picture of the game describes much more than words alone. This graphic shows us exactly what the game is about.

lacking many of the game options, levels, and artwork but will give a rudimentary idea of what the title is about.

While you may be tempted to have a little fun, pay close attention to the details and what you can do to improve upon the visuals. Your job is to enhance the work of the rest of the team, adding that perfect audio touch. If the developer is thinking ahead, they will even have made it easy for you to add your sound effects and test them in the game during your design phase. By having a separate sound folder under the game's root directory, it becomes a simple task of replacing and renaming files. All you have to do is fire up the game to get instant feedback.

For non-DVD-ROM games, developers may provide movie files of various parts of the game, character movements, animations, menu screen shots, and so on. Some even go as far as to record someone playing—stopping at every menu screen, flipping to each option, meticulously going through every action currently in place. For sports games, I've even received tapes recorded at an actual game—not of the players but of the crowd reactions and various other happenings on the sidelines they wanted recreated. Their research gave me exactly what I needed without having to attend a game myself. Organized development teams will also provide a *track sheet*, which specifies times and events to pay close attention to as you watch. If you can't be there on-site, this is a great way to share information.

Whether you receive your visuals in the form of a video file or an alpha version of the game, it is also possible the developer will rely entirely on your ideas and experience to provide sound effects for the project. Basically, they will say, "Here's the game. Make some noise." The perception of free reign doesn't mean the developer won't have anything to say about the sounds. Far from it. They will provide specific guidance and will always be close by to share opinions.

The company climate may be one where artists are given space to work without overbearing management types constantly peeking over their shoulder. This lack of micromanagement will be appreciated and let you create freely.

As you play the rough game, keep meticulous notes. Gather ideas for every place a sound effect should appear and any initial thoughts of what they should sound like. Develop your own comprehensive list. After some quality time, present these ideas to the developer for approval before starting any work. Some selling may be involved, explaining your reasoning for including some sounds and not others. This is basically the same process they would have followed in-house had they developed their own list, except they are choosing to have the "expert" make the determination.

There are no hard and fast rules governing the choice of sound effects. Understand how a particular sound will impact the game, the player, and the soundscape. A pinball game should have sounds happening almost constantly, even when the ball is at rest. This game is designed as a fast-action stress-relieving game. An intellectually stimulating game requiring concentration, such as chess, would require fewer sounds—maintaining a serene atmosphere instead. The overall theme of the game, level, or section will guide the final choices. At this point, there is no problem going overboard with suggestions. It will make for some extra work on your part having to create sound effects that may end up getting dumped anyway, but for the sake of the game, it's worth the effort to go all out.

The other school of thought says that because you don't get paid any more or less (depending on the negotiated deal) why should you do more work? There is a fine line between doing enough work to "get by" and going beyond what is expected. Your judgment and experience will ultimately dictate your decisions, but personally, I like to leave a developer feeling I did my best and insist on always working hard and going the extra mile. If that means creating more sound effects than the game will use, then so be it. Working hard will pay off in the longevity of your career.

There will be times when no matter how hard you work, a developer will never be satisfied. You may think a sound effect is perfect, but they continually request reworks or new sounds altogether. Your best approach may be to pull out your best diplomatic skills and talk to them. Eventually, a sound will be good enough. Eventually, you'll have a case where any of a couple of dozen different sounds will work fine. Remember, though, if *none* of your efforts seem to satisfy them, it may be they are just plain difficult to work for. It happens.

Beta Testing

Another important practice of determining sound effects for a game project is the process of *play testing*, also referred to as *beta testing*. Game companies have different methods, depending on their resources. Larger ones have an in-house staff whose job is to play the game, look for bugs, and suggest improvements or they farm out this type of work to outside firms that provide this specific service. Small game developers use themselves as the guinea pigs. The end result is the same: a list of needed sound effects from different people and personalities. The variety of opinions gives a good cross section. Typically, the developer will stick with the majority and put this plan into action.

Play testing is also a good test bed for valuable outside opinions of sounds that may already be in place. If sounds have been created earlier in production, it becomes difficult for the developer and sound designer to fairly judge what

they've heard every day—their familiarity clouding the ability to gauge a sound's effectiveness. By letting play-testers express their unbiased thoughts, the game can only benefit. They aren't there to bolster anyone's ego, just lend their opinion. This final form of checks and balances will help get it one step closer to the marketplace. Ultimately, the game player will have the final say about your work—but it's too late then for any changes. This process is the next best thing.

As the sound designer, you can get involved in this step a little deeper by providing the quality assurance team with a checklist to consider—with questions such as "Does this sound fade correctly?" or "Do any of the sounds cut off abruptly?" or "Is more than one sound triggered for the same event?" These are usually things you look for when conducting your own run-through, but fresh ears will be able to pick up on things you may have grown deaf to after months of listening. Everyone working together will most definitely create a higher-quality product.

Creating Original Sound Effects That Fit

It's been said that those of us who create sound in the video games industry can also take a lesson from Hollywood. Bobby Prince, of *Doom* fame, presented the paper "Tricks and Techniques for Effective Sound Design" in 1996 at the Game Developers Conference. The paper listed common attributes of movies that had won Academy Awards for the best sound effects. The listed commonalities offered a good jumping-off place when thinking about game sound design. These sounds

- Focused the viewer's attention
- Were bigger than life
- Didn't get in the way of each other
- Placed the listener into another "reality"
- Always had some sort of background ambience in place as well

These basic ideas will work just as well in games.

Getting Organized

It's time to start making some noise! You've been hired, your list of questions have been answered, and we are off to a good start. If it hasn't happened already, the developer should assign one or two individuals to act as the liaison to the sound designer. Rather than getting mixed signals from numerous artists, programmers, and so on, the company can assign the producer, creative director, audio director, or audio lead the task of communicating the specs and signing off on the work. This ensures clear and effective communications, which I believe is *the* key to obtaining sounds which match the developer's vision.

If you are a locally based contractor, stop by the developer's work site, meet the rest of the creation team, and discuss the game's intention. It's a good fact-finding mission, become a mental sponge and absorb everything related to the project. If you are unavailable for a visit, be sure to obtain copies of artwork, storyboards, and any story text as has been mentioned. Now is not the time to have secrets. You are part of the team and on their side.

An alpha version of the game can be delivered with placeholder sound effects already in place. Library sounds or effects taken from other games can be inserted

as a way of giving life to soundless artwork and to show you where new effects are needed. Placeholders can be words instead of sounds. In a game I worked on, the producer inserted words such as *click*, *bonk*, *explode*, and *shot*. As I played the game, every time I heard his voice, I created a sound to match the action. This worked out very well for me, and the producer maintains an interesting psychological advantage—his booming voice having a subconscious effect on my psyche.

Creating a Sound Palette

The first order of business is to choose a sound "palette" and organize your files so that they are easily called upon (as discussed in Chapter 8). I generally grab sounds I've developed or recorded within the genre I will be creating, put them into their own directory, and draw upon them as the work progresses.

Create new directories and start throwing in any sound that might sound like it belongs in the game. If it's a cartoon-type game, grab your "cartoon" sounds. If it's a war game, grab all the gunshots and explosions you have lying around. You won't necessarily be using them all, or any of them. You are establishing a theme and a good starting point. You'll look to this folder for the bits and pieces to form the core of your game sounds.

Why bother with a palette? I too was resistant at first. Why spend extra time preparing to create when I could just jump right in? On a couple of larger games, I tried just that, but found I was spending administrative time away from the actual design process looking for ideas anyway. By spending a couple of days at the beginning, I only had to break my creative spell a few times now that all of the sounds were handy. You would drive yourself crazy choosing from millions of possible sounds. By narrowing the possibilities down, you

- Naturally build an aural theme based on the couple hundred or so sounds you've chosen
- Ensure that the game sounds have similar qualities because most are made from elements from your palette
- Will design better, more original sounds by limiting your choices and forcing yourself to be more creative

Try it both ways, and I guarantee you'll always start the process by forming a sound palette. Jamey Scott, former sound designer and composer for the defunct Presto Studios (developers of *Myst III*, *The Journeyman Project* series, *Gundam 0078*, and others), believes putting together the initial palette is the most important step—finding sounds that will mix well. He uses a sampler in his sound design process and for each game, develops an entirely new sound palette to keep them original. He finds using a sampler has many advantages over straight computer files and sound editors. "Layering sounds internally in a sampler works very well for me, more so than doing it on a computer. That way, I can save my banks as a palette rather than having sources in various folders all over the computer. They are all looped, EQed, and noise filtered to my specifications. Plus returning to them to make any changes is a simpler task."

Effective Creation

Most sound guys believe video games are on the same level as feature films and strive to grab the player's attention with their sounds. Nothing is more satisfying

that having a player remark that the sounds are cool. Realistic Foley or "over-the-top" sounds can have that impact, and we certainly aim to please.

Most sound designers are never satisfied with stock library sound effects. If they use them, they are manipulated in several ways—pitch-shifted, filtered, layered, textured, reorganized, reversed, inverted, compressed, expanded, or cut into smaller elements—anything to give them a new life and make them less recognizable. Nothing is more annoying than hearing the same sound effect used on television, radio, and in other games. It happens more frequently than you probably notice.

I used to have a large German Rottweiler who ran around the backyard barking at the sky whenever he heard a certain hawk screech sound. I have a Hollywood Edge sample disk I used to enjoy playing for the neighbors and friends, and we would all laugh at the silly dog and his antics. The exact sound is in dozens of TV shows, movies, commercials, and video games, and, unfortunately, the poor dog ran barking into the backyard several times a week without my help. This experience opened my eyes to how incredibly overused some library sounds really are. Our job is to change that.

As an example, let's talk about the creation of a different sound effect—using one from a previous project of mine. It is a real-time strategy game within the "space" genre where units are maneuvered in formation to battle against other players. It is a PC game with final sounds to be delivered as 22 kHz, 16-bit .wav files. This particular sound is a "shield" sound which activates when the unit is fired upon.

I wanted the shield to have an electric quality to it—a controlled surge of energy that might sound as if it was absorbing or deflecting a shot from a laser weapon. I wanted it to be original, so I stayed away from the stock library effects and turned instead toward one of my synthesizers for inspiration.

I ultimately settled on a patch (similar to the keyboard sound in Van Halen's "Jump") and recorded about 4 seconds of a three-note chord. I saved it into my audio-editing program, Sound Forge, as 44.1 kHz, 16-bit, stereo. Experimenting with a few different effects processors, I opted for a nice Doppler effect in another program (Goldwave). I edited an existing effects patch to give it a quick 1-second Doppler increase with about 3 seconds of Doppler decrease. Back in Sound Forge, I pulled up a radio static sound file, ran it through a 1-Hz stereo flange effect and equalized it to increase the high-frequency range. I then cut that file to 4 seconds to match the manipulated keyboard sound and mixed the two sounds, keeping the static barely perceptible. I gave the new mixed file about a 1-second fade-in and faded out the last 2 seconds with a linear fade. Now it was beginning to sound like something. I normalized the file to maximize the sound, adjusted for any abnormal level peaks, and finally saved the new file as *shield.wav*.

Later, the producer wanted a dull, metallic clank mixed in to give the player some distinction between a shield hit and a hit to the unit's space suit. I pulled up a nice clank sound, EQed out most of the highs, and mixed to the shield file. All is well; producer happy.

To convert down to 22 kHz is a simple task. The resample feature in Sound Forge does the trick. Because some of the higher-frequency band gets lost in the conversion, I usually add some EQ to compensate—just a slight amount gives it the right touch. Another check on the levels and now the effect is ready for the game. The total amount of work on this one sound effect: 2 hours, 15 minutes. A lot of manipulation? You bet! You could do this same edit using a multitrack editor.

JESSE HARLIN
Composer

My philosophy regarding gear: I don't like gear! NAMM is a nightmare to me. I don't view gear as toys—I view gear as tools. If I went to my toolbox and found that my hammer just suddenly stopped working for some reason, I'd be pissed off and I'm the same way with gear. Life has gotten significantly easier the more software gear I use and the less outboard gear I use. When my gear works, I'm happy. When it doesn't work, I want to throw it out the window.

Computers: a Mac Pro running 10.7, four hard drives (main system drive, three additional terabyte drives: one dedicated to work files, one dedicated to samples, one dedicated to everything else)

Audio interface: Propellerhead Balance

Software: Logic 9 (been too busy to upgrade to Logic X yet), Sound Forge for Mac, Microsoft Office, Wwise, Spotify, Pandora, Youtube, an iOS app called Visual Metronome, Dropbox

Multitrack system: Logic

Monitors: a pair of Adam A7Xs

Sound modules/VST instruments: Kontakt, Komplete, PLAY, Reason, EXS24

Keyboards: Controller Keyboard: AKAI MPK88. I need to have a full weighted keyboard.

Other instruments: Random ethnic percussion instruments (bongos, spoons, mark tree, assorted mallets), a badly tuned acoustic guitar, two bamboo flutes, a kazoo, two harmonicas (one in A, one in C), and a Snoopy brand jaw harp

Microphones: one Shure SM58

Software that I often use: Camtasia, FMOD Studio, Unity (with Fabric)

Creative Forces

Jon Holland, a former game sound designer turned full-time composer with many game credits, reflects upon a past project.

> Combining unexpected sound sources with recognizable sounds or timbres will yield truly original sound effects. I remember on *Vectorman*, I combined the sound of detuned dinosaur steps with the crack of a bullwhip. Then I layered that with a regular thunder sound to get a lashing thunderstorm feel. Even though it was a Sega Genesis game, the sound was very effective and had definition that cut right through. You have to be creative and try things even if you can't see an obvious correlation immediately. Experimentation should be paramount if you want sounds that are difficult to duplicate.

Jamey Scott has many tricks up his sleeve, too. For a previous Presto project, the game had many machines that required their own personality and uniqueness. He normally starts with stock engine or mechanical sounds but runs them through a fast LFO filter, warbling the pitch and then mixing in what he calls "clunketty-clunk" sounds. For machines that are primitive, he ensures they sound rickety and unpolished on purpose. He will also start completely from scratch on some, preferring to mix low-frequency rumbling sounds, mid-range mechanical noises and on top some high-frequency whining. He tends to shoot for a full-frequency spectrum sound—massive and very full.

For odd creature sounds, Jamey creates something like an exaggerated insect noise—a high-pitched screech but with a very low-frequency sound to make it memorable. He's been known to use his own mouth noises, or to grab someone walking by in the hall, as interesting touches. After tweaking and layering, you would never know their origin.

Joey Kuras makes good use of the world around him for his sounds. Sometimes, there just isn't a particular sound in any of the libraries he uses, so he ventures out with his portable rig and microphone. A previous *Beavis and Butthead* game required the sound of large gymnasium bleachers opening. So, he went to a local school and had the maintenance crew open them while he recorded. Instant sound effect.

The boxing game *Knockout* used a lot of embellished punching sounds, occasionally punctuated by the sounds of a breaking jawbone. Joey made use of many stalks of celery to add just the right touch of crunching and snapping.

Test Drive 5 and *6* required over-the-top engine and car sounds. His trek led him and his microphone to southern California's Marconi Auto Museum to record some track-ready muscle cars firsthand. Play these games, and you'll agree that the effort was worth it.

Several games' need for sounds of grenades bouncing led him to a military surplus store for dummy grenades. A quiet afternoon of grenade tossing produced some nice effects.

Assaf Gavron and Oosh Adar, sound designers in Israel who worked on Electronic Art's (EA) flight sim, *USAF*, relayed this interesting method of effects creation. Oosh describes this particular session.

> In flight simulations, there is a lot of mid-frequency activity in the cockpit. Most of those sounds are being processed by filters and a bit of distortion. I had to create a "G" effect (heavy breathing in an "over G" situation) that needed to sound like you were hearing yourself over the headphones—the sound being in the same

mid-range area. I didn't want to repeat the same software treatment as in the radio connection because it's a bit different and it's better to avoid a crunchy mid-range overload. I decided to record it live. I made a heavy-breathing session and listened to it. It sounded oddly like phone sex. Every detail of the breathing was so clear and it was not even sexy, it was dirty, full of "aahhcchhs" and "fifs." Staying away from the mic and the other usual tricks didn't work either, it was too dynamic no matter what I tried. So, I closed the mic in the closet to imitate claustrophobic air pressure ambience and I brought a long plastic tube (one and a half meters) and connected it to the mic. The plastic tube acts as a natural band pass that creates the illusion of distance. Now, if someone was looking through the window it looked dirty but sounded perfect. The breathing was far away but still close and it sounded filtered but not software generated. The "resample" to 22.5, plus some fine-tuning tricks, made it sound right.

Experimentation, experience, and the willingness to leave the studio once in a while can lead to some fantastic sound creations. These guys are incredibly creative and will stop at nothing for the right sound. I can't wait to hear what they have coming up next.

Presenting the Final Work

Now that you've spent a great deal of time creating these fantastical sound effects, it's time to make delivery to the client. It is not just a simple matter of sending a DVD or e-mailing the sounds and saying, "Here they are!" It can be done that way, but usually there is a little more to it. You are making a presentation and selling them to the client.

When presenting finished effects to the producers, I usually send more sounds than needed. I work up several effects, letting them in on the process and giving them the chance to choose the ones that match their vision. Some have minor subtle differences, changes in length, layering, or effects processor settings. Others use completely different angles to get the same point across. Some are "happy accidents" I'll throw in that might work from a completely different angle. These serve two purposes: to give an idea so far out that it might just work and to make the others sound that much more right for the game.

The producer will more likely be happiest with their choice, believing in it enough to sell it to the rest of the team. If you had made the choice for them, it would be more like swimming upstream against a strong current. The psychological trick is for them to make the choice, take the responsibility, and do the rest of the legwork. I usually have my favorite, and if I believe in it enough, I'll say so to help slant the decision. But, most often it's their choice entirely.

Also occasionally included (if it isn't already obvious by the file names) is some sort of documentation that describes what each sound effect is for. It will highlight which sounds are for specific actions and which less critical ones could be mixed and matched, such as button presses. This key will save some headache for everyone involved and score points for the organized sound designer.

Other sound designers have their own unique delivery methods that help them stand out from the crowd. Darryl Duncan, of GameBeat Studios, has a fresh idea that works for him.

Aside from delivering good work, we feel that our package and delivery method must give attention to detail. We find that it truly is the little things that the clients appreciate. A small example of that is this: when we deliver music or sound effects,

we create a detailed Excel spreadsheet that allows the client to listen to all of the delivered assets right from the Excel document. They simply click on the music/sfx title and the music or sfx plays right from within that document, as they read a detailed description of the version they are hearing, what it is meant for in the game, etc. We have found that this is one of the simple things that our clients really appreciate and has even led to other projects from word of mouth about this simple service feature we offer.

Conclusion

Have you ever watched a B movie and actually liked the sound effects? Occasionally, the amateurish production has some charm to it, but for the most part they are not that great. Would you buy a B video game or even set out to make one? Of course not! With all of the competition for shelf space, we set out from day 1 to make a product that will be profitable and perhaps even win us a few accolades from our colleagues in the process.

There are no hard and fast rules, no secret formulas and no prescribed methods for creating the consummate assemblage of sound effects for a game. It takes fluid communication and a firm vision from the development team coupled with a sound designer who shows no bounds to their creativity and patience. The tips and tricks discussed in this book should give a solid foundation for you to build upon and thrive in this gratifying industry. Knock 'em dead.

10

Field Recording for Games

Any game sound designer will tell you that in the course of creating, you're going to eventually have to get your hands dirty and suffer a little for your art. Now, I wouldn't look at this as a bad thing, actually quite the opposite. These opportunities for adventure are where the great war stories come from that really make this part of what we do the envy of the nonaudio folks. I mean, where else do you have the excuse to spend the day pointing microphones at exotic cars, military vehicles, weapons, explosives, aircraft, boats, animals, and other cool noise-making objects all in the name of great game making?

While you may be pursing sounds for a specific purpose, you're also adding another skill and talent to your repertoire which will lead to more work and yet another potential income stream. Yeah, field recording is a good thing to add to your list of services. I've always been a strong advocate for the "diversify and thrive" way of thinking, and this really is one of those skills you should really consider. At least, a third of what I do revolves around my portable recording rig and a great way to keep busy when you're not engaged with other work. Plus, it brings an entirely new dimension to the artistry of sound design.

Sound libraries have always been a great resource for sound designers, but one thing you'll discover quickly working in games is that these will never quite provide the exact sound you need every time. It's one thing to create sounds for the predictable, linear medium of TV and films, but in the game world, the ever-changing experience demands sound that can be believably manipulated by the game programming into something realistic. For example, racing games often require multichannel recordings of a car's interior, engine compartment and exhaust all at a variety of steady rpms. Playback of these will then be replicated

in relation to the players throttle, steering, and brake control inputs as well as the camera perspective. This complex scenario requires custom sound files which cannot be found in sound libraries. Field recording is the only option.

Consider weapon sounds as well. Sure, there are plenty of sound libraries out there which offer an assortment of "standard" guns, but what happens when you need something rare or a little off the beaten path, something brand new or recordings from a variety of realistic listening perspectives? What about sounds for a large first-person shooter with a huge assortment of weapons that can be heard up close, from far away, behind obstacles, from inside of enclosures, suppressed, single shot, bursts, and magazine dumps? What about weapon "handling" sounds for all of these weapons, inserting magazines, opening and closing the bolt, dry firing, etc.? There is a definite move toward realism in today's games, and the only way to ensure weapons are depicted accurately is to record the real things in their element.

And, if you're still debating the value of field recording, be sure to consider what the uniqueness of an unlimited palette of fresh sounds will bring to the quality of your sound design. Take Diego Stocco for example. This standout sound designer listens to the world around him, always keeping an ear out for unique sounds. When he finds one, he goes out of his way to capture it and use it to create some truly awe-inspiring sounds. One set of sounds he created using the metal grate of an air vent demonstrates his unique thought process. Tying a thick rubber band to the grate and then "playing" it with a violin bow became a huge howling sound which could be varied by stretching the rubber band. He also pressed electric hair clippers to the same grate, turning it on and off to create an incredible buzzing tone which resonated through the metal ducts. This is the kind of experimentation which produces unique, captivating sounds that keep game sound on the cutting edge. And, it's something you can do as well.

One of the many possible adventures awaiting those who make field recording part of their repertoire. Watson Wu, with a multi-channel field recorder, manning the commanders hatch on a US Marine Corps AAV.

The Purposes of Field Recording

Field recording by definition is any recording made outside of a controlled studio environment. So, pretty much any audio recording you make whether it's in a garage, your backyard, or out in the middle of nowhere is considered field recording. Recording inside a studio is already challenging enough, but add in portable equipment, wind noise, airplanes, birds, and all of those unpredictable annoyances, and you've got yourself a real challenge! If you enjoy fresh air, meeting interesting people, and doing things that can be downright fun, then you'll probably find yourself out in the field more and more.

Obviously, this book is slanted toward game sound production, but there is quite a variety of other purposes which I think will help put this whole field recording thing into perspective. You'll find that once you have the skills and the equipment, other opportunities have a tendency to present themselves. As far as I'm concerned, this is a good thing and one more way to sustain an enjoyable career. Film and TV productions, newscasts, sound effects libraries, and even music production all have dedicated professionals whose task is to capture clean audio no matter what the situation. Working as a field recordist can put you in a wide range of situations with definite challenges and rewards.

As part of a film or TV production crew, the field recordist (also referred to as a "sound recordist" in this case) is not only expected to record actor dialog and specific sounds that may be happening in a scene, but also to record "on-location" sounds for later sound design, location ambience, and room tone for Automated Dialog Replacement (ADR). Each of these tasks requires a specific thought process and sometimes different equipment to accomplish successfully. As part of a location sound team, the variety of recording activity and the pace of the shooting schedule will keep you hopping.

Live action news teams typically have a dedicated sound recordist whose job is to make the on-air talent not only sound good but to record "story"-related sounds as well. If the focus of the segment makes a sound, it's a good idea to let the audience hear it. These folks often find themselves in wildly unpredictable and uncontrolled situations as they chase down dramatic news stories.

Sound effects libraries have to be recorded by someone, and this is one instance where field recordists really get to show off their skills. Recording everything from ambience to explosions, crickets to jet aircraft, there are plenty of noise-making objects to be collected and cataloged, so there is plenty for these folks to do. And, knowing fellow sound designers will be listening very critically, and using them in their work is a great motivator to get it right. Plus, having a viable and usable collection of sounds is a nice feather in your cap. Whether you do this type of recording for official sound libraries or not, you'll find that building your own personal library will make your future work infinitely easier.

Music production is a little known venue for field recordist but one where they *can* play a major role in a performance. For in-studio productions, ambience or sounds which help support the "story" are often used, especially in the ambient genre, and nonmusical sounds can be used as musical elements in beats or as percussion. Recorded live music productions will typically require audience reactions as well as location-related sound needs for television simulcast and future CD/DVD releases.

There are a wide variety of opportunities in field recording, and whether you focus on one specific corner of the profession like games or become adept at them

all, your skills and talents will play a major role in any production. And, with the variety, you'll find yourself placed in exciting situations and always challenged—plus, the pay isn't bad either.

Field Recording Prep

Now that you've decided field recording might be something you could get involved in, like any other endeavor, your success is directly relative to the amount of preparation. Before running full throttle into the great unknown, it's always wise to take a moment of pause to evaluate what you're facing and plan for every contingency. It can be incredibly difficult choreographing the intricate ballet of the logistics involved to not only get the recordists and equipment to the field but also scheduling the location, finding and gathering the recording subjects (such as tanks, exotic cars, weapons, etc.) and their special needs, that you can't take the preparation phase too lightly. There's nothing worse than having one cog in the wheel derail the entire session, so this is the time to ensure you'll be able to get what you came for no matter what.

I've had many close calls over the years, and even though I make it a point to learn from these sometimes harsh lessons, the one constant is that there are always sinister forces working against you. The key is to be ready for them, be flexible, and keep a positive attitude no matter what. Above all else, planning is everything, so don't take this step lightly. Your clients are relying on you!

After 8 months of planning and obtaining, the proper permission my team showed up at the Marine Corps Air Ground Combat Center in 29 Palms, California to spend a week recording military vehicles for the game *Operation Flashpoint: Dragon Rising*. My contract was very specific, and our main objective was to record the venerable M1A1 Abrams Main Battle Tank. I was assured many times by many people that a tank would be made available for us, and normally, those assurances would have been sufficient. But, I've spent time in the military and have had enough "surprises" in both my audio and military careers to know better, so I took it a step further and hired a military "consultant" to accompany us on the adventure.

Normally, I'm the acting military consultant on our excursions, but because of this particular subject matter and importance of these vehicles, we needed an ace in the hole. Interestingly, the executive officer of the tank battalion stationed in 29 Palms was retiring, and the timing could not have been more perfect—he was interested and available! Having just returned from a combat tour in Iraq, this grizzled war veteran was just the kind of salty dog we needed on the team to make things happen. And, you'll see why in just a minute.

The team showed up bright and early Monday morning at the main gate, and we were escorted to the Public Affair Office to get our safety brief, sign waivers, and meet our guardians for the week. By mid-morning, we were heading out to scout our recording location and arrange for our tank to meet us there. We were really looking forward spending some time with some great machinery!

"Uh, Mr. Marks, sorry but we weren't able to get a tank for you this week. There is a large exercise on the north end of the base and they're all tied up. But, we do have this Humvee you can record." said our escort smiling at the idling vehicle.

"KEVIN. UP!," I yelled, commanding the immediate presence of our consultant, newly retired Major Kevin Collins. Not even 2 hours into our journey and

I'm having to initiate my "get a tank at all cost" contingency plan. Our escort looked at me befuddled, not sure if he'd lost control of what was supposed to be an easy detail to manage and wondering why I was yelling.

"No tank." barely spitting out the words through clenched teeth at Kevin. And, before I could say another word, "I'm on it!" And, in a puff of desert sand, he was in motion toward his old unit.

The look on our escorts face was priceless as he realized his authority had been totally and entirely usurped. But, like I said, this wasn't my first rodeo and we were ready for this very scenario. Now, the good news is, no more than an hour later and we had our very own tank rolling in on our position with the best wishes from the commanding officer. The crew was at our disposal for the entire day—and oh, what a day it was! As you can imagine, it was incredibly exciting having the car keys, the crew, and a full tank of gas of the commanding officers personal battle tank. It was quite an experience, and we were all smiles back in the hotel later that night reviewing the day's recordings knowing we'd have a very happy client.

I wish I could report the rest of the trip went off without a hitch, but many times we had to tap into the tenacity of our hired gun. "KEVIN, UP!" was the phrase that we used to secure an LAV-25 (Light Armored Vehicle) and an AAV (Amphibious Assault Vehicle)—two other key vehicles that had been specifically "promised" but somehow became a problem at the last minute. We had 5 days on location, and it had to work and I was never more happy to hand over a hefty paycheck to our personal insurance policy because without him, it would have been disappointing for a lot of people.

Not every field recording trip is this dramatic, of course, but the lesson learned is to be, if anything, over-prepared. While having access to exotic cars, weapons, explosives, and other game-related subjects is a huge part of what we do, the most important part is the ability to record them properly and with high-quality

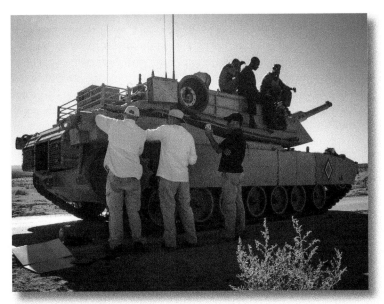

Watson Wu, myself and Kevin Collins placing mics and running cables on the mighty M1A1 Abrams Main Battle Tank for the *Operation Flashpoint: Dragon Rising* recording session.

results. Taking deliberate time ahead of the session will increase your odds of capturing what you need for your project. I can't stress it enough.

Here's a good checklist of things to consider before recording day:

- *Define the objective of the recordings.* Identifying the purpose of the sounds and how they will fit into the production will help get your planning off to a good start. Will the recorded ambience playback in surround? Is the car engine you're recording a "signature sound" that will be front and center in the production? Is the sound meant only as a low-priority item which will be buried under explosions and gunfire? Knowing the sounds importance, priority, and use within the project will determine the amount of effort needed to capture it. Also, knowing whether the sounds will be recorded for a big budget or for a cell phone game will also provide appropriate direction.

- *Define the sounds needed.* Make sure you have a solid list of required sounds before making any plans since these will determine your equipment needs, recording techniques, crew, and location. Most field recordists like to take advantage of the access they have to a subject and will typically record every sound that object can make while it's sitting in front of them. But, a tight budget and schedule can preclude any extra recordings other than what is specifically needed. If you only need to collect static vehicle sounds, for example, then you won't need to worry about how to record the vehicle as it blazes down the road at 100 miles per hour. And, if you did need sounds of an exotic car traveling at high speeds, you'll need to find an appropriate place to make that happen—a safe place where the drivers can open 'er up, that is relatively quiet and within budget. Knowing what specific sounds you need will lead you another step closer to the big day.

- *What is the available budget?* Budget constraints will affect the equipment you rent, the size of your team, the location you use, and a myriad of other factors. Knowing what you have to work with will help balance these factors against obtaining quality recordings and a decent paycheck. Recording in your backyard with your own car is one way to satisfy the needs of a low-budget project. The opposite end of the spectrum will allow for track rental, suped-up vehicles with professional drivers, a team of experienced recordists and top-notch equipment. Either way, your challenge will be to remain within the budget and grab great sounds.

- *What equipment do you have available?* Take inventory of the field recorders, microphones, and all of the accessories you have access to early in the process. Your collection of gear will grow for each project, but only having a Zoom H2 on hand to record gun shots might not have the best results. Factor equipment rental into the budget if you need but exhaust your on-hand gear first in an effort to keep the "to-do" list short. Knowing what you have to work with will help determine recording methods and your plan of attack ready for D-day.

- *Anticipate the recording conditions and scout the location.* Having some idea whether the location of choice will be acceptable is definitely something you need to know before the day you show up to record. Even if you plan to head out to the middle of nowhere, it's no guarantee there won't

be issues. Is it under a busy flight path? Is it a popular area for off-roading? Is there wildlife, especially birds and insects, who might pose noise challenges? If you happen to be renting warehouse or shop space, are there local businesses that might have noisy equipment running? Don't forget the weather forecast too. Rain, wind, or temperature extremes will be a definite factor. Check out your location beforehand, and if you have to, find another place, day, or time to record. If you are stuck with it, though, you'll be a step ahead and can plan accordingly.

- *Plan for necessary staff.* If the field recording session calls for a single person "running and gunning" or several crew members to cover all of the bases, it's a good idea to think the process through and decide in advance. Too many folks standing around tend to be a distraction, too few puts undo pressure on the crew on-site. As a good rule of thumb, make sure each person has a specific duty to perform and reason to be there. One person should be "in charge" as the recording supervisor. Specific recordists who focus on capturing the best audio and handle the gear and should be appointed. Larger sessions might require assistants to set up mics, run cable, and control curious onlookers. Sessions which have an element of danger, such as when recording weapons, explosions, or heavy machinery, it's a smart idea to contract a medic or ambulance service depending on the risk. Additionally, having a consultant on crew who is highly knowledgeable about the subjects you are recording will ensure you get what you came for and are usually worth their weight in gold.

Equipment Choices

Once you have an idea of what you're hoping to record, the equipment you may already have available, the proposed location, a budget, and a crew, it's time to decide what you really *need* to make it all happen. Like a combat unit choosing weapons, ammunition, and supplies based on their mission, developing a mindset that you are in fact heading into "battle" will ensure an excellent probability of success. The choice of microphones, recorders, and accessories can make or break a recording session, and nothing is more heartbreaking than showing up in the field with the wrong gear. Remember, you don't have to own all of the gear you use and it's typically more practical (and cheaper) to rent.

Field Microphones

Microphones come in all shapes and sizes and having the right one pointed at the sound can make a huge difference. The most expensive one isn't always the best choice, and the one that is perfect won't always be practical. Field recording can often be a bit of compromise as you evaluate the conditions, sounds, and equipment, the microphone you pick for any given situation can either solve prevalent issues or make them worse. Remember, sometimes microphones are chosen specifically for what they can't hear rather than what they do.

Let's face it, there are so many types of microphones to choose from that it becomes a real effort to find the right one for each situation. Most field recordists have their "go to" mics, the ones they grab first whether it's because they like the way it colors the sound or because they always have good luck with it. But, until

Using an array of multiple microphones at various distances will give the sound designer plenty of material to create the perfect machine gun sound for the game when back at the studio.

your experience guides you, there are more scientific ways of choosing a useable mic for a given challenge.

Microphone Types

There are basically two distinctions of microphones: "type" and "polarity pattern." "Type" refers to the physical construction and characteristics of the mic, and "polarity pattern" describes how the microphone hears sound. Both have equal influence when deciding what is best for a given situation and should be given close consideration when making your choices.

Types

- Stereo. These types of microphones are designed to capture a stereo image using a standard XY pattern, MS (mid/side), or matched pair configuration. These are great for ambience and sound effects when required in stereo format. Granted, mid/side isn't really stereo, and it's actually an entirely separate recording format, but for the sake of simplicity we'll consider it "stereo."
- Shotguns. From short shotguns to long, mono, and stereo versions, these mics capture a narrow-focused image of whatever sound it is pointed at and reject sound to the sides and rear. These are perfect for recording sound that needs to be brought "closer" or separated from other sounds. Often, these mics can save the day when recording in noisy environments or when you aren't able to physically walk up to the source of the sound.
- General purpose. Utilitarian microphones which can be used in a wide variety of situations, these are great for general sound effects, voice, and any other instances when a mono format is desired.
- Lavalieres. These tiny microphones are designed specifically to capture voice in a variety of situations, but their small size can be useful for other sound-capturing applications when the size of another mic is an issue.

- Dynamic. These mics are generally robust, inexpensive, resistant to moisture, and can handle sounds with heavy attacks, such as gunshots and snare drums with ease. Their sensitivity doesn't allow them to capture quiet sounds well but are great with loud sounds.
- Condenser. Capable of capturing very quiet sounds, these powered microphones are perfect for whispers, quiet ambience, and other sounds where their subtle nuances are desired.
- Miscellaneous. In addition to the standard field microphones, other mics offer solutions to very specific needs. Contact mics record the vibrations of an object and are not susceptible to issues "sound wave"-capturing mics do. Hydrophones are specifically designed to record sounds in liquid. Binaural microphones simulate how a person would hear a sound, typically a "head" and microphones for "ears." Surround microphones have six mics placed in an array to capture sound from each direction for playback on a 5.1 system.

Polarity Patterns

- *Omni-directional.* The omni pattern has an equal response at all angles with a full 360 pickup angle. These mics have a very natural sound and are good if the room or space ambience is desirable.
 Use omni-directional:
 - Where the sound source to microphone distance is small so that the fact that it is nondirectional does not cause a severe disadvantage.
 - Where the source can be very close. This type is less susceptible to popping and no bass boost (proximity effect) from close use.
 - When wind is a significant problem. Pressure-sensitive microphones respond much less to wind noise than directional or velocity-sensitive mics.
 - Because of the requirement for a small size such as a lavaliere.
 - When multiple, spaced omni's are used in one type of stereophonic recording—useful with certain large-scale effects such as a train moving past the array of mics.
- *Cardioids.* The unidirectional pattern is most sensitive to sound arriving from the front of the mic and much less from the rear. The most common type is the heart-shaped pattern and should be used if a more isolated pickup is desired.
 Use cardioids:
 - When the sound field can be differentiated into desired sound coming from one direction and undesired sound from 180° away such as placing a mic near a sound source on a busy street and pointing the mic at the sound and the back of the mic to the street.
- *Super-/hyper-cardioids.* Unidirectional mics come in other variations like the super- and hyper-cardioids. These have a very focused pattern and are used when the source is far away or there is a lot of ambient noise to deal with.
 Use hyper- and super-cardioids:
 - When you want to discriminate against reverberation and have a mic with a relatively small size.
 - Where the source of noise can be placed in the null zone between 110 and 126° from the front and the desired source is on axis such as

on a boom capturing an actor on-mic and placing the camera in the "null"—typically with noisy film cameras.
* These considerations lead to the selection of these mics for boom use.

Use short shotguns:
* For greater discrimination against reverberation and noise at high frequencies, although they are equal in bass and mid-range frequencies.
* When, if the sound source is moving, a boom operator can't accurately aim the mic because of poor off-axis sound.
* The most often used boom microphone.

Use long shotguns:
* For the greatest discrimination against off-axis sound over a wider frequency range than the short shotgun.
* Outdoors and when the sound source is further away than normal.
* Indoor use is not generally recommended because the interaction of the complex polar pattern of this mic type with room acoustics leads to coloration.

Microphone Selection Factors

Unfortunately, it takes much more than simply picking a type and polarity pattern for the perfect mic to stand out—although it is a good start. How do you plan to mount the mic? What are conditions like on location? Are there any weather extremes which might be a concern? Answering appropriate questions which are specific to your mission will help you close in on the right equipment.

* Visible characteristics. The size of the microphone can impact the decision if it must be carried all day or if cramped space requires something small. For example, large microphones are difficult to mount inside of an engine compartment when gathering vehicle sounds under driving scenarios—a lavaliere would make better sense than a long shotgun. Additionally, the method of mounting the mic may be a factor if a shock mount, mic stand, blimp, boom pole, or gaffers tape is used.
* The method the mic uses to change acoustic energy or "sound" into electrical energy. There are advantages and disadvantages to using pressure- or velocity-sensitive mics, especially when wind noise is a factor. Contact mics are an entirely different sort of mic in this respect and are able to capture sounds from an interesting, nonsound wave perspective.
* Directional characteristics (polar pattern). Whether you intend to collect sounds from a full 360° around the microphone or from a focused area, the polar pattern selection is not only chosen because of the direction of the wanted sound but often as a way to minimize any unwanted sounds.
* Susceptibility to wind and handling noise. Wind is by far one of the biggest challenges of field recording and having a microphone which is able to "ignore" its effects can sometimes save the day. Wind covers and other accessories can be effective, but sometimes the right microphone makes all of the difference. Many field mics come with a "low-cut/high-pass" feature as well which can minimize wind and handling noise.
* Coverage of the frequency spectrum without discrimination. Microphones are designed to be as generally flat in their frequency response as possible but due to their construction and circuitry will have bumps or dips in various spots along the spectrum. If the fundamental

frequency you are recording is within the "flat" portion of the mics frequency response, then you can expect no coloration unless that is what you're looking for. Other interesting "features," such as with some lavaliere microphones, have a bump in the higher frequencies to actually compensate for these mics hidden underneath an actor's clothing. Keep this in mind when selecting lavs for sound effects recording.

- Coverage of the polar pattern across the frequencies. Unfortunately, frequency response isn't always consistent throughout the entire polarity pattern of the mic. This isn't so much a concern when using a shotgun mic, for example, but if the desired sound covers a wider area such as in ambience recordings, a better representation can be captured if the frequencies are constant throughout the entire pattern.

- Power requirements. If the microphone of choice requires power, this added condition will need a reliable source. Some mics utilize internal batteries or can be powered from the recorder with phantom power, neither of which will impact a mobile setup other than restricting your choice of recorders. Others that require a separate power supply might influence your ability to stay mobile. Ensure the power requirements don't hamper your capabilities.

- Susceptibility to temperature and humidity. Extreme hot or cold conditions can not only affect the human equation but the gear as well. Batteries tend to become unreliable in cold conditions and equipment that usually runs hot increase the chance of damage or failure. Also, the overall sound and capabilities of a microphone, especially the delicate diaphragm when heated or cooled, can color the sound in ways that can make you cringe. If your location is going to be a challenge, research the equipment that can withstand the temperature and use it.

- Ability to handle loud and soft sounds. Recording sounds with a large dynamic range can test even the most experienced recordists. It's challenging enough to record strictly loud or soft sounds on their own, but when sessions are mixed, such as when recording gunshots and weapons Foley, microphones which can record both equally as well is a plus. Knowing what types of sounds you're heading out into the field to record will ensure you take the mic that can handle both extremes when needed is a good thing.

- Ruggedness. Studio mics are typically more delicate due to their need to capture the smallest nuances of instruments and vocals, and that's not to say you couldn't take some nice large diaphragm condensers to the field if needed, but why bother if the mic can't take the more demanding conditions? Ensure the mic selection is robust enough to handle the journey, being mounted to a vibrating, jostling vehicle, for example, and being knocked around by overly aggressive ninja recordists.

- And finally, how the mic sounds. Unfortunately, how the mic sounds can't always be the first reason to choose one, but it should weigh in as part of your decision. Some mics sound REALLY good no matter what you point them at, and if they meet other criteria in your list, then these should be part of your arsenal. If you have several which are worthy, always choose the one which will capture your sounds the cleanest and in the highest quality because after all, you're reputation and future employment possibilities are on the line.

TOM TODIA

Sound designer, Field recordist

A professional Audio Engineer with experience in the Major label market, Tom has worked with recording artists ranging from Ziggy Marley and Brian McKnight to Jennifer Lopez and Gloria Estefan. Helping him to become a well-versed audio developer, he has handled extensive voice-over and ADR sessions for the likes of Sony and the PGA.

After relocating to Orlando, Tom focused his studies on interactive audio and game audio development. He founded the audio contract company "Engine Audio" whose clients include Electronic Arts, Ubisoft, Zee Gee games, and more. Tom is now a regular blogger in the game audio community and is currently working on a variety of unannounced game development projects.

Gameography:

Tiger Woods Golf (EA)
Madden NFL (EA)
NCAA Football (EA)
Assassins Creed 3 (Ubisoft)
Tiny Planets (Zee Gee Games)
Depth (Depth Game)

www.engineaudio.com

Describe your thought process for creating music and/or sound effects.

I try to create a specific audio tone in my head before starting a project. The esthetic direction of the game visuals is an important element to consider when developing this tone. Some good adjectives that might help frame my direction would be gritty, dark, heroic, suspenseful, childish, retro,

minimal, comical, natural, etc. Without a proper tone, it's difficult to know where to start.

Are there any particular secrets to your creativity?

My secret is that I try to study the best. I am a devoted fan of Walter Murch, and I use his work as a muse for my own. I have always found him to be the great master of nondiegetic sound. Nondiegetic refers to audio that is implied but not connected to anything directly visible in the scene.

Are there any secret techniques that you regularly employ?

The secret to design is the psychology of sound. Enhancing game moments with sound that places the audience in a particular mindset is the key. Silence, for instance, is a way to project fear in the mind of the player. Silence is psychologically uncomfortable for most people.

Do you have any interesting sound gathering stories?

I recently did a weapons recording shoot on some property in central Florida. The property owner was nice enough to allow me to use his land, but I didn't realize how much of an avid shooter he was until we showed up. He brought a host of firearms and ammo to let us use for free, along with some explosives. As a field recordist, that is what I would call a nice surprise.

Do you have any advice which can help lay solid groundwork and ensure a successful production for the audio content creator?

I would suggest that you do your homework on the topic you are about to design. Each type of storyline has its own unique cultural baggage in terms of audience expectation. Not that you should copy others work, but if you are creating a laser sound, there is an expectation that the audience will bring with them. Real lasers do not generate sound, but everyone has watched Star Wars and there is audio baggage that comes with that.

When do you find you are most creative?

Had I been asked this question 20 years ago, I would have said that late night is when I am most creative. These days, I prefer to work early in the morning. A little coffee and daylight seem to be my friends these days.

Any worthwhile creative advice you'd like to share?

I am a huge fan of finding sounds that remind me of what I want the audience to hear, but are not the actual sound itself. I think this comes from playing a lot of charades with my family. I always found the "sound like" trick to be more fun and inventive than going directly for the literal.

Is there a typical workday for you?

I wish there was! No, other than trying to balance my time with work and family life, there isn't anything typical about my workday.

What skills should composers have to succeed in the games industry?

You should enjoy playing and analyzing games. You should study game music and the implementation techniques used to bring the soundtrack to

life. Being a talented composer is an important start, but being immersed in the world of video games is a must to survive in the field.

Do you have a specific ideology which drives your way of doing business?

I suggest looking for people who are (or will be) in need of your production skill. This might sound really obvious, but it must always remain in your thoughts. Companies that are organized and efficient are more likely to finish a game worth buying. Money is, of course, important but so is your work history. We spend a lot of time working on the contracts that we find so you want a finished product that you are proud to showcase.

I insist that the people that I do business with have money. In my early days of game audio development, I was happy to work on a project to gain experience and build credits. Eventually, you have to recognize your own value and put a price tag on it.

Any good business advice to offer?

Create an LLC (or S corp.) and make a solid business agreement between yourself and any partners in your business (if any). Also, hire a good accountant and take their advice seriously. They are worth their weight in gold when it's tax time.

Any horror stories which have impacted how you do business?

No, I must be lucky!

Any specific "lessons learned" on a project which you could share?

I started my career in the music industry. So many of the projects that I loved the most never made it to an audience. This is an annoying reality for game production as well. Most of the time you are unable to show off or discuss an unfinished project because of a Non-Disclosure Agreement. It's frustrating and you have to keep it in perspective.

There are many pitfalls when "working" in the game industry. Have you had any bad experiences?

Offering your services up for too small of a paycheck is something to avoid.

How did you find your way into the games industry?

I have always loved music at a deep level. I knew how hard it was to make it as a professional musician, so I thought I would become an audio engineer instead. There is a joke built into that last statement. Working in a recording studio led me to some sound for film projects. It turned out that I loved sound of all kinds, not just music. I have played games obsessively since the days of the Atari 2600 console. When my lovely wife told me that I was too old to play video games, I decided it was time to turn them into a career. How else could I justify buying more games?

Any other advice you'd like to share?

No, I am running low now.

Field Recorder Choices

In addition to choosing the most practical and highest-quality microphone, the second half of the field recording "equipment" equation is the trusty field recorder. We've come quite a long way in mobile recording technology in just the past few years, and while it might seem to improve the chances of capturing incredibly high-quality audio, it actually makes your choice that much more difficult. As with microphones, there are countless reasons to choose a specific recording device over another, and, of course, it all depends on what you're recording and how you're recording it. Once you've defined your variables, selecting an appropriate recorder may become obvious, but most recordists still prefer to bring more than one type just to be safe.

Recorder Features

Field recorders worthy of making the journey with you can have features from the simple to incredibly complex. In some situations, cumbersome technology can be a bad thing if you have to struggle with settings, inaccessible buttons, and unpredictable recording media, especially when you're constantly in motion. Having plenty of "features" is nice, but if you don't need 'em, why bring 'em? Keeping things uncomplicated will let you focus on the sounds at hand and not the gear.

- Ease of use. There is plenty to occupy your mind during a session, and the gear should not be what monopolizes your thoughts. The Aaton Cantar X, for example, is a great recorder, but requires quite a bit of experience with it before it becomes second nature. Even something as simple as the Zoom H4n, with its submenus can muck up the works and slow things down. Be sure the recorder you choose is a comfortable fit with your thought process, allows you to make adjustments, and swaps out batteries and memory cards easily.

This Sound Devices rig is well-suited for recording all of the subtle details from a variety of weapons on this recent shoot.

- The appropriate amount of recording channels. A two-channel recorder is typically the right amount of tracks for field recording, but there are many occasions where four or more are what you need. First, make sure the recorder you select has the amount of tracks you need, and second, make sure they can all record simultaneously. Some gear may have eight channels, but only record on six channels at once, and some require an additional mixer to even do that. If more than eight tracks are needed, choose a recorder that can link with additional units to give you the amount you need.
- Connections. Selecting a recorder with the appropriate microphone connections is the obvious first concern. But, if you're using external power sources, interfacing with other recorders, a mixer or computer and syncing to time code as well, it becomes imperative the holes match up to the mishmash of cables you plan to plug into them. Conversely, these will directly influence the choice of microphones, cables, and adapters you might need, so make sure everything interconnects properly.
- Phantom power. A recorder with built in 48v phantom power will allow you to connect microphones that require power to operate properly, but, unfortunately, not all portable recorders have this particular feature. As mentioned previously, some microphones allow for batteries within their capsule to cover this, but if your recorder doesn't have phantom power and the mic won't take batteries, an external phantom power supply is the only other option. And often, the mere addition of an external power supply will influence the choice of recorder especially if you're trying to pack light.
- On-board effects. Occasionally, having features such as a limiter, compressor, high-/low-pass filter, or EQ is advantageous to the situation, and if you anticipate needing any of these, make sure they are on the recorder. Limiters can be definite life savers if you get a too aggressive with your gain settings and high-pass/low-cut filters are great for excessive wind noise or handling noise if you need it.
- Pre-roll. Some recorders come equipped with a "pre-roll" feature which lets you grab the sound you thought you missed. Once you engage "record standby," the unit records into a memory buffer of a specific length usually around 6–8 seconds or shorter if a high sample rate and resolution are selected. Once the "record" button is depressed, the buffer is written to the memory card or hard drive until the recording is stopped. The key when using this feature is not to panic or make noise when you realize you're missing the sound—just calmly press record and relax.
- Headroom. Distortion and clipping can make field recordings totally unusable. Some recording gears are designed cheaply and don't quite have the needed headroom to capture forceful sounds cleanly. If loud sounds are on the agenda, ensure the equipment has sufficient headroom to accomplish the task or consider connecting external attenuators (also referred to as "pads") to the recording chain.
- Gain "knob." A knob or fader is key to making smooth gain adjustments while recording, whether you're being subtle or gain riding with wild abandon. Many of the new pro-sumer portable recorders are lacking this vital feature and have instead resorted to noisy blister buttons which can be heard in the recording no matter how careful you are. There are obvious instances, such as when recording ambient tracks, when "set and

forget" is fitting but not having to worry about this additional noise leaking into your recording will let you concentrate on other things.

- File formats. For the best audio quality, high sample rates and resolution are preferred. 44.1 kHz, 16 bit, wav files are the absolute minimum, but nowadays there is a stronger demand for 96 kHz, 24 bit quality, and it is quickly becoming the new standard. Uncompressed file formats such as .wav are also the best way to go, but due to smaller memory buffers or storage capacity, some recorders only allow for compressed formats such as mp3.

Storage Media and Backup Capabilities

How the field recorder stores audio data may be a personal choice but whatever is ultimately chosen must be easily transferred from the device to a computer for editing and archiving. The ability to connect directly to a computer via USB or Firewire and removable media cards are the standard options, but there are still excellent older field recorders which may use DAT, CD/DVD-R, and even mini-discs. On-board hard drives and flash memory cards are the most reliable and the easiest to manage large audio files by a simple drag and drop. DAT tape is still viable, but the huge disadvantage is the "transfer" has to be done in real time by pressing "play" on the DAT and simultaneously recording onto a computer DAW. You might as well go grab some lunch and catch a movie when you do it this way.

Ultimately, you're looking for storage medium fast enough to capture high-resolution audio during the recording process, large enough to hold it all, and the ability to be easily swapped out of the recorder and replaced with minimal down time. Compact Flash (CF) and Secure Digital (SD) cards fit the bill, are plentiful and affordable.

Power Requirements

Field recorders can be incredibly thirsty for power—especially if you're running a multiple, linked unit arrangement. Understanding what your rig needs, how it will consume the energy, how the power might be affected in temperature extremes, and recharging capability will definitely influence what you use and the backup power sources you bring.

Most genuinely portable units will contain internal batteries, either of the replaceable/rechargeable variety or single-use batteries. Some allow for easy, convenient replacement, while others require unhooking cabling, unpacking from their case, and using a tool to open the battery compartment. Most are equipped with an external power connection which is ideal when internal batteries are too difficult to change quickly or if lengthy recording sessions are planned. These systems allow for multiple connections for several pieces of equipment and easy battery changes but can add a bit to your load.

For long recording sessions, plenty of batteries on hand is a necessity. Bringing more batteries than you think you'll need is the smart way to go. Unless you can tap into a power source directly or as a recharging station, "more than enough" is the safest route. Also bring plenty of AA and 9v batteries for powered mics and other gear with hidden power needs.

One of the cruelest jokes mother nature has for us field recordists is the effect temperature extremes have on batteries and the devices they supply. Hot running gear in hot temperatures can play havoc on internal batteries greatly reducing battery life or sufficiently "cooking" the chemicals, so they aren't electrically

reactive at all. Lithium and NiCad batteries work great in extreme cold, but NiCad and NiMH batteries don't recharge correctly in anything lower than room temperature. If your session will take you to either temperature extreme, do a little research in advance to make sure you've the right batteries and enough juice.

Recorder Size

When space or weight isn't an issue, a stationary table full of audio gear will definitely get the job done. But, if you've got to be on the move, which most field recordists are, you want to pack light. In the not-too-distant past, balancing quality audio with compact and lightweight gear used to be a major challenge. The good news though, you'll find a great selection of highly portable equipment on the market these days that will really surprise you.

It's a good idea to consider size and portability when planning for a recording session. Do you have to carry it all day? Will you have to squeeze into tight spaces to grab sounds? Will the external battery system really add that much weight? Will I have any other equipment such as a microphone matrix box, preamp, mixer, or wireless receivers that will add to the weight? Answering these types of questions will help you select an appropriate-sized recorder to go with the rest of what you're carrying.

Ruggedness

I'm not going to compare field recordists to baggage handlers, but it's safe to say that no matter how careful you are with your equipment, stuff happens. During the chaos of packing, getting to the session, setup, tear down, and everything in between, your prized recording unit is going to get some knocks. There are plenty of inexpensive recorders available, but keep in mind they are cheap for a reason. The plastic cases aren't as durable as we'd like, and buttons and access doors tend to break. Add the distraction of "heat of battle" mayhem into the mix and you've got a good chance something is going to get squashed.

If you predict one of those crazy sessions, it's not a bad idea to make certain your recorder of choice is built to withstand it. A sturdy metal chassis is a good start, and an additional production case will not only provide padding and storage space but add a bit of moisture resistance as well. Of course, units such as the Aaton Cantar are designed to operate in rain and messy conditions without one.

If you're recording while walking, running, or in the back of a bouncing pickup truck, also consider shock resistance as part of your decision. No matter how rugged your storage medium seems to be, remember that even CF and SD cards can get jostled and lose connection with the contact points which will introduce a glitch in the file or cause it to be lost altogether. CD/DVD-R, hard drives, and even DAT's can be bumped and mar the recording, so nothing is totally impervious.

Comfort

Finally, lugging around gear with sharp edges, buttons, and switches you have to contort to access or are so small you can't work them, display screens that are difficult to view, cases with abrasive surfaces that rub you in the same spot all day, headphones that squeeze your head like a vise, constantly tangled cables, and any other thing with the potential to annoy you during those day-long outings, are enough to drive you absolutely nuts. Even expensive cases with padded shoulder straps and supple material can literally rub you the wrong way.

Tools of the Trade

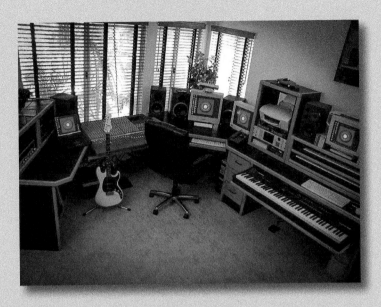

AARON MARKS

Composer, Sound designer, Field recordist

I previously considered myself a mid-level game composer and sound designer, having found my niche with mid-sized developers and online companies, but lately I've been spending a lot of time on AAA projects. Always open to catching the big fish, I gear my mindset and equipment list toward that goal. Previously, I had a collection of gadgets, impressive to studio visitors but basically just taking up rack space and eventually was streamlined to inventory only what is in constant use. If it hadn't been used it in a year, out it went.

Computers: 2 "admin" PCs, 1 "audio-only" PC, and several laptops (for writing and remote audio work). The "audio" PC has 2 soundcards (SoundBlaster LIVE Platinum 5.1 sound card and the Emu 1616 card), dual head video card with 2 displays plus several external hard drives for easy sound effect and sample library access and constant backups

Audio interface: Emu 1616 m interfaces

Software: Sound Forge, Cakewalk Sonar, Adobe Audition, Nuendo, Vegas Pro, ACID Pro, Kontakt, FMOD Studio, and numerous plugins

Multitrack system: *Nuendo, Cakewalk Sonar, Vegas Pro*

Monitors: Event PS8 active monitors and subwoofer, Alesis Monitor Ones, Alesis M1 active monitors, Orb center channel speaker

Outboard: numerous effects processors and compressors

Keyboards, MIDI controllers, and sound modules: Alesis QS8 with various Q-cards, Akai S5000 sampler and extensive sample library (yes, I still

have use for an external sampler!), Roland Juno 106, Kawai K-1, Kurzweil MicroPiano, Akai AX-80, and an Axiom 25

Instruments: Electric, Acoustic and Bass guitars, Roland TDK-7E electronic drum set, standard acoustic drum set, numerous hand percussions, coronet, saxophone, flute, kazoo

Microphones: Rode K2, NT2000, NT4, NTG3, NTG2, M1, AT4047, Shure SM57, Countryman B3

Remote recording: Fostex FR2, Tascam DR-680, Zoom H2, M-Audio Microtrack, laptop, and occasionally a really long microphone cord

Sound effects libraries: Sound Ideas, Hollywood Edge, Hanna Barbera, Warner Bros, LucasFilm, BBC, etc. and of course, my own custom collection

Yes, we are adventurous souls. Yes, we are all tough and eat nails for breakfast. But even the smallest rash or blister will distract you and take energy away from your recording session. Keep comfort in mind when selecting gear and accessories unless you feel it's necessary to suffer for your art.

Accessories

Microphones. Check. Field recorder. Check. Batteries and storage media. Check. Forgetting anything? You bet. In-studio recording is nothing close to the logistical nightmare field recordists can face. If something breaks in the studio, it's usually an easy matter of grabbing a new one out of the closet or worst case, a quick trip to the local music store. If something breaks in the field, of course, it gets a

These field recorders were chosen for their small sizes, ruggedness and comfort as well as for the variety of captured sounds and redundancy. Watson Wu, Nathan Smith and myself pictured here in the California high desert.

bit more complicated. So, when packing for the field, consider all of the possible things that can go wrong and prepare accordingly.

Here's a quick checklist to contemplate when accessorizing your field recording kit:

- Backup recorder—it doesn't have to be a duplicate of your main recorder but definitely something that can also get the job done in a pinch.
- Backup mics—in case your main microphone gets damaged or if the situation dictates the use of another kind of mic, bring some spares.
- Shock mounts—bring spare suspension bands and any extra usable shock mounts just in case you need to hang another mic.
- Wind covers—bring everything you have, softies, blimps, fuzzies, and high wind covers since you never know which way the wind will be blowing.
- Mic stands/boom poles—for stationary mic placement or extra reach.
- Cables—cables fray and connections loosen. Have plenty of extras on hand.
- Snake—multiple mic inputs with long runs can be easily managed with one of these.
- Pads/in-line attenuator—assuming the microphone itself isn't overloaded, in-line pads will reduce the signal strength to a more manageable level for the recording device.
- Parabolic reflector—boom pole not long enough and the shotgun mic isn't receptive enough? A parabolic reflector will bring that specific sound closer.
- Location sound logs—you need to keep track of what you're recording and the settings you're using.
- Gaffer's tape and cable ties—cables and microphones need to be secured to reduce cable noise and tripping hazards.
- Bungee cord/carabiners—to organize multiple cables and reduce tripping hazards.
- Spare mechanical parts for boom, blimps, and mic stands—things break or wear out at the worst times.
- Tools—small screwdrivers, needle nose pliers, knife—whatever you can grab.
- Soldering iron and solder—for field expedient repairs.
- First aid kit—man versus nature repair.
- Spare batteries/battery charger—don't even think of getting caught without power.
- Power converter—12 V to 120 V converters will let you plug into your cars cigaret lighter and have usable power.
- Headphones—spare headphones are a definite must.
- Ear plugs—attenuating loud sounds underneath your headphones isn't a bad idea when recording weapon shots, explosions, or any other ridiculously loud noises. Protect your hearing at all cost!
- Gloves—trust me on this one.
- Appropriate adapters—everything has to plug in to something. Plan for your primary and backup recording setup to work properly.
- Water, food, shade, etc.—not so much part of your "kit" but something to think about and definitely nice to have if you need it.

A quality suspension and windscreen is essential when using microphones while on the move.

Once you've got everything assembled, the absolute last but most vital item on your checklist is to hook everything up and make sure it actually works. I can't stress this enough—test your gear BEFORE heading out to the field charge the batteries, connect the mics and cables, make a test recording, and anything else you deem appropriate. The goal is *not* to find out your stuff isn't working when it's too late to do anything about it. Gear that's been laying around in the closet, rental equipment that landed unceremoniously on your front door step that morning, and even the rig from yesterday's recording session can stop working for any number of reasons. Damage, incompatible batteries or media cards, and altered settings can happen at any time, so make sure you've got a fighting chance.

Recording Techniques

Field recording can be highly unpredictable. Loud sounds, soft sounds, and sounds with a large dynamic range are possible at pretty much any time. Different microphones capture different nuances of the same sound, some sounds need to be close mic'd and others need be captured from a distant perspective. After the large investment in time and money to get to the location with the gear, it's wise to ensure your time is well spent and a variety of recording techniques can be employed to double your chances of capturing brilliant takes.

Two-Channel Recording Methods

- Record the same signal from one or more microphones. A single mic, a pair of them, or an array of several through a mixer running to both channels is a great way to ensure you can capture sounds you haven't been able to sound check, unexpected sounds, or sounds which are both soft and loud. While this method provides redundancy, recording each channel at a different line level will give the editor two versions of the same recording to choose from. By having a 10–15 dB level difference

between channels, you are protecting for distortion with the lower one and allowing the softer sounds to be recorded at healthy levels with the other. Either way, you'll have a pick of channels to use during the editing process and can use the best one.

- Record a left/right stereo pair from a stereo mic. There is definitely something to be said for realistic sound recordings and aside from binaural recording, stereo is the preferred method. As humans, we are used to hearing simultaneous versions of the same sound. Unless you have a specific reason to record in mono, stereo recording gives you more options since you can always make a stereo recording mono, but not a mono recording into a stereo one very believably. The only drawback by using this method is both the left and right channels must be used together, instead of as separate mono channels as in the first example.
- Record "dual mono." This method uses two different mono microphone sources recorded on separate channels and provides protection against the issues each type of the mics can have as well as providing redundancy. Shotgun and lavaliere mics, for example, are both great for recording, but each has their own issues to overcome. By recording both, it gives the editor the greatest flexibility to use the channel which has the best volume, timbre, and perspective. And most of the time, the "best" sound typically comes from a mix of both sources.

Multichannel Recording

Not every occasion calls for a multichannel recorder, but when it does, the added tracks can give you the greatest flexibility. As with the two-channel techniques, redundancy is easily obtained and the chances of capturing the perfect recording are increased exponentially. The same techniques can be employed on a wider scale or mixed with multiple available tracks for the same reasons mentioned before. But, by adding those extra channels to your recording device, you now have the ability to capture multiple perspectives of the same sound limited only by the number of channels and microphones. You can record in surround for an incredibly realistic perspective. And, you can also pick up a multitude of sounds happening at once such as recording an exotic car from the engine, exhaust, interior, suspension, and tire locations, for example. Multichannel recorders will also allow for audio slating and running any time code to a separate track if needed. There are many advantages to having a multichannel recorder in your arsenal and definitely something to keep charged up and ready to roll at a moment's notice.

Production Agreements

It's obvious the equipment and techniques used in field recording are a bit different than what game composers and sound designers operating a studio environment are used to. What's also different is the type of agreements and contracts you'll encounter when working as a field recordist for a game project. We talked about contracts for music composition and sound design in earlier chapters, and you would think that all game-related "work for hire" agreements would be similar, but even I've been surprised almost every time I've been hired for this type of work.

Watson Wu (center) giving subtle orders during a recent field recording session while Chris Latham (right) awaits his instructions. Note the multiple field recorders and array of microphones deployed for this weapons recording session. (Courtesy of Watson Wu.)

Production agreements for field recording can run the gamut from informal arrangements where no actual contracts are signed to a full on, lawyer-influenced document where every point is meticulously discussed. I've done projects where all that was said was "I'll pay you $1000 to record as many farm animals that you can in 2 days."—basically a gentleman's agreement between two parties where I "sold" them some recordings and they paid me. There was no official contract, no lawyers, no formality, but it was still paid work. On the other end of the spectrum, I've had 10-page documents spelling out every little detail, transfer of rights and ownership, payment, and everything else in between for a week-long expedition that took months to prepare for. This little corner of game audio still feels a little like the Wild West where anything goes but as always, make sure your interests are covered and you get paid for your efforts.

The companion website (www.crcpress.com/cw/marks) has the below field recording contract example you can use as a template, feel free to customize as necessary to fit your specific project. Whether you use something like this or a "letter of intent" in the form of an email, both can and should be considered a legally binding agreement to both parties and taken seriously. Obviously, points which are important to both sides should be covered, but at a minimum, ensure that these specific items are addressed:

- The list of sounds to be recorded and delivered
- The agreed upon fee for services, logistics, and final sound files
- Ownership and rights to the recorded sounds
- The timeframe in which the sounds will be recorded and delivered
- The final delivery format and whether they will be edited/complete sound effects or raw recordings
- Payment

With these basic details laid out and negotiated, both parties will know what is expected and there will be little chance of any misunderstanding—and that's just the way we like it.

Interview

WATSON WU
Composer, Sound designer, Field recordist

Watson Wu is an American composer, sound designer, and field record-ist. At the age of 11, he started classical voice training then later on classical piano. During junior high, music became a passion which Watson wanted to make a career of it after completing school. This was fueled when a professor visited his high school advanced chorus class and offered him a music scholarship to attend Miami Dade College, then later on to Florida International University. Since 2001, Watson has been in the business of creating audio content for video games, film, TV, and ads. He and his team have worked on AAA titles such as *Assassin's Creed, Transformers, NCAA Football, Madden, The Need for Speed* franchise, *Red Orchestra 2, Operation Flashpoint, Warhawk,* and many others. Some of Watson's other credits include *Lexus, Guts|Glory|Ram, Daniel Craig's A&E Documentary, 71 (the movie), The Voice, G4TV, It's Me or The Dog, Australia's Got Talent, NBA, NHL,* and a U.S. Army ad.

www.WatsonWu.com

Do you have any interesting sound gathering/sound creation stories?

For a *Transformers* game, I was contracted to field record various exotic cars, muscle cars, and trucks. During the recording of a customized twin turbo Corvette with over 1000 horsepower, one of my mics was completely melted. I was a bit miffed and had to cancel the now ruined day. After replacing the mic (on a different day), we decided to remove the engine hood to shave off another hundred or so degrees. Everything worked out the second time around.

For *Assassin's Creed*, I was contracted to field record full-scale cannons, and consequently, a secondary fireball toasted one of my mic blimps. The really expensive mic would have died if it wasn't housed in a high-quality blimp!

From these mishaps, I've learned to bring more than enough high-quality gear, so I can continue my sessions without much interruptions. I figured this is better than going home in shame without the needed sounds.

Do you have any advice which can help lay solid groundwork and ensure a successful production for the audio content creator?

You have to have good equipment, more equipment, and backups to ensure good-quality work. I often read my briefs over and over again to make sure that I'm on task. You have to have a solid foundation before jumping into work. It's too easy to get distracted.

Do you have any interesting sound design creation techniques which affect the type of sounds you create?

To create interesting sound design, it's important to have multiple options such as an abundance of raw files, Isotope RX, Waves and other plugins, layering of sounds, and trial and error from mixing.

When do you find you are most creative?

The motivation or the fear of a fast-approaching deadline sometimes sparks my creativity. During my early years, some of my best sounds were created late at night. Recently, it has been both late evenings as well as early mornings. Learning to improvise has been very helpful with my compositions.

Creativity is spontaneous, so I always have a small "Always With Me" field recorder to capture raw recordings (it would be great, but I can't carry my Sound Devices recorders and mixers every day). I just love to collect my own recordings. The more I have, the better and easier I can create sound effects.

Over time, and many professionals can agree to this, your creativity process can be turned on and off like a switch, especially during crunch modes.

Any worthwhile creative advice you'd like to share?

To be creative, surround yourself with creative people as well as creative items such as art.

Is there a typical workday for you?

My workdays depend on the project(s) I'm working on. It can be a combination of field recording, then designing sounds. It can be a full day or week of recording gun or car sounds to writing and recording music. It's never the same.

What skills should composers have to succeed in the games industry?

Composers in the game industry should be able to make changes to their tracks without being too attached to their creations. They should be able to easily apply key changes, do a different cadence, alter instruments, improvise, etc.

Do you have a specific ideology which drives your way of doing business?

I believe that treating people with respect and kindness will ultimately pay off. Word of mouth is *The Best Way* to acquire more work. Fortunately, I

have had multiple contract jobs where I didn't have to get involved in bidding wars. People who know me know I love playing and working on games and am also very excited to work on many other types of projects.

Any good business advice to offer?

Be honest with your client as well as with yourself. Can you really do the job? What does your client really need? How can the client benefit from your skills/talents? Most important is that you have to love video games!

Any horror stories which have impacted how you do business?

I've had a few jobs where I've stretched myself too thin. Since then, I've brought in other professionals when the work load is just too much to handle by myself.

How do you approach negotiations with a new client?

I try to probe the client and see what kind of budget they have. If a client has never dealt with what I do, I will educate them on how the entire process works. Using real examples from past projects really helps.

Do you have any negotiation tips which work well for you?

When a client wants a quote, I first find out what my costs are. From there, I add in what will satisfy me and what will overly satisfy me. When working in the dark, I will ask for an amount "range," so they don't have to give out secrets. I recommend reading books such as *Rich Dad, Poor Dad, The Millionaire Next Door, Joe Girard*, and others alike for negotiation tips.

Do you have any contract stories which others could learn from?

I have had a few potential jobs that I was prepared to walk away from, and I've actually walked away from a few—the negotiators were quite unreasonable. Sometimes, it isn't worth it when you have to deal with very difficult and stubborn people who mistreat you. Also, don't ever let anyone pressure you to sign a contract unless you have the time to understand the entire agreement.

Do you have any tips when working with developers?

Developers want to work and quite often want to get to the point. During the development of *Transformers*, I had conversations with the audio lead after each of the delivered vehicle recordings. When something unclear was communicated to me, I would ask for examples. "Can you mouth the sound of the revs, when you ask for more revs? Do you want high-sustained revs or up and down revs being done for a minute?" Constant communication is always the key to success.

What advice can you give when working with a developer which has ensured a good working relationship and a good final product?

It's always too wise to ask questions such as "Am I on task or is there something else I can do to ensure that we're on the same page?" DO NOT ASSUME you're on task unless they say so.

I take on jobs that I like and it's natural then for me to compliment the work these developers have done. If you can, don't work on jobs that you dislike.

What advice can you give when working with a developer to ensure you are able to make great sounds?

Ask as many questions as you can. Write down and/or record the answers to make sure you're both on the same page. Also, reserve more variations that may work better according to the in-game environment. I worked on a project where I had to design some gun sounds. The producer loved what I did, however, later on it didn't do so well in the game. He came back and asked for gun sounds with minimal echoes. With the reserves I had, I was able to quick edit new files for him. He was in heaven!

Have you ever had any development issues negatively influence your workflow?

During a composition bid, the audio director told me to write a demo in a particular style. His superior hated it, so I lost that job. This is also true in the middle of some jobs I've worked. Find out who the "yes" man is and what style(s) of music they like.

Do you have any advice to ensure successful audio implementation?

Successful implementation means that the audio doesn't annoy anyone. Only "Go Over The Top" when you are told to do so or have permission to do so.

Staying organized is important, especially if you are working on multiple projects, which is part of your daily routine. How do you keep up with it?

I often use Excel and a calendar to plan out milestones. With everything typed out, I can review and check off the items to ensure that I'm accurate and on time.

Any specific "lessons learned" on a project which you could share?

When I was working on my first few large-budget field recordings of guns, I wished I had budgeted more ammunition as well as additional working days. Spontaneous bad weather almost ruined my session. With more ammunition and days, I could have had more chances to capture all of the recordings that we needed. Just enough is not good enough. More is better!

There are many pitfalls when "working" in the game industry. Have you had any bad experiences?

Make sure you REALLY want to work in this industry. It takes a special person who can work super long hours, be able to tolerate office politics, and be able to listen the many hours it takes to write/record music, create sound effects, direct VO sessions, and field record 16 to 18 hours per day.

My lessons were from learning everything the hard way. There weren't any new media composition or field recording courses when in college, so I learned everything on my own.

How did you find your way into the games industry?

I found my way into the industry by reading two publications. First was a music production magazine featuring composers who were making a living writing music for games. Second was the first edition of *The Complete Guide to Game Audio*. I followed their advice, attended both GDC, E3 events, joined organizations, and worked hard to get here.

Any other advice you'd like to share?

If someone says "No" to you (for a job or contract work), "No" really just means "not today." Don't ever give up when you get turned down for a job. Every professional has had their rough days, and you're no different from them. If your chops are really good, then keep going! Just please, please, don't stalk anyone. My friends Chris Rickwood, Aaron Marks, and others didn't get here overnight. It took years of hard work and sacrifice to get to where you want to be.

Production Agreement

This Production Agreement (this "Agreement") is made and entered into as of the _____ day of _____ 20____ (the "Effective Date" hereinafter) by and between:

Company A, Inc., whose principal place of business is at _____ (hereinafter referred to as "**Company A**"); and

Company B, LLC, whose principal place of business is at _____ (hereinafter referred to as "**Company B**").

Company A and Company B shall individually be referred to as a "Party" and collectively as the "Parties."

WITNESSETH:

WHEREAS, Computer A develops computer games and software; and

WHEREAS, Company B desires to provide certain sound effects to Company A for incorporation into Company A's games and Company A desires to purchase same from Company B.

NOW, THEREFORE, in consideration of the mutual covenants and other terms and conditions contained herein and other good and valuable consideration, the sufficiency and receipt of which are hereby acknowledged, the Parties hereby agree as follows:

1. DEFINITIONS
 In this Agreement, unless the context otherwise requires, the following terms shall have the indicated meanings;
 1.1 "Business Days" shall mean any day other than a Saturday, Sunday, or a legal holiday in the United States.
 1.2 "Intellectual Property Rights" shall mean any and all (by whatever name or term known or designated) now known or hereafter existing (a) rights associated with works of authorship throughout the universe, including, but not limited to, copyrights (including, without limitation, the sole and exclusive right to prepare "derivative works of the copyrighted work and to copy, manufacture, reproduce,

distribute copies of, modify, perform, and display the copyrighted work and all derivative works thereof), moral rights (including, without limitation, any right to identify of authorship and place any limitation on subsequent modification), and mask works; (b) rights in and related to the protection of trademarks, service marks, trade names, and goodwill (including, without limitation, rights of publicity, merchandizing rights, and advertising rights); (c) rights in and related to the protection of trade secrets and confidential information; (d) patents, designs, algorithms, and other industrial property rights and rights associated therewith; (e) other intellectual and industrial property, and proprietary rights (of every kind and nature throughout the universe and however designated) related to intellectual property that are analogous to any of the foregoing rights (including, without limitation, logos, rental rights, and rights to remuneration) whether arising by operation of law, contract, and license, or otherwise; (f) registrations, applications, renewals, extensions, continuations, divisions, or reissues thereof now or hereafter in force throughout the universe (including, without limitation, rights in any of the foregoing); and (g) rights in and related to the sole and exclusive possession, ownership, and use of any of the foregoing throughout the universe (including, without limitation, the right to license and sublicense, assign, pledge, mortgage, sell, transfer, convey, grant, gift over, divide, partition, and use (or not use) in any way any of the foregoing now or hereafter including, without limitation, any claims and causes of action of any kind with respect to, and any other rights related to the enforcement of, any of the foregoing).

1.3 "Production Fee" shall mean US $_____.

1.4 "Work Product" shall mean the sound recording work described in Section 2.1.

2. SERVICES

2.1 Company B shall create the audio recordings of _____ in accordance with the following settings and specifications: _____

3. DELIVERY

3.1 Company B shall deliver the Work Product to COMPANY A by _____ (date).

3.2 Company B shall deliver the Work Product to COMPANY A as: _____ (ex. 96,000 kHz, 24-bit, stereo, .wav format)

4. EVALUATION

4.1 COMPANY A shall evaluate Work Product delivered by Company B and notify in writing of the evaluation result within fifteen (15) Business Days from the date when said Work Product is delivered to COMPANY A. COMPANY A shall be deemed to have approved the Work Product on the last day of the said period of time if it fails to notify Company B in writing of the evaluation result within the said period.

4.2 In case the Work Product is not approved, Company B shall redeliver corrected version of the Work Product based on the new instructions

of COMPANY A within the period to be determined by the Parties depending on how serious the deviations are.

4.3 The procedure stated under this Article 4 shall repeat until COMPANY A is satisfied with the Work Product and the Work Product is approved by COMPANY A.

5. INTELLECTUAL PROPERTY RIGHTS

5.1 Company B acknowledges and agrees that all Intellectual Property Rights created under this Agreement will be the sole and exclusive property of COMPANY A. The Parties agree that all Work Product was specifically commissioned by COMPANY A as work made for hire. If any Work Product or any portion thereof is determined not to be a work made for hire, Company B hereby irrevocably assigns to COMPANY A in perpetuity throughout the universe, all right, title and interest of Company B in and to such Work Product, including without limitation, the adaptation right, the right to prepare derivative works, the complete right to exploit or otherwise use such Work Product, and all other Intellectual Property Rights embodied in or pertaining to such Work Product. To the maximum extent permitted by law, Company B hereby waives all "moral rights" with regard to the Work Product created pursuant to this Agreement.

5.2 Company B agrees that it shall not at any time including any time after expiration or termination of this Agreement attempt to register, assert, or claim any interest in the Work Product or any work similar to the Work Product.

5.3 Company B shall ensure that all third parties who work on the Work Product execute, before providing such services, an agreement which shall include a promise to maintain confidentiality as required by this Agreement and which includes an assignment to Company B of all Intellectual Property Rights in such work, and Company B hereby assigns to COMPANY A all such Intellectual Property Rights to COMPANY A.

6. PAYMENT OF PRODUCTION FEE

6.1 Company B will send invoice of the Production Fee to COMPANY A for the Work Product within ten (10) Business Days after COMPANY A gives its final approval for the Work Product pursuant to Section 4.3 and COMPANY A shall pay the Production Fee to Company B on the 10th of the following month ("Payment Day"). If the Payment Day is not a Business Day, such payment shall be due by the following Business Day. The Payment shall be made by wire transfer to an account designated by Company B.

6.2 With respect to any and all Payments to be made by COMPANY A under this Agreement, if any bank fees arise, COMPANY A shall bear all related bank fees charged by US bank institutions and Company B shall bear all related bank fees charged by US bank institutions.

7. TERMINATION

This Agreement may be terminated by either party ("Terminating Party"), without prejudice to any other rights or remedies, only for cause by providing a prior written notice to the other Party ("Breaching Party") with immediate effect, if any of the following events should occur:

a. If Breaching Party fails to make any payment to the other when due under this Agreement and such failure continues for more than fourteen (14) calendar days after receipt of written notice specifying the default.

b. If Breaching Party fails to perform any of the provision of this Agreement which failure remains uncorrected for more than thirty (30) calendar days after receipt of a written notice specifying the default.

c. If Breaching Party files a petition in bankruptcy, or a petition in bankruptcy is filed against it, or becomes insolvent, bankrupt, or makes a general assignment for the benefit of creditors, or goes into liquidation or receivership.

d. If Breaching Party ceases or threatens to cease to carry on business or disposes of the whole or any substantial part of its undertaking or its assets.

e. If control of Breaching Party is acquired by any person or group not in control at the date of this Agreement.

8. REPRESENTATIONS AND WARRANTIES

8.1 Company B hereby represents and warrants to COMPANY A as follows:

a. Company B is a corporation duly incorporated, validly existing and in good standing under the laws of the United States of America and is fully authorized to carry on its business as it is now being conducted and to enter into the transactions herein set forth. Company B has all requisite power and authority to execute this Agreement and carry out all the actions required of it herein. This Agreement is a legal, valid, and binding agreement of Company B enforceable against Company B in accordance with its terms, subject to bankruptcy, insolvency, reorganization, and similar laws of general applicability related to, or affecting creditor's rights generally, and the general principles of equity.

b. The execution, delivery, performance of, and compliance with this Agreement, or any agreement or instrument contemplated hereby, by Company B will not result in any violation of its organizational documents, or be in material conflict with, or constitute a default in any material respect under the terms of any agreement, instrument, judgment, decree, or, to the knowledge of Company B, any order, statue, rule, or governmental regulation applicable to Company B, or result in the creation of any lien, charge, or encumbrance of any kind or nature against the assets of Company B.

8.2 COMPANY A hereby represents and warrants to Company B as follows:

a. COMPANY A is a corporation duly incorporated, validly existing, and in good standing under the laws of the United States and is fully authorized to carry on its business as it is now being conducted and to enter into the transactions herein set forth. COMPANY A has all requisite power and authority to execute this Agreement and carry out all the actions required of it herein. This Agreement is a legal, valid, and binding agreement of COMPANY A enforceable against COMPANY A in accordance

with its terms, subject to bankruptcy, insolvency, reorganization, and similar laws of general applicability related to, or affecting creditor's rights generally, and the general principles of equity.

b. The execution, delivery, performance of, and compliance with this Agreement, or any agreement or instrument contemplated hereby, by COMPANY A will not result in any violation of its organizational documents, or be in material conflict with, or constitute a default in any material respect under the terms of any agreement, instrument, judgment, decree, or, to the knowledge of COMPANY A, any order, statue, rule, or governmental regulation applicable to COMPANY A, or result in the creation of any lien, charge, or encumbrance of any kind or nature against the assets of COMPANY A.

9. INDEMNIFICATION

Company B shall indemnify and hold COMPANY A and its affiliates, directors, officers, employees, and agents, harmless from and against any and all claims, losses, liabilities, costs, and expenses (including legal fees and costs) reasonably incurred by COMPANY A arising out of or related to any claim or action alleging the Work Product used and/or released by COMPANY A infringes the Intellectual Property Rights of any third party.

10. CONFIDENTIAL INFORMATION

10.1 "Confidential Information" shall mean any and all nonpublic information related to a Party (the "Disclosing Party") or its businesses, other than information expressly designated by the Disclosing Party as "NON-CONFIDENTIAL," which is directly or indirectly disclosed by the Disclosing Party to the other Party ("Receiving Party") or comes to the Receiving Party's knowledge in the course of the contact and communications for the purpose of this Agreement, regardless of the form in which it is disclosed. "Confidential Information" includes, without limitation, any information in tangible or intangible form, which relates to any research project, work in process, released or unreleased software or hardware product, or future product development plan of the Disclosing Party or any other matter relating to the Disclosing Party such as the Disclosing Party's engineering, manufacturing, marketing, business plans, strategy, servicing, financing, or personnel matters, and includes, without limitation, any know-how, data, process, technique, design, drawing, program, formula or test data, trade secret, prices, techniques, algorithm, and computer program (source and object code), which relates to the Disclosing Party, its present or future products, sales, suppliers, clients, customers, employees, investors, or business, whether in oral, written, graphic, or electronic form, and any information received from others that the Disclosing Party is obligated to treat as confidential.

10.2 Access to Confidential Information received by the Receiving Party shall be limited to those employees with a bona fide need to know, but only to the extent necessary in connection with this Agreement.

10.3 The Receiving Party shall not disclose Confidential Information to any third party without the prior written consent of the Disclosing Party. The Receiving Party shall use the same degree of care in

keeping Confidential Information confidential as it uses for its own confidential information of a similar nature. The Receiving Party shall not use, copy or summarize any Confidential Information except for the purpose of performing its obligations and exercising its rights set out in this Agreement.

10.4 The following shall be exceptions to the obligations under this Article 10:

a. If the information is now or later enters the public domain through no act or omission on the part of the Receiving Party; or

b. If the information was known to the Receiving Party at the time of its disclosure or becomes known to it without breach of the obligations under this Agreement; or

c. If the information is independently developed by the Receiving Party; or

d. If the information is disclosed by the Disclosing Party to a third party without restrictions on such party's rights to disclose or use the same; or

e. If the information is disclosed by the Receiving Party pursuant to judicial order, a requirement of a governmental agency or by operation of law; or

f. If a prior written consent is obtained from the Disclosing Party for the disclosure of the information; or

g. If the information is disclosed by the Disclosing Party to the Receiving Party after written notification by the Receiving Party that it will not accept any further Confidential Information in confidence.

10.5 Upon termination or expiration of this Agreement for any reason whatsoever, each Party shall promptly deliver to the other Party any and all tangible Confidential Information belonging to such other Party, including, without limitation, any data files and materials, letters, notebooks, reports, and other work materials related to the business of the other Party (including all copies of such Confidential Information) that are in its possession, custody, or control. This Section 10.5 shall survive the expiration or termination of this Agreement for any reason.

10.6 The Parties hereto shall be bound by this Article 10 for a period of _____ years from the termination or expiration of this Agreement, and thereafter all of the obligations hereunder shall cease and neither party shall be under any of such obligations whatsoever to keep Confidential Information confidential.

10.7 The Disclosing Party hereby represents that, to the extent of its knowledge, Confidential Information does not contain the confidential or proprietary information of any third party.

11. FORCE MAJEURE

Neither Party shall be liable to the other Party for any delay or failure in the performance of its obligations under this Agreement if and to the extent such delay or failure in the performance arises from any cause or causes beyond the reasonable control of the Party affected including, but

not limited to, acts of God; acts of government or governmental authorities; fire, storm, flood, or earthquake; war (declared or not), rebellion, revolution, or riots; strike or lockouts.

12. ASSIGNMENT

Either Party shall not assign or transfer this Agreement, or rights or interests under this Agreement without the prior written consent of the other Party. Any assignment or transfer without such consent shall be null and void.

13. Term

This Agreement shall be in force on the Effective Date and, unless sooner terminated pursuant to Article 7 ("Termination") hereof, shall continue in effect for a period of _____ months from such date.

14. GOVERNING LAW

This Agreement shall be governed and construed in accordance with the laws of _____ (state/country) without reference to the principles of conflict of laws thereof.

15. ARBITRATION

In the event of any claim, dispute, or controversy, which may arise among the Parties and be notified in writing ("Dispute Notice"), out of, or in relation to, or in connection with the interpretation or performance of this Agreement or any of the terms hereof, or a breach hereof ("Dispute"), the Parties hereto shall promptly conduct discussions and negotiations in good faith with a view to resolve such Dispute effecting as nearly as possible the intent and purposes of the Parties hereto. Any resolution of such Dispute shall be set forth in a writing signed by the Parties. If such Dispute cannot be satisfactorily resolved by the Parties themselves through friendly consultation within a period of thirty (30) calendar days after the Dispute Notice, such Dispute shall be finally and exclusively settled by binding arbitration in accordance with the Rules of the United States Commercial Arbitration Board. All arbitration proceedings and briefs filed in connection with the arbitration shall be in English. Judgment on the award rendered by the arbitrator(s) may be entered in any court having jurisdiction thereof. Notwithstanding the foregoing, the Parties may apply to any court of competent jurisdiction for injunctive relief (including but without limitation to temporary restraining order, preliminary or permanent injunction and other equitable and provisional relief as deemed necessary).

16. AMENDMENT

Except as otherwise provided in this Agreement, this Agreement can be amended or modified only by a written instrument signed by both Parties hereto.

17. ENTIRE AGREEMENT

This Agreement constitutes the entire agreement between the parties hereto concerning the subject matter of this Agreement and supersedes any prior written or oral agreements between the parties hereto.

18. SEVERABILITY

If any provision of this Agreement is subsequently held invalid or unenforceable by any court or authority agent, such invalidity or unenforceability shall in no way affect the validity or enforceability of any other provisions of this Agreement.

19. Survival

Unless stated otherwise, the provisions of Articles 5, 9, and 10 shall survive the termination and/or expiration of this Agreement.

20. NO WAIVER

No failure or delay of either party to require performance by the other of any provision of this Agreement shall in any way adversely affect such party's right to require full performance of such provision after that. No waiver by one party of a breach of any provision of this Agreement shall be taken to be a waiver by such party of any succeeding breach of such provision.

21. NOTICES

All notices, demands, requests, consents, or other communications hereunder shall be in writing and shall be given by personal delivery, by express courier, by registered mail with return receipt requested, or by facsimile or email, to the Parties at the addresses shown below, or to such other address as may be designated by written notice given by either Party to the other Party. Unless conclusively proved otherwise, all notices, demands, requests, consents, or other communications hereunder shall be deemed effective upon delivery if personally delivered, three (3) days after dispatch if sent by express courier, ten (10) days after dispatch if sent by registered or certified mail with return receipt requested, or confirmation of the receipt of the facsimile by the recipient if sent by facsimile.

To Company A, Inc. To Company B, LLC

_____ _____

_____ _____

_____ _____

IN WITNESS WHEREOF, the Parties hereto have caused this Agreement to be executed by their duly authorized representatives as of the Effective Date, each party retaining one (1) copy thereof, respectively.

Company A, Inc. Company B, LLC
By: By:
[signature] [signature]
Name: Name:_____
Title: Title:_____

Tools of the Trade

CHRIS RICKWOOD

Composer

My studio is a haven for content creation. Over the years, I've slowly accumulated a ton of expensive tools that I rarely use. So, now I've been actively stripping down the tools I use to the point where I can take my complete system anywhere I go. All my core computers now fit into one laptop backpack.

Computers: Macbook Pro—A fully loaded Macbook Pro serves as my main machine (crazy, right?). I have two portable drives that have all of my projects and meat and potatoes libraries on them. This allows me to work anywhere in the world

ASUS ROG laptop: A fully loaded gaming laptop to run all of the game builds I'm working on. This too allows me to be fully mobile

Rack mounted PC slave: A ridiculously specced machine (for 2015) that is connected using Vienna Ensemble Pro. 16 core i7 with 64 GB of RAM and obscene amounts of SSD storage hosting all of my orchestral sample libraries. I haven't come close to maxing this thing out yet, so it should last at least another year. If I absolutely had to, I can take this with me in a travel rack

Audio interface: RME UFX

Software: Logic Pro X for music, Ableton Live for sound design, Reaper 5 for high-speed sound editing, Sample Manager for batch processing

Monitors: 5 JBL LSR4326 with subwoofer for surround monitoring, Avantone MixCubes

Sound modules/VST instruments: Native Instruments Komplete—especially Kontakt and Reaktor, Fabfilter, SoundToys, GRM Tools, u-He Uhbik,

Valhalla reverbs, Sonnox Inflator and Limiter, McDSP Analog Channel, MOTU Mach 5, All major sample libraries

Keyboards: Yamaha KX-88, Keith McMillen K-Board for mobile rig, Ableton Push 2

Other instruments: Roland Electronic Drum Kit, Teenage Engineering OP-1, Dave Smith Mopho Keyboard, Akai EWI5000

The Business Side of Field Recording

While you negotiate a fair contract, be sure to consider your costs of doing this type of work, what costs can be passed on to the developer and, as always, what it will take to make a profit. Field recording can be an adventure from many aspects including the challenge of managing your bottom line and keeping this offered service a sustainable part of your lifelong career. Setting yourself up for success by having a good contract in place before you start work, planning the session down to the last cable connection, and keeping an eye on where your money is going at all times can't be overstressed.

Field recording "sessions" can come in all shapes and sizes, from the "run and gun" style, single person, two-channel recorder, single microphone setup, record everything that makes a noise-type session to the 10-day, major cross-country road trip, staff of 8, 36 channels of linked recording devices, 36-microphone setup, multiple weapons and vehicles, logistical nightmare, big-budget session. Obviously, the more complex a session, the more money it will take to capture quality recordings and this is where the developer will step in to protect their investment.

I've been contracted a few times to walk out to my backyard and record dogs, chickens, goats, and horses. Because I actually have these critters on my payroll, there isn't any real difficulty and other than my time and skills to record them— there isn't any relevant expense I need to pass on to a client. But, for large sessions where vehicles, weapons, explosives, or really anything that requires travel, multiple channels, or a variety of recording subjects, the field recordist doesn't usually have to foot the bill for everything.

As a field recordist, I expect to be compensated for my time, skills, and finished recordings. Depending on your business model or agreement, it's also possible that you could pay for your own travel, food, lodging, rental equipment, and staff. For recording locations that are within a couple of hours from home, it's a small expense and easily budgeted into your fees. If the rental gear is something you are leasing for your own personal reasons, then you can expect to pay for that out of your budget. Any assistant you bring might also have to be paid out of your funds as well. There are accepted and expected expenses you will sometimes have to take care of yourself, but that's just the cost of doing business. In situations like these, you know what you need to get the job done, the client is hiring you to complete the job successfully so, the bottom line, do what you have to do to make it happen.

For larger sessions, the client has to take on more of the expense due to the scale and nature of the project. You are still being hired to achieve the goal of capturing quality recordings, but, because of the often large expense associated

I got to write home about shooting (and recording) this little gizmo called a 'mini gun.' Thanks to Watson Wu for including me on that adventure!

with recording high-performance cars, WWII tanks, aircraft, and large military weapon systems, for example, other than taking out a sizeable loan yourself, the developer has to provide the financial backing. Big games always have really cool weapons and vehicles, and coincidentally, these things in real life are not cheap.

For weapon and explosive sessions, the developer will pay for rental of the range and weapons, and cover the costs of the weapons operator, medic, ammunition, and explosives. When recording race cars, they will pay for the track and vehicle rental, driver and fuel. Airfare and lodging are usually paid by the client, unless negotiated differently. If they require specific recording devices or microphones, they will usually pay for those as well.

These examples illustrate the extremes of this part of the business. Field recording can be expensive for a developer, but there are ways we can help from keeping it cost prohibitive. Many times I've been hired because of my connections and access to specific things and for my ability to find alternative ways to record certain subjects. For example, instead of renting a track to record muscle cars, use local roads, and a little patience to get the sounds you need. Use personal contacts, a gun enthusiast who might be looking for an excuse to go shooting or someone with some land where you might be able to shoot or blow stuff up safely. Use personal assets like cars, motorcycles, ATVs, boats, guns, and pets to acquire sounds economically. Sometimes, all it takes is a little creative ingenuity and you'll get another experience to tell your friends about.

That's a Wrap

Field recording is definitely an art form all its own. Players expect to hear high-quality sound in their games, and we can't let the incredible challenges we often face get in the way—we've got to deliver. Through proper planning, preparation, equipment selection, and sound recording techniques, we can not only deliver

but knock their socks off! While it can be difficult work in harsh conditions with grueling hours, the adventures keep most of us coming back. Having an excuse to strap yourself into a classic warbird, hitch a ride in an exotic car, shoot antitank weapons and machine guns, hike into the rugged wilderness, or even just get out of the studio is worth the time we spend smashing headphones tightly over our ears.

11

Voice-Over in Games

Quality voice-over matters. And this single statement has huge connotations which, if not fully considered by everyone in the development chain (the game producer, script writer, voice director, voice actor, audio editor, and programmer), can literally make or break the perceived value of a game. It doesn't matter how wonderful the music, sound effects, and gameplay are, if character dialog and narratives are so bad that they make the player cringe, the overall quality of the game will be affected in a really bad way.

By now in this maturing industry, you would think this is a no-brainer. But unfortunately, voice-overs are the weakest link in every game project. Even some recent big budget, AAA games suffer horribly from bad scripts, bad acting, bad editing, and bad implementation. There are so many factors along the way which influence the final quality that it's understandable why it can happen. A strong, professionally crafted script is a necessity. Hiring experienced and talented voice-over artists and voice actors is paramount. The voice-over session director has to have vision and keep their head in the game during the arduous recording process. The audio editor has to have some serious skills to construct voice files which sound authentic and natural. The programmer has to use dexterity to integrate the voice files to be triggered and played back with their subtleties intact. Yeah, it's a wonder character dialog and narration ever sound right in a game.

So, why am I harping on how bad voice acting is in games? Well, it's because I want to make a point that you'll remember and I want it to become your mission to make it better—for the sake of all of us who create games and for the game player who spends their hard earned money and keeps us employed, that's why. Even though music and sound design may have initially attracted you to

Actor Ian McNiece test reading his role of Verkhal in the game *I, of the Enemy.*

the audio side of this business, as the "person with the microphone," you will be tasked at some point to record and edit voice-over sessions as well. And just like I've asked you to remain open to the possibilities of field recording, you'll find that you already have most of the skills and talents to hire, record, direct, and edit voice actors which can become yet another income stream which will allow you to sustain a long and fruitful career.

The sound person's role in voice-overs can vary greatly depending on the project, the budget, and available resources. I've had projects where it was simple editing of voice files the developer sent me. I've also had other projects where I had to actually write the script, audition and hire multiple voice actors, record and direct their sessions, and do all of the editing. I've had many opportunities over the years to do my own voice acting, saving time and making a little extra as the voice talent too. I've done everything from silly grunts and giggles for basic sound effects to full-on character dialog acting opposite a familiar Hollywood actor who I'd seen in dozens of big screen movies. Yeah, this side of games can be quite exciting and definitely something to write home about. And my guess is, if you give it a chance and prepare yourself accordingly, you can make this a worthwhile sideline.

The Goal of Voice In Games

As you already know, establishing a strong foundation is an important first step in any task, and I believe knowing why voice exists in a particular project will ultimately help those who create and integrate it. Just like music and sound effects, voice-over has several specific missions to fulfill, and understanding their purpose will allow you to concentrate on their goals and ensure they sound

believable and as natural as possible. Voice is about the only "real" human element in games, and with all of the challenges we face, it's almost impossible to be totally convincing.

Games have the capacity to be an enormous storytelling medium, and unlike film, players can interact directly with characters and literally, become part of the story. This type of experience can't be totally immersive unless the character portrayals are well-scripted, expertly-performed, and authentic. The team should always, first and foremost, make this the highest priority and rally together to make it happen. This should really be the only thing that matters.

But, a strong performance isn't everything. There are often many things happening in a game experience, all competing for the player's attention and the subtleties of a voice-over can be totally buried. Consider the effect of lost dialog or narration, especially if the game has a complex storyline. If certain dramatic elements go unnoticed, the story becomes disjointed and confusing, making it hard to follow or appreciate. Ensure the story is intact and the important voice performances are heard.

There are many instances outside of the actual story where voice in games serves a different master. Most importantly are the occasions where vital clues are revealed which ultimately prevent the player from wandering around a vast landscape with no idea what to do next. Imagine playing a game such as *Grand Theft Auto*, where there is plenty to keep you occupied when free-styling but with many underlying tasks to complete for character and level upgrades. Often, voice-over will be the primary method players are notified of available missions, so you can see why it absolutely needs to be heard and understood.

Voice-over is often used as part of the game interface as well. Important information about health status, the player's inventory, off-screen activity, instructions, and a load of other relevant possibilities depending on the game take advantage of "plain English" to convey useable awareness into their virtual world. Voice can act as an indicator of what we should be feeling both physically and emotionally, both very important in a well-crafted game experience.

Voice Placement and Creaton

If you've ever experienced the first 5 minutes of *Medal of Honor: Pacific Assault*, you'll have heard several uses of voice-over in rapid succession. Character dialog, narration, game interface, and vocal sound effects all take center stage of the heart-pounding opening sequence as you prepare to storm a well-defended beachhead. This historical-based depiction has to not only be entertaining and tell a story but also, in some fashion, remain true to the actual experience. An accurate script and believable character portrayals are indeed an obligation, and creating each one of these types of voice-overs will present their own set of challenges for you as the sound specialist.

Character Dialog

Games with a heavy storytelling element often make use of colorful and intriguing characters to draw the player into the action. And whether it's observing a conversation between game characters or being involved one-on-one in an exchange of words, this is an effective way of providing background story information, player motivation, important clues, and making the virtual world feel authentic and alive.

Characters can appear in everything from opening cinematics, cut scenes, and tie-ins between levels as well as during gameplay. And, depending on the goals and placement of the dialog, these will be created in a variety of ways. An actor performing single "one-shot" lines of dialog which are triggered at various points during gameplay will be recorded and edited much differently than multiple actors performing a scene for a cinematic with specific synchronization concerns. Be sure to find out how and where these voice recordings will be used and make a solid plan to get it done.

As far as the creation side of character dialog goes, there are three distinct approaches that will be used depending on the workload of the animators, where voice-over begins in the cycle, and the availability of the voice actors.

Voice Then Animation

Creating quality animation and cinematics takes a considerable amount of production time and it's always best to start on these early. And, if game characters are taking a prevalent role in these, the audio person or team should also put this high on their list of priorities in order to facilitate the process. The most common and preferred method is to capture great vocal performances first and build character depictions and mouth movements around them. This allows the voice actor to do their thing and create a believable character without having to worry about specific timing or other distractions. You'll find that this will create more natural flowing characters and allows the skill of the voice actors to take the spotlight.

Voice and Animation Together

When time becomes a critical factor, it is possible to speed up production by working on the animations and voice-overs simultaneously. Each team will focus on their particular task, and the completed dialog will be edited and synchronized to the rendered animations at the final step. While this approach is quicker, the downside is the dialog will most likely suffer. Because the animator has no "performance" to base their work on, they will have to approximate the routine by acting the scene themselves or by watching another "nonactor" perform in order to render body language and mouth movements. Because they are not actually experienced actors, the subtleties of the performance will be overlooked and the sound editors will end up having to force something cohesive from an entirely separate interpretation of the voice artist. It's not impossible to make this work, but great care will have to be taken to ensure the dialog is as close to natural-sounding as possible.

Animation Then Voice

For times when animations and cinematics are completed before the vocal performances have been considered, this will be your final option. Similar to the automated dialog replacement (ADR) process used in film production, actors will physically synchronize and perform while viewing prerendered character depictions. While the actor will have the chance to practice each line before recording and get comfortable with the characterization, it will still force them to act unnaturally by having to base their performance on someone else's rendition. Sound editors will still have to step in to cut and synchronize the recorded dialog to match mouth movements more accurately. And, as you've probably guessed, both the recording process and editing can be quite time-consuming to make it right.

Interview

RODNEY GATES
Sound designer, Owner (SoundCues)

I became interested in sound and music at a young age, making "story" cassette tapes on my Yorx stereo with a crude electret-condenser microphone with old needle-drop sound effects on LP added in, at the age of 13 during the sizzling-hot summers of Phoenix, Arizona (it was better to stay indoors).

The teen years naturally led to an interest in the electric guitar, and after getting my first one at 15, I proceeded to learn every single Metallica song I could, with my brother on drums. I never went the band route though, like my brother did, but instead saved my money working in food service and wholesale printing to get a Tascam Portastudio 424 four-track cassette recorder. I remember vividly the moment I recorded a guitar part over a previously recorded rhythm track and played it back together (a defining moment for any recording engineer). It was then I was hugely bitten by the recording bug.

I decided to finally jump into something that would hopefully prepare me a little more professionally—the Conservatory of Recording Arts and Sciences in Tempe, Arizona. What a great school. I sponged up the information they taught me there and couldn't wait to intern someplace. I had really gained an interest in postproduction and Foley artistry, and I remember I wished I could have interned at Skywalker Sound when it was over. However, with limited placement there and the fact I didn't know anyone up in the San Francisco area to stay with, I opted for New York instead. I briefly interned at the Soundtrack Group in Manhattan, whose focus was music production, working the graveyard shift of 12 to 8 a.m. The highlight, if you want to call it that, was making hot chocolate for Busta Rhymes and his posse.

I could see myself spending years there, paying my dues, only to finally get the chance to assist on some sessions, and maybe one day become a house engineer. I didn't think that was the path for me. So, what to do instead?

I moved back to Arizona a little disillusioned and went back to a regular day job, for several years actually. Phoenix was mostly a dead town for recording skills, with just a handful of studios. It wasn't until becoming so impressed with the audio in 2002's Medal of Honor: Allied Assault on PC that I fully realized there must be people with careers in game audio—this seemed like the niche for me.

After spending a year creating a custom demo and mailing it out, I finally began my career as an associate audio designer at Sammy Studios in Carlsbad, California in early 2004, working on a fun vampire-western FPS, *Darkwatch*.

Sammy turned into High Moon Studios in early 2005 and was eventually purchased by Vivendi-Universal at the end of the year, as I began working on the title, *Robert Ludlum's, The Bourne Conspiracy*.

A little later, when the Vivendi/Activision merger completed in mid-2009, *High Moon* fell under the new Activision/Blizzard parent and we began developing *Transformers: War for Cybertron*. The two other projects we had going on there (sequels to *Darkwatch and Bourne*) were cancelled at that time, so I began to feel a little redundant.

When an opportunity arose at Sony Online Entertainment, I started there in November of 2009, and still remain to this day serving as their audio director.

In 2013, I formed a new company called SoundCues, LLC. Through SoundCues, I will create and sell virtual instrument products to composers everywhere. This feeds another passion of mine (and is both creative and technical, like sound design) while providing quality instruments for sequencing musicians.

Gameography:
H1Z1 (currently in development)
Landmark/EverQuest Next (currently in development)
EverQuest II—Tears of Veeshan expansion (SOE—PC, 2013)
EverQuest—Call of the Forsaken expansion (SOE—PC, 2013)
EverQuest II—Chains of Eternity expansion (SOE—PC, 2012)
Dragon's Prophet (SOE—PC, 2013)
PlanetSide 2 (SOE—PC, 2012/PlayStation 4, 2014)
EverQuest II—Age of Discovery expansion (SOE—PC, 2011)
EverQuest—Rain of Fear expansion (SOE—PC, 2012)
Everquest II—Destiny Of Velious expansion (SOE—PC, 2011)
Magic: The Gathering—Tactics (SOE—PC, 2011)
EverQuest—Veil of Alaris expansion (SOE—PC, 2011)
DC Universe Online (SOE—PC/PS3/PS4, 2011)
James Patterson's Catch a Killer [SOE—Facebook, 2010 (discontinued)]
Everquest—House of Thule expansion (SOE—PC, 2010)
Clone Wars Adventures [SOE—PC/Mac, 2010 (discontinued)]
Everquest II—Sentinel's Fate expansion (SOE—PC, 2010)
Transformers: War for Cybertron [Activision—Xbox 360/PlayStation 3/PC, 2010 (uncredited)]

Robert Ludlum's The Bourne Conspiracy (Vivendi-Universal—Xbox 360/PlayStation 3, 2008)

Darkwatch (Capcom—Xbox/PlayStation 2, 2005)

www.soundcues.net

Describe your thought process for creating sound effects.

I create every sound with a similar approach—after reviewing what it is I'm designing for and hearing what I want it to do in my head, I break it down into syllables that will realize the sound and begin the design process using suitable elements and/or processing in a DAW like Pro Tools or Nuendo.

When it's complete, I decide how best to divide the final sound so that the game engine can play it back correctly, and with some variability (for each sound, you really need to design it several times, to combat repeat playback in-game). These divisions can simply be frequency-based or sometimes the particular thing the sound is designed for dictates how it should be split up (a physics-based exploding prop, for instance, would require different parts to be triggered at certain stages of its destruction). Looping files such as ambient beds are typically created much longer than what they will eventually become, to not only ease in loop creation, but also allow for the capability to use different parts of the longer loop for LR and LSRS stereo files to avoid any chance of phasing once collapsed down to 2.0/2.1 stereo playback, as another example.

Are there any secret techniques that you regularly employ?

Well it's not really a secret, but it's certainly effective: dropping a dry-fire pin click just before a gunshot really makes the sound pop.

Also, when I'm recording loud sources such as firearms (or smashing televisions in the back of a retail electronics store), I am not timid with the level. I use analog-stage limiters on my Sound Devices MixPre to my advantage to get awesome Hollywood-sized recordings right off the bat, at least for some of the channels I'm recording. There are far too many recordings of "popcorn" guns or impacts out there, and that's not what we're after.

Another cool thing is with voice design—using a combination of a throaty actor (not necessarily a deep-voiced one) with SoundShifter Pitch pitched down a few semitones (keeping the line duration real time) with a send to LoAir yields some excellent-sounding dragon voices on par with Smaug from the second *Hobbit* film. Fun stuff!

For any "ethereal" voices, I will regularly take the voice, reverse it, send to some interesting stereo or surround delays (different delays per channel, between 280 and 350 ms, with various feedback settings) and automate the pitch of those delays before hitting the reverb. Print those files, then reverse them again and add your regular environmental delay/reverb to it to finish it off. Variations on this, plus adding other effects plug-in chains to the mix can be really fun, especially when using Charles Maynes' plug-in vector matrix plug-in concept (detailed here: http://designingsound.org/2013/01/a-plug-in-vector-matrix/). Depending on your plug-in chains within the vector matrix, this can really sound like synthesis for your sound. Also great for things like magic portals, etc.

Do you have any interesting sound gathering/sound creation stories?

I have been fortunate enough to attend two separate weapons/explosives shoots, one in 2005 for *Robert Ludlum's The Bourne Conspiracy*, and another in 2009 for *Transformers: War*

For Cybertron. Not only are they fun, but you learn so much from trips like these. Whether it's your equipment's functionality, mic choices and placement, etc., you find "fast favorites" for weaponry which only improve the quality of the recordings the next time out.

Funny story: During the first trip, near the end of the second day of recording, there happened to be a lot of pistol and shotgun ammunition left. Under the watchful eye of the weapons armorer, we all took turns firing the various weapons to use it up. The biggest beast of the lot was a .50 caliber Desert Eagle. The very first shot for one of our team kicked its brass casing from the round right into his face, nicking the skin just above the eyebrow. This startled him so much that he turned around as if to say "what happened?" but didn't realize he was swinging the pistol around toward all of us. There was a moment of everyone being startled as he was commanded by the armorer to "point it to the ground," but the best part was that one of our assistants had (very dramatically) dropped to the ground—literally "hit the dirt." Raucous laughter ensued.

Do you have any advice which can help lay solid groundwork and ensure a successful production for the audio content creator?

Absolutely. The choices for schooling has increased dramatically since I attended the Conservatory of Recording Arts and Sciences back in 1996 to 1997, many of which are now offering sound design classes within their programs. However, along with the growth of learning opportunities, the cost has exploded as well. It's common that tuition can hit the $100k mark these days, which is a huge commitment of resources for any student starting out. You will need to decide what the best plan is for yourself and go from there. Also, realize that there is also a LOT you can learn about audio/music/game audio production techniques and fundamentals on the Internet now too, which wasn't the case back in the late 1990s for me. Just about all of the popular game audio middleware solutions are available for free, giving you an edge with learning how sound works in games. You must also know that it is very popular right now for companies to hire sound designers on a limited term/contract/open-ended "temp" status for a given project, then cut them loose. Some friends of mine have never worked officially "in-house," missing out on the benefits and perks of full-time employees, but it's the nature of the business lately. Overall, having a solid background in basic audio production, a natural interest in the art of sound design, and the understanding of digital audio workstations will lay an excellent foundation down for you. Once you land the gig, you should also check your ego at the door. Making video games is a hugely collaborative effort spread across many disciplines, and feedback from any one of them is valuable.

Do you have any interesting sound design creation techniques which affect the type of sounds you create?

When working within the sci-fi genre, I have this habit of using a rectified low-frequency sine wave for added emphasis on certain sounds, sometimes for UI selection sounds, an additional element in sci-fi vehicle engine loops, etc. I feel it "techs" it up a bit. I'll match the sound's root note if it's tonal, with this added emphasis being an octave or two below.

When do you find you are most creative?

When I am trying to nail an initial concept for something. It isn't a "time of day," but rather the point early in a project when experimentation can be high. It can be a fun time, even if the game you're creating things for isn't fully up and running yet. This is the point where I typically make new discoveries in sound design that I file away for later use, if not used then.

Any worthwhile creative advice you'd like to share?

Keep your mind open to learning—not necessarily something related to your craft (like programming). A successful sound designer or composer will always listen, and learn from other disciplines. Learn how to do new things. Creativity and inspiration can come from interesting and unexpected places. I jumped into sample library development because it scratches an itch that I have outside of video game sound. Not an easy thing to do with two young kids at home and existing full-time work, mind you, but it's a necessity for me.

Is there a typical workday for you?

Wow, that depends. I typically start the day around 3 am, working on my SoundCues sample libraries. This is meticulous work, and I usually get around three good hours per day for this. This lasts until 6 am, then it's all about getting the kids off to school and getting ready for the "regular" day. Once at SOE, around 8 to 8.15 am, that new day can bring a number of things to the table—a remote voice session with a voice director and talent up in Los Angeles for a third-party game that we publish, sound design for creatures or weapons, or music contracting and correspondence with external composers for various live or in-development projects, or sometimes all three. Lately we have been doing a bit of audio work with the Web group, creating fun little Easter eggs for an upcoming title. Toward the end of a project, there can be marketing video interviews, and community forum correspondence during our Alpha and Beta stages.

With all of our titles being online, and the oldest one ("EverQuest") being 15 years old, we jump around all of them throughout the year, covering various game updates and expansions as we go. It's an interesting mindset you need to have to tackle all of the various tools that have been built over the years. Discovering how they all functioned was what I liked to call "audio archaeology." The sound folks who came before are no longer there to ask, so the learning curve at first was pretty steep. These days, we have a great team and everyone knows what they're doing across all of the existing game engines and tools.

What skills should composers have to succeed in the games industry?

Outside of the obvious qualities like excellent musicianship, keen production skills, orchestration knowledge, and deep MIDI sequencing/DAW knowledge, I'd say networking. That's number one. Representation by an agent can definitely lend credibility to a lesser-known composer, and turn an ear toward your music as well. But networking is number one. At any given GDC, and of course via Facebook and Twitter, there is a lot of opportunity for composers to meet 'n greet with the people that will think of them as new projects come along. There are a number of composers I've met who I really, really like in person, as well as love and respect their music, but that doesn't mean there are projects for them wherever I'm working. Because of this, fostering great relationships with them for the long haul is important.

Do you have any advice to ensure successful audio implementation?

On the programming end, whenever possible, try not to reinvent the audio wheel. As technology changes to bring new game experiences to even greater heights, the tools we use inevitably change as well. However, having to start from complete scratch again is a waste, unless the tools were bad to start with.

Soon we will have the ability to begin integrating Wwise into our latest games in development which will be a huge leap forward, and I am very much looking forward to it and getting away from antiquated, proprietary toolsets.

Another important fact is to be sure the tools you are using are compatible with the many consoles out there, or you will be designing your audio more than once. That is truly a pain to maintain and inevitably results in different-sounding games from platform to platform due to restrictions with each tool and/or severe memory differentiation.

Staying organized is important, especially if you are working on multiple projects, which is part of your daily routine. How do you keep up with it?

It's all about resource management and delegation. Having the right people on the team working on the right things that play to their strengths while allowing them room to work on their weaknesses helps them become even better sound designers. Working on the multiple projects at SOE, both live and in-development, is a bit like whack-a-mole sometimes, especially as the game titles' updates/expansions overlap or stack up at certain times of the year, but we always get through it with minimal overtime.

Any specific "lessons learned" on a project which you could share?

Not just a given project, but in general. Programming. If I had it to do over again, I would have delved into programming and probably become an audio programmer. In general, programmers have a far better chance of surviving rounds of layoffs and finding new jobs relatively quickly, compared to other disciplines. The backbone of all games is code, so if you have even a mild interest in it, you should consider pursuing it.

There are many pitfalls when "working" in the game industry. Have you had any bad experiences?

Not for me specifically, fortunately, but for many others. The instability of the industry is a reality, and studios can close on a moment's notice. New graduates from audio production curriculum need to know that many of the new positions are typically temp and/or limited-duration contract (6 months/1 year/'til the end of the project), and they may bounce around from place to place for a number of years before landing a full-time gig with salary and benefits. But there's no security in that either, necessarily. Working in game audio can be very rewarding, but I wish it were more stable.

Do you have any development stories which served as a good lesson learned or something which can be avoidable in future projects?

One of the biggest things is to be sure that you do not have to use separate toolsets for multiple SKU releases. Case in point: On *Darkwatch*, we created all of the audio in the game *first* for the PlayStation 2 using Sony's proprietary software, SCREAM. When it came time for the Xbox version, it all had to be recreated in Microsoft's XACT. Not fun. Fortunately today, with all of the middleware solutions out there like Wwise and FMOD, it is less of an issue.

If interested, you can read more about this particular example here: http://designingsound. org/2011/04/rodney-gates-special-early-challenges-authoring-sound-for-darkwatch-on-two-very-different-platforms/.

How did you find your way into the games industry?

Well, funny you should ask, Aaron! I remember pestering a certain author of a certain game audio book not so long ago with demo submission ideas, and thanks to his input, it somehow was a hit with someone in particular.

Paul Lackey, the head of then Sammy Studios' audio department e-mailed me one day a few weeks after I had mailed out several submission envelopes. Now, I almost didn't even send one to "Sammy" Studios because I thought the name sounded ridiculous, but luckily for me I did.

Within a relatively short time (which feels like an eternity when you're outside trying to get in), I was off for an interview and got the gig. Turns out I was the only one being interviewed, so fortunately for me, I didn't blow it! I never heard back from any of the other studios, which was what I expected, so who knows how long I could have been mailing demos out.

It was an awesome opportunity for me, more so as I learned later, being able to skip over QA or not having to start as an intern, and I won't ever forget it. These days I look for that same kind of ambition in people really trying to get into the field of sound design for games and see what I can do to help make that a reality.

Any other advice you'd like to share?

1. Don't be lazy.
2. Go to school (or learn as much from the Web as you can).
3. Learn Pro Tools. It is the standard, even though I prefer Nuendo.
4. Research the craft of sound design from every source available (you should already be doing this).
5. Create great demo material.
6. Increase your network (via social media and GDC).
7. Jump on any internships or junior level positions for initial experience.

More on all of these in detail here: http://designingsound.org/2011/04/rodney-gates-special-getting-the-gig-a-guide-to-becoming-a-video-game-sound-designer/.

Narration

Narration is also a vocal storytelling tool but one that isn't always related to a specific character animation or portrayal like character dialog. This voice can be from a designated "narrator" character or a character in the game which relates story elements—normally a voice which looms over a cinematic, various parts of gameplay, and cut scenes between levels, for example. We've all seen television documentaries with an unseen narrator voicing prepared text in a dramatic fashion to set the mood and sell the emotional atmosphere of the scene. Games use this same technique for the same reasons and you can expect to be involved in their creation.

Because there are no specific character renderings where mouth movements and voice-overs have to be synchronized, creating them is mostly about capturing a good performance and not stressing over timing issues other than maybe the overall length of a monologue. How the narration will be used and implemented will dictate how they are performed and edited, whether as single lines, paragraphs, or the entire script. When I'm recording narration, I will have the voice talent repeat each line or paragraph a few times to help with the editing process. Occasionally, inflections or misspoken names or words will need attention and having other options in front of you will help stitch together a convincing performance without having to rerecord.

Game Interface

The interface is another area in the game where voice is used frequently. This "artificial intelligence" will normally remain unseen and accompany the player throughout the game relaying important clues, the player's health condition, next objectives, and even feedback for specific actions. In a way, this "character" provides a conscience, so there is a more human connection between the player and the game. *Halo* is a great example of a first-person game, where the character *Cortana* doubles as the interface as well as an in-game character. Games with a third-person perspective, where the player looks down on the game world, also typically use a vocal interface to let the player know of activity off-screen and other relevant data to make the communication and flow of information easier. This type of voice-over will get the most use during a game, so great care should be taken to make it shine.

For the most part, there will be no mouth movements to synchronize with, and these one-shot lines of dialog will be recorded, edited, and triggered individually. I will normally have the actor record several takes of each line, both to ensure there are no similar vocal inflections which could become repetitious and to have numerous variations available if the developer wishes to use them. As with all recording sessions, the goal is to not have to have the actor return for an unneeded session. Get what you need the first time while you have them standing in front of you.

Vocal Sound Effects

As the name implies, "vocal" sound effects are the ones which are both voiced by an actor and used in conjunction with an in-game character of some sort. Not to be confused with regular sound effects which could be created by voice, these specific sounds can provide important details about the players' character, whether they've sustained an injury, are near death, are too tired to continue running, or unable to lift an object, for example. The accompanying grunts, groans, gasps, screams, or breathing sounds are an effective way of revealing this type of information without detracting from the gameplay and keeping the experience as "real" as possible.

Vocal sound effects are also associated with nonplaying or off-screen characters as well. These supporting roles broaden the experience by adding other humans or creatures into the communal mix and make it that much more believable. These characters may use vocal sounds, such as a teammate "gasping" while being injured, to give the game player important information and to add emotion to what might be happening. But, one-shot phrases, such as "I'm hit!" or "Let's get 'em!" could also be heard—categorizing them as vocal sound effects as well. While these might be similar to one-shot narration or game interface commands, how they are used and implemented is what classifies them as sound effects.

Creating these types of sounds will be identical to what we talked about for game interface voice files. For dialog, ensure the voice actor does them "in character" and record several takes of each line for variations or to give you more choices during editing. Each line will be edited as an individual sound file and triggered as needed in the game. Nothing new there. But, what I would suggest (and something I found out personally during some of my own vocal recordings)

My "go-to" voice actor, Jon Jones, giving another enthusiastic performance.

is to record any death sounds, screams, or yells at the end of your voice session. In order to capture believable versions of these types of sounds, the voice actor will need to put everything they've got into it, sometimes over exaggerating, and this is going to tear up their vocal chords pretty good. So much, in fact, any other dialog you try to record from them after that will more than likely be totally unusable. Get all of their dialog and narrations recorded first, then leave it all on the field for those awe-inspiring death sounds.

Prepping for Voice-Overs

Voice-over production can definitely be a challenge. There is already a tremendous amount of pressure on the audio folks to create magic. But what everyone on the development team needs to understand is that it truly is a "team" effort and any weak link will certainly affect the end product. The script must be expertly devised and written, a comprehensive vocal asset list must be organized, facial motion capturing could be considered, a solid budget for the entire vocal production must be in place, and strong actors must be hired. And all of this must be in place and organized before the record button is ever pressed.

Large development teams will take advantage of their available talent and have dedicated individuals or teams working on each element of the process. Of course, their budgets are larger and they can carry more talent on their payroll. But, just as often, small developers will rely on one or two folks to carry out these duties. Don't be surprised if a majority of it falls to the audio person—everything from script writing, asset list assembly, hiring the voice talent, session directing, recording, editing, synchronizing, implementing—well, you get the picture. It can definitely be an interesting ride for someone who just wanted to do music or sound effects for games.

Script Writing

Games with complex storylines rely heavily on character dialog. Other games use voice simply to disclose important information. No matter what the intent, a solid script is the foundation to everything else that follows. Hollywood has always employed talented script writers, and games should be no different. While some development houses understand this importance, there are even more who do not and ultimately, it's the game player who has to suffer. It might be something worth discussing if you become involved in a project with a shoddy script.

The more you hang around this corner of the industry, the more you'll discover the subtleties and nuances which can take something "amateur" and raise it up to a "professional" level. Anyone can arrange music loops and create a "song" but it's the practiced composer/musician who can really make "music." Anyone can speak into a microphone and you'll be surprised by the sheer number of people who claim to be a voice-over artist. Anyone with an education can "write" and again, you'll be really surprised by how many people think they *can* write at a proficient level. It's this particular obstacle that games have to overcome. It's a bitter pill to swallow, but doing something because you "can" should always take the backseat to finding the right talent for the job, even if it's someone other than yourself. Script writing is one of these tasks that benefits greatly by hiring a professional.

Film and television have set the bar incredibly high for character dialog, and games with substandard speech will stick out like the proverbial sore thumb. Having a skilled voice director and talented actors is a step in the right direction but to really give the project the best chance at success, a professional script writer is the best bet. Sometimes, the first time this is even suggested is when the audio person is reviewing the script with a fresh set of eyes—so, be ready to break out your best diplomatic skills and make a solid case to hire one.

While utilizing the talents of a professional writer is ideal, there are also budget and time considerations which can foil any good intentions. The good news is, if you have to cut corners, voice-overs for the game interface, one-shot voice commands, and vocal sound effects don't necessarily have to be written by the script writer and more often than not, these are written by the development team, the audio person, or even by the voice talent on the fly with excellent results. Lines like "Your health is low," "Enemy spotted!," and "Take cover!," for example, are no-brainers. There might be the occasion to use specific character personalities for these, and if it's important, then get the script writer involved to maintain continuity. Strong game characters definitely have their own verbiage and can benefit from someone who's familiar with them.

And speaking of adlibbing, there's something really cool that happens when voice talent gets totally into their performance—they become that character! And if the team is smart, they will plan on this phenomenon and allow the "character" to be themselves and be ready for it. Unless there is a reason not to, such as the voice being synchronized to a prerendered animation, let the voice-over artist off their leash and see what happens. I'll always record the script as written, but I will also let the voice actor go wherever the character takes them. Having extra lines of dialog, laughs or casual outbursts available for later editing can add a little spice to the overall production.

I had been working on a game with a pirate as the main character. Most of the dialog was for certain scenes and we recorded several takes of the script. But,

I could tell the voice actor was really enjoying himself and getting into the spirit of the character, so I let him play around. Good voice actors typically have interesting personalities themselves and this guy was no different, and as expected, the unscripted and unrehearsed performance was brilliant! I walked away with so much great material that I found myself not only taking the dialog portion to a new level but also having many pirate laughs, "arrrggg's" and vocalizations found their way into screen transitions, finale screens, button presses, and other sound effects. It was a fun project.

I know this is probably hard to believe, but actors are just regular people with a cool job. Unfortunately, their sometimes "celebrity" status leads us to believe otherwise and our expectations can often exceed their capabilities. It's because of this, I make it a point to have rewrite authority of any script I'm tasked to record. While something may look good on paper, when it's spoken out loud and in character, it might be difficult to perform. And if the session clock is ticking, trying to track down the script writer or producer who can authorize a change could cost them money. Because I'm there, in the moment, with the actor and a microphone, having the ability to make slight changes to the script to alleviate any tied tongues can keep the ball rolling and keep the voice talent from having to come back at a later date. You're not asking to rewrite the entire script, just change a word or two if several initial attempts don't yield acceptable results, so, make sure to either have someone on hand from the developer who *can* make changes or get that authority yourself and in writing.

Vocal Asset List

Being organized is extremely important when dealing with vocal assets, especially for games with thousands of lines of dialog. Listing the needed vocalizations and then tracking their creation, editing, implementation, and testing can be a full-time job, so it's a great idea to have an official asset list for everyone to work from. Whether the developer has created one or leaves it up to the script writer, audio department, or contractor, there is a lot of information that needs to be available to the session director and voice actors.

Understand that voice actors work from a disadvantage since they aren't actually present in the "scene" and don't have their body language or facial expressions to help sell their performance. And, they can't rely on the animators to provide the subtleties of a live actor either. For them to get it right, they need as much information as possible and to see the whole picture.

The vocal asset list will not only provide the actual lines of dialog to be voiced but can also detail where the voice-over appears in the game, in what context, what the characters' motivation is, and their state of health. Other details, such as character information, age, accent, sex, and if numerous variations are required could also be pertinent. A good session director will take this information, guide the actor appropriately, and maintain consistency throughout their performance.

The list should be updated or amended as each step is accomplished or redefined until the work is complete. Obviously, big game projects will have hundreds of pages and you can see why someone needs to be meticulous about these details. Smaller games won't have near the stress of multiple actors and characters, but for the sake of everyone's sanity, it's still important to keep track of the state of all of the sound assets.

Tools of the Trade

NATHAN MADSEN
Composer

My studio has been put together slowly, over the years and it is heavily virtual rather than hardware. I do mostly in-the-box productions (i.e., virtual instruments), so if I'm tracking live musicians, I'll go to a certain, local recording studio to track live players. Most of my clients, however, don't have the budget for live musicians, so I'll do everything virtually. Should I need a specific microphone, I'll rent it.

Computers: Mac Pro, 8 core, 32 gigs of RAM, 4 internal HDDs totally 3.6 TB (one for the OS, one for the project folders, and two for the samples and SFX libraries), Macbook Pro 4 core, 8 gigs of RAM

Audio interface: MOTU 896mk3

Software: Logic Pro X is my main DAW. Reason 6.5 is used often and I use Pro Tools 11 for large VO editing sessions. Sound Forge for Mac, Triumph, and Peak Pro 6

Monitors: JBL S38BE—I've had these monitors since college and they actually sound amazing. I've considered getting more monitors but so far, these are getting the job done

Sound modules/VST instruments: East West, 8Dio, Komplete Ultimate 8, Sample Modeling, Spectrasonics, Vir2 Instruments, CineSamples, and Embertone. I'm kind of a sample library junkie!

Keyboards: Roland Fantom X8

Other instruments: Three saxophones, violin, flute, guitar, and electric guitar

Microphones: SM58, MXL910

Remote recording gear: Roland R09

Facial Motion Capture

There's no question that games are becoming more character driven. And because of the difficulty of creating convincing game characters, there is plenty of incentive to use any available tool to help the voice actor convey their characters personality. While motion capture has been a great asset to creating credible animations for body movements, facial motion capture is what takes this overall character rendering to a new level. By electronically converting the facial movements of a real person using cameras or laser scanners, the resulting digital database allows for a more realistic and nuanced animation. And by attaching "markers" to an actor's face while they are in front of the microphone voicing their character (or by using markerless technology to track lips, nostrils, eyes, and even wrinkles), mouth, eye movements, and all of the subtle expressions which make up the performance will match the voicing.

Of course, you're probably sitting there wondering what this has to do with audio. Well, it doesn't really but it might be something you'll have to put up with during your voice-over recording session. It makes better sense and is a more efficient use of the actor's time (and the developer's budget) if the facial motion capture is accomplished as the dialog is recorded. This not only keeps the actors from having to return to perform the script again but also ensures the mouth movements and facial expressions will match the recordings exactly, which will ultimately benefit the quality of the rendered performance.

If you're involved with the audio recording when facial motion is also being captured, expect your patience to be tested a bit. Having a few more people in your space, an actor with markers physically attached to their face, scanners or cameras setup which could possibly interfere with your microphone placement, music stand or the actors movements, and all of the other distractions and noise that come along with the added crowd, all of which add to the already challenging task. The good news is, if you're ready for it and can keep the chaos under control, it'll all work out just fine.

The Money Side of Voice-Overs

As an audio person, you can expect a variety of experiences when dialog is needed for a game project. If you're a third-party contractor, a developer might task you to simply record and edit voice talent they've already hired. Or, they might expect you to be the one to find, audition, hire, and direct as well—so, be ready for anything! What immediately comes to mind for me as the businessman is, how do I set a price for my role and how do I ensure the voice-over artist fees are covered by the developer and not as part of my budget? Unfortunately, there's no such thing as an unlimited expense account, so you definitely need to find out what they are willing to pay and then work within their budget.

In order to make your involvement productive and the experience fruitful, your role should be spelled out in detail as early as possible. Once that train leaves the station and you're chuggin' down the tracks at full speed, you'll want to concentrate on the "creative" instead of the "business" and end up donating a lot of your time without even knowing it. It's easy to set fees for recording and editing voice-overs, but what is your time and talent worth when it comes to searching and auditioning for that perfect voice? It's definitely something to keep in the back of your mind.

The easiest solution is to determine an hourly rate for these nonaudio-type activities and discuss whether you would simply bill your client for the hours

you've worked or negotiate a "project fee" or maximum number of hours for the entire effort. They need to be able to manage their expenses and a solid number to work which will make their lives a little easier, but billing by the hour isn't totally unheard of. As we discussed in Chapter 3, the rate you charge depends on your overhead and your business needs.

One way to make this process easier for everyone concerned is for you to have a well-stocked voice talent pool. For a majority of games, there will be some need for voice-over, typically simple interface commands, quick instructions, or vocal sound effects. For these easier scenarios, I have a couple of incredibly versatile voice artists that are my "go-to" performers. I have preset agreements and fee structures with them (they know I will offer the most allowed by the game's budget), so all I have to do is get them in the studio, hand them a script, and off we go. Occasionally, I need to reach a little deeper into the pool for different skills, so I make it a point to have several available just in case. For larger, more character-driven game projects, I expect to have to search but I'll always start close to home first.

How Much Do Voice Actors Cost?

If you are tasked with hiring voice actors, the developer is unknowingly admitting they don't know much about this particular subject and are asking you for guidance. As the audio "expert," they assume you've probably dealt with this before and are looking to you for the answers, the right voices for their game, and at the right price. Whether you've experienced this before or not, it definitely helps to have some insight so you can look good in front of your client. So, let's get to it.

Voice actors can charge whatever the market will bear. Some charge per "project," others by word, line, or page of script, and others per "session." It basically comes down to whatever you want to negotiate. However, because most really want the work, they will usually accept your conditions and a fair payment in return for their characterizations and performances. The most widely accepted method is per "session" (originating from standard union "day" rates for voice work), which is a four-hour block of time. You can agree to a fee for less time in 1-hour increments, of course, but for most applications you'll find 4 hours to be a good amount of time for typical projects to get what you need and allow the actor to maintain concentration and perform with consistently. For large scripts, though, expect multiple sessions with the same actor.

When estimating nonunion projects, the finished script is a key piece of the puzzle. Be sure to get a copy well before any voice actors are hired then count the number of lines of dialog or the number of pages for each character. A good fee range for an average to above-average actor is $100 to $250 per page of script. Lines of dialog, depending on if the script writer is using a film studio style guide or not, can be anywhere from 25 to 60 lines per page. Be sure to consider the length of the lines—longer monologues will be more involved than single word lines and would take longer to produce.

Another consideration is the amount of time you expect the recording process to take. Most of the time, it can take some time for the director and voice artist to settle on a character voice, attitude, and pace. Because you will want to capture several takes of each line for editing flexibility later, this will also add additional time to the process. A well-rehearsed actor could read a page of dialog in 2–3 minutes, but stumbles, mispronunciations, and a myriad of other situations always arise.

While I like to keep a session rolling, taking the pressure off the performer by planning for extra time will be more realistic and produce better results.

Whether the project is "union" or "nonunion" depends first on the developer, or if left up to you, it's your choice which type of actor you use. Nonunion voice actors, of course, have far less restrictions and no set limitations unless negotiated specifically. Personally, I pay these actors as much as the budget will allow and often act as their "agent" when negotiating with a developer. My pool of talent knows I will actively find them work and ensure they are paid decently. Some projects are well-funded and others are more limited, such as smart phone- or Web-based games, but because of our relationship, they enable me to still get high-quality voice talent for lower budget games, something which my clients appreciate.

Union actors have a set fee structure and work conditions, which are not unreasonable, but it definitely changes your workflow and can cost more. During the spring of 2016, union, off-camera voice work rates for New Media and Interactive projects was $627.75 for a single, 4-hour session/day with a maximum of three character voices and $269.75 for each additional voice. The rate for one voice and one hour was $404.65. The developer may also have to contribute up to 16.8% above their total compensation to the Actors Pension, Health & Retirement as well. These fees change, of course, but this will give you a good idea of what to expect. Obviously, this knowledge will help the developer to budget accordingly and determine whether union or nonunion is best for their situation.

Choosing Voice Actors

Casting the "right" voice actor for a game character is a huge part of the job and if you get this right, you're almost there. The perfect voice portrayal is only part of it though, they need to have the skill and talent to pull it off as well. "Voice" acting is a bit more challenging than regular acting because facial expressions and gestures are not visible to help the actor "sell" the character and this has to be done entirely with the voice. Looking past their looks and personality and focusing on what only their voice can do are something that will help you choose wisely.

Most of the time, I never see an actor's face or performance when I'm auditioning or recording them. Instead, I've got my back turned and am listening intently through headphones. By not looking at them perform, I'm forcing my opinions to be made directly from what I'm hearing and not letting anything else distract me. And trust me, most voice actors are incredibly engaging personalities and it's hard to separate their talent from their outgoingness. And when this happens, you won't discover it until you're trying to make the edits work long after they've gone.

Before you begin the grand search for voice actors, review the script and character details to get a good idea of the specific qualities you'll be looking for. What characters need to be voiced? What is their age and gender? What accents do they have? Do the characters have specific vocal qualities such as speed, pitch, tone, inflection, unusual tics, or impediments? What other creative details can the developer provide to help you make the appropriate choices? Answer these questions and you'll have a good start. But, don't be totally attached to any of these. There are times when that perfect voice just can't be found, isn't available, or is cost prohibitive and plan "B" needs to be initiated. The good news is, the game player won't know the character voice wasn't the original choice so, as long as the character is believable, you'll still have something that works.

Occasionally, the developer will have already chosen, negotiated with, and provided appropriate actors themselves—all you have to do is get them in front of a microphone and press "record." But, if left to your own devices, you've got some work to do. Start out with your own "talent pool," folks you've worked with before or have made previous contact with, and see what you already have available. Next, review any demo reels which seem to find their way into your inbox or check out searchable voice-over artist directories on websites such as voice123.com or voices.com.

Voice demos will give you a general idea of an actor's abilities and voice qualities but to make sure, auditions of some type are a good idea. As you begin to narrow down your field, consider a test script of the specific character you're trying to voice. If the actor has the capability to make their own recordings, have them send you their performance for evaluation. You could also have them audition over the phone while you direct them, not only to listen to their character rendition but to see how well they take direction. Be sure to record the conversation yourself or have them do so on their end and send you the audition for later review.

Depending on the size and scope of the game project, live auditions can also be a good option. This can be arranged through a talent agency or you can organize your own "cattle call," bringing potential candidates directly to you. While a studio setting is a great place to hold auditions, a quiet room in a talent agencies office will work just as well. Either way, have a microphone and recording device setup to capture the performance for your archive and later review.

Sorting through the demos and auditions will take some time, of course, especially for a game with a large cast. There is a certain pressure in choosing not only the perfect character voices individually but the overall blend of actors as well. Obviously, the ability of the actor to capture the essence of their character is your foremost concern but don't forget to evaluate attributes such as voice quality (tone, inflection, timing, naturalness, and sincerity), their ability to pull you into the portrayal, how they take direction, your ability to get along with them, etc. Larger, dialog intensive games will have you working together over a longer period of time, so those last points might have some impact. Sometimes you just know and other times you have to whittle down the list until only one remains.

For games that don't require a specific character but instead only need "one-shot" lines of dialog or vocal sound effects, consider what the voice is supposed to accomplish and let that be your guide. For example, what mood do the vocals need to support? Excited? Encouraging? Informative? Whimsical? Happy? Select the actor who can give you the right blend of the vocal qualities and mood that the game needs.

I worked on a pirate-themed video slot machine a few years back and remember hiring and recording a great pirate voice for the game. The developer requested a *Pirates of the Caribbean Captain Barbossa—Style* portrayal and that's exactly what they got—the voice actor hit it out of the park! It wasn't until the voice was in the game that we realized that even though the voice was a perfect rendition of the character, it was a bit too dark and sinister for what was supposed to be a fun game. So, it was back to the drawing board with a new actor and a piratey–leprechauny character voice which, in the end, was exactly what the game screamed for. The developer had to pay two different actors for their work and I had to do everything twice, but ultimately, the animated pirate got the right voice for the mood of the game, which was critical for what became a very successful game.

Of course, don't forget to include the developer in the decision-making process. While they may have tasked you specifically, it's always better to have them weigh in beforehand so that all time in the studio is productive. Send them your final candidate choices for approval and once they've officially signed off on the actors, it's time to get this show on the road.

Recording Voice Talent

Now that your actors have been chosen, getting them in front of a microphone for their chartered performance is the next big step, and unfortunately, it's not something that is as easy as it sounds. How you go about it will depend on things like the actor's location, your studio capabilities, the developer's needs, and a variety of other challenges. In today's worldwide economy, people can be anywhere on the globe, and it's unlikely that you'll be close to the developer or the actors anyway, so, don't despair. There are still plenty of ways to successfully direct and record voice sessions.

Personally, I like to hire local voice talent so that I can get them onto my turf, where I have the most options and control over recording sessions. If time is critical or scheduling is an issue, I've been known to grab my portable recording gear (see, I told you field recording skills could come in handy!) and head to their location. For this scenario, I set the mic up in a quiet room or closet and get what I need quickly without the stress of having them drop everything and head to my place. I've had several voice-over projects that needed to be done overnight and having this ability and an accommodating actor can really save the day. In other situations, such as recording several actors at once where there isn't room in your studio or because you need a more central location for the actors and developer to attend, renting a commercial recording space is another possible option.

More and more these days, professional voice artists have their own ability to record which can also come in handy if the need arises. Because I always monitor their performance with my back turned anyway, the fact that they aren't even in front of me doesn't become an issue. If I need to provide direct feedback, I will do so over the phone or via Skype while they record their own performance. If the script and direction are obvious, I'll have them record several takes of each line on their own, with a variety of inflections and have them send me the unedited files. There has been the occasional noise or recording level issue which led to some over-the-phone troubleshooting, but for the most part, this works out well. Overall, there are plenty of options to get an actor's vocal performance recorded, so this will be the least of your worries.

Voice-Over Sessions

A recording engineer, director, actor, and a familiar recording space are typical ingredients for a productive voice-over session. Each participant will concentrate on specific assigned duties, you are able to make the most of your room, and quality work will result. Of course, it's not a perfect world so this won't always be obtainable but that doesn't change the fact that you have to get it done. At times, it'll just be you and the actor in the studio and you'll find yourself playing the role of host, script editor, director, coach, diplomat, drill instructor, and somewhere in there, recording engineer. Stay ready for those extra duties but be sure to keep your focus on why you are there in the first place and be aware that it is very easy to get distracted.

General Rules for a Smooth Session

Voice-over recording is an interesting dichotomy of personalities, pressure, and chaos. But, despite all of this, the developer is putting a lot of faith in you and the actors to give the game what it needs. The extra effort you take beyond just setting up a mic and hitting "record" can pay off with an actor who is able to focus and perform at their best. Consider these suggestions during your planning phase and prepare to be a gracious host.

- The climate and "energy" during the session should be suitable and positive. You generally want to always stay positive and encouraging, offering constructive criticism if needed and keep any negative vibes outside of the studio. Because they work hard to please their clients, they will take their cues from everyone around them, including the intern in the corner who might be mocking the actor by pretending to stick their finger in their mouth. Any mixed signals or things like this could impair their confidence and the performance could suffer.
- The actor's workspace should be equipped appropriately. The actor could always stand in front of a mic with the script in their hand but a comfortable stool, a floor pad to stand on, a podium to hold the script, and appropriate lighting will make it easier for them and you. You want the actor to concentrate on their performance, not the fact that their feet hurt or that they are having a hard time seeing the script. Plus, a script that isn't being jostled won't make any unwanted noise at inopportune times. Make it as easy as possible for them to do their work.
- Drinks and snacks should be abundant. Find out what the actor likes to snack on and have plenty available. Physical energy and hydration are important for long sessions, especially if the actor didn't have time to eat beforehand. Make it a nonissue before they even get started.
- Throat spray, lozenges, or lemons should be available. Most professional voice actors know how to take care of their voices and typically carry their own supplies. But for times when they don't, have items available that help soothe the throat. Relieving the minor pain or scratchiness that might develop during a performance will allow them to continue on hopefully to the end of the session. Chloraseptic spray, Hall's Throat Lozenges, fresh lemons and even honey, for example, will provide some great relief.
- Identify any special needs of the actor and accommodate them if able. Picking anything green out of a bowl of M&M's is easy. Having a steam room, masseuse, and astrologer available might be a bit much. Most of the time, these folks are very easy to work with and usually it's only very small requests such as the kind of sparkling water or a favorite fruit they would like on hand. But an occasional request for the absence of overly fragrant flower arrangements or certain animals is something you should also expect and be ready to comply with. Having them feel at home goes a long way.
- Studio visitors should be kept to a minimum. Keeping the chaos and distractions to a dull roar is important for the actor's performance and to keep the session moving. The recording team should be minimal, the game developer should have a limited number of people attending, and the actor should expect any entourage to spend their time in the waiting

room. For efficiencies sake, you only want to have to do each voice session once and ensuring all of the material and takes needed are completed can't usually be done unless everyone is paying complete attention.

Recording

You'll more than likely always wear the "recording engineer" hat, unless the voice talent is recording themselves in their own studio and sending you the raw files, of course. I've been hired many times over the years just to record voice talent and it's something I really enjoy. Studio engineering is one of those basic skills which can be used in many ways in games and whether you're recording sound effects, musicians, or voice artists, your main goal is to always produce clean and usable recordings no matter what is put in front of the mic.

When a voice actor is your recording subject, you'll have specific recording engineer duties that must be considered to capture great recordings no matter what the situation. Obviously, the "mechanics" of the process is in your hands, and neither the actor nor the developer will care how you get the end results. It's completely up to you which recording software you use, what interface the mic is connected to, which mic you use, and the general setup of your gear. You'll concentrate on the overall sound quality of the voice recording, what input levels are used, equalization, and any effects processing. If the actor is wearing headphones, you'll control their volume and listen for any bleed over from them into the mic. Overall, the physical recording process and any needs associated with it are your responsibility.

Once you've got everything set up and placed properly, the standard rules of studio recording will apply. As the engineer, you should be set up and ready to

A well-equipped vocal booth will give the voice actor everything they need to perform their role. (Courtesy of Aaron Walz.)

hit "record" before the session begins. It's a good idea to do a quick test recording and play it back listening for any noise or equipment issues. Sound and level checks can be done while the actor is warming up and rehearsing in front of the mic. I usually record their warm up, not for any nefarious reasons but as reference should they come up with an interesting vocalization for their character. It's also a good chance to get the microphone placed correctly and set their levels while they are unaware. And once they are ready to roll, you'll be ready and won't spoil any gained momentum for a level check.

The use and implementation of vocal elements in games are unlike any other medium, of course, so looking forward in time to editing cohesive performances together is important. You won't have the luxury of the voice artist returning just to redo a line or two, so you need to get everything while they are in front of you. Having the actor perform each line or block of the script several times will give you variations to work with and at the same time, will allow for the actor to practice each line and perform them better each time increasing the chance for "the" take. Multiple takes including a variety of voice inflections, rates of speech, loudness, and articulations should ensure plenty of material to work with later. I can't begin to tell you how many times I thought I had what I needed only to find that the influence of the actor's presence clouded my judgment. I promise you'll thank me for this tip later.

Some others tips to consider:

- Record "death" sounds, yells, and screams last. When performed with all of the force and drama needed to be believable, these particular types of vocalizations can wreak havoc on vocal cords. Only after the rest of the script has been performed and successfully captured should you even think of having the actor take a crack at these. If not, expect to have them back for another session after they've recovered.
- Record an entire character voice-over within a single day. Consistency is important, especially when having to edit performances which were done over several days. If done all at once, you'll have a better chance at maintaining uniformity than you would if the actor came back 2 weeks later with a cold, your favorite mic was on the fritz, and the cat bumped your mixer settings. Not to mention that the actor could have a difficult time recreating a complicated accent or vocal style upon their return.
- Record "nonhuman" or "crafted" characterizations both dry and effected. Recording any audio signal with effects processing will limit your options and that really cool plug-in you thought would be perfect can't be undone when the developer doesn't like it. The best way around this conundrum is to record the vocal performance dry on one track and an effected one simultaneously on a separate track. This will allow you and the audio team to experiment and create appropriately during editing. And by having that "effected" track going as well, the actor can respond in real time to the features of the effect and manipulate their performance to match. Throw a delay or long reverb on an open mic and see what I mean.
- Preplan workflow for scenes with multiple actors. Remember the "chaos" I mentioned earlier? Try putting several overly eager actors together in a room and maintaining any semblance of order. It is possible to record

a group of actors, especially for scenes where they can play off each other's performances, but you'll need to establish your dominance quickly for this to work. In the end though, capturing them one at a time and blending them in editing might be a better approach. It will definitely be more difficult to capture a variety of takes in a group setting and quality control will be quite a chore with more actors present. But while a cohesive live performance might sound better, use and implementation of the voice files within the game might be better as separate files.

- Acquire a signed contract or talent release before payment. Unless the developer has taken care of this, as their agent, you will be responsible for securing the rights to the actor's performance. Since my talent release form is less than half a page and written in plain English, it's not usually a problem obtaining an actor's signature before they leave. And because I can't pay them until they transfer the rights to me or the developer, they are usually well motivated to do so. Most of the time, I have a check in their name sitting next to the release form which they will eyeball the entire session so neither of us forget.

Directing

While the recording engineer is laser focused on the mechanics of the recording process, a dedicated session "director" will concentrate solely on the actor. Having someone who can devote their time to the cast will not only ensure great performances but with the complete picture in mind, can also fulfill the style, quality, and consistency needed to make the voice acting great. Of course, not every vocal session will have the guidance of a director, so these duties will also fall to the recording engineer when they're flying solo. Because having the overall vision of the game project is important, I'll often insist the game producer or dedicated director at least be on the phone or observing via Skype so that they are involved and can provide their thoughts as it is happening.

The actor's performance is key. The director will pay very close attention to things like how each line of dialog is spoken, vocal inflections, the ability of the actor to remain in character, their energy and consistency, their motivation, and many of the other subtle performance-related issues. They will follow along with their script, make appropriate notes, and decide when it's best to interject or redo any dialog. Having someone who is experienced in acting is a plus since they will not only be evaluating the performance in real time but will also be providing qualified feedback to make it shine. The overall goal is to get everything needed from the actor in the least amount of paid sessions, and active participation is necessary.

A director who is a good communicator knows how to draw out a great performance and can do all of this without frustrating the actor is worth their weight in gold. At times, they will play the role of acting coach, diplomat, or Marine Corps drill instructor—employing any means necessary to get the actor in the right state of mind. Some actors respond to demonstration, where they are shown how to perform the dialog. Others would rather craft their character after carefully considering the character's back story, motivation, and persona. Still others react best when verbally motivated by someone yelling in their face! (Trust me, motivating a tired actor to do believable death sounds can take some work!) And of course, knowing what your actor responds best to is the real trick.

Active listening can be difficult even under perfect conditions. Long sessions really push the limits of a person's concentration and sometimes being able to keep your head fully in the game takes quite an effort. Whenever I'm tasked with directing, I purposely turn my back to the actor (or if that isn't physically possible, I'll close my eyes while they perform) and concentrate on what I'm hearing and not what the actor may be doing. Most of the time, you'll know a good take when you hear it. If you don't, provide a little coaching, have them do a few more takes, and move on. If it's still weak, revisit the line toward the end of the session and you'll probably have better luck. Just remember, the role of the director should always be taken seriously—the quality of the game depends on it!

Voice File Editing

The audio editor has a very influential role in the success of voice-overs in a game. When you think about it, the involvement of any "nonactor" in the portrayal of a character can contribute negatively to the overall quality of the acting, even if the actor was absolutely brilliant. So, while the process of "editing" isn't inherently difficult, the ability of the editor to piece together a cohesive and believable performance does takes a bit more attention to detail, patience, and objectivity. The game player won't be distracted by a sound effect that might be sloppily edited but they darned sure will notice choppy and inconsistent dialog. Great care should always be taken to preserve the subtleties and integrity of an actor's performance. The audio editor can literally make or break it.

The rules of general audio editing we've discussed in previous chapters also apply when editing voice files. How they get chopped up, saved, and implemented are all dependent on how they will be used within the game environment—so be sure to do your homework before starting. Will the voice file be triggered as a "one-shot" sound effect? Will dialog and animation have to be synchronized? How will occasions with multiple actors be triggered? Will long narratives be played back as a single recording, will markers need to be embedded in the file, or will each sentence need to be saved and triggered individually? There are many possible approaches to voice files so you definitely need to have a conversation with the developer about them.

When editing voice-overs, your top concerns are the quality of the performance and the quality of the edits. What makes editing voice files especially challenging is the need to keep the performances sounding natural despite sometimes having to piece together words from various takes. And whether these takes were recorded in quick succession, at different times during the session or during other sessions, they will always have differences in volume, inflections, voice quality, or a myriad of other issues that will have to be melded cleanly.

When editing typical dialog, start by listening and comparing multiple takes one line at a time and choose the most appropriate one. Because you always want to keep a natural rhythm to the dialog, be especially mindful when editing various sentences together. If you're not careful, you'll end up choosing takes which sound good individually but don't work together. Pay close attention to voice inflections ensuring they don't happen in the same place in each line. If you have only one take with an inflection issue, you can still fix it by making use of a pitch shift to create or soften as needed. Pitch shifting is also another useful tool to make any other adjustments to the overall performance.

After recording voice actors, auditioning and identifying good voice-over takes are a key part of the editing process.

Good rules of thumb when editing dialog:

- Edit to the "sound" of the voice and not to the "picture" such as an animation you might be synchronizing to. It's easy to key on the visuals but edited dialog will sound most realistic when you've taken your cues from the sound and not from what you see.
- Edit on phonemes instead of at word breaks. Because you ultimately want an even blend of various takes, combining within a word will sound natural instead of having the next word sound different. Overlay and crossfade within the word as sound slides to the next to keep the edit unnoticeable.
- Edit on hard sounds, plosives, or "stop consonants." P, B, K, G, T, and D, for example, are the best points to accomplish these edits since no crossfading is necessary and the cut will be hidden by the sharp sounds.

Vocal Sound Effects

Vocal sound effects used in conjunction with an in-game character are created and edited as standard "one-shot" style sound effects. Player injury or death sounds, yells, screams, vocal taunts, and one-liner dialog events will be triggered to play as needed during gameplay and will be edited as individual sound files. And because avoiding noticeable repetition is one of our mantras, multiple takes will be created as well, edited singly, and saved as variations (grunt_01, grunt_02, etc.) to be triggered sequentially or randomly. You'll, of course, be creating these in the highest sample rate and resolution possible and will down-sample and use prescribed naming conventions as per the developer's request.

Character Dialog

Character dialog will be used in cinematics, animations, and gameplay, and the editing process will consist of piecing together the best or most appropriate takes into a unified performance. The pace and flow of the dialog are important considerations as well as inflections, pauses, and the overall "tone" of a character. There are many subtleties present in a good actor's performance which should be preserved as much as possible, and usually, it's these minor details which will make the difference between a good performance and a great one.

Going with your very first impression when auditioning multiple vocal takes will help you choose more instinctively. Keep in mind, the more times you playback a line of dialog, the more it will begin to sound "okay" and eventually will sound totally acceptable if you're not careful. It's very easy to lose objectivity after hearing something a dozen times in a row. Most of the time, I place a marker within the sound file near any line which I think is good the first time through to help remind me of my first impression. Since a game player will more than likely only hear the dialog once anyway, that initial gut reaction will more than likely be the right one.

How you edit and save the dialog will depend on how it is used and triggered within the game. Normally, one-shot lines of dialog are triggered at each instance and will be saved as individual files. Short and long narratives will be edited in a variety of ways depending on the situation. Dialog can be saved as a single file to be played through from start to finish, such as in a cut scene or tie-in between game levels. If there are any specific timing points or if input from the game player is needed before the next line is prompted, a single file with embedded markers at each line might work. The programmer could also set playback of each line at a specific time within code for the same effect. Another option would be to edit each of these lines as a separate file and trigger them individually. As you can see, there are a few ways it can be done, so be sure to ask ahead of time. Finish the delivery preparations with correct file labeling and conversion to the final format. Piece of cake.

Multiple Characters

Many times in a game experience, a game character will speak directly to the player as if they were actually standing there with them. This immersive technique is what makes it an "experience" regardless of the fact that it's just pixels on a screen. Include the player in a crowd of game characters and you really have a party! Whether the player is interacting directly with multiple characters or is simply observing their action as a bystander, the sound editor will have the challenge of creating a believable conversation while working within technical boundaries.

If you hadn't considered the use of a multitrack program yet, now might be a good time to fire it up. Depending on how complex the conversation between several characters is, the use of any effects processing, or differences in volume and EQ between actor performances, a multitrack program will definitely make it manageable. And, once again, depending on how the voice files will be implemented and triggered, your direction will become obvious after discussing this with the developer.

Natural conversations between individuals are not simply one character talking then stopping, then the next one speaking and then stopping, and then the next one starting, and so on. More often than not, there are interruptions, false starts, changes in thought, outbursts, pauses, and a myriad of other occurrences that make up a likely spontaneous exchange. A good script writer will understand

Use multitrack software to ensure continuity and a believable flow of dialog between multiple characters.

this and employ appropriate methods to produce a natural flow between the characters. Unfortunately, this is one of those situations where an audio editor needs to go beyond simple "editing" and pay close attention to everything the script writer and actors have done, if not, the results could be less than stellar. If you find yourself having a harder time with this type of editing, be sure to keep the voice-over session director (or someone with acting knowledge) available for their opinion when constructing a complex scene.

The best strategy to assemble a scene with multiple characters is to use a multitrack program of your choice, open a single track for each character, and import the appropriately chosen takes into them. Begin with the favorited takes as a starting point but stay open to other options in case the lines between the various actors don't work well together. For instance, if three characters in a row have vocal inflections on every third word, that might start to sound unintentionally comical and that the characters are mocking each other. Unless that was the point, having other takes close by will give you additional selections to make it sound right. Once you have takes that work well together, the next step is to decide on their timing.

Timing

Timing is an art form, one which is most noticeable in comedy, for example. Delivering a punch line too soon or too late can change the impact of a joke or even alter its meaning. Dramatic pauses are often used to reveal an implied meaning other than what might be spoken, or heighten the suspense. Now, knowing that the "pause" is an important storytelling tool, some thought needs to be applied to this element so that the rhythm and tempo of dialog is used to its full potential despite any programming limitations. Be sure to keep this at the forefront of your editing efforts.

Because there are several ways to implement dialog between multiple characters, it's important to discuss this in detail before committing to a final file structure and delivery. And once you've got specific instructions, you need to answer that burning question, "Where do I put the pauses?" When assembling a conversation, it's best to create it in a natural flow just as if it was being performed live, in its entirety on your DAW. If a character interrupts another, place the dialog so that it overlaps, keeping each character on their own track. If a character pauses at the beginning, end, or in the middle of their line, maintain that silence on the track and mute or set the track level for that portion to "0" to prevent any unwanted background noise. Preserve all of the dialog elements and subtleties when building the session so that the total performance works well.

CHRISTOS PANAYIDES
Sound recordist, Sound designer, Voice-over artist

I was born in May 1976, and after high school and the army (here in Cyprus, it is mandatory), I began to work professionally with sound. I worked for 8 years at a radio station creating commercials and working as a sound engineer on various programs. This gave me the opportunity to understand more about the art of sound, which then led me to work at a TV station for 5 years where I got to work with sound in its best form—where picture and sound become one. Here I worked as a sound engineer in on a TV series and during live football broadcasts.

It was during this time that I started my own studio and for the last 10 years I have been recording sound effects for sound libraries, advertisements, games, and for my own use.

My determination to do something important in the field of sound effects has me looking to find ways to exhibit my work. Searching the Internet, I was able to find a company who was interested in my field recordings and sound effects and this was the beginning. Several of my collections have been purchased by companies that sell sound effects. My last collection was approved by The Hollywood Edge and will be a part of their catalog. The road to success has started.

www.cpaudiosound.com

Describe your thought process for creating sound effects.

A picture is worth a thousand words and a sound is half of that experience! I can't imagine a world without sound. My initial goal as a sound designer is to field record very specific sounds and to do it very cleanly. Back at the studio is where hundreds of new sounds effects are born!

Every sound is special, so I need to put much effort when creating each one. The idea is to translate the picture into sound. I record sound effects every day and every time I listen to something, various pictures come to my mind. But when I have to create something very

specific, I try to give the audience, if they close their eyes, the sensation of actually being there. When creating customized sound effects, I always think what I would like to listen to when seeing a specific picture, what direction it moves, for how long, and when in the allotted time.

Are there any particular secrets to your creativity?

You have to trust your ears. After many years producing sound effects, I have learned to trust what I hear even if it seems bad or odd. Most of the time, I record with my eyes closed.

Are there any secret techniques that you regularly employ?

There is no secret technique other than keeping a "to-do" list which, for me, lays out how I plan to create a certain sound. My best suggestion is to find out what method works best for you. Many sound recordists will just record a ton of sounds and wait until they're back in the studio to edit the best tracks. Others prepare a specific list of sounds and record them. Both techniques can be the right approach but for me, good preparation and the right gear is what works best.

Do you have any interesting sound gathering/sound creation stories?

Every session always has a story! Sometimes, you try to record a specific sound but for some reason, it doesn't work in for the game. So, you always have to be on the lookout for that.

A few months ago, I was working with a motorcycle racing team. There were five bikes and me with six microphones, three recorders, and a lot of cables, stands, and batteries. After devising a plan and some sound checks, we began the session. Two of the recorders ran without a problem but one of them stopped (as we found out later) after 10 seconds of recording. Consequently, I ended up losing more than 4 hours of 192 kHz/24-bit recordings and, unfortunately, about 100 sound effects. I learned a valuable lesson that day. You should constantly check your recorders throughout the session!

Another time, during an in-house session one summer, we were getting ready to record some artificial rain sound effects using rice, metallic plates for creating thunder, etc, and after 3 hours of preparations, it suddenly started to rain! So, we went outside and recorded the real thing instead!

Do you have any advice which will ensure a successful production for the audio content creator?

When you record in a studio, remember that all sounds need to sound natural! When you record outdoors, the first thing you need to do is to walk around the area and check for any challenges which might interfere with your recording so you can plan to use the right equipment to eliminate them. Also, keep in mind that every day is unique and when you return to a location for recording, the weather conditions might have changed and you might need something you originally had not planned on. So, always think ahead and you will never miss something when recording outdoors.

Again, having a "to-do" list and the right gear will give you the best chance for success.

Here is my equipment for outdoor recordings.

- Field recorder (Tascam HD-P2)
- Zoom H2
- Compact flash card + one more as a backup
- Headphones (always two pairs)

- Stereo microphone
- Shotguns ×2 or ×4
- Wind protection for microphones
- Shock mount for microphones
- Microphone stands
- Mic stand adapters
- Cables
- Batteries 4 to 5 packs
- Notepad for notes
- Video camera/photo camera (for behind the scenes and archive)

When do you find you are most creative?

When I record sound effects, *that* day is always my favorite. Most of the time, I try to record early in the morning, even before the sun comes up. If there is a specific project that needs sound effects during the night like night ambience, then I enjoy that creative time. When I'm doing sound design, nighttime is always my most creative time.

Do you have a specific ideology which drives your way of doing business?

Be fair with all of your clients, whether they are big or small. You should always work with the same enthusiasm. Do what you agreed to do and do exactly what they ask for. A good plan always gives you a schedule to follow and better results.

As in any work, the customer is always right and that means you need to work and deliver your work in the prescribed time, according to the customer's requirements. Before I proceed to production and final mix of any sounds, I ask the customer if I'm headed in the right direction. Ideally, a rough sample should be sent to the client for their review to prevent any misunderstandings.

How do you approach negotiations with a new client?

When you reach out to new customers, you should always do some research to see what they have done so far and what you can do for them. An informal meeting is a good start and if the customer shows interest, you should find out what their real needs are and what they want their production to convey. Take lots of notes and prepare for that next appointment.

Do you have any production stories which others could learn from?

A great customer had asked me to do sound design for a TV commercial. It was for a new courier company and they really wanted to present their company in an original manner. Their specs and notes were sent to me and, as I do every time, I carefully read what they wanted and I set an appointment to discuss their needs.

They explained their ideas which included an airport arrivals board with the actual sounds, the sound of airplanes, PA, etc. So, my task was to record sounds at an airport including an actual arrivals board. After making my requests with the airport managers, I was given permission to record one. They allowed me to record from the backside of the board and the sounds came out great. The video editor sent me the final video and after several hours of work on my part, I had all of the sounds created and sync'd. I remember thinking that it sounded very good.

Unfortunately, the customer thought the sounds were horrific and were very clear that they thought the sounds couldn't have been from an arrival board and should be changed

immediately. Their suggestion was that I should use the sound of an old cash register combined with a vintage typewriter instead!

Yeah, this wasn't the best situation but I always try to remember that the customer is always right and I will work hard to make them happy—no matter what!

Staying organized is important, especially if you are working on multiple projects, which is part of your daily routine. How do you keep up with it?

Good planning is half of any project!

How did you find your way into the games industry?

In my career in television and films here in Cyprus, I had the chance to do some sound for a game and this is what actually made me want to get involved even deeper in the games industry. Aaron Marks was the person who really inspired and motivated me to get involved in this industry and now, I really want to make my mark on the world of games! Thank you, Aaron Marks.

Continuity

After the arrangement of a scene is locked, it's time to concentrate on the overall continuity. Any perceptible difference in volume, EQ, or other audio qualities can distract a player and unintentionally pull them out of the experience. So now, instead of them remaining absorbed in the storyline, their mind will wander as they attempt to figure out why there was a change in the audio. In television and film, ADR is used to salvage dialog in a scene that for some reason had to be replaced, such as if someone off-camera sneezed or something fell over during the line. If it's done correctly, the viewer will never hear or notice the difference. But, because ADR is usually recorded off-set, in another location using a different microphone and recorder, appropriate volume and EQ adjustments need to be done precisely in order to match the original used take. And if it's not done absolutely correct, it'll be obvious and very distracting. In games, the best we can do is to ensure the audio is totally consistent from the beginning of the scene to the end, checking the evenness of volume, EQ, compression, effects, and everything else in between. Once this step is complete, it's on to creating the appropriate sound files and prep for delivery.

File Rendering

Implementation will ultimately dictate how voice files are rendered. Obviously, anything designated as a "one shot," such as vocal sound effects, single lines of dialog, and even each line of dialog in a multiple character situation, will be edited to play immediately upon triggering. For cinematics, the final character dialog could be created as single lines to be placed by the developer if needed but will more than likely be delivered as a single, mixed audio file, synchronized to picture and ready to be dropped in and rendered by the developer. Because you already built the scene in its entirety and mixed it appropriately, the final bounce will consist of selecting all of the tracks to be used, adjusting the final output volume and compression, if used, and saving the entire scene as an audio-only version. Further opening in an audio editor will be used if any overall loudness, EQ, or effects processing is needed, but remember to leave all silence intact to ensure proper synchronization.

Cut scenes or tie-ins between missions and game levels can consist of a cinematic, slideshow, scrolling text, or other similar options. Dialog files can be triggered in code to accompany screen changes and text or they could be set to trigger after input by the player, such as in a "call-and-response" scenario. Short sequences will most likely be edited as a single audio file unless they contain long pauses and silence, then they could be broken down into multiple files to save space. More variations for longer narratives can be created as a single, mixed file, individual lines of dialog, or even separate files for each character. And, for additional flexibility, any of these can contain embedded markers as well. It starts to sound a little confusing but it really does depend on the developers' needs. Again, stay curious and ask lots of questions.

Story-intensive games rely heavily on character dialog during gameplay, and with some games having over 10,000 lines of dialog, there will be plenty of work to do. Most of these types of games will have fairly complex programming or scripting in place to handle the endless gameplay possibilities. And, whether the player will be interacting directly with nonplaying characters and other players or observing a structured scene, you as the editor, need to be in the loop early on.

Simple dialogs such as at the start of a race—"Three, Two, One, GO!"—or in the middle of a battle—"INCOMING! TAKE COVER!"—are typical one-shot sound files which are treated and edited as sound effects. Since they will be expected to immediately play when triggered, all silence at the beginning of these files will be deleted. If the dialog is to accompany any sort of character animation, be sure to ask what "frame" the voice sound file will be triggered and adjust accordingly. Any file which is triggered at frame "1," there may be acceptable silence in the sound file in order to match any animated pauses such as if the character moves before speaking. The programmer could also trigger the sound file at any "frame" in the animation, and if that's the case, a tight edit at the beginning of the file will ensure immediate playback. In multiple character situations, this type of editing and triggering will be repeated as necessary. It might get a little complicated, so make sure you've got a surefire way to keep track.

Synchronization

Early in this chapter, we talked about the three methods used when recording voice-over for animation—voice then animation, animation and voice together, and animation then voice. Once animations and cinematics are locked to the point where frames won't be changed (although final artwork may still need to be completed), the audio editing can now tie these two elements together into a synchronized work. Whether you are simply preparing voice files and sending them to the developer for synchronization or you are the one meticulously lining up the voice to mouth movements, great care needs to also be taken at this stage to make it work correctly and maintain a high level of quality. Film and television have created a dialog performance standard which is hard to even match, but we have to keep pushing despite the disadvantages.

The first order of business is to import the cinematic or animation into your DAW of choice. Hopefully, the developer will be able to provide you these in a usable format but be prepared to either convert or create them yourself if needed. Cinematics are typically in some sort of video format anyway, and conversion software is plentiful if you need to change it to a format your multitrack software can utilize. Animations may be slightly more difficult depending on the project.

If you have access to individual picture frames, by knowing the frame rate the developer is using, you can create something workable (such as by using RAD Game Tools Bink Video). If you have access to a rough version of the game with the needed animation in place, consider doing a screen capture or recording to video from a camera pointing at the screen. I'll always ask for assistance initially but developers can have higher priorities and your goal is to always be easy to work with and be "the problem solver"—so, this could be your chance to show them how good you really are.

Synchronizing is the easiest when the first method, "voice then animation," is used. If you hadn't insisted on recording dialog first, or if it wasn't possible, you'll soon see why syncing the animation or cinematics around them will be hugely difficult at best. If the animator was able to spend some time creating the visuals, the chances that you'll be able to line up the first word with the rest falling into place are good. At the very worst, only minor adjustments will need to be made, perhaps a longer pause between lines was created for some sort of body movement, but no major changes since the visuals were created to prerecorded dialog. It's just a matter of lining up each bit of dialog with their respective mouth movements, adjust words or pauses as needed, and save the final audio as requested by the developer.

If the narrative is to be synchronized to a cinematic and the developer needs only a timed audio file, you will sync the dialog at the beginning of the sequence and bounce it as a single file. While you are always concerned with keeping audio files as small as possible, the silence in these files won't have any impact on the final size of the cinematic since music or sound effects may also be included in the final mix.

When synchronizing to "animation and voice together," expect to spend a little more time than usual finessing the recorded dialog and animations together. Usually because of time constraints, these two are created separately and synchronized solely by the audio person. If you're lucky, the animator will have created a natural and expected physical performance of the characters and syncing won't be too painful. But, more than likely, no matter how good the animator and the voice actors are, their separate performances will need the smooth and patient hand of the audio editor not only to line up mouth and body movements, but also to ensure consistency in volume, energy, and vocal characterization. For the most part, delicate surgery will be needed to match lines of dialog, words, and even syllables, depending on the extent of the dialog. Be sure to pay close attention to not only the synchronization but also maintaining the most natural vocalizations as possible. This is where having multiple takes of each line of dialog still available will give you many options during the process, so choosing the best takes beforehand isn't always necessary.

If you're syncing "animation then voice," you'll have an even better chance of lining everything up properly because the voice actor will have performed their dialog directly in sync with the completed animation—assuming the session director and recordist were on their game, of course. Yes, syncing is easier, but remember, this method forces the actor to "act" according to the animator's "performance" instead of the voice expert creating the best rendition of the character. Be sure to pay particular attention to voice inflections and overall "attitude" of the character since you'll have zero control over the timing. It is especially helpful to have multiple takes to choose from, giving you the best chance to create a worthy vocalization.

The Final Step

After the voice files are built and synchronized, their final edits will depend on their use within the game. This is a good point to review your notes and make sure the developer was clear about their needs and make sure everyone is on the same page before you proceed. When audio, visual, and programming assets start crashing together, it can get ugly in a hurry.

For cinematics, you'll typically render a synchronized voice file of the entire sequence. When the developer builds their final version, they will combine music, sound effects, and dialog and easiest for them if they can line all of the audio up with the first frame. Even if the dialog starts somewhere later into the sequence, this will save them some time if all of the added content starts at the same place. Because the final rendered edition will be a mix of all audio, the file size will remain the same regardless of any silence in a track. It's important to always be conscious of file sizes but this case is the exception. There is also a possibility the client could want the voice file to start as the dialog starts—in which case, they will take on the responsibility of lining up the file with the correct frame.

Delivering files for animations is similar but it depends greatly on when the voice file will be triggered in programming—so, be sure to ask what they have in mind. There are times where mouth movements will start immediately and there are others where the animated character could stand idle as if contemplating an answer or begin an action before speaking. It would seem logical to trigger the accompanying audio file at frame 1 of the animation but it's possible to start it at any point. It's not a hard fix for the programmer but it can cause confusion and a pointed finger at you because they don't sync.

If you are creating the animation yourself from sequenced graphic files, the first frame is obvious but you'll need to know the frame rate being used for syncing correctly. If you're grabbing a screen capture or using a video camera, the frame rate will be correct (unless there is some inherent drag on your computer during the capture), but knowing where the first frame starts in this case can be a challenge. While you should always strive to be self-sufficient, this is one of those instances where the developer's interest is best served by them building an animation and giving it to you in some sort of video format—this will definitely guarantee your best work. For times where this isn't possible, the only advice is to do the best you can with what you have available and then be ready to explain the challenges.

Once all of your questions have been addressed, creating the final rendered file is next. If the trigger is set to the first frame, save the file with any beginning silence included. If it will be triggered at the first mouth movement, save it with a tight edit so that the voice will playback immediately.

Normally, high priority voice-overs such as featured dialog will be saved in an uncompressed, high sample rate and resolution format. 44 kHz, 16-bit, .wav is standard but 48 kHz wouldn't be unheard of depending on the console you are creating for. Low-priority voice-overs, such as those heard over a radio or headset, could use lower sample rates and resolution (8 kHz, 8-bit is great for these applications) or compressed formats with excellent results. Voice files are normally created in mono, but an elaborate use of effects processing would require the final file to be saved as stereo or even surround. Be sure to review the delivery specs and save your work appropriately. And above all, always be mindful of the audio quality during conversion and final formatting and adjust as needed.

Tools of the Trade

ELSPETH EASTMAN
Composer, Voice actor

I create every day and it's right in my apartment, so I like something comfortable with a lot of desk space. I'm able to do just about anything with the tools I have because I've gotten acquainted and learned how to use them (knowledge is power!). Most of what I use is all computer-based.

I'm rather minimalist when it comes to gear. I used to have a bunch of hardware that I never used and collected dust because I found it easier to mix right in the multitrack system. If it's been sitting there for more than a year, sell it! Also, good headphones are a must. Keep your cords untangled too!

Computers: iMac, 3.06 GHz Intel Core 2 Duo, 16 GB of RAM, 1 TB hard drive, OS X Lion Macbook Pro, 2.8 GHz Intel Core 2 Duo, 8 GB of RAM, 500 GB hard drive, OS 10 Mountain Lion

Multitrack system: Logic Pro

Audio interface: Blue Icicle XLR to USB (for the mic!)

Software: Logic Pro, Cubase, Screenflow

Monitors: A pair of Rokit KRK 8s

Sound modules/VST instruments: East West Quantum Leap Platinum Orchestra, Symphonic Choirs, Voices of the Apocalypse, Stormdrum 2, RA, Goliath, Voices of Passion, Gypsy, The Dark Side, Kontakt 5, Absynth, Massive, Battery 3, Reaktor, FM8

Keyboards: M-Audio Keystation 88-es controller

Other instruments: Clarinet, beatboxing whenever it strikes my fancy

Microphone: MXL 990 Condenser, pop filter

Other hardware or notable items: 1 TB Western Digital Hard Drive, Magic Mouse, Sony MDR 7506 headphones, and people to give impartial feedback on my sounds

Beta Testing Game Voice-Overs

Once the "creation" process is completed, it's time to step back and take an objective look at all of this hard work. By "objective," I really mean OBJECTIVE! Impartial, detached, unbiased, neutral—however you say it, the fact that a celebrity voiced the main character, a lot of money was spent, hours upon hours of effort were made, or any of this shouldn't influence whether the final quality is acceptable or not. It's very easy to justify why the voices *have* to be used in the game and this is that moment where, whether you and the team admit it or not, all of the initial good intentions and the plan to have noteworthy character voices all goes south in a hurry. It might not always be practical, but if you're at least willing to throw out all of the work and start over, your opinions will become crystal clear and you'll be able to make an honest assessment.

Like the music and sound effects we've covered in previous chapters, dialog, narration, and vocal sound effects will be implemented and tested before we give the final thumbs up. Obviously, we'll be making sure that the proper files trigger at the right time, the editing is acceptable, the dialog is consistent in volume and equalization, and the overall quality is excellent. But, specific to voice-overs, there are a few other things that should be reviewed as well.

- Do the voices fit the characters? Initial character concepts which guided the selection of a voice actor and the dialog written for them may have changed over the course of the development cycle. What may have sounded like the perfect voice at the beginning of the project may sound inappropriate after everything finally comes together. The final depiction of the game character, both look and movement, could have matured into something completely different and now the vocalization doesn't quite work. Look specifically how the voice and the character depiction work together and make sure they really do work.

- Are the voices synchronized to their respective animations appropriately? Nothing says "mediocre" more than voice-overs that don't match the mouth movements. One of the most vital roles the sound person can take, and the one you'll have the most control over, is the synchronization of the vocal assets. After the creative work and implementation are complete, stepping back and taking a fresh look, unencumbered by the ability to make any adjustments, will allow you to make a fair assessment of the work. When working closely on a task, by playing something over and over again, it's very easy to make yourself believe that what you're hearing and seeing is fine. But, when you are able to push back and look at it again with a little distance, it's much easier to see if it's really working. Be sure to go with your gut instincts and go back and fix anything that needs it.

- During portions of the game where vital information is revealed, is the dialog heard and understandable? Clues to successful game completion are often given as dialog and it's paramount these are heard. Music and sound effects are constant competition to dialog in the soundscape and one of the goals when beta testing is to make sure important narratives cut through. Anything that seems buried, consider bumping up the volume of the dialog or lowering the volume of the rival music or sound effect (either on the file itself or in programming), an EQ adjustment to

one or the other, or whatever might be necessary. This is more than likely the last time you'll have the chance to make an evaluation before release of the game, so ensure the player knows what their goals are instead of leaving them to wander around the game forever. You hold the key to their success!

Conclusion

Remember—quality voice-over really does matter and it's up to you to champion this cause through your attention to detail, patience, and focus on the ultimate in-game, player experience. Often, it's just the sound person who is involved with the majority of the process, and it can be hard to be objective when so much of your personal efforts are involved. But, someone needs to make a stand, make honest and objective criticism, and have the courage to say when it's just not working. The development team counts on your ears and expertise to frame an effective soundscape, so be sure to take all aspects into account and give it your best to raise the quality level of voice in games.

12

Blending the Total Soundscape

An assault of unorganized game sounds is nothing but noise, pure, and simple. With an onslaught of voice-overs, music, and sound effects, a game can quickly become a chaotic nightmare—forcing the player to run away screaming or to simply turn off the racket with a flip of a switch, neither of which are good for the games business. The development team has the difficult task of finding the perfect balance, relying heavily upon the audio content providers. Sometimes this cohesive blend materializes entirely by accident; other times, after months of planning and perfecting. I've heard people say they would take luck over skill any day, but in the billion-dollar games industry, success rides squarely on abilities—not chance.

Have you ever walked into an arcade and been blasted by sound as the door was opened? The same racket happens on a tradeshow floor, where each booth has a noise-making machine determined to attract attention. That is what a really bad game sounds like—the kind of mess where so much is happening at once you have no idea of what's going on. And, believe it or not, there are games out there where sound overpowers the experience instead of enhancing it.

Some games attempt to combat this lack of foresight and experience by giving the player the "power" to adjust all of the audio elements, making them responsible for their own experience. If it doesn't work, the blame can be placed on the consumer—not the developer. Of course, there are some advantages to this feature—but the point is, we *can* make a difference and can affect the success of the soundscape *ourselves*. By simplifying the game experience and mixing the sound elements ahead of time, the player can spend their time playing and enjoying a game instead of adjusting parameters.

Can music, sound effects, and narratives exist simultaneously in the sound-scape without negatively impacting the game experience? Yes, they can, but a certain amount of care needs to be taken to ensure they do. When working on a new piece, a composer's initial mindset is usually to create music able to stand on its own. The majority will add several layers of melodies, countermelodies, and percussion tracks to keep the music interesting and alive. After all, this is what musicians and composers do.

There are times when this type of music works well in games—in intro sequences, cinematics, menu screens, and other stand-alone cues where no real thought from the player is required. Music intended as background music, though, has to be just that—in the background. Layers tend to interfere with other audio in this type of situation. I know you want to make some great music to showcase your talent and sell lots of soundtrack albums, but busy, complex scores do nothing for the overall soundscape of the game. If music is the only audio playing at a particular time, you are home free; knock yourself out, make the best music you can. But if your music will be sharing real estate with other sounds, lay back a little and make some room for the rest of the audio. Save your elaborate performances for the soundtrack remix release and let your profession-alism shine through for the sake of the product.

Sound effects require a bit of finesse. During gameplay, they must take priority over the music to ensure the player receives the needed feedback. A driving game may be the exception, where music creates the pulse and rhythm. For something as simple as a menu screen, a jamming techno cue could be playing—pumping up the player for the experience they are about to receive. The player clicks on a button, and except for the visual cue of seeing the button depress and the screen changing, gets no other feedback. There may have been a sound effect associated with the button depress but it was either too low in volume or lost in the music.

Some choices need to be made. Do you turn down the volume of the music? Do you increase the volume of the sound effect? Do you dump the sound effect? Another alternative, and probably a better solution, is to create a sound which will actually stand out from the music or to create a hole in the frequency spec-trum of the music. Either way, this will enable the sound effect, whether subtle or not, to be heard. By utilizing opposing frequencies, or ones that are not over-loaded by other audio, the game can be experienced as the developer intended—not sacrificed to chance.

As an example, a bass-heavy rock track will definitely not leave room for any other low-frequency activity in the soundscape. Sound effects, such as hits or explosions, may barely be heard or could overload an audio playback system—causing distortion. Instead, consider keeping those sound effects in the mid to upper ranges or remix the music with less bass. Look for the hole in the frequency range and jump into it. Music with a lot of high-frequency percussive activity won't leave much room for small effects that go "click." Consider making them "thumps" instead. By maintaining awareness of other audio in the game, you can create practical sound effects which work the first time.

Voice-overs, narratives, and speech require the same considerations as the other sonic activity. Rules that apply to FM radio jocks won't work in this busi-ness. They get away with full-bodied vocalizations that saturate the entire fre-quency band because they can. They want you to pay attention—they want that booming voice to grab hold or else they would be looking for another line of work. If other audio is present when they speak, a technique called *ducking* is used to

decrease its volume and keep the voice on top. This type of speech unrealistically becomes what producers expect of their narrative recordings as well. They want them full, with lots of low and high end—making them bigger than life. But they do not realize the impact it can have on the rest of the audio. When an overly full narrative is mixed with music and sound effects, it becomes mud. By narrowing the spectrum the voice uses and developing a good mix with EQ, the words will be easily heard and understood—and the rest of the audio can be heard clearly, too.

A common mistake inexperienced musicians and music producers make when doing final mixes of a song is to solo each instrument and individually tweak them to perfection. When all of the instruments are brought together later, the resulting competition for space creates a mix which is generally muddy and blurred. Another few hours of adjustments will follow to persuade them all to sound good together. Most of the time, if you were to solo one of the instruments, like a piano or guitar, it will sound thin and unimpressive—nothing like what you would expect it to. But what ultimately matters, for the good of the song's overall production and when doing *any* audio for video games, is that everything blends. By allowing each instrument to work within a narrowed spectrum of the frequency band, they can all be heard clearly and as intended in the compilation. The misconception that all of the elements must sound perfect on their own needs to be overcome and we sound guys and gals must ensure that developers understand this concept and stick to it.

Consider a wailing sax, hammering piano, or guitar riff competing with a narrative as an example. All of these elements have primary occupation in the middle range of human hearing. If they just happen to all be playing at once, you wouldn't be able to understand a word a character is saying. To put it more musically, you never hear a vocalist singing during an instrument solo—right? Same idea. A saturated soundscape means degraded effectiveness, with the only options being to turn it down or turn it off. We can prevent either from ever happening.

Maintaining Consistency in Production with Audio Elements

Fitting together audio elements like puzzle pieces is just one of the many tricks to effectively master game sound. Maintaining consistency is another issue an audio content provider must apply. All audio requires the same character; that is, the element which cements it to this, and only this, particular game experience. Having an effect distract the player during gameplay because it sounds out of place or like it's from another game breaks the magic. Even that one innocent little sound effect thrown in the game as an afterthought has the ability to screw up an entire production. A little melodramatic, I know, but you know what I mean.

The easiest way for a developer to ensure consistency is to use the same composer, the same sound designer, and the same voice actors for every aspect of the game. This will provide the same basic flavor by using the same recipe ingredients, thus providing overall uniformity. Each artist has his or her own style and equipment which contribute to his or her "sound," and by utilizing the same providers, this will keep a game's audio sounding cohesive.

In the event last-minute audio is needed and the original content provider isn't available, extreme care should be taken by the developer. Ensure the stand-in audio provider has other music or sound effects from the game to measure their new offerings against. If possible, find out what programs, settings, effects

processing, instrument samples, and sound libraries were used during the production—to at least increase the chance of similarities or maybe even get the audio folks in touch with each other so that they can talk about it and share ideas. It's no secret that if I ran all of my sound effects through some acoustic processor to add ambiance, you would be able to hear it. The setting I used is the unknown, and unless it's a company secret, I shouldn't have a problem sharing it with someone else involved in the project. All they have to do is ask.

Another way for an audio content provider to ensure consistency is to devote time to only one game for the duration of the project. If a developer is particularly concerned about this, they will more than likely ask prospective composers and sound designers up front whether they can commit solely to one project at a time. Often, this focus alone will obtain the desired consistency.

Another good rule of thumb is to not separate working sessions with considerable gaps of time. For instance, Joey Kuras had to revisit sounds he created for *Tomorrow Never Dies* many months after he had completed the initial sound list. After designing new sounds, the old ones didn't quite sound like they belonged. He ended up spending extra time EQing and adjusting the volume of the previous sounds to bring them up to speed. Although he used the same equipment as the first time around, his DAW and equipment settings had changed enough in the interim to make the new effects sound different. By making adjustments during the same time frame, the chance of this level of edit is remote and better consistency results.

Consistency in Music

There are some specific steps we can take when composing, recording, and implementing a game score to help maintain its uniformity. Recording artists in the mainstream music scene work hard to ensure their CD releases measure up to other music on the market and that all of the songs on that CD sound like they belong together. We can take a lesson from this.

I recently worked on a project that could have benefited from this type of consideration. By the time I became involved in the project, the opening title sequence and main title screen music had already been done. These had been licensed from the mother company and were done by two different composers. They had similar qualities, with similar style, but were obviously recorded in different studios with different musicians and instruments. They sounded very different. The plan was to implement these into the game as direct audio. I was tasked to write several cues—one as direct audio and the rest as MIDI files to trigger the sound bank, chosen with the guidance of the audio director. So, now we had three different direct audio tunes composed by three different composers—recorded in three different studios by different musicians and instrumentation *and* several other pieces of music done in a completely different format and style using a sound bank with only average-quality samples. Yikes!

Musically, the game didn't show any consistency and sounded uneven—but somehow most of it worked. The intro sequence was designed to tie the game into its real-life counterpart that used the same theme song and because it would probably only be watched a few times during the course of ownership, it didn't become that much of an issue. The direct audio music used for the credit sequence would probably only be seen a couple of times at the most, so that became a nonissue as well. The only real difficult connection was between the main menu direct audio cue and the rest of the game music, MIDI files triggering an internal

sound bank. These were heard every time the game was played, and because they were of different musical styles, there was noticeable contrast. The developer made a conscious choice to do this, creating a different rhythm for each part of the game, but it still sounded incongruous.

What could we have done to develop some consistency? The first thought would be to develop the sound bank using similar instrumentation as the original direct audio piece and to compose all of the music in the same style. Another idea would be to have a single composer redo all of the direct audio cues utilizing the same instrumentation. Yet another option would be to use MIDI cues and the same sound bank for all of the music. Plenty of ideas, any of which would help.

This example helps illustrate many points. Music is a highly personalized experience and composers will always create with their particular "sound." As mentioned in an earlier chapter, every element a composer uses—from their instruments, samples, and talent, to the microphones, signal processors, and recording mediums—contributes to this sound. As you become familiar with an artist, you can recognize their work. I remember hearing a new song on the radio the other day. I had never heard it before and by the first measure I had guessed who the artist was without them even singing a note. Their style and sound was obvious. This concept plays out the same with video game composers. Different composers on the same project are obvious. Not that it can't work—it just has a different sound and may distract the player enough to remind them they are just playing a video game.

If all of the music is within the same genre, using the same main instrumentation will tie the experience together. If direct audio will be used, ensure the recording method is the same. If the songs are recorded live, make sure all of the songs are recorded live. If the instruments are all plugged directly into a mixing board and triggered via MIDI in the recording studio, make sure all of the music is done that way. Finally, when the music is implemented into the game, use consistent playback methods. Have all of the music streamed from a DVD or have it all trigger a sound bank. The type of music occupying the majority of airtime should set the tone. If there are several cinematic tie-ins, make sure the rest of the music has those same elements. By doing so, the entire production will have a constant audio personality. This is a good thing.

Music Mastering

A game score can take another important lesson from the record industry. Before any CD release is made, the music is taken to the next level with what is known as the *mastering* process. This is where subtle EQ, volume, and compression are used to even out the rough edges and to blend the music into one cohesive work. Often, 10 different songs recorded for an album will end up with 10 slightly different mixes. Some will have more bass, others more high end, and others will have volume mismatches.

When a listener plays an entire album, they might have to continuously adjust the volume for each song or turn down the bass—which may be perfect in the first nine songs, but blows out the speakers on the last one. Mastering takes all of these differences into account and ensures the listener can relax during the playback experience and not have to re-engineer songs on the fly. During this process, all aspects are matched from song to song so that the EQ and volume knobs never have to be touched. It's a process which often gets forgotten in the rush to meet a deadline.

BRIAN SCHMIDT
Composer, Sound designer, Audio programmer, Game audio pioneer

Brian Schmidt is one of the true pioneers of the game audio industry. The 2008 recipient of the Game Audio Network Guild's Lifetime Achievement Award, Brian has been creating game music, sounds, and cutting-edge technology since 1987. With a credit list of over 130 games and a client list including Zynga, Microsoft, Sony, Bungie, Electronic Arts, Capcom, Sega, Data East, Namco, and many others. Brian has used his combined expertise and experience in music composition, sound design, and his deep technical knowledge to further the state of the art in game audio.

Brian is the creator of GameSoundCon, the industry's only conference dedicated to video game music and sound design and serves as its executive director. Brian is a frequent and in-demand speaker on game audio and game audio technologies, having given literally hundreds of educational and inspirational talks all over the world at events such as the Game Developers Conference, Microsoft's Gamefest, Sega Devcon, and the Audio Engineering Society Conference, SIGGRAPH, and esteemed institutions such as Yale University, Northwestern University, and Digipen have invited Brian to share his knowledge and insight into the industry.

Brian began his career in game audio in 1987 as a composer, sound effects designer, and music programmer for Williams Electronic Games in Chicago writing music and creating sound effects for pinball machines and coin-operated video games. While there, he was the primary composer of the video game *NARC*. His main theme from *NARC* was later recorded and released by The Pixies. In 1989, Brian left Williams and became one of the industry's first independent game audio designers, where he worked on such games as *John Madden Football*, the Desert Strike Series, the award-winning *Crueball*. Other credits include *Guns and Roses Pinball*, where he collaborated with Slash to create a truly interactive Rock and Roll game experience.

In 1998, Brian was recruited by Microsoft to lead the direction of game audio technologies. While there, he joined the then-fledgling Xbox organization as the primary architect for

its audio and music system. Brian's work at Xbox brought Dolby Digital Surround Sound to interactive gaming through, where he pushed both the technical and business aspects. Through his 10-year tenure at Microsoft, Brian continued to drive and advance game audio technologies through tools such as the award-winning "XACT" (Xbox Audio Creation Tool), the first-of-its kind tool to provide interactive mixing for video games. Brian was also responsible for the overall audio system of the Xbox 360 game system, including the XMA audio compression format, winner of the G.A.N.G. "Best New Technology Award" and finalist in IGDA's "Best New Technology" category. In 2013, Brian created the independent game company, EarGames, which creates "video games" where audio drives the gameplay, not visuals. Brian currently works as a consultant to the video game industry working with companies large and small.

Brian received undergraduate degrees in music and computer science from Northwestern University in 1985, where he created the first dual degree program between the School of Music and the Technological Institute. He went on to complete his Masters in Computer Applications in Music in 1987, where portions of his thesis work was published in the prestigious *Computer Music Journal* and presented by invitation to the AES special conference on Audio Technology.

Brian currently sits on the advisory board of the Game Developer Conference, is a founding board member of the Game Audio Network Guild (G.A.N.G.), is a former steering committee member of the Interactive Audio Special Interest Group (IA-SIG) of the MMA, and has been a featured keynote speaker at GDC and Project BBQ.

www.gamesoundcon.com

Are there any particular secrets to your creativity?

Uninterrupted time. Find out when you're most creative and block out chunks of completely uninterrupted time to do creative work. No e-mail, no Facebook, put your phone in another room. The briefest of interruption can kill a creative flow. A corollary to that is, don't get lost in the world of technology. It's really (really!) easy to lose hours or days exploring this synth or that synth, trying this plug-in or that plug-in. It can be a complete rat hole and it is NOT composing.

If you have time between projects, by all means explore previously unexplored areas of some of your tools. But don't do that mid-project.

Are there any secret techniques that you regularly employ?

I'm sure this is a "secret" technique that plenty of people already use. Use at least one nonkeyboard instrument in your pieces. Just that one instrument can make your virtual score come alive. Even if you're inputting MIDI data, a nonkeyboard input device can make a big difference. For example, drum parts just sound different if they're input from something like v-drums (by a real percussionist, using sticks with full arm motions) than by playing drum sounds from a keyboard.

When do you find you are most creative?

I'm a morning person, it turns out. Before kids, I'd be up at 6 (sometimes I'd start the day with a call to a west-coast client who hadn't gone to bed yet). So I'll often leave the "busy work" time until mid-afternoon, when productivity drops off. No sense wasting your most creative, full-of-energy time doing e-mail.

Any worthwhile creative advice you'd like to share?

Always definitely worth reiterating: Don't waste your most productive time doing e-mail or Facebook. Make sure you are set up to work 100% uninterrupted when needed.

My system's set up so that I switch over monitors and audio from my "business computer" (e-mail, Excel, etc.) to my creative computers. I don't see or hear incoming e-mails, etc. while I'm composing or doing sound design. I make sure my phone is on silent, or just put it in another room. Eliminate the 21st century distractions which can kill productivity.

Is there a typical workday for you?

I wear a lot of different hats, so it's difficult to generalize. If I'm in the middle of a creative project, I like to start my day with coffee and composing. If it's a time leading up to GameSoundCon, I'll generally try to work on content in the morning and then logistics after lunch.

What skills should composers have to succeed in the games industry?

This may come as a surprise, but I would say organizational skills and people skills. Of course, being able to write and orchestrate are a given, but there are an awful lot of people who do those very well. Being easy to work with and creating a reputation for being on time with great quality are extremely important in developing a long-lasting career.

Do you have a specific ideology which drives your way of doing business?

Treat people with respect, be straight, and think long-term. People can usually smell out hidden agendas, so I've found that being very straightforward with people is not only appreciated, but also gains respect.

Another is to always look for a win–win business solution first. This goes hand in hand with long-term thinking. While there may be short-term advantages that you can get from looking at everything from a zero sum perspective, when you try to make sure that your client is getting as good a deal as you are, you build a trust and relationship that is difficult to achieve otherwise. I'm not saying be a pushover—just to look first for business deals that benefit everyone.

Any horror stories which have impacted how you do business?

In almost three decades, I can't really think of a business horror story. I think that's because of the "be straightforward" philosophy. Or maybe I've just been very lucky. About the worst I've had happen is a company goes bankrupt before they paid me.

How do you approach negotiations with a new client?

I always try to sell my competitive advantages—to bring the discussion into the area where I stand out from the competition. Show how using your unique skills (whether it's technical expertise, deep understanding of a particular musical style, or depth of experience recording live musicians, etc.) will make their game better.

Do you have any negotiation tips which work well for you?

Always spend some time before negotiations putting yourself in the shoes of the person across the table. Think of what their questions, issues, and negotiating points and arguments

would be. That puts you in a much better position to respond to them. Whether it's on pricing, rights, schedule, etc.

Do you have any tips when working with developers?

Communication. Establish clear channels of communication early. That can be specific e-mail contacts or the ability to use a bug database.

Do as much as possible to become "part of the team." Whether it's in-person visits, lunches, conference calls. Don't just be "that remote composer who hands us .wav files once in a while."

Integrate into their system as much as possible. If you can get VPN (virtual private network—that lets you access their game), do it.

Love their game as much as they do. They are working on the game a lot longer than you probably are.

Have you ever had any development issues negatively influence your workflow?

I had to work on a game where I never, not even once, was able to see the actual game. I had screen shots and videos, but never actually played the game until it had shipped. That was pretty bad.

Staying organized is important, especially if you are working on multiple projects, which is part of your daily routine. How do you keep up with it?

This is where the "organization skills" I mentioned before come in. Be disciplined about splitting up your time. If you're doing creative work, block of large enough chunks of uninterrupted time (no e-mail, no Facebook, etc.), to get significant work done for one client. The goal is always to make the client feel like they are the only project you're working on.

How did you find your way into the games industry?

I pretty much fell into doing games. I'd been finishing my Masters in computer music outside Chicago when I was told that a local pinball machine company (WMS) was looking for someone who could write music but also program in assembly language. (*Note*: I sort of exaggerated my "assembly language" experience.) But, I'd also been a huge pinball fan my entire life. In fact, my mom used to get annoyed I spent so much time and so many quarters playing pinball when I was a kid. It turns out it was "job training," and in fact at the end of my interview, I was asked if I wanted to play an unreleased pinball machine. Of course, I said "yes!," and I discovered later that it helped quite a bit that I was a very good pinball player. People who work on games want people who love games.

For game music, various pieces are submitted at milestones during game development. Over the course of the month or two a composer is working, the last music cue submitted will have changed in volume and EQ from the first one and will be noticeably different in the game if they were to be played side by side. Some composers get around this by comparing each submission to the first piece they've done, but to do it right, a couple of days at the end of the final cycle should be set aside for the mastering process. This helps guarantee a consistent collection of music. Unfortunately, it won't be appreciated much by the player when done right—but you can bet it will have the opposite effect when done wrong.

Consistency in Sound Effects

Sound designers can naturally benefit from lessons learned in the music world to take their craft up another notch, to bring commonality to the player's experience, and to increase the chance for audio success in a game. More so than composing, it is important for sound designers to be able to commit to one project at a time to achieve consistency. I can't remember how many times I've tried to work on several sound effects projects at once and ended up losing perspective on all of them.

What ended up happening is I began treating it as one big project, even though none were related—using the same sound palette, trying to take shortcuts. At the time, it seemed logical—but when I sat back to listen to the four games side by side, they sounded the same and none had its own personality. It's a pretty straightforward idea, but difficult when you are busy.

Another step to ensure uniformity across the entire lineup of effects is to process all of the game sounds using the same sound processor settings. Using the same EQ, volume, reverb settings, and so on will furnish them with a similar *feel*. Jamey Scott uses this trick with much success in his projects. This type of final mastering gives the sounds an overall homogeny.

Sound Effects Mastering

Mastering can also be accomplished on purpose, planned in advance as the final step before delivery. Running all of your sound effects through mastering software to adjust compression, limiting, volume, and equalization is a great idea that many nonmusicians don't ever consider. They associate the process with music, but it can be equally valuable with sound effects. A final "mastering" session sees to their overall uniformity and ensures consistent playback quality, giving the final mixed audio a certain characteristic which ties it to the game. Good software can add a pleasant analog warmth, clarity, and presence; allow hard digital clipping; or add a smooth, tape-like saturation to the mixed sounds for a feel that is truly unique. Some sound designers use this process as their secret weapon to give that final polish to their work.

The final step, before submitting finished sound effects, is to listen to them in their entirety back to back—one after another. Listen specifically to their volume or perceived loudness with respect to the other effects and make adjustments to those that seem out of place. Be sure this comparison is conducted aurally and not visually. Some sounds can "look" softer than others but will actually be louder when played. Your ears have to be trusted on this one. There will be some sounds which need to be softer or louder by design, such as soft button clicks or thundering explosions, and you can ignore those. The rest will require some consistency, and by listening to them as a whole, there won't be any surprises later on. With the myriad of details needed to complete a game project, it is easy to let a sound slip through the cracks. This process will ensure it isn't your fault and will keep the game sounding smooth.

Early in my sound design career, I worked on a *Bingo* game project—initially delivering about 85 sound files for the number/letter callouts. I had edited the best takes from the voice talent recordings and just sent them in. It was pretty cut and dried and I didn't think much of it. The calls seemed fairly consistent and I was in a hurry to meet the deadline. It wasn't until the following week, when they were placed in the game, that I noticed the conspicuous volume differences between them. That's when I discovered the little trick of listening to them all

back to back, as well as randomly, to ensure they were even in volume. Looking at the sound files and using the same normalization and limiter settings didn't work as I had expected, but the time spent listening sure did. The middle-frequency range is generally better reproduced by most multimedia playback systems, and this all-voice sound effects project required some extra care.

Consistency in Voice-Overs and Speech

After discussing the considerations for music and sound effects, voice-overs, speech, and other narrative sound files would need to show consistency as well. Everything previously mentioned, from using the same equipment and signal processors to the mastering process, should be utilized in this pursuit. Additional factors can also help maintain uniformity when working with voices.

This might sound obvious, but always use the same voice talent for a specific character. There are exceptions, for instance, an alien creature who has the vocal range from the growling lows of James Earl Jones to the high screech of a 5-year-old girl, where you might need at least two voice actors to accommodate the requirements. (Unless you can find someone who has that range, of course.) And there are always the times when you need a line at the last minute and you are the only one around to perform the substitution. But, as a whole, using the same voice makes sense. People who play these games aren't dumb and they will notice anything out of place, cheapening their gaming experience. If there is a female voice announcing warnings and malfunctions aboard your spaceship, make sure it's the same voice. Make sure your little gremlin characters start with the same voice, even if it is processed beyond recognition.

Another consistency trick is to record all of the narratives in one session, using the same recording technique, the same microphone, and the same settings. By doing so, there won't be any concerns about the voice actor's tone sounding different either. Human voice qualities can change depending on the time of day, how tired they are, how humid or dry the air is, or whether or not they just drank battery acid. If they have to return later, you may suffer the possibility of them having a cold, for example—which could affect their sound and ruin your efforts. Equipment properties may have changed, and unless you have instant recall available on every piece of gear you use, they too will sound different. It will all add up to the same person sounding conspicuously dissimilar in the game.

Consistent audio quality is an important issue for everyone on the development team to concern themselves with. Much effort and thought goes into not only the creative aspects of audio production but how it all fits into the game. By utilizing the aforementioned ideas and techniques, it is possible to produce a game with sounds that are enhancements and not distractions.

Quality Control

Video games, though nothing but coded strings of 1 s and 0 s, are like any other product and require some form of quality control. As the sound person, there is much to do from your end to ensure the audio portion of the product is up to par. Creating a third of the game experience is a heavy responsibility and it behooves you to not leave this step to the developer entirely. You are the audio expert, you know the intentions behind every piece of music and sound, your name is in the credits, and this final product is what might attract your next big money-making

project. There is a lot riding on your sounds and you can't just leave it to fate or a low-level code programmer who doesn't understand audio.

If the audio was built using top-notch professional studio equipment, those standards are usually acceptable and odds are it will also sound professional. Using experienced and talented craftsmen along with great gear will increase this chance of success. Starting out with quality will boost you past mediocrity, giving less need for a separate quality control phase. But, regardless of how good you and your sounds are, it is always a good idea to keep track of their progress once they've left your hands.

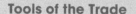

Tools of the Trade

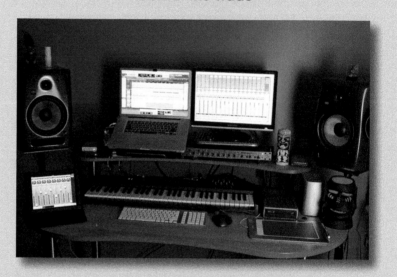

TODD KINSLEY
Composer, Sound designer

Like a lot of audio pros, my system used to be much larger, and consisted of a lot more outboard gear. However, with the massive advancements in audio software over the past decade, I've found myself making my studio setup smaller and smaller. Since I don't do much recording of live instruments these days (except guitars, which I run direct), I don't really need much in the way of hardware. I finally accepted this fact a few years ago, and decided to use it to my advantage, by going portable. My DAW is now centered around a Macbook Pro laptop. With only that laptop, a portable keyboard controller, and some headphones, I could complete 80% of the audio work I get paid to do. This means I can work from almost anywhere, which gives me an incredible feeling of freedom!

Computers: 17 inch Macbook Pro laptop, 2.3 GHZ Intel Core i7, 16 GB RAM, 670 GB internal hard drive, 4 external firewire hard drives that give me over 3 TB of storage

Audio interface: M-Audio Fast Track Ultra 8R

Software: Pro Tools Native, Adobe Audition, Audacity

Monitors: KRK RP8 Rockit Powered G2 Limited Edition (Ferrari Gray)

Mixdown: V-Control software on an Apple iPad for tactile mixing

Sound modules/VST instruments: EastWest/Quantum Leap (EWQL)—Symphonic Orchestra, EWQL—RA, EWQL—Silk, EWQL—Ministry of Rock, EWQL—Stormdrum 2 Pro, EWQL—Choirs, Big Fish Audio—First Call Horns, Steven Slate Drums EX, Prologue—Chipsounds, various others

Outboard gear/effects plug-ins: POD HD500X (for the guitars)

Keyboards: M-Audio Oxygen 61, M-Audio Oxygen 8

Other instruments: Various electric and acoustic guitars and bass, My voice (singing and voice-overs)

Microphones: Shure KSM27, various others

Remote recording gear: Zoom H4n, Rode NTG-2 shotgun

Other relevant tools: I have bins of various gear acquired over the years that has become obsolete with my current streamlined setup

Check Mixes on Several Systems

Before any final music or sound effects are delivered to the developer, it is a good idea to listen to them on different systems and different speakers. This will check the integrity of the audio across a wide range of possible playback systems, whether it's a cheap set of multimedia speakers bought from a swap meet to a full-on $10,000 home theater surround sound system. The options are infinite and you want to have the confidence your audio sounds good on all of them. Play back at different volumes, from very soft to as loud as the neighbors can stand. Listen for an even mix in each cue or effect. Make sure the low-end frequencies don't distort and the high end is present and not overpowering at any setting. If all of the audio sounds good on the various systems and settings, they've passed the test. If not, fix them.

Check Your Sounds in the Actual Game

This sounds obvious, but more often than not the sound person gets left out of this final step. If you're able, listen to the audio in the game. If not, make sure a trusted member of the development team, with audio experience, is there to perform this crucial assessment. Some actually believe this process to be the most vital phase of the production cycle. Most composers, sound designers, and producers insist the audio guru listen to their sounds in the actual game—typically happening around time the game goes into beta. At this point, the effects and music should be in place and the sound team should sit down and study their audio intently. It's not uncommon for the audio to sound great in the studio but not so hot (too loud, too soft, too long, or too short, as examples) once they're in the actual game.

KEITH AREM
Director, Composer, Sound designer, President (PCB Productions)

Keith Arem is creative director and president of Los Angeles-based PCB Productions and PCB Entertainment. Arem is one of the leading talent directors and content producers for the interactive industry—serving as the director of audio for Virgin Interactive and Electronic Arts Pacific. Arem holds a Bachelor of Arts Degree and Master's Studies in Audio Engineering from CSU.

Arem and PCB Productions have directed, produced, and recorded over 600 commercial releases in the game, music, television, and film industries—including franchises for *Call of Duty: Ghosts, Modern Warfare 1, 2, and 3, Black Ops 1 and 2, Saints Row 3 and 4, Spiderman series, Ghost Recon series, Lord of the Rings, Sleeping Dogs, Tony Hawk series, Transformers series, Ridge Racer series, Everquest series, Rainbow Six series, Persona series,* and *Titanfall.*

www.pcb.cc

Describe your thought process for scoring/creating sound effects.

When I am designing an element, I try to envision the entire sound field and consider other elements that will be combined into the scene. Sometimes the score needs to accentuate action, but also needs to respect the dialog and sound design, and allow it to breathe. When I am designing a sound, I focus on organic elements that blend together and try to make a unified sound. For the final mix, I try to visualize the sound field (i.e., panning—left to right, height—top to bottom, reverb depth and ambience—front to back).

Are there any particular secrets to your creativity?

Building a work space conducive to your creativity is key. I find that my best ideas come quickly, so if I spend too much time finding assets, building

templates, or wiring patches, then it distracts me from the flow of creating. Being creative in the studio is like cooking in a kitchen. Having your food purchased, prepared, and assembled means you can jump right into cooking. Having my building materials assembled first always speeds up the creative process, since I can jump into making sounds, rather than spend time setting them up. I prepare and build my templates early to minimize setup, so I can focus on the creativity and not waste energy during recording sessions. That way I can concentrate on the immediate creative elements, and not be distracted by technical concerns during a session.

Do you have any interesting sound gathering/sound creation stories?

Sometimes creating sounds can be hazardous, especially when you're on location with sports teams and machines. I've lost dozens of mics to engines, extreme weather conditions, or overenthusiastic athletes, but the most dangerous incident happened when we were capturing jet boat engines for an arcade racing title. Our team was directly behind one of the engines, capturing the afterburners, when one of the boat technicians casually suggested we move to the side. A couple minutes later, a 25-feet flame blasted from the back of the boat, right where we were standing. We made sure we never stood directly behind them again.

Do you have any advice which can help lay solid groundwork and ensure a successful production for the audio content creator?

Managing expectations is one of the smartest things to do with a client. Some clients have preconceived ideas of how things should be accomplished, while others may have a concept for a sound, but no tangible example to reference. Sometimes these ideas don't always translate into the real world, so it's important that they understand what is feasible or sonically possible. I spend much of the early time on a project understanding and listening to the client's goals, and then helping to educate them on how we can both achieve those goals.

When do you find you are most creative?

My best "ideas" come when just before I wake up in the morning, but my best "work" is always at night. It's difficult to be creativity in a 9–5 environment, so I designed my facility to work day or night, while not disrupting the workflow for our clients.

Is there a typical workday for you?

Never. Every day is a new challenge, and it always keeps you on your toes. Each project has to be better than the last, and each title has to find a way to achieve the best quality.

What skills should composers have to succeed in the games industry?

Working in the game industry means creating what is best for the title, and not always what is best for our own ego. There are hundreds of people lined up for your job, so the most important skill is being able to deliver on time, on budget, and exactly what the client needs. It's important to have your

own creativity, your own style and ideas, and always be flexible when ideas and schedules change.

Do you have a specific ideology which drives your way of doing business?

The game industry thrives on new ideas, but the best ideas are ones that can be accomplished. When I evaluate a project, I don't under-promise, and I don't over-promise—I try to hit my target exactly.

Any good business advice to offer?

As a service provider, attitude is everything. Being open to ideas, while proposing new ones, is instrumental in surviving in the game industry. My philosophy is "plan for the worst, and hope for the best." That way, you'll always be prepared if things hit the fan, and always pleased when they don't.

How do you approach negotiations with a new client?

It's always best to express any concerns or stipulations before you start a project. During the "honeymoon" phase, it's best to talk about dates, costs, approvals, and expectations, before the stress of work sets in. If there are problems at the beginning, it's best to work them out early, or they will fester during the development stage. Always be truthful in what you can and cannot do, and don't make promises that you can't ultimately fulfill.

Do you have any tips when working with developers?

Developers live and breathe their games. They will live with their projects day-in and day-out, and are looking for people to help them achieve their vision. Listen, advise, and collaborate, and most of all, don't base your convictions on the last project you finished—I guarantee things have changed in the past couple of years.

What advice can you give when working with a developer to ensure you are able to make great sounds?

Always try to educate and manage expectations with your team. Sometimes you'll receive a request that seems impossible, because the developer has a great idea but may not have a realistic idea of how to achieve it. Managing the team's expectations, and finding creative solutions to achieve those goals, is key to making great sound.

Have you ever had any development issues negatively influence your workflow?

The most counterproductive issues can arise from people outside of the creative process. Often an idea or suggestion may come from someone outside of the development process, and while their intention may be good, their timing can be horrible. Having your team, developer, and publisher understanding the timetable for creative input will save many hours of redoing work.

Do you have any advice to ensure successful audio implementation?

Audio implementation is always best when the sound designer can work closely with the team. Assets can change on a daily or hourly basis, and it's infinitely better to be on-site to bend with those changes. Working closely with the audio programmer or level designer will always insure a better fit for your sounds.

Staying organized is important, especially if you are working on multiple projects, which is part of your daily routine. How do you keep up with it?

Try to tackle one small item at a time, only if you can finish it at that moment. It helps to rotate through your projects throughout the day, and address one complete item at a time. When one project demands your full time, you need to be able to delegate your other responsibilities, so you can focus on the issues at hand. Multitasking can work great, if you keep everything moving forward and don't neglect the overall project.

While analyzing the audio in the beta version of a game he was working on, Joey Kuras discovered a programmer on the project had taken one of the sound effects (footsteps) and cranked up the volume so that they could be heard at the same level as the rest of the sounds. What were intended to be subtle, barely discernible Foley effects turned into a loud series of crunches which sounded seriously out of place. Thankfully, Joey's screening session caught the problem and it was corrected in time.

Remember, you are the person getting paid for your particular audio expertise. Your opinion and experience is a valued asset in the production process. Often, the developer will be in such a hurry that they attempt to cut corners to make a deadline and your opinions will be left unsolicited instead.

> You must insist, prior to releasing your sounds, that you are permitted to test them in the game.

The example with Joey is just one of many stories I've heard where your intentions to make quality audio are thwarted by someone on the team who doesn't have a clue. They don't do it deliberately; it's just they don't know any better. Your job is to stay on it to the very end and make sure your hard work is presented to the game player as intended. Tenacity is a good quality to have.

Teamwork with the Developer

As an audio contractor, it is sometimes quite tough to build a relationship with a development team who's been together for a year or more. You are the new kid on the block, entering the picture late in the game. And, with your part completed within a couple months or so, you won't be around for long either. Not having every member of the team present as one cohesive unit can be a serious stumbling block. As the outsider, you must fight this phenomenon and work a little

Tools of the Trade

AARON WALZ
Composer, Sound designer

I often work in my home studio and create professional music, sound design, voice-over, and solo live instrumentation recordings and integration. At times, I also work in the studio at Kabam, which is fancier. I use tools that I know well and that won't get in the way of my creativity. I'm all about efficiency and productivity, as well as creating a comfortable atmosphere conducive to happy music-making.

My studio is based on smooth operation, depth of knowledge, and ease of performance. I believe that you don't have to have all the newest and best toys; however, you better know your tools inside and out. That's where the real magic lies. And have tools that you really need and use. If it's in a gear bag or closet for months, you probably don't need it.

Computers: 12 Core, Dell XPS laptop, external hard drive for all sound libraries and DAW files, several mobile devices

Interface: M-Audio Firewire 410, but I'm switching soon to a Saffire Pro 24 DSP; Digidesign Rack

Software: Like another Aaron, I am a Sonar guy since days of old (when it was called Cakewalk). However, I also use Protools. I like Protools now that it finally has quick bounce. Sound Forge and Goldwave are my audio editors of choice

Monitors: I tend to like powered monitors. Behringer (not my favorite), Roland, Klipsch, Dynaudio Acoustics BM15A, Genelec Monitors and Sub, Avantone Active Mix Cubes, Blue Sky EXO2 (in the plans), car speakers, device speakers. I'm fascinated with listening to my work and other

music through various monitors to see the coloration. I have to be careful because I dislike mid-range in my mixes, so I need very honest solutions and diversity

Headphones: Beyer Dynamic DT 770 Pro (love these), KRK KNS 8400, Sony MDR 7506

Monitor system: PreSonus Monitor Station with talkback—perfect for VO sessions and multiple monitor selection

Other: Millennia STT-1 Origin Channel Strip, Furman M-8Lx Power Conditioner, Studio V3 Blue Preamp

VST instruments and sample libraries: Kontakt, Play, Gigastudio, NES 8-bit, Kong Audio Guzheng, Dizi & Erhu, lots of SampleTekk, Bob Orchestral Brass and VR Sound stuff, Lyrical Distortion, Quantum Leap, Garritan Stradivari, Best Service Whistler, Livesynth Pro, old school soundfonts … and more stuff

Plug-ins: Melodyne, Waves, Ozone, Altiverb, etc.

Keyboards: Roland Fantom X8, M-Audio Oxygen 49, my childhood upright Wurlitzer

Other instruments: Various drums, finger cymbals, ocarina, recorder; I bring in an excellent violinist, flautist, and other instrumentalists to warm up and enliven my mixes; my voice

Mics: Rode (I'm half Aussie) NT 1000, Shure SM 58, Rode NT4 (in the plans)

Remote recording: Zoom H4N digital recorder

bit harder to show them you are part of the team and are as passionate about the project as they are. Enthusiasm is infectious and if you display a steady stream, you'll score points quickly.

This bond with the team will strengthen the overall quality of a project. When they see you working hard toward making the game better than anything else that's ever been done, they won't resist your ideas and opinions as much. Nobody likes a snooty, self-centered boob concerned only with making the game a show-case for their work. Games, films, and television shows that only seem to serve one actor, artist, or director are often doomed to failure. The public picks up on these things quickly and will understandably demand the total experience. They want good artwork, good gameplay, and good audio as the total package. Working with a unified development team will naturally lead to good quality control, where everyone is interested in the overall picture and not just their own agenda.

Conclusion

Exercising good quality control is as integral to the process as hiring the best team money can buy. As all of these incredible pieces of the game project come

crashing together, this is the time for attention to every little detail to get them to mesh perfectly. It doesn't matter if every component is a masterpiece on its own. What does matter is how all of the individual masterpieces fit together to form the big picture. By maintaining tight control of every aspect, the developers can ensure a great game. By maintaining good control of your audio submissions, the developer will benefit from your valuable knowledge, experience, and talent and have one less issue to concern themselves with at crunch time. Now you can continue on your path to game audio superstardom!

13

Middleware and Scripting

The thought of "programming" often scares away talented composers and sound designers to games. One of the long-standing misconceptions has always been in order to be in "game" audio, you had to be able to get under the hood and "code" as part of the process. While it's never a bad idea to understand a little about how programming works, you could still sustain a lifelong career purely as a content provider and never have to see the grittier side of development. But, having said that, there are unlimited possibilities a person with audio expertise can do for a game soundscape with the right tools in hand.

Without a doubt, modern game players expect a rich and entertaining aural experience. In the earlier days, it was considered a major triumph to have more than just a few sounds in a game. And as technology advanced, more storage, memory, and processing power led to more possibilities and a focus on audio improvements became an almost equal part of the equation. Less repetition, more variety, randomness, interactivity, and adaptable sound behaviors were all reachable goals but were often left out due to time constraints or because of the effort needed to do them correctly.

Before the days of middleware, most of what was implemented in a game project was because of audio folks who befriended programmers and spent quality time working side-by-side. Larger developers who had the resources created their own in-house sound tools and improved upon them with each successive project. After a couple projects working out the kinks, their efforts paid off with a nice improvement in the use of sound. Other game developers took notice, created tools and audio features to match, and then went even further by building on the ideas which in turn led other developers to build on those and so on. And true to

the nature of game creators, we share and the entire industry (and subsequently the gamers) benefit from an even more enveloping experience.

Eventually, industrious individuals with a love of games and a nose for business stepped in to fill the void and support the complexities of implementing compelling audio for today's generation of games. Because developers are always interested in efficiency while keeping their costs down, they soon reaped the benefits of well-thought-out and powerful tools created by outside resources who are able to concentrate on that one task alone. What used to be the duty of a lone programmer has become a boutique industry creating what we call "middleware." For the record, "middleware" gained popularity in the 1980s as a way to link old and new systems and applications but has only recently become a mainstream solution to the intricacies of many facets of game development.

While "middleware" is the tool, "scripting" can be considered the actual act of creating and defining sound behaviors either using these tools or as part of some other form of manual programming. And while you take a moment to wrap your head around that, be sure to keep reminding yourself that you still don't need to know traditional programming to work in game audio! It's been said that if you can drive a stick shift automobile, you have the ability to fly an airplane. So, it's not a stretch to say that if you can safely use multitrack software such as Pro Tools or SONAR without poking your eye out, you can also use middleware and script with the best of them. I promise.

Dynamic Audio

Why all the fuss about middleware and scripting? By now, I think you understand audio in video games is like no other medium. Processor and memory resources on any game platform are finite, and all assets have to play nice and share these limitations. Gameplay is unpredictable, players are unpredictable—a game experience is almost never the same like a conventional linear format such as film would be. These two factors, limited resources and unpredictability, have always been major challenges to the development team. Audio assets are limited, but must feel limitless. Randomizing and lowering repetitiveness are the key, and middleware tools are what help us create more with less.

Conventional methods of implementing and triggering audio are quickly falling by the wayside. Playing one music cue for exploration, triggering another when a few bad guys show up, and then triggering yet another for the appearance of the "boss" is a simple example of adaptive music but isn't as dynamic as it could be. Through middleware, we can take these three music cues and create a variety of submixes, create more musical transitions, trigger random musical "riffs," and adjust volume, EQ, and effects processing as needed. In a sense, doing more with less to create something unique.

Sound effects can be used much more creatively as well. Building a "dynamic" environment beyond repeating a simple ambience loop, for example, is one of the strengths of middleware tools. Time of day, weather conditions, and seasons are in constant motion, and a single ambient loop could never accurately track these conditions or do so without being monotonous. Sound-making objects in reference to the location of the player can be manipulated to include distance, location, obstruction and occlusion considerations, and even objects that react to danger or the player's presence. So, instead of a single sound file playing a mix

of many sound elements, these sounds can be triggered individually and with greater variety and flexibility with these types of tools available.

Middleware

The term "middleware" officially refers to software solutions which aid in asset creation, implementation, and management. These have grown into influential tools which ultimately make game audio better while using less resources and programming effort. The development cycle for even the smallest game is already complicated and time-consuming, so why keep reinventing the wheel? Developers could spend large amounts of time and money to create their own in-house programming tools if they wanted to and many have done so because they understood their value.

Now that dedicated third-party companies and individuals have stepped in to create these powerful tools, it's no wonder why middleware has really become widely popular among the development crowd. Being able to define complex sound behaviors using any audio format, having a prewritten robust audio engine with all of the bells and whistles, having the capability to create and implement these on almost any game platform—all compelling arguments to use these "solutions" on every project.

The best part, in my humble opinion, is these really awesome tools allow the composer and sound designer to remain in creative control of their audio well beyond the creation phase and all the way to implementation. I don't know how many times I've created audio assets and sent them on their merry little way never to be seen nor heard from again. Entrusting the development team to implement them with the same audio sensibilities as me is often "iffy" and it really is nerve-wracking to let nonaudio people play with your sounds. I've mentioned some of the horror stories of the past, where footsteps get implemented as loud as gun-shots, which happens when involvement of the sound designer stops after asset delivery. But, when the audio creator stays the course and is involved in scripting, a better final mix will almost always be the case.

Middleware software tools are designed for the nonprogrammer in mind. There is a certain complexity built in to them due to the nature of the task, but it's nothing a composer or sound designer can't handle with a small amount of tutelage. Instead of having to understand and write complicated code, setting values, toggles, and other parameters via faders, line graphs, and numeric entries is easily accomplished through an intuitive interface. The latest versions of these tools have taken on the appearance of familiar territory as they incorporate audio workstation-like qualities. So see, all of that worry was for nothing.

Allowing the folks who live and breathe audio to take a more prominent role in implementation has taken game audio to another level practically overnight. Not all games are complex enough to use audio middleware, nor do they have to. A sound designer creating sound effects and sitting with a programmer to mix a game is still totally viable, something I did just last week myself. But, for more involved game projects, allowing the audio creator to actually define how their sounds behave in a game gives them new insight and permits them to create accurate sound files instead of having to coerce them to work at the end of the development cycle. Plus, maintaining their audio vision through to the very end by establishing what sounds play, under what conditions, and what parameters are assigned to them when they do playback, ensures everything fits together

nicely. The workflow may be a bit more involved but this new reality is easily embraced when its value becomes apparent.

Third-party, audio middleware solutions have gone from scarce to quite abundant, fueled by much enthusiasm in recent years. From the developers enamored with their power and ease of use and audio content providers who retain creative control, to the game player who is the ultimate benefactor of their contributions, there is a reason why middleware is one of the best things to happen to game audio since the sound card.

Use in Sound Design

A "dynamic" audio environment is the key to an immersive experience. In "real" life, there are so many things happening around us at any given moment, most of which we have learned to ignore. My computer fan is running but I rarely realize it. The TV is on in the other room but I don't notice it most of the time. There are birds chirping, wind chimes ringing, and fingers madly typing—all of which I basically ignore during the course of my day. Now, it's not to say that I actively "ignore" them, it's just as humans, we tend to prioritize and disregard stimuli that are inconsequential or monotonous. But, they are still making sound and it's these types of almost trivial sounds that give life to an environment.

Simple audio reproductions of this type of setting would normally be a looped ambient recording specific to each location. The longer the loop the better, but space considerations would ideally keep these on the short side. Maintaining that "endless" feeling, especially in a shorter loop, can be destroyed by repeating sounds a player will eventually notice. Continuous sounds, such as a light wind, a river, or freeway traffic, have the best chance of remaining indistinct but these might not match the activity within an environment. Instead of trying to include every sound within the loop and risking distraction, you could take this a step further by firing off random one-shot sound effects to break up the monotony and create something more believable. This is a good first step to a dynamic environment but, at some point, even those "one shots" would get monotonous. To counter this, several variations of each would be needed which, unfortunately, continues us down the path of adding still more files, using more space, and more processing resources.

Middleware tools have truly taken on the challenge and really do allow us to create much more, with much less. Imagine the power to trigger a variety of birds and insects whose activity corresponds with the time of day within a game. Triggering variables in wind, rain, thunder, and lighting in different sequences and intensities could be an ever-changing experience and allow for unpredictable weather. Or prompting blowing leaves, snow, sand, or other environmental sounds to reinforce what the player may have happening in front of them. By establishing randomness through the use of volume, panning, EQ, and pitch-shifting, for example, you can create a true dynamic audio environment that will never repeat itself, take up less storage space, and ultimately save the amount of time it would take to create the variety of finished sound effects needed to accomplish the same thing.

And it's not just ambience and audio environments where middleware shines either. Randomness of sounds is important but difficult using standard programming. Footsteps, for example, can easily be one of the most heard sounds in a first-person shooter, and they have the potential to really annoy the player if there are only a few. The more variations of a sound which can be put into a game,

the better—whether the sound designer is physically creating dozens of sounds which will be triggered randomly or, as the purpose of this chapter insinuates, through the enthusiastic use of middleware tools.

Implementing dozens of footsteps, or gunshots, or breathing, or any type of simple sound can take up unnecessary space. Middleware will allow you to use just a minimal amount of sounds, for example, a few "footstep" sounds and a few "surface" sounds (like leaves, gravel, snow, etc.) and create an unlimited amount of footfalls. Yes, footsteps are "minor" in importance, but repetition is the plague which we always struggle with. Utilizing slight up and down pitch changes, pitch bending, volume, EQ adjustments, and the mix of elements all allow enough subtle difference and variety to give the appearance of randomness and all with only a few original sounds.

Recurring complex sounds such as explosions also pose a challenge where middleware is the perfect solution. Obviously, in the dynamic environment of a first-person shooter, for example, explosions will come in all shapes, sizes, and distances. The common scenario would be for the sound designer to create a dozen or so variations and implement these with volume adjustments relative to the player's perspective. But even taking it just one step further using middleware would ensure a more accurate representation and an unlimited amount of variations.

I know when I'm tasked to create explosions, I'll grab numerous elements to mix together and reorder them to make variations. My base sounds typically include several prerecorded explosions, debris (dirt, concrete, water, metal, etc.), and other materials such as fireworks, fire bursts, subelements, or any other sounds relevant to the theme. Instead of mixing these elements to create "finished" sound effect variations, they can be configured in middleware to trigger independently, where pitch shifts, volume, and layering alternatives will be nearly infinite. Add EQ settings for obstruction and occlusion considerations, real-time panning, and effects processing and you've got pretty much every "explosion" scenario covered. No repetition, dynamic and "living" sounds, saved space, and one happy game player.

Use in Music

Adaptive music, by its very nature, is a complicated state of affairs for both the composer and the audio programmer. Not only do a variety of music cues need to be artfully crafted but they must also fit together purposefully, seamlessly, and musically while doing so within an ever-changing and unpredictable environment. Yes, it is a tall order indeed but I promise you, it is not impossible and in fact, made much easier with the use of middleware tools. And knowing what options are available, it will allow the composer to create more efficiently, effectively, and with more overall impact in the process.

On a basic level, audio middleware has the capacity to take completed pieces of music and trigger them at appropriate, designated times. And while this is a standard feature of most available programs, it's only a rudimentary solution to building a soundtrack within a game. Avoiding repetition is important, transitioning between pieces of music is always a challenge, and well-orchestrated music structures and behaviors are vital.

Repetitive music can definitely be annoying and luckily for us, there are several ways to combat this. Before middleware, the obvious solution was to create longer music loops, longer individual music cues, and more music overall. While this reduced repetition, physical storage space of the files became another

problem. Compressed audio formats or reduced sample rates and resolutions helped that issue but now you had to deal with reduced fidelity and potential playback issues, so it isn't quite the perfect solution.

Middleware tools can alleviate these issues, while solving repetition in several ways—it all depends on how the composer and developer want to approach it. One method, very similar to creating a nonrepetitive ambience track, is to randomly trigger "one-shot" musical riffs or sounds which would overlay an active piece of music. Obviously, the music should be uncomplicated and free-flowing and the triggered elements should make musical sense, of course, but this can have endless possibilities if thought out correctly.

Another effective method is to create several submixes of a piece of music, ranging from a stripped-down, basic version to a full-on "boss" level version which can be triggered between them as a scenario may dictate. When creating "level" themes, for example, it's important to keep that theme intact while the player is on that level or world. Several mixes of the same piece of music not only allows for some dynamics to support the gameplay but it greatly reduces repetition. For the composer, there is always a little work involved to keep things musical but I think we all naturally create variations while putting together a piece of music, so it won't be too much outside of the normal workflow. Other methods are available, depending on the tool in use, so be sure to research what your team is using to fully appreciate the capabilities.

Transitions between pieces of music are another fundamental challenge where the choice of tools plays a pivotal role. Any movement which a player controls, such as between menu screens, entering a new space, or even pausing the game for example, can trigger a change of background music. Making these particular shifts sound less jarring should be considered when building the accompanying audio. The composer has the option of creating transition pieces, such as a "stinger," "intro," or "outro" which can be triggered appropriately to lead into the next piece of music. But beyond those, there are also scripting considerations which can make them work. Setting the transition at the end of the cue, on a downbeat, crossfading, fading out then fading in, dove-tailing, or simply stopping the current music, playing the stinger and starting the new music—any of these or other options can be applied depending on how the development team wants to accomplish it. Most middleware options have some variation of these techniques in their arsenals.

But probably what middleware tools are most suited for is their ability to define sound behaviors in the game, build interactive musical structures, and edit and mix the music and soundscape in real time. Whether a full-orchestral score or a simple ambient soundtrack accompanies the player through their adventure, there exist an almost infinite number of situations where music can punctuate a dramatic moment and support the story as it unfolds. Through the use of middleware, each possible route a player takes can have a different piece of music set to play, not only to guarantee the audio experience is different for each one, but more importantly, to ensure the appropriate mood is revealed and how the player feels about the choice they had made. A different audio experience awaits the player if they choose another path the next time. The composer will spend some time crafting individual music cues for each path, creating numerous variations, or establishing rules to play generative music. The use of MIDI and variable triggered instruments or by turning tracks off and on in an ongoing piece of music, similar to multitrack audio production software, are examples of possible options.

MARK SCHOLL

Composer, Sound designer, Percussionist—International Game Technology (IGT) and Screaming Tigers Music, Inc.

Mark is a full-time composer and musician who has created audio for over 70 game titles for IGT and many other game companies and contributed music for a variety of TV shows including *The Amazing Race*, *Dancing With the Stars*, *Gene Simmons Family Jewels*, Hulk Hogan's *Hogan Knows Best* to name a few. Mark received two Emmy Awards as part of a team of composers writing music for several years on the Guiding Light and has also scored several TV commercials and infomercials. Prior to his full-time composition career, Mark played drums, toured internationally, and recorded with pop superstar Barry Manilow for over 11 years. He was also the music director and drummer for American Idol's Kimberley Locke, as well as touring with Andrew Lloyd Webber's *Music of the Night* and performing in the musical *Harmony*.

Mark resides in Northern Nevada with his wife and a family of dogs on a massive 40-acre ranch.

www.screamingtigers.com

Describe your thought process for designing sound.

I like to do a lot of layering, especially for big events sounds. Layering gives you more textures and depth as well as helping to create a unique signature sound with a stronger impact. There are also many small subtle button/select sounds in a game. Those sounds will be heard over and over again and as a result I like to make those sounds reasonably subtle and as pleasant to the ear as possible because if they are too harsh, they can get very annoying very quickly. Sometimes there are sounds that accompany dynamic game play movement, like footsteps or

weapon hits for example, and in order to give them a more natural dynamic feel, I will create several versions of the sound and then have the engineer either randomly trigger or cycle through a series of the sounds.

Sound effects that are intended to go with animation must have an accurately timed representation of that action to get a clear sense of what will be in the game as the timing of the sound is as crucial as the actual sound itself. The animations are usually created long before the sound work begins and I will request those video files before I start. After I have created my sound effects package, I will go through and assess the volume and EQ balance from one sound to the next as that is also important within the context of the game. I will usually have the effects package implemented into the game build itself to get a real sense of how the sounds are working both individually and interacting as a group.

Are there any particular secrets to your creativity?

As with anything creative, I think it is a bit of a mystery, but I do find that visuals from the game are very helpful to stimulate ideas. I like to get a cinematic or some representation of game play with screen shots or maybe a preliminary build of the game. A lot of times that will help to give me a direction.

Years of experience allow me to get started quickly, as I'm constantly on a timeline with all of my projects. I am also constantly buying fresh sample libraries which give me a very expansive arsenal of instruments to work with.

Are there any secret techniques that you regularly employ?

Finding the right instrumentation, sound, and direction is key to beginning any game. The game themes are often pretty clear as to what musical and sound direction would be appropriate, but sometimes I will listen to other composers I admire to find a feel and direction that might be close and start creating something original from there.

Do you have any interesting sound gathering/sound creation stories?

I have a portable Tascam stereo recorder that I have used dozens of times recording around my property including leaving it on in the garage during a huge thunder storm. I ended up with one of the best thunder claps I have ever heard!

When do you find you are most creative?

No special time since I have projects running constantly but I need to be in a relatively calm quiet headspace to be able to start writing.

For the past several projects where I have been a full-time composer, I have to write on a consistent weekly daytime schedule. As a result, I will simply have to sit down and start creating but of course I don't always feel inspired to write. I have found that once I can get past the "blank slate" stage and have struck upon a nice idea that feels like it is working, my creativity always seems to flow much more smoothly and quickly at that point in my writing process. Sometimes I will have more creativity "the next day." If I get to a point in the composition that I am getting stuck or I am starting to not like the idea, I have learned to let it go until tomorrow. When I come back in the next day, I will hear things more clearly and will often have a flow of ideas that is inspired by the previous day's initial thoughts. And occasionally "the next day" has inspired a totally new direction.

Is there a typical workday for you?

Not really except that I isolate myself when I am composing since that requires the most continuous creativity. When I have sound design, voice-over, or other smaller musical details to work on, I can do that on days when I have lots of meetings or admin work to do.

What skills should composers have to succeed in the games industry?

Beyond the innate talent for composition, which is paramount, there are dozens of skills that every composer needs to succeed.

At this point, you really need to be a multi-instrumentalist which is mostly achieved by using the many great sample libraries out there. You should also have a good understanding of what the natural instrument is capable of in order to create a realistic simulation. Have a highly functional understanding of at least one of the many exceptional DAWs such as Digital Performer since it will be your prime creative tool. But, that's just the tip of the iceberg; many other skills are definitely needed to be successful.

You need to have a solid, practical understanding of recording, performing, producing, mixing, and mastering. If you have bigger budgets where real players can be used, you will need to know how to orchestrate and arrange for live instruments. You need to have the ability to work under pressure. Create various styles of music authentically or some hybrid versions if the situation calls for that. You need to understand how the nonmusicians you are working with communicate (such as game producers, game designers, directors, engineers, artists, etc.). You also need to be personable and get along with people. You need to be highly adaptable since situations constantly change and you need to be OK with that too.

Being a composer can be an incredibly rewarding experience, but it is also highly subjective and therefore is wide open to all kinds of criticism and as a result you need to be OK with constant criticism. Pretty much every successful professional composer has had to revisit their work at the request of the person paying them (sometimes even starting over from scratch) as your vision may not be matching up to the vision of the producer. This also requires learning to think quickly and come up with new ideas and directions. I know it sounds like a lot but there are many layers to the onion!

Any specific "lessons learned" on a project which you feel are important?

Organization and backup files are both very important! I also find it to be quite helpful if I write out a score (or at least a melody/chord chart) for most pieces that are fairly involved musically even if I am not planning on adding any live players. There seems to be many times when you need to revisit a project long after it is complete. Being able to just reopen a file and start working is ideal. I had a hard drive crash several years ago and lost a bunch of files for a few projects that were already completed. Most times that may not have been a problem—but sure enough, one of the projects wanted to make some new additions based on the original idea. Well, I did have the score parts in another location which made it easier to reference melodies and adapt them for the new outlet, but I had to rebuild my entire Digital Performer template from scratch.

Do you have any negotiation techniques or stories which others could learn from?

As my wife Robbin constantly reinforces with me, ask for what you are worth. For most people, it is very easy to feel insecure when you are putting a fair size number on the table because, as we all know, there is always someone else who is willing to do the project for next

to nothing. However, you are doing yourself a disservice if you don't account for the amount of time it will actually take for you to complete a project. Music composition, sound design, and everything that goes with those two jobs such as performing, arranging, orchestrating, recording, mixing, mastering, writing charts, hiring additional musicians, etc. are all very high skilled jobs that take a lot of time to complete.

It is always good to come to the table with a high/low number in mind—one side or the other has to throw out a number first and it is good to know what to counter with in the event that they throw you a lower number than yours and you need to work up from there. Also if you have a number in mind that you really feel you need to make on a specific project, don't be afraid to put it out there first and let them counter. Sometimes the biggest challenge is that you may be dealing with people that don't really know how much work is involved to write and produce a lot of music. A very good friend of mine has a humorous insightful observation in these situations, *How long does it take to write three minutes of music? Well, three minutes!*

One final thought that I have learned about negotiations is that the person who is willing or able to walk away from the table is the person with the most negotiating power.

What sort of things do you feel are important during the development process?

Communication with your team is really important as this is ultimately a joining of creative forces. All games involve a lot of people from start to finish. Even though most of the work is done by individuals working in their own studios, there is always a need to discuss direction and come together for update meetings along the way. Once I have written a main theme (or two) and have produced them enough in a direction that conveys the right feeling, I like to invite people to my studio, or send MP3s via e-mail or upload to FTP if they aren't in the same city, usually before I add some live instruments. It helps to confer like this to make sure that all of the team leads are happy with the direction. I think that it is also a good way for your team to gain a little insight into how involved the composition process is. I have had very favorable results come from these interactions and it creates a nice sense of camaraderie.

Do you have any interesting creation techniques which resulted in a notable piece of music?

I come from a very extensive live performance background, including lots of work with symphony orchestras and big bands. All of my live performance experiences have been a very insightful in how all kinds of instruments are performed and how challenging it is to actually get a sample to simulate the real thing. As a result, I have always preferred using at least a couple of live instruments if possible, because even though the samples can sound great, they will usually lack the emotional depth that a well-performed instrument brings to a piece. I mostly bring in guitar and/or some live horns to add on top of the samples. The mixture of these elements will often create some really exciting results that you may not get from just one or the other. Not that I haven't used just samples for a piece but if there is a budget to account for the additional players, then I will write out a couple of charts and set up a session.

Like many composers, keyboards are my writing instrument, but unlike many composers, drums are my first and strongest instrument. I have a ton of both modern and vintage drums in my studio. Another technique that I use fairly often is that I have written orchestral score pieces that lend themselves to a massive drum-ensemble-type march somewhere in the composition. I will use some samples to set the foundation (like Taiko drums—which I don't

have) and then I will play numerous tracks of huge toms and/or various snare drums over top. It creates this thunderous dynamic effect that samples wouldn't be able to achieve on their own. Another technique that I use is that I will also play a live drum kit or hand percussion over top of samples and/or loops for more modern edgy pieces (maybe a hard-rock-type vibe) to create a live energy with a very modern sound.

What advice would you give when looking for and possibly getting involved with certain game projects?

There are tons of people out there trying to do games and many upstart companies that are seeking funding. These can be great places to start, but the downside is that they usually don't have any resources to fund until they shop for a publisher or some kind of venture capital backing. I have had both good and less than good experiences with these types of situations. I have discovered that it is best to only get involved in a project if I truly like the game concept and believe in the idea. If the game doesn't end up selling or getting funded, you can always use your music elsewhere but hopefully the experience was a good one and you were able to learn something along the way. You do have to be careful to not get taken advantage of in these kinds of situations though.

As a side note, at a composition seminar that I attended years ago, I remember one of the composer panelists saying that he felt that there is no wasted writing. If you do take on a project that doesn't end up going anywhere, you can always keep your music and possibly find another use for it in the future.

Do you have a specific ideology which drives your way of doing business?

There are very few people in the world that really enjoy their work; composing professionally is an incredible thing to be able to do—so enjoy it!

Any business advice you can offer?

Composing for games, TV, or films is a multidisciplined team effort to reach that finished product. If you have the opportunity, search out talented people/teams that you blend with personally as it really helps the camaraderie and ultimately it shows in the final product.

Any horror stories which have impacted how you do business?

Just some advice—if you can identify them up front, stay away from highly political people! They are often working on some subversive, self-serving directive that you may or may not even know is there and it can turn out not so good for you if you aren't paying attention.

I have been incredibly fortunate to have mostly worked with great, creative people, but there have been a few not so great ones that really illustrate how good it is when the chemistry is right.

Do you have any tips when working with developers?

Be easy and flexible to work with! No one likes to work with someone who does nothing but complain.

What advice can you give when working with a developer which has ensured a good working relationship and a good final product?

Consistent communication is really important. People like to be kept in the loop on projects so share what you are doing when you have something presentable to share. That can also be really helpful if there is a need for a change of creative direction.

What advice can you give when working with a developer to ensure you are able to make great sounds?

Making great sounds is subjective of course, but you really have to have great tools in place to do the work. Apart from your primary sequencing software, invest as much as you can in the fantastic sample libraries that fulfill the directions you need to create in. These tools change constantly, so it requires paying attention to new releases to stay up-to-date.

You can be a great writer, but at this stage in the game, you also have to produce most of the work on your own, and the tools are almost as important as your talent as a writer.

Have you ever had any development issues negatively influence your workflow?

Technology is constantly changing so we have had platform modifications or changes that have initially impacted the creative teams negatively. Those problems often work out for the better eventually since updates usually address the problems.

Do you have any advice to ensure successful audio implementation?

Establish a good relationship with your primary implementation engineer!

Staying organized is important, especially if you are working on multiple projects, which, as I understand it, is part of your daily routine.

Many times I have had up to a dozen games active at the same time. Depending on deliverable dates for each project, I will prioritize my schedule based on what needs to happen and when. My preference is to focus exclusively on one at a time to get to a certain point of development but that doesn't always happen, so I may just get a couple of days set aside for each during the week.

How do you keep up with it?

Our game development teams all have project managers that keep us apprised of schedules and hit lists. I also create a priority list of each game and systematically check off items as I deliver them. I am constantly communicating with my different game team members which can also prove helpful.

Do you have any development stories which served as a good lesson learned or something which can be avoidable in future projects?

I have occasionally started working on a game too early in the production and the game completely changed creative direction! Suddenly, what I was working on was no longer even close for the new direction of the project. It helps to wait until there is a clear art direction before you begin.

Any horrible endings to a project which others could learn from?

Some projects are just doomed to fail no matter how hard people try. You just have to be able to let that go when it happens, because it happens more than you would think.

How did you find your way into the games industry?

I think the same way that most everybody in the entertainment business finds their way in—drive, determination, lots of research, going to the occasional conference, and the most important of all, connections. I was actually working as a music director for a show and met a couple of composers working at a huge gaming company. I kept in touch and at some point they asked if I would like to join the company. Networking definitely paid off!

Any other advice you'd like to share?

There are very few composer jobs in the world—be very happy to be there if and when you get that chance!

Always finish what you say you are going to do when you say you are going to do it.

Be positive. If asked during meetings about how things are going, find informative ways of highlighting any negatives with clear solutions.

Be a nice person.

The goal of anyone involved with the creation and implementation of music is to create an as dynamic audio environment as possible. Even in high-intensity racing games, for instance, high-volume, in-your-face music tracks shouldn't play 100% of the time—there has to be some quieter times as well. Maintaining sanity is important but providing a "low point" to serve as a counterpoint to the "high points" is how a dynamic range is established. If the volume is always playing at the same high level, sounds and music that should have the most impact will probably hardly even be noticed because there is no relief in the overall intensity. Variables such as volume changes are an important consideration.

A good storyline will have plenty of drama built in, and it's the goal of the music to enhance and support this. Through skillful construction and attention to detail, a good game soundtrack would be one which adapts to each of the multiple twists and turns. For example, when no danger to the character is present and they are free to explore their surroundings, simple, nondramatic music might play to give the player a sense of calm. But, if they enter a dark, foreboding space or maybe a bad guy appears, the music should transition to something a little more tense and dramatic. When the "boss" character suddenly appears, their health is low, and time is running out, the music should reflect the desperation and intensity of the situation. Involvement of the composer, beyond simply creating the appropriate cues, can have significant impact on how successful the music is ultimately delivered to the player. With an understanding of what options are available and directly contributing to the process by actually setting the conditions in which their cues will be triggered themselves through the middleware applications, the composer can almost singlehandedly take the soundscape to the next level.

Scripting

In programmer-speak, any program or series of instructions interpreted and executed by another computer program is called a "script" and the actual writing of these scripts is referred to as "scripting." For our purposes on the audio front, the act of creating commands, settings, and triggering through middleware tools could principally be called scripting as well since we are undoubtedly doing the same function, except through a nice graphical user interface. But, there still may be a time when you'll find yourself down in the weeds doing a little programming yourself. It's not as scary as it seems, and while I still stand by my statement that you don't have to know programming to create audio for games, it's never a bad thing.

I've discovered over the years that developers don't expect you to know how to program code. More than likely, if you're involved in their project, they hired you to create and chaperone the audio through the development process. Unless I'm using middleware tools, the closest I get to actual implementation is when I sit with an audio programmer, review the game, and direct them adjust volume or what sequence to play a series of sounds. But, if I can't be on-site at their facility or if I need a little more control over issues that might be difficult to explain to nonaudio folks, there are other ways to "script" when middleware isn't being used for a project.

One of the easiest and most convenient methods of scripting is to have access to an editable text file. Discuss with the programmer which specific audio features you would like to control and they can format a simple document which integrates your values into their code. Because they will have to set these particular values anyway, it's just a matter of giving you control—which, in the end, takes some workload and pressure off of them. It's definitely win–win for you both!

This text document can be structured according to your needs, allowing such things as setting playback volume of sounds (between 0 and 10 or 0 and 100, depending on how much control is needed), defining a set of sounds which will either play in a sequence or randomly, and setting file names. Essentially, the developer will have your nonprogrammer capabilities in mind and create a very easy to read, plain English document where numbers and file names will be obvious and all with zero learning curve. I always request a "legend" anyway, just in case there is a strange set of characters or numbers, but for the most part, it takes little translation.

This scheme works best when you also have access to a playable version of the game project, which will allow you to test newly created sounds and mix them prior to submitting them to the developer. For me, this works great and I am able to receive more relevant feedback on my work. Instead of them only hearing the obvious and focusing on whether something is too loud or too soft, they can hear the sounds in context, at the correct volume and can evaluate the sounds on their merits. It's all about making their jobs easier and for you to retain control of how the audio is heard in the final product.

Middleware Solutions

As middleware continues to evolve, there are a multitude of solutions available to get the job done. Four leading tools have risen to the top of the current heap which we'll discuss in more detail shortly, as well as some other viable options. The good news, once you understand the basics and concepts of one, you'll be able to transfer that knowledge to others to create some dynamic and compelling audio experiences. Become familiar with each tool's strengths and weaknesses but what I highly recommend is to pick one and become amply skilled at it. It definitely looks better on a resume to say "skilled" or "expert" at a program than just "familiar." Plus, knowing one inside and out will give you a hint to hidden capabilities of others you might not have worked with yet.

The great news for us, audio content creators, is most of these middleware tools are free downloads and only the developer pays to license their use if they are utilized in a game project. For training and familiarization, we also luck out with an abundance of online tutorials to give us the insight we need to use them like a pro. Forums and support for these applications are prevalent, so there really is no excuse

why you won't want to invest a little time when you get the chance. I've also found that some features, in a roundabout sort of way, make great sound design tools, especially when piecing together ambience or creating variations of repetitive sounds.

Once it is determined middleware tools will fill a specific need for a game project, choosing typically comes down to required features, the effort needed to integrate it, its familiarity within the team, and price, among others. All are capable of supporting multiple consoles, platforms, and operating systems, especially the most current crop. Some will integrate with existing developer-created and commercial audio engines while others are the actual audio engine. Each is highly capable in its own way and ultimately comes down to what works best for that particular project.

FMOD, Wwise, Fabric, CRI ADX2, Miles Sound System, and Unreal Audio System are names you'll become quite familiar with over the course of your game audio endeavors. All are unique and fill specific niche areas of the audio scene but, interestingly enough, there are more similarities between them than not. As I recommended earlier, pick one and learn it backwards and forwards, and this knowledge will translate to the others when that time comes.

As with anything dealing with technology, features, and capabilities of these middleware tools are updated on a continuous basis to meet demands. Because the goal posts are in constant motion, I suggest that you visit the company website during your personal investigation for the absolute latest in functionality. With that in mind, let's take a look at a few of the more popular solutions and their highlights.

FMOD—Firelight Technologies (fmod.org)

FMOD is advertised as a sound effects engine which plays and mixes sound files of a wide range of formats for numerous game consoles. It's currently divided into four separate parts: FMOD Studio is the main tool sound designers will find themselves working with; FMOD Designer 2010 is the version prior to Studio which still serves as a great tool for authoring complex sound events and music behaviors, and the FMOD Event Player will act as its auditioning tool; and FMOD Ex is part of the package for the developer which will serve as the audio playback and mixing engine. All of these integrate seamlessly to provide the needed control over all audio in a game project.

FMOD Studio was designed to emulate familiar Digital Audio Workstation (DAW) interfaces, something any sound designer or composer will immediately appreciate. In addition to the authoring tools, the latest version allows for live in-game editing and mixing with attached hardware control surfaces—again, something very familiar to those who work with audio. The great advantage to live editing and mixing is it can be done while the game is running, instead of dealing with the annoying cycle of saving changes, rebuilding, and then running the game again.

FMOD handles a variety of audio formats, depending on the needs of the project. Options range from standard WAV, AIFF, MP3, and even MIDI, but extend to OGG, FLAC, and a myriad of other compressed formats. Support for older PSP and PS2 formats, Windows, Xbox, and raw audio data are just some of what's on the list. Be sure to check out their webpage for the full, current listing.

RICHARD JACQUES
Composer

Fairly recently, I set about building a studio complex here in central London. Like many composers, I had a really nice studio in my home over the years then moved to a commercial studio before deciding to build my own. I had simply outgrown other spaces for my needs, especially with regard to tracking live musicians, working with visiting engineers and producers, facilitating voice-overs, etc. It was a daunting project but now I have three production rooms, two live recording rooms, and a main mix room. When phase 3 of the project is complete, I shall be reinstating a 7000 sq ft hall with amazing acoustics for live orchestral recording, with a capacity for 75 players plus choir. It's a dream that is now becoming reality, and will give me the flexibility of being able to do literally any kind of project in my facility.

My philosophy behind gear is to buy the best! I am a fan of the best analog and digital gear working side by side. I do have a large Pro Tools system and a great deal of analog outboard to call upon. This is the best of both worlds in my opinion, digital flexibility and recallability and analog warmth and signal chain.

Computers: Logic rig—Apple Mac Pro 12 core 32 GB RAM, 4 TB SSD; slave rigs—Apple Mac Pro×8 (some 8 some 12 core) all with 4 TB SSD drives, all running Vienna Ensemble Pro; Pro Tools rig—Apple Mac Pro 12 core 32 GB RAM, 3 TB SSD; 2×Carillon Audio PC's (running old GigaStudio libraries)

Audio interface: Various including Prism ADA8s, MOTU 2408, and Avid 192s

Software: Logic, Pro Tools, Sibelius, Kontakt; plus about a billion plug-in software synths and effects plug-ins

Multitrack system: Pro Tools HD3 with 48 i/o

Monitors: Dynaudio M2, Focal 5.1 system, Dynaudio M1.5, Tannoy PBM 6.5, Dynaudio BM5, Quested, Yamaha NS10M, Avatones, old boom box, TV

Sound modules/VST instruments: Komplete 9 Ultimate, Omnisphere, Stylus, Trilian, Sylenth, Albino, Arturia V Collection, Spitfire Audio, Vienna Instruments, Project SAM; these are some of my "go-to" instruments but there are many more of course

Outboard gear/effects plug-ins: Waves, UAD, McDSP, Inward Connections Vac Rac, Purple Audio MC76×2, Distressor×2, Lexicon 480, Crane Song, Thermionic Culture, Neve bus compressor, Fairchild limiter, Roland Space Echo

Keyboards: Roland RD 700, Roland XP80, Roland RS-09

Other instruments: Various acoustic and electric guitars, trombone, percussion, toys, Akai EWI, Hammond module with Drawbar controller

Microphones: C12VR, U47, Coles 4038s×8, SM57, SM 58, RCA 44 ribbon×2

Remote recording gear: Soon to have a rack of Neve 1081Rs for orchestral recording

Other relevant instruments/equipment/hardware/software you may use: Various controllers such as six expression pedals for controller data, 2×iPads for sequencer control; Access Virus Indigo, Studio Electronics SE1, Roland TB303, Roland TR 606, Roland TR 808, Oberheim Matrix 1000, various Akai samplers

As expected, all current consoles, platforms, and operating systems are supported and the beauty of FMOD Studio, a simple drop-down menu will enable you to create audio behaviors for any of these. Windows, Mac OS, and Linux support for PC-based games. iOS, Android, and BlackBerry for mobile applications. Previous consoles as far back as the original Wii, Xbox, and PlayStation 2 consoles are supported, not to mention the current Wii U, Xbox One, and PlayStation 4 systems. Additionally, Google Native Client is included as well as AMD TrueAudio and Sound Blaster sound cards and codecs. It's safe to say that you'll be able to use these tools on any of your projects with great success.

Integration to developer-created game engines is important, and while there will always be some effort to get these to mesh properly, Firelight Technologies is working to make this easier. Many third-party game engines already include FMOD as part of their packages, streamlining already complex development cycles. Unity, Unreal Engine 3 and 4, CryEngine, Torque, Havok, and Source are but a few of existing engines which use FMOD as their primary or secondary sound effects system.

It's not typically an "audio" function, but as an audio resource to the team, this is always nice-to-know information. Licensing FMOD is available in various structures depending on the final use of the product. For you, the content creator, FMOD Studio and Designer are free to download and use. For the developer, there are various costs based on whether the game is for commercial release as software or as an electronically distributed title such as Xbox Live Arcade, for example. There is even a free, noncommercial license available for a developer who does not intend to release their work, such as a student team or developer who might be creating a proof of concept title for testing.

Learning new tools can be a chore. The good news for most middleware solutions, documentation, and tutorials have been well thought out and produced to ensure you can and will use these programs. It's not only a great way for the

company to get business, but it gives folks like us the resources to learn and apply the knowledge. FMOD's user documentation is conveniently embedded within the interface for handy reference. And, for more formal "training" purposes, another well-known game sound advocate, Stephan Schutz, has created and narrated a great FMOD 101 tutorial series that will get you up to speed quickly. Links to his series can be found at his website (stephanschutze.com) and are also available on sites such as YouTube.

Overall, FMOD Studio is a capable game audio tool. The new design has been inspired by familiar DAW layouts, which includes a mixing and mastering capability, for that final polish and shine. Live, in-game mixing and creation of sound events will expedite the development process, giving quicker previews and finalizing. Be sure to check out fmod.org for the latest functionality and features.

Wwise—Audiokinetic (audiokinetic.com)

Wave Works Interactive Sound Engine, Wwise for short, is an audio middleware solution for video games and interactive media which includes both a cross-platform sound engine and audio authoring tool. Its architecture supports source, source control, and effects plug-ins as well as other features like a real-time game simulator. Using a graphical interface, it allows sound creators to do a myriad of tasks to include importing audio files for use in games, applying effects processing, mixing in real time, simulating audio environments, defining game states, and managing sound integration. Audio can also be authored directly "in game," which is a great feature for previewing and tweaking sound behaviors. And, for the cherry on top, this can be done over a local network while the game is played on another host system, instead of having to be in the same room with the game and away from your audio tools.

It's strengths are many. Minimal dependency on programmers, which translates into a shift of duties to the sound team, of course, but with much better results. It has the ability to author sound behaviors for multiple game platforms simultaneously. Its layout is customizable to allow for a variety of scenarios and to keep you working efficiently. It also enables sound designers and composers to work completely independent of each other, streamlining the development process and not forcing entities to have to work together.

All current major platforms and consoles are supported. Windows 32-bit and 64-bit, XP, Vista, Windows 7 and 8, and Linux and Mac OS are fully supported. Android, iOS, Windows Phone 8, PlayStation Vita, and Nintendo 3DS for mobile and handheld systems. PlayStation 3 and 4, Wii and Wii U, Xbox 360 and One—all provided for and covered. Additionally, several off-the-shelf game engines have been adapted for easy integration. Unity, Unreal 3 and 4, CryEngine, Marmalade, and the Orochi 3 engine are on the list. And, it's touted as a straight-forward process to integrate with in-house game engines as well. Of course, licensing for use in these systems is required with a full or limited commercial license, academic, or level B and C licenses available as needed.

Audiokinetics takes training for Wwise quite seriously with their free Wwise Certification Program (wwisecertification.com). This self-paced online course will give you insights and skills to fully understand and establish sound triggering systems, practice audio integration workflows, create and mix virtual soundscapes all while learning system, and use performance optimization techniques. An optional certification test gives you the opportunity to become an official Audiokinetic Wwise 101 Certified End User and to have your name listed in their Wwise Creators Directory. Official and user-created tutorials are also prevalent on sites such as YouTube as well.

Overall, Wwise is a powerful audio middleware tool which is user-friendly and intuitive. As with all "new" software, there is a little bit of a learning curve but it's not much of a stretch for anyone familiar with audio creation programs. The effort is well worth it, ultimately giving the player a rich and enjoyable experience.

Fabric—Tazman Audio (tazman-audio.co.uk)

Based on Unity's game engine audio functionality, Fabric provides audio creators an extensive set of high-level audio components in order to create complex and rich audio environments. Because the tool is written entirely with Unity's scripting language, it doesn't require any external plug-ins and can be used on any platform which Unity supports. Most current consoles, platforms, and operating systems are included as well as Web-based platforms and TV uses such as Android TV and Samsung Smart TV which gives them their "Build once, deploy everywhere" slogan and saves the developer from having to port specifically to other platforms.

Developing audio structures and behaviors is based on components which are building blocks where further structures can be built upon. Current available features of Fabric include elements referred to as Audio, Dialog, SamplePlayer, Timeline, Music, Sequence, Switch, Group, Blend, and IntroLoopOutro components. As each piece of the puzzle is designed, they can be further combined and stacked for interesting (and unexpected) results. Triggering and controlling these components is quite flexible giving you control over when to play and stop sounds while setting volume, pitch, and other various parameters.

Music is supported and all sound design and mixing features are available for music behaviors as well. Even those pesky transitions between pieces of music, which can be the most difficult and nonmusical train wrecks if not massaged appropriately, are covered. Fabric components, such as OnBeat, OnBar, and OnEnd, enable smooth switching between cues that make sense and are fitting. Balancing and mixing music and sound effects together can be done dynamically, using Side Chain or Event Overrides. Digital signal processing (DSP) effects are also part of the Fabric framework with available custom effects such as

BRIAN TUEY

Sound designer, Composer, Audio director—Treyarch

Brian Tuey entered the game industry in 2000 working for a small developer in Hollywood as a game designer where he worked through several children's games before moving on to Luxoflux. There, he worked on the *True Crime* and *Shrek* series games, handling both game design and sound design responsibilities. After *True Crime 1* and *Shrek 2* shipped, he focused solely on sound design and moved from Luxoflux to Treyarch, where he has been since 2006. He began his work at Treyarch on Call of Duty 3 before becoming the audio director for *Call of Duty: World at War*, *Call of Duty: Black Ops*, *Call of Duty: Black Ops 2*, and *Call of Duty: Black Ops 3*.

Since coming to Treyarch, he has been able to work with many industry talents such as Sean Murray, Jack Wall, Trent Reznor, and M. Shadows to name a few.

He lives in Los Angeles with his wife, three kids, and the big pit bull, Brutus.

Describe your thought process for creating sound effects.

This is an interesting question. The first thing that I try to do is understand a few things:

- What is the purpose\focus of this particular effect?
- Where does it sit in relation to key components of the mix?
- Do I understand what it is and how it works (or supposedly works in the case of fictional objects)?

Without having a good understanding prior to starting anything, it's difficult to be inspired to create an appropriate sound. Knowing the specific purpose of a sound is crucial. Does it directly affect gameplay? Is it to help tell the story of a location or object? Is it to notify the player of a change in game state?

There are certain sounds you will make that have priority over others. With finite development time and usually a lot of work to do, time management becomes just as important as creating audio (in fact, it's required)! When you understand what the purpose of a particular asset is, it becomes easy to prioritize it in relation to everything else going on in the soundscape.

Equally important is having a fundamental understanding of where you want an asset to sit in relation to the rest of the mix. Our job is to create a seamless and believable soundscape that helps immerse the player and tell a sonic story. This is even more important when working in 3D space where distances and blends between close and far assets become important to telling that story.

Lastly, I try to understand the fiction behind how an object works. That usually gives us some good inspiration when creating something that

doesn't actually exist and is something we have done often when working on our Zombie mode for COD. It's also the most difficult. When creating something that doesn't exist in the real world, it can take quite a while to build a language that makes sense in the universe you are creating. Using the real world for inspiration is a great way to get started on something that doesn't exist.

The trick is to find the right inspiration, put in the right amount of time, and make sure it works with all of the other assets that may be playing at the same time.

Do you have any interesting sound gathering/sound creation stories?

It's really difficult to get truly new source that's fresh. We've employed several techniques at Treyarch from recording dry ice freezing metal (mainly because we couldn't get funding to actually blow up a building) to creating our own circuits that produce sound. Shawn Jimmerson (a sound designer I work closely with) and one of our audio programmers, Stephen McCaul, have been designing and building a wide variety of hardware to create all kinds of new "techy" sounds that are fresh and new.

Source material can take ordinary sounds and transform them into something unique simply by layering them in with standard sounds that are easier to get.

I've been really fortunate to work with Activision and Treyarch over the years. One of the perks of working on a game like *Call of Duty* is the ability to get out in the field and record weapon audio. Each project we spend a few days at a few different closed ranges and record several really powerful weapons that you normally wouldn't get to see. One of those was an old Type 92 Japanese HMG for *Call of Duty: World at War*. It was not the most powerful weapon we ever recorded on the range, but it had a really unique sound.

I don't know how long it had been since it had been fired, but the armorer kept looking at it skeptically. He got it loaded, double checked everything, and then laid into it. It fired four or five rounds then jammed, making an awful sound. He loaded it up and tried once more (I think he may have been nervous at this point). Sure enough, it jammed again after another four or five shots fired. He refused to fire any more after that, so we had to make all of the Type 92 sounds from those eight to ten shots. When he stood up he said, "Nope. I'm not shooting that thing anymore. Maybe that's why they lost the war."

Another time I was in the studio recording my pit bull, Brutus. It was one of our "media" days at Treyarch, so there was press all around the building. My session with the press wasn't going to take place for an hour or so, so I decided to take the time and get some new source sounds for the MP dogs. He's not a trained dog, but he's really smart. I've taught him some of the more basic things you can teach dogs, and one kind of silly thing. If I ask him to "meow" and I meow at him, he'll eventually start howling and

whimpering (perfect for an "injured" dog sound without actually hurting one).

Anyway, he wasn't being very cooperative so I was really playing it up—meowing, cooing, and even howling at him. I wasn't paying attention to my surroundings at all.

When I looked up, I saw a ton of the media that was here standing in the mix room looking through the glass barrier of the vocal booth watching me meow at a giant dog. I could swear they even had cameras rolling.

Either that was a great ice breaker or really bad for first impressions. I'm still not sure.

Do you have any advice which can help lay solid groundwork and ensure a successful production for the audio content creator?

I have two.

Stay as organized as possible. Have a naming convention (and actually stick to it) for everything you do, from game assets, session files, and of course, any source material. Losing sessions by taking shortcuts when you are in a hurry early will cost you twice as much later. There are always a few assets that need to be touched up by the end of a project that might be from very early on in development. Taking time to properly organize over the course of the project will give you the best shot at being able to make those adjustments when time is of the essence.

I've learned those lessons the hard way.

The other very important lesson I've learned is that while everyone is not a sound designer, everyone does in fact have ears. Listen to feedback as you go and try to understand what someone who isn't a sound designer is trying to tell you. Often times as sound designers, we can get caught up in a really cool technique or some very specific (but sick sounding) part of a bigger sound, but it may be falling flat as a whole by the average listener. It's those people for whom we are making these experiences, so their opinion is important.

Stereoizer, Sample Panner, and Audio Capture which are in addition to Unity's standard audio effects.

Once these structures and components have been set, Fabric has what is called Runtime Parameters which link the audio to the game component properties by mapping them to custom graphs, then driving them from built-in game parameters, or modulating them as needed. Localization of dialog assets for multiple languages is also intuitive and is included.

Creating and implementing audio for any Unity-based game project is greatly assisted with the many flexible features of Fabric. Learning is easy with the many online video tutorials and resources, but downloading and reviewing the tool will always be the best way to discover the wonders of the program. There are several audio middleware options when working with Unity, but this program in particular is well suited for it and definitely worth taking a look.

CRI ADX2—CRI Middleware, Inc. (criware.com)

CRI ADX2 is touted as game development technology which makes "unprecedented" next-generation sound designing possible. This DAW-like audio authoring and implementation tool is advertised as easy to use and intuitive through a graphic user interface. A proprietary audio codec, high-compression and high-quality streaming, and cross-platform support make this a well-rounded middleware option when creating rich audio environments and behaviors. An interactive sound management tool, a randomizing capability, and its in-game playback and review features make this a useful tool in the implementation arena.

At the root of this middleware solution is its high-fidelity, high-compression, low-CPU load proprietary codec, called HCA (high-compression audio), which will run on all game platforms, mobile devices, and embedded systems. As an example, 48-kHz sample rate can be compressed up to 1/16 its original size with good fidelity and its load on the CPU is significantly lower as compared to MP3 and AAC formats. High-quality streaming is also possible through the use of an intelligent traffic control mechanism which gives the option to multistream sounds and read-in background data while these sounds are played. It is also equipped with the codec "HCA-MX," which reduces the CPU load of a large number of simultaneously played sounds.

The ADX2 interface is rich with features enabling its users to perform effective and dynamic sound control. Effects processing, parameter changes, and a myriad of other controls can be done directly from this tool empowering sound designers to work completely independent of game programmers. On board is the Interactive Sound Management Tool (AISAC) where, as the name insinuates, sounds which may vary by their nature can be designed and controlled through this feature. Automobile engines sounds can fluctuate due to many factors, audience applause at a football game is dynamic and ever changing, as well as rain or wind—all of these types of situations can easily be created to react naturally. Randomization is also a simple operation using this tool, where volume, pitch, pan, filters, and other parameter changes can be made and triggered every time a sound is played.

Debugging within a game environment can be a challenge, but with ADX2's In-Game Preview feature, effective control of sound effects while seeing them within the game in context is completely possible. Real-time parameter changes can be auditioned and reviewed giving lots of flexibility in the process. Mixing a game correctly is half the battle and is made much easier with the full-featured and intuitive tool.

Music has also been given proper consideration, and the ability to create interactive and dynamic music behaviors and transitions is available as well.

"Block Playback" allows the combination of arbitrary sound blocks and brings a natural transition between them either using rhythm or drum fills, for example, to change scenes. These specific tools can also be used extensively on the sound design side of things, giving the same abilities when building complex ambience and environmental atmospheres with smooth and well-planned changes.

ADX2 currently supports only the major and current game consoles and allows sound data to be used across them all. PlayStation 3 and 4, Xbox 360 and One, WiiU, Windows, and the mobile consoles PlayStation Vita and Nintendo 3DS are on the list as of publication, but be sure to check directly with CRI for the latest.

As far as training, CRI has a plethora of good tutorials posted on YouTube for your educational pleasure that you'll find quite informative. I'm always a big believer in obtaining the software and then taking it for a test drive; these online resources should give you enough insight as to whether the program makes sense for the game and your audio team or as a way to get up to speed and make it work for you quickly.

Overall, you'll find ADX2 quite robust, user-friendly, and capable for whatever project you're working on. It's got all of the appropriate bells and whistles, the interface is laid out in a useful way, and it integrates well with the major current consoles. Having another middleware option available to choose from is always a good thing and this one is worth taking a look at.

Other Middleware Options and Solutions

Luckily, for those of us in the games industry and those wonderful game players out there, the development of third-party audio middleware tools is really picking up some steam. While we took a look at some of the more popular solutions in use, there are many, many others which might not be as popular, but also might solve problems which others can't. Whether it's the licensing fees, supported platforms or hardware, key features, layout, which is more user-friendly—you get the idea. There is always something which will do what you need it to do if you just look outside of the box once in a while. There are a couple others, for a variety of reasons, are definitely worth mentioning: The Miles Sound System and The Unreal Audio System.

The Miles Sound System—RAD Game Tools (radgametools.com)

The Miles Sound System is the oldest commercial audio middleware tool, licensed for over 5200 games on 14 different platforms. In the early days, it was a solution for DOS applications and also had its use with low-end audio chipsets with little CPU usage and in time, grew in popularity and deployment. The appearance of new commercial middleware tools, such as the ones we covered earlier, forced RAD Game Tools to step up and remain competitive. Many upgrades and redesigns later, Miles is now able to compete alongside these newcomers while regaining some of their lost ground.

MSS touts itself as the most sophisticated, most robust, and most fully featured sound system available. Refined over many years, its toolset can integrate high-level sound authoring with 2D and 3D audio, with streaming, environmental reverb, multistage DSP filtering, multichannel mixing, and optimized audio decoders for MP3, OGG, and Bink Audio. Intuitive editing for audio presets, events, environments, filters, and mixing is done all in Windows and deployed to multiple console platforms.

There are many great features which help in our quest for compelling game audio. Grouping samples, applying filters, and side-chain compression for ducking sounds for dialog can be accomplished with busses. Hot loading sounds from MSS to the game allows you to pause the game, edit the soundscape, and resume with updated assets, all without having to rebuild or reload the game. The built-in Bink Audio decoder plug-in is their own proprietary audio compression scheme which uses 30% less CPU than both MP3 and OGG formats. For developers who wish to use MP3s, MSS includes the rights to use this format as part of their license, so no need to incur additional licensing costs. Miles also uses a very fast, clean-room OGG Vorbis decoder as well.

Overall, MSS is quick, uses as little memory as possible, and decodes all compressed audio data on-the-fly which keeps the sound footprint dramatically smaller than most. It runs on every platform and its code base is constantly updated by the Miles team. Any time a workaround is discovered for new audio hardware, platform, console, or operating system, it is immediately implemented and all MSS licensees benefit. It's practically bulletproof and allows for bad input data without crashing. Because RAD Game Tools has been in business since 1991, they've got a strong following that they are very interested in keeping and keeping happy.

Unreal Audio System/Unreal Engine—Epic Games (epicgames.com)

The Unreal game engine was created by Epic Games for their 1998 FPS game, Unreal. Somewhere along the line, Epic discovered a huge revenue stream through the licensing of their game engine to other developers and the Unreal Development Kit (UDK) was born. Primarily developed for first-person shooters, it quickly found its way into MMORP's, Stealth, and RPG projects with great success. Because the code is written in C++, it was universally accepted and showed a high degree of portability.

Included in the UDK, the Unreal Audio System supports the application fully. Its strength is in the ability to create 3D location-based sounds, giving complete control of volume, pitch, filtering, modulation, looping, and randomization. These can all be accomplished individually, or as a group or "class" of sounds when the entire collection may need adjustment, such as the player wandering into a cave and all sounds might have a specific reverberant quality added to them.

UDK has its own distinct audio vocabulary which will make sense once you've played with the program a bit, but it's fairly obvious once you understand the workflow. These definitions of sound categories and actions give the user plenty of flexibility to create a rich audio experience. Sound Cues are composite sounds which allow the modification of audio playback, the combination of audio effects, and application of audio modifiers with Sound Nodes altering the final output. These are specified through the use of their Sound Cue Editor tool. Hierarchies can be created, where specific properties from the "parent" class can be passed down to the "children" class, all connected through the Sound Class Editor. This type of structure allows you to pick and choose what effects are added or what adjustments are made to a group instead of having to deal with them on an individual basis, such as when using the Reverb Effects or Sound Attenuation tools. Ambient Sound Actors are also another great feature, allowing you to anchor a sound to a specific spot, place a sphere around it to designate when the player will hear it, and how the sound behaves once the player is within that sphere either adjusting loudness or effects for example. There are many more features you'll discover such as the Dialog Voice and Dialog Wave, and Volume Ducking tools—all will come in quite handy at some point in development.

One notable limitation of the UDK is that it only imports uncompressed .wav files. These can be any sample rate, although for quality 22 and 44 kHz is recommended, and have to be in 16-bit resolution. It does support multiple channels, everything from mono and stereo files up to surround formats of 7.1.

Overall, the Unreal Audio System provides a well-rounded set of tools and features to craft sounds within the game for the desired feel. Audio assets can be created outside of the UDK, imported, and then given the appropriate instructions to fit the variety of situations a player could face in a game. It's all about giving the player an experience, and if your team is developing with the Unreal game engine, this will be an obvious choice for sound management.

Wrap it Up

It has been interesting over the years watching game audio production and implementation transform into such a major undertaking. And, as expected, it was an inevitability as the demand for a higher quality audio experience and the technology to create it converged. Audio middleware has accepted the challenge and as its usage and popularity increases, so does the quality of its interfaces, tools,

and features. The next evolutionary step is the standardization of these specific tools which, coincidentally, is taking place as we speak. You probably already noted the many similarities in the graphic user interfaces and the available features of each, which blurs the lines and makes the choice a little harder, but for the content creators like us, it's a win–win. Just like the experience of your primary DAW gives you the knowledge to open and be immediately productive on pretty much any other DAW, middleware tools are approaching this type of consistency rapidly—and that is a good thing indeed.

14

Game Platforms and Audio Development

Fortunately, for composers and sound designers today, providing audio content for the myriad of gaming consoles and platforms isn't as difficult as in recent past. The historical launch of the Sony PlayStation 2, Nintendo GameCube, and Microsoft Xbox opened an era of audio development which allowed audio creators to utilize familiar tools instead of dealing with often laborious development systems. The introduction of the seventh-generation systems—Sony PlayStation 3, Nintendo Wii, and Microsoft Xbox 360—made it easier to create sound, although implementation considerations had become exponentially more complicated with the increase of platform capabilities. Of course, the latest eighth-generation consoles—Sony PlayStation 4, Nintendo Wii U, and the Microsoft Xbox One—have once again changed all of the rules, and our job on the audio front has become more involved but infinitely easier. Previously, an audio content provider would have to acquire and license a development system and spend time learning it before they could even begin creating. Thankfully, those days are long gone and composers and sound designers now have far more freedom with far less restrictions.

It's not to say that there aren't any development systems involved. Each new console has its own proprietary kit that allows developers to create a game title and audio you create will have to pass through it at some point. The big advantage for us is that we can deliver our music and sound effects as *.wav* files (as we normally save and edit to anyway) or as *.mid* files—all of which are converted as needed to useable formats after delivery. As an in-house audio specialist, you may be more directly involved with this conversion; outside third-party contractors have less of a chance. For the most part, console development systems

are always closely guarded, except to licensed developers and qualified content providers.

So, the good news is—we can make great audio in a fashion we are accustomed to. The bad news is, there is still a wide variety of platforms and system standards we must conform to. Despite the massive improvements of the new offering of consoles, we are still restricted to some fairly solid boundaries. The game consoles themselves have built-in limitations and it's the developer's choice of implementation that will introduce others, depending on how they use the available features and resources. My plan is to address the current known hardware features in this chapter, but I strongly suggest that you investigate any further developer restrictions prior to starting a project. Be aware there are always issues beyond what I've discussed here and no matter what challenges a particular game system has, it all comes down to how the developer ultimately uses it for their final game product.

Currently, there are several consoles and platforms which games are being developed for. As new ones are launched, games for older platforms will eventually stop being produced. Simple economics dictates that once the gold mine is played out, so to speak, it's time to move on to the next. When the previous edition of this book was published, the Nintendo 64, Sega Dreamcast, and Sony PlayStation 1 were long gone and it's doubtful you would ever do music for one of these platforms. (Although, that's not entirely true either. Just a couple of years ago I did some music for a Dreamcast project!) With that said, I won't waste time discussing historical audio details of how it used to be done. Instead, I shall concentrate on the consoles and platforms you *will* provide content for: PlayStation 4, Xbox One, Wii U, CD/DVD PC, coin-op, Web-based, and mobile devices. Even though the next-gen consoles are a major part of the market force, there is still enough of an interest in recent platforms and their games—and for those just starting out, there is a good chance you may still run across solid projects for them. Plus, it never hurts to be familiar with them, so you can really appreciate the latest console offerings and their features.

Eighth-Generation Consoles

The eighth-generation of game consoles began with the release of the Nintendo Wii U in November 2012, followed by the Sony PlayStation 4 and the Microsoft Xbox One in November 2013. For those keeping score at home, the Nintendo 3DS and 3DS XL and the PlayStation Portable and Vita handheld systems are also included in this generation as well, which we'll review, to include their older versions, in the "Other Gaming Platforms" section later in this chapter. Experts agree this could be the last generation of "home" consoles due to the proliferation and competition of smartphones, tablets, and smart TVs, but we'll have to see how the chips eventually fall before we start considering these crazy predictions.

Typical console generation cycles have been between 5 and 6 years but due to the addition of motion- and camera-based controllers, manufacturers actually only consider themselves halfway through a 10-year cycle for the seventh generation. And because the lifecycle of these systems have been extended in this way, there is still a good possibility you could actually be involved in game production for them. Everyone always has a tendency to look toward the latest and the greatest, but remember that finding your niche in this industry has its merits and this might just be yours.

As you peruse the latest gaming systems, you'll probably notice the audio creation lines are getting pretty blurry. What used to be a major challenge when working between multiple platforms has really almost become unnoticeable. Yes, there are still a few minor console-specific considerations but with the abundance of highly capable audio middleware solutions to help the process, it's getting less and less of a challenge. So much so, instead of having to concentrate most of your brainpower on technical issues, sound designers and composers enjoy overwhelming creative freedom and more options than ever before. Yep, life is pretty good these days!

Sony PlayStation 4

November 2013 saw the release of the much anticipated Sony PlayStation 4 (PS4). Touted by Sony as "the world's most powerful console," its AMD x86-64 Accelerated Processing Unit (APU) is attracting a broad range of developers who are definitely enjoying the new muscle. Unlike previous versions, the PS4 can stream games instead of needing a DVD copy and emphasizes social interaction, allowing players to share gameplay videos via the PlayStation Network. It utilizes the DualShock 4 controller with an added touchpad and "share" button as well as an LED light bar to allow for motion tracking. Updated camera accessories, compatibility with the PlayStation Move peripherals, and second screen capabilities through mobile apps and the PlayStation Vita round out its latest attributes.

Under the hood, it's running a semi-custom, 1.6 GHz, 8 core central processing unit integrated into the AMD APU and 8 GB of RAM. 500 GB hard drive (upgradeable by the user), DVD and Blu-ray Disc capable, HDMI video up to 4 K, wireless, Bluetooth, USB, and Ethernet all make this console a very adept machine. Audio-wise, its optical S/PDIF audio output gives the multiple audio formats the capability to playback in stereo, Dolby 5.1/7.1, DTS 5.1, and AAC surround. The DualShock 4 controller has an embedded mono speaker and a convenient stereo headset jack built in.

The PS4 uses a dedicated Audio Co-Processor (ACP) which can handle approximately 200 channels of simultaneous audio as well as encoding/decoding, voice chat, and other basic audio activities. By having a separate audio processor, this allows developers to ultimately use less CPU overhead during memory-intensive audio file decompression. More complex audio will be redirected to the CPU to perform, such as any digital signal processing (DSP) effects which will have to be programmed via the game code since there is no onboard effects processor this time around. Unfortunately, there are over 300 less audio channels as compared to the Xbox One's 512 channels, and the ACP is not programmable by the game team (anything they need to accomplish will have to be done in code). The good news is, there is now 16 times more total RAM available over the PS3 and a larger and faster hard drive, so more overall audio is possible.

Audio source files are created in uncompressed formats (such as .wav) in 48 kHz, 24- or 16-bit, and then added to the game as MP3, OGG, AAC, or Sony's new audio codec ATRAC9. While the compression rates still average between 8:1 and 13:1, because of the larger available memory, developers can utilize higher bit rates for greater audio fidelity without creating larger files. Of course, audio content competes directly with graphics, cinematics, and programming content, so higher fidelity is possible if other assets aren't using the resources.

Developers always have the option to write their own proprietary audio engine, but the PS4 is finding a greater use, not only for Sony's SCREAM tool and synth

engine which are available to licensed developers, but also for off-the-shelf audio middleware solutions such as FMOD and Wwise. And because middleware is gaining in features and popularity, sound designers and composers can create compelling audio landscapes using familiar tools and an ever-growing support group. Brad Meyer, Audio Director at Sucker Punch Productions, agrees that these added capabilities not only increase the detail of sound design for the PS4 but also increase the number of layers and variations of repetitive sounds. "For example, a single smoke bolt in *inFAMOUS Second Son*, one of the first powers you acquire, plays one of over 1000 possible permutations of sounds each time you press the R2 button. This level of detail we're dealing with at the onset of the new generation makes the prospects of the next several years that much more exciting!"

A feature of the DualShock 4 controller is the built-in speaker which, if used thoughtfully, can be an effective way to communicate information and sounds to the player. While this new "moving" sound source can add an additional layer to the soundscape, its limitations need to be considered when creating and implementing audio for it. Because it is connected via Bluetooth, the inherent latency will cause sounds to arrive late, so synchronizing to visuals or other time-critical sounds will be more difficult. Options around this are to not synchronize these types of sounds or to perhaps send the reverb of these to the main speakers. A recommendation by Brad Meyer is to "use the controller speaker sparingly in order not to fatigue the player or lose the sense of intimacy that selective use of it creates." It's also possible that a player could turn the volume down, off completely, or use headphones—so routing all controller speaker sounds to the main mix should always be considered.

It probably goes without saying that as compared to the previous console generation, the PS4 has a lot more horsepower and available features. But, just because you have 16 times more memory to play with, for example, it doesn't mean that you'll be able to create and implement 16 times more music, sound effects, and dialog. Like any system, bottlenecks exist which can challenge the amount of data flowing through them. PS4 games must be installed to the hard drive before playing and because of this, streaming audio such as large tracks of music from both the disk and the hard drive isn't possible. The other issue is the actual speed of the hard drive is only twice as fast as that of the previous version. So, again, "more" doesn't always mean "better" unless all of the conduits have been upgraded equally, which hasn't been the case here.

Overall, the PS4 platform is a clear improvement for game developers allowing for even more stunning graphics, gameplay, and sound. For the audio creators, fashioning rich and intricate soundscapes with more variations, less repetition, and higher quality is the new norm. The SCREAM tool is definitely suitable, but with the PS4's ability to use other audio middleware solutions, it greatly increases the ability of the team not only to use the full potential of the system but also to satisfy the player's hunger for "bigger and better." As long as the minor limitations such as load times, data streaming, and competition between other game assets are considered, the probability of a successful production is definitely improved.

Microsoft Xbox One

The Xbox 360 predecessor was released in the North America, Europe, and Australia in November 2013 and released the following year in Japan and 26 other markets. While its primary purpose is that of "game console," Microsoft increased their focus on entertainment by also including the ability to pass

television programming from a set-top box to a built-in electronic program guide and multitasking other applications such as Internet Explorer and Skype similar to Windows. The Kinect camera has been upgraded to 1080p with expanded voice controls, a new controller with "Impulse Triggers" that provide force feedback, and the ability to record and save game highlights was also a new feature rounding out this exciting new platform.

Hardware-wise, the Xbox One runs on a custom 1.75 GHz, 8 core CPU, with 8 GB RAM, 500 GB hard drive, DVD, Blu-ray, and CD capable, HDMI audio and video up to 4k, USB, Ethernet, Wi-Fi, and all of the standard bells and whistles. A 7.1 proprietary surround capability through the HDMI output was initially available at console launch but was later upgraded to include Dolby 5.1/7.1 surround via the S/PDIF optical audio outputs. There is an internal system speaker and a stereo headset output on the controller to complete the audio-specific features you might find an interest in. A notable element is the cloud access, which for us, audio folks, could mean unlimited possibilities for upgradeable and interchangeable music and sound effects, especially for games with open-ended storylines.

The trend in the latest consoles has been to offload any CPU intensive audio encoding/decoding or decompression to dedicated audio processors, and of course, the Xbox One is no different. Dubbed "SHAPE" (Scalable Hardware Audio Processing Engine), this custom audio block was created from the ground up to give developers the ability to push highly complex audio while still freely exchanging data with the main CPU. It is capable of 512 simultaneous audio channels, 48 kHz/24-bit, and contains 4 full digital signal processors to not only process high-quality sound for its games but also assist Kinect's voice commands. And like the Xbox 360, it uses its own proprietary XMA audio file format offering user-tunable quality and providing between 6:1 and 14:1 compression. MP3, OGG, or any other format is also usable if needed but playback would have to be through game programming or middleware software codecs running on the CPU. It operates on blocks of 128 samples, instead of the Xbox 360's 256 sample block size, which decreases latency while allowing for increased resolutions.

Fixed-function blocks are offered within SHAPE which focus on specific audio tasks. At its core, it is designed to perform basic operations which not only relieves the CPU from audio overload but also allows it to be used for effects processing or software synthesis. Overall, there are six specific function blocks, each with a dedicated task. The XMA Decoder is capable of decoding up to 512 concurrent XMA formatted voices. The SRC (sample rate converter) allows for high-quality frequency resampling of 512 mono channels of audio data for anything from format conversions to Doppler effects or pitch variations. Dedicated Mix Buffers accumulate up to 128 audio mix channels do not require access to system memory, but do have additional virtual channels available if needed. FLT/VOL is a module which provides variable filters and volume scaling, providing low/high pass, band pass, or notch filtering for more than 2500 voices or mixes. This block is what is used most commonly for distance, obstruction, and occlusion modeling. The EQ/CMP block provides three-band equalization and dynamic range compression for up to 512 channels. The final block contains the DMA hardware which transfers audio data to and from the unified memory space, enabling transferring without a SRC, transferring final mix channels, and CPU-based processing in the middle of what is referred to as a SHAPE-based audio graph.

There are no digital-to-analog convertors on the Xbox One—all audio is output strictly digitally either through HDMI or S/PDIF. This little factoid, along

with the default output rate of 48 kHz and 24-bit resolution, now requires better software and tools to meet these high-fidelity demands. Greater quality samples and sound libraries, as well as pristine voice-over and field recordings, are needed now, more than ever, so stocking your studio with the best tools and sounds available is a must to work on any projects for this platform. Expect to deliver any assets in at least 48/24.

Creating audio for the Xbox One has been streamlined and there is less of a learning curve over the previous version. XACT and DirectSound are not supported by this platform, which leads one to properly assume that the ever-popular audio middleware solutions have once again come to our rescue. Personally, I'm happy that I don't need to spend time learning a console-specific tool and can use FMOD, Wwise, or whichever program the developer has licensed for the title to get the job done. Of course, with more available channels and audio horsepower, it's likely that more audio will actually need to be created which will lead you to many other challenges. But, we do what it takes to make that game player happy, don't we?

Nintendo Wii U

Released in November 2012, the Wii U was considered the first of the eighth-generation consoles. While its comparative lack of power and use of older disc media type in contrast to the PS4 and Xbox One isn't exciting, it does offer the Wii U GamePad as a new feature to home consoles. Acting as an auxiliary interactive screen similar to the Nintendo 3DS, the handheld controller with embedded touchscreen gives an additional layer of playability, portability, and the ability to play games without a TV. All previous Wii peripherals are compatible, especially the Wii-mote which contains a small speaker for that "moving" sound element.

As far as hardware is concerned, the Wii U is powered by an IBM Power PC, 3 GHz tri-core CPU with 2 GB RAM. Audio specifics include a dedicated 120 MHz audio processor with six audio channels for the console and two channels for the controller, an HDMI proprietary 5.1 audio output, RCA analog stereo AV "multi out" port, and stereo speakers, headphone jack, and microphone on the GamePad. Further specs are hard to come by, even if you're an approved developer, but we can assume that it is as least as capable as the Wii with 64 overall audio channels, 44.1/48 kHz sample rates and 16-bit resolution, and a shared memory system.

Creating audio for the Wii U is straightforward as far as the music and sound design processes go, so no worries there. Implementing, which is where things tend to stray, used to be a bit of a challenge using proprietary Nintendo tools (such as MusyX), but our well-known audio middleware solutions have once again changed the way we do business. It still depends on what tools the development team will be using, of course, but you won't always be tied to just Nintendo's tools. Since others are becoming more popular, tools such as FMOD, Wwise, Unreal, and Adobe Flash are just a few of your possibilities. If the developer is using game engines such as Unreal Engine, Unity Engine, or CryEngine, for example, audio middleware has firmly established support for these and will prove the easiest and best solution all around. Nintendo has also licensed Autodesk Gameware software tools specifically for the Wii U which allows developers using Unity to implement and adjust audio parameters with FMOD. So, they get it and are making it easier for the entire development team to create great games on their platform, even if they aren't as public with their system details and development tools as us audio professionals (and book writers) would like.

Previous-Generation Consoles

Seventh-Generation Consoles

The seventh-generation consoles, then referred to as "next-gen" (short for "next-generation"), officially began with the release of the Xbox 360 at the end of 2005—and the subsequent introduction of the PlayStation 3 and the Wii. Each offered its own breakthrough technology at the time, utilizing the latest hardware and software contributions, designed to entice game players to invest in these "better" products. The obvious enhancements were with their graphics and the focus on high-definition visuals, found on the 360 and the PS3. Nintendo chose a different route, offering an entirely unique game controller instead.

Regardless of the advertised upgrades, the playback of audio and the ability to implement audio content for these next-gen consoles had also made significant strides as well. Each platform offered a larger selection of onboard DSP effects, more audio channels, better control of them, and a myriad of audio playback and implementation options not previously offered. This translated into an incredible game experience for the player and a more flexible creation and implementation process for the content provider at the time.

With the introduction of the "new" audio middleware tools such as FMOD and Wwise, and Microsoft's Xbox Audio Creation Tool (XACT) and existing RAD Game Tools Miles Sound System, as examples, the lines were blurred, enabling true cross-platform audio development for the first time. There are still some very specific issues with each of these platforms, of course, but with the introduction of the eighth-generation consoles, we are well on our way to finally being able to create and implement audio for multiple-platform releases using a single, more familiar tool, instead of the learning curve and issues involved with having to be proficient with many. These middleware tools, combined with the power and capabilities of the seventh-generation consoles, have allowed the creative talents of all of those involved with the audio side to literally explode.

Microsoft Xbox 360

The first of the next-gen consoles was released with much anticipation in late 2005. The successor to the Xbox, dubbed the Xbox 360, sold more than 84 million units by mid-2014 and has proven to be a popular console—especially among fans of the *Halo* game series. With major improvements under the hood—including a 3.2 GHz triple-core Xenon processor, a 500 MHz ATI Xenos graphics processing unit, and a hard drive up to 200 GB—the console provides the hardware for a great game experience. This increase in benefits not only provides the same advantages as those found on the original Xbox (discussed in more detail later in this chapter) but also takes them to the next obvious level. Be sure to review that section as well for a full understanding. Audio advancements were also significant, both in hardware and implementation options available to the developer and open up incredible choices for audio presentation.

- 256 audio channels
- 320 independent decompression channels using 32-bit processing
- Support for 48 Hz, 16-bit sound
- Playback in Dolby Digital, DTS, and multichannel WMA Pro

JON HOLLAND
Composer

Jon Holland is a musician/producer based in California. Primarily a recording artist, he has also composed and produced music for television, film, and popular video games including *Sega Vectorman 1 and 2*, *Goosebumps*, and *Ms. Pac-Man*.

Early days began with formal guitar training starting at age 9. Soon after, Jon began exploring the instrument on his own leading to a far more textural and ambient sound. He purchased his first Moog synthesizer soon after and a lifelong passion for electronic and acoustic sound-scapes began.

www.facebook.com/JonHollandMusic

www.youtube.com/user/JonHollandTV

Describe your thought process for creating music and/or sound effects.

After a detailed conversation with the team producing the game, I'm able to pin down the mood they are looking to create. Film soundtrack references are usually a very good starting point. I will watch the films they have referenced and it doesn't take long for me to get my own ideas on how I would like to proceed.

Are there any particular secrets to your creativity?

I think for me the key is to not over think the initial musical direction that I have chosen. I trust my instincts and it usually works out, especially when I have tight deadlines.

Are there any secret techniques that you regularly employ?

Unplugging the Internet is probably the most used technique...lol.... Focus and confidence are most important to me.

Do you have any advice which can help lay solid groundwork and ensure a successful production for the audio content creator?

Listen to as much diverse music as you can when you're not on a project. Listen to the mixes and learn to identify what you are hearing. YouTube also has great production tutorials for all levels. When you are in your creative space (physically and mentally) open your mind and don't be afraid to try things. Move on quickly if you feel that you're getting stifled, or just take a short break. Eventually you'll find a mood that works for you and hooks you into finishing both your composition and your final mixes.

Do you have any interesting sound design creation techniques which affect the type of sounds you create?

I'm not doing much sound design for sound effects but I am doing tons of sound design in my music. Using plug-ins and effects processing is the most important element to finding an original voice for me.

When do you find you are most creative?

Late at night. Almost always. Whether I like it or not that's when I seem to concentrate best.

Any worthwhile creative advice you'd like to share?

Don't give up so easily on something that really excited you enough to begin with. Like I said, move quickly but try things. Often the end result sounds nothing like the initial idea but it led you to the end.

Is there a typical workday for you?

Not really. It all comes down to pressure from somewhere or some inspiration that I got while driving or in the shower. The desire to just get in the studio and work on music is quite random when I don't have deadlines. I never know when the next all-nighter will set in.

What skills should composers have to succeed in the games industry?

Some semblance of musicality, confidence, and a personality that makes people want to get involved with you because they trust you and like working with you. You don't have to be Mozart, you just have to be able to deliver something that is more than what was expected. That will get you noticed.

Do you have a specific ideology which drives your way of doing business?

Be confident and realistic about what you agree to deliver. If people like what you do, the business part just becomes a formality in many cases. Know your worth and don't be afraid to ask for a fair fee for what you are bringing to the table. Remember, if done well, your music and sounds are half of that game's experience.

Any good business advice to offer?

Walk before you run, but be prepared to run if things take off and you are in a position to negotiate. If game producers like what you have done for other people or simply like your music submissions, they tend to trust your ideas and you eventually become essential to their project.

Any horror stories which have impacted how you do business?

I haven't had many bad experiences in the games business. The only bad memory I can think of is one of providing sound effects for a project (headed by a first-time producer) and being

asked to redo some of them only to eventually submit the first ones and being told that I finally nailed it! That led to my focus on music and less sound design. But given the right team I'm always open to things.

How do you approach negotiations with a new client?

I try to find out the game's budget and then propose a reasonable fee for what I am providing. I also want to make sure they trust me enough to let me do my job so I don't have to waste time redoing things. I don't like to spend any more time on something than I have to. When it's done it's done. I simply want to have a good understanding of what they expect from me.

Do you have any negotiation tips which work well for you?

Allow for worst-case scenarios and factor that into your fee and schedule.

What advice can you give when working with a developer which has ensured a good working relationship and a good final product?

Nothing more than good communication. It does wonders for relationships.

Do you have any advice to ensure successful audio implementation?

Find out what will happen to your audio after you hand it over. Will they be using it "as is" or are they going to edit it to their taste? Hopefully you will have your work implemented as you delivered it. Give them exactly what they asked for.

Staying organized is important, especially if you are working on multiple projects, which is part of your daily routine. How do you keep up with it?

I keep multitasking to a minimum once I start in order to be effective. If you are organized before you begin you can get it all done and stay sane. Time management can affect organization, so devote time to your priorities.

Any specific "lessons learned" on a project which you could share?

I was once asked at a preproduction meeting by a programmer on a particular game why I always wrote in a minor key. He was convinced that I should write only happy music and that would only be possible if I wrote in a major key! I didn't agree with him even though I do like to write even happy music with a melancholy feel at times. I simply trusted that the powers to be had picked me out of a dozen composers to write the game's score and that I should just be me. That game score became one of my biggest successes. To this day, I still get random fan mails from people who grew up with the game. I think that's pretty cool.

How did you find your way into the games industry?

Persistence, confidence, good timing, and the solution to a particular game developer's needs. I zeroed in on a particular game developer in San Diego and kept coming back to check on what they were working on and eventually they had a place for me. Luck was obviously a big factor.

Any other advice you'd like to share?

Be yourself and don't look at music for games as "Game Music." It's music. Just make the best music you can make.

All sound files are encoded and compressed in the XMA audio format through the use of the Xbox Audio Creation Tool (XACT), enabling a significant increase of possible audio content. The Xbox 360, for our purposes, is a friendly platform. The most significant difference between the original Xbox, which had physical audio processors, and the 360 is that audio is handled mostly within software. Instead of dealing with the restrictions of a built-in audio processing unit, software updates allow the console's audio capabilities to improve as needed.

Composers and sound designers can enjoy making assets utilizing their familiar tools (as *.wav* or *.aiff* files), so there are no compromises to worry about during the creation phase. If you're only required to deliver these final audio files to the developer, then your job is basically done there. But, if you're to be a little more closely involved, then expect to get intimate with XACT. Luckily for us, XACT is provided free to registered Microsoft game developers and content providers as part of both the Xbox Development Kit (XDK) and the DirectX SDK—which can be found at www.xbox.com/en-US/developers.

XACT supports both the Xbox and Xbox 360, along with the PC. Its primary purpose is to prepare audio files for implementation, such as compressing and converting *.wav* and *.aiff* to *.xma*, assembling and encoding audio stems into 5.1 surround format and creating wave and sound banks for streamlined audio management. It also organizes sound groups for ducking, fading, and other purposes; establishes the compression presets; and handles the assignment and parameters of internal DSP effects. The best advantage of XACT for the composer and sound designer is, along with the development kit (which in this case is a slightly modified version of the consumer console), it allows the content creator to make their own audio builds and test the sounds in the game, assuming the developer has made this capability available. I don't know how many times I created a sound I thought was fantastic only to hear it in the game months later and realize it didn't quite match. Having a way to immediately test your sounds in the game definitely prevents this from happening.

Creating and implementing audio can be as simple or as complex as the developer's overall audio vision. Games such as *Halo 3* are an incredible maze of intricate audio files, triggers, effects processing, and mixing painstakingly interweaved to bring you that final, mind-blowing experience. Every bit of the lengthy development cycle is used to do it. Typically for games of this type, the entire audio team is working together to ensure its success. But, that doesn't mean a single composer/sound designer couldn't do great audio for the 360. They definitely can!

After completing my first Xbox 360 project, I realized that, while there is a lot to do and to think about, with proper management of time and assets, it really wasn't that bad—and actually far easier than some of my previous endeavors. Using my standard audio production tools and techniques, XACT and access to a 360 dev kit, the developer and I were able to work together to create an audio-rich game experience far beyond what I expected was even possible. We set our milestones early on, both stayed on track and with each new game build, I was able to review the music and sounds I created. As part of the next milestone, I tweaked any audio that needed adjustment and repeated the process until 3 months later we had a pretty good-sounding game.

The final step came when I sat down with the programmer for the mixing process, basically playing each level and adjusting properties (such as volume and panning) in code. He'd create a new build after each pass through the game and

we'd repeat the process until the entire game was mixed to our liking. During the process, we discovered a few sounds which needed minor adjustments in EQ or timing—and for that, I had brought my laptop and external drive with all of the files and programs I used for the game. While we could have done some of this in the code using the power of the 360, we preferred at this final stage of the development, not to break anything because the code and assets were stable and working correctly.

As a third-party contractor on this project, and because it was within commuting distance, I insisted on being a part of the mixing phase so I could take a little of the pressure off the developer and because I was hired as the audio expert and this final, absolutely critical stage, could make or break the overall quality of the audio. Yes, I could have just sent the files to the developer and walked away—and sometimes for various reasons you have to do it that way—but because my name is on the project and reputation is on the line, it was an easy choice. The worst-case scenario would be to have someone on the team who has a good ear or other audio experience to be present, especially if the composer or sound designer can't be there.

Overall, though, creating audio for the Xbox 360 was a pleasure—and instead of having to concentrate so much on technical issues, I was able to stay on the creative side of my brain more often and really focus on the quality of the music and sound effects.

Sony PlayStation 3

Considered one of the "next-gen" consoles, the PlayStation 3 (PS3) is a considerable improvement over its predecessor the PS2. Released in late 2006, it has sold a respectable 80 million copies by the end of 2013 but has lagged behind the other next-gen platforms. Despite this fact, it's still a pretty amazing machine. It houses a powerful 3.2 GHz cell broadband engine CPU, an NVIDIA RSX Reality Synthesizer graphics processing unit, and up to an 80 GB hard drive. While it might not be at the top of the sales heap, audio-wise it is a strong contender for the first spot. Playback of standard and Blu-ray DVDs and standard and Super Audio CD formats is a definite plus but it also offers other consumer- and developer-friendly audio features.

- Dedicated audio processor
- 512 audio and voice channels
- 44.1 or 48 kHz sample rate
- Playback in stereo, DTS, 7.1 Dolby Digital, and Dolby TrueHD
- Access to a 256 MB shared memory system

Like the Xbox 360, the PS3 has also moved toward software-based audio with an audio system created from the ground up. This move allows for virtually unlimited power and content free from the limitations of the previous generation. Some of the key audio features include easier integration and testing of audio, cross-platform capabilities, and the ability to author custom DSP effects or utilize those already onboard.

The real advantage to having available effects processing (such as reverb, EQ, filters, pitch shifting, distortion, and vocoder) is the ability to have the audio deliverables dry and allow for any final processing to match the environment or

situation, as well as the ability to change it if needed due to new artwork or environment. It is also great for localizing dialog into different languages, allowing the same processor effect for each version without having to apply it separately. With less need for preprocessing audio assets, it streamlines the creative process, gives more control to the developer, and ensures the effect always matches what the player expects.

Music can be handled in a variety of ways. As expected, it can stream directly from the disc or loaded into RAM as needed using compressed or noncompressed formats. Unlike the PS2, which required all audio in the VAG format, developers can mix and match depending on their needs. But, similar to the PS2 (which often used a variation of the *.mid* format in conjunction with a sound bank), the PS3 can use actual *.mid* files—triggering a soft synth or samples to create the soundtrack. The advantages to this are fast loading times, flexibility, and a small footprint—which are perfect for networked Internet games.

With the PS3, Sony started moving away from anything proprietary, and for us audio folks, this was a great thing. They are now using open-file formats and common-feature tool sets and allowing the audio team to use Sony tools or other more accommodating and robust tools such as FMOD. This gives the developer the flexibility to use the best features of the PS3 and to use data they have already created (perhaps for an Xbox 360 version of the game) without having to re-author it. SCREAM, which was used for the PS2, has been adapted for use on the PS3 as well—but the current version doesn't address many of the next-gen issues. Sony had promised that it will evolve over time to be more open and extensive, with a more "sound design" looking interface.

Creating audio for the PlayStation 3 is much easier with Sony's new line of thinking. Composers and sound designers can work with familiar creation tools, delivering their assets as digital audio or MIDI files as needs dictate. The ability to use audio middleware applications such as FMOD gives the audio team even more familiar territory in which to work and create an entertaining audio experience. Content providers who are also deeply involved with integration of their audio can do so without a huge learning curve, especially if they have used these middleware applications in other non-PS3 projects.

Nintendo Wii

Nintendo's follow-up to their GameCube platform was released in late 2006 and has proven to be the most popular of the next-gen consoles. By the spring of 2012, the Wii had sold more than 101 million units not only to their loyal fans but to a large number of nongamers as well. Of course, the main selling feature was their wireless game controller and unique motion-intensive gameplay element which got people off the couch and into the game.

Technical specifications of the Wii aren't well advertised, but there are some details available. The CPU is a PowerPC-based Broadway processor reportedly clocked at 729 MHz and its GPU is an ATI Hollywood chip clocked at 243 MHz—neither of which have ever been officially confirmed. Memory consists of 88 MB, 24 MB as part of the graphics package and 64 MB of SDRAM. There is also an additional 3 MB of memory embedded in the GPU for other purposes. There is no hard drive on the unit, but saved game and other info can be stored on the 512 MB of built-in flash memory, which is expandable by up to 2 GB with an SD card.

Audio-wise, the console feels like a step back from the GameCube's capabilities with the reduction of the digital surround sound feature. But, what it does have is sufficient for what it is designed to do.

- 64 voice capability
- 44.1 and 48 kHz sample rates at 16-bit resolution
- Playback in stereo and Dolby ProLogic II embedded in the analog audio
- Mono playback on the controller at 6.3 kHz sample rate, 4-bit resolution
- Access to a 512 MB shared memory system

While not as sophisticated as the 360 or PS3, it does house features such as reverb, chorus, and delay effects processing (plus a wavetable synthesizer using DLS)—giving a wide variety of sound options to the composer and developer. Creating and implementing audio on the Wii is fairly straightforward, and where the composer or sound designer is concerned, you can again create using familiar tools and deliver your audio content as digital audio and *.mid* files. There are specific tools the developer will use for implementation, and as part of the team, you'll become familiar with them.

There is a little bit of a learning curve, as there is on most applications, but it is learnable and will give you a good end result. Unfortunately, because there is little information on the Wii or its available tools in the public domain and the inconvenient fact that I am still bound by NDAs, I can't go into much more detail. But trust me, you'll be fine when it comes to creating audio for this platform.

On a previous Wii project, I was tasked to create music, sound effects, and dialog. Producing the assets was straightforward—all created using my standard tool set and delivered as *.wav* files. The developer integrated the audio assets and invited me over for the final mix. We played the game, often having to remind ourselves of the purpose of my visit, and I'd call out volume levels to the programmer sitting nearby. Using the interface connected to the dev kit, he'd make adjustments, I'd reload and play the game, and we would repeat the process until we were confident it sounded appropriate. For any sounds that needed further adjustment or just didn't fit with what we were seeing, I'd create alternative sounds or make minor timing tweaks on my laptop and that was that. In the end, there were absolutely no surprises on my end and the audio was excellent.

Sixth-Generation Consoles

Gone, but not forgotten, are the previous sixth-generation game consoles still entertaining gamers around the globe. While the commercial gaming world has moved on to the newest money-making consoles to showcase their games, there is still an extensive community which creates games for this market. Obviously, these consoles are not as viable as the latest and greatest editions—but with millions of them still in circulation, there is a chance you could still be asked to create audio for any one of them.

Official manufacturer-sanctioned ventures have given way to an immense community of home-brew, hobbyists, and student game projects which capitalize on the wide array of tools and available information to learn how or to satisfy their need to create. If you're first starting out in the games industry, finding a project for one of these consoles will teach you far more by doing than you ever could just

reading about it. So, if you find yourself with an opportunity like this, it would be well worth the investment in time to take in all you can about the process.

In this section, we discuss the major sixth-generation consoles: the PlayStation 2, GameCube, Xbox, and GameBoy Advanced (GBA). Because this is "old news," there is plenty of information available and we actually know more about them than we do with the next-gen consoles. This makes creating audio for this previous generation a bit easier and definitely negates the need for approval by the manufacturer just to gather information.

So, while you peruse this section, consider the differences between their next-gen and eighth-gen cousins—what was improved upon and what processes were abandoned. Doing so will help you appreciate the improvements of the latest generations of game consoles and how manufacturers are finally making it easier on the developer and, ultimately, on the composers and sound designers who create audio for them.

Sony PlayStation 2

The Sony PlayStation 2 was the first of the sixth-generation game consoles to hit the streets in North America in October of 2000. While not radically different from the original PlayStation regarding the way sounds are prepared and used, there were still improvements in quality and storage. Most of the effort, it seems, went toward processor speed and graphics support—bowing to public demand for "better-looking" games. The use of the DVD storage medium and streaming capabilities did allow for higher-quality audio than in previous years, but it ultimately came down to how the developer utilized the console resources and what elements took priority.

The main processing unit on the PS2 is known as the Emotion Engine (EE), a CPU capable of 128 bits and a clock speed of 295 MHz—supported by 32 MB of RAM. Graphics capabilities are enhanced by a separate CPU, a "graphics synthesizer," and 4 MB of embedded cache VRAM. Sound processing for this console exists on its own, on a processor known as the IOP (input/output processor), to keep from having to share other resources. The IOP has a complement of two SPU2 chips, allowing for a combined local sound memory of 2 MB.

The SPU2 chip allows for high-quality sounds, up to 48 kHz sample rates, although original source files are not required at this high sample rate. Creative decisions still need to be made regarding file size and quality in order to conserve space. For those files that do use a lower sample rate, they will be up-sampled to 48 kHz at the time of output. Generally, most audio will be stored and implemented at a lower sample rate.

As audio is completed, the PS2 requires conversion of audio files to a Sony proprietary format known as VAG (like the original PlayStation). This particular format applies data compression of 3.5:1, which can change the resolution of the sound during output—but overall, it is consistent. Event-based and streamed audio is mixed in the SPU2 using 48 total voices and routed to either analog stereo or digital optical outputs for playback. If the player is using a Pro Logic decoder, they can experience the audio in Dolby Surround instead of standard stereo—a nice feature.

The 2 MB of sound RAM can be utilized many ways at the developer's discretion. Sound effects can be stored for instantaneous playback, music or background ambience loops can be streamed using RAM as a buffer from the DVD,

and sound bank samples can be stored for triggering from MIDI files—or a combination of all three.

This increase in RAM brings many advantages over the original PlayStation. Higher-quality audio and longer loops can be stored on disc, and streamed and better-quality sound bank samples and sound effects can be stored directly in RAM. It is also possible to stream continuous music and background ambiance at the same time, both in stereo or surround.

Direct audio falls into two categories on the PS2: PCM and ADPCM. PCM (pulse code modulation) is uncompressed audio (like the *.wav* or *.aiff* format) used for music and ambience, voice-overs, and complex sound sources. This format encourages a higher-quality sound that uses software-based effects and is easy to implement programming-wise. The downside is its need for high storage space on a disc and its limit of only two channels. ADPCM (adaptive delta pulse code modulation) is a compressed format used specifically for simple sound effects, MIDI triggering, and streaming. This smaller-size file doesn't require as much disc space or processing power but is lower in quality.

If you work in-house for a Sony-sponsored developer (although, at the time of publication, it is unclear of Sony's involvement or support, if any, in their older generation consoles), you may be involved in the audio conversion to VAG. These developers are licensed to use the development kit, which includes various tools for conversion. Outside audio contractors will more than likely be required to deliver their music and sounds as uncompressed digital audio files such as *.wav* or *.aiff*. Different developers may request different formats based on their needs, so be sure to check with your project lead to be certain.

Overall, the PS2 console does not limit the process of composing music and designing sound effects. The only real limitation comes when final conversions are made and smaller file sizes are needed, but it won't change your creation process. The exception is if the developer requires a sound bank or instructs you to use one they provide. This will limit you to a 2 MB bank of samples and may change your way of musical thinking. Instead of delivering music in a PCM format, a mutually acceptable sequenced format like *.mid* will suffice. Both methods are workable and you can still provide excellent work.

On one of my PS2 projects, I ended up delivering music cues for direct audio use as *.wav* files, a 2 MB sound bank of my choosing as *.wav* files, the key groups and mapping specific to our mutual sampling equipment and the remainder of music as *.mid* files. The sound bank and direct audio were converted directly to VAG, the *.mid* files and sampler-specific details were pieced together into a platform-workable format—all done by the developer. As the composer, the direct audio cues were a no-brainer. I was able to create music using standard audio production methods and could go all-out using whatever sounds I wanted. The challenge came designing a 2 MB sound bank and composing acceptable cues using it. In the end, overdubbed percussion and countermelodies helped keep the music interesting and dynamic despite only having minimal instrument samples of drums, bass, piano, organ, and synth to work with. A PlayStation 2 game project can certainly test your compositional abilities.

Nintendo GameCube

Nintendo's offering after their N64 console was the GameCube. The physical console size was smaller, but substantial improvements under the hood promised a quality gaming experience. There were improvements in every feature across the

board, including a proprietary 1.5 GB optical game disc (instead of the previous game cartridge) that allowed for larger file sizes and more audio.

The GameCube's main controlling unit is a 405 MHz, IBM Power PC, 3D-enhanced microprocessor unit known as "Gekko." Twenty-four MB of 1T-SRAM, considered the fastest RAM available at the time, acts as the main system memory—with 16 MB of auxiliary RAM (A-RAM) as the main source for elements such as sample audio data. Associated with the MPU is the system LSI referred to as "Flipper," where graphics, the AI, and audio processing are accomplished. Despite other elements sharing the pipeline, audio is processed as a separate entity on a special audio digital sound processor (DSP) mounted to Flipper without compromise. This chip is a proprietary DSP with an attached "accelerator" hardware that organizes data flow, decodes PCM samples, and flows audio to the audio interface. The audio interface is a two-channel analog or digital connection capable of 48 kHz, 16-bit, stereo or surround encoded audio.

The basic path of audio begins with data being loaded into A-RAM, where it is moved as needed to the audio DSP for processing. The DSP manages the information; adds any chorus, reverb, or delay effects; and sends the audio through the interface to the playback system. Audio from the optical game disc can be streamed directly to the audio interface without expense to the rest of the program, completely independent of the DSP, or can be routed through the DSP for additional processing if needed. It is completely the developer's call.

Audio can be produced as 16- or 8-bit PCM (uncompressed audio such as .wav or .aiff) for two-channel playback or as ADPCM (compressed audio) for a maximum of 64 simultaneous-channel playback—all of which is capable of 3D and can be encoded for surround. The Nintendo 64 console used ADPCM exclusively and the introduction of PCM audio on the GameCube was a noteworthy enhancement.

The beauty of this platform, at least from a composer or sound designer's perspective, is that no development kit is needed for audio creation like their previous consoles. Music and sound effects can be produced as you are accustomed to and delivered to the developer for implementation. There is an audio tool available from Nintendo developer support called MusyX (pronounced "musics") that simplifies implementation, so all the audio creator has to do is deliver the files to the programmer—who then simply inserts them into the game. The advantage is that the final audio mix can be performed by the person with the ears and not by the one who is deep into the code.

The MusyX tool emulates the GameCube audio system and can handle all of the audio needs for a game title. Sound effects, sequenced interactive music, and streamed audio are its main function—but it can also provide dynamic voice allocation and programmable audio macros. All 3D surround functions such as panning, volume and effects processing, and multiple sequencer instances (including cross-fades) can be created using this tool as well.

Sound effects can be randomized and panned easily, without actual loop points. A programmer would only have to make a call to one sound event, which would trigger the sound designer's bank of sounds established using the macro tool. Where there may be several sounds involved triggered at random moments, the programmer only sees it as one instance. The sound designer becomes completely responsible for when, where, and how loud a sound plays.

The macro function is a powerful part of the MusyX tool, designed to free the programmer from having to make creative decisions. When a game company

hires a composer and sound designer, they are paying for their skill in audio and don't have to be concerned with involving the programmer. This tool can design macros, using provided templates or by building your own, to be as simple as "start sound, stop sound" or as complex as managing the complete soundscape in an entire level. These macros can even be used in place of MIDI files, with better results due to smaller data transfer.

The GameCube console can play streamed audio direct from the game disc or trigger a sound bank via MIDI or programmed macro files. Interestingly, the system has the capability of using different sets of sound samples—much like sound fonts that can be loaded and used for different occasions. Instead of having to trigger from the same set of sounds for an entire game, this offers the potential of replacing them for different levels or situations—keeping the audio fresh and the player entertained.

As the composer or sound designer, you can expect to perform many different functions for the GameCube platform. Ultimately, you could provide music and sound effects as .wav files, or other PCM audio formats, and either stream them from the disc or trigger them from MIDI files and macros. Music can be delivered either as direct audio or as sequenced data files, which in turn would require one or more sound banks to be created as well. Macro programming may be required using the MusyX tool. However, this tool is not available to content providers unless they are a licensed GameCube developer. Programming your own macros is said to be relatively easy linear programming, so don't concern yourself too much having to learn something complex.

Sound effects creation will be slightly more involved. Instead of delivering single one-shot effects, sounds that can be layered will need to be produced for more options and interactivity. If you are creating a sound effect for a big machine, for example, instead of layering several other sounds into a single file and then looping it over and over, GameCube audio lets you apply components of the sound (such as individual hums, whirrs, and clanks) separately and have them play back randomly without an actual loop point. Be prepared to work with a different mindset. You should note the ideas which began in these early consoles have continued on in both the newer consoles and in audio middleware tools with great success.

Microsoft Xbox

The Xbox was Microsoft's first entry into the game console business and, at the time, was well received. Looking past the initial hype, the capabilities of this machine far exceeded any previous company's attempt at a home game console. With a Pentium III–class 733 MHz CPU, 64 MB RAM, 250 MHz custom GPU, DVD, and 8 GB hard drive (a first in console gaming history), this platform was set up to be a powerhouse. Initially, you got the sense that the Xbox was a beefy PC without all of the artery-clogging administrative functions running continuously in the background. Basically, you'd be right—except for the added features designed to move enormous amounts of graphic and audio data.

The main processing unit for audio data is the Xbox Media Communications Processor (MCP), which includes four independent audio processors: the setup engine, Voice Processor (VP), Global Processor (GP), and Encode Processor (EP). Audio data flows from the setup engine to the VP, to the GP, and finally to the EP for connection to the outside world that will give analog or digital outputs in stereo or 3D positional audio.

The setup engine's main function is the setup of data transfer for multiple output streams and to expand 16-bit data out to the Xbox format. By doing this in hardware, it relieves the programmers of having to deal with various software issues to achieve the Xbox format. The setup engine will also accomplish parameter ramping and other housekeeping functions if needed.

The Xbox VP is a hardcoded fixed-function DSP. It has a 256-voice synthesizer running at 48 kHz, either mono or stereo—and all running concurrently. Of those 256, 64 can be 3D encoded for surround applications. A single band of EQ, essentially a filter block, is available for specific obstruction/occlusion effects—such as a voice being heard through a wall from another room. A hardware submixer also lies on the VP, allowing any number of the 256 voices to be grouped into different submixes and rerouted back through to make further use of different filters and EQ settings a second time. The 256 voices use the DLS 2 (downloadable sound) standard and allow for an array of possible game sounds and instrumentation.

The Global Processor (GP) is a fully programmable DSP designed specifically for effects processing, but can be used for other things as deemed necessary by a developer. Since the goal is to make sound effects and music more interesting and dynamic, the unit ships as an effects processor with preprogrammed settings. Sound processing using modulation, chorus, compression, flanger, reverb, and distortion is possible out of the box—and a developer can also add capabilities of its own.

The EP receives all of the audio data from the GP and creates the final audio output. This EP is capable of real-time multi-speaker encoding and automatic multichannel mixdown to stereo. It has been designed to handle all aspects of multichannel data internally, including multichannel *.wav* files.

The 8 GB hard drive, new to console gaming with this platform, has some very distinct advantages. Because it has a lower seek time and throughput than the DVD drive, the hard drive is used primarily to augment the system RAM. It can serve as a temporary cache or as an audio buffer to reduce hits to the DVD, which will allow other information to be accessed unencumbered. How the hard drive is ultimately used is left to the developer. An average audio budget for an FPS- or RPG-style game was about 6 MB, which works out to about 10% of the shared budget—which wasn't bad for these consoles.

The software used to create and implement audio for the Xbox is based on DirectX 8 and Windows Media software. The basic application programming interface (API), DirectSound, is designed specifically for the Xbox and accomplishes programming direct to the hardware. The DirectMusic API is a complex tool that takes care of most of the audio content design and implementation on a content-driven basis and is created with a program called DirectMusic Producer. With these tools and DirectX audio scripting, the programmer only has to give high-level cues—such as "entered hallway," "fired gun," and "enemy died"—and the sound designer decides what audio events will happen. The composer can react to other cues and design various levels of the same music. For example, if a programmer cues two bad guys in a room as the player enters, the composer would dictate music of low intensity to play as opposed to if the room had 20 bad guys waiting in ambush. In that case, the music would more than likely be at its highest level of intensity as decided by the content provider. The programmer sets up the cues; the composer and sound designers decide what audio plays during them.

Tools of the Trade

TOM SALTA
Composer

My room is a simple, comfortable space where I can work without interruption (well, usually). I have a single keyboard controller and a main computer that runs my DAW (Digital Audio Workstation) where I record and mix everything. I have a few high-quality microphones, an audio interface, analog summer, studio monitors, and a good pair of headphones … that's pretty much it. These days, depending on the style of music you're writing, you can usually do most everything within the computer. But regardless of how far technology has come, I always prefer utilizing live musicians and vocalists in most of my compositions to add a human and organic element, creating a deeper emotional dimension to the music.

Like the old cliché says, it's not what you have, but how you use it. Less is more. Focus on just the essentials you need, do your research and get the highest quality gear you can afford. Learn to listen to and know what you're hearing.

Computers: MacPro, Mac Mini, MacBook Pro, iPad Mini

Audio interface: Apollo Quad

Multitrack system: Logic Pro X

Monitors: Blue Sky Sat 6.5

Sound modules/VST instruments: Spectrasonics Omnisphere, Stylus RMX, Trilogy, NI Kontakt and most of their other VIs, EXS-24, and more … plus LOTS of sound libraries

Outboard gear/effects plug-ins: Dangerous D-Box

Keyboards: Doepfer LMK4+

Other instruments: Studio Electronics MIDI-Mini, Roland 1080s, 5080

Microphones: Custom Made Large Diaphragm Tube Mic by Roy Hendrickson, AKG C460B

Creating audio for the Xbox is essentially the same as anything else. Composers and sound designers can utilize their existing audio editors and sequencers and deliver sounds as *.wav*, *.wma*, or any sequenced data format such as *.mid*. There is no need to learn any new tools just to create audio. DirectMusic Producer is a tool Microsoft provided if you want to do any DirectMusic content, DirectX audio scripting, DLS collections, audio path configuration, or wavetable synthesis. Any work done on the PC is compatible and can be cross-platformed to the Xbox. However, DirectMusic Producer is not necessary if the developer intends to use strictly linear audio, such as a single music cue playing in the background or standard one-shot sound effects.

The greatest challenge a composer may have when creating music for the Xbox is the need for various levels of intensity for the same music. Film composers may be more practiced at this and perhaps we can take a few lessons from them. The ability to take the same music theme and use it in quiet moments as a soft, minimal piece and then turn the intensity up to 10 during the action sequences makes them perfect for this type of work. Check out any James Bond or Star Wars flick to see what I mean. The familiar themes are *everywhere*.

Music is always in various layers, so it won't be as difficult as it may seem. The lowest level of a piece could be a piano playing the simple melody. The next level up would add percussion. The next would add bass, then a countermelody, then strings playing in harmony, then full-on drums and electric guitar. It may be as simple as building the massive score at the start and then working backward, taking tracks out one at a time until you reach the simplest form.

Sound designers will have greater responsibility and creative license when producing sound effects. A programmer will set the cue and the audio provider will simply decide which sound effects to play and when. Various sound effects for the same action will have to be created—a lot of extra work. Creating sound effects in different layers and triggering them as needed will keep you on your toes.

Microsoft took a new approach with the Xbox by providing direct support to game creators. Besides standard developer support they are also providing "artist support," where content providers (such as composers and sound designers) can contact them directly for answers.

If you are an artist working on an Xbox title with questions or ideas, you may contact them at mailto:content@xbox.com or visit their developer webpage at www.xbox.com/en-US/developers.

Nintendo GameBoy Advanced

One of the most popular game platforms in our short video game history was the Nintendo GameBoy. This compact handheld device was tremendously popular with our mobile society—where adults and children alike take their fun on the road. Millions of systems and games have been sold over the years, with millions more after the introduction of the GBA.

Technical specifications for the GBA are impressive, considering it was released in 2001. The 16.8 MHz CPU is capable of 32-bit ARM with embedded memory—versus the previous 8-bit for the GameBoy Color. Memory consists of 32 KB plus 96 KB of VRAM (internal to the CPU) and 256 KB WRAM (external to the CPU). The 2.9-inch TFT color LCD screen is capable of 240×160 resolution and 32,768 possible colors (512 of those simultaneously). The audio hardware

is basically the same as a normal GameBoy, with the addition of two dedicated hardware sample channels and an improved redefinable channel. The upgraded audio capabilities include the following:

- Two pulse-wave channels capable of variable-width pulse wave with four settings
- One variable-frequency white noise channel
- One redefinable channel switchable between 16 and 32 bytes, with four volume settings
- Two 8-bit sample channels

It is additionally capable of 32 sampled voices and, believe it or not, is also certified for Dolby Surround Sound! Music is implemented on the GBA through a dedicated program code known as the *audio driver*. Audio drivers come in several forms; a basic driver ships with the system's development tools. They are normally workable but require extra finesse to operate correctly. Dedicated drivers are available from a few companies, and while often powerful, they are limited in that they are made to suit as many scenarios as possible and often have excessively high processor times.

The final option, recommended by GameBoy audio creators, is the best way to get the most out of a limited chip: get your hands dirty and code your own drivers, customizing them to fit your client's requirements. Very few people these days actually have both the technical and creative know-how to take this route, so an alternative would be to conspire with a competent audio programmer to work with you.

The limitations of the GBA system will ultimately define the music. If you're composing music in a certain style, you are limited to certain sounds, rhythmic patterns, and other factors that govern why certain pieces of music fall into that genre. The key is to find a palette of sounds that fits the style and fits within the constraints of the project. These confines can actually help composition. If you're composing a piece of music to be played by a pianist on a single piano, for example, you wouldn't waste time composing parts for guitar, bass, and strings.

Some composers who specialize in GameBoy audio will compose straight to the target platform through a dedicated editor and driver. Their composing rig connects to the GameBoy circuitry to trigger internal sounds, so what they compose is what they hear. Final files delivered to a developer will be as *.bin* files for inclusion in the product's code. Another method is to utilize custom audio tools such as the GameBoy version of MusyX, which is similar to the GameCube version. This program offers macro-based programmable MIDI and sound effects playback to include a Dolby Surround Sound encoder and 32 mixed sample voices that fully support programmable sound generation (PSG) voices adopted directly from the original GameBoy system. Because this program doesn't offer its own sequencing program, musicians can utilize their current software and save the music as *.mid* files for implementation.

The pitfall to avoid when composing for the GBA console is not knowing the limitations of the machine. Even knowing the limitations, experienced GameBoy composers might go a step further to try to beat the machine—to get it to do things it's not designed to do—even if no one else notices. Getting wrapped up in this endeavor, though, often leads to being surprised by a deadline. Running out of memory or running out of processor time can be another problem.

Customized drivers generally use only 1%–2% of the CPU resources compared with the 15%–30% for ready-to-buy drivers.

The GBA console will certainly challenge any composer. It may even be the last true game composer's machine, at least from an "old-school" perspective. The latest handhelds are powerful enough to stream MP3s. But with this one, you'll really need to concentrate and work within the box to make a melody shine. Keep the tunes simple, clean, and tidy—and remember that spaces or silence between sounds is still part of the music.

Other Gaming Platforms

Just outside the major game console realm are many other popular gaming platforms you can expect to create audio content for. While those with their home theater playback systems offer a tremendous gameplay experience, there are other ways to have a good time—if not better. Typically, games created on home consoles will be ported to at least the PC—but may also see a new life on handheld, smartphone, or coin-op systems. But, obviously, not all games are specifically targeted for the Xbox One, PS4, or Wii U. A large proportion are actually created exclusively for the devices which fall within this "other" category.

First-person shooters thrive on the PC because of the very precise control offered with a keyboard and mouse. Real-time strategy games have better luck on a PC as well because of the multitude of menu controls and the easily accessed interface. Other games do well because of the age group of the players and the portability of the device, such as the PlayStation Vita and New Nintendo 3DS. Rarely do any games created for handheld platforms get considered for anything else, so there will be plenty of opportunities as a composer or sound designer to work on exclusive games on exclusive platforms. Working on so many platforms may seem a bit overwhelming and has a tendency to cloud the process, but throughout the differences of technology and integration options, the creative mindset will pretty much stay the same.

CD/DVD-ROM Games

CD and DVD-ROM games, for the PC or the Mac, rely on several variables in the scheme of development. Unlike consoles (which have standard and predictable hardware), home computers can have a wide range of processors, graphics cards, sound cards, memory, and peripheral devices that add complexity to the task. Developers must target specific minimum system requirements and hardware standards for their game to work as advertised, but always run the risk of surprises and conflicts. They must decide whether or not to take advantage of any new features, such as surround sound or onboard effects processing. It's a jungle—one fraught with many twists and turns. But for those who work on this platform a high-end PC will always be light-years ahead of any next-gen console.

There are many different ways for a CD/DVD-ROM game title to deliver sound. Many current titles still make use of standard linear music and sound effects—basically those that are turned on and play from start to finish. Some games make use of interactive audio tailored specifically to what a player may be experiencing at the time. How this is actually accomplished is left to the developer's imagination.

When a game is first installed on a player's machine, several things will happen that affect the sound and how it is used. Considerations such as file size and

processor speed will first determine what format the audio will be stored in. Other data elements, such as graphics or program data, will decide what has to be crammed through those skinny little pipes and how it will be done successfully.

CD/DVD-ROM games can make use of PCM (*.wav* and *.aiff*) or compressed formats (*.wma*, *.mp3*, *.ogg*, etc.), Red Book audio, sequenced data files (*.mid*), or any other proprietary format deemed appropriate by a developer. These sounds can be implemented in many ways, with varied results, dependent on the hardware inside the player's computer.

Most game sounds are delivered as an audio data file such as *.wav* or *.aiff*. These are then stored on a game CD/DVD or loaded to the hard drive during installation. Most sound effects will further be stored in the system's RAM as a game is launched for immediate triggering and playback. Those less critical sounds will remain on the hard drive. Direct audio such as music (because it is considered a lower priority and because of storage considerations) usually remains on the disc. Music playback will depend on the system resources—whether it is streamed directly from the CD/DVD, bypassing the processor altogether, or buffered onto the hard drive or RAM. It could also be played as Red Book audio, as you would do it if you put the disc into an audio CD player. It is essential the large file sizes of linear background music not interfere with any other elements of a game. Red Book audio bypasses everything by going from the CD, down a separate wire to the sound card and directly to the speakers. Unfortunately, this type of audio also takes up a lot of storage space and isn't always the right option. With today's effective compression schemes, 256 kbit/sec MP3s (for example) will easily rival uncompressed *.wav* files—and as long as you have a decent sized buffer you're good to go. But, it is a delicate balance indeed.

Once all of the audio is set to play, CD/DVD-ROM games will normally use a licensed audio development tool or library of prewritten code—often referred to as an API or SDK (software development kit), such as the Miles Sound System as an example—to make an efficient use of it all. And don't forget licensed audio engines and tools such as FMOD and Wwise which also support the PC. Or if a developer chooses a more individual path, they will budget extra time into their development cycle to create their own solution. But for a relatively cheap licensing fee, the time and energy saved is usually well worth the expenditure and these prepackaged audio tools can handle most of a developer's needs. A developer has many different ways to present audio, with many features such as the following available in a drop-in application.

- Multiple channel mixing
- On-the-fly format conversion and decompression
- Volume and panning control
- EQ and effects processing
- Interactive audio structures and behaviors
- 3D surround sound and localized support

You can see why it becomes important the sound designer and composer know what content is needed, what format, and an idea of how it will be implemented. Overall, doing work for CD/DVD-ROM titles is fairly similar to other game platforms. Music and sound effects will be created in a linear one-shot format or as several pieces for interactive or random use. These will typically be delivered as *.wav* or *.aiff* files, but compressed formats such as *.mp3* and *.ogg*

are rapidly becoming more appealing for their small file sizes and reasonable audio quality.

Music can be a bit more complicated, with several variables. Linear music can be performed and delivered much the same as sound effects, but obviously as larger files. In addition, it can be burned as Red Book audio (the standard audio CD format)—something you don't normally do with sound effects. They can also be delivered as a sequenced data file, such as *.mid*, to include customized sound fonts which can be very beneficial for sound effects that repeat often. By storing them in the sound card, they won't take up RAM resources and will make room for other applications. Customized sound fonts can change from level to level or scene to scene, providing fresh sounds for both the music and sound effects.

You may also have an opportunity to work with the various formats of 3D audio, interactive music, and many of the latest hardware features of the home computer market. Be sure to keep up with what is happening and you won't be surprised when a developer starts talking about something new. Console game platforms vary little in technology until the next one is developed a few years down the road. Home computers are in a constant state of flux. This type of new technology has a way of subtly creeping into the game market and it makes sense for you to stay informed.

Web- and Smartphone-Based Games: Java and Flash

Doing music and sound effects for games can also mean providing content for the Web-based or smartphone-based genres as well. The scale is not quite as grand as other types of games, but they do have their advantages. Where else can you knock out a game a day? Where else could you work on games with various themes every week instead of the same large project that spans several months? The pay is the same (except you're doing fewer sounds so the paycheck *is* smaller, but the fee per sound effect can be billed at your same big game price!) and the variety keeps things fun. I spent many years contracting for an online game company that put out a new game every couple of weeks and eventually amassed more than 60 of them. I had a blast and always looked forward to that next project.

Online Web and smartphone games are typically produced as Java or Flash applications that can be played directly on a Web browser or a phone. They are generally casual, novelty, or casino games, with many recently moving toward multiplayer action. They are extremely popular with Web enthusiasts and smartphone users, as well as those who don't like the over-complexity of today's brand of video game entertainment. One popular online game site's demographics found that 85% of their clientele were actually middle-aged women!

The one huge difference between online/smartphone games and other console games is the need to produce decent quality with very small file sizes. Because developers must take into account the unpredictable bandwidth of the Internet and how users may connect to it, as well as the limited phone hardware capabilities and work within those constraints, content size becomes the main issue. Generally, sound effects are very short in nature—to keep content size to a minimum. Music is a low priority and normally not considered for these types of games but short loops can be used with acceptable results if sound effects are sparse.

In a world where composers and sound designers strive for high fidelity, this type of work may be considerably frustrating. Web/smartphone-based games

must use every trick in this book to keep file sizes to a minimum, which sometimes means cutting a lot of corners. Where 44.1 kHz was the norm, it now becomes 8 kHz. Where 16-bit resolution once ruled, 8-bit takes over. There is no such thing as stereo; all files are done in mono. Expect to deliver content as 8 kHz, 8-bit, mono, and like it. Now, that's not to say that there won't be instances where you'll be delivering your files as 44/16. While many Java and Flash developers still lag with the old stigma toward low-quality audio as their solution, broadband Internet connections, multiple approaches, and workarounds (such as streaming or loading audio from an exterior source such as a Web address, for example) are allowing for increased audio quality and thus your deliverables will be of higher sample rates and resolutions.

Flash content is converted in its own process with its own compression and can be delivered as *.wav* or *.aiff* files while some developers will take *.mp3* files. Java requires the *.au* format using μ-Law (pronounced "mu-Law") compression. This type of compression is a specific algorithm for voice signals as identified by the Geneva Recommendations (G.711), which defined this method of encoding 16-bit PCM signals into a nonlinear 8-bit format commonly used in telecommunications and Java applications. A-Law compression and MP3 are sometimes possible, depending on the sample rate and resolution and what audio is supported by the system the game would be running on. Overall, you'll need to become very intimate with this format's idiosyncrasies if you work in this particular world. An Internet search of terms like "audio for java" will return a number of great resources on the subject.

Creating audio for these types of games takes a little more finesse than other full-resolution sound projects. I recommend initially creating all content at the highest possible sample rate and resolution, then converting down to what is needed. The big problem when resampling to a low rate such as 8 kHz is that most of the higher-frequency activity is lost, causing severe loss of definition. Listen to a really bad AM radio broadcast and you'll know what I mean. It is essential to keep the end conversion in mind and construct audio that works effectively. Subtle sounds such as "clinking" brass shell casings hitting the ground will sound like small pebbles and that expensive cymbal crash will sound like a cheap child's toy. None of those high-frequency sounds will make it, so don't be shocked. But, on the other hand, you *can* create sounds with predominantly low end all the way down to 4 kHz with good clarity. Do your best to work within the given parameters and make the files as clean and healthy as possible.

Nintendo Dual Screen

The Nintendo Dual Screen family (commonly referred to as the DS) are portable handheld game consoles which began releasing in 2004 with the DS and 2006 with the DS Lite versions. In 2011, the 3DS was launched, followed by the larger 3DS XL in 2012, and the nonfolding redesign of the 2DS in 2013. The current versions, known as the New Nintendo 3DS and 3DS XL, were released late 2014. For handheld fans, these latest versions are keeping this market alive despite heavy competition from the smartphone market.

Creating audio for the DS is typical of older game projects, where memory is a scarce commodity and some finesse is involved to make everything sound good. Audio can be delivered as digital audio, MOD, or MIDI files, depending on the developer and the tools they are using for implementation. Various sound development kits are available for the DS, and the available capabilities are

dependent on the needs of the game—which will obviously affect the available audio resources in these nonstandard SDKs. The best news in all of this, though, is that audio middleware tools are now supporting the 3DS OS which is an almost perfect solution where you need to get a lot out of limited console resources such as the DS.

Overall, in an effort to maintain a small audio footprint, all the tricks of the trade will come into play. Digital audio files will be down-sampled and often delivered as mono files. Sound samples triggered by MIDI messages will be massaged to include the smallest amount of notes and instruments needed while keeping the overall file lengths as short as possible. There's no need to include a 10-second sampled note if only a second of it gets triggered, so shaving down your sample bank can definitely save some space. The only saving grace in this lower fidelity world is the speakers and headphones are forgiving and audio quality doesn't usually make or break the experience.

New Nintendo 3DS/3DS XL

The "New" 3DS and 3DS XL are updated versions of the 3DS and 3DS XL featuring a faster processor, face-tracking for improved 3D viewing angles, additional buttons, and a new pointing stick. Released in late 2014, and early 2015 in the North American market, the many improvements have kept this platform viable. Inside, it packs a 268 MHz quad-core CPU, 256 MB RAM, 1 GB internal flash memory storage, removable 4 GB Micro SD card, a microphone, and stereo speakers with pseudo-surround capability.

Audio-wise, because it operates using the Nintendo 3DS OS, it shares the same features as the preceding 3DS. Nintendo 3DS Sound is the operating systems built-in music player and sound recorder supporting MP3 audio and AAC audio (mp4, m4a, or 3gp) which can be played from the SD card, even when the console is closed. Sound manipulation options and several audio filters are available to the player, and 10-second voice recordings can also be made and edited.

Nintendo 2DS

Released in late 2013, the 2DS was marketed to a younger audience as a strategy to broaden Nintendo's market-share. This cheaper cousin uses a slate-like design (instead of the familiar clamshell case) with a single screen and offers compatibility with DS and 3DS games. Its operating system is the Nintendo 3DS OS, with the same capabilities, but its CPU is only a dual-core and only offers 128 MB of RAM. The only audio limitation worth mentioning is its lack of stereo speakers, instead only using a single, mono speaker.

Nintendo 3DS/3DS XL

Nintendo's successor to the DS, the original 3DS consoles (not to be confused with the "new" 3DS versions) were released in the spring of 2011 with the larger-screened 3DS XL version appearing a year later in 2012. Utilizing the Nintendo 3DS OS, which offers backwards compatibility with the DS series games, to include the DSi series as well, its internal hardware is almost identical to the 2DS. A dual-core CPU, 128 MB RAM, 1 GB internal flash memory, and a 2 GB SD card (3DS) or 4 GB (3DS XL) are included for game saves and additional user-created audio content. It does have stereo speakers with a pseudo-surround capability and a microphone.

Nintendo Dual Screen/Dual Screen Lite

As the name implies, the main point of interest of the original DS was the two 3-inch LCD screens—one of which is a touch screen, which introduced a new dimension to gameplay and more visual space in 2004. Under 10 ounces in weight, it carried two ARM CPUs running at 67 and 33 MHz, 4 MB of RAM, and a serial flash memory storage of 256 kB. It supported game cards up to 256 MB, but the drawback for these is their slower data transfer rate compared to smaller 64 MB cards.

DS Audio Development

Considering the limited processing and storage capacity, audio features are not the highest priority of this particular console. It does feature stereo speakers (except for the 2DS), which have the ability to project a form of virtual surround sound using 16 simultaneous channels and a built-in microphone for unique applications. Some games incorporate speech recognition, online chat, or the use of voice as part of the game experience—requiring players to blow or shout. There is also an optional MP3 player variation which plays files stored on a removable SD card.

For a previous DS project, game composer and sound designer Jamie Lendino created a custom sound bank and the MIDI files to trigger them appropriately, finding the composition phase to be the only normal part of the entire operation. Creating a sound bank within the memory constraints proved a bit of a challenge, juggling sound quality for size, but it was doable and his results were good. The SDK being used had the capability of pitch-shifting the samples within the sound bank to the appropriate notes, and this neat little feature allowed him to use fewer samples and save some room.

The interesting challenge was not only to create a workable sound bank and music which was engaging, but also to help keep the implementation process easy and enable the developer to hear the audio as it was intended. Jamie found that unless he was duplicating the Windows Media Player sound set, which the developer could play on their Windows PC, he would either have to record them as digital audio files for the preview, or spend a little time with the programmer to get the DS audio engine set correctly. He found that by helping the developer adjust the sound set, setting specific instrument volumes and fine-tuning everything they could then "freeze" the sound bank so that the entire team could be on the same page and hear the MIDI files as they were meant to be heard. The side benefit was that when the final audio files were delivered all they had to do was drop them into the game and the music was done, without having to do a final mix.

To create commercial games for the DS, developers are required to be accepted into Nintendo's official developer support program. They must be an established "company" with a development team experienced in certain areas to qualify. Additional information on this aspect is available at the Nintendo Software Development Support Group website at https://developer.nintendo.com.

There is also an enthusiastic "home-brew" network for the DS which is quite robust. Several online resources, which at the time of publication were active, discuss various methods and techniques for creating and handling audio—and while not Nintendo sanctioned, are still a great way for audio folks to learn and confidently work on DS titles. Many thanks to Jamie Lendino for sharing them with us.

- https://gbatemp.net/threads/nintendo-ds-homebrew-tutorial-a-begn-niers-guide-to-getting-started.356509/

- https://patater.com/files/projects/manual/manual.html#id2617237
- http://osdl.sourceforge.net/main/documentation/misc/nintendo-DS/homebrew-guide/HomebrewForDS.html#sound

Sony PlayStation Portable and Vita

The PlayStation Portable, officially known as the PSP, is Sony's handheld game console—which was first released in North America in the spring of 2005. Competing specifically with the Nintendo DS, the PSP and a remodeled version referred to as the "Slim and Lite" have better overall features than the DS but haven't enjoyed quite the same success. It is the first handheld to utilize an optical disc format, has a larger 4.3-inch LCD screen, and can connect to the Internet, to the PlayStation 3, and to other PSPs. It also doubles as an MP3 and movie player, which makes it much more than just a game console.

The PSP weighs in at only 9.8 ounces, but don't let that fool you. Its CPU runs at 333 MHz (as compared to only 67 MHz on the DS), and its GPU runs at 166 MHz, with 2 MB of VRAM onboard. It also has 32 MB of RAM and 4 MB of embedded DRAM. It is incredibly powerful for its size and game developers can use these features to create some incredibly intense games.

The PlayStation Vita released late 2011 in Japan and early 2012 in Europe and North America as an upgrade to their portable line followed in 2013 and 2014 with the PCH-2000 Slim series. Sporting a 5-inch touchscreen, two analog sticks, Bluetooth, Wi-Fi, and optional 3G, it all runs off of a 2 GHz quad-core CPU and separate GPU, 512 MB RAM, and 1 GB internal flash memory. Removable storage consists of the PlayStation Vita Memory Card in sizes from 4 GB up to 64 GB.

Sound-wise, we're looking at minimal focus by the manufacturer—with only two small speakers and a headphone jack, although 5.1 is possible with the right headphones. But, considering the purpose and portability of this handheld, it is sufficient. Internally, we aren't faced with anything too unexpected for the handheld market—and creating audio for it is predictable. Digital audio or MIDI files triggering an internal sound set, as we've seen on most other consoles, will get the job done. Space is always an issue, so expect considerable compression, down-sampling, and conversion to mono files to ensure all of the needed assets will fit.

Once you sign a deal with a Sony-supported PSP developer, expect to sign an NDA which will then enable you to get brought up to speed in both the use of the audio engine and the types of files needed on your part. Each development house and game will utilize the available tools a little differently, so what may have worked on a previous PSP project may not necessarily work on the next one. But, if you are prepared for a little change of technique, you won't be caught by surprise.

There is also a considerable "home-brew" niche within the PSP community. The good thing for us is the information which is made available with no specific strings attached. Do a little search on the Internet for "home-brew PSP development" and you'll see what I mean. The following are a few sites I thought were worth taking a look at. You'll find many more!

- www.edepot.com/reviews_sony_psp.html
- http://wololo.net/2014/02/15/the-50-best-psp-vita-homebrews-in-2013/
- http://deniska.dcemu.co.uk/

Coin-Op Games

I've focused mainly on the home market of video games thus far, but there are other systems that we can provide audio for—such as the wonderful world of "coin-op." The highly proprietary games in the big cabinets cover a broad scope and variety of possibilities. Besides the standard coin-op games we all know and love, where the player stands in front of the machine mashing a shelf of buttons, the new generation of games takes on many shapes and forms—from consoles you sit in or ride on to those you stand on and gyrate. The array of audio needed is as diverse as the game platforms available on the market today.

As far as system specs are concerned, coin-op machines are generally designed from the ground up—depending on their mission. The developer/manufacturer will piece together each component for an explicit purpose—its audio parts being no different. Audio subsystems, playback amplification, multi-speaker place-ment, and other proprietary hardware and software are all designed to meet the needs of the game—and almost no two are alike. There are some coin-op units that use an existing console, such as the Sega games running on their Dreamcast system and Sony's PS2. These units are essentially a home game console with custom peripherals stuck in a cabinet that requires quarters.

There is no one standard for audio generation and playback in coin-op machines; it's all over the map. Composer and sound designer Michael Henry (while at Atari Games/Midway Games West) did the music and sound effects for the coin-op game *San Francisco Rush 2049*. The cabinet featured a five-speaker fully discreet surround sound system running on proprietary hardware designed in-house for that particular game. There were two main speakers above the video monitor, two speakers located in the molded seat behind the player's head, and a subwoofer in the seat which thumps the player's bottom end. In addition to the use of a five-channel surround music mix, Michael was able to pass real-time sound effects to any of the five speakers. If the car hit a curb, a big THUMP from the subwoofer would rattle the seat. If a car approached from behind during a race, you'd hear it in the rear speakers and the sound would pan to the front speakers as the car passed. Sounds in the environment were also fully positional. If the car passed a giant lava lamp in the Haight–Ashbury track, the bubbling sound passed from front to back and left to right—depending on where the car traveled.

For the coin-op sequel to *Rush 2049*, *Hot Rod Rebels*, Michael designed a patent-pending audio delivery system that involved actual chrome car exhaust pipes mounted on the cabinet below the seat. Big rumbly dragster and funny-car engine sounds were directed to the pipes to enhance the realism of the driving experience. If you put your hand down near the opening, you could even feel air blowing out of the exhaust pipes. There have also been shooting games where speakers were mounted in the gun, so when the gun was fired, the sound actually came from the weapon. There are motorcycle games where you sit on a realistic-looking molded plastic motorcycle that has a subwoofer and other speakers in the bike for engine sounds.

While many coin-op games may not require such sophisticated audio imple-mentations, it all depends on what the game needs to convince the player they are really "in the game." Therefore, audio systems can often be built from scratch for just one game and then you'd start all over again on the next one.

The original *San Francisco Rush* and *Rush the Rock* (Alcatraz edition) had an interactive audio component. The composer who did the music for these, Gunnar

Madsen, came up with a clever implementation for the music. When the player sees the screen where they would register their name, a tune plays with vocals that say, "What's your name?" When the player finishes entering their name and selects "End," the music seamlessly goes on to a tag that says, "That's your name!" Just one example of crafty implementation. The interactive music component required a custom-designed audio system that involved custom hardware, audio programming resources, and some of the lead game programmer's time.

In the case of *San Francisco Rush 2049*, the developer had a proprietary system to deliver five channels of discreet sound. Michael would make a surround mix of music tracks using Pro Tools and then save out and convert individual tracks. These were then interleaved or multiplexed using a proprietary tool. After he converted the music tracks to this format, a game programmer would add them to the game—and then Michael would go back and audition it in the actual game cabinet and make changes if necessary. In the end, if you want to implement anything in a coin-op situation it will mean working closely with a game or audio programmer. This applies whether it is music or sound effects or any in-game real-time effects processing such as panning, reverb, Doppler, volume adjustments, and so on.

Composing and creating sound effects for coin-op games is like everything else in coin-op: it depends on the game. In the case of the interactive music for the original "Rush," Gunnar needed to set up sample banks with instruments and score the music using these. At some point, the samples would be transferred to the coin-op, burned into ROM, and played back in the cabinet for testing—after which additional adjustments would be made.

For most coin-op titles, you'd approach composing just as you would for any other consumer platform. There are some differences, however. For example, play times for a level are usually shorter in coin-op than in a typical consumer game—so, long drawn-out compositions are usually unnecessary. The player will almost never hear the end of the music track because the game will be over. Remember, coin-op games are designed to suck the quarters from a player's pocket and several dollars is usually needed just to complete a level.

Unless the game has some specific requirements such as interactivity or another proprietary format, you will most likely deliver audio to the developer as 44.1 kHz, 16-bit, stereo—typically in an uncompressed audio format such as *.wav* or *.aiff*.

As far as a development kit, there are no commercially available audio tools specific to coin-op because most developers design their own. A developer may provide the composer or sound designer with a PC card or software that emulates their proprietary audio subsystem and sometimes with specific software tools to generate content as well. Generally, all you will need is the usual assortment of audio and music software. In the case of console-based arcade games (cabinets with a PlayStation or Xbox inside, e.g.), the developers will normally provide the audio tools, conversion utilities, and so forth. These are obtainable directly from the companies or through the licensed developer you are working with.

Coin-op is certainly unique. If you walk into any busy arcade and listen for a few minutes, you'll meet the biggest challenge when creating audio for these types of games: simply getting your sound effects, voice, and music heard intelligibly over the noise. Any subtlety in a music track or sound effect will be lost in a busy room. Most coin-op audio providers will make sure their audio sounds

brighter, either through EQ or some sort of effects processing, to help the audio cut through the noise level in a typical arcade. If you happen to be involved in the cabinet design, clever speaker placement will also help solve this audio nightmare. You don't want speakers that are too far away from the player or amplifiers that are underpowered. Use your ears and listen from the player's perspective. Get out of the studio and into the field. Michael Henry often hits an arcade when one of his games is out on test to hear what it sounds like in the real-life situation.

Tools of the Trade

CORINA BELLO
Sound designer

Computers: Macbook Pro 15″ Retina 2.7 GHz quad-core 16 GB RAM

Audio interface: Focusrite Saffire Pro 14 interface

Software: ProTools, Logic

Monitors: Adam F5 monitors

Outboard gear/effects plug-ins: Waves, Izotope Ozone for mastering, Sound Toys, Paul Stretch

Keyboards: Artiuria Minibrute analog synthesizer, M Audio Axiom Pro 61

Microphones: Rode NTG2 and Rode Blimp

Remote recording gear: Zoom H4N portable recorder

Conclusion

Without going too crazy with the technical details and totally losing sight of audio production issues, this is the basic state of today's game consoles and platforms you will be creating audio for. Simultaneously researching and trying to understand each of these platforms is enough to cause your head to spin, but I can assure you, once you get into a project on a specific console and with the support of your development team, it will make better sense. The beauty of music and sound production in this day and age is that most audio can be created using techniques and programs familiar to you without the arduous task of having to adapt to a whole new process each time. It can get quite involved when the various audio tools (such as MusyX, SCREAM, or XACT) come into play, but at least these run on the PC or Mac and don't require new and expensive hardware. But even then, with the overwhelming acceptance and use of audio middleware tools, it's highly unlikely you'll ever be down deep in the weeds unless you're working on an older platform.

Game sound creation and implementation with 3D surround options, interactivity, adaptive behaviors, and quality issues to constantly consider is quite daunting. But, it's these advances which drive audio production toward each proceeding generation of platforms and consoles. As always, I highly recommend you become familiar with the properties of the latest platform incarnations, not only to get a better overall picture of the features and limitations, but to help you be as efficient as possible when creating audio for them. There's definitely an adventure waiting for you—one that I promise you'll enjoy!

15

The Developer's Guide to Audio Content

If you are a game developer, or happen to play one on TV, this chapter is specifically designed with you in mind. There are many aspects of "all things sound" that musicians and sound designers have gathered over years in the trenches, most of which are never fully understood by nonmusical game creators. The intention of this chapter is to shed some light on these invisible subtleties and to talk about audio issues in general.

As a developer, audio often tends to be the misunderstood entity in creating a game. There is a certain psychology that can be applied to enhance the gaming experience in regard to audio content providers. It's not merely adding music, sound effects, and narration and hoping it works. There has to be a definitive plan to make it work right. More times than I care to remember, I've heard game players complain about a game—not about the graphics, not about the game play, but about the sound. Why is that? Were their expectations too high? Was there too much audio bombarding their senses? Was the audio just bad? There are other audio issues to deal with in conjunction with making the content pieces fit.

- What if you need to hire a game composer, a sound designer, a field recordist, or some voice talent for your project? How would you go about finding them and that one who fits perfectly? Game audio folks don't normally advertise in the local phone book, that's for sure.
- What actually goes on with a composer/sound designer after you've made the order for audio content? Music and sound effects don't magically appear. There is some serious work involved. By having a general

idea about what goes on behind the scenes, your expectations will more closely match your requests.

- What can you do as a developer to make dealing with an audio contractor a fruitful experience? Certain guidance and motivation is needed. A developer can certainly influence the quality of the audio content by their interactions with the contractor.

These are all valid concerns—ones which, in my conversations with many developers, appear to be the "questions of the day." Answering and understanding them will help make the process of game creation easier for all of us.

Understanding Sound

Video games are pure, unadulterated entertainment that stimulate many of our senses. The ability to provide quality sound happens to be one of the most recent technological advancements to game evolution. We've had graphics drawn with millions of colors and worthy artificial intelligence for many years, but decent audio implementation and playback systems have not caught up with our expectations until recently. With these new advancements, we are discovering the need to be skillful and in control of what the player hears and feels on an emotional level.

The games industry is experiencing what the film industry encountered when sound was first introduced into movies. Technology has advanced to the point where those simple "bleeps and bloops" have given way to the potential of 8- and 10-channel surround sound, full orchestral scores, Hollywood sound effects for every tiny thing, narration, celebrity character voices, and now multiplayer voice interaction—all competing for a player's attention. The aural experience has gotten literally insane!

Our goal is to use the music and sound to *enhance* the player's gaming encounter, not distract them. We want the players to enjoy the audio, not turn it off. We want them to become totally consumed by the sights and sounds of our hard work. We want them to tell their friends! Before that can happen, though, we must understand what sound can and cannot do for us.

The Psychology of Sound

There is a certain psychology associated with what we hear and what we experience. Throughout our lifetimes, on an individual basis, we have each encountered sound. Our reactions to it vary depending on the events associated with those sounds and the context in which those sounds are presented.

For instance, the sound of tires squealing can have a wide range of emotions attached to it. If I'm sitting at a stoplight and hear a tire screech close by, my first reaction is fear, an accelerated heart rate, and a quick look around to make sure I'm not about to be hit. Once I see it's a car of teenagers peeling out around a corner, my emotion turns to anger at their recklessness. But, as the light turns green and all alone at the intersection, I mash my foot on the accelerator and smile as the tires fight to grip the pavement, I feel exhilarated as I return to my younger years. The same sound, three different emotions.

Sound effects in games serve many functions. Primarily, they are a method of aural feedback that simulates what you would hear if you were actually in the game. If I shoot my weapon and it's not empty, it goes "bang" instead of "click."

If I hit something with it, it goes "thwack-oomph-thud." If I depress a button and it opens a door, it goes "click-kachunk-whoosh." Every direct action has a corresponding sound reaction.

Sound effects can lend believability to an otherwise unbelievable place. Ambience and general Foley sounds bring a scene to life and lend an air of realism. For example, a good driving game will use sounds of city life, wind, scenery ambience, animals, and even insects—all of which we have heard ourselves in our travels. We expect to hear them and are satisfied when we do, even on a subconscious level. These sounds don't have to be "in your face" to do the job; they just need to be there somewhere in the background.

Guttural satisfaction cannot be discounted either. Sound effects are also designed to entertain and wow the player. Hollywood goes with bigger-than-life sounds and games can too. After spending 5 minutes in a battle with the boss bad guy, you want to hear something to make the effort worthwhile. This little sonic reward can bring a smile to the player's face and keep them coming back for more.

Music has an equal effect on us as well. A fast tempo raises our heart rate; a slow tempo makes us relax. The choice of instrumentation, whether soothing or obnoxious will have an effect. Events associated with certain music can trigger flashbacks whether they are pleasant or not. Music can set the stage and place us in a different world, a different country, or a different time. Music can make you laugh, make you cry, make you aggressive, make you docile, make you feel love, or make you hate. It is a powerful force that when used properly, can bring an entirely new dimension to a gamer's experience.

Music is primarily designed to create a certain atmosphere or feeling for the player while in the game world. It can create a dark and mysterious world, adding tension and desperation to reinforce the seriousness of a situation. It can be silly and fun, clowning around to keep the mood light and upbeat. Music, like sound effects, can also add a sense of realism. Whether the scene takes the players to the Wild West or to India, the musical accompaniment helps put them within that setting. If it is done correctly, it will not only provide a hint to their location but serve another purpose: to give the game experience a pulse. Driving games usually have tracks throughout the world players can test their skill on. Most of these types of games will have an emotionally upbeat and fast tempo which keeps the game moving. Techno or rock serves this purpose well and by adding an instrument native to that particular locale, it provides an obvious regional flavor to the scene. Creating a rhythm, whether slow and thought-provoking or fast and out of control, can be done through the use of appropriate music.

By understanding the effect and exploiting the deep-rooted psychological aspects of music and sound, video games can be taken to the next level of believability and entertainment. It's not a difficult prospect, just one that requires some thought and proper planning. Remember the power, then be sure to turn it on.

Soundscapes

Chapter 12 discussed the concept of a soundscape in detail, but I want to reiterate the importance of this useful philosophy just in case this is the only chapter you dive into. Basically, the game soundscape is every element that makes sound: the music, the sound effects, and the narratives. It is the purposeful blend of these elements that form an organized presentation known as a "soundscape." Without this type of order, there is audio chaos.

As a developer, you must concern yourself with the overall balance of graphics, gameplay, and audio. Before you can do that in earnest, though, you must treat the audio features as a single entity—as the soundscape. Some developers have dedicated audio directors or producers whose sole function is the coordination of the project's sound. Others utilize a single person or audio company for the music and sound effects and rely on their expertise to harmonize the efforts. Both are steps in the right direction and I applaud those who are serious enough to pursue these routes.

The complexity and density of any music will first be determined by its purpose. If it serves as an opening sequence, a cinematic score, or menu screen music, it can be busier. If it is to play as background ambience, extra care should be taken to make the music simple—using less countermelodies and percussive elements. If the music serves its purpose, it won't compete with other audio.

Sound effects should normally take priority in the soundscape and not be buried in the music. Music with a lot of mid-frequency activity will encourage the design of sound effects that stick more to the high- or low-frequency ranges. If sounds are created with the music in mind, they can be designed to complement the sonic activity already in progress.

Narratives, or voice-overs, are primarily located in the middle of the frequency spectrum. Instruments such as piano, organ, guitar, and saxophone have dominance here, too. A concerted effort must be made to prevent a blazing guitar solo to play over important narration; a game-winning clue could be lost in the melee.

When the final audio pieces are assembled, take some time to ensure an equitable mix. The first instinct is to reduce volume levels of offending audio in order to hear those with priority. If there is time before the project deadline, resist that urge and look for other solutions instead. All it might take is an equalization adjustment to make the one stand out or to produce a gap in the spectrum. You want all of the audio to be heard clearly. Pulling a sound out of the mix is like casting it aside. Why was it created in the first place? All of the audio serves a purpose and it is extremely important that it be heard as intended.

Size versus Quality

Composers and sound designers will always create their audio product with excellence in mind. Music and sound effects are saved to digital files that can be quite large in order to preserve their sonic integrity and high quality. The typical standard is as follows:

- 44 kHz sample rate
- 16-bit resolution
- Two-channel stereo

Each minute of this format produces a file size of roughly 11 MB and an hour of this audio can almost completely consume the space on a CD, as an example, leaving little room for anything else. As a developer, the amount of storage space and processing speed available is of great concern. For all elements of a title to fit into a nice, tidy package, priorities are made and file sizes are economized.

In the end, only two aspects of a game have the ability to be resized to conserve valuable storage: graphics and audio. Smaller graphic files with fewer colors and pixels equal a grainy, unrealistic visual presentation. Graphic artists can balance

their artistic vision and file sizes by adjusting parameters to an acceptable conclusion. Sound artists face similar considerations.

To make a smaller sound file, the sound quality must be degraded in such a way that less information will be stored. We can do this by lowering the sample rate, the resolution, or the number of channels to a size which is more accommodating. While compression schemes such as .mp3 and .ogg are available which solve this dilemma somewhat, understanding what the reduction in file size does to the quality will help convey that neither compression nor sample rate/resolution reductions are without a cost.

The following table (from Chapter 7) is reprinted here for reference. When asked to reduce a file's size, I will first decide how important the stereo or surround image is. If converting to mono doesn't make an appreciable difference, I do this first—cutting the file size in half. Or, for slightly less audio quality but maintaining the stereo field I could reduce the sample rate to 22 kHz. Either way, the quality of the sound is less affected by a higher sample rate. Frequency degradation becomes obvious as sample rates are lowered and the sound quality starts to collapse. The very last choice I would consider would be a change in resolution. Sixteen-bit audio resolution is better than 8-bit, but it is also twice as large in size. Eight-bit resolution is prone to excess noise, and care should be taken to ensure the audio volume level is louder than any noise by-product associated with the loss of resolution.

Memory Storage Requirements for 1 Minute of Sound

Type	Mono	Mono	Mono	Stereo	Stereo	Stereo	Encoded Dolby Surround	Encoded Dolby Surround	Encoded Dolby Surround
Resolution	8-bit	16-bit	24-bit	8-bit	16-bit	24-bit	8-bit	16-bit	24-bit
Sample Rate (K)									
96 kHz	5626	11,251	17,280	11,251	22,501	34,560	11,251	22,501	34,560
48 kHz	2813	5750	8640	5626	11,520	17,280	5626	11,253	17,280
44.1 kHz	2646	5292	7938	5292	10,584	15,876	5292	10,584	15,876
22.05 kHz	1323	2646	3969	2646	5292	7938	2646	5292	7938
11.025 kHz	661.5	1323	1985	1323	2646	3969	1323	2646	3969
8 kHz	480	960	1440	960	1920	2880	960	1920	2880
4 kHz	240	480	720	480	960	1440	480	960	1440

Each year, the quality of video game music and sound effects gets closer and closer to that of movies. As the sound quality increases, so does its file size and the trade-off between size and quality must be debated.

Always specify that you want your sound effects originally created in the highest quality possible.

Because new technology has become more mainstream, some development teams may soon opt to go even higher—to 96 kHz, 24-bit audio. Why? Because you want to develop the sounds in the highest fidelity and then convert down to what is needed for the game. If a game needs 44 kHz, 16-bit, stereo audio and it is discovered later that it can fit 48 kHz, 24-bit, stereo, it may already be too late for the content provider. Converting up won't change the sound quality at all and nothing is gained except a larger file size. The entire recording process would have to start again from scratch.

DARRYL DUNCAN
Composer, Sound designer, President—GameBeat Studios

Darryl is an accomplished veteran songwriter and producer who has been involved in the music industry professionally since 1980. Darryl began composing original songs when he was 14 years old. His songs began to gain considerable recognition in Hollywood leading to his first big break when he received a major music publishing contract from A&M records in 1986. He then went on to sign with Warner Brothers Music in 1991. Darryl has written and/or produced music for artists such as Jeffrey Osborne, Michael Jackson, Chaka Khan, Earth, Wind & Fire, and R. Kelly to name a few. Darryl was also himself a solo artist on Motown in 1987. He had several charting singles and a #1 record to his credit. His music has also been featured in major motion pictures.

Today, Darryl is the Founder, President, and CEO of GameBeat Studios, LLC. GameBeat is an established provider of original music production and sound design services for the commercial advertising, gaming, and digital media industries. GameBeat, known for their unique versatility and creativity, has been responsible for the music and/or sound effects in some of the gaming industry's biggest selling titles, including *John Madden Football*, *Dance Dance Revolutions*, and *Microsoft's Zoo Tycoon*. Today, GameBeat's clients are primarily in the advertising industry. Their portfolio includes TV and radio commercials for McDonald's, Wal-Mart, Charmin, Motorola, Burger King, Altoids, Toyota, Sears, The Illinois State Lottery and others. GameBeat has won numerous advertising industry awards for their work including eight Telly awards, three Addy awards, and two Millennium awards.

http://gamebeatstudios.com

Describe your thought process for creating music and/or sound effects.

My thought process musically is a little unorthodox in that as soon as I receive interest in my services, and even before I sign a contract for those services, based on what they initially tell me their needs are, I hear the entire score, track, or piece of music in my head often while I am still on the phone with the prospective client.

Throughout my career, this is how I have always created music or sound effects for various advertising or gaming projects. I will almost immediately hear the full piece of music, rhythm, melody, key, instrumentation, arrangement, and even most of the lyrics in my head instantly. Then it is just a matter of me getting into my studio to hash out the music or sound effect and record what I hear in such detail in my head.

Are there any particular secrets to your creativity?

I don't know if you call it a secret, but I don't have the best memory and I use what I call my "lick saver" which is nothing more than a digital recorder, it could be an app on my iPhone or iPad, but I always keep some type of digital recorder handy because when musical inspiration hits me, if I don't record what I hear in my head it will disappear as quickly as it came. So often I am able to use this recorder to hum the parts, beats, melodies or lyrics, or whatever it is I am hearing in my head. Because so often it is full arrangements and complete music I hear in my head, my "lick saver" sessions are very frantic and I find myself needing immediate silence, because if I hear another piece of music while I am trying to record my quick ideas down, I often lose it all. So I am not sure if this is a secret because I am sure many composers probably do this, but this is one of the methods I use to make sure I capture all of the music and audio ideas swirling around in my head.

Do you have any interesting sound gathering/sound creation stories?

In fact I do. When I was creating the sound effects for Microsoft's Zoo Tycoon game, the expansion pack to that game was called *Dinosaur Digs*. And of course it was the zoo simulation game with a variety of dinosaurs. Of course we only know what dinosaurs sound like based on various Hollywood movies, but in this game there were 17 different dinosaurs and while we all know what Hollywood considered a T-Rex or a pterodactyl bird to sound like, we have no reference for many of the less popular dinosaurs. So with this in mind, it was my job to create sound for creatures that were not very popular species of dinosaurs. This clean slate approach was fun because it gave me the flexibility to do whatever I wanted in the creation of these sounds. Who would or could dispute what these creatures actually sounded like.

So with that in mind, I went to work mixing the most basic and elemental vocalization of present day animals with that of other present day animals and blending, mixing, and morphing them in a variety of ways to create the one of a kind sounds of some of the more obscure dinosaurs from the game. A good example of that was, I took the trumpeting of a typical elephant and the deep growling of a dog I recorded from a local kennel and mixed them together and pitched this blend down substantially to create the guttural growl of one of the game's dinosaurs. Another example was the need for a new prehistoric bird sound. I decided to mix the scream of a Monkey and the chirp of a parakeet, once again mixing them together and pitching them down resulted in the ideal prehistoric bird and was quite an ominous intimidating sounding creature.

Do you have any advice which can help lay solid groundwork and ensure a successful production for the audio content creator?

Well like almost any creative field, extensive and careful preplanning is a must. If we are talking about sound design work or music production, it is important to establish and maintain a very clear and direct line of communication between yourself as the audio content creator and the producers or production leads with the developers you are working with. You have to create and finalize a very detail and error proof sound list, provide for alternates, recuts,

revisions, etc. You should also definitely have a very good working knowledge of Microsoft Excel as it is a very valuable tool when working with large sound design or voice-over/dialog projects.

Musically, it is important to be on the same page creatively with the developers' visions for the projects music. I ALWAYS ask for reference music files from the developers so that I know what they are hearing for the project and I can immediately be in the same creative ballpark musically. So often communication fails when we use only words to describe a musical direction, it is important in my opinion to have reference tracks so that both parties can agree that this is the general direction when want the music to go.

Most new or aspiring game composers and sound designers fail to understand just how much paperwork is actually involved in successful audio content creation. Start it early, make sure it is detailed extensively, and cross-check it with your development team regularly and you will be on the right track.

When do you find you are most creative?

I am definitely most creative in the evening hours and even very late night hours. Being a night owl and not a morning person, I am in my studio well into the evening hours taking frequent breaks. I have been known to regularly work well into the 2 to 3 a.m. hour. For me that is when the magic happens.

Any worthwhile creative advice you'd like to share?

I think the advice I often like to share with sound designers and music producers alike is this. We all at times find ourselves working on a project and we just don't like the way it sounds, is progressing, or feels and we are often inclined to just "trash" that particular direction and start over from scratch. But I have a technique I use that is not new to many but really works well—simply stop and take a break. If your project deadline allows, make that break at least a full 24 hours, 2–3 days work even better. Keep in mind, when we work on a piece of music, it's all we hear for several days straight and the mind and ear can become extremely fatigued without you even knowing it and the music will begin to sound strange, odd, or stale to you. Even though you were not feeling things when you last left off, you will be surprised by how new and fresh that same music or sound design work will feel to you when you give your ears and your creative mind a good long rest. The longer the better. I have come back to a piece of work 2–3 days later and it felt so new, fresh, and different that I hardly recognized it and I am then able to approach it with a new creative mindset. I realize that tight deadlines will make it impossible to stop for 24 hours, and if that is the case, even giving yourself and hour or two from the project can really help. This practice has saved me from abandoning a particular creative direction many times and I ended up with a final piece that I was quite happy with and very proud of.

Is there a typical workday for you?

My workday is not very complicated. Being a night owl, often working later into the night, I generally don't start my "typical" day until as late as 10 a.m. at times. Once I get to the studio I find myself first replying to e-mails and making business calls. Being a one man operation for the most part, I have to juggle multiple hats in running my business. The biggest challenge I have is balancing actually being creating by making music or sound effects and actually working the phones and taking meetings searching for new clients and projects. I am confident that this balancing act will improve and be much more fruitful as I just recently hired an

agent to represent me to game developers and ad agencies and to focus on the new business part of things.

After about 2 hours of "administrative things" I get to working on whatever projects I may have on my plate at the time. So, I am usually turning up the volume by noon or so. I don't generally eat breakfast (I know that's bad, but I am just not hungry), so most of the time I have a very late lunch, around 2 or 3 o'clock. I typically take another "administrative" break to make and/or return phone calls and then I am back to work making music by 5:30 or 6:00 p.m. If I am not crunching to meet a deadline I may call it a day around 8:00. If I do have a pressing deadline to meet, I have been known to work well into the morning like around 1 or 2 a.m. Those times when I don't have any client projects to work on, I am excited to get to work on writing R&B and Pop music just for fun. Since songwriting is my true passion, sometimes I enjoy not having a pressing client project on my plate so that I can do what I do best and enjoy most, write songs!

What skills should composers have to succeed in the games industry?

This is a very simple answer but one that most aspiring game composers seem to overlook. Outside of the obvious, which is being good at what you do, I firmly believe that you must also be highly versatile in the styles and genres that you are able to compose and produce. Because different games can incorporate just about every style of music there is, you have to be able to convincingly compose any style that a developer asks of you. Depending on the type of game it is, the music almost always requires the complete musical palate emotionally, so you may need to compose something very orchestral and dramatic in style and then need to create something in a hard edge dubstep style of a serene ambient style. So that styles you may be called upon to create will most likely be very different from each other, even styles that may not be your personal favorites.

Developers often prefer to deal with two to three composers for a particular game, but the more diverse a game is musically, the more composers game developers need to seek out and deal with. Sure all composers have a specialty genre or a preferred style, but showing a high level of versatility works in your favor. It will be a feather in your cap if you can tell a client that you are fully capable in creating music in all or most of the styles they need. This not only makes the developer comfortable in that they won't have to deal with many different composers, but it also assures that you are able to make more money on the project since you are providing more of the music.

Do you have a specific ideology which drives your way of doing business?

My ideology is very simple. At all times, I do my best to assure potential clients that I am highly skilled at what I do. I make sure they are fully aware of my music industry background, my past project credits, the awards I have won, and my overall experience in the industry. The more comfortable you can make a potential client feel that you are the man for the job, the better your chances of winning that job. A game developer almost always seeks the bids of multiple composers or sound designers before deciding on who to go with, so know that there is always stiff competition you will be up against when trying to win a particular project. It is very important that there are no mysteries or secrets as to what makes you most capable and qualified for the job. It's OK to brag a bit (in moderation) about what you have done, how authentic and powerful your music is, past projects, etc. Often, game composers that are very new to the field are trying to win major project, in these cases you will not always have a track record or credits list to rely on. In cases like these, make sure that your music speaks for itself,

because as a new composer trying to break in, it is often all you have to convince a developer that you are right for the project. It is sometimes very hard to get the sound design part of a project as a new sound designer because it is difficult to present a compelling sound effects demo; however, it is much easier to convince a developer that as a composer you can do the job based on your existing catalog of music tracks.

It is also very important to know that even major developers enjoy saving money on their project whenever possible. As a new composer/sound designer hungry to break-in to the industry, it is sometimes in your best interest to offer your services at a fraction of the going rate and, yes, even sometimes for free so you can develop a solid working relationship with that developer, but most importantly, to also gain an industry credit on a game title. Definitely seek out independent and low budget game projects, because while these certainly will not pay much, they will be solid and important credits to add to your portfolio. This is very important because while you may not have made much if any money on a project, you can use that credit when soliciting your services to the next game developer inquiring about your talents. Credits are extremely important and the more you have the more impressed a potential client will be, thus improving your chances of winning a new contract. So, remain versatile, get on as many projects as you can and know when to charge a little, a lot, or nothing!

Any good business advice to offer?

Yes, simply know how to do business from an administrative perspective. Often we spend so much time perfecting our craft, which is good, but many often overlook the importance of knowing how to conduct business. Know how to write a good business letter, a good and properly worded e-mail. Know how to and when to make follow-up calls or send faxes. Know how to speak articulately when communicating with developers. All businesses, no matter what type they are, recognize and appreciate when they are doing business with someone competent and knowledgeable in basic business practices and methods. Don't just be "John Doe" composer, but give your company name, create letterhead, business cards, and a Web presence. The more professional, organized, capable, and competent you are from a business standpoint, the more impressive you will be to potential clients. You should always remember, it is much more to being a successful game composer than just the music, a business mind should be behind all you do.

Any horror stories which have impacted how you do business?

Well, in my early years as a sound designer/composer, I failed to take seriously the importance of file redundancy—BACKING UP DATA! I did about 3 weeks' worth of work on a sound design project and unfortunately 2 days before the project was to be delivered, the hard drive where these audio assets were completely failed and were unrecoverable. Not only did I lose all the data, I also lost that clients business. Since then, I stand by the old adage in the computer industry that says: "If your data doesn't exist in three different places, it doesn't exist at all." So definitely spend the money for data backup solutions and backup regularly and religiously!

How do you approach negotiations with a new client?

This is a very tough one because I have found it to be an issue not only in my gaming projects but also in my commercial advertising work. Know that it is the job of the client to save as much money as possible, there are simply no rules in the gaming or advertising industry that say how much a project should pay or is worth, so it pretty much comes down to what is agreed upon. These negotiations can often feel like buying a car (which I loathe), but know that their

job is often to secure your services for as little as possible, while your job is not to get the job for as much as possible, but to at least be compensated fairly for the work and time you will put in.

It is a very delicate balancing act between pricing your services so low that you don't make any money in contrast to the time you will spend on the project and on the other end you can price yourself so high that you give the potential client sticker shock that you scare them away. This will assure that you have little longevity in the gaming industry. I am personally from the school of thought that ideally, I prefer to price my services as average to on the low side of average. Yes I know, who knows what is "average" for a given project? But there are some things that will help you determine how much you should charge. Some of these include who is the developer, publisher, what is the game franchise, game platform, and a few other factors play an important role in determining what the idea price should be for your services. You will have to weigh this all out. In my opinion, it is better to be a bit too low than too high. Because being too high you will not only lose that project, but it is like you they will never even be called again to bid thinking you will be too high. Being on the low side of average helps in a few ways, it helps them know that you are flexible, affordable, and it assures that whether you win this project or not, you will at least get called again to bid on their next project because they know your rates are reasonable.

Success as a game composer/sound designer is all about repeat business. So if you are relatively low the first time, you do business with a particular client, but the work you do for them blows them away, then you can feel comfortable charging them a bit more the next time, because you know they are already familiar with your work and are comfortable doing business with you, so that slight increase in your rates will not spook them. Start relatively low, do great work, and increase your rates slightly on the next project and over time (with a limit) as the relationship evolves and develops.

What advice can you give when working with a developer to ensure you are able to make great sounds?

I touched upon this earlier, but a very open and frequent line of communication is a must. Make sure the developer hears work in progress so that you don't get to the end of a project and have a large part of the audio rejected by the developer. It is important to make sure that you are on the same page creatively with the developer every step of the way.

Have you ever had any development issues negatively influence your workflow?

The only issues that may have negatively affected my workflow and this is probably every experienced sound designers nightmare would be when a developer seems to constantly be changing the specs of what they want or adding to the sound spec at the last minute and seemingly never satisfied. That is why when it comes to sound design we ALWAYS create multiple versions of a particular sound effect. So, if a single sound for a particular action is needed, we make sure we create three to five versions of that same sound, each being very different from the other. That way when a client is not happy with the original version we created, we have back up. Alternately, even when they are satisfied with the first submission of a particular sound, we still give them all the version created as simple "bonus" sounds they can use. This always makes them happy.

Do you have any advice to ensure successful audio implementation?

This is an excellent question, because ultimately the best and most realistic sound effects in a game in my opinion is when the sound designer is directly involved in the actual

implementation of those sounds into the game. That is why on major projects I often offer, as a part of my contract, one or two visits to the developers' actual locations to assist in the implementation of sound into the game. Even if it is a cross country flight to get to the developers' studios, it is important that any game my name is connected to sounds as good as possible and this is more likely to happen if you are involved at every step including actually implementation of the sounds.

Most of the guys who actually do the implementation are programmers, code guys and these guys are not generally the most creative types in the game developers' food chain. Sure they are brilliant at what they do, but it has been my experience that when it comes time for them to implement the sounds into the game, their approach is strictly technical and getting the sound into the game is where it ends for them. Ideally, it is the sound designer who really should be present to assist in the blending, mix levels and FX levels, etc. as those sounds are actually implemented. This is primarily because they are the ones who know exactly how they intended for these sounds to coexist with each other. This is often less of an issue if the developer is working with a specific proprietary audio dev kit where the mixing, tuning, and effects and such are also handled by the sound designer in that audio tool software, but even in those cases, a close collaboration with the implementing programmers is crucial to achieving the ideal audio atmosphere in the final product.

Staying organized is important, especially if you are working on multiple projects, which is part of your daily routine. How do you keep up with it?

I think I am pretty extreme when it comes to project organization. I don't believe there is any trick to organization other than to simply organize yourself. There are times when you are working on two to three projects at a time and one or two of them may have tight deadlines. So staying organized is a must. I typically like to do everything in folders, both on the computer and actual physical folders. Everything for a specific project goes into those physical folders, and I mean everything including sound lists, storyboards, artwork, graphics, handwritten notes, and important e-mails that were printed out. Absolutely everything will go into this folder. This makes it much easier before, during, and after a project is complete because I know that if it is related to this project and can be held in my hands, it will be kept in this folder.

The same of course goes for every digital file for a particular project inside the computer. My actual audio session folder will not be inside this folder only because it exists on a separate dedicated audio drive for ProTools, but everything else goes here. Including an "alias" to that ProTools session file so I can even open that projects' recording session from this project folder.

My folder structure typically looks like this:

Clients Folder
- Acme Game Developer
 - Game Project A (game title)
 - Game Project B
 - Contract, paperwork correspondence
 - Storyboards and artwork
 - Sound FX list
 - Music cue list

- Rough music mixes and SFX elements
- Final music deliveries
- Final sound FX deliveries
- Misc

There are many pitfalls when "working" in the game industry. Have you had any bad experiences?

I think the best lesson to learn in this industry is that the competition is fierce. You must be prepared for rejection at every turn as there are literally hundreds of studios after the same small pool of available work that you are. I think my biggest struggle has been actually finding the work. Many things have changed in the industry in the last several years especially with sports games which now primarily rely on simply licensing the music of established major label acts instead of needing original music from music houses. But there are still many developers and game franchises that depend of original music in a variety of styles. Just remember to have a powerful, versatile demo reel so that you can stand out among the many that will surely be after the same contacts you are.

How did you find your way into the games industry?

After spending most of my career in the mainstream music industry as a staff songwriter and producer for A&M and Warner Brothers records, I made a conscience decision to leave it. I was looking for something where I did not have to depend on a "hit record" to make ends meet. For me, that was the gaming industry. I was always a hardcore gamer so I decided to promote myself as a game composer and sound designer. Of course, I could compose music but I really had no experience at all creating sound effects. So I decided to teach myself the art of sound design. I ultimately created a sound effects reel to accompany my music demo and promoted myself to various game developers. After job hunting for about 6 months, I finally had three solid game industry job offers.

One of these offers was to stay right in the Chicago area and work for a Schaumburg, Illinois–based company called TerraGlyph Interactive. The second offer was from a Random House company called Living Books in the California Bay area. The third offer was to work for an Electronic Arts developer called Tiburon in Orlando, Florida. They were the developers of the extremely popular John Madden football video game and wanted me to be their in-house audio guy to come in and start their nonexistent audio department. As I job searched for those 6 months, guess how I spent my free time? That's right, playing John Madden football on my Genesis, so the choice for me was a no-brainers. I moved my family (a wife and twin 1-year-olds) to Orlando, Florida.

I remained with Tiburon for 3 years after which I left to start my own company GameBeat Studios. Fortunately for me, Electronic Arts headquarters in Redwood City, CA, decided that they wanted to hire me directly to continue to work on the Madden franchise. This was a true blessing because it gave my new company a major credit out of the gate. This credit helped me a great deal to secure new clients and contracts.

Any other advice you'd like to share?

The biggest piece of advice I can offer those aspiring to create game audio for a living is to be damn good at what you do. Average and mediocre no longer makes it in my opinion. You must perfect your craft and be one of the best out there at what you do.

One company decided to do a television commercial for its game and wanted to use original effects. They contacted the sound designer who worked on the project and requested their sounds in 44 kHz, 16-bit, stereo. Unfortunately, he didn't have them at that sample rate and proceeded to spend a few sleepless nights recreating them. It would have been just a few minutes of work had they already been available, instead of having created them originally in the final requested sample rate and resolution of 22 kHz, 16-bit. These days, computer storage space is inexpensive and larger file sizes aren't a burden. Encourage your contractor to use the highest quality, for the game's sake *and* for future possibilities.

This quality-versus-size issue basically comes down to a final trade-off: what quality of sound is acceptable for its affected file size. Be sure to discuss with your sound crew what they recommend, if there is a choice involved. Their expertise and quest for high standards are a perfect source for advice. Sometimes (especially with Java and Flash games), 8 kHz, 8-bit, mono files are about all you are going to get—and you'll just have to make the most of them. There won't be any options. But, overall, the higher the sample rate and resolution, the better the sound quality—and this is what we should all be pushing for.

Working with Contractors

The process of determining the appropriate audio content, creating it, and then implementing it isn't always a painless experience. Game producers and contractors alike need to understand each other's professional needs and responsibilities so that the audio creation process becomes less grueling for both. This section describes the process of determining what you will need from a third-party audio provider and what that person will need from you.

Early concepts of art and gameplay have a tendency to change and continuously evolve, so music and sound design at the outset of a project isn't really an efficient use of time. Producers have the difficult task of trying to determine the audio needs of the game early in the development cycle, and if a contracted sound person is used, the producer must find someone whose skills and credits match those of the game being developed and negotiate a contract. When you are spending $30,000 for sound effects or $75,000 for music, for example, you want to get your money's worth.

Take a long-range look at what sort of sounds the game may need, such as general Foley sounds, imaginative or "far-out" sound effects, music, and narratives. Specify whether or not your game will have a wide range of settings and characters. It's important to bring the development team together to begin thinking at least conceptually about the game audio as early as possible. If you've decided on a composer and/or sound designer, bring them in on the discussions and listen to what their experience has to say. Much time can be saved and the process will have more grease for a smooth ride. Don't be tempted to wait on the audio implementation details until later. However, as mentioned in Chapter 9, starting work on the actual game audio too early in the process often leads to major headaches down the line.

When a game is far enough along (for example, at the point when characters, their movements, and a defined gameplay model are present), the composer and sound designer should enter the picture. By allowing them to meet with the development team, view some rough game levels and perhaps see some rough animations, their idea machine will begin to churn out possible routes to take. A few specific questions will bring direction and needed information together to start off smartly.

Original sound creation can involve some serious logistical challenges. Watson Wu had to procure a seaplane for a recent recording session in southern Florida. (Courtesy of Watson Wu.)

Reconnaissance and Homework

The actual task of finding a third-party contractor can be as arduous as creating the game itself. Unless you've worked with a particular audio team in the past and are comfortable using them again, you'll need to take care of some advance work. This type of investigation can be done painlessly if done during downtime or between projects and not at the last minute.

Even before the project is put out for bid, the media buyer can do his homework. Investigating various audio companies and individuals beforehand is a good idea to help stay ahead of the game. Web search engines can help, developer resource websites are prevalent, and the numerous unsolicited e-mails, inquiries, and resumes can be (finally) taken advantage of. Because everybody knows everyone in the games business, you could also touch base with your counterparts at other game companies and find out who they use or recommend. Word of mouth and networking are powerful resources, so be sure to use them to their fullest. I've gotten most of my jobs that way. Request a current demo reel, references, and past work examples and retain them on file until the time comes.

As of publication, the websites that follow in the table "Selected Web Links to Investigate for Gaming Project Help" were available for industry-wide talent (not

Selected Web Links to Investigate for Gaming Project Help

Gamasutra.com	www.gamasutra.com
Game Audio Forum	www.gameaudioforum.com (specifically, the "job opportunities" section)
Game Audio Network Guild	www.audiogang.org
GameDev.Net	www.gamedev.net/classifieds
Indeed	www.indeed.com (post a job opening and watch them come to you!)
Google	www.google.com (search "video game" composer or sound designer)
LinkedIn	www.linkedin.com (search for video game composers or sound designers)

just sound artists but programmers and graphic artists)—many also serving as general development resources.

When that time does come, the producer alone (or with several of the team members) should sit down to evaluate the submissions. Generally, you are looking for

- Great work
- Creativity
- A shared vision
- Reliability
- Experience
- Someone who you feel can work with the team for the length of the project

After the field has been narrowed to a couple of choices, pick up the phone or invite them over. It's a good idea to actually *talk* to the candidates. Check their production schedules (some busier sound guys are booked 2–3 months in advance), ensure they will be available, see which one you feel is best at communicating and receiving ideas, and who you can get along with. A gut feeling will tell you the one who is right for the job.

So, now we've moved from the courting stage of our business relationship to engagement and the possible commitment of marriage. Both parties bring their interests (and sometimes lawyers) to the table and work out an agreement both feel comfortable with. Overall, negotiations for sound design are fairly simple. More complicated negotiations come up when music creation is involved, such as hashing out ancillary rights, payment for different SKUs, bonuses, property rights for soundtrack releases, and so on. Spend a little time working out an equitable agreement. That is, get the business out of the way so you can focus on the creative aspects of making a great game.

The key contract point is the cost the developer will incur for the audio services. Price varies per contractor, each has a different overhead to meet and costs that need to be covered. Some, with more experience, can demand more—which will definitely be worth the price for the maturity, experience, and hassle-free production. Other factors can increase the price too, such as

- Rush jobs
- Special requests
- Processing prerecorded narration
- Auditioning, hiring, and producing voice talent
- Abnormal amounts of revisions or change orders

So, do your best to plan ahead. When it comes to the bottom line, the final costs are, of course, negotiable—but don't expect the contractor to work for free or below their expenses. It costs money to be in business and we want to support those who work hard for our cause.

Questions Composers and Sound Designers Will Ask

When a developer has made the final contract negotiations and the documents are signed, the other details regarding the project are released to the audio provider. This is the point where "clear and concise" can mean the difference between complete audio bliss and a sound disaster. Words have a way of meaning different things

to different people and the sound guy will ask for the specifics in order to make it crystal clear to them. (For more information, see "Asking the Right Questions" in Chapter 5 and "Meetings with the Game Development Team" in Chapter 7.)

What is the intended genre for the game?

You want the music and sound effects to follow the spirit of the game. Make sure you give your sound contractor a feel of what the game is about, what genre it falls into, and what similar games are available.

What sample rate, resolution, number of channels, and file format is desired?

The development team will have done all of its math to determine how much space and processing power will be allotted for graphics and sound. This will help decide how high the sound quality can be and what parameters the audio will be created within.

Will sound effects be altered by any software or hardware processors?

Driving games are one example where the reverb effect is used quite frequently in tunnels, caves, and in cityscapes. This is the kind of information the sound designer needs to know. Additional processing by a game engine will determine to what extent certain sounds are processed beforehand by the sound designer. (If a sound designer applies reverb to a sound the developer had planned on applying reverb to in the game, that could be a problem.) Decide as soon as possible if there are plans for this type of processing and communicate them. That way, the sound designer is sure to not overprocess any files. Music is normally left untreated, but be sure to let the composer know if their music will change in any way.

Are any ambient sounds or music tracks needed?

We don't want to have the player distracted by silence. This question may jog memories or give you ideas not thought of previously. If you intend for music to play instead of ambient sounds, communicate it. This will prevent a phone call late in the production cycle for forgotten sound.

Will certain audio have priority during playback?

There can be instances during gameplay when one single sound or musical cue punctuates the moment. All other sounds become irrelevant and this one bit of audio takes priority. Because other sounds won't be drowning them out or playing over them, you won't have to make considerations for other effects or music being heard at the same time. By pointing to them, the sound designer or composer will know which ones to really make shine.

Will there be any voice-overs or speech commands that need to be heard?

A composer or sound designer can also be involved with processing speech via EQ or volume to ensure they can be heard and understood. This is a similar process to having the vocals stand out in a song mix. It will also give the audio contractor indications if room is needed in the soundscape for speech and they can leave frequency holes for them to be better heard.

Tools of the Trade

CHRISTOS PANAYIDES
Sound recordist, Sound designer, Voice-over artist

My Cyprus-based studio is equipped with a selection of microphones and sound processors with the ultimate goal of creating high-quality sound. The studio is heavily soundproofed which allows me to record from the slightest sounds to those with much intensity.

My philosophy: It's not the equipment but the man who uses it!

Computers: Win7 i5, 8 GB RAM, 3 × 500 GB internal hard drive, 5 × 500 GB portable hard drive, 2 × 1 TB portable hard drive

Audio interface: M-Audio Audiophile 192, Realtek HD

Software: Sound Forge 10 pro, Adobe Audition 3.0, Audacity, Acid Pro, Sony Vegas 11 Pro

Monitors: Alesis M1Active 520USB, Sony, Tannoy, Yamaha NS10

Effects plug-ins: Waves plug-ins, Izotope, Sonalksis

Microphones: Rode NT1-A, 2 × Rode NTG-2, Neumann TLM 103, Neumann U87, AT 2020, MXL900, MXLV67i dual capsule, MXL 550/551 (Thanks to my friend, Aaron for this Xmas gift!), Behringer B-1, Behringer B-2, SE 2200a, Behringer C-2, AudioTechnica Lav AT 803B

Remote recording gear: Tascam HD-P2, Zoom H2, Reinhardt.tv Soft ZepII, Rycote, Rode Boom, Ultrasone pro 650 headphones, Sennheiser HD 202, Sennheiser HD 201, Beyer DT 100, Portable Vocal Booth

Other relevant equipment: Tascam DP 01FX, Behringer UB802

Many audio contractors can also handle dialog needs including auditioning, hiring, and recording actors—even celebrities. Ian McNeice (*The Black Dahlia, The Hitchhiker's Guide to the Galaxy, White Noise, Bridget Jones' Diary,* and *Around the World in 80 Days,* to list a few) is one of the many Hollywood actors available for voice work. Ian is seen here recording for the game *I, of the Enemy.*

Are any narratives needed? Will there be background sounds or music to accompany narration?

Narratives fit into the sound recording category and generally anyone capable of music and sound design can also record narration. If you already have narratives recorded, the sound artist can often provide the service of editing, maximizing the sound, and adding any additional background or Foley sounds. If narratives are to be recorded, they would need to know if they will be providing the voice talent or not and budget accordingly. A good question to ask your prospective sound artist is if they have any experience directing narrative sessions. Or make it clear the games producer or another designee will fill that role.

Any special sound considerations?

Is the game intended to be a trendsetting title with surround, copious use of adaptive audio, and beyond studio-quality sound? Are you planning to advertise the game's cinema-quality sound?

What platform are they creating audio for?

This information will suggest what type of playback system the consumer will likely use. This indicates the confines for the final music and sound effects. As sound people, our interest is to make submissions work well with all audio systems—from dime-store speakers to high-end studio monitors—but the main focus is on the system the majority of players will be using.

What type of music, if any, will play as the sounds are triggered?

This would give the sound designer an indication of what other sonic activity will be happening during gameplay. If the music intends to be a soft orchestral

score, the sound effects can be geared to that mood and not sound obtrusive. If a rock soundtrack is to play, harsher sounds and careful manipulation of an effect's higher and lower frequencies will ensure these stand out. The sounds should all work together to enhance gameplay and not fight for attention. The composer could also leave room in the frequency spectrum for certain sound effects if they know about them ahead of time.

Are any sound resources available to the composer or sound designer for licensed materials?

Some games are based on film or television properties produced under licensing agreements. If you have secured use of the *actual* sounds or music from these works, do the composer and sound designer have them at their disposal to manipulate for the game or are they expected to recreate them? While the sound designers may not have an actual hand in creating any sound effects originally, they are equipped to convert them to the proper formats and sample rates, synchronize them to animations and cinematics, and edit appropriately and need to know if this service is desired, too.

Are any special file-naming conventions required for final delivery of audio?

If the development team is organized, or if they waited until late in production to bring an audio provider on board, they may already have file names embedded into the code. While renaming files is not a big deal, it may help cut down on any confusion when delivery is made if they are already named appropriately.

Getting to Work

The contractor has been hired, the previous questions have all been answered, and we are off to a good start. This is a good point for you to assign the one or two individuals to act as the liaison to the composer and/or sound designer—someone responsible for communicating specs, signing off on the work, and so on. This will prevent mixed signals, ensuring clear and effective communication—*the* key to obtaining sounds that match your vision.

This is the point where the audio creation process begins in earnest. If it is a locally based contractor, have them stop by, meet the rest of the creation team, and discuss the game's intentions. If they are unavailable for a visit, consider sending copies of artwork, storyboards, and any story text that may have been written. If there are any animation ideas, movie promos, or even a rough version of the game available, send those along, too. Now is not the time to keep secrets. The contractor has signed an NDA, so there should be no fear. They are part of the team and on your side.

Working with Sound Designers

There are several ways sound effects needs are conveyed to the sound designer. A sound asset list could be delivered, specifying a description of the sound, what it is used for in the game, and the requested duration. I usually refer to this as a "wish list" because often enough it never gets totally fulfilled. Numerous changes in the game see to that and what initially seems like a good idea at the time becomes something different later on. For more information, see "Sound Effects Lists" in Chapter 9.

Providing the audio provider with a working copy of the game will allow them to not only get a feel for the experience but be able to create better audio for it! Mark Temple, president of Enemy Technology, insists on providing his contractors with as much information about the project as possible. His game, *I, of the Enemy*, is shown here.

An alpha or beta version of the game can be delivered with placeholder sound effects already in place. General library sounds or effects taken from other games can be inserted, giving life to soundless artwork and to show the sound designer where new effects are needed. Other placeholders can be words instead of sounds, such as *click, explode*, and *shot*. As the designer plays the game, they create a sound to match the action.

For a better idea of what it takes for a sound designer to craft audio, see the example in the section "Effective Creation" of Chapter 9.

Working with Composers

A developer can convey music needs to a composer in a manner much like you do for a sound designer. A list of requested music can be made, highlighting specific details such as the length of each cue, whether it needs to loop continuously, and in what format it should be delivered. Or you can forward a beta copy or video file of the game and leave it up to the composer completely. A list is generally the best approach, but be sure to leave the door open to other suggestions from the music professional just in case.

A composer will need to have plenty of details and care should be taken that your vision is conveyed. I don't recommend telling them exactly what to play and how to play it. Unless your musical background is substantial, this will not guarantee their best work. But, if you point them in the right direction and trust their expertise and musical judgment, the results will be dramatic.

Timelines and milestones in a development project can be critical. Resist the temptation to procrastinate and don't wait until the last minute to bring a composer on scene. For truly inspired performances, musicians and composers need time to let ideas surface. If your game is something special and can benefit from

a brilliant score, use your time wisely and share schedules and expectations with the artisan. Professional music people are not prima donnas—they just need room to let the music grow. Capitalize on this phenomenon and make your game great.

To learn more about the game composer's world, also see Chapter 8.

Music Creation Example

When a composer receives the call for music, the developer, without even knowing it, has set a massive creative wheel in motion. Music in our culture is taken for granted and most do not understand the often monumental effort it takes to create something great out of thin air. When all you hear is the end result, it is easy to discount the behind-the-scenes effort.

This example will illustrate what a composer goes through when creating a short musical piece for a game. This particular one is a music cue from a previous PlayStation 2 project. The developer requested a 30-second loopable cue to be delivered as a .*mid* file and a 2 MB sound bank of instrumentation which would be triggered by the .*mid* file. The game was of the sports genre and this music was for the main menu screen.

Before any music was composed, time was spent viewing video of actual gameplay, the menu screen itself, and a video of the actual live event which the game was emulating. I took copious notes of initial thoughts, ideas for instrumentation, and direction of the piece. I listened to audio examples of licensed music that would also appear in the game and additional ideas the audio director had in mind. After a few hours of concentration, I put everything aside until the next day. The intention was to let my mind process the information and to form ideas that I could pursue later, during the composition phase.

The next morning, I began the task of assembling instrumentation and other sounds which would form my basic "sound palette." We had decided on a dance theme with piano and organ as the primary instruments—and I started with those, along with a bass sound, a synthesizer, a pad, and percussions. After spending hours sifting through sample and keyboard libraries, I narrowed the choices to 10 patches and two to three possibilities for each drum sound. I initially started with seven- to eight-note samples of each instrument, enough to cover most of the keyboard range, with the further intent of discarding those that didn't get used. I didn't want to limit myself and this gave plenty of options if I decided to play an instrument higher or lower than its normal range. I also chose drum and percussion sounds that would blend well with the musical style and the other instruments. At the end of this process, I felt confident there were plenty of sounds to work with and began the next step.

With only 2 MB of space available for the sound bank, I had to make tough decisions early on that would affect the musical output. Composers don't normally work well within tiny restraints and I was attempting to make it as painless as possible. How long should the percussion sounds ring? How much sustain should the keyboard instruments have? The idea was to make the sounds as short as possible without using loop points, but long enough so the instrument wouldn't fade too quickly. I chose to work with each sample and estimate the music needs, making each sample slightly longer than I would probably need. After composing, I planned to come back and re-edit the samples to save space and figured it easier to shorten them later rather than to make them longer.

Each sample was imported into an audio editing program; in this case, Sound Forge. One by one, I adjusted each sample to maximize the file. Samples from the

BRADLEY MEYER

Audio Director (Sucker Punch Productions)

The Rev. Dr. Bradley D. Meyer is an accomplished audio director with more than 17 years' experience having managed the audio departments at Berkeley Systems, Shaba Games, Free Range Games, and now Sucker Punch Productions. He was also a lead sound designer at Konami. In his career, Brad has worked on most pieces of hardware from cellphones to consoles to PCs on franchises such as *inFAMOUS*, *Spider-Man*, *Shrek*, *Tony Hawk*, *Frogger*, *Dance Dance Revolution*, *Teenage Mutant Ninja Turtles*, and *You Don't Know Jack*.

Brad has a keen interest in interactive audio systems and strives to push the technological envelope of each platform while designing meaningfully emotional soundscapes. He has extensive knowledge and experience in systems design and technical sound design and is proficient in several scripting languages. Brad is a frequent contributor to gamasutra.com and designingsound.org covering pertinent topics in sound design for the modern developer. He has also lectured extensively on game audio and served on the Program Advisory Committee for the Audio Production department at the Art Institute of California—San Francisco.

Brad is an ordained minister and a doctor of metaphysics *and* immortality, so he can talk about the constructs of our physical realm or marry you to the human of your choosing.

www.bradleymeyer.com

Describe your thought process for creating music and/or sound effects.

When creating a new sound, I usually start with a brainstorming session in which I try to conceptualize what I want my sound to actually sound like. I usually end up with a short laundry list of some ideas of sounds and things to record. Ideally, I then go out and start recording. Part of the voodoo will often happen during recording: tweaking something one way or rubbing something against something else often creates the perfect sound I never would have normally considered. My next step is what I call "assembly." This is where I start to layout ideas for the actual sound effect in my DAW. This could be things I've recorded or sounds from my library. Sometimes things just fit right in as is, but often there's some kind of tweaking involved whether that's just pitch or EQ or something more drastic like spectral gating or morphing. There's invariably some rounds of tweaking and adding effects where

suitable. Once I get something I think I'm happy with, I'll bounce it out, master it, bring it into the engine, and play around with it, then repeat steps as necessary.

Is there any specific method to your creativity?

Creativity is as much about experimentation as anything. Trying stuff, recording anything and everything, playing around with plug-ins, learning a new technique. Any experiment is a good thing that will help you as a sound designer even if the end results for a specific sound don't work out.

Inspiration is another great place where I find creativity. Sometimes, it's as simple as listening to a movie or a game and deconstructing the soundscape and individual sound effects. Other times, it's talking with friends and colleagues about techniques or bouncing ideas off of friends. The game audio community is such an amazing resource for inspiration and brainstorming.

Are there any secret techniques that you regularly employ?

If there was a secret technique and I mentioned it, it would no longer be secret. Seriously I happily share my creative process with whomever asks, but an interesting thing I find is that across all the immensely talented sound designers and composers I know, I don't think there's a strong common thread of how to create something wonderful. We all seem to have our own methods (which are hopefully constantly evolving).

If I'm totally stuck on a sound, taking a break, going for a walk, or having a change of scenery can often help get my brain in a more creative position. When I lived in Hawaii, I had the benefit of working right across from the beach and would often float in the ocean trying to conceptualize how I wanted Frogger to sound. Nowadays, I may just go for a walk around the block or sit outside for a minute to clear my head.

Do you have any interesting sound gathering/sound creation stories?

So many. Some favorites:

Diving into the ocean at Kualoa Park to simulate cannonballs for a ship battle in *Ys VI: The Ark of Napishtim*. I was jumping in while Jaren Tolman, our lead sound designer, was holding the boom and our other sound designer, Stillwind Borenstein, was running the ProTools session on his laptop.

That first swing of a hammer into a melon for a gore recording session also at Konami. So perfectly wet, juicy, and disgusting.

Creating and recording a thick, goopy mixture of cornstarch and water with a turkey baster for the symbiote movements in *Spider-man: Web of Shadows* and watching my coworkers stare at me with a mix of awe and what-is-your-problem looks.

Coming across fresh bear tracks in the backcountry while recording for *SummitX Snowboarding*. Fortunately, that was all we saw of the bear, and fresh spring corn snow made its way into the game.

Recording in a glass artist's studio with Andy Martin and being lured into a metalsmith's workshop next door since he had some cool, old machines that he thought were neat and we would want to record them. He was right. Some super awesome WWII-era machines. The fun thing was how into it he got; excitedly taking us from one machine to the next showing us where the coolest sounds came from and running each one so we could get some good captures.

Recording at a blacksmith's shop (also with Andy Martin) where we asked the blacksmith, David Lisch, to heat up some iron and clench it in water. We were getting some awesome sounds of the water bubbling as the hot iron hit it when I remembered I brought my hydrophone. The sound of the water bubbling from inside the bath was pretty awesome, and I'm looking forward to finding a use for it someday.

Rolling a trash can stuffed with foam and concrete chunks around the office to create some of the continuous concrete movement power sounds for *inFamous Second Son*.

And really just that look of bewilderment and wonder of coworkers every time they see me with a microphone.

Do you have any advice which can help lay solid groundwork and ensure a successful production for the audio content creator?

Be persistent. Be inquisitive. Be a ceaseless champion of all things audio. Share your passion with others to teach them the power of sound. Keep an eye on your workload and your schedule and prioritize to ensure a balance of quality work and quality of life.

Do you have any interesting sound design creation techniques which affect the type of sounds you create?

I focus mostly on recording and manipulating sounds to make my content. I used to use a lot more synthesis than I do now and I attribute that in part to working with Andy Martin, who is a fantastic, inspiring, and insanely talented and creative sound designer. The sounds I'm going for will often dictate my methodology in regards to microphone usage/placement, but beyond that while I may have an idea for how to capture the sound I want, experimentation is key.

When do you find you are most creative?

When I'm well rested, not stressed or overworked, and excited about a project. Usually happens in early or preproduction, but sometimes ideas just come randomly in the night. Like why haven't I ever recorded the sound of peanut shells being crushed? (There's a giant bowl of them now on my desk waiting for a free moment to be slaughtered for the sake of sound design!)

Any worthwhile creative advice you'd like to share?

Don't be afraid to fail. Doing something wrong will usually open up doors to a better solution.

Is there a typical workday for you?

Not really. I mean nowadays as I'm settling into middle age, I get in a lot earlier than I used to (9 a.m.!!!!) and leave around 6, except during crunch. While there's a lot of commonalities in an "average" workday: running around talking to different team members, following up, answering questions, going to meetings, providing direction to my sound designers, doing stuff in Wwise, scripting, having a cup of coffee in the afternoon, and hopefully actually designing some sounds, every day is always a bit unique in the work I do and decisions I make.

What skills should composers have to succeed in the games industry?

An understanding of the unique demands of games. It also helps to have nonlinear, adaptive scoring techniques and ideally some experience with Wwise or FMOD. Also important, if not more so, is the ability to communicate and the willingness to experiment.

Do you have a specific ideology which drives your way of doing business?

Be fair to your client, but don't undervalue yourself.

Any good business advice to offer?

Be creative! Especially in the indie/start-up realm. Pro bono work should be avoided, as it undervalues the whole industry, but there's more than one way to be compensated for work.

How do you approach negotiations with a new client?

I usually start with a meeting (phone, Skype, or preferably face to face) to get a sense of scope, project, needs, budget, etc. From all of this, I put together a bid as comprehensive as I can and present it to them, ideally in person so we can discuss it further.

Do you have any contract stories which others could learn from?

Be wary of micromanagement and inefficient time sinks. If there isn't already a working relationship with a client, I may add a line in my contract limiting the number of revisions for a delivered sound without further payment to prevent being taken advantage of. You always want to keep your client(s) happy, but you should be mindful of doing so at the expense of your quality of life.

It seems like, unfortunately, the larger the company, the longer it takes them to pay you. When contracting for a small start-up, I always got paid within a month or so. Trying to get vendors and contractors paid working for some of the large corporations I've worked for over my career has sometimes taken 6 months or more!

Do you have any tips when working with developers?

I've spent almost my entire career working for developers with a few contract gigs interspersed from time to time. In those instances where I have been a contractor I have found it imperative to stay in frequent contact with the developer. As in any relationship, communication is so important. Not only to ensure you're in the loop for anything that may affect you, but it helps you build rapport and once a developer trusts you, they will often give you a bit more creative freedom. Trust and communication are probably the most important foundations for any business relationship. Far more so than Pro Tools chops or a nice mobile recording rig.

What advice can you give when working with a developer which has ensured a good working relationship and a good final product?

ABC: Always Be Communicating. Be open to revisions and feedback. Use your expertise and knowledge to help the developer achieve their goals. (Often they don't realize their audio goals and it's up to the audio designer(s) to define and execute them.)

What advice can you give when working with a developer to ensure you are able to make great sounds?

Try to ensure you have enough time in your schedule to experiment and iterate with the team. If it's a solo gig and you don't have enough time and you can afford it, hire another designer to help you so you can focus on quality rather than mere coverage.

Making great sounds is not only about creating great sound effects, it's also largely about implementation and mixing. If you need programmer support, speak out early and often. In regards to mixing, you should be mixing the game constantly throughout development, but

try to also carve out some time at the end of the project during bug fixing to do a comprehensive pass of the entire game. Ideally, changes will have settled down by then and you can have a pass at the game in its near final state.

Have you ever had any development issues negatively influence your workflow?

The hardest time for game audio is traditionally toward the end of a project. We're trying to finalize content and tweak the mix and invariably things are changing all around us. It can be very disorienting and challenging to stay on top of the swirl of new work, revisions, requests, and bugs. Do what you need to stay on top of everything. This could mean tracking your tasks with the software of your choice, enlisting the aid of a producer, or delegating work to others. Regardless, DON'T PANIC. Time spent freaking out is time that could be spent assessing the issues at hand.

Years ago, Rob Bridgett at Radical Entertainment lobbied his team for separate audio milestones 2–4 weeks after the rest of the team which would give them time to react to late changes and also set the schedule more reasonably to allow the fallout to settle and for people to understand how much audio is affected by their changes. At Sucker Punch, we do something similar albeit not as formal whereby all the tail end people (lighting, sound and visual effects) are given more time at the end of the project to finish their work, respond to changes, and fix things with less scrutiny than the rest of the team because of the pressure we're under and the way we are cascadingly affecting by other changes to the game.

Do you have any advice to ensure successful audio implementation?

Know your tools. For example, in Wwise, there are often multiple ways to do one thing. Some may be more efficient than others in regards to memory or CPU usage, other times there are no difference. Know the tool and you can make the right decisions early on rather than trying fix a whole project toward the end.

Learn scripting. I came into the industry when we would throw our sounds over the fence to programmer to hook up and then go ask them to do stuff like randomize the sounds or pitch. As the industry has evolved and we've gotten tools to do much of these things ourselves, there's still a level of power you can only access with scripting or coding knowledge. Most teams do not have a dedicated audio programmer (it's considered a luxury, but should be mandatory). Knowing how to script is not a substitute for an audio programmer, but it will give you the power to achieve more of your goals.

Communicate! It's rare that one person can handle all the implementation for a project. Scripting can take you a long ways, but invariable programming resources are often needed. Figure out your needs early and work with your team to ensure resources are allotted for you to achieve your goals.

Staying organized is important, especially if you are working on multiple projects, which is part of your daily routine. How do you keep up with it?

Communication is most important tool to keep up with the ever shifting world of project development. E-mail, IM, chat rooms, wiki pages, and most importantly face-to-face talking keep me in the loop with what's going on. I'm also a Perforce troll. Reading every change list that gets checked in helps me ensure that nothing slips through the cracks. If I see a check-in that I think may have sound needs that I don't know about, I go over and discuss it with the person who checked it in, evaluate the needs, and add it to my schedule.

Any specific "lessons learned" on a project which you could share?

Audio should not be something reserved for the end of a project. Get involved as early as possible. Since *Spider-Man Web of Shadows,* I've done audio concepting on every project I've worked on, experimenting with audio concepts, sound palettes, and systems design in pre-production. Starting early not only gives you a leg up on the actual production schedule, but it also gets the rest of the team engaged with audio early and keeps audio on people's brains which is critical for success.

There are many pitfalls when "working" in the game industry. Have you had any bad experiences?

Crunch is a natural one.

Canceled projects can happen a lot, and are often a demoralizing time. All that work and energy: gone. But it's something you need to learn to deal with. Something I struggled with early in my career was this notion of having a creative job, making art for a living. But never lose sight of the fact that it's commercial art. You're doing it to get paid (and ideally because you're passionate), don't let your work get to precious because sometimes your darlings get killed.

Working on a project and having the funding yanked: always a pleasure. As is working for a start-up constantly on the edge of going out of business. Never sure if you are going to get paid and just hoping a publisher would pick up one of your titles. Ah … good times.

Do you have any development stories which served as a good lesson learned or something which can be avoidable in future projects?

I've worked on several big projects with VERY small audio teams. As is often the case, things slip through the cracks or get added at the eleventh hour while forgetting to notify the audio team. On a recent project, I changed my process where I would stub in sounds whenever new content came online. They weren't ripped from a commercial library and dropped in or anything, but they didn't have the love and time of proper design applied to them. As things began to harden in the game, we would go back and do a final pass on these sounds. It gave us coverage, where there were no missing sounds in the final product, and also felt like it gave us more time to focus and concentrate on the design of the critical elements of the game.

Any horrible endings to a project which others could learn from?

Horrible endings are often a confluence of many things in many areas going wrong. I've worked on more than my share of nightmare projects, but each one has served as a learning experience, which is something to take away from every project: no matter the success or failure, there's always something to learn and improve upon.

Any other advice you'd like to share?

You're not alone. There's a huge supportive community out there and if you're willing to put your passion to work, you can achieve your goals.

How did you find your way into the games industry?

I lied and I got lucky. At the same time. You can read the whole story here: www.bradleymeyer.com/wp-core/2013/04/.

same instrument were sized similarly and all were saved as separate *.wav* files. These files were then imported into a dedicated hardware sampler; that is, a piece of musical equipment that allows playback as notes are triggered from a keyboard or other MIDI device.

Inside the sampler, each individual sample was assigned an instrument patch and a range of notes to be played over (technical terms such as *key grouping* and *key mapping* describe this process more accurately). Discrete MIDI channels are assigned to each instrument group, organizing separate patches for easy sequencing and manipulation. Much time is spent testing these sounds to ensure there are no dead spots and that all of the notes blend naturally. Simple adjustments and tweaks are made to make the digital files sound musical. Once everything is set, the samples and key groups are uploaded back into the computer, burned to CDR, and tested a final time in the sampler. Sample selection, editing, and the loading process ended up taking the better part of the day, and after 2 days, a note has yet to be composed. We'll remedy that shortly.

A lesson developers can learn from this is that technically a lot of work has to be accomplished before actual music creation can begin. In this case, we are creating a sound bank for a PlayStation 2 game—but similar processes are involved for "standard" music creation as well. The composer must choose from their array of sounds, the ones that fit together and belong in a specific game. They must set up keyboard rigs, samplers, and other instruments. Some composers will try to leave their studio setups plugged in and ready to go, but because different types of music require different processes, preparation time is always a necessity.

After the technical aspects are dealt with, the composition phase can begin. I started early the next morning by firing up the keyboard rig, loading samples and key groups, and opening a sequencing program on the PC. The software would become the canvas, where separate layered performances would trigger sampled instrumentation to be saved in the final requested *.mid* format.

There is no one way music composition begins. Composers have their own methods that can even change from project to project, depending on their resources. In this case, the dance style dictated a solid groove as the foundation, so I began with drums. The electronic drum kit was maneuvered center stage and I spent about a half an hour beating out ideas. Another 15 minutes and a drum take I could live with was recorded to the sequencer. In the sequencing program, I spent some time cleaning and tightening up the performance and setting a good loop point as close to the 30-second mark as practical. The beauty of a sequencer is the ability to move drum hits around and to add parts that a human couldn't possibly play. Next, a half hour was spent creating percussions (bongos, woodblocks, tambourine, and such) to complement the drum pattern and give inspiration for the performances to come. These were also cleaned up in the sequencer and saved to the working file.

With a solid groove established, I tried a couple of different approaches in search of the music. I started with the bass then moved to the piano to see how these ideas were fitting together. After about an hour, a legitimate idea was forming and I pushed to flesh it out. Another half hour later, the main piano and bass line were recorded with acceptable results and it was into the sequencer again to clean them up.

Next came the organ, with some arpeggio riffs and spark of a melody, another hour had these recorded. Some synth counterpoints and exclamations came to mind and these were recorded next. This was a good point to step back and listen to the piece as a whole because most of the elements were in place.

After some lunch and fresh air, I came back to the studio for a clean look at what I'd been up to. A few minor tweaks were made here and there, adding chords instead of single notes and making volume adjustments. Just for fun, I threw in some subtle bongo rolls and other punctuations and spent the remainder of the day fine-tuning the piece. It was sounding great and I was thoroughly convinced it would fit the bill. Now that I was happy, it was time to get the opinion that really mattered. An audio .mp3 version was made and sent off to the producer and I shut down for the night, waiting for the thumbs up.

The next day, I received the blissful word that all content providers long to hear. The client accepted the cue! And off I went to work on the next in the series of contracted cues. After the music was completed, the final step was to whittle the sound bank from the 5 MB I was using to the 2 MB required for the PS2 console. The sounds were all recorded as 44 kHz, 16-bit, mono audio, and the goal was to keep the quality as high as possible. I first threw out sounds that didn't get used and then shortened long sounds that weren't sustained. This narrowed the collective size down to 4 MB. I looked at what instruments could possibly be combined, desperate for any space at all. Even after dumping one instrument, the savings were inconsequential and I decided to resample instead. In the audio editor, the sound files were resampled to 22 kHz, leaving them at 16-bit resolution and burned to CD.

The final phase was to test them in the sampler and in the cues. Some very minor adjustments needed to be made, mostly volume parameters, but overall, the music remained as intended. I shipped out the new sound bank disc and the updated .mid files and that was that.

The total amount of effort for this one 30-second music cue came to 4 days. Two days were spent in preparation, getting organized and readying the sounds. The last 2 days were spent composing, tweaking, and delivering the final sound bank. It was a lot of work—basically, 96 hours for a 30-second return on the investment. This is a great example of the "behind the scenes" efforts most developers never see, so be sure to keep this in the back of your mind when asking for music with a short deadline.

Soapbox Time

Pardon me for a moment while I get up on my soapbox, but this is worthwhile, I promise. Producers and developers who are naïve to music and sound effects creation tend to place undue demands on the composer and sound designer and/or ask for the impossible, and in the process kill any inspiration. It is tremendously frustrating to negotiate and work with those who don't know the basic concepts of our processes. One original sound can take 2 hours on up to create; it is not just taking something from a sound effects library disc and converting it to the needed format. One minute of original music can take 8 hours or more to compose and record, depending on the style. A lot of hard work, creativity, and several days' preparation can go into creation. An entire game can be done in 2 weeks, with much pressure on the audio content provider, but it can take a month or two easily.

The art of music and sound design is just that: art. Composers and sound designers are artists complete with egos, emotions, and insecurities. Great music and sounds cannot be regurgitated on command. Please keep this is mind when making requests.

Thanks. I'll get down now.

The Next Step

After the music and sound effects are created, other matters should be focused on to guarantee the audio will fit the game like a glove. Maintaining consistency is the first issue a sound designer and composer must apply. All sounds need the same character; that is, the element that cements it to this (and only this) game. Having a sound distract the player during gameplay because it sounds similar to another game they are familiar with or is out of place breaks that spell.

The best way to ensure consistent game audio is to have the audio provider devote time to *only* your game for the duration of the project. Ask prospective contractors up front whether they can commit solely to one project at a time. Often this focus alone will obtain the consistency you are pursuing. For instance, sound designer Joey Kuras had to revisit the sounds he created for *Tomorrow Never Dies* many months after he had completed the initial sound list. After designing the new sounds, the old ones didn't sound right. He ended up spending extra time EQing and adjusting the volume of the other sounds to bring them up to the new level. Although he used the same equipment as the first time around, his mixing board and equipment settings had changed enough in the interim to make the new effects sound different. By adjusting all of the effects at once, the chance of this is more remote—and greater consistency results.

An additional step to ensure consistency across your audio is to process all game sounds using the same sound processor settings. Using the same EQ, volume, reverb settings, and so on will furnish them with a similar feel.

Another concern to address with your composer and sound designer is that of quality assurance. Some believe this process does the most to guarantee the sounds work perfectly in a game. Every composer, sound designer, and many producers I've talked with insist the audio experts listen to their sounds in the *actual* game. Typically, this happens around the time the game goes into beta, when the music and effects should be in place. The sound team should sit down and study their audio intently. It's not uncommon for audio to sound great in the studio but not so hot (too loud, too soft, too long, or too short, for example) once it is synchronized with the action in the game. As related in a previous chapter, while analyzing the audio in the beta version of a game he was working on, Joey Kuras discovered a programmer on the project had taken one of the effects (the sound of footsteps) and bumped up the volume. What was intended to be subtle, barely discernible Foley effects turned into a loud series of crunches as loud as gunshots! Thankfully, Joey's screening session caught the problem and it was corrected in time.

Production Nightmares

In a perfect world, the audio creation process would go off without a hitch. The audio would come in on time, on budget and would be precisely what your game needs to make it a hit. But we all know there is no such place. We strive, instead, to keep the pain of the process at a tolerant level and just deal with it.

Many variables can come into play as the laws of Mr. Murphy blossom exponentially. The producers may not choose the proper adjectives to describe the game and in turn, the description may not mean the same to the content provider. The production could go through so many changes the composer or sound

designer loses interest. The audio guy could suddenly become a monk. We've all had our own experiences to share. Many, I'm sure, we'd rather forget altogether. But, I'd rather we all learn from them and not be doomed to repeat history.

I once ended up replacing a sound designer late in the production of a fantasy game because the producer was becoming ever dissatisfied with him. It seemed the milestone work was being submitted later and later and the overall creative quality was rapidly declining. He became unpredictable to the point where weeks would go by without ever hearing from him and then the work he did submit stunk. It turned out that some of the magical spells used by various wizards in the game were just him recording profanity and simply playing them backwards. While it wasn't recognizable, someone with audio editing software could reverse it and a possible lawsuit could develop.

That was something this small developer couldn't afford. I was able to step in late in the game and help out. The other guy? He was never heard from again.

Lee Moyer, founder and executive producer of the former Digital Addiction (now head of Lee Moyer Design and Illustration), related this story.

As we were working solely in online games, we needed only the shortest of sound effects so as not to blow our "bit budget." We had two spells in our game *Sanctum* that provide the only noise as effects: Elven Piper and Organ Grinder. These spells were given only to beta testers and were therefore valuable due to their scarcity. Some players went months before first encountering the drone of Elven Pipes. Since we desired short, almost existential, sound bites to score some of the 375 spells in *Sanctum*, there was a need for sound help. The first sounds we got back were created by a contractor. They all sounded okay, but did not seem to match the actual effect within the game. Our contractor's taste did not match our own understanding of the virtual world we'd created. Conveying our needs to an outsider was almost impossible, and so we turned inward. We had a musically talented staff and the sound libraries we needed. Company founder and lead programmer Ethan Ham and QA lead Matt Hulan did the lion's share of sampling, playing, and editing.

Mark Temple, owner and Executive Producer of Enemy Technology, has many games to his individual credit. One of his biggest pet peeves is trying to work with composers and sound designers who are not computer literate. Yes, believe it or not, even in this day and age there are still some out there who don't know much beyond their immediate sound applications. He has made several treks during hectic schedules to visit a contractor just to get a copy of the game running. He's also had to instruct them how to zip and unzip files, attach sound files to e-mail, or to connect to the company FTP site. It gets a little frustrating when your efforts should to be focused on producing the game, not troubleshooting someone else's lack of knowledge. He makes it a point when hiring anyone that they know their way around a computer.

Mark offered other situations he has faced and ideas we discussed to avoid them. While in the middle of a contract, his sound designer left the project with half of the milestones complete and half of the sound effects budget. A new sound person was brought in, but the effects had a different quality and it became difficult to match the previous work—not to mention the time spent to "spool up" the new guy. Reluctantly, they opted to start from scratch, thus going over the sound budget and past their time schedule. People leave in the middle of projects all the time—sometimes for creative differences, sometimes

because they don't get along with the development team, or sometimes because a bigger carrot has been dangled in front of them elsewhere. There are as many different ways to prevent this as there are reasons to leave. Honest communication and understanding of the creative processes involved is a good start. Contract points that give the proper incentive (such as increasing the milestone payments with the largest at the completion of all work) are another option, but overly aggressive ones will spoil the relationship early. Find the balance.

A potential contract sound designer whose work was outstanding, wanted to do the job but didn't have the right equipment or money to buy it. He didn't get the job in this case because neither party had the resources to make it happen. Developers in the past have been known to either loan or buy equipment for the contractor. It depends heavily on the need for the contractor and the cash flow of the developer. In this case, though, it was seen as a lack of commitment from the sound designer. Talk about it together and see what solutions are available before passing on the deal.

Attempting to "one-stop shop," Mark found few sound designers who could also compose and produce music. The idea was to bring one less member onto the team to save time and money. Looking in the right place may have helped this situation. If they had done previous research, they could have had a list of names and demos at their disposal—but that didn't appear to be the case. There are plenty of online sites that cater to this very thing. (See the website resources listed in this chapter.)

Conclusion

There tends to be a stigma attached to hiring any outside third-party contractor. It seems a highly unnatural act to search beyond the company walls after you've spent a tremendous amount of time and effort collecting and nurturing your own talent. But, even established companies with in-house audio departments need to look elsewhere on occasion, especially when a flood of work drowns your staff or when everybody goes on vacation at the same time.

Many arguments can be made regarding in-house audio talent and contractors. If you have the financial resources to pay someone to staff your audio department, despite not having enough work to keep them busy, these particular bragging rights might become expensive. Hiring outside help only when there is work to be done can actually make good sense. Some very large game developers have recently let their in-house staff go for this very reason. It is often cheaper to hire a contractor as they are needed rather than have someone collecting a paycheck with no work on their plate.

Artists are more creative in the worlds they have designed for themselves. Avoiding a rigid nine-to-five schedule lets them budget their own time and work when they are at their best. Their happiness and security can definitely be heard in their much inspired work.

Working with these types of people is no different than coaxing excellence from your other team members. Graphic artists, programmers, composers, sound designers, actors, and voice talent are all looking to you for the proper motivation and mothering—and although the audio contractor is not immediately within the corporate view they respond to the same positive stimulus as well.

Tools of the Trade

NEAL ACREE
Composer

I find more value in having a smoothly running studio than in constantly staying up-to-date and dealing with software incompatibilities and spending creative time on troubleshooting. I also believe that knowing your library inside and out is of more value than having every new library that's out. While I am inspired by new sounds and do invest a decent amount of time and money in them, much of my sonic palette has been in place for years and I know every sound, texture, and frequency in it. This is essential to streamlining the creative process.

Audio interface: Apogee Symphony I/O

Software: Logic Pro for composing, Pro Tools for mixing

Sound modules/VST instruments: Kontakt, Vienna Ensemble Pro

Keyboards: Yamaha KX-88

Triple-A titles can be an expensive endeavor and the audio budget alone can be very large. $750,000 isn't uncommon for a larger game, with at least two full-time in-house employees focusing just on audio, this makes the cost of audio an easy $1,000,000 and up! That's not to say that great audio can't be created and implemented for less, but also consider that film composers can demand a minimum of $2,000,000 for a triple-A film—and that's just for the music. Games are serious business and if the publisher wants serious talent working on it, the budget, man hours, and schedule definitely need to reflect it.

Even though there are no hard and fast rules, no secret formulas, and no prescribed methods for creating the consummate assemblage of audio for a game, it can happen. It takes fluid communication and a firm vision from the development team, coupled with audio contractors who show no bounds to their creativity and patience. Together, we can take on the gaming world and keep them lining up at the stores. I'll see you there.

16

Postscript

Game over? Not hardly. Audio for the video game industry is a continuous pursuit. For the composer, musician, and sound designer, it's a quest to be heard, to create noteworthy compositions, to sell them, to make a living, and maybe to gain a little notoriety in the process. For the developer, it is the aspiration to take their game to the next level with the ideal audio enhancement, to create a truly entertaining experience, and entice consumers to spend money on their product. It's by no means a simple proposition for anyone, but when it does work, it is a beautiful thing!

Getting into the game industry will be easy for some and very difficult for others, but whichever way it happens for you, don't take it at face value. You need to also be able to sustain yourself. Some will get a job with the first phone call they make, others will get 100 "no's" before they ever get a nibble. The ultimate trick now is to use that momentum to get the next job and the next and the next. Be sure to look in the right places, make yourself known, and use every bit of talent and skill you were born with. You will need all of it every day of your new career to establish a solid foothold in the industry. It can be done, and you can do it!

Once you do become involved in the games industry and begin pumping out massive quantities of incredible audio, be sure to also take care of yourself, your family, and your industry. Always do your best work and what's best for the project. The optimal way to attract new clients is to offer superior workmanship on every project. This keeps you in demand and the standards high throughout the industry. Never give your music or sound effects away for free or below cost. This only cheapens your work and other game audio creators' worth. By charging rates similar to everyone else, the people who make a living at this endeavor won't

have to lower prices to match those who are giving it away. Don't let yourself be taken advantage of. While most game developers are part of honest, hard-working companies, there are a few without scruples who will sway you into poor decisions that will cost you money. Always protect your interests and remember that you are in business to make a profit—definitely not to take it in the shorts.

You've read all about the ins and outs of game audio, from the composer and sound designer's side to everything the developer has to consider. You know what tools you need, how to get organized for business, where to look for work, how to make the deals, and that ever important skill of actually doing audio for the various game platforms. It's been an enlightening tour—one that I hope has given you the insight to fulfill your personal and professional goals. Many game composers and sound designers are incredibly happy in the games industry; there's no other place they'd rather be. There is so much to offer the skilled artisan, and anyone of you with the ambition can be quite successful at it.

But, don't let it stop there. This book was originally conceived by the surprising feedback I received from my early articles in *Game Developer Magazine* and on Gamasutra.com—by the many people who typed in my e-mail address (the current one, by the way, can be found on my website, http://onyourmarkmusic.com) and told me what they thought. Their questions and concerns are what became the basis of this project and I've incorporated every one of them here.

So, let me know what you think. Did this book help you? Did you learn the skills to thrive in the games industry? Did I accomplish my goal? Let me know how you used this information and what it did for you, and most of all, please share your successes and the experiences you have in the business. I'd really like to hear them. And if you ever see me wandering the aisles of GDC, E3, SIGGRAPH, ComicCon, or any of those other glorious trade shows, be sure to come over and say "hi." I'd really enjoy meeting you.

Take care, work hard, and make us proud!

Appendix:
The Grammy Awards
and Other Game
Audio Awards

So, fame, fortune, and the satisfaction of a job well done isn't quite enough motivation for you, huh? Well then, how would you like a Grammy Award for your troubles? Starting with the 42nd Grammy Award Ceremony in 2000, game scores were at last able to compete for one of those enviable golden gramophones. The National Academy of Recording Arts and Sciences (NARAS) Board of Trustees approved three categories to include music written for video games:

- Best soundtrack album for motion picture, television, or other visual media
- Best song for a motion picture, television, or other visual media
- Best instrumental composition for motion picture, television, or other visual media

Other visual media is the term designed to encompass video and computer games, multimedia, and the future possibilities of the Internet into one tidy little package.

Eleven years later in 2011, the game audio gods were smiling down as Christopher Tin accepted a Grammy for his theme to the game *Civilization IV*, Baba Yetu, at the 53rd Annual Grammy Awards in the "Best Instrumental Arrangement Accompanying Vocalist(s)" category. Because this piece had been released separately on Christopher's own classical crossover album *Calling All Dawns* in 2009, it was eligible outside of the "Other Visual Media" categories even though it had been specifically written for a game.

While we hope that this considerable win draws more interest to our little corner of the world, the story behind the struggle just to be eligible in the first place captured

its own significant attention. Our very own game industry music notables—led by powerhouse Chance Thomas (*Lord of the Rings Online, James Cameron's Avatar: The Game, King Kong, Dungeons and Dragons Online, X-Men, Heroes of Might and Magic, Quest for Glory V: Dragon Fire,* and *Dota 2*) and supporting cast (Tommy Tallarico, Mark Miller, Ron Hubbard, Brian Schmidt, George Sanger, Bobby Prince, Tom White, Michael Land, Alexander Brandon, Murray Allen, Greg Rahn, and others)—presented a persuasive case to the Awards Committee.

And to think this all started by accident. Chance Thomas had met one of the key leaders of the Academy and during a conversation, mentioned composing for video games. This man of great stature and influence scoffed, wrinkled his nose, and said, "You mean, like *Pac Man* and *Donkey Kong*?" If only outwardly unaffected by the situation, Chance explained he had just completed a game soundtrack using a live orchestra and other high-brow instrumentation such as classical guitars and layered voices. The nose became unwrinkled and eyebrows raised in pleasant surprise. Now that he had the Academy member's attention, he casually asked if there could ever be a Grammy category for game scores. The answer even surprised Chance, who was to write up a formal proposal and send it to the address on the business card being thrust into his hand.

Thus began a 2-year journey into what Chance has described as "like getting a bill passed through Congress." Endless letters, e-mails, phone calls, faxes, meetings, and an ever-growing number of allies on the inside led the Awards and Nominations Committee to eventually review the proposal. Their interest became evident when they scheduled a Game Music Summit in December of 1998 with a dozen of the game industry's top music professionals. This Working Group on Game Music Awards and Membership opened the eyes of the committee, giving them clear insight into the quality of game music. On May 6, 1999, NARAS made the announcement many had eagerly anticipated: Game scores would be allowed to compete for Grammy Awards beginning with the year's 42nd awards ceremony.

This new attention can only be positive to gaming and to the music makers within the industry. There is no better advertisement than putting "Musical Score by Grammy Award Winner..." on the box cover.

Who's Eligible?

Because the Grammys are awarded to honor excellence in recorded music and the music is judged on its own merits, not just any game soundtrack is eligible. Many past and current games have an outstanding score, but unless the music is available in its own stand-alone format it won't be considered.

To meet the eligibility requirements, a game score has to be commercially available as either its own separate music CD or stored in Red Book audio format on the game CD-ROM or "enhanced" CD (able to play on a standard CD player). NARAS has the exact definition of a commercial release, but for our purposes, it must be a serious commercial distribution and not from our own "vanity" label (i.e., not burned on our CD-R and available only through our personal website).

NARAS Details

Are you interested? Let's talk about how to become a part of it all, shall we? There are three categories an individual may join for the Recording Academy.

GRAMMY AWARDS
February 23, 2000
8 pm, ET/PT on CBS

This is where it all began for game scores—the 42nd Annual Grammy Awards. While no game scores were nominated for a Grammy, the long road to eligibility had finally come to fruition. (Courtesy of Grammy.)

Voting Member

This is where everyone wants to be—an actual voting member of the Academy. You and your peers determine who will be nominated and who will win a Grammy by two separate rounds of voting. Professionals with creative or technical credits on six commercially released tracks (or their equivalents) and those who have had credits as a vocalist, producer, songwriter, composer, engineer, instrumentalist, arranger, conductor, art director, album notes writer, narrator, music video artist, or technician are eligible in this category. Proof, such as photocopies of album jackets or liner notes, is required.

As game composers, most of us will be eligible in several categories—everything from songwriter, arranger, and engineer to musician and producer. And if you have at least six tracks on a single game, or on a combination of others, you are eligible for this category.

Associate Member

This nonvoting membership is open to creative and technical professionals with fewer than six credits and to other recording industry professionals such as writers, publishers, attorneys, label staff, and artist managers who are directly involved on a professional basis in the music business. By joining this category, you are getting involved and showing your support for the process. And after you have your six credits, it's an easy transition to Voting Membership status.

Student Member

This category of supporting members is made up of college students pursuing a career in the music industry. This level allows students access to networking, educational programs, and performance opportunities and prepares them for their future in music.

Applying

The applications process is fairly easy.

- Go to www.grammypro.com/join.
- E-mail mailto: memservices@grammy.com.
- Call (310) 392–3777 for an application.

Fill out the application online or mail (or even fax it back), along with any proof of participation and membership fee and you are set. After the Academy's membership committee reviews your application and verifies your eligibility, you will receive notification of their decision.

If applying for Voting Membership, you must list your credits and show proof by way of a copy of the album jacket or liner notes. Associate membership also requires proof of credits (if you have fewer than the six credits for voting status). Alternatively, send a business card and detailed description on your company letterhead outlining any professional affiliation to the music industry for consideration.

Other Game Music Awards

While NARAS is the most prestigious organization to recognize musical achievement, they are not the only ones who acknowledge excellence in our work. The Game Audio Network Guild (G.A.N.G.), a nonprofit organization focusing on the advancement of interactive audio, recognizes excellence in game audio at their yearly awards ceremony. The G.A.N.G. Awards identify the highest quality and achievement of individuals, projects, and products which offer a significant and positive impact on the art and craft of producing interactive audio, its community, and the interactive industry as a whole. They recognize music, sound design, and voice acting as three distinct disciplines and judge them on production value, quality, innovation, and impact on the community. G.A.N.G. can be found on the Web at www.audiogang.org/.

The Academy of Interactive Arts and Sciences (AIAS) offers the Interactive Achievement Award in the Best Sound Design and Best Original Score categories at their yearly presentation. This previously combined category was split after a proposal, considerable lobbying, and follow-up by a now familiar name, Chance Thomas. Awards are usually presented at GDC or other major game-related conventions. This is also a superb way to show your support for continued industry excellence. "If we will support and nurture this, our own Academy," Chance Thomas adds, "it will become meaningful to our careers in offering education, networking opportunities, legislative support and of course an award that means something to our peers." More information and a membership application for this growing organization are available on their website at www.interactive.org/.

In addition, there are also several industry and other events which hold their own yearly awards competitions. The Game Developers Conference (GDC), Independent Games Festival (IGF), *PC Gamer* magazine, Spike TV, and the British Academy of Film and Television Arts (BAFTA) are among some that recognize achievement in various video game categories—including music and sound design.

And you thought nobody would care about all your hard work. Granted, it wasn't always this way—but thanks to many of our long-established colleagues in the games business, we can now have something to show for it besides a paycheck.

Index